ATLAS OF EMOTION

ATLAS OF EMOTION

Journeys in Art, Architecture, and Film

Giuliana Bruno

Verso, New York

First published by Verso 2002
This paperback edition published by Verso 2007

The Moral rights of the author have been asserted

Verso
UK: 6 Meard Street, London W1F 0EG
USA: 180 Varick Street, New York, NY 10014-4606
www.versobooks.com

Verso is the imprint of New Left Books

ISBN 978-1-85984-133-4

British Library Cataloguing in Publication Data
A catalogue record for this book is available from the British Library

Library of Congress Cataloging-in-Publication Data
A catalog record for this book is available from the Library of Congress

Printed and bound in the UAE by Oriental Press, Dubai.

Contents

Acknowledgments

To give acknowledgment is to revisit the landscape of people who have helped this book come to life. In 1991 I launched an ongoing seminar on architecture and film at Harvard University that, in the course of navigating space, encountered the terrain of affects. My first debt of gratitude thus goes to my students, who accompanied me on this intellectual adventure, witnessed the preliminary formulations of the project, and contributed greatly to its growth. They have been a challenging and responsive audience.

Over the years, parts of this book were developed in the form of lectures. I am particularly grateful to Annette Michelson for inviting me to speak at the pioneering symposium she co-organized on the "Cine City: Film and Perceptions of Urban Space, 1895–1995," held in 1994 at the Getty Center for the History of Art and the Humanities, in Santa Monica. Her continuous support of my work, her valued friendship, and her inspiration have enabled me to envision what the larger scope of the book could be. I also would like to thank Clark Arnwine, Jesse Lerner, and Ruth Bradley for publishing a short version of my presentation in a special issue of the film journal *Wide Angle* in 1997.

The crossover of my work into architectural territory has been enriched by a long-standing dialogue with the faculty of Princeton University's School of Architecture; there I presented early stages of the book as part of a 1994 lecture series and discussed the finished work in 1999, under the auspices of Gaetana Marrone and the Program in Women and Gender Studies. I am indebted as well to Michael Hays, Jorge Silvetti, Mohsen Mostafavi, and all who have welcomed me to speak often at Harvard University's Graduate School of Design; and to Pellegrino D'Acierno for making my work a part of "(In)Visible Cities: From the Postmodern Metropolis to the Cities of the Future" at Columbia University and Cooper Union in 1996. I acknowledge equally the stimulating panel on film and architecture held at Pratt Institute's School of Architecture in 1994, and am grateful to Frances Schmitt for inviting me to speak as part of the Alcan Lectures at Vancouver's Museum of Art in 1995.

Another of the book's bridges was strengthened by an invitation to the plenary session at the 1994 meeting of the American Association of Geographers, in San Francisco. I would like to thank the sponsoring groups of cultural geographers, the journal *Environment and Planning D: Society and Space*, Patricia Meoño-Picado, and Mona Domosh. The occasion provided the additional pleasure of roaming a hotel inhabited by thousands of geographers and conversing with Derek Gregory and Michael Dear, among others.

A fruitful crossing into the realm of art took place in Paris at the symposium "Art(s) and Fiction," organized in 1996 by Pierre Sorlin, Marie-Claire Ropars, and Michèle Lagny, who published an evolving section of the present work in a book

of the same title. My "Geography of the Moving Image" was fittingly developed at a seminar and lecture I gave in Japan in 1995, at the University of Tsukuba, for which I thank Yoko Ima-Izumi; and at the Screen Studies Annual Conference, in Glasgow, where I attended the opening plenary in 1994, for which I thank the editors of *Screen*. The thoughts that have become "*My* 'Voyage in Italy'" were appropriately tested in various transatlantic situations: especially at the 1997 AISLLI Conference of Italian Studies at UCLA, where thanks are due to Luigi Ballerini, who invited me to the plenary, and to Marguerite Waller and Lucia Re for their support; and at the 1998 Società Italiana delle Letterate Conference, in Orvieto, Italy, where Paola Bono invited me to give a keynote address, Paola Zaccaria helped me to relocate my voice in my mother tongue, and—beginning with Lucilla Albano's sensitive response—many made me feel they could hear it. Thanks to Patrizia Calefato for editing the proceedings.

A huge debt of gratitude goes to those who offered to comment on the entire manuscript: the gift of their intellectual friendship is quite moving. I am grateful to Stephen Greenblatt, who has given me the support of his wonderfully restless intellectual passion throughout the years and, in this case, put it in the service of a very helpful reading. I also thank Tom Conley, who reviewed the work in close cartographic sympathy and provided a generous and ample reading that spoke to me deeply. I am equally indebted to Mark Wigley, who amiably and scrupulously made his way through the different layers of the work, engaging me with his attentive, sensitive way of thinking and reading. His suggestions, always to the point, led to changes that substantially improved the manuscript.

A number of other colleagues and friends also have been helpful in a variety of ways. I thank Beatriz Colomina for many gestures of intellectual *simpatia*, sustained dialogue, and good times. Norman Bryson's interest in this work from the beginning, his collegiality, and his support have sustained its progress. I cherish the ritual café conversations I have had with Wolfgang Schivelbusch, which always go beyond the object of our work and touch the very process of writing. Similarly, I value the long-standing communication I have shared with Tom Gunning on our mutual scholarly passions. A dialogue on film and life matters with Laura Mulvey and Miriam Hansen has mattered much. I am indebted to Chantal Akerman, not only for letting me into her exemplary artistic world but for being a real friend at a time when it was most appreciated. I am grateful to Ewa Lajer-Burcharth, Svetlana Boym, and Cornel West for making me feel that I have more than an intellectual home at Harvard; and to Thyrza Nichols Goodeve for offering inspired commentary of my work on art and film. For their involvement, thanks also are due to Robert Brain, Elena Dagrada, Alice Jarrard, Joseph Koerner, Giuliana Muscio, Louise Neri, Katharine Park, Isabel Segura, Robert Sklar, John Stilgoe, and Henri Zerner.

I also thank my research assistants, who have helped me to navigate the intricate labyrinths of libraries and archives and who have been my closest interlocutors at crucial times. I am grateful to Nick Popovich, who assisted me in the early stages as I tested his research skills with my many tentative directions; and to Andrew Herscher, who was helpful in the evolution of the architectural research.

Thanks also are due to Renata Hejduk; to Curie Chong for copyediting the work-in-progress; and to Geoffrey Taylor for helping with permissions for the illustrations. For her many contributions and intellectual energy, I am particularly grateful to Charissa Terranova, who truly has shared my enthusiasm for this work and took part at deep levels in many moments of discovery.

Many individuals and institutions facilitated my research and helped me to realize a visual form for my ideas. The book owes much of its textual and illustrative shape to the extensive support of the many branches of the Harvard University Libraries, whose resources were so phenomenal that at times my research seemed hopelessly unending. For their expertise and for their understanding of my research needs, I particularly thank: Roger E. Stoddard, Curator of Rare Books, and Anne Anninger, Curator of Printing and Graphic Arts, at Houghton Library; David Read at the Special Collections of the Harvard Law School Library; and Dana A. Fisher of the Ernst Mayr Library of the Museum of Comparative Zoology. I also extend my thanks to Violet Gilboa of the Judaica Division at Widener Library. I am especially indebted to the resources of the Francis A. Countway Library of Medicine; the Theatre Collection; and the Map Collection at Pusey Library and its director, David Cobb. For my research elsewhere in the United States, I thank the staffs at the Huntington Library, San Marino, California; the Pierpont Morgan Library, New York; Scala/Art Resource, New York; and the Theatre Historical Society of America, in Elmhurst, Illinois, especially Richard Sklenar, Executive Director. I extend special thanks to Pat Morris at the Newberry Library, Chicago, for his help in my research on imaginary maps.

In my archival research overseas, Donata Pesenti Campagnoni, Curator of the Collections at the Museo Nazionale del Cinema in Turin, was helpful. I also wish to thank Cécile de la Perraudiere at the Archives Louis Vuitton for a delightful tour of the private museum and generous access to its archives; and Pilar Vélez and Núria Rivero, Director and Curator, respectively, of the Museu Frederic Marès, Barcelona, for a special tour and access to the museum's collection. I am grateful to Laurent Mannoni for his generous offering of material from the collections of the Cinémathèque Française; to the staffs of the Bibliothèque Nationale de France and the Musée des Arts Décoratifs, Paris; and to Bruno Ciufo at the Istituto Centrale per il Catalogo e la Documentazione, Rome, for guidance through the maze of this archive.

Many others sustained my visual research. I am grateful to Gerhard Richter and his gallerist, Marian Goodman, for offering generous access to the artist's work; and to Peter Greenaway and his assistant, Annabel Radermacher, for opening the filmmaker's private archive to me. I am equally indebted to Lillian Kiesler for access she provided to Frederick Kiesler's archive; and to Susan Edwards, former curator of the Hunter Galleries, for leads into John Eberson's work. For their generous contribution of images for reproduction, thanks are due to Louise Bourgeois and Jerry Gorovoy, and Robert Miller Gallery; Heide Fasnacht; Toba Khedoori and David Zwirner Gallery; Annette Lemieux; Annette Messager; Seton Smith; Hiroshi Sugimoto and Sonnabend Gallery; J. Morgan Puett and Shack Inc.; and Bernard Tschumi. I also thank Lynne Cooke, Curator at Dia Center for the Arts, and Karen

Kelly, Melissa Goldstein, and Bryan Walker; Lia Rumma and her gallery manager, Paola Potena; Carolyn Alexander of Alexander and Bonin; Jo-Ann Conklin, Director of the David Winton Bell Gallery, Brown University; and Michelle Maccarone and Claudia Altman-Siegel at Luhring Augustine. Special thanks are due Karen Polack at Sperone Westwater for fulfilling so many requests.

For their contributions to the book's visual text, I am also indebted to Giorgio Busetto, Director of the Fondazione Scientifica Querini Stampalia, Venice; Max Oppel at Wittelsbacher Ausgleichsfonds, Munich; Leah Ross of the Museum of Fine Arts, Boston; Shaula Coyl at the Los Angeles County Museum of Art; W. Otterspeer at the Akademisch Historisch Museum of the University of Leiden; and to the Pinacoteca di Brera, Milan; Barbican Art Galleries and Whitechapel Art Gallery, London; and Oeffentliche Kunstsammlung Basel, Kunstmuseum.

At the Harvard Film Archive, I wish to thank the former and current curators, Vlada Petrić and Bruce Jenkins, as well as John Gianvito, Steffen Pierce, Heidi Bliss, and Katie Trainor, for supporting my work on film and for their efforts to make the archive into a growing resource accessible to all scholars of cinema. The Film Study Center at Harvard University enabled me to digitize prints and to obtain frame enlargements of films. I am grateful to its founder, Robert Gardner, and its director, Richard Rogers, as well as to Dana Bonstrom and Mike Mislind, who lent technical expertise. Sabrina Zanella-Foresi, my former teaching assistant, has been not only supportive of the book's project but of invaluable help during the process of illustrating the filmmakers' work. I have been similarly supported by Allan Shearer, my current teaching fellow, and able to rely on him in many ways that go far beyond his gifted handling of various technologies. To the film distributors, and particularly to Cinepix and World Artists for their help with film stills, I offer special thanks.

I am very grateful to Colin Robinson at Verso, New York, for sustaining this project at its inception and for allowing me the time and space needed to carry it through to the end. Janet Jenkins was more than a thoughtful editor as she worked on the manuscript of a writer for whom English is not a native language; she gave a rare gift as she swam alongside me through the depth of writing. I am equally grateful to Jeannet Leendertse for undertaking the graphic design of the book and offering her artistic skills to its visual interpretation; and to my brother, Pierluigi Bruno, and Roberta Pedretti, partner in his Visual Design studio in Milan, who affectionately lent their time and expertise as I tried to direct the visual course of the book and to select from the mass of images that I had accumulated.

Luisa Sartori's artistic engagement with maps and her understanding of emotional landscapes sustained my enterprise, as did the intellectual and affective bond I enjoyed with Paola Masi and Maria Nadotti. In the same spirit, I wish also to acknowledge Jonathan Buchsbaum, Leslie Camhi, Deborah Drier, Gabriele Guercio, Andrea Juno, Anne Lovell, Paola Melchiori, and Antonella Russo. Elettra Barth, Sam Berlind, Susan Brown, Emmanuel Ghent, Robert Mals, Lorraine Massey, Gioia Munari, Luis Sierra, and Joyce Silvano all sustained the making of this book, though they may not be fully aware of it. And my thanks would not be complete

without offering my gratitude for the warm, cultivated leisure offered by Morris and Roslyn Fierberg; Kristina Boden; and Gerry, Max, and Isabel Kagan. Many more faces and places are inscribed in the writing of this book, which took place en route between my three (dis)lodgings, in New York, Cambridge, and Anacapri. Most significant among these presences are my mother and late father, Italia Iorio and Pietro Bruno, who are a part of this book. I am especially grateful to my mother for the strength and survival skills she has demonstrated, which have afforded me the mental space I needed to complete it.

This book is for all those who inhabit my sentimental geography. It is dedicated in particular to four people on two coastlines: to my mother and brother, on the Mediterranean seashore; and to two people in this island-city off the coast of America, without whom I could not have written it. My dedication to Sally K. Donaldson is for her presence in the journey from a ruined map to a tender map, and for her aid in navigation. The book was named with Andrew Fierberg in mind, for having been there for me, with volumes of understanding, through the making of another big book and for sharing always the intellectual intimacy of a very tender love.

PROLOGUE

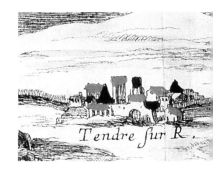

In 1654, Madeleine de Scudéry published a map of her own design to accompany her novel *Clélie*.[1] Her *Carte du pays de Tendre*—a map of the land of tenderness—pictures a varied terrain comprised of land, sea, river, and lake and includes, along with some trees, a few bridges and a number of towns. The map, produced by a female character of the novel to show the way to the "countries of tenderness," embodies a narrative voyage. That is, it visualizes, in the form of a landscape, an itinerary of emotions which is, in turn, the topos of the novel. In this way, the *Carte de Tendre* makes a world of affects visible to us. In its design, grown out of an amorous journey, the exterior world conveys an interior landscape. Emotion materializes as a moving topography. To traverse that land is to visit the ebb and flow of a personal and yet social psychogeography.

This map of tenderness has accompanied me for years and, as an *emotion*al journey, has done more than just propel the writing of this book. As a manifestation of my own sense of geography, it has come to embody the multiple trajectories of my cultural life, punctuating my inner voyage. Because it constitutes an important site of the book's own mapping, it will return at several points, not only as a subject of investigation but as a cartographic model and itinerary.

Scudéry's map effectively charts the motion of emotion—that particular landscape which the "motion" picture itself has turned into an art of mapping. Its tender geography has served as the navigational chart that has guided me in my endeavor to map a cultural history of the spatiovisual arts. Placing film within this architectonics, *Atlas of Emotion* explores the relation of the moving image to other visual sites, "fashioning" in particular its bond to architecture, travel culture, and the history of the visual arts as well as its connection to the art of memory and that of mapmaking. Our lives are tangibly permeated by the arts and by other practices of visual culture—especially those designed by fashion and dwelt upon by architecture—but the place of cinema within this habitable, spatiovisual configuration often has been overlooked in critical studies. It is the design of this very "space" that my book intends to address. To this end, it pays particular attention to the field screen of moving images we so intimately inhabit.

In drafting this cultural history, I have felt compelled to interlace the language of theory with fictional tales and, in a few places, even to mix the two registers together. As I have tried to bridge the language of scholarly analysis with subjective, even autobiographical discourse, I have watched my research being "drawn," quite literally, to the emotional cartography of maps like Scudéry's, which draw, and draw upon, experiential trajectories. It has been my experience that a book can emerge from a sense of place and that this landscape comprises the location conveyed in images. *Streetwalking on a Ruined Map*, the predecessor to this *Atlas*, grew out of such a geographic atmosphere.[2] Its constellation of spatial, urban images included one spectacle in particular: in a frame enlargement from a lost film by a woman film pioneer, a female figure on an anatomical table is set before a core of onlookers; an "analytic" operation, a cutting through her body, is about to be performed. I took this image of the anatomy lesson to be a representation of the architecture of cinema's own anatomic-analytic spectacle. Film, a language of edit-

ing "cuts," is developed for a spectatorship in a theater very much like the anatomical amphitheater, in which matters of life and death were analyzed and anatomized. This image accompanied me in what became a multilayered "analytic" journey, where the subject anatomized turned out to be my own cultural turf.

It seemed suitable that reimaging a map would be the next step in this cartographic trajectory of refiguring and relocating the moving image within a cultural history that engages with intimate geographies. As Scudéry's map took over in my imagination, *Atlas of Emotion* began to take shape, growing in the form of her tender geography. It was a new venture and yet one that was not too far from the terrain of cultural and emotional anatomy—and my own, at that. In fact, the complex levels on which Scudéry's map engages the exterior as an interior even include a specific figurative level: in a way, this map pictures a woman's interiors and, from one perspective, resembles a womb, elaborately decorated with fallopian tubes.

This point was made more "pregnant" by the fact that, as I proceeded in my scholarly observation of the terrain of a corporeal map, my own womb took center stage by growing tumors and bleeding excessively. I was afflicted with a disease that, more or less overtly, was becoming associated with the life of professional women, often with no children. Was the stress-loaded university campus actually a field of tumoral growth? Is the story of my womb part of my intellectual history and enterprise? Isn't cultural movement intimately effective as a politics when, in feminist terms, it understands politics intimately and thus can critically see the impact of imaging on our most intimate space?

I confronted the picture before me: a womb that needed to be cut, and cut out. No matter how much I felt that, as a scholar, I had outlived the anatomy lesson, it was back on the scene. In an uncanny turn of events, like the return of the repressed, the completion of this *Atlas* was delayed as I devoted myself to investigating alternative medical procedures to treat tumors that would avoid all cuts and preserve my womb. It was a quest that, on the surface, took me away from this book but in fact wrote "atlas" all over me and contributed to a shift in the orientation of my research. What began as a cultural history of art, travel, and film became a search for their intimate geography. In seeking a cartographic form in which even uncut tumors might "shrink" and become manageable, I confronted the "cuts" of various separations of the past, including the voluntary excision of maternal language and country of origin that had been made in rerouting my own identity map. It was by thinking geographically that I actually moved away from the prospect (view) of the anatomy lesson and toward Scudéry's tender mapping.

It is ironic that at this moment I underwent a medical experiment of embolization suitably, but alas, called "roadmapping." Less surgical than the old (analytic) way, this procedure, like Scudéry's map, makes a passage. Roadmapping is an exploration that links interior and exterior, leaving no visible scars. You can even watch it happen in motion on a screen, following the traveling technology as it passes through your body, where it then implants, becoming effective over the course of time. Yes, this was a movie. Quite a movie, indeed. It touched on the matter of cinema, the fabric of film. In this sense, roadmapping "suited" me, for, in many

ways, it represented the very scene that I was developing intellectually. This process incarnated—fashioned—the making of the *Atlas*. As I revisited a 1654 map of emotions, a map of (e)motion pictures was written literally onto my skin. It was the architecture of film. A geopsychic "architexture."

Atlas of Emotion came together through a diverse set of intellectual journeys, even passing through the fabric of my body. Although the inappropriate tale I have just recounted may seem disconcerting, disturbing, disquieting, and even obscene—and most probably it is—it represents the habitual experience of any writer. It is the (ob)scene of our daily life, the inappropriateness of writerly activity. Thus a very celebrated author once likened his book to a one-way street, admitting that the path of the book had been engineered by a woman and cut through the author himself.[3] Such writerly experience, however, is normally kept to oneself, especially if it is of such an intimate nature. Sometimes it is positioned some distance away, in the more remote zones of the paratext—that is, kept in a dedication or hinted at near the bottom of the acknowledgments, usually assigned to the lifeline that enables the writing. The type of knowledge exposed in the paratext, which also includes the prologue, in fact represents the writer's own exit from the work, although it is positioned first in a book. It testifies to the end of one's learning process. In this respect, what I expose here should not be taken as a promise for what is to come in this book. I couldn't possibly take you on such a voyage and, besides, you wouldn't want to go there. I am only trying to peel off one of the many silent layers that comprise the intimate experience of writing. For writing, a solitary, unsharable condition, is yet inhabited, and very peopled. It is, in many ways, part of and vehicle for the many passages of an intimate geography.

Atlas of Emotion, mapped out in various cognitive explorations and passing through many different places, is a construction made of multiple passages. It was assembled as a montage of language and illustrations, which I particularly enjoyed selecting and routing in the form of a visual travelogue. Bringing together diverse registers and various layers of intellectual passions was a wonderful challenge. En route, I sometimes found myself all over the map. After all, my curiosity had pushed me to explore, from a cinematic viewpoint, a vast haptic terrain—the intersection of art, architecture, and (pre)cinema—beginning historically with Scudéry's seventeenth-century map of *emotion*s and theoretically moving on to traverse a number of centuries, various fields of inquiry, and a multiplicity of scholarly disciplines.

The meeting of history with the history of representation and its theory was not always a given, but today it is a particularly vital part of cultural investigation. There is a definite way in which cinema studies can contribute to this endeavor. Film theory, which over time has encountered different methods and employed them to learn how to "look" differently, has not, generally speaking, been especially interested in geographic matters or attuned to art and architecture and their scholarly perspectives. Yet there are apparent common concerns and many fascinating routes that research which pursues this interface may open up. Hence, I have tried to learn how to "space" differently. I apologize in advance for any mistakes and oversights I may

have made in the attempt. While I am aware that, taken singularly, my findings may not represent new discoveries for experts in the particular fields I traverse, I dare hope that something may be gained, transdisciplinarily, from a mobilized cinematic "premise." In my work, my deep respect for the expertise of specific fields has been accompanied by the challenge of trying to ferry some of this knowledge across territories and transfer it to film theory, in the hope of enriching it and, in turn, of expanding the range of what film may contribute to other fields. In my writing, I have tried to make room for such exchange and to create space for topoi, resisting the easier model that would follow a chronological order. It has been quite a journey—one for which the reader may need his or her own map or, indeed, this prologue.

Writing this *Atlas*, I often wondered how the map had come together for Scudéry and whether this insight could help me to map out my own book. Was the map a gift offered to herself, and to the reader, once she was able to chart the narrative itineraries of her novel? Maps, records of learning, after all, follow experience. They come into existence after the path has been traveled, much like the introduction of a book, which, as we have claimed, can be drafted only after one has already finished the work. It is then that the writer/cartographer can map out her territory. This includes what she could not or did not reach in her exploration: her *terrae incognitae*, those seductive voids that, if one knows the topophilia of the lacunae, are not there to be conquered but are textures exposed, where the markings of time take place.

I can see now, at the end of my map zone, that this book is shaped as an architectural ensemble. It is a construction that has a peculiar, reversible way of being entered and exited. Walking in and out and through the curvilinear ramp that leads up to Le Corbusier's Carpenter Center (the building at Harvard University in which I have been teaching the past eight years while developing this book) must have had a real effect on me. It is on this ramp that Le Corbusier and Eisenstein, or rather architecture and film, by and large, have come together in my thinking and affected the book's own architectonics.

Imagine a ramp that takes you through a building-book. As you enter the lobby you get a glimpse of the structure of the work. You see the layers of the different floors/chapters and can peek at the development of the edifice, sighting what is possibly housed there. Part 1 of the book is designed in this way. It functions like a lobby, from which the floors spiral out. Indeed, the book quite literally spirals out from this point—that is, from the "premise" of ARCHITECTURE and the cinematic narrative it generates. Chapter 1, "Site-Seeing: The Cine City," is a filmic travelogue. Looking at the history of cinema from a viewpoint that emphasizes geographic, architectural, and social space, it creates a sequential display of the cinematic city, from the panoramic travelogue films of early cinema to filmic views of the near future. This montage of cine cities examines the way in which space is housed in the movie house. It pays particular attention to the architecture of film theaters—one of the most disregarded topics in cinema studies and yet a significant generative agent of cinema. To show how cinema is "housed," we look at a montage of its history as if we were watching films in different kinds of movie theaters and come to interrogate

architecture as a maker of cinema. Looking at how different architectures of film theaters engender diverse visions of cinema and its practice, we sit in Frederick Kiesler's "house of silence" and compare the experience to that of John Eberson's "atmospheric" movie palace. Hiroshi Sugimoto's series of photographs devoted to film theaters then leads us to the geography of film. From this urban screen of lived space, chapter 2, "A Geography of the Moving Image" is developed, in which the reader gets a beginning view, a panorama *in nuce*, of the theoretical extent—and extension—of things to come in the haptic space of "site-seeing."

As the Greek etymology tells us, haptic means "able to come into contact with." As a function of the skin, then, the haptic—the sense of touch—constitutes the reciprocal con*tact* between us and the environment, both housing and extending communicative interface. But the haptic is also related to kinesthesis, the ability of our bodies to sense their own movement in space. Developing this observational logic, this book considers the haptic to be an agent in the formation of space—both geographic and cultural—and, by extension, in the articulation of the spatial arts themselves, which include motion pictures. Emphasizing the cultural role of the haptic, it develops a theory that connects sense to place. Here, the haptic realm is shown to play a tangible, *tact*ical role in our communicative "sense" of spatiality and motility, thus shaping the texture of habitable space and, ultimately, mapping our ways of being in touch with the environment.

As it traverses various practices of space, this atlas focuses on the potential interchanges between geography, architecture, and film; their theorization; and their place in art. It is a study that questions ocularcentrism and challenges some common assumptions. Film is largely considered a visual medium and, generally speaking, so is architecture. This book, by contrast, attempts to show that film and architecture are haptic matters and develops their spatial bond along a path that is tactile. In its theoretical shift from the optic to the haptic—and from sight to site—*Atlas of Emotion* thus moves away from the perspective of the gaze and into diverse architectural motions. In fact, the atlas is not a map merely of spaces but of movements: a set of journeys within cultural movements, which includes movement within and through historical trajectories. On the way, the fixed optical geometry that informed the old cinematic *voyeur* becomes the moving vessel of a film *voyageuse*. Here, we actually travel with motion pictures—a spatial form of sensuous cognition that offers tracking shots to traveling cultures.

Arguing that this form of "transport" includes psychogeographic journeys as well, I investigate the genealogy of emotion pictures, mapping a geography of intimate space itself—a history of movement, affect, and tact. I will set forth as a major premise of the atlas that motion, indeed, produces emotion and that, correlatively, emotion contains a movement. It is this reciprocal principle that moves the entire book, shaping the haptic path it takes through its various cultural journeys. The Latin root of the word *emotion* speaks clearly about a "moving" force, stemming as it does from *emovere*, an active verb composed of *movere*, "to move," and *e*, "out." The meaning of emotion, then, is historically associated with "a moving out, migration, transference from one place to another."[4] Extending this etymology, the book

creates its own (e)motion, enhancing the fundamentally migratory sense of the term as it employs, in practice, the haptic affect of "transport" that underwrites the formation of cultural travel. It is here, in this very e*motion*, that the moving image was implanted, with its own psychogeographic version of transport.

Cinema was named after the Greek word *kinema* (κίνημα), which connotes both motion and emotion. My view of film as a means of transport thus understands transport in the full range of its meaning, including the sort of carrying which is a carrying away by emotion, as in transports of joy, or in *trasporto*, which, in Italian, encompasses the attraction of human beings to one another. It implies more than the movement of bodies and objects as imprinted in the change of film frames and shots, the flow of camera movement, or any other kind of shift in viewpoint. Cinematic space moves not only through time and space or narrative development but through inner space. Film moves, and fundamentally "moves" us, with its ability to render affects and, in turn, to affect. Retracing the steps of the cultural history that generated these "moving" images—our modern, mobile cartography—the book spirals backward into lived space. Making a cultural voyage back to the future, we see movies before cinema as we explore the protofilmic construction of visual space in the moving topographies of Western culture, especially those written off as sentimental or feminized, and hence marginalized. We go in search of a language of affects, beyond its psychoanalytic manifestation, and follow its course as an unstable map of "transports."

In Part 2 of the book, for example, I show that the cultural movement of e*motion*, historically inscribed in traveling space, is the generative site of the moving image. Cinema was born of modernity's symptomatic stirring and has fashioned a psychogeographic vision inextricably linked to TRAVEL. Chapter 3, "Traveling Domestic: The Movie 'House,'" looks at the way the motion picture, in addition to dwelling in motion, developed out of the modern culture that produced (im)mobile travel. Approaching, in a liminal way, interior as exterior and breaking the dichotomy between voyage and home as assigned socio-sexual spaces, we see that gender difference is written on this moving landscape, negotiated on its perimeters, and mapped as an architectural threshold. Crossing between architecture and film, we dwell in the manner of Chantal Akerman's passengers and inhabit the "architextures" of Michelangelo Antonioni. "Fashioning Travel Space" in chapter 4, we look at the self-made design of the modern *voyageuse* and revel at her representational "apparel" and "accoutrements." In the genealogic makeup of travel space, we tour with such necessities as a *voyageuse*'s traveling bed and move from the traveling desk to the moving image.

This fabrication—a fashioning of the self in space—takes the route of GEOGRAPHY in Part 3 of the book, in which we picture inner landscapes. As we examine "The Architecture of the Interior" in chapter 5, we enter the Western construction of a protofilmic space of viewing, which later became the imaginative traveling space of the movie house. Scanning emotional spaces at the juncture of art and science, we revisit the making of a museum of images and document a physiognomy of space in the form of film's own intimate archaeology. We travel in a "room": from

the camera obscura (literally, dark room) to the curiosity cabinet, from the exhibition rooms of automated body doubles to those containing wax simulacra and *tableaux vivants*, from the mesmerizing effect of display in the sentimental museum to that form of nineteenth-century geography dressed in "-orama." Focusing on the "interior design" of panoramic culture, we take the urban itinerant route of *mondo nuovo* and access the new geography of vision that fashioned a shifting landscape of privacy and publicity and, in so doing, affected the design of the modern home. As we speak of the architecture of interior space, we travel inside out, as when we delve inside the globe of a georama; or outside in, as when we visit nineteenth-century houses whose walls are decorated with panoramic wallpapers. In this house of moving pictures before cinema (our own panoramic wallpaper), the world was at home, although sometimes unhomely.

After traversing this house of images as a protofilmic movie house, we take "Haptic Routes" in chapter 6. Here we argue that the moving image cannot be comprehended within the optical limits of perspectivism and retrace other forms of Western picturing marginalized by the theory of the gaze. I claim that cinema was born of a topographical "sense" and has established its own sentient way of picturing space. The modern art of viewing space—that is to say, the cinema—partakes of the representational codes established historically through the art of viewing, especially with *vedutismo* (view painting). The motion picture, a spatiovisual assemblage in motion, further embodies the sensuous assemblage and corporeal mobilization established in picturesque aesthetics, especially garden design, and also reproduces the material navigation of landscape that was inscribed, as a form of mapping, in the ebb and flow of nautical cartography.

The exploration of cartography continues in Part 4 of the book, on the ART OF MAPPING. Chapter 7 surveys "An Atlas of E*motion*s," as mapped on the threshold between art and cartography. It investigates the making of the geographic atlas as it proceeded along with the mapping of gender and its inscription in the cultural landscape. Focusing on the art of mapping and demonstrating its bond to the design of affects, this chapter traces a history of emotional cartography, from Scudéry's version to its current return in contemporary visual arts. It touches on the affective maps of the artist Annette Messager and on the mattress-maps of Guillermo Kuitca. The type of cartography foregrounded here is a "tender geography," tender to gender in the way it maps a moving anatomy of lived space, a geography of inhabitants and vessels. Having traveled this route of lived space, the chapter moves on to the terrain of cinema, where it shows that this cartographic form of representation, once embodied in the *emotion*al maps of early modernity, now inhabits film's own "emotion pictures"—themselves a geography of inhabitants and vessels.

The motion of emotion that takes place in this form of cartography can take us backward, and hence move us forward, for it is the modern reinvention of the old art of memory. By setting memory in place and placing it within an architectural trajectory, the art of memory was an architectonics of recollection. In our own time, in which memories are (moving) images, this cultural function of recollection has been absorbed by motion pictures. In this sense, film is a modern car-

tography: its haptic way of site-seeing turns pictures into an architecture, transforming them into a geography of lived, and living, space.

Following the path from early film theory to contemporary perspectives, chapter 8 explores the architectonics of (re)collection as a filmic space. It deals with the imaginative formation of "An Archive of Emotion Pictures." Such an archival project includes rediscovering the neglected work of researchers such as Hugo Münsterberg, the psychologist who, at the turn of the century, strove to find a method to analyze and measure the emotions while, alas, becoming attracted to motion pictures. As we follow this line of inquiry, we take the moving image further into the imaginative terrain of the emotions. Along the way, we encounter the picturing of geopsychic space as practiced in writing and visual art as well as in maps that design the *emotion* of lived space and the trajectory of "bio-history"—the history, that is, of *bios* (βίος), the inhabitation and course of life. At the end of this psychogeographic route, we eventually arrive at situationist cartography, a filmic mapping directly inspired by the art of mapping of the *Carte de Tendre*.

Aligning art and film theory in the articulation of a theory of the haptic, dwelling on the physiology of "tactilism," inhabiting the sensorium of emotions, and moving with mnemonic traveling archives, my work on the archive of emotion pictures sustains the views of chapter 5, which first conjoined cinema and the museum in an intimate mapping. It is in a current transference between these two sites that image collection turns into recollection: a geopsychic mapping takes place in the interface of a field screen, in between the map, the wall, and the screen.

This is the space developed in the next section of the book, on DESIGN. Positioned between cinema and the museum, the work of Peter Greenaway, explored in chapter 9, is a prime exemplar of this interface. Greenaway—who trained as a painter; has been attracted to architecture, fashion, and cartography; and has engaged in charting the interaction of these fields within the space of cinema and beyond—has created a spatiovisual map that represents areas of the cultural archive we have examined. His work, which ranges across filmmaking and art-making to curatorial-museographic activity, has been written on the flesh and on the drafting table and crosses many boundaries between the visual arts and cinema. Foregrounding the place of design in this architectonics, I consider the new "architextural" image created on Greenaway's screens. In theorizing that fashion, architecture, and cartography share narrative space with cinema, I bind them on the surface of lived space, where the *habitus* of inhabitation meets the *abito* of dress. As we travel filmically in the shared "fabric" of apparel, building, and mapping, I dwell on the fiber of these domains, and particularly in the folds—the texture—of their geopsychic design, where wearing is, ultimately, a wearing away.

In chapter 10 we explore this "architexture" further in the space of the art gallery and the museum as we take a cinematic walk through Gerhard Richter's installation *Atlas* (1962–present), an assemblage of photographs, collages, and sketches that, in its current form, pictures intimate space. In this *Atlas*, pictures become an environment, an architecture. Richter's project captures the very generative moment of filmic *emotion*, taking hold, as it does, of the fabrication of the

movement of life with life in motion. Moving through Richter's artwork, one is actually "transported" into that haptic "architexture" of recollection in which a filmic-architectural bond is pictured, figured as a map.

This investigation closes with a reflection on the textural hybridization of art, architecture, and film, and it is at this point that we notice that an editing splice and a film loop link turn-of-the-century cinema with millennial forms. The archive of emotion pictures this book has mapped can now be found in the space of the art gallery, in that hybrid interface between the map, the wall, and the screen we have discovered. On the walls of the contemporary gallery/museum, in installation spaces, and on the surface of museum architecture itself, one may encounter, and even walk through, the genealogy of cinema and its archaeology. The moving geography that gave rise to the invention of cinema here returns to art as filmic architexture: the cinematic, culturally internalized, comes to be remade in visual architexture. Cinema, whose death has often been proclaimed, is alive and well within the hybrid imaging of the spatiovisual arts.

On this note, our voyage approaches a conclusion. To this point, the chapters of this book, like the floors of a building, have taken shape in clearly autonomous and yet interconnected ways. The reader, moving from one part to the next, as in the architecture of a building, may notice both repetitions and variations: a topic sketched out simply in one location may be fleshed out more fully elsewhere; an element of decor in one place may become structural matter in another. Although there are thresholds and threads, the chapters/floors are somewhat independent. Certainly there is an ascending path to be found in reading this work, as there is in most buildings. However, the reader may also decide to take the elevator and, say, go straight to Part 4, the ART OF MAPPING, to survey "An Atlas of E*motions*" or "An Archive of Emotion Pictures" before visiting elsewhere. Or she may first stop off at Part 2, on TRAVEL, and sit for a while in the "house" of pictures; or begin her visit with DESIGN and shop for cinema outside of cinema, in the art gallery and the museum. She may even choose to skip floors. In any case, the effect of the work is cumulative: whichever path is followed, there are different points at which fragments come together narratively. They may even come to form a platform for a *veduta*, a site where a panorama or a bird's-eye view of the place/book is obtained.

The construction of this book, as inscribed on the trajectory of a ramp, can be exited the same way it was entered: with a travelogue. The end of this study is not an argumentative conclusion: as an incurable lover of fiction, I could not help leaving some room for discovery by fashioning an ending that is open. Part 6 of the book, HOUSE, is thus rather a montage of views from different places in the book that comes together in a house and takes us on a "Voyage in Italy" which traverses the literature of women's travel diaries, as reinvented in Roberto Rossellini's filmic-architectural tour. In this critical voyage I address topophilia, the love of place, in relation to the shifting landscapes of house and home, recalling the migratory root of the emotional passion, its "moving out." As we have shown, the moving image—our nomadic archive of imaging—is implanted in this residual cartographic *emotion*. It is here, then, that we can try to rethink our current practices of psychogeographic map-

ping in the face of our hybrid histories. Recreating a fictional cartography of displacements, homing, and roaming, the last part of the book dwells subjectively on the geopsychic relationship between affects and place that has been mapped in the book.

For an *Atlas of Emotion*, a landscape is, in many ways, a trace of the memories and imaginations of those who pass through it, even filmically. An intertextural terrain of passage, it contains its own representation in the threads of its fabric, holding what has been assigned to it with every passage, including *emotion*s. To look at how affects are fashioned and "worn," in film as well as in film theory, the diary with which the book concludes embarks on an intimate panoramic tour in which geological excavation meets archival digging. This final haptic journey, which is "my" voyage back to Italy, suggests that, in order to see something new analytically, we may have to take the same old road. And if that means going back home, once there, we must look carefully into the armoire. And so at last we leave the map. Bon voyage.

New York City, 12 December 1998

ARCHITECTURE

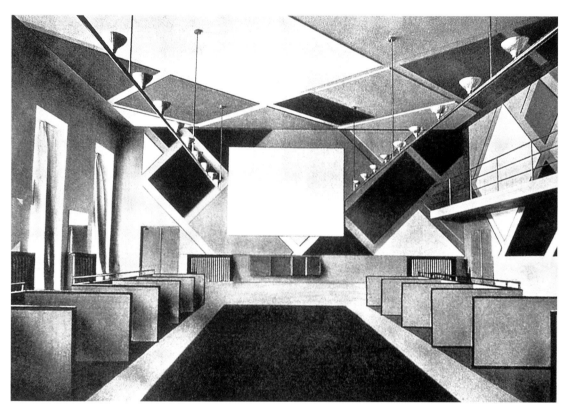

1.1. Café and
Cinéma de L'Aubette,
Strasbourg, 1928.
Theo van Doesburg,
architect.

1 Site-Seeing: The Cine City

*Space . . . exists in a social sense only for activity—for (and by virtue of)
walking . . . or traveling.*
Henri Lefebvre

Film's undoubted ancestor . . . is—architecture.
Sergei M. Eisenstein

This book, written by a resident alien, appropriately begins with an "error." The
title of the first chapter is deliberately misspelled. Sightseeing has become site-seeing.
An error implies a departure from a defined path; the semiotics of the term incor-
porates the notion of erring, or wandering.[1] *Error*—the deviation from a route, a
departure from principles—is bound to such wandering. As an act of navigation on
a devious course, it implies rambling, roaming, and even going astray.

Atlas—a map of theoretical and *emotion*al itineraries—has developed as an
errare. Woven over the course of several years, it bears the textural layering of a
palimpsest. The work proceeds by making tours and detours, turns and re-turns,
opening up on different vistas of the production of space. In this errant way, fore-
shadowed in the prologue, it investigates cinema—the "movies"—as a multiform
practice of geopsychic exploration. To traverse this psychogeography is to "err"
through the shifting grounds of socio-cultural mobilities. In such peripatetic fashion,
we thus set out to wander in the topography of interiors with a filmic map, to design
an atlas of emotion pictures.

HORIZONS OF ERRARE

The path of *errare* unfolds, first of all, as a theoretical turn that looks at the history
of cinema from an architectural point of view. As an *error*, site-seeing partakes in a
shift away from the long-standing focus of film theory on sight and toward the con-
struction of a moving theory of *site*. As it designs a cartography of film's position
within the spatial arts and their practices, our erring is ultimately a movement from
the optic to the haptic—an affair that touches on a range of movements.[2]

The English language makes this transition from sight to site aurally seam-
less. Site-seeing, too, is a passage. As it moves from the optic into the haptic, it cri-
tiques scholarly work that has focused solely on the filmic gaze for having failed to
address the emotion of viewing space. Many aspects of the moving image—for exam-
ple, the acts of inhabiting and traversing space—were not explained within the
Lacanian-derived framework, which was not interested in pursuing the affect of spa-
tiality, even in psychoanalytic terms. Locked within a Lacanian gaze, whose spatial

impact remained unexplored, the film spectator was turned into a *voyeur*. By contrast, when we speak of site-seeing we imply that, because of film's spatio-corporeal mobilization, the spectator is rather a *voyageur*, a passenger who traverses a haptic, emotive terrain. Through this shift, my aim is to reclaim *emotion* and to argue, from the position of a film *voyageuse*, for the haptic as a feminist strategy of reading space.

The premise of site-seeing contests another aspect of the theory of the gaze as well: its favoring of a perspectival, optical geometry as a model for film. Confined to an optical position, this theory has tended to conceive of film space as a direct heir of Renaissance perspective and, understanding this in a narrow and reductive way, has reduced spectatorship to the fixed, unified geometry of a transcendental, disembodied gaze.[3] We now recognize that an optical model of this kind is unfit to account for the type of displacements that are represented, conveyed, and negotiated in the moving image. It not only has excluded a spectatorial articulation of the notion of public but has failed to engage in the sentient voyage and embodied psychogeography housed in the movie "house." In order to explore this realm and to expose the shortcomings of the optical-geometric model of film and its ocularcentrism, we do not, however, need to subscribe simply to an oppositional dichotomy. That is, we need not insist on positions that are skeptical or denigratory of visuality; nor need we treat visuality solely as a site of regulatory power over our bodies. There is another path to follow in tracing a composite genealogy for a filmic architectonics.[4] It involves an engagement with environmental history and its inhabited, lived space.

To build a theoretical map of an architectonics as mobile as that of motion pictures, one must use a traveling lens and make room for the sensory spatiality of film, for our apprehension of space, including filmic space, occurs through an engagement with touch and movement. Our site-seeing tour follows this intimate path of mobilized visual space, "erring" from architectural and artistic sites to moving pictures. Haptically driven, the atlas finds a design for filmic space within the delicate cartography of *emotion*, that sentient place that exists between the map, the wall, and the screen.

PANORAMAS OF MODERNITY

> *Mobility lies at the heart of the historian's method. . . . Knowledge*
> *depends upon travel, upon a refusal to respect boundaries, upon a restless*
> *drive toward the margins.*
> Stephen Greenblatt

In keeping with the kinetic origins of the cinema, known in its early days as the "kinema," a passage to site-seeing involves, first of all, locating a geography of movement for cinema within the haptic map designed by the modern age. In this respect, my efforts converge with recent work in cinema studies that focuses on early

1.2. Interior of the Titania
Palace Cinema, Berlin, 1928.
Schöffler, Schlönbach and
Jacobi, architects.

cinema and gives attention to film space.[5] Looking at the emergence of cinema in terms of a cultural space enables us to articulate the link between cinema and the culture of modernity.[6] Film came to place itself within the perceptual field that has been described by art historian Jonathan Crary as the "techniques of the observer."[7] It emerged out of this shifting observational arena and was affected, in particular, by the panoramic spectacle of display (especially anatomical display). A product of this representational architectonics, the motion picture developed from what cultural historian Wolfgang Schivelbusch has called "panoramic vision," and especially from the architectural configurations of modern life and their circulation.[8]

On the eve of cinema's invention, a network of architectural forms produced a new spatiovisuality. Such venues as arcades, railways, department stores, the pavilions of exhibition halls, glass houses, and winter gardens incarnated the new geography of modernity.[9] They were all sites of transit. Mobility—a form of cinematics—was the essence of these new architectures. By changing the relation between spatial perception and bodily motion, the new architectures of transit and travel culture prepared the ground for the invention of the moving image, the very epitome of modernity.

Film shared much in common with this geography of travel culture, especially with regard to its constant reinvention of space. I have argued elsewhere that spectatorship is to be conceived as an embodied and kinetic affair, and that the anatomy of movement that early film engendered is particularly linked to notions of *flânerie*, urban "streetwalking," and modern bodily architectures.[10] As wandering was incorporated into the cinema, early film viewing became an imaginary form of *flânerie*, an activity that was—both historically and phantasmatically—fully open to women. By way of the cinema, new horizons opened up for female explorations. A relative of the railway passenger and the urban stroller, the female spectator—a *flâneuse*—traveled along sites.

THE URBAN PANORAMA

Against this background of the intersection of filmic and architectural motion, and on the threshold of a geography of the interior, we begin our first site-seeing tour with a panorama of the cine city in history. This tour is not universal but subjectively localized. It returns often to the cinema of Italy, drawing on the filmography of a country particularly attuned to design, one that has "fashioned" the body and architectural space according to its rich history of visual representation. Drawing specifically on my own cultural map, this "cinetopophilic" travelogue offers a personal, partial view of the Western cine city that is meant to provoke some thoughts on the urban screen in general.[11]

A product of the era of the metropolis and its transits, film expressed an urban viewpoint from its very inception. As Paul Virilio put it: "Since the beginning of the twentieth century . . . the screen . . . became the city square."[12] Addressed primarily to urban audiences, early film fed on the metropolitan consciousness and unconscious. The city is present as "mise en abyme," to use Tom Gunning's metaphor.[13] An international genre of panorama films composed of "scenics" or "foreign views" made traveling through sites an extensive practice in the very early days of film and became instrumental in the development of the language of fiction films.[14] This travel genre was known in Italy as *dal vero*, or "shot from real life." In a mirroring effect, the life of the street, views of the city, and vistas of foreign lands were offered back to urban audiences for viewing.

Early movie theaters hosted a panoply of mobile urban picturing. The turn-of-the-century travel-film genre reveals how film began articulating its language by

1.4. The city becomes city-scape in *Panorama from Times Building, New York* (American Mutoscope and Biograph, 1905). Frame enlargements.

1.3. Time-space revealed
in *Pan-American Exposition
by Night* (Edison, 1901).
Frame enlargements.

striving for a form of *vedutismo*, which became, as we will later see, a practice of "view-tracking" and "view-sensing."[15] Following the course of view painting and pursuing its representational route, a composite practice of spatiality was born in film that mobilized place and transformed it into a site of landscaping. Early cinema envisioned "panoramic views" that incorporated site-seeing journeys and the spatio-visual desire for circulation that had become fully embedded in modernity.

From the depiction of foreign and domestic views to the simulation of traveling through space, filmic representation is never static. Not only do the subjects of urban views move, but the very technique of representation aspires to motion. A film like *Panorama from Times Building, New York* (American Mutoscope and Biograph, Wallace McCutcheon, 1905), for example, offered *vedute* in motion, portraying New York's aerial cityscape by first tilting upward and then panning across an urban bird's-eye view. In panoramas like this, the camera strives for diverse viewing possibilities from the height of buildings or from different perspectival points in the city. As seen in *Panoramic View of Monte Carlo* (Edison, 1903), the genre was also attracted to the street motion of urban strolling and frequently represented the daily urban circulation of male and female city dwellers.

Public circulation takes cinematic shape in these films, and the sidewalk becomes the site where gender openly dwells. In *At The Foot of the Flatiron* (American Mutoscope and Biograph, Robert K. Bonine, 1903), a film that records a street scene, architecture and body are more than metonymically conjoined as the camera scrutinizes the ankles of passing women at the "foot" of the building. The camera catches the reactions of passersby of all sexes when, at the windy street corner, women's skirts blow upward, revealing even more flesh. Architectural tours turned into gender travelogues as the sidewalk began to embrace sexual mobility and freer circulation for a growing female urban public. In *Panorama from the Moving*

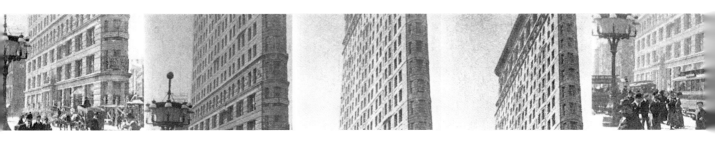

Boardwalk (Edison, 1900), the moving sidewalk—a novelty of world expositions—became a filmic scenario and the platform for traveling shots, which female urban strollers appear particularly to have enjoyed.

In the city travelogues, the camera practiced circular pans, up-and-down tilts, and forward, vertical, and lateral tracking motion, offering a variety of vistas across the city space, from panoramic perspectives to street-level views. In this way, the genre reproduced the very practice of urban space, which involves the public's daily activity and circulation. These moving panoramas were instrumental in developing films that eschewed static, theatrical views in favor of architectural motions. In the travel genre, film cameras were placed on railroad cars, incline rail cars, subway cars, boats, moving street vehicles, and even balloons for attempted aerials.[16] Movement was also simulated. Beginning with Hale's Tours and Scenes of the World in 1905, phantom rides were offered to spectators, who would watch films in movie theaters designed like railroad cars, with the screen placed at the front of the vehicle.[17] The attraction involved the very means that produced the moving visual space and affected the architectural shape of the movie house itself.

When the camera is placed at the very front of a moving vehicle—in trains, most typically; in subway cars, as in *Panoramic View of Boston Subway from an Electric Car* (Edison, 1901); on streetcars, as in *Panoramic View of the Brooklyn Bridge* (Edison, 1899); or on vehicles moving through the street, as in *Panorama of 4th St., St Joseph* (American Mutoscope and Biograph, A. E. Weed, 1902)—the camera becomes the vehicle: that is, it becomes, in a literal sense, a spectatorial means of transportation.[18] The travel-film genre inscribed motion into the language of cinema, transporting the spectator into space and creating a multiform travel effect that resonated with the architectonics of the railroad movie theater that housed it.

1.5. The architecture of urban motion in *Panorama of the Flatiron Building* (American Mutoscope and Biograph, 1903). Frame enlargements.

A LABORATORY OF CITY FILMS

In the 1920s, the city became the subject of a number of landmark films that shaped the body of the cine city in important ways.[19] These include *Manhatta* (Paul Strand and Charles Sheeler, 1921), *Paris qui dort* (René Clair, 1923), *L'Inhumaine* (Marcel L'Herbier, 1924), *Metropolis* (Fritz Lang, 1926), *Rien que les heures* (Alberto Cavalcanti, 1926), *Berlin, Symphony of the Big City* (Walter Ruttmann, 1927), *Sunrise* (F. W. Murnau, 1927), *The Crowd* (King Vidor, 1928), *The Man with the Movie Camera* (Dziga Vertov, 1929), and *A Propos de Nice* (Jean Vigo, 1930).[20] The city space also became a genre in German street dramas and in the Italian cinema of the street, both of which opened the road to women.[21]

Looking at these panoramas from an architectural perspective, the city emerges both as something more than and something different from the mere object of the films.[22] Here, metropolis and film interface as a distinctly modern production in which a correspondence between the city space and the film space, between the motion of the city and the moving image, exists. The machine of modernity that fabricated the city is also the "fabric" of film. The 1920s, a period of fluid exchange between architecture and film, created a nexus investing the actual mechanics of the bond. The modern architectural model of film even came to be projected onto the architecture of the movie house itself.[23]

Metropolis, inspired by Fritz Lang's vision of New York City, is particularly eloquent in exhibiting the electro-chemistry shared between cinema and the city. The film (written by Lang's wife, the novelist and screenwriter Thea von Harbou) presents the workings of the urban dream machine in architectural terms, with the utopias and dystopias of the machine age uniting the city and film.[24] In the

1.6. "Tracking" the landscape in *Panoramic View of Boston Subway from an Electric Car* (Edison, 1901). Frame enlargements.

age of mechanical reproduction, film and the metropolis intersect here as machines of reproduction, bound together by mechanicalism and by the mechanics of the body.[25] As a new type of artwork and a new scientific invention, film was manufactured reproducibly. Such reproducibility having become a cultural dream of the modern age, the ultimate dream now became reproduction itself. *Metropolis*'s laboratory manufactures such a utopian scheme, giving it the shape not only of architecture but of the architecture of the body. Turning laboratory into labor-atory, the film depicts the ability to conceive and reassemble that most elaborate work of art—the fabric of our own bodies, our own private working machinery.

Photography had introduced the power to reproduce a body, offering an image equal to our physical body. Film made it move. The laboratory of *Metropolis* animates this transition—the transition, that is, toward the "cyborg."[26] In an extraordinary, transformative sequence, the fabrication of a female body-double takes place in a laboratory which itself becomes animated. With this mechanical marvel—a design that blurs the distinction between machine and organism—the texture of the body becomes as reproducible as that of film. Film, the serial image, is made equal to the android, the serial body; they are both mechanical doubles—products of the same mechanical dream of reproduction. Like the android, film, too, is a type of "replicant."[27] Here, cinema, the reproducible artwork, exhibits the scientific potential of the future: the potential to reproduce technological bodies. The era that produced the motion picture strove to transmute and clone the body as it extended and displaced women's reproductive capacity. In celluloid imaging, replicants of ourselves can be exposed in spectatorial out-of-body experiences.

The mechanism that connects the inner workings of the metropolis to film is also cinematically rendered in René Clair's *Paris qui dort*. Looking at the city of Paris from the Eiffel Tower, we are offered a variety of vistas that turn the city into a cinematic event. These are views from inside the machine age. In this film, the city—the product of a scientific experiment—is a mechanism that moves at a specific speed, tempo, and rhythm. In this sense, one may say that the city is inhabited by the cinematic apparatus, which is invested with the power to analyze the workings of the urban experience in direct correlation to its own representational machinery. When Paris is asleep, the city is frozen as if it were an image arrested on a Moviola. As it begins to move, we experience the very moment that a photograph turns into a moving image. As Annette Michelson aptly notes, "René Clair's celebration of modernity therefore turns upon that threshold in our history which was

1.8. A vista of the filmic-urban "ray" in *Paris qui dort* (René Clair, 1923). Frame enlargements.

1.7. Traveling from streetscape to cityscape in *Panorama of Eiffel Tower* (Edison, 1900). Frame enlargements.

the invention of the motion picture."[28] It exposes the motor force that acts on the image to accelerate and decelerate, arrest and release spatiotemporality.

In the laboratory of *Paris qui dort*, the machine that freezes and propels the city is called a "ray." Although one is led to understand that the ray is the cinema, the ray is never explicitly called, or represented as, film. Yet there is a known historic precedent for linking the invention of the X ray with the moving image.[29] Produced at the same time, they share a common cultural function: both are forms of imaging that scan, examine, and document our physical matter, changing not only the perception of the body in space but modes of corporeal perception as well.

This conjunction of film and science was artistically acknowledged by László Moholy-Nagy, who made films about urban still life and harbor life—most notably, *Berliner Stilleben* (1926) and *Impressionen vom alten Marseiller Hafen* (1929). Moholy-Nagy envisioned a film project based on the dynamics of the metropolis and became involved in the science-fiction film *Things to Come* (1936), produced by the art director William Cameron Menzies. He made stunning plans for the film's set design which, regrettably, were not used, except for his flash-forward construction of the metropolis.[30] In his 1925 Bauhaus book, *Painting, Photography, Film*, Moholy-Nagy had portrayed the interaction of all the visual arts from a scientific perspective and even included pictures of X rays within the display of the cinematic "ray."[31]

What *Paris qui dort* only alludes to and Moholy-Nagy distinctively pictures *The Man with the Movie Camera* makes textually explicit.[32] The "ray"—the X ray— that scans the urban body is definitively the work of film here. More than a symphony of the city, Vertov's constructivist film shows that cinema moves (and moves with) the city.[33] An elegy to the intermingled laboratory of metropolis and film, *The Man with the Movie Camera* traverses the very history of the body. The film is thus a fascinating work of "radiographic" condensation which maps the history of film's genealogy and locates it within the body of the city.

The story, set in the space of a movie theater, begins with architecture. We embark on an urban tour with a visit to the interior of a movie house. Initially empty, still, and frozen, the theater slowly becomes energized, "animated" by the film-work just as it is activated by the people who come to inhabit it. The chairs begin to move as music fills the movie house and sets it in motion, and as the spectators of the city-film move into the theater space. The city's rhythm is constructed out of the architectural space of a movie theater.

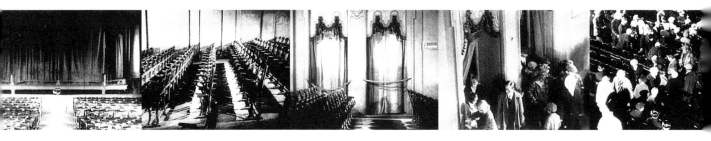

In *The Man with the Movie Camera*, the life of architecture is the life of its residents. When the belly of the city is asleep, a series of still-life shots is rendered with a montage of cinematic bodies in arrested motion. Sleeping people are frozen like wax models or photographs, waiting to be awakened by the invention of the cinema. Moving through a series of still body images connected by way of montage, Vertov activates nothing less than the shift from wax modeling to still photography and motion pictures. Thus the body of the city, once asleep, finally wakes up. The city, like the camera, begins to move about. As in the early panorama films, the camera's own movement is augmented and multiplied as it is coupled with the city's vehicles of transport. All the machines of modernity inhabit Vertov's movie as trains, trolleys, automobiles, airplanes, and the motion of factories fabricate the space of the film. In turn, film animates the city as a real means of transportation. The movie camera becomes a moving camera—a means of "transport."

A cart pulled by a horse carries some people as the camera transports us into their lives. Suddenly, everything stops. The "ray"—the X ray which is film—freezes their image. The arrest is a powerful epistemic break, an example of Vertov's theory of the kino-eye that exhibits the physical aspect of film's power.[34] Film is an analytical "cyborg": a relative of the X ray, it can dissect somatic traces. It can even freeze the body, as only death can, transforming it into a *nature morte*. Insofar as it is fundamentally "still" photography, film is inhabited by death. Like a waxwork or a mummy, its illusionary movement can return us to a state of stillness.[35] By freezing time in space, the cinema, at some level, can preserve body images, propelling them into a future they would not otherwise be able to enjoy. By way of its laboratory of

1.10. The makeup of urban emotion, from *The Man with the Movie Camera*. Frame enlargements.

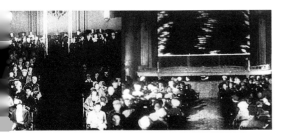

1.9. The movie house comes to life in *The Man with the Movie Camera* (Dziga Vertov, 1929). Frame enlargements.

reproduction, the cinema can fashion "replicants" that are—as Ridley Scott's *Blade Runner* (1982) would have it—"skin jobs." Terminal subjects. Still lives turned into moving pictures.

Despite its title, in *The Man with the Movie Camera* it is a woman, a film editor, who "fabricates" the film in this way. She labors over the celluloid strip, which consists only of a series of still images with bodies frozen into still lifes. Just as a seamstress would make a dress by cutting and sewing together pieces of fabric, the film editor cuts and splices film to manufacture movies. Editing—an analytic procedure—embodies, with its assembling force, the power to fashion that which we have called an "*emotion*." In this woman's laboratory, the mobility of the city ceases, and so does the course of life of the city dwellers. Suddenly their faces no longer move. They are frozen, dead, arrested on the editing table. Yet the force of editing, the arrest, also contains the power to release the movement. The moving image overcomes the death of "still" photography. And, just as it happens in the work of mourning, life moves on.

The Man with the Movie Camera "emoves," propelling the motion of emotion with this motor force of urban activity. Creating a choreography from the physicality of bodies on the run, the film takes pleasure in displaying the tensed muscles of people running, swimming, and dancing. Could *The Man with the Movie Camera* be an urban homage to locomotion studies? Perhaps so, for it is a grand spectacle of kinesthetics, fabricating its own moving elegy to the laboratory of the city, the body, and film.

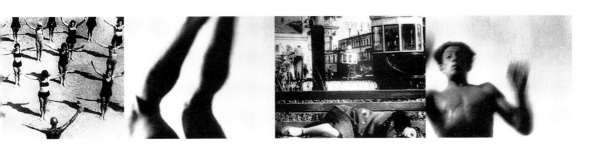

1.11. Set design in
L'Inhumaine (Marcel
L'Herbier, 1924).
Frame enlargement.

URBAN LURE, FEMALE ALLURE

With Marcel L'Herbier's *L'Inhumaine*, whose sets were designed by Robert Mallet-Stevens, Alberto Cavalcanti, Fernand Léger, and Claude Autant-Lara, architecture became a supreme screen of sets.[36] Concerned with modern ornament, *L'Inhumaine* would synthesize the design aesthetic of the 1925 Exposition Internationale des Arts Décoratifs et Industriels Modernes, for all who worked on this film (including Paul Poiret, who did the fashions) came to define avant-garde design at the Exposition in the following year.[37] The architect Mallet-Stevens, who designed the pavilion of tourism at the Exposition, was the theoretician of the film set. In his writing on decor, he conceived the set of a film as a work of draftsmanship and a working drawing.[38] He was particularly concerned with rendering haptic volumetrics and depth and emphasized aesthetic techniques of relief in the design of filmic decor.

L'Inhumaine, a film that turned the architect Adolf Loos into an enthusiastic film critic, opens with an industrial vista of Paris as displayed from the "moderne" villa of Mallet-Stevens.[39] This house is inhabited by "the inhuman one"—a woman. Claire Lescot is played by Georgette Leblanc, who conceived the idea for the film. Lescot is a soprano who presides over an international salon of men, hosting dinner parties served by masked waiters in an inner patio that resembles a refashioned impluvium. This particular set was designed by Cavalcanti, who, in his own *Rien que les heures*, would constantly return to the theme of food, conceiving the urban rhythm as its own metabolic matter.

Claire's salon is frequented by two suitors who battle for her affection. The engineer, Einar, ends up winning her love by showing her the workings of his very modern "cabinet of curiosity."[40] Claire delights in the marvels of this laboratory (designed by Léger), in which she can futuristically watch her audiences on a screen just as they are able to hear her sing. As the intertitles suggest, "she voyages in space without moving," reaching visions of artists in their studios, partaking of the bustling life on the street, and following people driving cars and riding trains. In this way, she lives "through the joy and the pain of human beings." No wonder her other suitor becomes jealous and poisons her.

But Einar's laboratory contains residual traces of its genealogy: it can perform alchemy. What is more, it is outfitted with an extra chamber, equipped with a mechanism for reviving the dead. This lab of transformation becomes activated in a sequence that resonates with Lang's *Metropolis*. With superimpositions and rapid montage, the laboratory offers what the intertitles call "a symphony of labor," which brings our *voyageuse* back to life and to the liveliness of her urban salon.

"Come to the City!" we hear in the films of the 1920s. It is screamed aloud in the intertitles of Murnau's *Sunrise*, where the energy of the street and the magnetism of cinema conjoin architecturally with the female allure.[41] In a film professing to be about "the song of two humans," the "inhuman" one is, again, a woman—the "Woman of the City," who comes to disrupt the married life of a peasant couple. Thus defined, she bears no name and possesses great allure. "Come with me to the City," she tempts the farmer, "Come to the City!" As her words fill the

1.12. The lure of the city "projected" on the screen of *Sunrise* (F. W. Murnau, 1927). Frame enlargements.

frame, a double of the film screen appears in front of the pair, projecting for him (and for us) the attractions of jazzy urban motion as the temptress dances to the *emotion* of the filmic-architectural canvas.

Besotted, the farmer tries to kill his wife but, in the end, is unable to carry through. Fearing her husband and anxious to escape a rotten situation, the peasant woman boards the trolley for town; he, repentant, follows her to the city. The trolley journey doubles the camera's own power to track motion and mobilizes the film's compositional penchant for painterly interplay. Entire segments of the history of landscape painting and design unfold in the window/frame of the two vehicles of transport (trolley and camera), united by motion. The journey, which bridges the countryside to industrial vistas and urban scenes, parallels the distance the couple itself is trying to bridge, which separates them from their turf and from each other. Once disembarked, they experience the attractions of the urban pavement, which becomes the locale of a sentimental voyage. Enjoying the erotics of the street and the dance halls, the enticements offered in cafés and restaurants, the two relearn what they can offer each other. On the grounds of modern architecture, they reunite. Fascinated by an imaginary urban space—a set design that looks ahead to the future of cities—the couple rekindle their love, based on their love of the city.[42]

FADS OF NOIR

It was René Clair who claimed that "the art that is closest to cinema is architecture."[43] This assertion is true in a number of ways, especially, as we will continue to observe in the next chapter, insofar as both enterprises are practices of space. Moving along with the history of space, cinema defines itself as an architectural practice. It is an art form of the street, an agent in the building of city views. The landscape of the city ends up interacting closely with filmic representations, and to this extent, the streetscape is as much a filmic "construction" as it is an architectural one.

If the urban landscape is a product of the city's own mapping, it is also a creation of its filmic incarnations, for these, too, become part of its geography. A

sense of place is actively produced by a constellation of imagings, which includes films, both those shot on location as well as those that fabricate their mise-en-scène. In fact, the important work of art direction and production design itself creates a sense of geography.[44] In many ways, a city becomes activated as a place on the screen as much as it does on the street. Think of New York, for example. As Donald Albrecht, an architect and curator interested in film design, has demonstrated, the New York City of films is a set as well as a location.[45] Life on the New York urban pavement absorbs the city streets of Hollywood and the shadowed interiors of film noir, creating a composite urban landscape. Edward Dimendberg and others have argued that film noir is quintessentially urban in nature.[46] With respect to geographic location, it claims a privileged role in the production of the urban terrain.

Filmic genres and cycles are specific to sites and even to means of transportation, and, in turn, they change the way we remap those sites. The railroad and the open landscape generated and shaped the western, outer space defined the domain of science fiction, the car determined the road movie, and the house delimited the border of melodrama—a border not readily trespassed. In many cases, however, these boundaries exist only to be transgressed. Thus in *Stazione Termini* (1953), a film by Vittorio De Sica and Cesare Zavattini (known in English as *Indiscretion of an American Wife*), the Roman railway station, the primary location of the film, turns into the set of a woman's amorous "transport": a liaison with an Italian professor, a culturally misplaced, irresistible Montgomery Clift.[47]

If landscape writes genres and cycles, the urban scenography is the map upon which film noir was implanted. To a large extent, the historical shape of the city determined this filmic mode: without the malaise associated with urban reconfiguration, this film cycle of equal darkness might not have been thinkable. But as it represents this space, film noir extends it—even into the tenebrous future that inhabits later films such as *Blade Runner*, with its set conceived by Syd Mead. Film noir has impressed its mark on the future landscape of the city and on the way we cognitively and emotionally navigate its space. In this sense, it continues the trajectory of the early urban panoramas, which the motion picture inherited from the shadow of nineteenth-century urban culture and fiction, remapping its penumbra in novel

1.13. Screening architecture in *The Fountainhead* (King Vidor, 1949). Frame enlargements.

ways. The noir stories emerge from the site of the modern city and, conversely, leave tracings of their footsteps on the urban sites as they redraw the physiological perimeters of the city for "things to come."

Noir as a "tactics" of urban planning is revealed in condensed fashion in such films as *The Naked City* (Jules Dassin, 1948) and *Le Samouraï* (Jean-Pierre Mieville, 1967).[48] In the mode of a remake, *Le Samouraï* returns film noir to the French cinephilic culture that gave it its name. A French neo-noir, shot in color, this film cites extensively from film's cultural past as it anticipates the hybrid, stark shapes of dark films to come. Here, Alain Delon is a lonesome outlaw, a border-crossing character who at once embodies a samurai, a western persona, and the urban version of the lonesome executioner produced by film noir. This pastiched urban cowboy looks back to the future: configured transfilmically, our solitary, dystopic character is a type of "blade runner."

Focusing on architecture and fashion, *Le Samouraï* engages, above all, our sense of "decor." Delon is "dressed to kill" and fashioned to seduce. Impeccably clad in the raincoat and hat that are *de rigueur* for the form, he is noir on all counts, and so attractively self-conscious that even a minor wound becomes an excuse for him to undress and present us with his rather remarkable naked flesh. No matter how messy the situation gets, he remains composed. Elegantly adorned to haunt the urban jungle, he persistently checks his attire, reviewing himself in the mirror to make sure his hat is in place. Minute, everyday gestures, like touching the hat, make up this film designed of body language. Dialogue is sparse, albeit sharp, and it is a "fashioned" space that propels the story. Our fashioned hero lives life accordingly. The space that he inhabits is transformed from the classic shadowy home of film noir into a stark, bluish-gray interior whose decaying architecture and peeling walls look ahead to further realizations of the cycle. Rigorously single despite a loving girl-friend, he relentlessly travels the city by car and on foot, haunting his victims until he becomes haunted himself.

Rather than providing the usual climactic chase scene, the film ends with a brilliant lesson on cartography. As it follows Delon's attempt to escape both the cops and everyone else who is after him, *Le Samouraï* avoids the characters' physical pursuits and, entering into a different zone of narrative space, narrates *with* space. Delon's escape, played out on the subway map of the city of Paris, is "tracked" remotely by the police on a transportation map. Instead of chasing, the point becomes "locating." The winner of the chase will be the one who best knows his map.

From the ruins of film noir, a story about mapping emerges. Ultimately, *Le Samouraï* tells no other story than that of the subway map of Paris. By way of tours and detours, it shows how a transportation chart can function to map and remap a city and how the landscape of this particular city is inextricably tied to its under-ground. The Paris *métro* speaks the anatomy of the metropolis: its plan is as intricate as the plan of the city itself. The subway map is indeed "the belly of Paris."[49]

Charted in this way, in the belly-plan, the filmic chase becomes a tactic in which tact plays an important part. The chase gives way to a haptic strategy of urban living in motion, a negotiation of the city space that is rendered as

cartographic navigation. Here, we engage in the very flux of psychogeography. Our urban hero knows his city "intimately"; that is, he knows all its inner workings. He has interiorized the subway map, practiced each of its pivots and sites of junction, digested every single point of entry and exit. So familiar is the streetwise Delon with this map that he can move jointly with it. He knows it "*comme ses poches*," like his pockets. No wonder this "blade runner" can outsmart the cops. He is "wearing" the map. Like a skin.

ON LOCATION: CITY WALKS

The physicality of the street and of the social epidermis materialized into fiction as a formalized architectural aesthetic in postwar Italian neorealism. This was a movement concerned with daily urban fiction. Its practice was exhibited, in particular, in films like Vittorio De Sica's *Ladri di biciclette* (*Bicycle Thieves*, 1948), which, as André Bazin effectively described it, is simply "the story of a walk through Rome."[50] Most neorealist works are similarly constructed and can be interpreted as city walks. Neorealism was a movement that developed street life filmically, exposing the living component of the production of space. Shooting on location with the city as its specific topography, it focused with precision on the urban mise-en-scène of the lived city. In this cinema, as in the philosophy of Henri Lefebvre, one may say that "architecture produces living bodies, each with its own distinctive traits. The animating principle of such a body, its presence, . . . reproduces itself within those who *use* the space in question, within their lived experience."[51]

Recognizing the role neorealism played in the construction of "the movement-image," Gilles Deleuze called attention to the "dispersive and lacunar reality" of the aesthetic, noting that "in the city which is demolished or rebuilt, neorealism makes any-space-whatever proliferate—urban cancer, undifferentiated fabrics, pieces of wasteground."[52] The movement-image is activated, in particular, in the series of fragmentary encounters with the parceled regional identities of the Italian nation that make up the landscape of Roberto Rossellini's *Paisà* (*Paisan*, 1946). It also informs the voyage of father and child in *Bicycle Thieves*, where the search through various urban wastegrounds for the lost bicycle is no longer a vector but a rambling—through sites that are life-styles and in a trajectory that can be fortuitously interrupted or deflected at any time.

To this landscape we can add another important urban fragment: the extraordinary long walk at the end of Rossellini's *Germania anno zero* (*Germany, Year Zero*, 1947). In a final sequence that serves to open the text rather than provide closure, the boy Edmund aimlessly wanders through Berlin. This walk constructs the city as a landscape of emptiness, rubble, and debris: an urban cancer that speaks of history and reveals how the traces of its ruins are left upon the urban fabric to mold its present and map the future.

UNHOMELY CITY VIEWS

> *In no other place—with the exception of dreams—can the phenomenon*
> *of the border be experienced in such a pristine form as in cities.*
> Walter Benjamin

Building on the ruins of neorealism, Pier Paolo Pasolini staged some memorable city walks. *Uccellacci e uccellini* (*Hawks and Sparrows*, 1966) is a walk undertaken by a father (Totò) and a son (Ninetto Davoli) in an imagined geography. Starting from a freeway under construction, the two walk along a heterotopic path. One sign on the road points to Istanbul, 4,253 kilometers away, while another points to Cuba, 13,257 kilometers away. Such markers contribute to our sense of disorientation as we traverse a site without a geography, with invented street names. We go from "Via Benito La Lacrima. Disoccupato," a street named after someone crying over his unemployment, to "Via Antonio Mangiapasta. Scopino," the street that puts the food consumer on the same level as the garbage collector. The characters walk the entire length of the film through a series of social situations, in a promenade that constructs a moving allegory of the joint itinerary of history and social space.

A different walk, from a different walk of life, makes up the cinematic land-scape of *Mamma Roma* (1962). The very etymology of *metropolis*—"mother-city"—is explored here in Pasolini's intervention into the terrain of the urban female. Anna Magnani, who had been the subject of Rossellini's *Roma città aperta* (*Open City*, 1945), is here a streetwalker named "Mother Rome." But Mamma Roma's Rome is no longer the "open city" of the neorealist vision.[53]

Mamma Roma is a film about architecture as a framework for life-style. In the opening scene, in a composition that mimics Leonardo's *The Last Supper*, Mamma Roma bids farewell to her pimp at his wedding party. She intends to give up her profession, move out of her old flat, and take her son Ettore to a better neighborhood outside the historic district of town. This is Rome, however, and not

1.14. Urban ruins in *Mamma Roma* (Pier Paolo Pasolini, 1962). Frame enlargement.

a postwar Hollywood fantasy about a dream located in a house in the suburbs. *Mamma Roma*, in other words, is no *Mr. Blandings Builds His Dream House* (H. C. Potter, 1948), a film about the force of "moving out" in the American landscape. In this latter film, after an elaborate tour that maps the space of his New York City apartment, the Cary Grant character decides to build a home out of town. "His" design prevails over "hers" and, despite the nightmare of construction and some healthy metropolitan cynicism, happiness at last finds a home outside the city. Things do not happen quite that way for Mamma Roma: in order to obtain her dream house, she is forced by her pimp to prostitute herself one more time.

Materializing the semiotics of prostitution, Pasolini makes Mamma Roma enact its peripatetics. In one extraordinary sequence, the streetwalker takes a long stroll, facing the camera and moving toward us. In this long take, she is accompanied for part of the time by other inhabitants of nocturnal Rome: first another streetwalker, her girlfriend Biancofiore; then a number of passersby who, one after the other, either alone or in small groups, "streetwalk" with her. They stride along with Mamma Roma for a while and then eventually exit just as they came in, moving off screen as she stays on and others move in. To the casual listeners entering and exiting her frame, Mamma Roma tells an architectural story that explains her entry into prostitution. She had been married off to a dirty old man, a repulsive urban developer, notorious for being paid to build an area now remembered as Cessonia, "toilet city," for he took the money and built only the bathrooms. As Mamma Roma tells us, the toilets—relics of his dirty deal—stand as urban ruins.

Mamma Roma's outlook on urban matters becomes increasingly clear as she looks out of the window of her flat. In point-of-view shots, twice, we are shown what she and Ettore see, and we hear her commentary on the ugliness of it all. The vista, so to speak, is of a cemetery. It is this "view" that Mamma Roma intends to leave behind, changing with the architectural view the view of her life. She walks the streets in order to buy a new house, to position herself in a different "perspective," and to actualize a social relocation into modern living.

Upon exiting the last streetwalking sequence, another panorama opens up: a long shot of the building complex to which she has moved.[54] The composition of the sequence in which Mamma Roma proudly accesses her new life emphasizes threshold. Tracking shots usher her and Ettore to the brink of the new urban scenography. Through the portal of the building complex, in a passageway, their new view is shown: a rather bleak display of postwar tenement buildings with sad, petit-bourgeois aspirations. This is Rome's *periferia*, its periphery, the sprawling edges of town where borderline living takes place. Once the countryside, this particular place is less than pastoral but not quite urbane. A mixture of public housing projects and private speculation, the *periferia* might be a new ghetto. But Mamma Roma sees it differently. She believes in her new INA-CASA low-income dwelling in the Tuscolano and is marching in to take her place in this entirely modern environment. After all, she has given up streetwalking to sell fruits at the local market.

It is now Ettore who looks out the window and contemplates Mamma Roma's new view. It is no longer the cemetery, but the rows of tenements look just as deadly. Composed and framed in the same way, the house of the dead and the dismal housing project seem interchangeable. Terminally adjoined through point-of-view shots, the two views metonymically converge. But while Mamma Roma clings to her imaginary view, Ettore begins to wander, exploring the margins of society as he roams the landscape of the "periphery." In a place where archaeological ruins coexist uncannily with the architecture of urban decay, Mamma Roma continues to struggle for the sake of her view.

Ultimately, however, she is forced to return to the streets. Pasolini reinstates the long take of her city walk: she travels first, again, with Biancofiore, who exits the shot to make room for another set of "passengers." As people stroll in and out of frame, Mamma Roma tells us a different story of how she took to the streets. This time, it happened because of Ettore's father. And now Ettore himself simply will not stay off the streets.

Eventually, Mamma Roma's petit-bourgeois aspirations come crashing down. Ettore, after he is caught stealing a radio in a hospital, dies in jail. Pasolini stages the filmic death as a moving *tableau vivant* that contains another painterly citation, this time to the mise-en-scène of Andrea Mantegna's fifteenth-century painting of the *Dead Christ*. As Ettore's feet fill the foreground of the frame, Mamma Roma's view of an open city closes in on her. She rushes home, and a cut returns us to the point-of-view tracking shot of the passageway that had marked her entry into the tenement life. At this point in the narrative, the entrance shows itself to be an enclosure. Upstairs, Mamma Roma throws herself at the window. It is the same view, yet as she looks a second time it looks different. Filmed with a different lens, it is a wider shot. Her subjective viewpoint has changed the urban landscape. As the world retracts, her view escapes her, recedes. For Mamma Roma, this is the end.

The shot of the view closes the film. It has been repeated many times as Mamma Roma's world has enlarged and shriveled. We are reminded of the way Homi K. Bhabha speaks of "the world-in-the-home" and describes how the "unhomely" moment comes into being. We experience it with Mamma Roma, as with Isabel Archer in *The Portrait of a Lady*, when they take the measure of their dwellings. "It is at this point that the world first shrinks . . . and then expands enormously. . . . 'Unhomeliness' [is] inherent in that rite of extra-territorial and cross-cultural initiation. The recesses of the domestic space become sites for history's most intricate invasions. In that displacement, the borders between home and the world become confused."[55] For Mamma Roma, who takes the measure of her dwelling and transforms it literally into a way out of streetwalking, the unhomely creeps in. The borders between home and the world become disorientingly confused. Her domestic space bears the mark of history and the dream of its potential changes. As the expansion and retraction of views builds the narrative setting of *Mamma Roma*, an architectonics becomes embodied in the very changes of this woman's "views from home."

THE URBAN FABRIC

For me landscape has everything to do with cinema.
Wim Wenders

The cinematic wings of Wim Wenders's *Wings of Desire* (1987) lovingly transport us in and out of cityscape and streetscape. This is a film made by a former painter who, by his own admission, was "interested only in space: landscape and cities . . . 'landscape' portraits."[56] Wenders, like Michelangelo Antonioni, is affected by a form of "topophilia," a syndrome, first defined by the geographer Yi-Fu Tuan, that manifests itself variously as the love of place.[57] Wenders's topophilia, as he describes it, concerns the "habitability" of place, which involves "always, a work of mourning, a resistance" that provides "the energy to travel inside the site to know it and describe it" filmically.[58]

In a topophilic film whose German title, *Der Himmel über Berlin*, refers to "the sky above Berlin," angelic city views meet cinematic bird's-eye views. The filmic angels, as the director has remarked, reference Walter Benjamin's own "angel of history."[59] A reference to it is whispered in the film's library, where the storyteller sits in front of globes. It is this angelic outlook, projected forward but looking backward, that *Wings of Desire* strives to reproduce. With such a view in mind, the film constructs—by means of architecture—a historic reflection on the grounds of the city of Berlin.

The film, by now, is an architectural document of a city that no longer exists; with the passage of time, it turns ever more clearly into a work of mourning. An historical meditation that, in Wenders's words, involves "women of the ruins," it takes us from the cityscape to the street and the often-empty plaza.[60] In this way, *Wings of Desire* brings us to inhabit the postwar void of Berlin before it was filled with the new construction that changed the specific sense of dwelling there and affected, along with the mental map of the city, its relation to the past. In this particular city, both for the inhabitant and the visitor, history was written onto the blank of the empty space, in the void that was a palimpsest of erasures.

Wings of Desire is, overall, a film about the haptic sense of architecture. The exploration opens with a close-up of an eye moving into an aerial cityscape, which in turn becomes reflected in the eye's pupil via superimposition. It is an image that resonates with a celebrated engraving by the architect Claude-Nicolas Ledoux, *The Creating Eye* (1804), in which an eye reflects in its pupil the auditorium of the Theater of Besançon.[61] The angels begin to guide us from aerial views to the streetscape, traversing the landscape of urban dwellers, whose interior monologues they can sense and externalize for us. A moving camera passing through window glass leads us to the interiors of apartments, capturing here a child's disappointed expectations, there a woman painting her wall or a man visiting a house that smells of his dead mother, who collected pictures and never threw anything away.

As *Wings of Desire* continues to externalize the interior space of the lives of Berliners, the sense of the haptic shifts; it becomes mobilized as a complex audio-

spatial strategy that carries us in liminal space. The tender angels—both messengers and passengers, like the cinema itself—are invested with the desire to affect lives. But the angel Damiel (Bruno Ganz) craves the actual historicity of those lives. Having become enamored of an acrobat (Solveig Dommartin), he chooses to become incarnated in the flesh so that he may love. It is at this point that the haptic comes to concern the actual recovery of the sense of touch. Such erotics involves, along with sexuality, an awareness of physicality, here represented as the ability to leave a footprint and to feel skin. With his "grounding" and the loss of angelic armor he must bear in order to enjoy physiological matters comes the sense of taste, and the need to acquire a taste for fashion. Damiel makes a bad bargain, giving up his armor for a dreadfully colored jacket. The angel's grounding is rendered as a different way of looking: the new visuality, fixed to the pavement, is color coded; no longer the black-and-white world of angelic transport, the haptic turns into a colorful view. But placed in the world of Technicolor and incarnated far too exactly, the haptic, fleshed out verbatim, ends up disappointingly literalized.

Matters of filmic texture are also engaged in Wenders's *Lisbon Story* (1994). This city film renders landscape with soundscape and might have been called "Panoramic View of Lisbon." It is a sound remake of the silent urban panoramas we considered earlier. Eloquent on cinema's early panoramic culture, *Lisbon Story* is nonetheless pervaded by a form of nostalgia that views the current state of image technology suspiciously. In this film, Wenders resists the potential to reinvent the haptic sense through new forms of imaging. But resistance belies fascination. This is made particularly clear in Wenders's *Notebooks on Cities and Clothes* (1989), a work shot on film and video that mixes the imagistic textures of cities and fashion within the landscape of Tokyo. Devoted to the work of the Japanese designer Yohji Yamamoto, the film demonstrates that street and clothes do, indeed, share a fabric. This fabric, as we will further claim, is a conduit. It is a fashion of habitation.[62]

URBAN DIARIES

To open the fabric of a city to view involves a liminal movement between exterior and interior. A taxi in different cities might provide this entrance into urban space, as in Jim Jarmusch's *Night on Earth* (1991). Such a travelogue might even take diaristic form, as in *Caro diario* (*Dear Diary*, 1993), an urban journal by Nanni Moretti in which the Italian author/actor wanders the streets of Rome on a scooter. This is autobiographical fiction turned filmic memoir. If the performance of autobiographical fiction materializes for Sally Potter in *The Tango Lesson* (1997) as a musical film journal, for Moretti, the filmic diary takes the shape of an architectural notebook.

In the first part of his episodic film, Moretti reveals a dream he has had, in which pictures become an architecture. Imagine a moving picture of houses. Think of a story made up only of architectures. Setting out to realize this dream, Moretti makes a journey around the city. "Traveling shots" of Roman facades are shown to

us as the filmmaker roams about on his Vespa. The camera movement doubles the vehicle's motion through town. As in the early panoramic films of the travel genre, we are literally transported, for when film becomes a traveling lens the spectator becomes a voyager, traveling even through history. Here, as we visit different parts of town, a montage of the city's history takes shape. We learn from Moretti about the history of the buildings and the various districts. Diverse architectural figurations are edited together to create a travelogue of specific atmospheres. Architecture, locally experienced in motion and reassembled for the spectatorial tour, is made to move. Rome becomes a moving architectural landscape.

But the architectural surface of the city is only a part of Moretti's dream. The filmmaker wants more than to travel along the facades of houses. Who, he appears to ask, inhabits the space of film and architecture? "Film directors do not inhabit films; they are evicted tenants, homeless people," says the filmmaker in the text of *Beyond the Clouds* (1995), a film by Michelangelo Antonioni and Wim Wenders. Moretti seems to rebel against this idea. He wants to be housed, craves the places others live in, is curious about the lives led inside the apartments of strangers. He wants to live (and live in) them. As the filmic set becomes a fantasy of home, every house becomes a possible set. The camera tilts up to look at a Roman attic as if caressing the space with palpable desire. As Moretti wonders what it would be like to occupy that space, the authorial dream meets spectatorial practice. Such is the pleasure of haptic wandering experienced by the film spectator: one imagines oneself residing in a space, in someone else's place, and tangibly maps oneself within it. The perfect architectural dream is a filmic dream. Pictures become an environment. Architecture becomes a film.

HOMESCAPE

My world is the imaginary, and that is a journey between forwards and backwards, between to and fro. Like Wim [Wenders], I'm a great traveler.
Jean-Luc Godard, in *Chambre 666*

As it moves between outside and inside, film pictures the architecture of the interior, writing the history of private life. Many films participate in this writing, but some do it intensely and primarily by way of architecture. Architectural views of interiors are found throughout the history of the world's cinema and particularly mark Japanese film, especially the work of Yasujiro Ozu and Kenji Mizoguchi. Our travelogue, however, will concentrate on architectural views that have made Western private life publicly available, beginning with one particularly salient example.

Jean-Luc Godard's *Le Mépris* (*Contempt*, 1963) tours in and out of the home(land), moving from bodyscape to homescape.[63] At the beginning of the film, the camera frames Camille (Brigitte Bardot) and Paul (Michel Piccoli)—a man who wears his hat in the bathtub—as they lie in bed in their Roman apartment. Bardot, reclining naked on her back in the foreground, creates a dictionary of her body in

the mode of amorous discourse, enumerating each of its parts, one by one, with her lover. Traveling the map of her body, Camille asks Paul to "locate" his love for her. Does he love her feet, ankle, knees, thighs, backside, hair, breasts? And can he now caress her, touch her shoulders? The camera extends this caress to her, moving as if it were his hands across her back and then up to her face, to her mouth, eyes, and ears. Yes, he loves her, he tells her, "totally, tenderly, tragically."

In this intimate love scene—one of the most intimate in film history— Camille's list creates an embodied taxonomy for a "tender" archive. This is an anatomy lesson of a particular kind: reclining as her own "Waxen Venus," she does not anatomize in order to dissect.[64] That is, her construction of body parts does not imply a parsing. She surveys the landscape of her body in a single take that contains both the singularity and the multiplicity of a mapping. Indeed, this take is a chart. It is a filmic *Carte de Tendre*. The vista explored by Camille is a scenography straight from Scudéry—the making of a sentimental landscape. The long take is a map of amorous transport, a filmic map of tenderness.

Having introduced us to a sentimental landscape by way of a body map, the film proceeds to explore the couple's life. Their marriage is disintegrating, a crisis rendered architecturally via the doomed purchase of a home. Paul has accepted an offer to work for a crass American film producer in order to pay the mortgage on their new Roman apartment. His assignment is to rewrite the script for a film version of *The Odyssey* directed by Fritz Lang, who plays himself. Around the notion of home ownership, contempt begins to set in.

The text of *The Odyssey*, which includes the course of Ulysses' travel and Penelope's in-house voyage, provides an interesting subtext for the film's amorous navigation. *Contempt* develops in the space where domestic life resides, tracing the unfolding of the couple's daily life in an architectural narrative. The camera travels creatively on a path that proceeds through the unfinished glass door of the bathroom, from kitchen to living room, and into the bedroom. It captures the characters' deteriorating relationship by mapping it onto objects of love and design—onto "bed and sofa"—and by retelling it as an odyssey in and out of rooms, in between and around spaces.[65] It is a landscape that resonates with the scenography and sound track of the opening scene.

Framed by Lang's ironic comment that CinemaScope is good only for "funerals and snakes," the widescreen format of *Contempt* functions to enhance the "scope" of architecture in the environment. This includes the location of the apartment, which is situated just outside the historic center of Rome. Like Antonioni in *L'eclisse* (*The Eclipse*, 1962), Godard engages modern architecture. Both films are essays on urban planning that survey the transitional life of Italian cities during the so-called economic miracle. In *Contempt*, as in *The Eclipse*, we watch a new city in the making, with a focus on the unfinished. Antonioni's urban meditation constantly returns to buildings in construction, lingering on their parts as if they were already incipient ruins. The opening and ending sequences of the film are passages in which architecture and film articulate each other. From the moment Monica Vitti appears in a silent exploration of a "house divided" to the shot of the window that opens to

reveal a new city, to the ending, in which the characters exit to make room for an extradiegetic urban exploration, the film portrays the "eclipse" of the classic image of Rome. Squared squares, the geometry of buildings, the stripes of the new urban crossing—all are Rome as it is being turned into a modern city, built on the margins of the historic center despite the picture-postcard vision that would ignore this phenomenon. The middle-class section of this plan is precisely the urban landscape of *Contempt*, which presents the transformation of the countryside into the new residential quarters of the city.

Contempt dwells on the marriage of film and architecture in many ways, including a visit to Cinecittà, the Italian film studio whose name means literally "cine city." We visit a film theater where a marquee displays the title of Roberto Rossellini's *Viaggio in Italia* (*Voyage in Italy*, 1953), a clear citation to a film we will investigate in depth later.[66] Framed against a poster of *Voyage in Italy*, the actors of *Contempt* inform us that they are making both the actual and the sentimental voyage of Rossellini's film. Following the script of the cinematic-architectural grand tour, the film takes us on an actual "Voyage in Italy": the couple travels to Capri, where their marriage continues to fall apart. The last part of *Contempt* takes place on the famed island, which is also, not coincidentally, the location of the "mise en abyme" remake of *The Odyssey* that takes the shape of the difficult navigation of the couple's love affair.

The end of the story is played out in a house that is "to die for"; indeed, Camille is literally led to her death there. The Capri location enables Godard to exhibit an unusual lyrical touch in conveying landscape; he luxuriates in several views of the island's deep blue sea and open sky. This filmic landscape is contingent on architecture, made possible by a house named Casa Malaparte.[67] The residence of the novelist Curzio Malaparte, it was largely designed by its inhabitant, who was responsible for articulating the amazing shape that Godard so coveted. Geography models this domestic architecture. The house is built on the entire length of a narrow promontory, on a cliff that extends out into the Mediterranean and drops some

1.15. On the staircase of Casa Malaparte in an emotional sequence of *Contempt* (Jean-Luc Godard, 1963). Frame enlargement.

650 feet into it. Casa Malaparte's most striking feature is a giant staircase, set in dialogue with the topography, that was made from one of the exterior walls and transforms a domestic ascent to the rooftop into a Mayan affair. Godard plays a cinematic game with this staircase, engaging in monumentalization by way of a high-angle shot and with a fluid rendition of the architectural slant. The film shows the house as a cinematic incline and engages its material resistance. In fact, at the top of the stairs, a white wall appears, which functions to block the open sea view one might expect to encounter there. The wall that materializes in front of us can be circumvented, however. Slowly degrading at the top, this wall filmically defines the set of the vista and opens a gradual view of the panorama. As we have learned from the panoramic travel genre, a panoramic view unfolds as we move around the wall-screen. It is only appropriate, then, that Fritz Lang, a filmmaker obsessed with architecture (he trained as an architect and had been a painter) would make an *Odyssey* on this filmic rooftop.[68] It is no wonder that Godard would film it.

AMOROUS CITY MAPS

> *How could I know that this city was made to the measure of love? How could I know that you were made to the measure of my body?*
> She said, in *Hiroshima mon amour*

Hiroshima mon amour —Hiroshima my love—is a title that speaks of two passions, superimposed: the difficult love for a city, and a city as the site of a difficult love. With Sacha Vierny as director of photography (a regular talent on the sets of Peter Greenaway), the film was made in 1959 by Alain Resnais, a director of architectural dramas. His *L'Année dernière à Marienbad* (*Last Year at Marienbad*, 1961) takes place in a hotel whose permeable impermanence is further mobilized by the setting of the story, a garden where statues, people, and trees stand in the landscape as equals. The film is an architectural exploration of a memory, perhaps held as a shared space between two people. This mental architecture is navigated via elaborate camera movements that endlessly traverse the hotel hallways, never distinguishing between the Chanel-clad characters and ornaments in architectural space. In the hands of Resnais, architecture is always linked with sensuality and the amorous is never too far from geography. Such a sensibility is written literally into *Hiroshima mon amour*, for the text of the screenplay—by Marguerite Duras, author of such autobiographical fiction as *The Lover* and *The North China Lover*, novels that speak of the geography of passion—is particularly sensitive to the architectonics of love.[69]

"He" is a Japanese architect. "She" is a French actress, in Hiroshima to play in a film about peace. As her voice-over recounts her amorous trajectory, her visual memory superimposes two journeys, the two "tales of love" of a "stranger from within" whose interior geometry the film designs.[70] For her, the city was made to the measure of love, made to the measure of his body. By means of this

metaphor—literally, a "means of transportation"—we are indeed metaphorically plunged into the site of an amorous "transport."[71]

Two men inhabit two cities. Hiroshima, now. Nevers, then. Two places, two times, both experienced through the body of a lover. Two strangers cling to her. A Japanese architect, now. A German soldier, then. Two different figures. Yet their hands, twitching in so much the same way, make their two bodies into one. As their physiognomies blur, the distant topographies blur with them: one lover turns into the other; the city of today turns into the city of yesterday. A city of travel becomes her city of birth. One body, one city, until they are only one site.

AMOROUS GEOGRAPHIES, CULTURAL "TRANSPORT"

The hybrid mapping of *Hiroshima mon amour* finds a contemporary incarnation in *L'anima divisa in due* (*A Soul Divided in Two*, 1992), by one of Italy's new *auteurs*, Silvio Soldini. *Hiroshima mon amour* meets Rossellini's *Voyage in Italy* in this film about the "transport" of cultural travel. Designed by a filmmaker whose urban sensibility recalls Antonioni's own, the film recounts the story of a Milanese security guard and a gypsy woman who have fallen in love and are trying to meet half-way on the road to acculturation and cultural transformation. Here, love is filmically envisioned as a moving matter, as Diotima of Mantinea saw it in Plato's *Symposium*: a force that "moves all," equipped with the power "to interpret and ferry across."[72]

By way of love, a process of cultural mimesis is set into motion in the film. Pushed to the limit, it touches slightly on what Roger Caillois has called "mimicry" in describing the disturbing affect of psychasthenia, a disorder of personality in which the body is so tempted by space that it blurs the distinction between itself and the environment and *becomes* the space around it.[73] In *A Soul Divided in Two*, depersonalization occurs through assimilation to space as the mimetic process invests the porous borders between bodies and cultural spaces. The lovers penetrate, absorb, and finally incorporate each other's culture by way of their touching skins. Each turns into the other, takes the other's space, assimilates somatic features and sartorial habits, and yet the two move unequivocally apart. An explicit reflection of Italy's relatively new interculturalism, this urban journey of two intimate strangers makes e*motion* a vehicle of cultural identification and transit. Ultimately, the "Voyage in Italy" of *A Soul Divided in Two* shows that the amorous journey goes hand in hand with the cultural one, leading us to inhabit the body and the city of others in liminal fashions. Mimesis as a form of identification is clearly an effect of cultural space. Along the amorous trajectory, mimesis—a prime component of film's imagistic power—shows itself to be a matter of cross-cultural touch. As it edges on "mimicry," it can become a spacing effect.

CHINA (IN) TOWN

In the wake of *Blade Runner*, with its "city speech" and "skin jobs," and in keeping with the best science-fiction tradition, many other filmic visions of the future—"Things to Come"—have been architecturally envisaged, shaped as a fusion of the spatiotemporal and the haptic. The representation of the city as a dwelling place of diasporas, a set design of the spaces between cultures, the locus of transience—a place of encounters in which (to borrow the title of Marco Bellocchio's 1967 film) "China is Near" in a new fashion—is shaping the cinema of the near future.

It is not by chance that such a vision has come significantly from Hong Kong, where the home and the airplane long felt close until the new airport tried to pull them apart. There, the city speech of the near future lives in a state of motion. The dynamics of places and of what Marc Augé has called "non-places" shapes the postcolonial city cinema of Wong Kar-Wai, who in *Chung King Express* (1994) and *Fallen Angels* (1995) has created portraits of a city that turn the screen into a moving canvas.[74] His dazzling camera movements are like painterly brush strokes, transforming the screen into a post-impressionistic space where bodies in motion become "traces" of moving color. Wong Kar-Wai's *Happy Together* (1997) sketches out a tender gay love story of two Hong-Kong émigrés against the backdrop of a deromanticized Buenos Aires as it meditates on new territories of immigration and novel forms of cultural transition. On the eve of Hong Kong's return to China, this becomes the matter addressed by Hong Kong director Peter Chan as well, who in *Comrades, Almost a Love Story* (1996), starring Maggie Cheung, charts the geography of various diasporic turns onto the city streets. The film follows a pair of (almost) lovers who, on the path of acculturation, traverse a composite urban map—a map that shifts from the old to the new image of cities, extending, both historically and geographically, from China to New York's Chinatown to China (in) town.

CITY WALKING IN LOS ANGELES

Geographies were expanding and retracting, fractured and joined in various forms on a field screen, even before they came to inhabit and become mobilized by the filmic screen. As I set out to approach the cultural movements of the geographic, I was reminded of a statement by Siegfried Kracauer, who noted that "the World Panorama has been superseded by a cinema."[75] Seeking traces of the geographic texture of the cine city in this way, it was inevitable that my tour would pass through the fabric of Hollywood. Taking Kracauer's suggestive remark, and following a critical approach to the urban archive of the feet as a part of my city tour, I thought it suitable to go to Universal Studios in Los Angeles to take the studio tour of the cine city, designed by Jon Jerde in 1991–93 and fittingly named "CityWalk."

In light of the fictional geography that has been created in the filmed history of city streets, it is not surprising that Universal opened such a CityWalk. A favorite part of the studio tour, this place would appear to enable one to city-walk

1.16. Motion pictures animate the movie house in *The Man with the Movie Camera*. Frame enlargement.

through the filmic city itself. However, much as I appreciated the irony of taking a city walk in the car-driven culture of Los Angeles, I was disappointed. This is a replica and not a replicant. A replicant, as *Blade Runner* has it, is a mechanical double that contains in its mechanism the workings of mnemonics and of the imagination, as well as a drive to historicity. Unlike that replicant that is the cinema—or the cine city that lives in the movie house—the Universal "CityWalk" retains no trace of the lived, fictional space of the cinema. It has no sense of the real as reel fiction.

STREETS TURNED INTO A PICTURE PALACE

> *One's body takes root in the asphalt.*
> Siegfried Kracauer

> *Botanizing on the asphalt.*
> Walter Benjamin

The cine city is a multi-faceted, haptic phenomenon, with aspects that involve not only the history of cinema but also its theorization. To continue our travelogue, then, let us turn to the way movies are "housed" in critical discourse and introduce in this way a topic that will become the subject of the next chapter. The bond between film and the body of urban culture that we have seen emerging in some corners of film history is also a proper focus of film criticism. An interest in the movement of architecture is exemplarily displayed, for example, in the writings of Siegfried Kracauer, which paved the way for, or intersected with, the reflections of his friend Walter Benjamin. Kracauer had a career as a trained architect and, as a critic, was always attracted to the urban pavement. His early interest in the texture of passageways was made manifest in his reflections on the "Hotel Lobby" and the "City Map," which for him were places of "Travel and Dance," altogether conceived as "decors" of the *Mass Ornament*.[76]

Interested in Italian neorealism, Kracauer drew on the material historicity it explored on screen for his later film theory, which was tuned to the establishment of physical existence. He pointed out the impact of location in this filmic style, which both emerged from and represented the bond between history and the street. As Kracauer put it, "when history is made in the streets, the streets tend to move onto

1.17. The emotion of motion in the city traversed by *The Man with the Movie Camera*. Frame enlargements.

the screen."[77] As Miriam Hansen shows, Kracauer furthermore thought of film as something "with skin and hair."[78] He called attention to German street films by conveying a physical attraction for the street, dwelling on urban textures—the pavement, the touch of feet walking over stones.[79] For Kracauer, the affinity between cinema and the pavement pertains to the transient, for the street, like the cinema, is the site where transient impressions occur.[80] It was indeed a clever coincidence, as he noted elsewhere, that the entrance to a Berlin *passage*, a place of urban transit, was flanked by two travel offices.[81] The Anatomical Museum—a place of transport—towered inside this arcade amidst the world panorama. Here, cities looked like faces.

Kracauer's interest in the space of the cinema included the architecture of movie theaters. In a 1926 article on Berlin's picture palaces of the 1920s, he showed that "the life of the street" transforms itself "into the street of life," giving rise to the cosmopolitan cinema audience.[82] The movie theater housed the city, which was itself a movie house, a theater of modernity's journeys.

1.18. The Ufa Cinema, located in the Turmstrasse, Berlin, 1924. Fritz Wilms, architect.

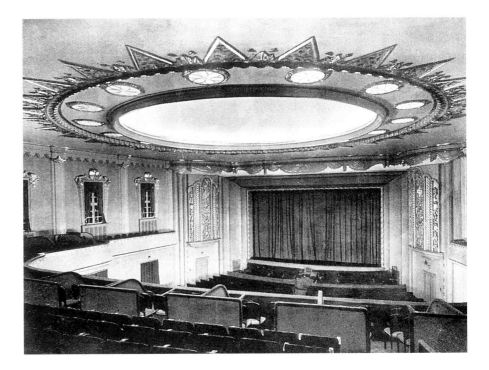

1.19. Lobby of
the Titania Palace
Cinema, Berlin.

1.20. Lobby of
the Savoy Theatre,
London.

HOUSING: AN ARCHITECTURE FOR FILM THEATERS

As Kracauer's work demonstrates, turning to the architecture of movie theaters is a crucial way to pursue film spectatorship as an architectural practice. It is an exploration of the intersection of wall and screen that we will conduct across the course of the book. Film is always housed. It needs more than an apparatus in order to exist as cinema. It needs a space, a public site—a movie "house." It is by way of architecture that film turns into cinema. Located in the public architecture of the movie theater, the motion picture is a social, architectural event. The film experience involves a spatial binding just as an architectural experience can also embody the fiction of a cinematic path. As the street turns into a movie house, the movie house turns into the street.

As architectural spaces, film theaters offer a variety of possible cinematic experiences and diverse means of mapping spectatorship. One can never see the same film twice. The reception is changed by the space of the cinema and by the type of physical inhabitation the site yearns for, craves, projects, and fabricates, both inside and outside the theater. Thus we can be utterly different spectators when we watch the same film in different places, for different models of spectatorship are figured in the architecture of the theater itself.

Let us take as examples two theaters in New York City: the Film Guild Cinema on Eighth Street, in Manhattan, and the Loew's Paradise Theater, in the Bronx, on the Grand Concourse at 188th Street.[83] Located in the same city and built in the same era, these two theaters nonetheless occupy different locations on the spectatorial map, and not only in a physical sense. Let us take an imaginary architectural walk through New York City and sit in these movie houses as a way of inaugurating our tour of the house of moving pictures.

KIESLER'S MOVIE HOUSE OF SILENCE

The Film Guild Cinema was designed by the vanguard architect Frederick Kiesler in 1928.[84] Located on a main street of Greenwich Village, it was placed in an area where the city's motion has never ceased to interact with film's own. Upon entering this urban theater, however, one encountered a space that was far from the stirrings of the metropolis. This was a filmic space devoted to one particular aspect of the urban experience: it was carefully designed to offer a perceptual voyage that distilled the experience of modernity.

1.21. An "optical flying machine": interior of the Film Guild Cinema, New York City, 1928. Frederick Kiesler, architect.

Kiesler's Film Guild Cinema was conceived specifically with film spectatorship in mind. The design, moving away from that of the stage theater, took into account generative aspects of the film experience and strove to offer an architecture for them. The architect, who was well versed in both the visual arts and theater design, took into consideration the importance of spatiovisual and acoustical aspects of film's performance and, considering the nature of its reception, worked with the light, sound, color, size, and angle of the moving image.

In Kiesler's design, the theater's center screen could change with respect to the size of the image projected, its geometry expanding and contracting according to need: starting from a one-inch square it could be enlarged to encompass different sizes and shapes. The device that enabled this flexibility was called the "screen-o-scope," which resembled the diaphragm of a camera. The theater's design also called for a multiple projection system that would extend the projection from the center screen onto the two side walls and over the ceiling. The height and width of the projected image could be manipulated to create a total film environment. The potential for multiple, continuous projection was never fully realized or utilized, however: a planned "projectoscope" was to have functioned like a planetarium, offering the same "global" journey—a powerful extension of spatiovisual borders.

Kiesler's movie theater was an expression of modernist aesthetics.[85] Its facade, a Mondrian-like grid, was illuminated to announce the lines of light that made up the architectonics of the interior, which converged with film's own architecture of light and habit of projection. The configuration of the movie house "projected" a specific film experience to its spectatorial body: through its architecture it designed a trajectory that reached toward absolute perception and conceptual cinematics.

The architecture of Kiesler's theater, built during the golden age of the movie palace, was radically different from the ornate, phantasmagoric, and sometimes monumental architecture of film theaters in vogue at the time. Here, the spectator was not transported into the dreamlands or journeys of the "atmospheric" palaces, which evoked specific lands and sites through their architecture. The journey was of a different kind, and the spectator a different traveler. Being in Kiesler's theater was like being inside a camera. The shape of the screen resembled that of a lens, and it manifested itself as a mechanical eye. The ceiling was slanted and the floor inclined, making the room, the locale of the movie house, similar to the interior of a camera obscura. Spectators were taken into this "room" and projected toward a lens. As their eyes met the mechanical eye of the screen, they were transported into the film and enveloped within the spatiality of the cinema. They resided inside what Kiesler himself thought of as an optical flying machine, moving at the speed of light waves.

The practice of film spectatorship that emerged from the architecture of this space, and from its metonymics, orchestrated a total artistic experience—one that even included an art gallery. This aestheticized notion of film space offered a place for film within the range of the spatiovisual arts. Kiesler's space was a full-scale visual ensemble that constructed a notion of cinema as surface. In his own words:

The film is a play on surface, the theatre is a play in space, and this difference has not been realized concretely in any architecture, either that of the theatre or the cinema. The ideal cinema is the house of silence.

While in the theatre, each spectator must lose his individuality in order to be fused into complete unity with the actors. . . .This is the most important quality of the auditorium; its power to suggest concentrated attention and at the same time to destroy the sensation of confinement that may occur easily when the spectator concentrates on the screen. The spectator must be able to lose himself in an imaginary, endless space.[86]

Film does not exist by itself, without an architectural environment. For Kiesler, this environment was an optical fabric and a perceptual fabrication. The architecture of film was to be conceived as a minimal space with a "play on surface." It must make itself almost invisible to allow for visibility. Architecture had to dematerialize to let the act of viewing exist, without distractions and, above all, without other sensory experiences. It must even forget itself so that the geometry of the screen might disappear in favor of a boundless experience of absorption in the surface, which is infinite space. According to Kiesler, no proscenium should separate the spectator from this field screen. No decorative elements or ornaments were allowed, for they might tear the viewer away, sending him or her in different directions. No curtains were to mark entries and exits, for there should be none. The pitch-black darkness must be as enveloping as this total experience. This was not a place of urban hustle and bustle, not the site of communal activity or loud public living. This surface-cinema was a place of private, concentrated attention and yet loss—a place where attention turns inward and individual boundaries give way to waves of perceptual unity.

Kiesler's theater set a model for an avant-garde cinema. In a way, it was reincarnated in the Austrian filmmaker Peter Kubelka's design for the "Invisible Cinema" at the former Anthology Film Archive building, a modernist sanctuary and museographic project for avant-garde cinema in New York City.[87] There, to ensure total perceptual fusion, the spectatorial seats even possessed a special architectural feature, a divider, which encapsuled the spectator in his or her view. Here, one was basically alone in the act of filmic viewing, insulated aurally as well as haptically. Communication with one's neighbor was discouraged, for it was difficult to achieve through the partition. In theory, talking and touching were not possible during the show. As with Kiesler's theater, in this view of cinema, architecture must nearly shut up—and shut itself down. The movie house is the house of silence.

ATMOSPHERICS: THE GARDEN IN THE PALACE OF CINEMA

In contrast with Kiesler's essential architecture of silence and its inward-directed voyage, there existed at the same time a design for the movie palace that offered a different spectatorial model: an extension of the urban spectacle of transit. The era of the movie palace opened a new age of filmic travel. The movement of urban crowds and their transit in and out of theaters was translated into space, architecturally shaped

by extravagant decoration and with curtains that were, significantly, called "travelers." (Im)mobile spectatorial voyages would take place within articulate designs of perambulation that plucked spectators off the sidewalk and into sumptuous lobbies and spacious auditoriums.

This circulation was particularly evident in New York City, even in the development of its theaters: nearly all of the movie palaces there had been "built on the ruins of business engaged, in one way or another, in transportation."[88] From one industry of movement to the next, the landscape of the city moved on. The movie palace, once the site of an urban transformation, continues to be a part of the metropolitan recycling. When I surveyed the present state of New York's movie palaces, I encountered a veritable map of metamorphosis. If I did not find the theaters in ruins, cut up into multiplexes, or transformed from a cinematic temple into the sanctuary of a church, I found myself in such establishments as a supermarket, a restaurant, or even a university cafeteria. Some food for thought: a form of imaginary architecture that feeds the metropolis, the movie palace lives, metabolically, on the ashes of urban gastronomy.

Transformation was inscribed into the genealogy of the atmospheric theater, for this space was supposed to absorb us and transport us to different places. In general, architecture was the primary experience in the movie palace. It was a place of excess and excessive space to be enjoyed while strolling, as a reviewer put it in 1929, "through lobbies and foyers that opened into one another like chambers in a maze."[89] The movie palaces both fashioned and featured an articulate social geography, including such essential places as "cosmetic rooms," "smoking galleries," and "crying rooms."[90]

Given its place in this architectonics, the movie was not the main affair of the movie palace. Design was. In dialogue with social architecture, design augmented the traveling work of the film text, which was not at all overpowering. The film was not centralized or even positioned in a crucial place of visibility. As William Paul shows, the screens of the movie palaces were extremely small in relation to the overall space, had illumination problems, and were often further marginalized by being inscribed into the ornament of a stage set.[91] This type of film theater could never be the sort of unified perceptual space in which one concentrated on a focused vision or became engrossed in the visuality of the screen. Coupled with the fact that the house lights were up, even during the show, one can imagine that the spectatorial experience was rather an *error* of vision—a spatial wandering.

Design was even more important to the version of the movie palace known as the atmospheric theater. These were palaces in which tourism took architectural form, as in the Loew's Paradise in the Bronx, built by John Eberson in 1929. Eberson, the master architect of atmospheric theaters, had studied in fin-de-siècle Dresden and Vienna before moving to the United States in 1901.[92] Given his cultural background, it is quite possible that he was familiar with the concept of *stimmung*, which encompassed atmosphere, sentiment, state of mind, mood, and tonality, and which had its roots in nineteenth-century discourse. Emerging from the texture of

landscape painting, *stimmung* entered the language of modern architecture and eventually informed Weimar film culture.[93] In the 1920s, the émigré Eberson, in his own way, transformed the notion into an architectural design that invaded the texture of the movie theater itself: the "atmosphere" of the atmospheric theater.

Eberson's wife, Beatrice Lamb, was an essential collaborator of the architect; in the 1920s, she directed the firm Michael Angelo Studios, which designed the theater interiors.[94] During this time, Eberson built cheap but elaborate fantasies of atmospheres with plaster and straw, remaking European architecture in the form of movie palaces. At one level, as the architect Robert Stern points out, "an atmospheric theatre gave the impression that the audience was seated in a great open-air amphitheatre."[95] Like the ancient Greek amphitheater, here architectural scenography converged with natural topography in a liminal exchange between exterior and interior.

Garden and landscape design featured large in the auditorium, often turning the theater into a Mediterranean courtyard. The Loew's Paradise, Eberson's masterpiece, was one such urban garden. True to its name, it contained the erotics of garden spectacle in its edenic architectonics. This movie palace was archaeological find, architectural marvel, and landscape garden in one, complete with weather reports. As in an Italian interior garden or a courtyard, in this 4,000-seat theater one could see the sky, framed by the architectural walls. The ceiling displayed clouds that drifted across the dark blue surface of a celestial map, with lighting that changed

1.22. Urban garden as interior landscape: Loew's Paradise Theatre, Bronx, New York, 1929, an atmospheric movie palace. John Eberson, architect.

over the course of time from blue to pink to orange and then into the twinkling of stars. The constellations were drawn with such cartographic accuracy they offered a veritable astronomy lesson.[96]

Entering what is now a ruined movie house, one senses that this theater was never too far from a variation on the picturesque dream.[97] A garden of the interior, a place of atmospheric imagination based on diversity and irregularity, with shifting architectural views, this was history in ruins. The Loew's Paradise was a lively relic of Italian architectural history and garden design. An architectural travelogue was provided for the wandering film spectator in a novel, picturesque reinvention of historic remnants.

This Bronx movie palace, built in a neighborhood of Italian immigrants, provided a fantasy vision of Italy.[98] In this sense, it resonated with the type of "sets" that refashioned Italian localities in the pavilions of international exhibition halls. The Grand Lobby, for instance, reproduced the nave of the church of Santa Maria della Vittoria, where Bernini's *Saint Theresa in Ecstasy* (1645–52) rules in ecstatic rapture. A working fountain set the atmosphere of the inner garden. Once inside the auditorium, elaborately designed in a hybrid and ornate Italianized architectural style—with niches, foyers, columns, carvings, urns, statues, and paintings, all draped with vines and flowery garlands and further accoutered with garden patios, pergolas, and terraces featuring *putti* overlooking cypresses and shrubs and stuffed birds that would actually fly—the spectator was "transported" into a *reel* imaginary courtyard. For total atmospherics, the curtain that draped the film screen reproduced a garden scene. On the side wall of the auditorium, one could even encounter a Michelangelo—a cast copy of his statue of Lorenzo de' Medici from 1526. Placed in a niche, sitting as Lorenzo does in his memorial tomb in Florence, in the New Sacristy of San Lorenzo, this funerary statue somberly watched the show. An heir of the architectural memory theater, the movie palace was the atmospheric remake of a "set" of architectural imaging, topophilically re-collected for public housing and exploration.[99]

PICTURING THE GEOGRAPHY OF THE MOVIE HOUSE

Picturing the architecture of the movie house, we can learn a great deal about filmic space. The images of movie theaters made by the contemporary photographer Hiroshi Sugimoto provide a condensed historic view of this filmic architectonics. His photographs will lead us to an exploration of the house of pictures, introducing a genealogic blueprint for the movie theater as the house of the cine city.

Sugimoto, a Japanese-born photographer who lives in New York City and Tokyo, makes series of photographs of seemingly unrelated places, including film theaters. Once asked in an interview to explain the content of these different large series—*Dioramas*, *Seascapes*, *Theatres*, and *Wax Museums*—he replied: "many people see no connection between the different fields. To me, it is very obviously one thing."[100] Speculating on what this thing might actually be, let me offer a filmic suggestion, for the syntagmatics of Sugimoto's disparate topoi does picture one thing:

1.23. Picturing the movie house: Hiroshi Sugimoto, *Kino Panorama, Paris*, 1998. Black-and-white photograph.

considered serially, the work offers an articulate drawing of film space, a map of its very origins.

What, indeed, is the relation between movie theaters, dioramas, wax museums, and seascapes? Read from the viewpoint of the cinema, these apparently different fields make sense as one itinerary. They are specific sites on a proleptic trajectory that leads up to the invention of the cinema. As we now see it, film evolves from a particular mobile architectonics: the panoramic and embodied visual space of modernity. It is heir to the culture of travel and the architectures of transit, to the worlds of dioramas and panoramas, and also to the physiognomic scene, including, among other phenomena, the wax museum. In their sequencing of dioramas, wax museums, seascapes, and movie theaters, then, the pictures map the very genealogy of the cinematic space, conceived as a means of exploration. The photographer's work pictures the hybrid, spatial archaeology of the cinema.

A panoramic tour of life anatomy, film takes us to an elsewhere "now here." Sugimoto represents this voyage of film images even in the form of his photographic series. The photographer explores his subjects serially, looking into the images analytically and connecting them panoramically. Once related to one another in their endless variations, and to all the other series, the pictures articulate, almost

literally, a film series. The dioramic seriality takes shape as a unique cinematic project.

Sugimoto's seascapes, moreover, are framed in such a way that they even resemble the film screen. They are liminal horizons. Conceived as a rectangular architectonics and devoid of anything but their light space, his seascapes and film screens share an absorbing geometry. Positioned next to each other at an exhibition, constructed as a spectatorial itinerary, the series unfolds as a project(ion). The voyage of seascapes and movie theaters is thus revealed as one: in the movie theater, in a way, we travel by sea, navigating film space.

Sugimoto's photographs of movie houses figure the *geography* of filmic architecture. In the photographer's view, movie palaces from the 1920s and 1930s, along with drive-in theaters, are "light" architectures. The pictures "expose" the zero degree of cinema: the transient moment of its emergence and passing. In his movie theaters series, only the white film screen is made visible. Film, that is, is rendered as a geography of light. Sugimoto achieves this by keeping his exposure time to the exact length of a feature film. The filmic text, which is not shown and not a show, is nonetheless palpable here, captured in a residual form. It is its trace that shapes the architecture of the cinema. The white film screen becomes a geography of duration. "Reel" time constructs film's real visual space—a spatialized sense of time. One is reminded of André Bazin's statement on neorealism: "No more actors, no more stories, no more sets, which is to say that in the perfect aesthetic illusion of reality there is no more cinema."[101] Or all the cinema there is. A movie theater.

What emerges from this nothingness is the movie house itself. In a way, Sugimoto's subset of *Interior Theatres* manages to condense the experience of the atmospheric palace with that of the Kiesler screen. Emerging from the architectural atmosphere, a blaze of light is projected out from the white film screen, casting, in turn, an eye on the surrounding "interior" space of the theater. When he pictures film, Sugimoto pictures an architecture, making tangible the geography of cinema in the architectonics of its reception. Here, we inhabit pure film theater space, which becomes the essential experience of cinema—the laboratory of movie-going. This is an emotional topography that takes place within the architectural transport of the movie "house." Cinema is indeed a house: home of voyages, architecture of the interior, it is a map of cultural travel.

The *Theatres* series, as well as the *Dioramas*, *Wax Museums*, and *Seascapes*, transmits a moving sense of spatial relations. Linked on the map of modernity, exposed as the very generative matrix of film, these series are connected by the remains of its morbid geography. Representing cinema at the moment of generative extinction, Sugimoto casts it as a melancholic space and links it to the other heterotopias of transparent death. On the map of modernity's time zone, the sea of film images meets the wax museum and the view of natural history.

Sugimoto's movie houses expose the geological time of history as well. Shooting with times of *longue durée*, this photographer renders the fabric of our physiological "wear." His articulated geography is a transient, floating world of ruination, a meditation on modernity's ruins—a place defined by "accelerated

decrepitude," as *Blade Runner* would have it. Indeed, Sugimoto's morbid physicality of duration challenges modernity's speed. As Norman Bryson claims, the modern was not simply about speed but "about being spread between different temporalities . . . and zones." In Sugimoto's world, this sense of the modern resonates with Buddhism, "a kind of speeded-up movie of the universe, with each and every thing (a building, a person, an animal) falling apart the moment it emerges."[102] Sugimoto's design for modern space is contingent on film. It incorporates the very speed of cinema in its rendering of ruination and makes it the actual "exposure" for the residual landscape.

Working in this way, this photographer does not simply make an image but constructs a scenography. He builds it as an architect would, and maps it like an artist-cartographer. He watches the space, listening for any variations the light may project on the site, and then "draws" his pictures. Ultimately, as he admits, the photographer "drafts" as a geographer or an astronomer does:

I work almost like an astronomer. I calculate the passage of the moon according to its phases, the seasons, and the time of night. I also have to figure the direction of the moon in relation to the position of the camera in the world. In the Northern Hemisphere, for example, the further north you go, the more horizontal the moon's trajectory, while the equator shoots straight up. These calculations are all in advance of the making; the photographs themselves function like paintings.[103]

Picturing space, Sugimoto sketches the draft of a hybrid cartography, connecting geography–architecture–cinema–art in a haptic mapping. Keeping this design in mind, and proceeding from the vantage point of Sugimoto's picturing of the architecture of movie theaters, let us take a plunge into the sea of moving pictures.

How could I know that this city was made to the measure of love?

How could I know that you were made to the measure of my body?

2.1. "Her" vision in *Hiroshima mon amour* (Alain Resnais, 1959). Frame enlargements.

2 A Geography of the Moving Image

By means of the . . . film . . . it would be possible to infuse certain subjects, such as geography, which is at present wound off organ-like in the forms of dead descriptions, with the pulsating life of a metropolis.
Albert Einstein

The evolution of the architectural screen, fleshed out in the architecture of the movie house itself, has been produced in dialogue with a cultural field that includes the "laboratory" of film theory and criticism. As we address the space of film genealogy and history, our site-seeing tour thus stops off at times to revisit "classical" film theory. A number of proposals from this period will be taken up in the course of fashioning filmic observation as a practice of emotion pictures.[1] I begin by proposing a geographic notion of the haptic, working from an architectural "premise" that will develop later along a geopsychic path. Here, the haptic is advanced in the material realm of architecture, in a continuation of the investigation of the urban pavement traced by Siegfried Kracauer, cut and mapped by Walter Benjamin, and charted by the architectural itineraries of the movie house.

In seeking a theory that explains the practice of traversing space, we might first revisit "Montage and Architecture," an essay written by Sergei Eisenstein in the late 1930s.[2] I take this work as pivotal in an attempt to trace the theoretical interplay of film, architecture, and travel practices, for as we site-see with Eisenstein's essay as our guidebook, taking detours along the way, their haptic maps begin to take shape. In this pioneering meditation on film's architectonics, Eisenstein envisioned a fundamental link between the architectural ensemble and film, and he set out to design a moving spectator for both. His method for accomplishing this was to take the reader, quite literally, for a walk. Built as a path, his essay guides us on an architectural tour. *Path*, in fact, is the very word Eisenstein uses to open his exploration. Underscored in his text, it becomes almost an indexical mark, a street sign. An arrow points to the itinerary we are to take:

The word path *is not used by chance. Nowadays it is the imaginary path followed by the eye and the varying perceptions of an object that depend on how it appears to the eye. Nowadays it may also be the path followed by the mind across a multiplicity of phenomena, far apart in time and space, gathered in a certain sequence into a single meaningful concept; and these diverse impressions pass in front of an immobile spectator.*

In the past, however, the opposite was the case: the spectator moved between [a series of] carefully disposed phenomena that he observed sequentially with his visual sense.[3]

Speaking of film's immobile spectator, Eisenstein reveals the perceptual interplay that exists between immobility and mobility. There is a mobile dynamics

involved in the act of viewing films, even if the spectator is seemingly static. The (im)mobile spectator moves across an imaginary path, traversing multiple sites and times. Her fictional navigation connects distant moments and far-apart places. Film inherits the possibility of such a spectatorial voyage from the architectural field, for the person who wanders through a building or a site also absorbs and connects visual spaces. In this sense, the consumer of architectural (viewing) space is the prototype of the film spectator. Thus, as Eisenstein claimed elsewhere, the filmic path is the modern version of an architectural itinerary:

An architectural ensemble . . . is a montage from the point of view of a moving spectator. . . . Cinematographic montage is, too, a means to 'link' in one point—the screen—various elements (fragments) of a phenomenon filmed in diverse dimensions, from diverse points of view and sides.[4]

To follow Eisenstein's path is to revisit a dynamic and embodied territory.[5] Here, the changing position of a body in space creates both architectural and cinematic grounds. This relation between film and the architectural ensemble involves an embodiment, for it is based on the inscription of an observer in the field. Such an observer is not a static contemplator, a fixed gaze, a disembodied eye/I. She is a physical entity, a moving spectator, a body making journeys in space.

The alliance of film and architecture along the perceptual path can thus be said to involve a peripatetics. Eisenstein's text illuminates this point by enacting a walk around the Acropolis of Athens, which he calls "the perfect example of one of the most ancient films."[6] This walk—a physical displacement—is a theoretical move whose itinerary binds the city voyage to film. In conceiving the Acropolis as a site to be viewed and appreciated in motion, Eisenstein was following the lead of Auguste Choisy, the architectural historian interested in peripatetic vision.[7] For both, the Acropolis envisioned a mobile spectator. As we walk among its buildings, it is our legs that construct meaning. They create, in Eisenstein's words, "a montage sequence for an architectural ensemble . . . subtly composed, shot by shot."[8] In this view, film is architectural and architecture is filmic. This is a genealogical hypothesis, of course, for film had not yet been invented at the time of the construction of the Acropolis. The cinematic itinerary, analogous to the montage of the architectural ensemble, was a trace left by the future.[9] The layout of an ancient site foreshadowed the work of the cinema, constructing a filmic path.

TOURING THE CINE CITY

The figure of the promenade is the main link between the architectural ensemble and film. As we have seen, this connection is created by way of peripatetics, located in the path of reception, and developed along the observer's route. The architectural ensemble and the cine city further share the framing of space and the succession of sites organized as shots from different viewpoints. Additionally, the elements of both are adjoined and disjoined by way of editing. Like film, architecture—apparently static—is shaped by the montage of spectatorial movements.

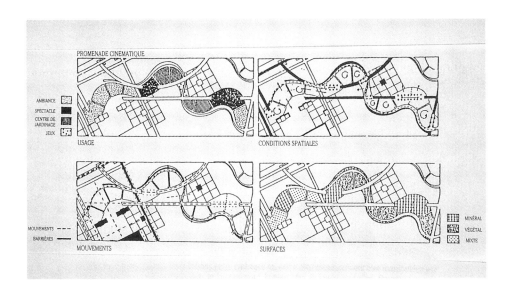

PROMENADE CINEMATIQUE

AMBIANCE
SPECTACLE
CENTRE DE
JARDINAGE
JEUX

USAGE CONDITIONS SPATIALES

MOUVEMENTS
BARRIÈRES

MOUVEMENTS SURFACES

MINÉRAL
VÉGÉTAL
MIXTE

2.2. Bernard Tschumi Architects, plan for "Cinematic Promenade," Parc de La Villette, Paris, 1982–97. Detail.

The architect Bernard Tschumi's theoretical project *The Manhattan Transcripts* (1981) offers a contemporary example of Eisenstein's way of thinking about motion in architecture. Proposing to outline the movements of the various individuals traversing an architectural set, Tschumi declares that "the effect is not unlike an Eisenstein film script."[10] He suggests that the reading of a dynamic architectural space "does not depend merely on a single frame (such as a facade), but on a succession of frames or spaces," and thus draws explicit analogies with film.[11] Tschumi cites Eisenstein again in his work for the Parc de La Villette (1982–97), where the architectural path he designed was called a "cinematic promenade."[12] Here, the itinerary that links the *folies* of the Parisian park is conceived as a film. The architectural-cinematic juncture is deployed on the grounds of motion along a sinuous route connecting the urban gardens of a metropolitan drifter.

Walking on these grounds and into the cinematic terrain of Tschumi's later architectural projects, such as Le Fresnoy National Studio for the Contemporary Arts (1991–98), one begins to understand the interaction between the two spatial arts, both of which function as dynamic terrains.[13] A dynamic conception of architecture, which overcomes the traditional notion of building as a still, tectonic construct, allows us to think of space as practice. This involves incorporating the inhabitant of the space (or its intruder) into architecture, not simply marking and reproducing but reinventing, as film does, his or her various trajectories through space—that is, charting the narrative these navigations create. Architectural frames, like filmic frames, are transformed by an open relation of movement to events. Rather than being vectors or directional arrows, these movements are mobilized territories, mappings of practiced places. They are, in Michel de Certeau's words, spatial practices—veritable plots.[14] This is how architectural experiences—which involve the dynamics of space, movement, and narrative—relate to and, in fact, embody the effect of the cinema and its promenades.

FILMIC AND ARCHITECTURAL PROMENADES

"Set" into a spatial practice, we continue our stroll through the architectural-filmic ensemble. During the course of this walk, a montage of images unfolds before us as moving spectators. What do we see, according to Eisenstein? "A series of panoramas," he tells us, speaking of the Acropolis and citing Choisy, whose "view" of the architectural field was potentially cinematic.[15] It is interesting to note that Choisy's history of architecture, permeated by a peripatetic, filmic vision, had been published at the same time that cinema took its first steps. Architecture and film were moving through the same cultural terrain.

By way of its inscribed journey, the Acropolis has become an exemplar of the filmic-architectural connection. Before the eyes of a mobile viewer, diverse vistas and "picturesque shots" are imaged.[16] A spectacle of asymmetrical views is kinetically produced. The Acropolis, in fact, turns the inhabitant of space into a consumer of views. A city space may also produce such a spectacle, often at the junction of architectural sequence and topography. In this way, an architectural ensemble provides spectacular occasions, constantly unfolding, and makes the visitor, quite literally, a film "viewer."

From this perspective, one also observes that an act of *fictional* traversal connects film and architecture. An architectural ensemble is "read" as it is traversed. This is also the case for the cinematic spectacle, for film—the screen of light—is read as it is traversed and is readable inasmuch as it is traversable. As we go through it, it goes through us. The "visitor" is the subject of this practice: a passage through light spaces.

This passage through light spaces is an important issue for both cinema and architecture. As Le Corbusier put it, building his notion of the architectural promenade: "The architectural spectacle offers itself consecutively to view; you follow an itinerary and the views develop with great variety; you play with the flood of light."[17] As the architectural historian Anthony Vidler shows, Eisenstein had followed Le Corbusier's own appropriation of Choisy's "picturesque" view of the Acropolis to illustrate his conception of a *filmic*-architectural promenade.[18] Eisenstein and Le Corbusier admired each other's work and shared common ground in many ways, as the architect once acknowledged in an interview. Claiming that "architecture and film are the only two arts of our time," he went on to state that "in my own work I seem to think as Eisenstein does in his films."[19]

In her illuminating study of architecture as mass media, Beatriz Colomina demonstrates that Le Corbusier's views were, indeed, themselves cinematic.[20] Further developing the idea of the *promenade architecturale*, Le Corbusier stated that architecture "is appreciated *while on the move*, with one's feet . . . ; while walking, moving from one place to another. . . . A true architectural promenade [offers] constantly changing views, unexpected, at times surprising."[21] Here, again, architecture joins film in a practice that engages seeing in relation to movement. As "site-seeing," the moving image creates its own architectural promenade, which is inscribed into and

interacts with architecture's narrative peripatetics and "streetwalking." In this way, the route of a modern picturesque is constructed.

Thinking of modern views like the ones Le Corbusier helped to shape in relation to promenades, one travels the contact zone between the architectural ensemble and film—a form of tourism. When an architectural site is scenically assembled and mobilized, as cities often are, the effect of site-seeing is produced. Such traveloguing is also produced by the cinema. Film creates space for viewing, perusing, and wandering about. Acting like a voyager, the itinerant spectator of the architectural-filmic ensemble reads moving views as practices of imaging.

THE ARCHITECTONICS OF SCENIC SPACE

In its capacity to produce views, cinema carries on and further mobilizes the drive of the spatiovisual arts to picture space. Exploring this issue in an essay on Piranesi and the fluidity of forms, Eisentein returned to the relationship between film and architecture, stating that "at the basis of the composition of an architectural ensemble is the same 'dance' which is at the basis of film montage."[22] This essay begins, poignantly, with another spatial wandering. The author looks out from the windows of his apartment, located near the film studios, and gazes out onto the city of Moscow, surveying its changing metropolitan contours and remarking on the expansion of the city space. He then looks at the walls between the windows inside, where a Piranesi etching hangs, and proceeds to read the architectonics of this image as a predecessor to the "ecstatic" shattering of space to which his own fictional film constructions aspired.

2.3. Windows as frames in Toba Khedoori's *Untitled (Windows)*, 1994–95. Oil and wax on paper. Detail.

As a practice of narrative space, film inherits art's historical concern with visual dynamics, especially in the realms of set design, stage setting, and the picturing of townscapes. As the art historian Anne Hollander aptly points out, film follows the legacy of pictured scenic architecture and landscape painting, whose "moving" images, in turn, prefigured what the motion picture now actually expresses.[23] Such attention to cinematic pictorialism, emerging now in film studies as an important methodological step in advancing the state of current film research, is beginning to address the vast, underdeveloped potential for the interdisciplinary study of art and film.[24]

Concerned with fostering this intersection, I take Eisenstein's position as the starting point of a critical path that proposes a shift in viewpoint as it travels from inside out and outside in: between the window, the painterly frame, and the screen of the city. For with respect to the architectonics of scenic space, cinema's pictorialism can be approached in different ways. One might, for example, see scenic space via the apparatus of representation, observing that, from baroque canvases all the way to Andy Warhol's Factory, painting has made use of what film scholars call a mode of production: a master/director may work collaboratively with others, with assistants and a crew, to stage scenes with models/actors who pose for a narrative mise-en-scène that is dependent on lighting and, on occasion (historically speaking), on the use of optical devices to help frame the view. Such an observation might be used to read the current drive that merges art and film on the screen and in the installation space, creating a hyphen between the visual arts and cinema in hybrid forms of scenic space.

Thinking in a more architectonic way, I suggest that we move away from a concern with the object of the picture to consider the larger scope of the representational affect enacted at the interface of art and film. This is a central trust of this *Atlas*, developed especially in relation to the cultural history of exhibition space, which concerns the development of the representational field screen.[25] I have chosen to follow the Eisensteinian route since, along this path, critical concern can move away from a focus on the pictorial object and toward "ways" of seeing sites and of considering the visual arts as agents in the making and mobilization of space. This particular site-seeing tour leads toward a bodily construction of intersecting, traveled sites.

A genealogic exploration of the experience of travel space offered by the cinema reveals that the cinematic way of mobilizing space has predecessors in the spatiovisual arts. We may recall from the previous chapter that the closest thing to film's mobile scenic space was the "panoramic vision" of the nineteenth century, whose spectatorial views bore the trace of the panorama painting as well as the railway and *flânerie*—urban promenades through the various "light" architectures of modernity. As an inscription of spatial desire, cinema also descends from view painting and from the construction of pictured space in architectural and scenic terms. In particular, it owes its representational codes to the picturesque space brought to the fore by eighteenth-century topographic aesthetics and discourses of the garden. The picturesque movement in art, landscape, and architecture constructed a new type of

spatiality in which spectacle was displayed through motion by inciting the observer to wander through space.[26] As suggested here by modern rereadings of the picturesque promenade in the "picturesque" architectonics of the Acropolis and Piranesi's views, film reinvented the picturesque practice in modern ways. It did so by permitting the spectatorial body to take unexpected paths of exploration.

CITY VIEWS

Continuing our walk—a trajectory through historical trajectories—to retrace the paths of architectural-filmic wandering, we return to Eisenstein and recall how he compared *vedute* to films more than once. He was intrigued, for example, by El Greco's *View and Plan of Toledo* (c. 1609), with its extraordinary multiple representation of the intersection of view painting and cartography.[27] Here the painter, imaginatively inscribed in the picture, offers a map of the city as a geographic spectacle, opening it against a view of the urban panorama shown in the background and thus enabling the beholder to inhabit a multiplicity of spectatorial positions. Eisenstein noted that, as in a film, in this view we see "a city . . . not only from various points outside the city, but even from various streets, alleys, and squares!"[28] As travel culture, the urban geography of view painting makes an interesting comparison with the cinematic viewing space. The spatial representation of view painting merged the codes of landscape painting with urban topography.[29] In its various incarnations, it was actively produced by traveling painters and was related to the picturesque voyage. Articulating bird's-eye-view perspectives and the viewpoint of the city walker, it presented a diversity of views, from the panorama to the street-level prospect to the detail of a practiced place. In this way, it offered a city to view by presenting a site for traversal. The language of film has come to embody this practice of viewing sites, even rendering feasible the "impossible" aerial projections and

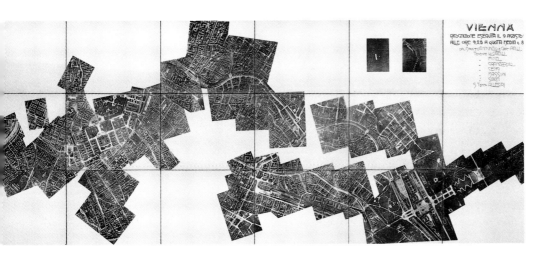

2.4. Aerial map of the city of Vienna, in a photo-collage by Gabriele D'Annunzio, 1918.

mobile streetscapes of view painting. Cinema has further mobilized a kinetic form of *vedute*—a multiform construction of scenic space, a practice of moving sight/site.

TRAVEL SPACE

"Viewed" through the lens of travel, the relationship between film and the architectural ensemble unfolds as a practice of mobilizing viewing space that invites inhabitation. Through the shifts in viewing positions and the traversal of diverse spatiotemporal dimensions we have outlined, the activity of the spatial consumer has come to the foreground of our picture. The spatial culture that film has developed, offering its own *vedute*, is a mobile architectonics of traveled space.

Film's spectatorship is thus a *practice* of space that is dwelt in, as in the built environment. The itinerary of such a practice is similarly drawn by the visitor to a city or its resident, who goes to the highest point—a hill, a skyscraper, a tower—to project herself onto the cityscape, and who also engages the anatomy of the streets, the city's underbelly, as she traverses different urban configurations. Such a multiplicity of perspectives, a montage of "traveling" shots with diverse viewpoints and rhythms, also guides the cinema and its way of site-seeing. Changes in the height, size, angle, and scale of the view, as well as the speed of the transport, are embedded in the very language of filmic shots, editing, and camera movements. Travel culture is written on the techniques of filmic observation.

The genealogical architectonics of film is the aesthetics of the touristic practice of spatial consumption. As in all forms of journey, space is filmically consumed as a vast commodity. In film, architectural space becomes framed for view and offers itself for consumption as traveled space that is available for further traveling. Attracted to vistas, the spectator turns into a visitor. The film "viewer" is a practitioner of viewing space—a tourist.

JOURNEYS THROUGH INTERIORS

Our tour, and its various detours, are aimed at unpacking the complex construction of a traveling medium by the very means of a practice of travel and a traveling theory.[30] Following Eisenstein's "picturesque" path, the film theorist becomes a tourist moving across cultural space. In the space of his text, Eisenstein traveled through the Acropolis of Athens, and from there to Mexico's pilgrimage sites and Rome's Saint Peter's Church. The itinerary reminds us that modern travel is the genealogical descendant of the pilgrimage.[31] Pilgrimage—a travel story and a spatial practice—induces travel to specific places, establishing "stations" and a narrative linkage through the various sites. This itinerary creates (and is often created by) hagiographic tales, and thus the path itself is narrativized: the pilgrim's itinerary joins up with the tourist's, making stories out of spatial trajectories and itineraries out of stories.

2.5. An interior map:
pelvic sonogram, 1993.

The type of travel writing and textual tourism found in "Montage and Architecture" is cinematic. Cuts and editing ties take Eisenstein from place to place. Once in Rome, he proceeds to walk through the interior of Saint Peter's and, here, the act of touristic montage produces an interesting twist. His move from external to internal architecture is significant, for it parallels the kind of shift from exterior to interior views that is central to the picturesque and instrumental in understanding filmic mobility.

Eisenstein discusses at length the eight coats of arms that adorn Saint Peter's famous canopy. The art historian Yve-Alain Bois, who has commented on Eisenstein's specific use of Choisy's axonometric vision to develop a cinematic peripatetics, remarks that, once inside, "instead of discussing the 'maternal' space of baroque architecture, to speak like [architectural historian Vincent] Scully, [Eisenstein] preferred to turn toward iconography."[32] Although this may seem disappointing, one might also recognize that the object of Eisenstein's iconographic reading is, in fact, a maternal space, the subject of an itinerant narrative. Here we have a gendered tale, a spatial rendering of sexuality, that deserves critical attention.

The eight decorations produced by Gian Lorenzo Bernini depict different facial expressions. Their reading is produced by way of walking around the space, where the drama unfolds, quite literally, step by step. Connected by the mobile spectator and associated by way of peripatetics, the apparently unrelated faces produce a story—a woman's story. The change of facial expressions, once placed in the gendered realm, becomes readable: the decorations depict the contractions and final release of a woman's face, suggesting the different stages of her labor and delivery. Ultimately, this architectural tour tells the story of the inside of a woman's body. Walking inside an architectural space, we have actually walked into an "interior." The sequence of views has unleashed an intimate story. The walk has created a montage of gender viewed.

GENDER IS HOUSED

By way of this promenade, the architectural tour, likened to the filmic tour, reveals a cultural anatomy. In Eisenstein's case the anatomy is female. The parallel between film and architectural language is negotiated over a woman's body, and the architectural-filmic tour ends up designing her bodyscape. That anatomy is variously embedded in film is apparent on the very surface of film language and spectatorship, which involve constructions and readings of physiognomic language by a spectatorial body. The very genealogy of film is embedded in a medico-anatomic field and exhibits various spectatorial tales of corporeality that make this the site of film's visual curiosity.[33] This is an architectonic matter, for, as mentioned in the prologue, the film theater is "constructed" as an anatomical amphitheater for the display and analysis of somatic liminality. An anatomy of gender is the actual terrain of the cinema and of its desire. Is this corporeal process, at work in the cinema, the nature of the architectural bond?

By connecting corpus and space, I am obviously answering yes to this question and suggesting that film and architecture are gendered practices, linked by their writing public stories of private life. The body-in-space is the narrative territory in which architecture and film meet on public-private grounds. Thus to speak of the body only as an object of architectural-filmic iconography, as in Eisenstein, is reductive, for the issue is much broader than mere iconography. It must advance from the realm of "sexual visions" to that of spatiality.[34] It is the history of cinematic space that is linked to the history of the body. The question, then, concerns the way in which gender shapes our spatial imaging as subjects. We must look for a mobile address for gender's dwelling, for gender is housed—and the house moves. It is the site of *emotions*.

LIVED SPACE, TANGIBLE SITES

Addressed in this way, the link between the architectural ensemble and film concerns a haptic geography. As Henri Lefebvre wrote of this spatial architectonics:
Space—my space— . . . is first of all my body . . . : it is the shifting intersection between that which touches, penetrates, threatens or benefits my body on the one hand, and all the other bodies on the other.[35]
Bodies in space design spatial fields, which, in turn, design corporealities.[36] Film and architecture are practices of representation written on, and by, the body map. As dwelling-places of gender, they are loci for the production of sexuality, not simply vehicles for its representation. Insofar as they are productions of space, their imaging is to be understood as an actual map—a construction lived by users.

Not unlike "sentimental cartography," film and architecture share a dimension of living that in Italian is called *vissuto*, the space of one's lived experiences. In other words, they are about lived space and the narrative of place. They are both inhabited sites and spaces for inhabitation, narrativized by motion. Such types of

2.6. Jan Brueghel,
Allegory of Touch,
1618. Oil on wood.
Detail.

dwelling always construct a subjectivity. Their subjectivity is the physical self occu-
pying narrativized space, who leaves traces of her history on the wall and on the
screen. Crossing between perceived, conceived, and lived space, the spatial arts thus
embody the viewer.

Film/body/architecture: a haptic dynamics, a phantasmatic structure of lived
space and lived narrative; a narrativized space that is intersubjective, for it is a com-
plex of socio-sexual mobilities. Unraveling a sequence of views, the architectural-
filmic ensemble writes concrete maps. The scope of the view—the horizon of
site-seeing—is the mapping of tangible sites.

INHABITATION

This experiential dimension—a sense of "closeness"—was recognized by Walter
Benjamin when he related cinema's new mode of spectatorship to the way we
respond to buildings. In his view, the spectatorial practice established by architecture
is based on collective use and habit: "The distracted mass absorbs the work of art.
This is most obvious with regard to buildings. Architecture has always represented
the prototype of a work of art the reception of which is consummated."[37] An heir to
this practice, film continues the architectural *habitus*. It makes a custom of con-
structing sites and building sets of dwelling and motion. It has a habit of consuming
space—space that is both used and appropriated. Being at the same time a space of
consumption and a consumption of space, it is a user's space. One lives a film as one
lives the space that one inhabits: as an everyday passage, tangibly.

The inhabitation of space is achieved by tactile appropriation, and architecture and film are bound by this process. As Benjamin put it: "Buildings are appropriated . . . by touch and sight. . . . Tactile appropriation is accomplished . . . by habit. . . . This mode of appropriation developed with reference to architecture . . . today [is] in the film."[38] Perceived by way of habit and tactility, cinema and architecture are both matters of touch. The haptic path of these two spatial practices touches the physical realm; their kinetic affair is a carnal one. In their fictional architectonics, there is a palpable link between space and desire: space unleashes desire.

The *habitus* is the absorption of imaging. In this domain, one both absorbs and is absorbed by moving images—tales of inhabitation. The absorption of the subject/object into the narrative of space thus involves a series of embodied transformations, for architecture and film are sites of "consumption," loci of the ingestion of lived space. Providing space for living and sites for biography, they are constantly reinvented by stories of the flesh; as apparatuses *à vivre*, they house the erotic materiality of tactile interactions—the very terrain of intersubjectivity. Their geometry is the connection between public sites and private spaces: doors that create a passage between interior and exterior, windows that open this passage for exploration. As moving views, the spatial perimeters of film and architecture always stretch by way of incorporation. Appropriated in this way, they expand through emotional lodgings and traversals. Fantasies of habit, habitat, and habitation, they map the narrativization of liminal space.

STORIES OF NAKED CITIES

As a view from the body, film is architecturally bound; sized to the body, experienced from life, architecture is haptically imaged and mobilized. Architecture is neither static structure nor simply just built. Like all tangible artifacts, it is actually constructed—imaged—as it is manipulated, "handled" by users' hands. And like a film, architecture is built as it is constantly negotiated by (e)motions, traversed by the histories both of its inhabitants and its transient dwellers. Seen in this way, architecture reveals urban ties: the product of transactions, it bears the traces of urban (e)motion and its fictional scriptings. A relation is established between places and events that forms and transforms the narrative of a city: the city itself becomes imaged as narrative as sites are transformed by the sequence of movements of its traveler-dwellers.

The fiction of a city develops along the spatial trajectory of its image-movement. Film—the moving image—travels the same path. The interaction is twofold, for film is architectural narration as much as "the image of the city" lives in the celluloid fiction.[39] In both views, the moving image plays a crucial role in the process of constructing the architectonics of lived space. Film, a principal narrator of city space, provides the very fictional dynamics of the urban text. As with all urban forms of traversal, its image-movement continually reinvents places as sites of narrative. Cities are filmic afterimages imprinted on our own spatial unconscious.

FILMIC MAPS

The erotics unleashed by the architectonics of lived space escalates in the metropolis, a concentrated site of narrative crossings that bears even deeper ties to cinema's own spatial (e)motion. This urban culture—an atlas of the flesh—thrives on the transient space of intersubjectivity. As when one travels with film, in the city one's "being" extends beyond the subject's walls. In 1903, when the cinema was first emerging, Georg Simmel proposed that, due to the "intensification of emotional life" in the metropolis, "a person does not end with limits of his physical body or with the area to which his physical activity is immediately confined but embraces, rather, the totality of meaningful effects which emanate from him temporally and spatially. In the same way the city exists only in the totality of effects which transcend their immediate sphere."[40]

The city is laid out clearly as a social body. Exposed as passage, it would eventually become "the naked city," joining up with cinema again, by way of situationist cartography, in the form of psychogeography—a map of *dérive*, or "drift."[41] Molded on the model of the *Carte de Tendre*—that spatial journey of the interior that mapped emotional moments represented as sites onto the topography of the land—situationist cartography was itself a psychogeography. As it graphed the movements of the subject through metropolitan space, one situationist map literally inscribed cinema into its cartographic trajectory through its reference to the American film noir *The Naked City* (1948), and in this way—that is, by way of the cinema—reproduced the everyday practice of the city's user.

Put forth as a map of potential itineraries and lived trajectories, the metropolis engages its dwellers and temporary inhabitants in geopsychic practices. It is the site of both inhabitation and voyage and a locus of the voyage of inhabitation. As James Clifford explained it in his mapping of "traveling cultures": "the great urban centers could be understood as specific, powerful sites of travelling/dwelling."[42] Conceived as a mobile tactics at the crossroads of film and architecture, the metropolis exists as *emotion*al cartography—a site of "transport."

CINEMATIC ARCHITECTURES

From modernist to situationist space to contemporary spatial discourse, architecture meets film on the grounds of the shifting metropolitan space. As Robert Mallet-Stevens declared in 1925, in a statement not far from Eisenstein's own formulation, "film has a marked influence on modern architecture; on the other hand, modern architecture contributes its artistic share to film. . . . Modern architecture is essentially . . . wide-open shots, . . . images in movement."[43] Following the encounter of poststructuralism (and especially the philosophy of deconstruction) with architectural practice, in crossovers that have included exchange between the architect Peter Eisenman and philosopher Jacques Derrida, contemporary architectural discourse

has been informed largely by a theoretical drive that encompasses various forms of mobilization.[44] Among the different shapes this architectural movement has taken, several exhibit the impulse to embody the moving image. This impulse, as in the case of Paul Virilio, is often consciously inspired by an interest in cinema and its effects.[45]

The work of Bernard Tschumi and others testifies to the desire of current architectural practice to intensify the link between film and architecture, refashioning the strong connection that, in theory and in practice, came into place in the 1920s around the notion of montage.[46] Rem Koolhaas, attracted to the "technology of the fantastic" since the time of his *Delirious New York*, continues to pursue an interest in the relationship between architecture and cinema.[47] An architect who has worked as a screenwriter, Koolhaas has said of architecture and film that "there is surprisingly little difference between one activity and the other. . . . I think the art of the scriptwriter is to conceive sequences of episodes which build suspense and a chain of events. . . . The largest part of my work is montage . . . spatial montage."[48] In his work, Koolhaas has built a bridge between the processes of screenwriting and making architecture by pursuing a form of filmic-architectural "writing" that floats libraries of images.[49]

2.7. Guy Debord and Asger Jorn, *Guide psychogéographique de Paris*, 1957, a situationist psychogeographic map that drafts the discourse of passions in "the naked city."

GUIDE PSYCHOGEOGRAPHIQUE DE PARIS

DISCOURS SUR LES PASSIONS DE L'AMOUR

pentes psychogéographiques de la dérive et localisation d'unites d'ambriance

par G.-E. DEBORD

The link between film and the architectural enterprise involves a montagist practice in which the realm of motion is never too far from the range of emotion. The two practices share not only a texture but a similar means of fabricating (e)motion, which includes their modes of production. As both art and industry they are practical aesthetics, based on producing and determined by commission. Their making of (e)motional space is a collaborative effort that demands the participation of several individuals working as a team; traverses different languages; and transforms project into product, which is finally used and enjoyed by a large constituency of people that forms a public. Economic factors are not only present but may even rule the passage between the different semiotic registers: from the drafting table to building construction to occupancy, on the one hand; and from script to the set of film production to occupancy of a movie theater on the other.

As the architect Jean Nouvel claims, a knowledge of "transversality and exteriority" links the architect to the filmmaker, who, as producers of visual space, share the desire "to experience a sensation—to be moved—to be conscious and be as perverse in traversing the emotion as in analyzing it—recalling it—fabricating a strategy to simulate and amplify it in order to offer it to others and enable them to experience the emotion—for the pleasure of shared pleasures."[50] Describing his own architecture in these terms, Nouvel states that "architecture exists, like cinema, in the dimension of time and movement. One conceives and reads a building in terms of sequences. To erect a building is to predict and seek effects of contrasts and linkage through which one passes. . . . In the continuous shot/sequence that a building is, the architect works with cuts and edits, framings and openings . . . screens, planes legible from obligatory points of passage."[51] Architecture and film interface, increasingly, on traversals, for as Nouvel puts it, "the notion of the journey is a new way of composing architecture."[52]

A filmically driven architecture may also work with the flesh as a site of "fashioning" visual space performed in the street scene. In the words of Diana Agrest, one may look at the "street as a scene of scenes," a site where a phenomenon such as "fashion transforms people into objects, linking streets and theater through one aspect of their common ritual nature."[53] Incorporating architecture into the practice of the visual and performing arts, Diller + Scofidio's transdisciplinary work, such as *Flesh*, *BAD Press*, and *Tourisms: suitCase Studies*, brings the fashion of traveling movements to the attention of architecture.[54] *SuitCase Studies*, for example, a traveling exhibition, provides a meditation on the mobility of architectural fictions, thereby doubling its theme. The installation travels in fifty identical Samsonite suitcases, conceived as "the irreducible, portable unit of the home." Doubling as display cases, they showcase two touristic sites: the battlefield and the bed, "the most private site of the body's inscription onto the domestic field."[55] On the map of gender, architectural space here meets the emotional ground of filmic tours.

TRANSITI: TOWARD A MAP OF "TRANSPORT"

When film and architecture are geographically envisaged, a relationship between the two can be set in motion along the path pioneered by Eisenstein and also envisioned by the art historian Erwin Panofsky, who recognized that film is a "visual art" close to "architecture . . . and 'commercial design.'"[56] This relationship has not been adequately articulated in contemporary film theory. During the era in which semiotics held sway in film circles, the materiality of architecture and design had interested the director and writer Pier Paolo Pasolini as a potential terrain of exploration. He claimed that "a semiology of visual communications will be able to constitute a bridge toward the semiological definition of other cultural systems (those which, for example, put into play usable objects, as happens with architecture or industrial design)."[57] Unlike other theoretical directions in film at the time, his project for a semiotics of "passions" was sensitive to constructing a bridge of material substance between film and architecture, even if it failed in practice to do so.

This "bridge" has not been a main preoccupation of subsequent theories and remains still largely to be achieved. As Steven Shaviro observes, despite some effort, in general, "much work remains to be done on the psychophysiology of cinematic experience: the ways in which film renders vision tactile . . . and reinstates a materialistic . . . semiotics."[58] I am particularly interested in building a theoretical bridge of material "design," in the terms fancied by Pasolini, to address the habitual transport of architecture and film. Such exploration, at a theoretical level, could be extraordinarily productive for the growth of both fields by creating converging paths that intersect with geography.

Indeed, a number of concerns articulated in this book from the perspective of cinema and its theory are finding parallels in current architectural theorization, especially in its concern with gender motion.[59] In sympathy (that is, literally, from "a shared passion"), I hope that more crossings will be created, for, as the cultural geographer Michael Dear asserts, despite an interest in film on the part of the architectural world, "the converse has not always been true of [film] critics."[60] The filmic energy present in the architectural field can be further mobilized. Corroding disciplinary boundaries, architecture and film should find their common terrain, even on institutional grounds: one can only imagine what interesting cultural practices would emerge if the field of cinema studies could find an institutional working place within schools of architecture rather than in the literary "locations" that have traditionally housed it and served as a point of reference. More synergy should also be fostered with the practice of art history and theory. My effort in writing this book while conducting film research in the department of "Visual and Environmental Studies" at Harvard has been to make palpable space for this transdisciplinary movement. There are signs that film, and by extension film theory, offer not only a way of mobilizing the architectural field but a way of conceptualizing architectural discourse and its work on gendering. If film is useful as a theoretical tool for architecture, conversely, architectural views, urban frames, and landscape itineraries have

much to offer to cinema studies. Minimally, as this chapter argues, these can act as a vehicle for the haptic grounding of film and its theorization as (e)motion pictures.

As we shall see, geography plays an important part in fostering this articulation. Mapping is the shared terrain in which the architectural-filmic bond resides— a terrain that can be fleshed out by rethinking practices of cartography for traveling cultures, with an awareness of the inscription of emotion within this motion. Indeed, by way of filmic representation, geography itself is being transformed and (e)mobilized. The dweller-voyager who moves through space drives the architectural itinerary of the city, the activity of travel, and film itself. All three practices involve a form of human motion through culturally conceived space—a form of *transito*.[61] Not necessarily physical motion, *transito* is circulation that includes passages, traversals, transitions, transitory states, spatial erotics, (e)motion. Adopting this e*motion*al viewpoint for both architecture and film viewing, two seemingly static activities, involves transforming our sense of these art forms. By working to conceive a methodological practice that is "in between," we aim to corrode the opposition between immobility-mobility, inside-outside, private-public, dwelling-travel, and to unloose the gender boxing and strictures these oppositions entail. Architecture is a map of both dwelling and travel, and so is the cinema. These spaces, which exist between housing and motion, question the very limits of the opposition and force us to rethink cultural expression itself as a site of both travel and dwelling.

The space of cinema "emoves" such cartographic rewriting. Layers of cultural space, densities of histories, visions of *transiti* are all housed by film's spatial practice of cognition. As a means of travel-dwelling, cinema designs the (im)mobility of cultural voyages, traversals, and transitions. Its narrativized space offers tracking shots to traveling cultures and vehicles for psychospatial journeys. A frame for cultural mappings, film is *modern cartography*. It is a mobile map—a map of differences, a production of socio-sexual fragments and cross-cultural travel. Film's site-seeing—a voyage of identities in *transito* and a complex tour of identifications—is an actual means of exploration: at once a housing for and a tour of our narrative and our geography.

TRAVEL

...somewhere in this world one could be better off.

3.1. Of flesh and bone:
Guillermo Kuitca, *Untitled
(Torino)*, 1993–95. Mixed
media on canvas.

3 Traveling Domestic: The Movie "House"

I love life, out of curiosity and for the pleasure of discovery.
Isabelle Eberhardt, *The Passionate Nomad*, 1904

The land one possesses is always a sign of barbarism and blood, while the land one traverses without taking it reminds us of a book.
Chantal Akerman, "Of the Middle East," 1998

It is 1906, and cinema is traveling. Somewhere between fiction and actuality, a travel genre grows. Let us take as an example *A Policeman's Tour of the World* (Pathé, 1906), engaging this movie-vehicle to take us around the globe so that we may consider the nature of cinema's transport. This film, one of the most elaborate hybrid texts of preclassical cinema, sets the scene of the travelogue.

Discovery meets detection in this chronicle of a world tour. A theft triggers a chase: a French banker has embezzled funds and is pursued by a detective. The chase, however, provides only a weak proairetic link and no real resolution to the story. The film's thin plot, rather than being resolved in a final capture, ends up drifting away. The interest of this film does not lie in getting the crook but in capturing something else: plot gives way to a set of traveling pleasures as we are transported by a series of tableau shots that take us to different parts of the world. In this travelogue, actuality footage from real locations is freely mixed with staged sets that fictionalize the locales. The chase, in effect, becomes an excuse to "mobilize" different world cultures as the film sets out the itinerary of a global tour.

We first travel to Egypt via the Suez Canal, then journey to India, where we witness a festival in Calcutta and visit a Bombay temple. We are subsequently taken to China, where we amuse ourselves in an opium den. From there, we travel to Japan and, eventually, to the United States, where we witness an election (probably in San Francisco) and are taken to the American West of Native Americans, identified as "the red skins." United in their opposition to "them," the crook and the policeman begin to bond as they move to their final destination: New York City, where the two reach an agreement. It is only appropriate that in the capital of capitalism the crook and the detective end up becoming business partners. In the city where Wall Street banks take the architectural shape of Greek temples and Gothic churches, business is worshipped literally. In the temple of money, the boundaries between theft and profit are exposed as loose. An interesting political twist occurs here in the framework of what is essentially an ethnographic journey. Mostly non-European sites have been observed in this tour, which, as Philip Rosen has noted, is shaped by colonial views but contains a double-vision that results in an ideological reversal: the logic of the colonialist tourist is ultimately undone, for he is exposed as a crook.[1]

As a travelogue, *A Policeman's Tour of the World* holds a significant place in film history. The hybrid terrain of the travel film, with its architectonics of mixed forms (actuality and fabrication) is pivotal in the development of film narration. For here, as elsewhere, the tour of the world becomes a vehicle for the very transition to fictional cinema; crossing borders translates into the cross-over into feature films. In this travelogue, actuality is transposed into fiction via detection—itself a form of "discovery." Discovery marks cinema in many different ways. The motion picture, a language of "curiosity," appears actually to have been fashioned out of a discourse of exploration. A travel scene is thus the primal scene of the motion picture.

A CULTURE OF TRAVEL

> *The true journey of discovery lies not in seeing new landscapes but in having new eyes.*
> Marcel Proust

An investigation of the sources of film's site-seeing unearths a complex cultural configuration, of which travel culture is a prominent component. As Charles Musser has shown, insofar as it was an object of representation, travel was one of the most popular and developed subjects in early cinema.[2] Moreover, cinema itself developed as an apparatus of travel and was born in the arena of tourism. Recent work in film studies has shown that a diversity of means contributed to the creation of the "touristic consciousness" that gave birth to the cinema.[3] In addition to new means of transportation, architectures of transit, world expositions, and aesthetic panoramic practices, these included travel photography, the postcard industry, and the creation of the Cook tours, which opened the way to mass tourism. Film was affected by a real travel bug.

From the architectural viewpoint, travel was at home in the movie house. P. Morton Shand's 1930 book *Modern Picture-Houses and Theatres* makes this touristic architectonics particularly visible in its demonstration of how the transit of modern (glass) architecture and the film screen converged in the design of the movie house itself. This architectural survey charts the descent of film from the culture of geography and the drive to tourism. It further considers science an essential constituent of the house of images and understands the moving image to be a hybrid cultural space, born on the threshold of scientific and other explorations:

To understand how and why the cinema has become what it is, it is necessary to see it in proper perspective to the period that witnessed its evolution. Up till a few years before the war, the film was little more than a scientific toy, a hybrid of the eighteenth-century "Diorama," and the magic lantern of nineteenth-century explorers' lectures.[4] "Scientific toys"—a cultural display that included the magic lantern shows of travel lectures—are in fact film's closest relatives. As it was more recently explained by Wolfgang Schivelbusch: "The new media of the nineteenth century—the panorama, the diorama, the magic lantern, 'dissolving views' and finally, film—were pure aes-

thetic, technical creations born of the spirit of light. . . .The magic lantern and 'dissolving views' can be described as a connecting link between the diorama and film."[5] Film architecture participated in this cultural movement that is the history of "light space": in connection with these other media, all of which spectacularly mapped modern space and produced the effect of simulated travel, it became an agent in the construction of modern visual space—a geographical tool for mapping and traversing sites.

With eyes still fresh from the direct experience of such a genealogy, the author of *Modern Picture-Houses and Theatres* revealed film's touristic effect when he described his encounter with early film:

Seated before these "animated pictures," we were thrilled to ride on the cow-catcher of a locomotive through cavernous tunnels and over precipice-spanning bridges; or to catch speckled glimpses of Greenland's icy mountains and India's coral strand.[6]

At the onset of cinema, spatial boundaries and cultural maps were stretching. In the movie house, film spectators were enthusiastic voyagers experiencing the new mobility of cultural transportation. It is not by chance that in the early days of film the movie house was called in Persian *tamâshâkhânah*: that house where one went sight-seeing and "walking together"—that is, literally, went site-seeing.[7] Film spectators were travelers thrilled to grasp the proximity of far away lands and expansions of their own cityscapes. "If the arcade was seen as a city in miniature, then the Diorama extended this city to the entire world."[8] Film—and the "house" in which its motion dwelt—was a way of further extending this cityscape, fragmenting it, reinventing its assemblage, expanding its horizons. "The city is no longer a theatre (agora, forum) but the cinema of city lights."[9] It is a "movie" house. A house of motion pictures. A place where dwelling exists as motion.

AT WAR: TOURISM AND THE CINEMA

In touring cities, exploring landscapes, and mapping world sites, early film also "discovered" otherness, made it exotic, and often acted as agent of an imperialist obsession. For cinema emerged at the height of historical imperialism. As *A Policeman's Tour of the World* makes clear, such ideology permeated the travel genre, even if against the grain.[10] It was inscribed in its journey "from the pole to the equator," which the filmmakers Yervant Gianikian and Angela Ricci Lucchi have unmasked in their postcolonial film *Dal Polo all'Equatore* (1986). The touristic drive—the gaze of exploration—was not always a mere expression of curiosity, for it was also complicit with the aggressive desire of "discovery." As Ella Shohat and others have shown, this mode of discovery is directed toward taking possession—conquering sites and their inhabitants.[11] Viewed from this perspective, the culture of travel exhibits its historical bond with colonialism. The filmic gaze, akin to the tourist's gaze, participates in colonial discourse when it becomes a form of "policing."

With respect to domination, the film machine and the war machine are bound not only historically but perceptually. Paul Virilio has demonstrated the

interdependence that exists between the technology of cinema and that of warfare, which have advanced in tandem as "sight machines" since the invention of film.[12] This includes the domain of mapping. Strategies of (in)visibility and apparatuses for watching, as well as the charting of territories, are essential parts of the war experience and its simulated routes. In today's world, image technology continues to play an important role in warfare, from its reconfiguration of mapping to its designs of virtual reality. As the architectural team Diller + Scofidio shows, there are many "tourisms of war."[13] Ways of seeing and systems of spatiovisual reproduction can develop into ways of controlling and destroying. Exploration and mapping are a means of knowledge that can be used as an instrument of conquest.

A film like Jean-Luc Godard's *Les Carabiniers* (1963) offers a grand tour of film tourism turned to conquest and warfare. Two young men are lured to the battlefield with the promise of acquiring consumer goods: cars, jewels, supermarket items, everything displayed in the metro stations, and, alas, women. While their girlfriends, Venus and Cleopatra, remain at home, the two men, Michelangelo and his appropriately named friend, Ulysses, go to war, traveling the world's map. Interestingly, for Godard, war is an occasion for sightseeing, a form of tourism that extends to watching films. The soldiers' world tour takes them from Europe to Egypt, Mexico, and the United States, where they visit canonical touristic sites. Here, tourism is conceived as pure filmic illusion and photographic reproduction. For example, the trip to Egypt is pictured simply through the snapshots Michelangelo has taken, culminating in an image of the Sphinx.

As our soldiers "discover" the world through war, they also tour the history of film. This reminds us that film itself is related to the "rifle," having in part grown out of the invention of the photographic gun by Etienne-Jules Marey.[14] Marey developed the *fusil photographique* to solve the problem of "shooting" a series of pictures. It was pointed at flying birds and running animals in order to "capture" their movement in images, advancing the "shooting" techniques Eadweard Muybridge had developed. From this perspective, the war machine marks the very semiotics of film genealogy, a trace of which remains in film language when we speak still of "shooting" a film.[15]

As a metacinematic work, *Les Carabiniers* plays tricks with the genealogy of cinema.[16] Michelangelo goes to the movies as if exploring the development of film language itself. In a sequence that parodies Edwin S. Porter's 1902 *Uncle Josh at the Moving-Picture Show*, he sees a few short films that epitomize the very origins of cinema. One recalls Lumière's famous 1895 train film, *L'Arrivée d'un train*, while another cites from Lumière's genre of the baby film. The last film on view is a parodic account of the battle between gender and filmic visual pleasure.

What will the soldiers bring back from their trip to the war? Pictures, of course. Ulysses and Michelangelo return with a huge pile of postcards. Like tourists, they have amassed images of sites seen and unseen: places commodified as they are placed next to various pictures of acquired goods. By way of cinema, war becomes equated with tourism. Like the cinema, war and tourism rely on image technology

and visual reproduction; all are implicated in the act of "discovery" and the desire to possess. The look that sees can also seize. As a form of capturing—that is, of appropriation—image-making resembles the "discovery" of foreign lands and the devouring look of window shopping. In a larger discourse on cultural mimicry and appropriation, Godard likens cinema to sightseeing and shopping and additionally exposes their shared relation to the image as commodity. In *Les Carabiniers*, pictures are commodities and possessions take the form of images. An heir of department store phantasmagoria, as Anne Friedberg has shown, cinema historically moves in the arena of spectacular image trafficking.[17] Like the tourist and the shopper, the film spectator is also in many ways a "consumer" of images.

Visualizing the touristic war of images as a taxonomy, Godard exposes the very cultural terrain that generated the cinema itself. Indeed, his taxonomy retraces the space of film's genealogy as we have come to know it. The list includes: monuments, that is, the typical objects of sightseeing, from antique to contemporary sites, the Pyramids to Berlin's Hilton; means of transport such as the railway and various advanced modes of travel; nature's wonders, which consist of touristic sites such as the Bay of Naples and other well-traveled landscapes; department stores, from the Parisian classics to the New York shopping scene; industry, from transportation to film. This grand tour of sites can be recognized as film's own grand tour: a voyage through the landmarks of modernity and its architectures of transit.

The exposé of cultural appropriation set forth in *Les Carabiniers* ends finally in an investigation of the construction of the visual inventory itself—the archive of images. The commodified pictures the soldiers bring back articulate a critique of the Western logic of "discovery," which Godard mocks by providing a parody of the way it manufactures causality between its ordering of the universe and taking possession. In this way, classificatory systems and analytic procedures themselves come under scrutiny and, ironically twisted from within, end up undone.

Godard's taxonomic work converges with that of Peter Greenaway, a filmmaker of visual archives also drawn to representational critiques, for whom "game-playing [is] . . . a way of ritualizing emotions."[18] Like Greenaway's own visual taxonomies, which are particularly involved with natural history, one of Godard's major picture categories engages nature. He points to the categorization of animals and plants as a site that articulates both systematizing logic and territorial expansion. The classification of nature—particularly the visual ordering of plants, assembled and organized into systems that tend to be hierarchical, enclosed, and totalizing—has played a notable role in forging areas of Western thought. The development of natural history has furthermore interacted with the project of European expansion. As Mary Louise Pratt puts it in a study of travel and transculturation: "The project of natural history determined many sorts of social and signifying practices, of which travel and travel writing were among the most vital. . . . Natural history asserted an urban, lettered, male authority over the whole of the planet."[19]

Godard's film raises precisely this question of male authority when, at the end of the classificatory sequence, the soldiers display a collection of female images.

Included in the taxonomy are women from around the world, exposed as goods on display. The collage of commodities creates a tour of female objectification as the collection surveys nineteenth-century pornographic photos and pictures of actresses, figurative paintings, historical figures such as Cleopatra, and ethnographic representations—including such colonial imagery as the Hottentot Venus. Woman is conquered. She is conquest.

VOYAGE (AND) HOME

Les Carabiniers points to the subjugation and violence that are created when travel becomes "discovery" and comes to mean conquest. It also reveals the sexual domination that is created when voyage is simply juxtaposed to home. The film presents a rigid sexual division of space. While the men have traveled (to war), conquering images, the women have remained at home. Ulysses and Michelangelo return to find their girlfriends awaiting them. The scenario is rendered all too familiar by the reference to Ulysses, the epitome of the male traveler who leaves the woman behind and dreams of her as he dreams of return. Ulysses stories figure prominently in travel and travel writing; the tale of a Penelope who awaits the voyager even travels from literature to film.

The fixed point of this travel story is that Ulysses has a place of return: a house, an emotional-architectural container with a woman in it. At the end of the trip, there is a permanent refuge, a secure harbor. In this tale, while man is synonymous with adventure, woman becomes synonymous with home. In such a way, the distinction between woman and home is collapsed so that woman *becomes* home. Superimposed, the two are equally static.

Like rigid taxonomies, binary oppositions embody forms of domination. The dichotomies voyage/home and male/female embedded in Godard's taxonomy are barely surpassed by Bernardo Bertolucci in *The Sheltering Sky* (1990). In this film, based on Paul Bowles's novel of the same title, a distinction is established between the traveler and the tourist, based on their desire for home.[20] Bertolucci does not entirely share Bowles's view that, although Kit travels, it is Port who holds the fascination for mapping and voyaging. He nonetheless must follow the scenario, which dictates that because Kit cannot handle nomadism, her journey will go painfully astray. This travel story mirrors Jane Bowles's own, for the writer, who was Bowles's wife, was the inspiration for the character of Kit, and her nomadism ended in a psychiatric institution.[21] From Godard to Bertolucci, binary systems are shown inevitably to subsume one side to the other. As the filmmaker and theorist Trinh T. Minh-ha suggests, questioning this system is the starting point of postcolonial feminist thinking: "If it is a question of fragmenting so as to decentralize instead of dividing so as to conquer, then what is needed is . . . a constant displacement of the two-by-two system of division to which analytical thinking is often subjected."[22]

By exposing the system of division, Godard's film provides an opportunity to unsettle the place of conquest. To overcome the static dichotomy that locks voyage

and home in a division of gender, we must constantly displace—that is, "mobilize"—
the very notion of place and its relation to sexuality. A traveling theory of dwelling is
called upon here to picture gender and space in a series of constant displacements, re-
viewing them and remapping them through the lens of more transient notions. Film
space is the very vehicle of this mobilized thinking, for, among other things, its site-
seeing offers us a way to mobilize the very space of sexual dwelling.

"NOW, VOYAGER"

A regretfully persistent resistance to acknowledging the mobilities of woman's place,
especially in modernity and its discourse, informs the binary assumption that equates
the figure of the male with voyage and woman with home—a static, enclosed space.
As cultural critic Meaghan Morris remarks, in this paradigm, *domus* is domestica-
tion.[23] But the site-seeing map of modernity values the female subject in ways that
quite often deviate from this set scenario. Bette Davis's voyage in the film *Now,
Voyager* (Irving Rapper, 1942), for example, suggests that travel can be a transfor-
mative female experience.[24] Along with fashion, itself a transformative mode for
Bette, it can act as the vehicle of a novel "self-fashioning." Travel (and its imaginary
mapping) is an important part of the expansion of women's horizons beyond (and
within) the boundaries of the home. In its own way, the home itself moves and cre-
ates possibilities for gender nomadisms. Voyage and home work together in specular
ways: rather than representing separate stances they can be considered intrinsically
interrelated. On the gender map, travel and home have been in constant interaction.

 The historical affirmation of women's right to travel meant trespassing the
very confines of the house, as well as the home country. Through travel, the bor-
ders of the domestic realm and its activities changed. Travel was a real domestic
conquest, and writing participated in this particular war of expansion. In 1863,
Mabel Sharman Crawford published "A Plea for Lady Tourists" and in the name
of tourism wrote:

*In a period of easy locomotion . . . ladies can travel by themselves in foreign coun-
tries with perfect safety. . . .*

 *It is surely unreasonable to doom many hundred English ladies, of inde-
pendent means and no domestic ties, to crush every aspiration to see nature in its
grandest form, art in its finest works, and human life in its most interesting phas-
es; such being the practical results of a social law which refuses them the right
of travel. . . .*

 *The exploring of foreign lands is . . . more improving, as well as more
amusing, than crochet work or embroidery with which, at home, so many ladies seek
to beguile the tedium of their unoccupied days.*[25]

Crawford was one of many who pleaded for, and eventually won, women's right to
travel. As recent feminist studies of geography show, travel in its many forms was
pursued by more women and produced more writing and more complex discourse
than is generally acknowledged.[26]

One of the most intriguing aspects of this complex phenomenon, from my point of view, is the linkage of travel to the home and the construction of a space that lies between the two realms. In women's writing, travel was often described in relation to the home in the form of a "passage." Ella W. Thompson clearly envisaged the empowering "architecture" of passage in her writings on travel, and begins her 1874 book with an image of opening the doors of the house:

Most women's lives are passed, so to speak, in long, narrow galleries. . . . Plenty of doors lead out of these galleries, but only those marked "Church," "Visits," and "Shopping," move easily on their hinges.

Most of us . . . cast longing eyes at the door marked with the magical word "Europe."[27]

Thompson's interesting spatial language makes use of interior design to suggest passage. It describes the aperture of women's horizons in architectural terms: as doors, which signify an architecture of the interior and thus supply a "hinge" for woman's own passage. Set between inside and outside, home and voyage, the door enables the transition to a different intersubjectivity. Such a passage was the opening to modernity's own spaces: shopping and traveling, to which filmic doors and cinematic windows would soon be added.

As a participant in the culture of travel, film increased the possibility for the female subject to map herself into the epistemology and erotics of mobility. Providing a greater assortment of women—more than just the ladies of "independent means and no domestic ties"—with access to the leisure activity of a wandering gaze, cinema extended the possibility of (self-)exploration across class and ethnic boundaries. Facilitating the female subject's journey through the geography of modernity, it expanded the horizons of female pleasures, opening doors of power and knowledge. The movie "house" moved gender divisions by removing their fixed borders.

3.2. The doors of passage in *Playtime* (Jacques Tati, 1967). Frame enlargements.

TRAVEL AND THE "MOVIE" HOUSE

Cinema was the door on which several cultural interchanges were hinged, including movement between the private and public spheres.[28] The private-public dynamic—the very dimension that shaped travel culture—particularly affected filmic spatio-visuality and determined the way it came into being. If we take the defining characteristics of "the tourist gaze" to be those described by John Urry and recognize their applicability to film, we can picture this filmic-touristic situation.[29] On the brink of private and public, tourism and film are both leisure activities and mass phenomena, whose devouring gaze is hungry for pleasure and spectacle consumption. Both involve the movement of people to and from places, attraction to sites, and motion through space. The touristic journey is by definition temporary, as is the virtual journey that takes place in the movie "house." The landscapes traversed and the townscapes visited are separate and yet connected to the everyday spaces of the viewer-traveler. Through movement, he or she passes through sequences, narrative

stages, and experiences of liminality. Cultural and emotional (dis)placements, as well as journeys between the familiar and the unfamiliar, the ordinary and the extraordinary, can produce the liminal zone of a home away from home. Markers and signs direct the spectator-passengers in their site-seeing.

Anticipation through daydreaming and fantasy, and the experience of this state as a phantasmagoria of visual space, further link tourism to film. Travel culture was positioned at the historical and genealogical juncture of a century that produced various forms of dream machinery, including the cinematic apparatus. As the cultural geographer Derek Gregory points out, travel writing in the nineteenth century employed descriptions of city and landscape often phrased in terms of daydreaming.[30] Florence Nightingale, in particular, writing of her trip to Egypt, interestingly traversed the liminal space between interiority and exteriority when she described "the waking dream of the living city within" and "the silent dream of the dead city without."[31] In general, the travel writer of the Victorian era positioned him or herself as if traveling, and perhaps writing, in a dream. Such descriptive passages of traversing sites have a remarkable visual quality. The imagined geography of "the imaginary signifier" was established in the vagabond culture of travel writing.

Travel writing is a language of visual description, moved by an intense female curiosity. Female travel writing was often so descriptively graphic, in fact, that it approached filmic observation. Its language was a form of (pre)cinematic site-seeing.[32] Thus in 1839, Marguerite, the Countess of Blessington, used the term "idler" to define herself as a traveler. In the fashion of a *flâneuse*, she claimed that travel offers "the true secret of multiplying enjoyment, by furnishing a succession of new objects."[33] We sense in her words the force of the urban (shopping) trip and the railway journey—the very language reinvented by the cinema. Film extended these "tracks," offering a way of multiplying pleasure by providing a succession of new objects, situations, and vistas, even to those who could not travel. Intensified enjoyment by way of the sequencing of novel attractions was embodied in the very articulation of filmic language, where the leisure of the leisure classes was offered to the idler-spectator.

Sarah Rogers Haight (1808–81), a "Lady of New York" who published her travel letters in 1840, provides another prefilmic example of the tactics of site-seeing: *Before we ventured to dive into the dark and mysterious labyrinths of Stamboul, we thought it best to take our usual precaution, that of ascending some tower to observe well how the land lies, and to take a fair departure. We have always found, by so doing when we first enter any foreign city, that we obtain an indelible impression of its general location, form, and extent, the proportionate size and peculiar appearance of its principal monuments and other prominent features. I would recommend all young and persevering travellers to adopt this practice.*[34]
Following the path etched by Ms. Haight and her fellow travelers, filmmakers appear to have adopted this very practice of viewing, which is a form of mapping. The drive to "comprehend" the city space in a bird's-eye view before plunging into its interiors—which we found in a film such as Wenders's *Wings of Desire*—is

clearly anticipated in travel practices. Mobilizing its encompassing embrace, film has absorbed the touristic drive to ascend to take in the larger "scape" as well as the desire to dive down to ground level and explore private dwellings. In such a way—that is, by incorporating a multiplicity of viewpoints—cinema has reinvented the traveler's charting of space.

Cinema's mapping of space and its rendering of voyage and home respond to a displacement that was effectively set in motion by travel culture and, more specifically, by women's travel writing. Edith Wharton opens the road to our understanding of this movement in terms of an emotional mapping when she compares the affective course of a female traveler to that of a film spectator:

The moment the big liner began to move out of the harbour Christine Ansley went down to her small inside stateroom. . . . She sat down on the narrow berth with a sigh of mingled weariness and satisfaction. The wrench had been dreadful—the last hours really desperate; she was shaken with them still—but the very moment the steamer began to glide out into the open the obsession fell from her, the tumult and the agony glow unreal, remote, as if they had been part of a sensational film she had sat and gazed at from the stalls.[35]

GENDER NOMADISM: THE JOURNEY OF DWELLING

As a mapping of space that is engaged in the (e)motional dynamics of establishing, traversing, and leaving places, film culture shapes the relationship between voyage and dwelling. Thinking of cinema in this way, and in relation to the developing discourse that James Clifford calls "traveling cultures," provides a means of further reflecting on the gender implications of a spatial mapping.[36] Indeed, cinema—a mobile site of gender dwelling—is "located" at the very core of these traveling issues.

Such a reflection is needed, for the theoretical discourse on space and travel does not generally take the cinema into account. Furthermore, critical questioning of space and travel does not always include a treatment of the diversities of the female subject or, if it does, often treats them in problematic ways. As Rosalyn Deutsche has shown, even contemporary spatial theory tends to erase both the female subject and the subject of feminism.[37] In particular, Deutsche challenges the problematic notion of "cognitive mapping," first introduced by Kevin Lynch as a mental "image of the city" and later interpreted by Fredric Jameson.[38] Lynch's observational research on orientation led him to approach the roving eye and moving body in space, extending the idea of the "architectural promenade" into mental space; but his concept was not ultimately able to sustain the pleasure of dislocation or to embrace multiple mobile mappings.[39] Fearing disorientation and anxious about unmappable space, Lynch sought reassuring measures; thus eventually, with contributions from Jameson, cognitive mapping became a way of ordering, even domesticating, space—of locking mapping into a regulative ideal. In her critique, Deutsche shows that the fixed and unitary viewpoint of cognitive mapping excludes female

3.3. A woman looks inside out: the journey of dwelling in *Playtime*. Frame enlargements.

subjectivity. This is particularly relevant to our discourse, for although cognitive mapping potentially hints at the narrative of inhabitation and could even contain a cinematic sense, ultimately, it has failed to travel with the flow of lived navigational space and to understand psychic mapping as a part of the socio-sexual terrain.

The existing discourse on travel is often equally problematic. Despite the use of travel metaphors in theoretical discourse and a growing interest in travel culture and theory, an effacement of difference (gender as well as ethnic) still appears to be taking place. These problematic aspects of expansive theories of travel and nomadism have been pointed out.[40] The critique of travel discourse, however, should not overlook the importance of travel to understanding changes in gender configurations, and by opposing nomadism *tout court*, end up reinforcing an immobilization of the female subject. We have not yet completed the task of expanding feminist horizons into the arena of traveling cultures.

Despite the richness of the fields of feminist theory, geographical studies, and film scholarship, a merging of the three disciplines has yet to occur. By rethinking each through the others, one might expand the range of all these fields. To look with geographical eyes at feminist film theory, for example, could expose how travel in (film) space may map sexual difference, and vice versa. A geographical approach could advance earlier notions of gender identity, based on psychoanalytically oriented feminist film theory, by incorporating the diversity of cultural landscapes. It could help us understand sexual difference in terms of space—as a *geography of negotiated terrains*. Thinking geographically could enable us to think of sexual difference in ways that integrate or even overcome symbolic notions as we venture into the terrain of an *architectonics of gender*.

Mobilizing gender positions requires a series of displacements. To start, we must retrace the genealogy of the female subject's position in site-seeing, undoing the fixity of binary systems that have immobilized her and effaced her from the map of mobility. The problematic equation between *domus* and domestication exposed by Morris is recalled here, for it extends from the textual to the critical discourse on voyage, and deeply molds it.[41] Such discourse traditionally maintains that a sense of destination is endemic to the activity of travel—a theoretical enactment of *The Odyssey* that *Les Carabiniers* filmically practiced. Considering home as the origin and destination of a voyage implies, as Georges Van Den Abbeele puts it in his book *Travel as Metaphor*, that "home [is] the very antithesis of travel."[42] Home is merely a concept, necessary to travel from or to leave behind. It exists only at the price of being lost and is perennially sought. In this logic, voyage is circular: a false move in which the point of return circles back to the point of departure. The beginning and the end are the same destinations. Or rather, they are *asked* to be the same, revealing the biological destiny behind the destination. The wish expressed is that the *oikos* be reinstated and reinforced. The anxiety of the (male) voyager is the fear that, upon return, he may not find the same home/woman/womb he has left behind.

Conceived as a circular structure, the metaphor of travel locks gender into a frozen, binary opposition and offers the same static view of identity. Travel as metaphor involves a voyage of the self, a search for identity through a series of cultural

identifications. If such travel is simply conceived as a return to sameness, or nostalgia for loss of that sameness—the home of identity or the identity of home—*domus*, domesticity, and domestication continue to be confused and gendered feminine.

In the collapse of *domus*, domesticity, and domestication with the female subject, both the identity of home and the housing of gender are at stake. This notion of home, conceived as the opposite of voyage, is the very site of the production of sexual difference. When seen as both point of departure and destination, and gendered female, the *domus* represents one's origin: the womb from which one originates and to which one wishes to return. This particular scene has been constructed by or for a male voyager. Psychoanalytically, it represents a recurrent male fantasy, one that historically returns in the travel and theoretical writing of (often) white males. The circularity of the male voyage is a problematic notion for the *voyageuse*. The question of origin, separation, and loss are much more complicated for a female subject. There is possession implied in positing an origin which was enjoyed, lost, and capable of being reacquired. This does not define the female condition, for in psychoanalytic terms, the female subject experiences neither that possession nor the possibility of return. This condition is manifest, both historically and geographically, in writing that describes women's experience of travel. As the Italian feminist critic Paola Melchiori, a passionate nomad, observes, dislocation has always marked the terrain of the female traveler. Analyzing the literature of travel as a site of sexual difference, she writes:

Reading women's travel writing, one notices an absence of the past. Women who leave are not nostalgic. They desire what they have not had, and they look for it in the future. The desire does not take shape as "return" but rather as "voyage." Nostalgia is substituted by dislocation.[43]

Thinking as a *voyageuse* can trigger a relation to dwelling that is much more *transitive* than the fixity of *oikos*, and a cartography that is errant. Wandering defines this cartography, which is guided by a fundamental remapping of dwelling. A constant redrafting of sites, rather than the circularity of origin and return, ensures that spatial attachment does not become a desire to possess. In the words of Rosi Braidotti, "the nomad has a sharpened sense of territory but no possessiveness about it."[44] For the *voyageuse* to exist as nomadic subject, a different idea of voyage and different housing of gender is to be sought: travel that is not conquest, dwelling that is not domination. A place where nostalgia is replaced by *transito*—a mobile map.

DWELLINGS OF TRAVEL: THE HOUSE AS VOYAGE

> *Having now examined the interior of my apartment, and learned what we can by looking out the windows, let us range about the house.*
> Emma Hart Willart, *Journals and Letters from France and Great Britain, 1833*

Reflecting on sexual and cultural identity in the act of traversing filmic and visual space leads us to different notions of travel and dwelling—ones that would not exclude or marginalize the female subject. The shift to site-seeing includes the femi-

3.4. Architectural dissection in Toba Khedoori's *Untitled (House)*, 1995. Oil and wax on paper. Detail.

nine gender: "Now, Voyager," she travels domestic in forms that are more mobile than usually acknowledged. If mobilization must be extended to the domestic realm, redrafting it beyond domestication, it will be the very act of exploring the architectonics of home that may trigger this different, mobile mapping. A form of such architectural thinking is visualized in an untitled series of paintings by Toba Khedoori, an Australian-born artist who lives in Los Angeles.[45] Khedoori's large, elegant paintings on waxed paper tour dwellings insistently. They depict facades of houses, cross-sections of interiors, windows, hallways, stairs, walls, doors, railings, and fences. Their subtle intervention on housing follows the architectural path of Gordon Matta-Clark and takes it into new realms as it contributes moving views to the analysis of dwelling. Khedoori's architectural fragments—remnants of a dissection—are metonymically related to the moving image: they are fragments of an architectural montage that can make a series of windows into a sequence of frames. Her imaginative dwellings adjoin segments of home to sections of trains and spectatorial seats. Kedhoori's floating world seems to suggest that a filmic map of traveling-dwelling is to be architecturally drafted.

Setting in motion a gender displacement necessitates this repositioning of "dwelling." No longer the spatial antithesis of travel, the house, as the dwelling-place of home, must be theoretically reconstructed. As we look at the notion of home with traveling eyes, and through the lens of various filmic and visual works, we must roam about the house architectonically. The video artist Gary Hill has con-

ceived the house as one in a series of *Liminal Objects* (1995–present), traversed by such lived matter as brains, which constantly change its perspective.[46] Views of these subjects are modified in the act of domestic traversal. Mapped as such a liminal object, the house becomes the center of our tour.

As we stroll around the house and refocus it, we may follow the architectural/photographic path traced by Seton Smith, a New York artist living in Paris, and question, as she does, the idea that *Five Interiors Equal Home* (1993).[47] We may wish to approach our "interiors" as out-of-focus spaces, as Smith does in her series of photographs *Interiors* (1993). In this way, we may position ourselves on staircases, reviewing architectural fragments such as beds, cradles, and gowns, or see ourselves through a "distracted mirror" that reflects doorways, as in her *Candle Piano Series* (1993). We may find ourselves on thresholds in front of oblique compositions or addressing mirrored mantelpieces, looking up at a ceiling. We may choose to sit in skewed corner chairs, to face reframed windows, or to travel in soft focus along any of the home passages, as in her *English Series* (1993). As we shift our focus in this way onto the various forms of traveling domestic, let us direct our lens at some stories of interior design, in the vital hyphen between the wall and the screen.

TRAVELING DOMESTIC: THE *HOUSE* WIFE

To further displace the appropriations of voyage, the static nature of home, and its equation with the female subject's domesticity, let us move inward and explore the domestic as the place of what Elaine Scarry has called "the making and unmaking of the world."[48] We may first consider the space of the house in *Craig's Wife*, a film made in 1936 by Dorothy Arzner.[49] Arzner is acknowledged as "virtually the only woman to build up a coherent body of work within the Hollywood system."[50] As a lesbian author, she has been reassessed by Judith Mayne in the context of queer theory and practice.[51]

3.5. Harriet is the pillar of the house in *Craig's Wife* (Dorothy Arzner, 1936). Frame enlargements.

Our first observation concerns the very title of the film. *Craig's Wife*: there is no name for the woman. Harriet Craig is defined in relation to her domestic role and by way of her husband's name. She is an upper-class housewife who, over the course of the film, will progressively come to embody a literalized definition of the term *housewife*. In a spatial way, the film offers a meditation on the relations between house and wife.

We quickly learn Harriet's ideas on wifehood and her passionate interest in the topos of the house when, at the beginning of the film, she reveals her unruly domestic philosophy to her newly engaged niece, a much more conventional woman devoted to the ideals of marriage. The two women are seated next to each other on a train, yet are appropriately separated in the shot composition by a man in the background, whose anonymous figure acts as the shadow of male presence in their lives. Harriet explains what a house represents to her: she had no means to sustain herself; marriage had been a way to secure a house and, thus, her independence. She means independence from everybody, including her husband. She will achieve this by pursuing a further architectural plan, in which the house will provide the "key" to her continued independence. Harriet intends, by any means possible, to arrive at possessing—and controlling—a room of her own.

Harriet's views of home are far too scary for her niece, Ethel, who intends to conform to the script of the "perfect wife." As her aunt's eyebrows rise ironically in disagreement and zipping noises from her purse voice her disapproval, Ethel's patriarchal beliefs, spoken too emphatically, become ridiculed. By way of shot composition and shot-counter-shot editing, Arzner offers two models to her female spectators: Ethel's passive acceptance versus Harriet's attempt to reverse the logic of patriarchy by working from within, against the grain of the system. This may have been what Arzner herself had to do, working in Hollywood as a lesbian director.

The choice between the two paradigms is actually a choice of "models," cloaked in the corporeal language of fashion. Arzner leads female spectators to identify with Harriet Craig by the way in which she has "fashioned" her transgressive subject. Her body language is irresistible. Not only is she physically more attractive than her plain niece; her demeanor and attire paint a far more seductive image. Arzner directs the course of events by accenting the sartorial difference between the two women. In this film, the position the viewer would like to occupy becomes a matter of the clothes she would like to wear. The minute you see Harriet's fabulous hat, you have no choice. Insofar as she has been made a fashion "model," Harriet, played by Rosalind Russell, is undoubtedly a role model. She "transports" other women into her world. For Arzner, fashion speaks, and speaks for the woman. Like the house, it is a road to the ownership of imaging.

As decor, fashion becomes embedded in architecture and in the very architectonics of the film. In *Craig's Wife*, these elements are essential. Architecture is conceived not merely as a set, nor is decor simply an object of set design. The house is the center of the film—indeed, it is the film's main protagonist. It is the core of (domestic) action and movement. In this respect, Arzner follows the path traced back in 1913 by Alice Guy-Blaché in her film *A House Divided*, in which architecture is made

to "house," both literally and metaphorically, various forms of division, including gender division.

In *Craig's Wife*, architecture also houses the battle of the sexes: the house becomes the locus in which the relation between space and sexuality is negotiated. It is the site of an *error*, a mistake that is also a form of erring: a movement that sustains a departure from the norm. For Harriet the housewife, "house" and "wife" have been incorporated to such an extent that the wife has *become* the house. This shift is epitomized in a long shot in which Harriet Craig looks like a column as she stands in front of the staircase of her home. She has become the pillar of the house. By way of this "error"—a collapse of body with building—Harriet tries to twist the terms of housewife from within, bending the sense of the word to her own needs. She aims at exchanging one side, the wife, for the other, the house. Harriet proceeds to make herself "suit" the house. Working at gaining possession and establishing control over her house as if it were her own body, she tries to free herself from being a wife. Interestingly, the house represents her way out of domesticity and domestication. It is by way of this interior deviation that Harriet Craig embarks on the road to independence. She does not have to travel far. She travels domestic.

Harriet's fixation on the house, exhibited from the beginning, grows as the film develops, reaching paradoxical proportions. Her obsession with space is conveyed in her very first entrance into the house, after the train ride. One look suffices to establish that Harriet has fashioned her space with the same attention she has used in fashioning herself. Both body and house are styled with extreme care. For Harriet, dress and decor are germane.

Harriet has not overdone the decor of her home. By keeping it somewhat sparse she can better control her environment. As she enters the house she surveys the interior, carefully examining its configuration as if trying to chart each movement that has taken place during her absence. She is especially trying to track every possible false move that may have been made by the other inhabitants: the maids (have they broken anything?); her husband (would he have smoked indoors?); her aunt-in-law (who has the awful habit of letting those neighbors in—with offensive flowers that do not fit her aesthetic, not to mention a child!). Harriet scans the site, mapping the position of each object and piece of furniture in her space. She must spot every change that might have occurred, for nothing, and nobody, should upset the design of her interior. The mantel catches her eye. The vase. How strange it looks. It is not sitting right. An object out of place. Out of her place. This cannot be. Everything must be put back in place.

As Harriet Craig's obsession with the house intensifies, a narrative shift occurs: Craig's wife is becoming a *house*wife. Wrestling with the topos of the term, Harriet works from within its confines toward her goal of freedom. To be free, one must be free of others. She must thus free herself from the presence of others in the house. She must make room—room for herself. She needs space. A lot of it.

Little by little, by controlling all movements within the house, Harriet achieves her goal. Nobody can abide living by her spatial rules or fit into her domestic topography. Thus she manages to void it of all unwanted presence. One by one,

they all leave: the maids, her husband's aunt, and finally even her husband. Harriet can at last suit her house to herself. She has fashioned a place of her own. Having become a *house*wife, she can finally drop the wife for the house. By the end of the film, she has, *tout court*, become the house. And now the house is hers.

Unfortunately, this is not a happy ending. As Harriet Craig sits alone in her home, having conquered ownership of herself and her house (albeit at high cost), Dorothy Arzner conveys an uncanny sense of sadness. The walls appear to be closing in on Harriet, as if there were too much space and yet not enough. A house devoid of motion, and with closed doors, is as much a prison as the marriage it was built to contain. Harriet's plan to open up space for herself suffers from this intrinsic limitation: it stops short of circulation. Furthermore, while her transition from house*wife* to *house*wife is certainly a transgression, it is a trespass that has occurred within limits. Merely to twist the terms of a definition means still to remain within the same boundary. To wander freely while traveling domestic, the road that would explore the house as voyage must be well traveled, and scouted with a less regimented map.

THE MOBILE HOME

> *A space is something that has been made room for. . . . A boundary is not that at which something stops, but, as the Greeks recognized, the boundary is that from which something begins its presencing. That is why the concept is that of horismos, that is, the horizon, the boundary. Space is in essence that for which room has been made, that which is let into its bounds. That for which room is made is . . . joined, that is, gathered, by virtue of a location, that is by such a thing as the bridge.*
> Martin Heidegger, "Building Dwelling Thinking"

Despite the interest of cultural studies in the notion of home and its inclusion in historiography by way of historical studies of private life, the connections between architectural and cinematic perspectives on the subject have yet to be fully mobilized.[52] As one who is interested in activating this link, the filmmaker Wim Wenders notes the cultural ambiguity of the word *home* in his book titled, significantly, *Emotion Pictures*:

The word is interesting . . . in American because it covers everything that we Germans have so many words for, meaning 'building', 'house', 'family house', 'home town'. . . . That is the only way to understand the paradoxical word combination 'mobile home'. The advertising slogan for a chain of motels is '. . . a home away from home'.[53]

The overlap that exists in the English language between *home* and *house* may have contributed to the lack of centrality, in Anglo-American studies, of the notion of the house and its architectural aspects. Despite such exceptions as the work of architec-

tural historian Georges Teyssot, an alternative outlook on the house has been long in coming.[54] As architecture theorist Mark Wigley observed in 1992, when it comes to sociosexual space, "still the question is not yet architectural—*home*, not *house*. The house remains unrevised."[55] Opening the house and its fashioning to a wide-angle investigation, the richly theoretical field of gender studies in architecture now reflects on the housing of gender.[56] As Ann Bergren puts it, there may lie in this land-scape, a "(re)marriage of Penelope and Odysseus."[57] It is precisely in this critical space that we can dwell filmically, for film—an architectural language—is the epistemic "motor" of a building/dwelling/thinking that is emotive. We may thus further mobilize "housing" by extending the architectural path into the space of "emotion pictures," considering its design as an architectonics of gender. As the example of *Craig's Wife* intended to suggest, the house is both an architectural and a cinematic construction: the movie "house" is a habitation for gender dwelling and gender roaming, constantly transforming the views of public and private by turning them inside out.

The voyage of modernity, of which cinema is an agent, is not only a mat-ter of traveling to exterior locales; it also includes interiors. The history of domestic interiors has unfolded together with the development of interiority, changes in socio-affective life, and the analysis of the body's own interiors. New "fashions" of inhabi-tation have produced new forms of domesticity, which move away from domestication. As a crucial cultural topos of the era that produced the cinema, the idea of the modern house developed out of a public voyage into the interior. The house contains, in all senses, a moving sense of space, as shown in *House: After Five Years of Living* (1955), a film made by the designers Charles and Ray Eames about the house they built for themselves in 1949. The development of subjectivity as spa-tiality hinges on architectural construction and is written in the very articulation of architectural discourse. To understand the space of the moving image, we must therefore once more turn to architecture and return to the house (of gender). Not at all because the object-house is more sexual than other spaces, like the street or the museum, and not only because it is inextricably linked to these sites, but because the house is, actually, both a private museum and a public library. It is a laboratory built on the threshold of diverse interpretive and creative perimeters, binding architecture to the cinematic drama of stasis and movement in the sensing of space.

FILMIC ARCHITECTURAL FASHIONS

With respect to the critical project of relating space, mobility, and gender to the moving image, the writings of the German architect Bruno Taut prove particularly illuminating, for they resonate with filmic discourse. Taut, as the film scholar Mikhaïl Iampolski remarks, had worked in the cinema, writing two film projects in 1920.[58] Using imagistic flow and cosmic light traveling through glass landscapes, these film scripts reinvented the poetics of the travelogue, played out on a cinematic-architectural mirror screen of emotive movements. If Taut's architecture, as Mark

3.6. Movements in the house: an apartment plan by Bruno Taut for *The New Dwelling: Woman as Creator*, 1924.

Wigley shows, played a crucial role in "the fashioning of modern architecture," it was also important in the fashioning of gender on the filmic-architectural screen.[59] In his 1924 book *Die Neue Wohnung: Die Frau als Schöpferin"* (The New Dwelling: Woman as Creator), Taut asserts that it is a woman's way of inhabiting domestic space that creates and modifies architecture.[60] Her reception of space has an active role in its construction. From this perspective, the architect addresses the evolution of architecture and the shape of his own work. Thinking of the issue representationally, he compares architectural drawings to painterly renderings of interiors, intertwining the history of art with that of architecture.

The impact of women's reception of architecture on the making of space goes back in history, where 'ladies' traditionally played a role in the shaping of the house. It was the Marquise de Rambouillet who introduced the private sleeping room in the seventeenth century. The Duchess of Burgundy promoted informal fashions. And one must not forget Jeanne-Antoinette Poisson, Madame de Pompadour, who ruled on fashion and architecture and, building and renovating a half-dozen houses, "promoted a general fashion for interior decoration that facilitated and accelerated 'modern' ideas such as privacy, intimacy, and comfort."[61] The eighteenth century saw the definite establishment of upper-class women in "fashioning" space. Most prominent at the time of cinema's invention was Edith Wharton, a writer who fashioned the house as an affirmative space for women and wrote books on architecture and gardening. She also co-wrote *The Decoration of Houses* and practiced the art of interior design, conceiving the house as a mental space, stressing the creative expression of women in the design of drawing rooms, and, overall, giving space to women's place.[62]

To consider the input of the *grande dame* and the modern woman in the construction of private spaces opens the door to understanding the creative input of female reception in modern architecture. Here, Taut makes an important contribution when he points out that architecture is made not only in the act of designing or commissioning it, but also by way of using it. Speaking of women's use of architectural space as an active function and recognizing imaging—that is, spectatorship—as a participant in the architectural enterprise, Taut touches on the birth of the

female "public." His architectural study programmatically addresses the new fashioning of female subjectivity as a public.

Acknowledging women's work in the house and their role as shapers of space, Taut speaks of mobilizing the environment. He designs a "mobile" home, one in which all trajectories are streamlined and rationalized to release women from domestic chores. Carefully outlining all movements that take place in the house, Taut works at making the new home the equivalent of fast, modern travel. This equation between house and travel is literally rendered. Taut actually sketches it, drawing all kinds of in-house journeys into his plans as he maps a new home for the new woman as a "transformative" object. In Taut's view, modern architecture actually becomes a means of transportation.

As a transitive prosthesis, this mobilized architecture is equated to another wearable art of the everyday: fashion. Speaking of the ideal form of habitation, Taut compares the house to a piece of clothing, quite literally calling it a woman's "dress." Does his scene expose the same conflation on which *Craig's Wife* rests: the "suiting" of house to woman? Actually, in a less arresting conflation, the architect's "house dress" turns out to be a means of *transito*:

[Designing] the ideal house . . . we must attain an organism that is the perfect dress, one that is to correspond to the human being in her most fertile qualities. In this respect, the house is similar to clothing and, at a certain level, is its very extension. Fertility and human creativity reside, now as ever, in transforming things. Today, we find visible signs of these changes in all those phenomena that until recently did not even exist, that is, the industrial creations. They have already transformed our everyday life, and they will transform the house. This is evident if we observe the means of transportation, that is, cars, airplanes, motor boats, ocean liners, trains, and if we fully comprehend the extent of revolutionary inventions whose possession has become indispensable to us: things like the telegraph, the telephone, the radio message, electricity, all the applications of the motor, to which we must recently add the increased manipulation of water and wind, and the stove made according to new principles of warming up food.[63]

In this modern physiognomy of architecture, the house travels (domestic). The modern home is fashioned as a haptic dwelling-place. Considered from our perspective, this mobile home resembles a movie house: it is a home of mechanical organisms and a means of transportation. It is not only a moving entity but a removable one, for such is the quality of the clothing to which it is compared. Furthermore, this house—a woman's dress, which corresponds to her way of living her body—is equipped with epidermic qualities. It shows its wear. It wears its history. As such a haptically moving site, this (movie) house is a special dress: its fabric is a filmic fabrication.

Although Taut himself did not make the connection between the house and the movie house, and did not even mention the cinema among the means of transport and communication that he equates with new forms of domesticity, his very cinematic language triggers our comparison. Moreover, the moving image *suits* his model. Taut's argument easily extends from the house to the movie house, for it touches on new ways of fashioning space and new sites of mobility. A haptic component binds

architecture to film. A new territorial "fashion" was taking place in both spaces of modernity, one that was changing socio-sexual roles. The female public of the (movie) house was indeed fashioning new forms of mobile intersubjectivity.

AN "ARCHITEXTURE" OF FILM NOMADISM

A product of modernity, the movie "house" embodies moving subjects. Cinema is a lived documentation of cultural (dis)location. It is a vehicle for reading traces of our inhabitation and a house that moves at the speed of our travel in space. Filmic movement is a cultural passage. A practice of imaging that participates in the modern philosophical project of mobilizing space, cinema has been home to various forms of nomadism, including some gendered female.

Traveling a step further to reunite Penelope and Odysseus, we look forward to an architectural cinema that houses a mobile dwelling of gender. The world of Michelangelo Antonioni, in which stories emerge from and drift out of place, offers a modernist example.[64] As Roland Barthes put it, Antonioni is "an Einsteinian traveller," for "he never knows if it is the train or space-time which is in motion, if he is a witness or a man of desire."[65] Antonioni has created an architectonics of space that has itself drifted, reaching as far as the cinema of Ming-liang Tsai, whose *Rebels of the Neon God* (1992) and *Vive l'amour* (1994) reinvent some of his touch as they disquietingly render the journey of urban dwelling .[66]

Described by Martin Scorsese as someone who makes films "with the curiosity of an explorer and the precision of a surgeon," this is the filmmaker who once told Mark Rothko: "Your paintings are like my films—they are about nothing . . . with precision."[67] In fact, there is a profound relationship between art and film in Antonioni's moving architectonics.[68] Indeed, he has been painting for as long as he has been making films, although for a long time he did not allow his work to be seen publicly or even privately. Witnessing the exhibition of his paintings called "The Enchanted Mountains" was an eye-opening experience, for in it one could actually observe his filmic process captured on canvas.[69] The paintings read as landscapes, with no distance or difference perceptible between what might be an aerial or a close-up perspective. Colors are mixed on different surfaces in a complex process that involves collaging, photographing, filtering, enlarging, and reprocessing the image. Watching Antonioni's films, one may at first find it hard to imagine that his cinema is related to landscape painting. Yet it is, for he is a modern landscape painter, grasping ahead for the architectonics of minimalism, which, as the art historian Michael Fried has shown, entails a scenography in which space makes "room" for and objecthood emerges from the changing views of a mobile beholder. As a scenography of situations, attentive to the duration of experience, minimal art belongs to "the *natural* history of sensibility" and borders on biomorphism.[70] Antonioni ventures into this minimalist geography, which is a spatialization of experience. In this sense, the particular mise-en-scène of his paintings exposes the texture

of his topophilic filmic geography: the "architextural" landscape of his cinema is laid bare on the landscape of the canvas.

As a filmmaker, Antonioni has fabricated an aesthetic based on the filmic anatomy of space. But architectural dissection accompanies geopsychic transformation in Antonioni's films. This is activated mostly by the haptic sense of his female characters, who wander constantly in their psychogeographic journeys. Nomadism, often gendered female, is indeed the "house" in which the films move. They ask us to move with them, through the space of an emotional "architexture."

Antonioni's nomadic filmography takes off with *L'avventura* (1960), a peculiar "adventure" in the southern Italian landscape in which plot completely gives way to filmic travel.[71] A group of friends, modern leisure-class nomads in search of pleasure, set off on a boat tour. One member of the group, Anna, disappears, and a very loose search is set in motion. All clues and leads are left hanging, and no resolution is achieved. Nothing happens in this film but topophilic rambling and erring—with precision. Site-seeing is driven by a camera in flux, whose position and rhythm actually appear to generate the events. This film is a voyage through space, progressing with the rhythm of the land it traverses and mimicking in its time span the intrinsic temporality of the space it touches. The film senses the landscape as if absorbing the very tempi of the sea and the volcano that make up its geography. Cinematic time is slowed down and transformed in duration to make room for this space. *L'avventura*, one feels, moves in geological time waves.

As a "geological" tour of a region, *L'avventura* owes something (as did *Contempt*) to Rossellini's *Voyage in Italy*.[72] In fact, the landscape of southern Italy as treated by Rossellini in his Bergman era opens the way to the world of Antonioni, now defined by Monica Vitti, creating a modernist hyphen. The female wanderings in the landscape mark the connection between these two filmic views. Claudia and Katherine are both northerners encountering the south as wanderers. In *L'avventura*, as in *Voyage in Italy*, the emotions of the female protagonists are displaced onto their motion through the terrain. Traversed and transformed by restless *voyageuses*, the land reads as an interior landscape in a constant shift between inner and outer worlds.

This *transito* includes eroticism. Desire is, in fact, circulation. In all senses, it moves; it is an emotion that harbors motion. Erratic desire moves Antonioni's films and, in particular, drives his female characters, who are often affected by a form of restless love. In one way or another, Antonioni's women are all erotic nomads. *L'avventura* provides no exception, for it conveys erotic flux even by way of semiotics. As the title of the film itself suggests, there is a relation between motion in space and desire. In Italian, *avventura* can be used to describe a particular "adventure": a love affair. Off on a haphazard search for her friend who is never found, Claudia encounters an emptied landscape, in which she is led to explore the realm of the senses. The adventure becomes a venture into an erotic terrain, with all the malaise that such venturing entails. Thus erotics merges with the filmic voyage and is transferred onto the contour of the southern Italian landscape, just as the landscape of Scudéry's *Carte de Tendre* writes its own amorous "adventure."

In Antonioni's cinema, the architectonics of character is topophilically dislodged onto architecture or landscape, where it dwells and moves. In all four films of his sixties' tetralogy, we experience a transfer of the interior realm onto spatial configurations. Such an architectonics travels from Claudia's erratic search in *L'avventura* to Lidia's nocturnal rambling in *La notte* (1961) to Vittoria's erotic meandering in *L'eclisse* (*The Eclipse*, 1962) to Giuliana's view of *Il deserto rosso* (*Red Desert*, 1964).

In *Red Desert*, Giuliana's unstable emotions actually end up "coloring" the post-industrial landscape of the city of Ravenna.[73] Giuliana seeks a lover who is at home traveling the world. It is no wonder that she finds herself with him, staring at a map, in a hotel room that changes tones—that is, whose color literally shifts with the emotion of her erotic perception. Homelessness is a perennial condition for the maker of *The Passenger* (1975). In this restless landscape, maps and *vedute* appear frequently. They generally function as potential sites of opening, places to escape to, views of an elsewhere that is nowhere. For Antonioni, cartography is an existential situation. A *veduta* appears in the opening sequence of *The Eclipse* to literalize Vittoria's search for a new world view, along with a subsequent bird's-eye view from an airplane. These views are steps in the reconfiguration of her emotional space and projections of her displacement in a love affair that is ending. This remapping is "architexturally" shaped. It is generated from the cinematic work of framing and reframing that progressively takes her out of the picture and into a new erotic space, signaled in one instance when she points her finger out of the frame of a painting.

The prominent sites of this woman's voyage on a *Carte de Tendre* are the walls of houses. When the film opens in the apartment of the intellectual boyfriend she is leaving, his body forms a still life with his books. Not one word is exchanged between them. It is the exploration of the space of the apartment that tells us of their breakup. This is a broken home, fractured in scenes in which body parts are equated with pieces of furniture, as in a low-angle shot that adjoins her leg to the legs of a table. The house is divided on filmic grounds: the two lovers cannot even inhabit the same frame or share a shot. Love being out of place, Vittoria moves around, trying to reposition things, reframing objects as if redecorating could "fashion" a new space for her. She touches everything with her hands as her restless body navigates the space in search of a place of comfort or a way out of the picture. When he enters her frame, and silence is broken, we know that the love affair is over.

Vittoria walks away from her lover's apartment and from his life, entering a series of different houses where, again, she will travel around and touch everything. *The Eclipse* actually unfolds as a voyage of the house. For her own apartment, she buys a new object of decor to fashion herself anew, while at the house of a Kenyan friend she goes through the entire decorative inventory to perform her makeover. There is a retrospective voyage in her mother's house, in which a haptic journey takes her into her childhood bed, where memories are retrieved by "handling" photos from the past. As she pictures herself in an erotic venture with Piero (Alain Delon), she will travel through his family home, fingering his identity as it is written on the walls of the house, drafted in the landscape paintings, and inscribed

3.7. The map of the *Red Desert* (Michelangelo Antonioni, 1964). Frame enlargements.

on his obscene pen. Along with his office, this house provides the set for an intensely touching, erotic story, a sequence of tactile encounters that gives way to an open ending. As both characters leave the site, exiting narrative space, we revisit alone the places where they had met on the street, pausing with strangers at bus stops, lingering at street corners, waiting at crossroads. Our eyes, like hers, feel the space as if touching the place where even new architectures, in the ruins of a new love, end up turning into relics.

Passionate about mapping space by way of "architexture," Antonioni has featured architects as real and fictional characters in his films and exposed architecture prominently in both interiors and exteriors.[74] The wide-ranging display spans from ancient Rome to the wonders of Noto's baroque urban planning to modern architecture, which is a prime location in his work. In *The Eclipse*, for example, Antonioni shoots at EUR, the Roman neighborhood planned by Marcello Piacentini for the 1942 World Exhibition and featuring Pier Luigi Nervi's Palazzo dello Sport, a fine example of rationalist architecture. Gaudí's *modernista* architecture takes center stage in *The Passenger*, where we tour two of his Barcelona creations, Casa Milà, known as "La Pedrera," and Palacio Güell. Architecture becomes exploration in *La notte*, where Milan's Pirelli Building, a 1958 work by Nervi, created with Giò Ponti, is featured in a credit sequence that, as Pellegrino D'Acierno has noted, functions as an architectural prelude.[75]

The building is literally "scrolled," via camera movement that unfolds its visual structure, as an introduction to the film's psychogeographic journey. The skyscraper's transparent texture is elucidated as the city becomes reflected in its view. As we travel down the facade, we move from window frame to window frame, as if actually unreeling the twenty-four frames per second that comprise the film strip. The frame of the window thus turns into the filmic frame, with the city imaged within its borders. The building turns into a film. Through such exploration of architectural composition, the making of cinema's language is laid bare and the very physicality of its fabrication revealed. We feel the textures of architecture and cinema haptically collide as the building turns into a celluloid band.

This "sensing" of space—a site-seeing—marks the voyage that Lidia (Jeanne Moreau) will take in the course of *La notte*. In a long sequence, Antonioni follows her walk through the city, all the way to the edges of town. Parallel editing interestingly juxtaposes her urban rambling with the immobility, both metaphysical and actual, of her husband Giovanni (Marcello Mastroianni), who sits at home while she wanders off. Lidia is at home in the city. The camera moves elegantly with her, sometimes tracking her weaving through urban posts as if to "approach" the very way she sees, sometimes searching for her around a corner, only to find her a small figure at the bottom of a building. In all these movements, both her eyes and the camera's lens again *feel* the space. Against the alienation of the time, Lidia tries to get in touch with her surroundings. Her curiosity is palpable. She comes to know the space by sensing it, even by physically touching it. Moving about, she touches the surface of the walls, peeling off their textural debris. Like Vittoria, Claudia, and

3.8. An architectural-filmic scroll in the opening sequence of *La notte* (Michelangelo Antonioni, 1961). Frame enlargement.

Giuliana, she apprehends the space tactilely. Dwelling in voyage, these women make haptic journeys of the interior.

In this world of transience, the spectator, too, becomes a "passenger." Antonioni's films call for a spectatorship as fluid as the psychogeographic navigation his female characters are asked to participate in. As he builds a moving space of shifting geometric compositions, we navigate a new filmic space—a cinematics of architectural passages and geographic fragments in which spatial representation is fractured and jarred. We are always pinned to the walls. We find ourselves at home in the interstices of intervals, recesses, gaps, voids, pauses, and transitions. We dwell in ellipses and eclipses. A practice of *tempi morti*—literally, "dead times"—shapes this architectonics of passage. It makes us stay when characters leave, feeding on the leftovers of the story, exploring the space they traversed and lived in. Lingering on, holding onto the frame, we absorb what they have left behind or sense what came before them, bonding with the space of their inhabitation. It is the passage of passengers. An *emotion*.

PASSAGES

Beginning with early cinema's interest in the physicality of movement, it has taken numerous filmic passages to arrive at a dwelling in motion and an exploration of female nomadic subjectivity. It has taken, for example, the strength of vision of Ulrike Ottinger in her *Johanna d'Arc of Mongolia* (1988), in which the space of female travel is reclaimed by seriously questioning the notion of nomadism. Ottinger has contributed an important film about "nomadic movements" in light of "nomad thought."[76] Along this trail, a significant passage has been made by the moving camera of Agnes Varda, who explores another dimension in *Sans toit ni loi* (*Vagabond*, 1985), a film about the laws of the home that is capable of sheltering in its narrative the many nuances of homelessness. Many equally forceful examples could be invoked here, but it has been Chantal Akerman who, ultimately, has undertaken the project of

3.9. Sites of passage in *Les Rendez-vous d'Anna* (Chantal Akerman, 1978). Frame enlargements.

reinventing film's lifelong fascination with the movement of daily life, which had been such a powerful attraction of the early cinema.

Akerman's cinema of passengers dwells on the house as a site of passage. There is the celebrated house in her *Jeanne Dielman, 23 quai du Commerce, 1080 Bruxelles* (1975), a film that has contributed a seminal "address" to feminist discourse by displaying the rhythm of a housewife's life and her experience of prostitution. From this address on the "avenue of commerce," Akerman's views open wide. In *News from Home* (1976), a primarily stationary camera records the movement of New York City, especially its active street life, on the surface and underground. From subway to street, the film explores the very etymology of metropolis—"mother-city"—for we travel to the rhythm of a mother's voice as Akerman reads the letters her own mother has sent her.

The relation of home, house, and voyage becomes the very subject of *Les Rendez-vous d'Anna* (*Meetings with Anna*, 1978). Anna is a filmmaker on tour with her film who, in the course of a series of encounters with strangers, passes by her home town to meet her mother. We do not enter the movie theater where Anna's film is screened; we are strictly prevented from entering the house of the German man she visits after a night's affair with him in a hotel room; and we do not visit her mother's house. We do, however, get to know more than two or three things about her. Precisely because of these architectural omissions, we are taken into Anna's own nomadic architecture and restless space. The film's geography is rigorously composed of trains, train stations, cinemas, car interiors, and hotel rooms. It is a geography of passage. In this moving panorama, structured by a railway trip, we track an intimate journey. We remain in one train station to meet a family friend, and meet her mother in another. Anna takes her to the railway's café and later, instead of going home, checks into a hotel with her. The intimate encounter with her mother, in which she discloses her lesbian life, can take place only now that they are away from the family house. It is the hotel room that enables them to narratively access the family house. Back in Paris, after a long car ride with her boyfriend, the two go

to stay at a hotel, avoiding both their homes. Finally, at home, we come to realize that Anna's life is virtually housed in an answering machine. A family or an unsentimental history can only be displayed in a place of transit—the railway, the hotel, the answering machine—a site inhabited each "night and day" by a different story, as the title of a 1991 film by Akerman further suggests.

This geography of transit, first established in *Hotel Monterey* (1972), an architectural survey of the random presences that populate a hotel lobby and elevator, constitutes the very narrative of *Toute une nuit* (*All Night Long*, 1982). Here a series of disconnected stories intersect on the urban pavement. A chronicle of one night in the city of Brussels, the film enters and exits the lives of a few urban dwellers as they come together or split up, kiss or fight, in a narrative mosaic of love in, and of, the city. Throughout these urban encounters—atonal fragments of a city symphony—we remain at the threshold. In fact, the film is architecturally marked by the threshold. It deliberately takes place on the steps of stairs, moving in and out of staircases. Doors open and close as we are left to ponder there. The film often stays outside the doors or halts by windows. It dwells on the sidewalk, the road, and the street corner. It inhabits cabs and city squares. It circulates in cafés, bars, and hotels. It is suspended on the balcony. It lingers in the corridors. *Toute une nuit* resides in the passageway. As a film of thresholds, it heightens the very space of transit as transition.

We travel with Akerman through an architecture of symmetrical compositions, a formally rigorous aesthetic of frontal long takes with stationary and moving camera. It is in this way—with frames fixed as if to seize motion—that Akerman constructs a "geometry" of passage. In this filmic geometry, she allows a woman to be in her own space and in the space of her voyage. The position of Akerman's camera indicates where the author stands in all senses, since it often includes the measure of her (slight) height. It is a position that marks her presence there, never so close as to interfere or so far that her presence as a fellow traveler is not felt.

In fact, writing for the installation that grew of out of her film *D'Est* (*From the East*, 1993), Akerman tells of an actual journey. This borderline work houses the

memories of someone who is not quite a stranger to the places she revisits, for, to a large extent, she revisits the sites of a Jewish diasporic geography.[77] For the installation, *Bordering on Fiction: Chantal Akerman's D'Est*, Akerman played with the "moving" nature of *kinema*:

I would like to make a grand journey. . . . I'd like to shoot everything. Everything that moves me. Faces, streets, cars going by and buses, train stations and plains, rivers and oceans, streams and brooks, trees and forests. Fields and factories and yet more faces. Food, interiors, doors, windows, meals being prepared.[78]

In Akerman's grand journey, motion becomes emotion as it touches the space of everyday life. She designs a world of faces and food, windows and streets, buses and rivers, trains and doors, oceans and rooms—a map that incorporates the nurturing architecture of the interior. This world is composed of still lifes and pictures of side rooms, which are framed and reframed in the monitors of the installation as if they were moving landscape paintings. It is made of endless tracking shots in which motion itself appears to be captured. It is in this movement of dwelling that we abide. An atlas of life, her cinema is quite a grand tour.

As an atlas, it is a cumulative journey. This additive quality is made apparent in the installation of *D'Est*, in a room where the film "resides" in triptychs of twenty-four video monitors. Here, remaining still, circling 360 degrees in a train station, or tracking the streets independently of the objects that enter the frame, the camera collects images, which accumulate in the space of the installation. Their impact grows with both awareness of and obliviousness to the camera's presence. The video monitors become a storage space of this mnemonic itinerary. In this place, we are transported.

The cumulative effect of this psychic buildup even takes us backward in history. With this script of motion, Akerman seems nearly to be reinventing the panoramic views of the early travel film, finding a new voice for the silent language of movement developed by the turn-of-the-century genre in its own urban panoramas. In her work we feel the impact of the powerful movement that mobilized cinema in the very days of its invention, attracting spectators into the house of pictures.

Chantal Akerman presents a body of work that continues to move through this map of sites, touching the interior physiognomy of space. She writes of this idea of traversal in a text for a project that again combines film with art installation. This project, which continues the diasporic voyage of *D'Est*, would move from the East to the Middle East. In "Of the Middle East," Akerman makes a distinction between the wandering gaze and a look focused on possession: an important distinction that, as we have seen, traverses the travel genre and its history. Advocating the position of nomadism for herself and her cinema, Akerman points out that traversing the landscape is not an act of domination. In her words, *transito* is an atlas:

[The way] I would like to film . . . corresponds to a certain wishful thinking on my part about nomadism, as well as to the idea that the land one possesses is always a sign of barbarism and blood, while the land one traverses without taking it reminds us of a book.[79]

The journey Akerman sets in motion is an analytic process, an itinerary that is not too far from self-analysis. The filmmaker constantly revisits her sites of habitation, as well as the movements of the house. She travels the interior—a place of passage that is familiar and familial and which can become known, that is, mapped, by way of psychoanalysis or film. Her discovery turns out to be about dwelling. Her voyage is a voyage back to—and a view from—home: "I want to film in order to understand. What are you going there for, someone asked? . . . I'll find out when I get there. . . . It's always your mother and father you run into on a journey."[80]

Such a journey of primal scenes is a passage. It is her retrospective *Portrait d'une jeune fille de la fin des années 60, à Bruxelles* (1993), a fictional self-portrait of a young woman from the late sixties in Brussels on a transposed Oedipal journey. On the road of filmic transfers, Akerman's cinema dwells in the process of "clinical" observation, capturing the in-between spaces of everyday life. This transitional geography is affected by what Antonioni defined as "*la malattia dei sentimenti*," the sickness of emotions—an erotic nomadism which is a modern disease, a form of dislocation. Moving from the exterior of the city to inner space, extending ourselves outward only to regress into the depth of mnemonic terrains, we are all nomads, retrospectively traveling the map of a filmic psychogeography on the brink of a traveling-dwelling.

THE VOYAGE OF THE HOUSE (OF PICTURES)

By questioning the dichotomy that would identify home with the female subject and voyage with male, we have challenged the view that travel alone implies mobility, while *domus* is necessarily the static site of domesticity and domestication. Dwelling-voyage implies a series of interactions. A voyage deeply involves and questions one's sense of home, of belonging, and of cultural identity. At home, one may indeed travel. Home itself is made up of layers of passages that are voyages of habitation. It is not a static notion but a site of *transito*. More than simply a point of departure and return, it is a site of continual transformation.

As the films of Antonioni and Akerman have shown us, the house moves. The house, with its material boundaries, is not a stationary tectonics. It is not a still architectural container but a site of mobile inhabitations. The house embraces the mobility of lived space. Like film, it is the site of an *emotion* and generates stories of dwelling. It is an assemblage of objects that makes up a moving landscape. The house (of pictures) is a montage of living signs, the "set" of a sentimental mise-en-scène that moves within its walls, decorating their very surface.

We must look for such narrative in architecture, for its mobile perimeters tell the history of private life and, in so doing, make a site for its public display. Sometimes, if questioned, houses would tell stories of love or of violence. One such case, as Beatriz Colomina has shown, is "E.1027," the house that Eileen Gray designed for herself on the rocks above the Mediterranean Sea and which actually

3.10. Refocusing the journey of dwelling: Seton Smith, *Curving Windows and Stairs*, 1996. Cibachrome print.

turned out to be a battlefield.[81] The war of E.1027 was inscribed on its very walls. The house bore several postscripts of violence in its narrative, including a violation by Le Corbusier, whose presence was marked on the walls; he also ended up swimming to his death there. The story of this house reveals, among other things, that the house is key to the way architects think about architecture. In fact, calling the house an "exhibitionist" space, Colomina elsewhere claims that what "distinguishes twentieth-century architecture [is] the central role played by the house," which includes its transformation, by way of media, new technologies, and forms of communications, into a new form of public and work space, more public than the street.[82]

If the home is becoming an increasingly media-based construction— becoming, that is, a "screen"—then, from a filmic viewpoint, we can observe that, conversely, the movie house and its extensions have increasingly incorporated onto their field screens shifting notions of the interior. Thinking this way, the house can be viewed as the hinge that opens the door between architecture and cinema. Take Eileen Gray's house, for example, which was itself designed as a traveling narrative; the story that developed within its design and left its marks on the walls could positively make up the plot of a film. In fact, it resonates with the house of *Contempt*. It also finds a potential correspondence with the work of the Israeli filmmaker Amos Gitai, who designed his *Field Diary* (1982) with tracking shots. In Gitai's documentary strategy, the narrative path, in which conflict is defined and negotiated architecturally, extends from the body politic to "territorial" politics. This is especially explored in *The House* (1980), where the filmmaker's architectural training translates into a compellingly political architectonics of film.

Exploring the narrative of the house turns out to be, in many ways, a filmic activity. The house is bound to the house of pictures. It is a site of moving pictures— an archive of picturing. The house, in many ways, is a "collection." It holds an accumulation of imaging that is personal, yet social. It functions as imaginary storage. This is literalized in the house-museum conceived by Isabella Stewart Gardner. The

assemblage of pictures on the walls of her house makes a journey, just as she made an architectural remnant into a site of passage.[83]

Houses, like films, can be a private museum. They can tell stories of journeys and of travels within. Filmically, they can always narrate this way, even at the zero degree of architecture and even when they are not places of border. They can be in flux even if not designed as nomadically as John Hejduk's exquisite mobile home project; even if they have not been mobilized in the gifted hands of Zaha Hadid; even if they are not the domestic dwelling-in-movement of any playfully spatial or even specifically filmic architecture.[84] An interior can be a "portable and customized structure" even if it cannot actually fold away like one of the compact A–Z Living Units designed by the artist Andrea Zittel.[85] Movement is possible for houses, which are as perceptually mobile as movie "houses"; even when they have not been touched by Steven Holl, they can become sensuously minimal phenomenological architectures or move in a different sense.[86] Interiors are an affair of the senses. They sense, and make sense of, our passing. They are a site of experiential nomadism, for they outline the movement within—the movement of emotion pictures.

THE WALL AND THE SCREEN

Like a film, the house tells stories of comings and goings, designing narratives that rise, build, unravel, and dissipate. In this respect, there is a tactile continuum—a haptic hyphen—that links the house and the house of pictures. The white film screen is like a blank wall on which the moving pictures of a life come to be inscribed. Etched on the surface, these experiential pictures, like film's own, change the very texture of the wall. The white film screen can become a site of joy or a wall of tears. It can act like the wall envisaged by Ann Hamilton in her moving installation *Crying Wall* (1997).[87] On its white surface, drops of feelings drip, seeping through as if all bodily liquids were conjoined on the "architextural" surface. One can feel the pain that the surface bears. The film screen sweats it, like this artist's wall. It holds it like the house's own wall. The screen is itself a wall of emotion pictures, an assemblage of affects.

Remembered and forgotten, the stories of the house constantly unfold on the wall/screen. They are sculpted in the corporeality of "architexture"; exposed in the marks of duration impressed on materials; inscribed on fragments of used brick, scratched metal, or consumed wood and, especially, in the non-spaces. They are written in the negative space of architecture, in that lacuna where the British artist Rachel Whiteread works, casting the architectural void of everyday objects and the vacuum of the domestic space.[88] The "volumes" of stories of her *House* (1993–94) become material once exposed in a solid cast of its hollow volumetric space.[89] They continue in the discarded *Furniture* (1992–97) laid on the street, in the filled holes of a *Table and Chair* (1994), in the *Amber Bed* (1991), or in the many *Untitled* beds (1991–92). They show in the peeling wallpaper or the paint stain of the *Rooms*

(1996–98), in the space of the *Closet* (1988), and in the unfinished or about to be demolished *Constructions* (1993–98).

Transformed in this way, stories unfold on the surface of the wall/screen. As in Mona Hatoum's sand piece *+ and -* (1994), the surface "absorbs" a moving design. In the hands of this Lebanese-Palestinian artist exiled in London, all marks that are made are constantly erased and redrawn on the sand.[90] Sometimes all that is left of the movement is a remnant—what she calls a *Short Space* (1992): hanging bedsprings, relics that speak of dislodging, the remains of diaspora.

In the hands of the Colombian artist Doris Salcedo, *La Casa Viuda* (I–VI, 1992–94) becomes, through the specific and traumatic historicity of her country, an *Unland* (1997).[91] Her series of untitled furniture pieces (1989 to 1995) testifies to a history that came to perturb an intimate geography. An armoire (*Untitled*, 1995), laden with cement, makes this visible through its glass doors. The folds of the garments that were stored there now seep through the porous texture of the cement. "Held" in this melancholic way, they have become further worn. By the force of this exhibition, which includes us as mourners, the work returns to us the very fabric of an intimate space—its "architexture." A bed and an armoire can, indeed, be a ruin on the ruined map of one's history—that map held by the house and traversed by the cinema.

As they narrate in their own "negative" space diverse stories of the flesh, recording the movement of lived space, films themselves act as domestic witnesses. The cinema thus functions as a moving document of our dwelling, the screen of our changing spatial history that "projects" its evolution. A site of traveling-dwelling, the motion picture designs our lodging in space. It is an agent in the very mobilization of the interior. A map of domestic motion, it is a site of shifting dwellings, the virtual trace of our haptic (e)motion.

HAPTIC SPACE TRAVEL

The invention of film—a kinetic cultural site—has inaugurated an era of circulation that is increasingly defined by an evolving spatiality. The tempo of spatial movement is the dimension that the filmic century has lived in, representationally. Along with cinema, developments in communication and circulation have been expanding our ability to inhabit territory, to dwell in and move on the map. At the same time, an uncertainty about location, and about being located, has arisen. This is bound to continue to affect architecture in terms of mapping, but not only as the technical challenge of draftsmanship—that is, of drawing and moving through space. As the installation projects of Laura Kurgan show, confronting obsolete systems of drafting becomes a complex cartographic issue when the experience of drafting engages with the drift at work in the map itself and in architecture, including the architectonics of communication, to which the cinema belongs.[92]

Current cartographic efforts to locate and track every moving object in space interact, in postcolonial terms, with a vast cultural anxiety about place(ment).

This particular version of "cartographic anxiety," which, as Derek Gregory shows, affects "geographical imaginations," is a syndrome that involves our shifting place on the moving map.[93] At the most basic level, we need always to be "in touch," either by Palm Pilot, cellular phone, beeper, answering machine, fax, e-mail, or Internet. New "links" keep being invented. Spatial connectors—metaphors, or "means of transportation"—continue to make their mark on our culture, constantly crossing between high theory and low culture as they change our forms of habitation and the measure of our dwelling.

The language of contemporary technology is obsessed with the virtual mapping of space. Cyberspace is an actual place, with Web "sites." This is a place of exploration and bonding with "navigators." "Cruising" the Internet, "surfing" and "browsing," we "visit" a Web site. Today's moving site is a home. We all have an address there. In fact, our street address has turned into an "e-dress." We might have our own "home" page. We enter conversations as if they were "rooms." Operating this way, our spatial culture reinvents the drive to make an imprint of lodging on traveling space. It reveals the ever-strong haptic desire to come into contact and be connected. Even virtually, the moving site must be habitable and inhabited.

The desire for inhabitation accompanies the expansion of our geography. Although projected forward, this haptic site-seeing extends back to the motion picture of the modern era, where the desire and ability to inhabit the moving image first "took place." The birth of the cinema is thus a trace left by the cyberspace of the new millennium. A product of spatial culture, film is haptic space that is simulated travel. It has housed our cartographic anxiety and its release. Its archaeology is a touching geography—a map of our passages through a brief moment in space, reinvented as we reach the end of our map zone.

THE END OF THE MAP ZONE

It is the fall of 1999, and "Claire woke up in some pretty strange places." So announces the voice-over that opens Wim Wenders's *Until the End of the World*.[94] Released in 1991, this film, which concludes our tale of domestic travel, is strikingly similar to the 1906 Pathé travelogue that opened our chapter. It represents essentially the same narrative structure that *A Policeman's Tour of the World* offered. A fictional travelogue led by Claire (Solveig Dommartin), *Until the End of the World* takes us on an elaborate world tour. We touch down in Venice, Lyon, Paris, Berlin, Lisbon, Moscow, Transiberia, Beijing, Tokyo, San Francisco, and Australia. As in the 1906 travelogue, a chase links the cities and countries we visit. A man is being pursued around the world and we are given a chance to travel along—to be "transported" from one situation to the next. Stolen money is again involved. A bank has been robbed, and money floats around the world, both making the tour and making our tour possible.

What, if anything, then, has changed in the world of filmic travelogues since 1906? In the era marked by the suffix *post-*, some (gender) mappings have

3.11. Moving beyond mapping *Until the End of the World* (Wim Wenders, 1991). Frame enlargement.

changed. In 1991, the voyager is decidedly female. This is the tale of a *voyageuse* who is chasing a man "until the end of the world." Claire is no police(wo)man. She is only curious to discover the identity of the mysterious man she has spotted at a public phone in a shopping mall. The two will eventually end up handcuffed, but only to a bed. This is a saga of heterosexual, amorous "transport." The travelogue is designed as a *Carte de Tendre*.

Claire's adventurous affair appropriately begins in Venice, at a decadent fin-de-siècle Italian party. Fashionably dressed, she is dazed and confused but determined to drive herself back to Paris. Of course, the road always provides new directions. "The chronotope of the road," as Mikhail Bakhtin has noted, "is both a point of new departures and a place for events to find their denouement."[95] This is a road to the end of the millennium. When an impending nuclear disaster drives everyone to leave on the same road, Claire, impatient as ever, decides to take a detour and thereby changes the direction of her life. The trajectory of this other road is not marked. We are off-limits. Claire has reached the "end of the map zone" according to the warning that appears on the computer screen that pilots her car. Claire dismisses the warning and moves on, only to find herself beyond the "end of the map zone."

A cartographic anxiety drives this filmic travelogue. In the postcolonial master narrative, mapping flirts dangerously with surveillance. Foreshadowing the expansion of the Global Positioning System, *Until the End of the World* presents cars that are driven "virtually," directed by computerized maps that are incorporated into the mechanisms of driving. A version of "cognitive mapping" has here turned into "mental piloting," imposing a limit to cartographic inventiveness.[96] The chase in the film is further enacted as an exercise in mapping. Expensive computer technology is involved in locating the man on the run. But the digital technology that makes it possible to locate the subject also leads to control over the citizen, for it is possible to know where he or she is at all times, in all places. The film comments ironically on such questions of control through the very design of technology. The Eastern-bloc computer used in locating people has a software program worthy of

the artist-team Komar and Melamid: a Russian bear appears on the screen and keeps "searching, searching." Virtual cartography becomes a parodic, hyperrealist version of a socialist-realist witch hunt.

Whether ironically or dramatically, *Until the End of the World* is engaged in discovering, locating, and mapping subjects in space. Such an obsession with searching and finding both reveals and covers a fear of being lost. In this sense, the film exhibits a cartographic impulse that is not only a matter of control and surveillance but a symptom of current mobile mappings of (dis)location. It is about where we are in border crossing. Set at the end of the millennium, *Until the End of the World* touches on the present day effects of deterritorialization and the potential for remapping both the world and the self.

As Claire goes off "beyond the map zone," she reaches her own *terra incognita*. As in the *Carte de Tendre*, by traveling "The Dangerous Sea" one reaches "Countries Undiscovered." The chase eventually takes her into a form of interior voyage—a voyage of the room—as she enters the home of pictures and voyages in the house of images. Here, the chase interestingly comes to a halt. The mysterious man Claire is chasing is not really an adventurer. He is not even a real departure from her devoted Parisian partner. He turns out to be a rather boring, nice man who is essentially involved in a domestic journey, albeit one with an Oedipal twist: he is trying, via a new technology developed by his father, to provide vision for his blind mother. Claire follows him through this voyage of visual discovery and ends up trapped by her own dreams. Absorbed by image technology, she travels the immobile journey of recollection. The future dreams the past here as virtual reality becomes a psychoanalytic journey *à rebours*, a literal means of rewinding, a tool for projecting on a screen scenes from one's own life voyage. A movie map. Here, cartographic anxiety is transferred to a scene of lived space that remaps fragments of the past.

Memory, imaging, mapping. *Until the End of the World* envisions postcolonial (dis)location as "cognitive mapping" gone astray. Weaving together alternative ways of relocation in the face of cartographic mutation, this 1991 travelogue remakes an itinerary sketched all the way back in 1906. While the space of *A Policeman's Tour of the World* was tainted by colonialist visions of domination, this film tackles movement at the very "end of the map zone," beyond mapping. Here one is always traveling and yet back home, in that house of images: the home of moving pictures, the "movie" house that is a movie *house*.

4.1. Self-portrait
of Esther Lyons,
travel lecturer, 1897.
Black-and-white
photograph.

4.2. School of
Fontainebleau, *Lady
at Her Toilette*,
c. 1550. Oil on wood.

4 Fashioning Travel Space

The delicate feeling of decency . . . forbids a woman to be the author of her self-portrait.
Henriette D'Angeville, *Mon Excursion au Mont-Blanc*, 1839

Fascinated by female curiosity, . . . I could not withdraw myself.
Anna Maria Falconbridge, *Narrative of Two Voyages to Sierra Leone*, 1802

As we have shown, "to travel is like filming": traveling cultures are the generative terrain of the cinema.[1] To unravel further aspects of this cultural history, a theoretical and historical voyage of site-seeing becomes methodologically necessary. We thus embark on a transhistorical exploration of film's genealogy, seeking to expose the geographical penchant of the motion picture and to map its topographical views. As we "track" down the relationship between film and the voyage of dwelling in time-space, several viewpoints emerge that link the film spectator to other "passengers." We first turn to the subject of travel lectures and investigate their relation to the origin of film with respect to a fashioning of space. It is a route that passes by the self-made design of the modern *voyageuse*. Looking at the genealogic "makeup" of travel space, we encounter the female travel lecturer. Let us stop to wonder at her representational "apparel" and "accoutrements."

MEET ESTHER LYONS, TRAVEL LECTURER

In a strict historical sense, film and travel met physically at the turn of the century on the set of the travel lecture. First accompanied by lantern slides, travel lectures later incorporated motion pictures into their display, furthering the parallel between travel and the moving image as they first propelled and then absorbed the travel genre. It was not by chance that these spectacles would merge, for the travel lecture itself was a form of simulated travel for its spectators—a virtual journey.

Charles Musser reminds us that the illustrated travel lecture constituted a "large fraternity. . . . Stereopticon lecturers (as well as photographers) were overwhelmingly men and represented the world as they saw and understood it."[2] But there were exceptions: female travel lecturers negotiated a place in the "fraternity," thus joining female pioneers of film exhibition and production. They also joined women such as Delia Akeley, Mary Jobe Akeley, and Osa Johnson, who played a role in establishing the tradition of the explorer-as-documentarist and helped to initiate ethnographic cinema, a field of study illuminated by Fatimah Tobing Rony and others.[3] Women furthermore participated in the business of travel lecturing as spectators. They were present not only physically, as part of the audience, but also as

spectators-in-the-text. Travel lectures were constructed as a spectatorial address to both the female and male public. Only apparently nonerotic, the subjects of the travel lectures—mostly landscapes and scenes depicting the local customs of the sites—nonetheless had a definite appeal. Women were driven to travel with and through them.

What was carrying them through these images, and away? Was it an "erotics of knowledge"—a spatial curiosity?[4] And what of the drive to possession and domination? As a way to address these issues, let us turn to one of the exceptions in the "fraternity" of travel lecturers: a woman named Esther Lyons. In 1897–98, Lyons gave four sets of lectures at the Brooklyn Institute of Arts and Science, one of the most important cultural institutions in North America at the time.[5] The Institute was home to eminent members of the "fraternity," including John Stoddard, Alexander Black, and E. Burton Holmes. "Miss" Esther Lyons, billed as "the first white woman to cross Chilkoot Pass," entered the visual discourse on exploration by lecturing on Alaska. Her talk was illustrated with nearly one hundred and fifty colored lantern photos. Lyons "fashioned" travel lectures in her own way: by impersonating the traveler. During the course of a lecture she would change into her Klondike costume and demonstrate how to pan for gold.

Fortunately, a record of Esther Lyons's travel lectures remains. Like Stoddard and others, Lyons published a book of travel photographs: *Esther Lyons' Glimpses of Alaska: A Collection of Views of the Interior of Alaska and the Klondike District*, printed in 1897.[6] Like her performance, the "collection of views" Lyons compiled bears a mark of distinction, a specific "view" that makes an intriguing authorial imprint. A large picture of Esther introduces—indeed, towers over—the beginning of the sequence of travel pictures. Miss Lyons literally inscribed herself into her travel, and did so in a peculiar way. The self-portrait has an unorthodox edge that provocatively tells us something about the act of "fashioning" (one's) space.

PICTURING (ONE'S) SPACE

The photographic portrait presents the beholder with a representation: it is a way of fashioning the self and, as such, follows a long pictorial tradition. As a form of picturing, the portrait has a strong physiognomic impact. It is a representation in which signs are sketched and read on skin, decor, and clothing. A portrait holds the corporeal imprint of the persona that it draws and redrafts, or that it photographically "designs" for viewing. In a way, the portrait presents a "map" of character. It makes a chart of the flesh. The self-portrait is a self-made map—a self made into a map.

Lyons's self-portrait offers intriguing access to such a self-made map, for here, the female explorer not only pictures a map of her self but charts a terrain for herself. As a prologue to the montage of landscape views, Lyons represents herself looking into a mirror. Her image is clearly reflected in the glass and faces the viewer. We are made to look at her looking at herself. However, she is not only staring at

her own image. She appears to be catching herself "in action": Esther is applying makeup around her eyes.

What are we to make of this making-up? Lyons, one of the few female travel lecturers, exhibits herself preparing for her public appearance, doing her makeup. What kind of explorer's action is this application of cosmetics? Is Lyons showing us that she is "wearing the mask of femininity" of many of her peers, pioneer cultural explorers who donned that mask in order to enter a male-defined field?[7] Are we to claim—as a nod to cinema (heir of the travel lecture) and a wink at its meta-discourse—that "the first white woman to cross Chilkoot Pass" is caught in an act of womanly "masquerade"?[8]

As we approach the design of this self-portrait in terms of a "cosmetics," we begin to see that the mirror image has traveled from the travel lecture to film in a number of ways. It has become a "fashion" for picturing female characters and especially for creating self-portraits of avant-garde women filmmakers. From the mirrored self-image in Germaine Dulac's *The Smiling Madame Beudet* (1923) to Maya Deren's *Meshes of the Afternoon* (1943), in which the filmmaker herself appears in a split mirror image, to Sally Potter's *Thriller* (1979), this representation appears repeatedly in women's cinema as a site of self-imaging, where it is set in the home—the woman's house of fiction. *Thriller* insistently shows a woman staring at herself in front of a mirror. She waits for clues as she searches her own image, inquiring about her narrative space. In this self-analytic film, the self-portrait, examined in its formal rendering, appears as the very object of filmic exploration. Potter pushes this mirroring of the self a step further in *The Tango Lesson* (1997), that courageous game of autobiographical fiction that turns the spectator into the reader of a diary, with Potter herself as the fictional protagonist. This nuanced text takes us along the intimate path of a self-exploration. Here, the screen itself ends up functioning as a moving mirror—a surface on which the director-actress fictionally projects herself as the other.

A narrative citation to the Lacanian mirror stage, the mirrored self-image is noted here in order to reflect further on the nature of that "reflection." The discourse on this significant image—a generative matrix of filmic identification—generally fixes on the gaze. Moving beyond theories of the masquerade and the gaze, and their relations, we must acknowledge that it is, above all, a picturing of space. The identification of the self with its own reflection, or its wearing of gender as a mask, is not merely a visual issue. What is missing is the "scene" of the gaze; the fact, that is, that self-identification is a *spatial* affair—a narrative drama set in intersubjective space and enacted on a *corps morcelé*, an imagined anatomy. Identity makes body tours. Placed within the scene, exploration and imaging become linked, beyond the gaze, on the very *topography* of the body. In this sense, the mirror stage is a space, a screen, on which identity is constantly negotiated.

Michel Foucault's observations on the mirror in the context of his essay on "other spaces" further this spatial reading and lead us to a haptic understanding of this topos. A joint, mixed experience, set between utopia and heterotopia, the mirror is read as a site of self-representation, a space of constant displacements:

The mirror is . . . a placeless place. In the mirror, I see myself where I am not, in an unreal, virtual space that opens up behind the surface; I am over there, there where I am not, a sort of shadow that gives my own visibility to myself; that enables me to see myself where I am absent. . . . The mirror . . . exerts a sort of counteraction on the position that I occupy. . . . Starting from this gaze that is, as it were, directed toward me, from the ground of this virtual space . . . I come back toward myself.[9]

A "placeless place," the mirror is a site without a geography that enables one to locate oneself via a series of displacements. A mirror makes it apparent that the eye has a location, is positioned in the body. Because of this "positioning" and the orientation of our gaze, we are unable to see ourselves other than as reflection. To thrust a self-analytic gaze upon itself, the body needs a place. The mirror-screen thus becomes the site of the subject's own visibility and self-projection, a dwelling place of the self in virtual space. As the vehicle of self-exploration, the mirror—a filmic site—is the starting point of a spatiovisual diary, for it houses the tours and detours of identity.

The picture of Esther Lyons participates in this intertextual dynamics of imaginary mapping. This portrait of an explorer gazing into space as she looks at herself is inscribed in an entire history of visual representations, a chain of filmic imaging of female subjects' explorations. Insofar as travel lectures historically lead to the virtual space of the cinema, they proleptically contain representational traces of the future, dreaming up film's imaginative spatial contours. Film has incorporated the representational drive and the "spatial unconscious" of travel culture, with its visible dislocations.

The image of Esther Lyons speaks to the cinema not only because travel lectures lie at the very foundation of film, but also because the construction of the female subject is inscribed along their spatiocorporeal path. From Lyons's self-portrait to Potter's *Thriller* and *The Tango Lesson*, the mirror-screen image bespeaks a trajectory—the search for fashioning the self in, and as, space. This movement is not necessarily an actual physical itinerary. It does not involve roaming through "foreign lands" but rather rambling close to home, or in-house; and this can turn out to be quite foreign or estranged. The voyage of the self is inscribed in a topography that knows the seductive flux of claustrophilia. Such motion can happen as one stands still, in front of a mirror, in one room. As filmic traveling itself makes clear, some of the best traveling occurs when one is motionless in a spectator's chair. *Transito* takes place in a house of mirrors—a house that moves.

INTERIOR EXPLORATIONS

The portrait of Esther Lyons, an explorer who chose to picture herself in an interior, speaks of inner exploration as it points to the expansion of female horizons. A traveler seated across from the landscape of her own image, Lyons was a peculiar nomad. As Rosi Braidotti points out, to move away from hegemonic and dominant practices is itself a form of nomadism: "it is the subversion of set conventions that

defines the nomadic state, not the literal act of traveling."[10] Esther Lyons was a woman who subverted a number of set conventions, not only because she broke the status quo of the "fraternity" by traveling and lecturing, but also because of the unconventional way she represented herself: as an explorer who sits still, in front of a mirror. As psychogeography, this "reflective" imaging conveys an expansion of space while suggesting an opening to interior space. Lyons's portrait tells us that as an immobile spectator sitting before a mirror-screen, every woman in the film theater is an "explorer."

Lyons's reflective image projects a position that permeates the texts of the majority of women travelers and explorers. The self-portrait of "the first white woman to cross Chilkoot Pass" is not an isolated case of authorial exposure. It acquires a particular shade of meaning when read in conjunction with the long-ignored or marginalized literature of travel writing, recently rediscovered in studies that deal with the role of women in the (un)doing of imperial visions. As the work of Mary Louise Pratt, Sara Mills, Alison Blunt, and others has shown, travel writing offers insights into the gendered space of transculturation and raises questions about the issue of self-representation.[11] This discourse must be carefully considered, for it exhibits the many nuances of cultural transit and gender formation. The representations generated by Lyons and other privileged Caucasian women occupied a space in the imperialist discourse marked by a set of complex relations. Participating in this discourse, they were nonetheless disruptive of its gender conventions.

A microhistorical specimen in a larger epistemological paradigm, the case of Esther Lyons acts as a vehicle for exploring the cartographies of the female subject. It is uncovered to call attention to such cultural mappings and to show that—on the grounds of gender and space—film interacts not only with architecture, as we demonstrated earlier, but also with geography—a phenomenon we have begun to address with respect to architecture. Rethinking film language as an agent in the construction and traversal of space and sexuality means aligning the moving image with other spatial practices that build the architectonics of gender. In the design of our "cartography," feminist film theory shares terrain with architectural theory as well as cultural geography, whose recent interest in gender and space has reshaped traditional fields of inquiry and, with the intervention of Doreen Massey and others, has opened them to social space.[12] A dialogue that connects these disciplinary fields is essential for expanding our understanding of gender, space, and their various configurations, of which the *geography of film* itself is an important component.

ADVENTUROUS SUBJECTS

The scenes and adventures of which Mrs. Morrell was a witness were highly interesting in their nature, and . . . will be read with pleasure especially by readers of her own sex.
Advertisement for Abby Jane Morrell's *Narrative of a Voyage,* 1833

With the geography of film in mind, let us return to travel culture as a terrain for the affirmation of public and private spaces for women. A close inquiry reveals that not only did more women travel than is usually acknowledged but that, by the time of the Cook tours, women even outnumbered men.[13] Even early on, women wrote extensively about their travels and presented in their work all the complexities of race and gender representation. The literature of the nineteenth century, however, bespeaks the difficulties of forming a female subject of discourse in the colonial world. The writing shows the struggle to acquire both a public role and a privacy of vision. Although allowed to express themselves in private forms of writing such as autobiography or diary, women were constrained by protocol that dictated what could be exposed and revealed, and how it should be done. Travel writing involved working within and against these rules. Entering the public role of traveler was not a given, especially because of restrictions that applied to forms of self-representation. The role of adventurer was not considered fully appropriate for a female, who as a writer could not refer to herself in relation to many adventurous subjects.

Sexuality was among such adventurous topics. Sexual language, the sexualization of topography, the gendering of landscape, and sexual readings of the act of travel itself—topics that inform male travel literature—are not prominent in the female writing. Sexuality had to be made an invisible topic and existed in the guise of its absence. Even for privileged Caucasian women travelers and writers, the exit from "home" was not a simple one, for beyond the physical act of leaving one's own home country, it was difficult to exit "domestic" gender conventions.

The struggle with self-representation lies at the core of many travel reports. There is an insistence on the personal and the subjective—*my* travel, *my* voyage, *my* excursion—in the titles and texts of women's books. This very insistence shows that self-representation was a site of tension. As Bénédicte Monicat writes, "while women's autobiographical writing was taboo . . . it appears to be the generating point of women's travel literature. . . . Women must not only justify the fact that they left 'the home' but also the fact that they wrote in constant relation with the fact that they are women."[14]

Although the genre necessarily implied writing from life, a woman could not let her life be seen by entirely revealing or exhibiting herself in public (writing). Positioned as it was on the threshold of the private and public realms, travel writing thus worked on self-representation through a complexity of voices, including autobiography, that reveal the hardship of self-definition. Autobiography was a difficult space, for, although the writing was dictated by very personal stories—even exceptional life experiences—the subjective style, too, was regulated by conventions. In order to affirm themselves as subjects of discourse, female travel writers had to transcend the subjective, however it valorized them as female subjects, and assume a scientific mode of discourse. Travel writing used a mixed language that combined scientific and autobiographical discourses. Negotiated between the two positions, it was, ultimately, a hybrid language.

HYBRID SPACES

Reflecting further on this hybridity, we return to the cinema—a hybrid language of its own. As a product of modernity, the filmic language is bound up with the particular practice in travel discourse of mixing scientific and personal registers. As an heir to travel culture, the motion picture is a spatial language which, like travel writing, intersects these diverse modes of discourse. As a travel report, the cinema is both a scientific and a philosophical tool of (self) representation. Understood as a hybrid space, the link between film and travel thus can be read as not only historical but representational. That is, the cinema is an offspring of modern travel culture in yet another way because it is discursively bound up with its hybridity.

An important aspect of this genealogical link is the architectonic component. A technology of amusement—a mixed language of spectacularly wide range— cinema inherits from the travel lecture the socio-cultural function of providing spectators with a psychic voyage in and through space. Architecture acts as the motor force of this imaginative flight. Not only were travel lectures illustrated by images of sites, first as lantern slides and then as movies; the sites themselves were often architecturally reconstructed to be experienced in spatial form by the audience. This, for instance, is how Albert Smith set up his panorama lectures at the London Museum, which was built in Egyptian style and thus known as the Egyptian Hall.[15] From 1852 to 1858, Smith presented his version of "The Ascent of Mont Blanc" as a real mise-en-scène, where spectators were introduced to the panorama in a simulated Swiss space. The interior was transformed into an exterior for the pleasure of the public-traveler. The room was converted into a plot of Swiss land featuring an

Alpine lake and flowers and such architectural embodiment of the Swiss national culture as a chalet. The lecturer entered the simulated room from a door of the chalet and began his performance by addressing the large number of women and men who had come to be "transported" by the show. It was cinema before the movies. It comes as no surprise that the Egyptian Hall became a film theater in 1896.[16] By the same traveling architectural logic, movie palaces would later incorporate the architectonics of voyage into their "atmospheric" design, creating a panoply of geographic sites, making interiors shaped as exteriors, becoming an elsewhere now here. As it followed the traveling track from museum-going to travel lecture to film, the public experienced a moving architecture. The exhibition space, which housed several forms of traveling curiosities, gave way to another geopsychic architecture of travel in the hybrid space of the movie "house"—a house that *moved*.

HYBRID SUBJECTS

The hybrid, spatial form of writing shared by film and travel reveals interesting correlations when viewed from the perspective of the female subject and her spatial curiosity. Sightseeing is a critical point of friction in travel culture, where—just as in the cinema—sight is inextricably linked to a practice of space and a definition of gender. In male travel rhetoric, the drive for spatial knowledge is expressed, in general, through the power of the look and often implies possession. The product of an all-encompassing eye, sightseeing is perceived as a male activity, despite the historical participation of women. As we have seen in women's travel writing, sightseeing for the female involved a struggle to "look" differently. As a difficult space of gender negotiation, it concerned both the expression of female curiosity and the form of its object: that is, the shape of the space traversed by the traveler. Women who wrote early on about sightseeing often exercised self-censorship in treating the powers and pleasures of this activity. They seemed to know that, no matter how far they had gone, they should not be caught looking. The enjoyment of connecting spatial practice with one's own viewpoint thus became the very "conquest" of women's travel.

This paradigm is interestingly echoed in that other form of transcultural imaging and spatiality, the motion picture. In film as in travel discourse, gazing into space is a pleasure and power that implies negotiating gender boundaries. Ultimately, cinematic language and spectatorship show similar tensions around the representation and gendering of site-seeing. One aspect of this link concerns the gender politics of cultural location. Like the cinema, the travel genre, as we have noted, is located at the intersection of the private and public realms. Historically, travel gave many women the opportunity to assume a public role through the publication of their private letters, diaries, and memoirs. The genre, even when approached by professional writers, always shows a mixture of intimate and public languages. Like the language of film, it allows for the exploration—and the "exhibition"—of private emotions and subjective viewpoints while positioning itself fully in the public arena.

This was true for North-American women, a number of whom were given an opportunity to escape their domesticity and enter public space through travel and

writing, a role they may not have been able to occupy otherwise. About two hundred travel books by American women were published before 1900, the majority of which offered accounts of travel to Europe.[17] These opportunities were open mostly to affluent Caucasian women but were extremely limited for African-Americans, for whom domesticity was still strongly equated with serving as a "domestic" and for whom travel, given their distinct diasporic history, bore different connotations.[18] Breaking out of the domestic horizon to enjoy public circulation was the product of a complex historical trajectory, which involved liberating travel itself from its own chains.

To the relatively small number of privileged Caucasian women involved in travel, one must add the growing female reading public. Women who could not travel craved the kind of freedom it represented and attempted to get it vicariously. It is reported that in the late 1840s, fifteen per cent of the books charged out to women from the New York Society Library were on travel.[19] For the female subject, the struggle to map herself into the space of public circulation was not only a question of authorship but of readership. As an issue of reception, the struggle involved traveling the sphere of consumption and participating in commodity circulation. Again, it was a matter of consuming—that is, absorbing—(travel) imaging.

Anticipating the film public, the reading public was made up of female travelers at home. On the eve of the invention of cinema, consuming travel writing and attending travel lectures offered women the pleasure of movement while seated motionless in a chair. These practices proleptically created the spectatorial chair of the film theater—a position from which female viewers traveled geopsychically. As much as shopping and urban *flânerie*, reading travel books, attending travel lectures, and, ultimately, going to the cinema progressively mobilized women still confined to the domestic sphere. This geography, although marked by open doors, was not, however, an open space: as we have shown, the anxiety of self-definition and self-inscription was written in many ways in women's voyages.

MY VOYAGE

Against this background, we can read further into the picture that Esther Lyons, our "lady traveler" and travel lecturer, published in her book of photographs. Lyons's self-portrait must be understood in the context of the gender, class, and racial tensions that accrued to the experience of mobility; that is, vis-à-vis the various tensions exhibited in travel discourse around the idea of female self-definition in transculturation. Her self-portrait makes a statement by revealing subjectivity and "femininity" and by juxtaposing this style of self-representation with a much more neutral, objective, style of photographing the land. The series of photographed landscapes that follow her self-portrait impart a decidedly distanced outlook. The pictures are almost always constructed as long shots of the land and are devoid of people. In contrast to the subjective viewpoint of her self-portrait, the landscapes aspire to a plain,

"scientific" matter-of-factness. The spatiovisual sequence of images causes Lyons's close-up to stand out in relief. This was *her* voyage.

Lyons's text is edited according to that hybrid mix of scientific and autobiographical registers which engineers, in travel culture, the potential for the subjective affirmation of the female subject. She does not feminize the land, as many male writers did, but hyper-feminizes herself in order to become the subject and author of a voyage into space. Lyons was privileged enough to be able to break a few societal rules by being an explorer and a lecturer, but, most of all, she broke the rules of decency that forbade a woman to be the author of her own self-portrait. She put herself in the picture—and remained the only character of the story.

FASHIONS OF THE FLESH

By putting herself into the picture, Lyons had already touched on an adventurous subject. She further transgressed by revealing too much of herself, and too much of her body. Sexuality, the taboo discourse, is written in her self-representation. The self reflected in the mirror is an eroticized body. Quite a peculiar way to show herself in action and portray herself in the field. What exactly, one wonders, is her field? Pleasure is what first comes to mind as one surveys her carnal display.

Lyons's pose—her set-up—reveals a painterly "touch." The explorer of the interior enters the lush art historical terrain of women's portraiture. Her image is inscribed in a long iconographic tradition in which women are shown in their interiors, leisurely making themselves up. Think of the erotics that seep through the nude portrait with a cape executed by the School of Fontainebleau in its portrayal of a *Lady at Her Toilette* (c. 1550). She returns a mirror image of herself as she makes herself up, fingering ornaments. A draped nude also faces the mirror that constructs her image in Giovanni Bellini's *Young Woman at Her Toilet* (1515). Lyons, the explorer, joins the many eroticized portraits of women doing their *toilette* and furthering their touch in the cosmetics of self-imaging.

The ambiance reads "dressing room." A decorated mirror and an ornate chair make up the set. Fashion and cosmetics are positively claimed as part of Lyons's image as world traveler. As she makes herself up, her body leans forward, accentuating the shape of her corseted figure. She wears a dress wrapped tightly around her. Her cleavage is adorned by a plumed décolletage. A feathered shawl lies on the carpet and lush textiles hang from the chair.

This dressing up is not exactly the image of geographical discovery one might expect in the portrait of an explorer—here, also, the book's author. It is an unconventionally "fashionable" authorial gesture that aligns Esther Lyons with the many other women for whom the possession of representational territories, including one's own image, was at stake. Like the makeup Lyons shows herself applying, this is the authorial "touch" by which the woman leaves her mark. She leaves her imprint on the landscape of the book and, with a touch of gender, pictures herself in.

PENETRATING THE INTERIOR

The eroticized self-portrait is accompanied by a caption that "illustrates" the picture. This, we are told, is "Miss Esther Lyons, an American girl, the first white woman to cross the Chilkoot Pass and penetrate the Interior of Alaska." The caption clearly illuminates the interplay of racial and gender issues as an important component in the discourse of exploration.[20] "Miss" Lyons is first of all defined as a single woman, and the sexual identity of the explorer is linked with national and racial traits. Although the body in the picture clearly reads Caucasian and female, the language of the caption doubles the message of the iconic sign. Sexual and racial codes work together in making the narrative of exploration, since the act of territorial exploration is sexually connoted: the ground is "penetrated" and furthermore described as an "interior." The words express the violence of the act of "discovery" in sexual terms and describe the subject/object of the act in racial terms. Although the pictures she compiled of Alaska do not sexualize the land, the caption Lyons uses to describe herself feminizes the region and thus participates in a fashion of travel discourse that inscribes codes of domination into the power relations between the sexes. Here, however, the subject of this genital sexualization, which is usually male, is female. This raises questions. Is Lyons masquerading as a male subject? Is she "performing" gender, assuming the role of transvestite? Or is she, a woman, describing the object of the conquest as a female body; that is, depicting the land as if it were her own body—a penetrable interior. Was this interior desired, possessed, violated? Or was it holding, enveloping, embracing? However we read this socio-sexual narrative in the interplay of subject/object identification, the problem of self-definition remains. Another anxiety of authorship is revealed, from this perspective, in Lyons's compilation of *her* views.[21] Miss Lyons, as the first woman to explore Alaska, does not know how to describe this act in her own way, in a register other than the dominant, white, heterosexual language of colonial discourse. As her self-portrait makes clear, she needed to discover something else along with the land she traversed. There was a *terra incognita* to be remapped with different racial and sexual codes. Perhaps this is why she turned to her interior for her own exploration.

Although Miss Lyons, as most Caucasian women travelers, appears to speak the language of the male traveler, it does not bear the implications of the language of her male counterparts. Discovery for the female traveler, who struggled to assert herself on the margins of imperial culture, was not necessarily an act of conquest; or, rather, it implied a different idea of conquering. As Mary Louise Pratt puts it: "If the man's job was to collect and possess everything else, these women travelers sought first and foremost to collect and possess themselves."[22] Our sexy female voyager represents herself looking into the mirror, gazing into space, in the act of conquering no other territory but her own (image). She is traveling a seductive and complex terrain: the map of her own face and body.

4.4. Travel fashions: a modern *voyageuse* "ready-made" for air travel.

TRAVEL FASHIONS

It is important to stress that this form of travel and conquest occurs by way of fashion and cosmetics. Mastering the territory of one's body is an actual act of exploration and includes playing with the skin's texture. Ultimately, this is the view designated by Lyons's own cosmetic map and framed in her picture. Her signature self-portrait, her "touch," opens a haptic view: making oneself over is a palpable gesture; applying makeup is a matter of an extended painterly touch. Cosmetics is a tactile refiguring, part of the haptic picturing that Lyons's brush paints, inviting us to explore this picturing further in terms of fashion.

Apparel, itself a haptic image, works as a mobile frame and plays the surface—the edge of one's interior and exterior—in the picturing of self. As Georg Simmel wrote in 1904 at the onset of film: "Fashion . . . is a product of class distinction and operates . . . just as the frame of a picture [which] characterizes the work of art inwardly . . . and at the same time outwardly."[23] For Simmel, "the power of the moving form which fashion lives . . . may be compared with the unequal relation that the objects of external perception bear to the possibility of being transformed into works of art."[24] Fashion, like motion pictures, lives on the power of the moving form and "depends upon the loss of sensibility to nervous incitements."[25] Fashion works, as film does, to frame and map the appearance of the body, redefining its sensibility and energetic borders.

Sartorial views encompass a range of functions, from picturing class to framing gender. In this respect, fashion plays a particularly important role in women's history. Outlining this situation against the landscape of modernity, Simmel wrote that "the history of woman in the outer as well as inner life, individually as well as collectively . . . [shows] that she requires a more lively activity at least in the

sphere of fashion, in order to add an attraction to herself and her life for her own feeling."[26] Simmel's overall view offers us a suggestive starting point for rethinking fashion in the realm of *emotion*. His assertions, however, stop short, for he affirms the emotional, liminal power of fashion but ultimately locks it into a form of compensation. In contrast to this notion of compensation, fashion, as Roland Barthes has insisted, might be more productively considered as a cultural affair and thus as a terrain for negotiation and a shift in socio-sexual roles.[27] It involves the making of style, for, as Elizabeth Wilson and others have demonstrated, fashion plays a role in redefining the social sphere, city life, popular culture, and gender performance.[28] Furthermore, fashion contains its own cultural history: as a form of representation, it is close to art for its conscious concern with the personal, physical habits and social processes of its time.[29]

Cinema plays a crucial role as agent in this scenography, beyond the mere observation that fashion is used in film. The sartorial performance that engages fashion and cinema, however, is a terrain that has received little scholarly attention, although Jane Gaines and others have made headway by looking at the fabrication of costumes and the female body.[30] Moving beyond the level of film costume to explore further the interaction between fashion and cinema, it is significant to note that the Latin root of fashion—*factio*—refers to the act of making. The intersection of film-"making" with this other form of making informs the concept of the "fashioning" of space, as well as the psychogeographic routes that are built and traversed in the construction of site-seeing.

In the making of space, *factio* joins up with the discourse of architecture. Investigating the relationship between fashion and architecture, Mary McLeod points out that, "as the history of fashion and modern architecture reveals, appearances *are* profoundly important to both modernity and gender."[31] Mark Wigley argues that modern architecture is tied to fashion in its very constituent elements, as he shows how the mid-nineteenth century theories of Gottfried Semper, who conceived of the wall as cloth, filtered into modern architecture's transformation of the status of the surface.[32] Speaking of modern architecture as dress design, Wigley claims that "architecture literally clothes the body politic. . . . The social subject, like the body with which it is associated, is a production of decorative surface."[33] Fashion ties architecture to the body metonymically, since clothing lies between the body and building. It informs architecture, for architecture itself is dressed, designed, and engaged with ornament and the lack thereof to such an extent that, in modern times, it has become an art of clothing. On the threshold of interior and exterior, fashion and architecture—and we can add, cinema—make private and social space, reversibly fashioning the body.

In order to advance this relation of *factio* to filmic "making" and to pursue cinematic texture as a *fabric*ation, it is vital to consider that fashion is an agent in the developing history of visual culture, of which modern architecture itself is an essential component. "If following Semper, to occupy a building is to wear it, then to wear a modern building is to wear a new set of eyes."[34] It is in this respect that

fashion and architecture intersect with the cinema, for they are all engaged in the making of visual space, which involves a new habitation of the self. Fashion, itself a sequential production of images like the cinema, should be thought of as a movement. Sharing the fabric of the filmic moving image, the fashion image is an imaginative construct that documents a material historicity. As such, it moves along with its subject (as well as that subject's picturing), traversing history and relocating geography. Fashion is motion. Perceived as a passing trend, it is indeed a fleeting image—a screen. In all its manifestations as passage, design approaches the terrain of the moving image. Insofar as it is a cultural movement, fashion partakes in the (e)motion that constructs and circulates the moving image and its geopsychic space. Sartorial views move as, and in relation to, traveling images—e*motion* pictures.

In the age of modernity, as motion came to define modern life, the female public's interest in fashion propelled interconnected trends of socio-sexual movement. Esther Lyons was not alone in her concern with appearance; that is, with the surface of the skin. Women in the age of modernity—the age of travel—ventured into department stores as much as they sought travel adventures and, eventually, the moving image, whose appearance is the very skin of events. On the way to becoming authors of their own image, women attended travel lectures and consumed a number of other precinematic spectacles, which are explored in subsequent chapters. Engravings that depict the audiences of these predecessors to film, which include magic lanterns, phantasmagorias, and other "geovisual" spectacles, always show a public of women fascinated—absorbed—by the elusive surface.

In women's travel discourse, travel and fashion are intimately connected. Like the cinema, they are ways of absorbing, or incorporating, culture as an imaginative, moving place. Many women writers were particularly inclined to visualize the spaces that surrounded them, giving attention to the interior as well as the exterior. Traveling in their writing through cultural difference often meant "fashioning" a localized knowledge. This included observing local habits, taking in the architectural interiors and sartorial customs of the place, and "picturing" it in their writing.[35] Female curiosity induced the voyager to take particular notice of the different fashions in vogue in the countries she visited and to comment on them as important signs of difference, surface evidence of cultural diversity. Social and ethnic difference is a complex negotiation of gender, written (designed) on the body of fashion.

This was the case for Lady Mary Wortley Montagu (1689–1762), a poet who befriended Joseph Addison and Alexander Pope, well-known figures in the emerging picturesque imagination who shaped its aesthetic definition. Traveling to Constantinople for leisure, Montagu wrote in distinctively visual terms about her transgression of wearing Turkish robes, playing out by way of fashion a fantasy about achieving more sexual and class freedom. In 1717, she pictured her sartorial gender performance to her sister, to whom she wrote of travel writing itself as a way of picturing. As she put it, "I intend to send you my picture; in the meantime accept of it here."[36] This is how she describes the Turkish attire she wished to adopt:

You may guess how effectively this disguises them, that there is no distinguishing the great lady from her slave, and 'tis impossible for the most jealous husband to know his wife when he meets her, and no man dare either to touch or follow a woman in the street.

This perpetual masquerade gives them entire liberty of following their inclinations without danger of discovery.[37]

Multiple "projections" of masquerade shaped the travel writing of this *voyageuse*, possibly the first woman to travel out of simple curiosity. In an album of views and a transgressive sartorial performance, a new self was being "fashioned."

In travel discourse, commentary on fashion was attentive to the (dis)placement of attire. In this sense, travel costumes, and the trunks used to house and transport them, became a great concern for the *voyageuse*. By the nineteenth-century, travel and fashion had joined in fabricating the new ways of modern women. Like the trunks that contain them, clothes work by way of continual absorption. They contain images and the imagistic potential for circulation and transformation—that is, for traveling. As they began to engage in the practice of travel, women confronted the makings of a new, transient subjectivity, one that needed a new form, shape, and "container."

An interesting commentary on this subject is found in the writings of Elizabeth Cochrane Seaman, better known as Nellie Bly. A woman who incarnated modernity's interest in speed (she went around the world in 1889 to challenge the speed record set by Jules Verne's fiction), Nellie Bly opens her book by addressing the subject of travel fashions.[38] She devotes the first chapter to the challenge of dressing, providing an account of her shopping activities, her search for dressmakers who

4.6. Fashioning space: Nellie Bly "suited" for an around-the-world tour in 1889, with one dress and a compact suitcase.

would understand her traveling needs, and the packing of her suitcase. She discusses in detail the anxiety involved in making up a minimal yet all-encompassing bag. A number of sartorial concerns follow in the book as Bly provides us with an extensive observation of the fashions and makeup customs of the cultures she encounters en route. More than anything, Bly is interested in fashioning a new cultural cosmetics. She ends up going around the world in one dress, showing us how the modern woman's new, mobile identity is to be differently fit and suited—fashionably self-designed.

Like a physiognomy, with its corporeal play of surface (in)visibility, the fashioning of body space has its transformative coding, which articulates a language of gender, class, and race. Adorning one's body has traditionally been the terrain of gender and socio-ethnic transformation; that is, it is both a display area and a traveling site in the negotiation for possession and control of one's own body image and its shifting grounds. The turn of the century gave a new twist to this interplay as women "fashioned" their own views. Fashion played a crucial role in modernity, for, among other forms of spatiocorporeal absorption and ways of representational attraction (such as the cinema), it enabled women to enter the modern age; modernity, via fashion and its own site-seeing, transformed cultural mapping. A new road was traveled by modern women, who fashioned modern spaces. Like the shopper, the female traveler participated in this voyage—modernity's redefinition of female subjectivity. What Simmel called "the power of the moving form upon which fashion lives" is female-driven.[39] From the sartorial viewpoint, modernity—the site of moving images—was a "girls' town."

HER COSMETICS

This is the view expressed by the filmmaker Maya Deren, whose forward views on fashion, film, and modernity represent an important stepping stone in the advancement of a theory of fashion and film. Deren wrote an unpublished text on the subject of fashion that reveals an early interest in dressing as a way of rendering different fashionings of space. Entitled "Psychology of Fashion," the text was written in response to an exhibition on the history of fashion that took place at the Museum of Modern Art in New York in 1945.[40] The show was the work of the architect Bernard Rudofsky and was interestingly titled "Are Clothes Modern?"[41] Deren, who still looks contemporary when she casts her own act of dressing onto the screen, wrote about the modernity of clothes in relation to modern space. She was particularly concerned with women's ways of addressing dress, anticipating a feminist interest in fashion.

As it relates to the interaction of fashion and modern art, Deren's report coincides with art historian Anne Hollander's recent assessment of clothes in the history of art. Hollander sees clothes "as a form of self-perpetrating visual fiction, like figurative art itself . . . as connected links in a creative tradition of image-making."[42] She believes that "dressing is an act usually undertaken with reference to pictures—mental pictures, which are personally edited versions of actual ones . . . because . . . art monitors the perception of clothing, and in a sense it may produce changes in the mode."[43] Concerned with mental picturing and portraying dressing as picture-making, Deren's writings are inscribed in the history of female fashioning which, as we have shown, was produced along with urban and travel imaging. For Deren, the laboratory of fashion and modernity go hand in hand to the extent that both represent mental landscapes. Her filmic writing continues the fashion concerns of the

4.7. The well-traveled suitcase packed with memories, as exhibited in the Sala Femenina of the "Sentimental Museum" of Frederic Marès, Barcelona.

modern *voyageuse*, who needed to equip herself with all the accoutrements necessary to chart her new map of subjectivity and to lug it around. As Deren herself put it, among the options for picturing the self, a "woman wishes to express, in the line of her clothes, a sense of speed and mobility."[44]

One particular aspect of this predicament underscores our attempt to map the modern interplay of female subjectivity, fashion, and space. Deren understood this movement to be an e*motion*. "The most important role of fashion is in relation to a woman's *individual psychology*," she claimed. "First of all, a woman's clothes serve as an outlet for her creative energies. Secondly, she uses those energies to create, in reality, some image she has of herself; a method of projection of her inner attitudes . . . a kind of expressionism."[45] Deren was sensitive to the liminality that links attire to affective apparel, making fashion part of its landscape. Fashion resides within the reversible continuity that, rather than separating, provides a breathing membrane—that is to say, a skin—to the world.

Turning one last time to Esther Lyons's alluring self-portrait, we see that it was a surface show of her own "makeup." Photography marked the first instance in history in which such a cosmetics of the self, which includes the scene of the *toilette*, could actually be reproduced. Film showed a map of the skin in motion and mobilized the view. Like precinema, early film was attracted to the face and the facade of things. This type of surface-view was imprinted in the locomotion-driven work of Muybridge and Marey, as well as in Georges Méliès's corporeal explorations, which

included the self-portrait. In a film still, Méliès appears simultaneously as himself and as his own mirror image—framed as a painting—suggesting that the power of film involved seeing oneself in multiple exterior projections in movement.

Esther Lyons offered us such a traveling view. Her eroticized self-portrait was indeed a provocative way to open a book of travel images. The sensualized fabrication of this woman traveler set the tone for the book's own voyage, "fashioning" an erotics of spatiocorporeal (self) exploration. To the extent that spatial movement involves an erotics, desire is in fact a means of "transport." Moving through the haptic territory of Lyons's *toilette*, we will continue our exploration in her traveling fashion.

GEOGRAPHY

5.1. Interior view of the collection of Athanasius Kircher, as shown on the frontispiece of *Romani Collegii Societatis Jesu Musaeum Celeberrimum*, 1678.

5 The Architecture of the Interior

I have just completed a forty-two-day voyage around my room. The fascinating observations I made and the endless pleasures I experienced along the way made me wish to share my travels with the public. . . . Be so good as to accompany me on my voyage. . . . When traveling in my room, [I] rarely follow a straight line.

Xavier de Maistre, *Voyage around My Room*

A cabinet of curiosity. A viewing box. Journeys in a box. Pandora's box. Two or three things I know about "her." Female curiosity. Traveling "matters." E*motion*al topographies.

We are in the Sala Femenina, the ladies' chamber, of the Museu Marès in Barcelona. A passionate traveler and collector, the sculptor Frederic Marès (1893–1991) assembled an astonishing and curious collection of memorabilia. He aptly named this space the "Sentimental Museum." Reminding us that a collection offers recollection, the name speaks of the journey offered by Marès's personal museum: the visitor experiences the spectacle of things that carry no value other than emotional power—objects transformed into narratives by way of *emotion*. In the Sentimental Museum we find ourselves on a "sentimental journey" of the kind encountered, at the outbreak of modernity, in Xavier de Maistre's *Voyage around My Room* (1794).[1]

The Museu Marès is a museum of private life that offers a tour of lived space. Although assembled during the twentieth century, the collection is set in the past and organized according to older models. To enter the space of the Sentimental Museum is to travel back to, and within, eighteenth- and nineteenth-century interiors and to wander in the stories they tell—tales of the room. For his melancholic museum, Marès collected only the seemingly banal, ephemeral apparel of daily life. The rarities of this collection are ordinary objects: objects cherished and touched by hands no longer living; used things that have no more use; belongings that no longer belong. When such contents are simply frozen, arrested in time, a museum can become a mausoleum. Here, we can take hold of time and experience it as in the work of mourning.

The Sentimental Museum offers history as a personal story, memory as memoir. When a collection promises recollection, as Susan Stewart notes, "the arrested life of the displayed collection finds its unity in memory and narrative. . . . The inanimate comes to life in the service of the awakened dead."[2] The objects in the Sentimental Museum, assembled with obsessive care and endless yet minimal variation, animate such private narratives. A series of items made of hair exemplifies the morbid fetishism of the collection. Displayed in vitrines that once housed anthropological, ethnographic, scientific, and natural history specimens are, among

other things: an infinite variety of containers (from snuff-boxes to jewel boxes), traveling tickets, fashion accessories, menus, ornaments, birth and marriage announcements, bills of exchange, labels, tags, advertising, emblems, shrines, *ex-votos*, souvenirs, keys, umbrellas, canes, pipes, buttons, embroideries, scissors, sewing machines, measuring devices, watches and clocks, eye glasses, lenses, binoculars, daguerreotypes, photographs, and picture postcards. In this display, most reminiscent of anatomical vitrines, the Sentimental Museum maps the topography of the everyday.

Such a geography, conceived in the shape of a journey around one's room, is inextricably bound to sexuality. Thus the Sala Femenina opens with a massive display of fans, wonderfully decorated with panoramic scenes, cityscapes, picturesque gardens, and landscapes. Beyond making breezes for the ladies, the fan may have had another imaginary function. As one opened it, the depicted panorama—often painted as a succession of views—unfolded. Its motion told the story of a moving site. The fan, one can imagine, was the everyday version of a *veduta* in motion—a mobilized view painting. A prepanoramic device, the fan was the ladies' own private cinema. It even displayed a striking resemblance to the phenakistiscope, a nineteenth-century prefilmic device that ladies could hold in their hands and manipulate by rotating a disk, causing figures of decomposed movement to appear in continuous motion.

Indeed, the Sala Femenina itself moves, and in many ways. After traveling through its realm of the everyday, we reach an apt conclusion to the journey around female space: a suitcase. Marès, who had obsessively arranged all the objects in his museum, wanted this suitcase to be placed in the "Female Room" and not, interestingly enough, in the "Gentleman's Chamber." The bag turns out to be Marès's own. Whatever the motives for his gesture, the suitcase creates its own spectatorial itinerary, associating journey with feminine space. It reads to the visitor as a gift to female curiosity, a widening of female horizons—an opening toward a different way of looking at gender and space.

The suitcase, an object of travel, is a collection of memories, like the room itself. Adorned with stamps of hotels and decorated with views of the cities visited, the suitcase tells the story of the traveler. Marès traveled extensively throughout Europe. He also went to the United States, Japan, and Egypt. The mapping of city views on his suitcase reveals that his epistemological models date back to the grand tour and the romantic journey, both of which had regarded Italy as a must-see. He seemed to like the "Voyage in Italy" and visited Naples, the last stop on the grand tour, at least three times.

During his travels, Marès collected the objects that are assembled in the Sala de les Diversions, the amusement room. This is the last room of the Sentimental Museum, the grand finale and a site of spectatorial pleasures that comes as a natural extension to the traveling pleasures of the interiors. It is not surprising to discover that Marès collected a number of precinematic devices. His Sentimental Museum—a space for emotion—tells the fiction of the real in its journey through lived space. In this scene, the motion picture easily finds its own space.

The archaeology of cinema not only is made an integral part of the Sentimental Museum but is mapped in an interesting, "curious" way. Marès's curiosity cabinet does more than just display the optical devices and apparatuses that led to the invention of the cinema. As elsewhere in the Sentimental Museum, taxonomy speaks transversely. The spatial arrangement of the objects—a sequence reinvented by the viewer's own associative walk—is particularly significant, for it creates the particular geography that constituted the birth of the cinema. Let us walk through this Spectacle Room. A mechanical doll, whose motion lures us into entering the space, welcomes us to the world of spectacles. We walk upstairs and leisurely enter the room of leisure. First we encounter a series of precinematic apparatuses: kaleidoscopes, magic lanterns, stereoscopes, and projectors. Next to these are three bicycles and, in the background, an entire array of mechanical dolls. A "curious" display, indeed. What, one wonders, links the cinema to a traveling vehicle and the automaton?

Our answer might be that by way of this spatial mapping, whose connecting thread is the spectacle of motion, essential aspects of filmic topography are displayed. The exhibition presents objects of leisure propelled by movement, suggesting that the optical devices that preceded "motion" pictures were, in many ways, traveling spectacles. Indeed, they were shown by traveling exhibitors in public spaces, and they were vehicles through which people vicariously traveled. Hence the moving image—a vehicle of travel—encountered the bicycle.

But what of the mechanical doll? Why is the automaton there, between the bicycle and the cinema? The automaton is a mechanistic being, an aesthetic, ludic object that contains its own principle of motion.[3] Film is close to such an object, for it, too, is an aesthetic and scientific toy whose seductive imaging contains its own principle of motion. Such motion analyzes and dissects bodily movement. A mechanical double for travel, the cinema exhibits the mechanics of the body. It is the home of a body-machine whose mechanized motion reproduces sensory emotions. The film body scans (imaginary) space and psychogeographies. As a body-double mechanism, it is the twentieth-century incarnation of the android, imaged and transformed by the age of mechanical reproduction. Film is a contemporary automaton, whose roots extend, like the displays of the Sentimental Museum, far back in time. Let us travel back into this moving, lived space.

"SHOOTING" ALONG HISTORY

> *Simulacra move.*
> Lucretius

In order to get to the root of the spatial curiosity that gave rise to the cinema, one must move, following the suggestion of Marès's Sentimental Museum, backward in time. Space travel is time travel. Retracing cinema's own traveling "affect," we will search for itinerant ways of mapping and consuming space before and beyond

"panoramic vision" and investigate the very archaeology of film. This is an area of growing historiographic attention. The informative work of Laurent Mannoni in France, David Robinson in Great Britain, Donata Pesenti Campagnoni and Gian Piero Brunetta in Italy, and others has begun to fill in the many gaps surrounding the technological birth of the cinema.[4] A variety of interpretations and methods emerge. Attentive to popular culture, for example, Brunetta sees cinema as having emerged from the intersection of modes of vision with the ritual forms and magic of popular spectacle, whose history he retraces. The number of routes open for inquiry shows that film archaeology engages, but also precedes, the advent of nineteenth-century photographic spectacles. Thus, for example, as Lisa Cartwright, Linda Williams, Mary Ann Doane, and others show, the scientific, medical gaze that analyzed the body in motion shaped the very grounds of the "film body" and its appearance on the experimental scene that included Muybridge and Marey.[5] Not only a history of the invention of machines and apparatuses, to which it is sometimes reduced, the archaeology of cinema must be considered an "archaeology of knowledge"—a social practice of cognition written, in many ways, on the body and its (e)motions.[6] A site that relates to other cultural sites in the transformation of social subjects, the archaeology of cinema is an epistemological field, a varied geography of *savoirs*—an actual terrain of exploration.

5.2. The Anatomical Theater in Bologna, 1638–49 (reconstructed), with a statue by Ercole Lelli of the Spellati ("flayed figures"), 1735.

A GEOGRAPHY OF FILMIC ARCHAEOLOGY

In addition to nineteenth-century geographies, which included dioramic and panoramic viewing as well as the corporeal spectacle of wax museums and architectures of transit such as rail travel and arcades (which, as mentioned, are essential components of film's genealogy), other spaces of exploration prepared the terrain for the invention of the cinema. The protocinematic arena came into existence in conjunction with and even before mechanical reproduction became involved in actual precinematic experimentation. If the history of precinema partakes of the field defined by Jonathan Crary as "techniques of the observer" it is because it involves an array of perceptual and spatial expansions.[7] This is a shifting field, marked by the development of various machines of the visible, including the camera obscura and the magic lantern, anamorphosis, the baroque theater of illusion, shadow plays, viewing boxes, optical views, and, particularly, *spaces for viewing* that constitute apparatuses of site-seeing and transport. As exemplified by anamorphic frescoes, where the optical game was played by a mobile spectator, the mobilization of space took place through a series of "*trans*lations" leading up to the "motion" picture. As Gilles Deleuze, commenting on the prehistory of cinema, put it: "one might conceive of a series of means of translation (train, car, aeroplane . . .) and, in parallel, a series of means of expression (diagram, photo, cinema)," whereby the cinema, from its very origin, appears to be an engine of the movements of translation.[8] Surveying selected aspects of this *transito* of "translations" in the complex field of precinematic expression, I will limit myself to those that foreground the particular (pre)filmic area I am engaged in exploring—the atlas of (e)motion—focusing here on the geography of site and of the body, and their relations, in the making of an architecture of the interior. For film archaeology inhabits a particular site of knowledge: the making of socio-cultural space, which includes the emotions.

This exploration into cultural genealogies thus travels backward beyond the origins of modernity—the very outbreak that made the cinema. As art historian Yve-Alain Bois has shown, the "rupture of modernity" can be said to have occurred in the late eighteenth century, earlier than conventionally assumed, although not as far back as the architectural scholar Manfredo Tafuri would have it: in the fifteenth century, a time that, for us, launches early modernity.[9] Investigating the roots of the modern scene that became the cinema, one might venture well beyond the nineteenth century to explore a shift in the production of space that came into effect in the eighteenth century, and even venture back to early modernity. But first, let us retrace our steps and search for protofilmic clues by rewinding all the way back to the archaeology of no-place—the utopia of film.

DREAMING FILM DREAMS

"Every epoch dreams its successor" and leaves utopian traces behind.[10] On this phantasmatic trail, protofilmic narratives can be found in existence even centuries before the actual birth of the cinema. In fact, filmic utopias have been traced all the way back to Plato's cave.[11] The scene of the cave as a prefiguration, even a simulacrum, of filmic perception shaped the theoretical terrain of cinema studies, especially guiding film theory's interest in the cinematic apparatus. However, if the association of Plato's cave with cinema's origins rendered visible important aspects of the filmic scene, it also ended up obscuring other areas of protocinematic figuration as it constructed a model for film spectatorship that was centered on mastery and fixity of the gaze. Looking elsewhere for the founding myth of cinema means looking differently: "spacing" a different spectatorial model, opening other paths of research, and highlighting different aspects of the language of cinema. Traveling back through the origins of film, we mean to design a different imaginary scene—a site in which spectatorial voyages take place, a "set" of multiple inhabitations.

As a trace left by the future, the myth of cinema has perhaps traversed the entire history of culture. One finds retrospective traces, for example, in the ancient Eastern shadow theater and in the activity of viewing Japanese scroll paintings, whose oldest models date from the eighth century. Especially developed during the middle ages, they continued to be produced for centuries.[12] The scroll was originally developed by the Chinese as a panoramic view of landscape and was adapted by the Japanese, who used the panoramic figuration to depict human nature and construct pictorial narratives. The Japanese scroll is a form of narrative painting that, much more than illuminated manuscripts, presents a "cinematic" technique of figuring narrative space. The format of the scroll physically resembles the unfolding strip of pictures in a film. The paintings are usually ten to fifteen inches high and up to thirty or more feet in length. In the first scroll paintings, the primary character was drawn in the picture more than once, appearing again and again over the course of the episodic development of the narrative. Further accentuating the filmic analogy, the images in the paintings were accompanied by a text. The image was always to be read in conjunction with a linguistic element, even in later scroll paintings, which used a format that alternated sections for pictures and written texts. These texts function like intertitles in film, illustrating and furthering the visual narration. The narrative of the scroll paintings quite literally unravels as the viewer peruses images that move horizontally and sequentially. Like filmic language, especially when it adopts continuity editing to stress the flow of images, the illusion is that of a continuous design that provides the sense of a spatiotemporal stream. According to one historical account, "the composition flows with such ease that we hurry to reach the next dénouement."[13] The filmic potential of the scroll to scan past and future while viewing the present has fascinated the filmmaker Peter Greenaway, who has suggested that "maybe we should re-invent the cinema as a scroll."[14] Maybe we should also reinvent film theory on this "reel."

PROTOFILMIC MAPPINGS OF (E)MOTION

In the realm of Western representation, much has been made of film's inheritance of dominant visual codes, especially those of Renaissance perspective. As we have mentioned, most theoretical discussions of the cinematic apparatus have insisted on viewing cinematic representation as an ideological technology of visual extent.[15] The cinema became a machine of the visible, and the camera was generally assumed to be constructed on a perspectival model derived from Quattrocento. A mechanical replica of Quattrocento's perspective, film could be seen as reproducing, *tout court*, its visual and ideological structure. The limited focus on perspectival representation has obscured not only other ways of looking but even the configuration and development of the Quattrocento paradigm as it relates to the imaging of scenographic space. As we diverge from the optical drive of most arguments centered on this limited understanding of the Renaissance and turn away from the tradition of viewing the Renaissance as the central model for film, we will trace various shapes of Western spatiality in the realm of precinema and Western cinema. Working with spatiovisuality, we will forward the hypothesis that both the genealogy of film and the dominant codes of cinema have "inhabited" diverse forms of Western cultural space, one aspect of which began to take shape around the sixteenth century.

The twenty volumes of the *Magiae Naturalis* by Giovan Battista Della Porta, published in several revised editions between 1558 and 1589, offer a point of departure.[16] Della Porta's writings are of particular interest in the mapping of a corporeal geography of the image. An eclectic Italian philosopher, scientist, writer, and magus from Naples, Della Porta practiced a wide-ranging conception of knowledge.[17] His work spanned a great number of disciplines and included the development of optical techniques. He wrote on such subjects as geometry and optics, along with astrology, alchemy, and the occult sciences, and was particularly interested in physiognomy, to which he dedicated the volumes of *De humana physiognomonia*.[18] He also dreamt the cinema:

To give pleasures to the gentlemen, there is nothing more ingenious and beautiful than viewing—on a white cloth, in a dark room—scenes of hunting, banquets, battles and plays, and, finally, seeing all the desirable images so clearly and luminously, and in such detail, that you feel as if you have them right in front of your eyes.

Facing the camera, where you plan to have this representation, there should be a spacious site, lit by the sun, where you will set trees, houses, woods, mountains, rivers, animals which can be real or made artificially, with wood or other materials. You should have little children enter them and move them, as it is customary in the staged comedies. Have deer, boars, rhinoceros, elephants, lions, and all the animals you please, and have them enter your plain as if they were entering and exiting from their own dens. The hunters should then come and pretend to hunt them, equipped with arms, nets, and everything necessary for the representation of the chase. There should be sounds, made from marine seashells, and the playing of horns and trumpets. The spectators in the room will see the trees, the animals, the

5.3. A map of gender difference from Giovan Battista Della Porta's *Della fisonomia dell'huomo*, 1627.

faces of the hunters, and the rest of the apparatus in such a naturalistic way that they will not be able to judge if they are real or imaginary.[19]

Della Porta's description of the camera obscura prefigured the filmic spectacle in many ways. Here, the camera obscura was envisaged as a representational tool that served as a multiform entertainment device. Speaking of the functioning of the optical device, Della Porta engaged the space of the viewer and focused on reception, picturing a scene of spectatorial pleasures. He also prefigured narrative space, conceiving moving scenes that unfold to tell a story sequentially. Della Porta, who actually used the word apparatus, envisioned a spectacle especially prepared for exhibition. The performance for a public—"fashioned" on a white screen-fabric in a dark room—involved a narrative structure, a set design, actors, and even sound effects. In this way, he foresaw the potential not only to reproduce but to reinvent a scene, envisioning an actual mise-en-scène for narrative action. Della Porta's descriptions of the camera obscura marked an advancement in conception which made it more than a mere recording device. Revealing a protofilmic space of representation and exhibiting the work of the imagination, his conception went beyond figuring the projected image as a matter-of-fact reproduction of the real and, by way of an architectural representation, constructed the very "space" of a voyage in filmic fiction.

In Della Porta's description, the camera obscura becomes a movie camera, a passage that is spatial. The transfer centers, and acts upon, an interior. Camera, from the Latin *camera*, means room, and this meaning is still held in Italian. In the transformation, the very semiotic imprint of "camera"—the chamber—is inscribed and passed on to film. The camera obscura does not simply become a filmic instrument; it fashions a filmic space: a filmic "room." It becomes a house of pictures—a movie "house."

Working on the space of the image, its projections and reflections, Della Porta experimented as well with another site: the body. His philosophy connected these two lines of exploration, so central to his era. While the age of exploration was mapping out space, anatomists such as Andreas Vesalius, in his *De humani corporis fabrica* (1543), were mapping out the body. The geographies of space and the body were combined in Della Porta, whose extraordinary writings on physiognomy and other somatic matters paralleled, and reconfigured, his interest in spatiovisuality.

Della Porta's geographical "curiosity" covered the vast field of material metamorphosis and physical *trans*mutation: he traveled from astral and alchemic movements to physiognomic transformations in animals and humans. He also dedicated books to such transformative matters as the fashion of women's ornaments and to bodily alchemies such as perfumes. Della Porta explored the production of imaging—embracing everything from the body to space—and "fashioned" the physical realm as a movement from matter to matter. His subjects, ranging from the transmutation of metals to the transformation of images that occurs in attire and physiognomy, indeed turned image production into alchemy.[20] The entire field of image production was envisioned as transmateriality: a material circulation, a matter of *transito*. No wonder he dreamt the cinema. He was mapping its very space.

5.4. Picturing the character of passions: Charles Le Brun and Sebastien Le Clerc, *Caractères des passions gravés sur les dessins*, 1696.

Understood in this way, optical devices and treatises such as Della Porta's were indeed propelling the formation of an image-movement. They also increasingly foregrounded the role of movement in the expression of such corporeal matters as passions and emotions. The magic lantern, for example, was used to further the findings of artists such as Charles Le Brun (1619–90), who experimented with physiognomy in a kinesthetic way. In his *Conférence sur l'expression générale et particulière des passions*, Le Brun strove to map onto the body the ever-changing passions of the interior.[21] He compiled a dictionary—an atlas—of facial expressions, conceived as movements, as visible signs of passion. Rather than picturing the body as a static image, Le Brun mobilized it by showing how the motion of emotions is written, drawn, and etched onto its surface. In this mobile physiognomy, where passion is "transport," the face becomes a trace of interior events. A graph of historical presence, the face, set in motion, becomes a map of one's history.

Beginning in the 1770s, the "pathognomy" of Johann Kaspar Lavater set out a foundational approach to the study of emotions, "the art of interpreting the passions."[22] As Patrizia Magli shows, Lavater's interpretation of the passions was a form of measurement based on a process of *découpage* and simulation.[23] This work, turned self-portraiture, became an architectural art form with the visions of Jean-Jacques Lequeu (1757–c. 1825).[24] Lequeu's extraordinary, sexually charged drafts-manship constantly returned to his own face and body, which he endlessly carved in architectural form, from tomb to archway, and often "fashioned" in the form of a woman. More than mere architectural physiognomy, the work of this architect, defy-ing geometric correspondence, showed the moving transformation of emotion, which was represented as a tangible shifting. In the hands of Lequeu, the building became related to the materiality of the body's own transformations and, made with life matters, resonated with its digestive pathos.

These figurations of passions, including the architectural designs of Humbert de Superville, which will be treated later, constituted a moving emotional topography.[25] They fashioned a concept of emotion that saw it in constant movement between the space of visibility and invisibility. Anatomies of the visible surfaced through these passionate analytic movements in such a way that subjectivity itself became kinesthetically shaped. This landscape of passage between the body's ex-terior surface and the geography of the interior was being imaged just as a new geog-raphy of space and movement was itself taking shape. The ground, shaped carto-graphically, was being readied for precinematic space, the corporeal machine of *emotion*. Utopian traces of emotion pictures were being left behind.

One specific road in the depiction of emotions led to a distinctively gener-ative encounter with photography. This road was paved by Duchenne de Boulogne (1806–75), whose method was transformed by Charcot, his most famous student, into a well-known prefilmic theatrics. Duchenne's *Mécanisme de la physionomie humaine* (1862) sought to map the mechanism that underlies the expression of pas-sions and make it applicable to the plastic arts.[26] It was the result of an experimen-tal practice. Duchenne stimulated the faces of his patients with electrical probes in order to trigger muscular response and thus to demonstrate the role muscles play in conveying different emotional states. Using a camera to describe his findings (and build his theory), he recorded the resulting facial expressions "acted" out by his sub-jects. His photographic archive exhibits a torturous athletics of human emotions. In an effort to "locate" the actual place of an emotion—in muscular tissue and the apparatus of its movement—Duchenne scientifically engineered a mechanics of pas-sion that, by way of photography, accessed the terrain of the visual arts.

The various efforts that shaped an anatomy of visible passions on the sur-face of events interacted closely with several practices in the visual and spatial arts. The camera obscura, at the most immediate level, had long been an important object of research and study for landscape and view painters as well as for architects in their efforts to map inhabited space. In the eighteenth and the nineteenth centuries, the magic lantern's views provided an anatomy of landscape, often depicting the

5.5. *Emotions* painted on glass for magic lantern shows, c. 1750–1800. Detail of sequence showing desperation–ire–spiritual rapture.

emotion contained in landscapes, seascapes, and cityscapes—scenes that transferred to early film and became major topoi in the development of film language.

A space for viewing was created out of the interaction between the analytic and the spectacular gaze these devices produced. This ground of tangible visions included the use of the camera obscura in the performance and display of anatomy, as shown in the artwork that illustrated medical books.[27] The optical device was used in many ways in the visual arts as a tool for anatomizing physical space. As a view into the texture of this space, it exhibited somatic penetrability before cinema established its own version of this passage. This fluid landscape not only included but shaped the landscape of the emotions. Physiognomy, after all, was conceived as a window through which the interior "perspired" outwardly, made itself present, semiotically manifest, even historically readable: the interior mapped itself tangibly onto the surface of the skin. As the corporeal boundary between inside and outside, physiognomy, when further mobilized as a "pathognomy" and seen to represent the motion of emotion, led to the landscape of motion pictures. This pathognomy of lived space activated filmic views.

In the genealogical journey that the Greek term *kinema*—as both motion and emotion—took to become "our" cinema, pathognomic research and Le Brun's endeavors to trace e*motion* thus played a particularly important role. They also had direct prefilmic heirs. Certain eighteenth-century lantern views mapped the physiological movement of emotions, pinpointing their location and the spaces between them. These views were sequentially organized, as Le Brun's studies were. The slides frame the movement in and out of, as well as through, interior states, making an actual material map of emotions. These emotional views even look like film strips. In a group preserved in Italy, at Turin's Museo del Cinema, we see a prefilmic strip of the corporeal movement between different emotions written on the face of women

and men. In one case, the facial embodiment of shifting interior states includes passages between "laughter–crying; depression–joy–sadness; joy–crying–desire; anger–simple love–terror."[28] Another strip depicts emotional changes between "desperation–ire–spiritual rapture; veneration–horror–melancholy; fright–jealousy–grief; fear–hope." These lantern strips, like celluloid film strips, are indeed moving maps on which the interior is externalized and mobilized. It is displayed in its transmutation, shifting from one state into the next. Each face corresponds to a frame. "Dissolving views," which followed "animated" views and represented the most important advance in magic lantern technique in the nineteenth century, allowed for even more sophisticated effects of transformation. Here, two or more lanterns could project views superimposed on the same screen, thereby capturing subtle changes. The technique became a way to spatialize the movements of passions as they are written on the body, which itself was represented as an ever-changing and dissolving space. Thus represented, *emotions* prefilmically inhabited the body's own haptic motion, passing through the light of shadows.

A LANDSCAPE OF SHADOWS

In the archaeology of corporeal mappings, protofilmic traces left by the future are also found in the wide-ranging and unorthodox scholarship of the Jesuit priest Athanasius Kircher (1602–80).[29] Furthering the "inventive" territory of Della Porta and his technological imagination, Kircher devised multi-media experiments in automation, optics, and acoustics. A polymathic thinker, he covered a world of knowledge in the more than thirty-five volumes he produced, which ranged in subject from painting to geometry, astronomy to magnetism, music to the occult. A believer in the power of imagination, he also collected this knowledge in a "cabinet," a place of study and a laboratory formed at the Collegio Romano.[30] Eventually housed in a three-hundred-foot-long exhibition hall, his museum dis-

5.6. The magic lantern in the shadow of death, from Athanasius Kircher's *Ars magna lucis et umbrae*, 1646.

played—alongside his mechanical devices of "perpetual motion"—alchemic, scientific, and mathematical instruments; geographic, anatomic, anthropological, and natural history specimens; and objects collected on his trips or sent to him from all corners of the world. Kircher was interested in all kinds of geographies, including Eastern spaces, and was especially fascinated by the Taoist vision of nature as a living organism, a notion he conveyed to the West. He also wrote on the geography of the underground in his *Mundus subterraneus*, in which he pictures everything from the subterranean world to the physiognomy of the sun.[31] His *Ars magna lucis et umbrae*, published in Rome in 1646, made a particular contribution to the widening of visual horizons by adding another layer to the general interest in the geography of the image.[32] Kircher's investigation unites light and shadow, anticipating the filmic embodiment of the spectacle of penumbra, a technology of light which is an art of shadows. His version of the magic lantern also strove to enter the dark space of death, attempting to represent the body of the dead, beyond death

5.7. Title page from Robert Burton's 1621 book *The Anatomy of Melancholy*. 1893 edition.

itself. Two beautiful images that illustrate his treatise on light and shadow show, in one case, a skeleton, and in the other, a naked woman burning in purgatory. Death was by no means a casual inhabitant of the optical space, as shown, for example, in the work of the natural philosopher Christiaan Huygens, an important figure in the development of the magic lantern whose 1659 kinetic drawings represent the dance of death in "animated" views.[33]

Spectral views were "fleshed out" also in the experiments of Etienne-Gaspard Robert (1763–1837), later known as Robertson, whose interests spanned from balloon aeronautics to optics, physics, and magic.[34] Robertson developed shows of "phantasmagoria" he had seen, devising his own performances. This self-described "physicist-philosopher" added darkness and preromantic morbidity to the cognitive apparatus of the Enlightenment, whose experiments and "illuminated" views clearly had a dark side. Set in the sinister Capucin convent, Robertson's simulated theater of demonic and ghostly imaging sought "sensational" effects. As shown in an 1845 engraving in *Le Magasin Pittoresque*, it made an architectural spectacle of death, set with other curiosities such as "The Opening of Pandora's Box" and "The Head of Medusa." Death inhabited the very space of Robertson's phantasmagoria and the shape of its architectonics. Furthermore, as Antonia Lant has shown, it participated in the egyptophilic mode of (pre)cinema, evoking the Egyptian necropolis and its own cult of death.[35] Incorporating elements of movement into its funerary show, phantasmagoria moved the spectacle a step closer to motion pictures through its deadly touch. The electrifying spectacle was interestingly compared to the impact of railways: in an 1832 account, it was reported that spectators were made to feel that they could "touch" the images.[36]

Phantasmagoria would have a great "phantasmatic" influence. For Walter Benjamin, among others, the word assumed a central discursive position and was taken to define the visual culture of mid-nineteenth century.[37] Phantasmagoria was a form of prefilmic curiosity that became a part of cinematic language, as did its deadly touch. The skeleton's dance was an integral part of other machines of the (in)visible, such as the nineteenth-century's choreutoscope. Such devices prefigured a fascination with (in)visibility and the modern interest in phantoms that, as Tom Gunning shows, permeated photography and later traveled to the "photoplay," establishing itself as a traveling motion picture show before the cinematic magic of Georges Méliès.[38]

Viewed through the phenomenon of phantasmagoria, the moving image, which emerged as an intimate exploration of physical space, ends up moving beyond the limits of the body's own geography. Film thus ultimately embodies the technology of death. As André Bazin claimed, a "mummy complex"—a process of embalming a body image—lies at the origin of the plastic arts of which the cinema is a representative. As he saw it, "put under psychoanalysis, the practice of embalming the dead might turn out to be a fundamental factor in their creation."[39]

THE FASHION OF AUTOMATA

Cinema—like the cemetery—is a space that is home to residual body images. Film and the cemetery share this special, corporeal geography. They are sites without a geography, or rather without a fixed, univocal, geometric notion of geography. They inhabit multiple points in time and collapse multiple places into a single place. As a site, the *cine*ma relates to the resting place of our *cine*res—our cinerary remains—for they are both "heterotopias."[40] As "other spaces," they are permeable systems of opening and closing, a type of space that refers to all other spaces and, ultimately, to every space imaginable. Cinema and the cemetery, like the garden, are such heterotopias, for they are capable of juxtaposing in a single real place segments of diverse geographic worlds and temporal histories. In fact, a heterotopic space can hold indefinitely accumulating time and fleetingly transitory aspects of time, which reside in the architectonics of the place itself as well as in the historicity of the bodies that inhabit the site. Like the city of the dead, the city of images is funerary: its moving stillness monumentalizes the body and, holding the trace of its historicity, gives body to memory.

The space of death inhabits film in many ways, as we saw in our analysis of *The Man with the Movie Camera*. As a machine of death, film technology engages in a time play with spatial movements. Capable not only of multiplying time and space but of extending time with prolonged mechanical movement, as well as freezing frames and slowing or accelerating movement, the language of film inhabits a boundless desire to capture life. The shadow of such longing is a drive to trespass spatiotemporal confines—that is, to overcome the finiteness of death. Preserving the moment in time and space, film travels the geography of death and immortality.

If the mechanics of death goes beyond embalming to arrest time and halt motion, the illusion of superseding corporeal limits is partly a function of the infinite movement it contains. Film incarnates this ability to "animate"; it is a machine that activates lifelike (e)motion. Its automatic movement cannot, however, be stopped at will by a hand's action; or, if this movement is arrested, it can be started all over again. As a spatiovisual device of this sort, film's infinite mechanized motion recalls that of the mechanical doll. As we began to see in the geography of the Sentimental Museum, the automaton's spectacle of repeated movement, simulating the body's own, was a step in film's genealogical phantasmagoria—an earlier mechanical attempt to extend the life of time and space.

The fascination for automata, which extended from the eighteenth through the nineteenth centuries, was embedded in the struggle against decay. The motion of animation played with the edges of "passing" as movement transformed the inorganic into organic matter. The fashion for automata engaged this particular type of passage: death. In this respect, the terrain of the automaton is the very world of the mannequin. As Benjamin remarked in his work on *passages*, "fashion was never anything but the parody of the gaily decked-out corpse. . . . [It] lures [sex] ever deeper into the inorganic world—the realm of dead things."[41] One of fashion's functions is to offer sex appeal to the inorganic. It is such modern eroticism, with its

mimicking ability to move between the organic and inorganic, that passes from the automaton to the mannequin to film. Film genealogy, written on the corpse, is indeed a "fashion" affair.

The deadly rhetoric of the automaton's display returned to the cultural scene in another form of simulation as it was remade with film's own entertaining principles and spectacular displays. Setting physical forms in motion, both types of machine (automaton and cinema) turn these figures into stories, offering delightful forms of repetitive pleasure. Objects of leisure, the automaton and the cinematic apparatus both hide the mechanism that creates movement, pretending to require no effort in representation or reception and creating the illusion that the graceful technical exhibition entertains automatically.

A playful technology and sensuous aesthetic, the automaton is also a predecessor of film's sentient space. Like the automaton, whose operational movement was a signifier of early modernity, the moving image "embodies" the principle of its own motion for the benefit of live audiences, who delight in this "moving" operation—the exhibition of simulated lives moving in space. A spectacle of such movement, the moving image is ultimately "animated" by the emotion of motion. It is a *moving* anatomy, reprising the somatic space of automata, scanning intimate space obsessively, making its own geography of the flesh.

DEATH DISPLAY: WAXWORK AND *TABLEAUX VIVANTS*

The exhibition of automata in the public spectacle of science and the cabinets of the virtuosi was part of a larger display of mechanical representation that developed during the early modern period in the visual arts as well as in natural and experimental philosophy. As the art historian Barbara Stafford shows, the Enlightenment's mode of recreation consisted of diverse forms of visual education and amusement that often relied on the display of new and sensuous technologies and were informed by the body.[42] This new kind of exhibition involved both the indoors and outdoors: fashioning the gallery and the garden, it ranged from balloon launchings to phantasmagoric spectacles. The spectacle of thought itself was found in the rhetoric of experimentation and observation, visible in medical displays and the public performance of science.

The curiosity that led to the formation of the spectacle involved a visual attraction for the geography of the body and its transformations. This passion for inquiry embraced the topography of the flesh and the mechanics of emotions. With the automaton, flesh was turned into machine as machine was turned into flesh. The mechanics of such precinematic exhibition presented itself also in other anatomical displays, such as the waxwork and the medical cabinet—spectacular shows of anatomy, pharmacology, and natural history.

Waxwork, a medium that began by joining anatomy and art and eventually became a public spectacle, also helped to inaugurate the deadly display of moving

pictures.[43] The funerary origin of the form is notable. Anyone "may have their Effigies made of their deceas'd Friends, on moderate Terms," announced the advertising handbill of Mrs. Mills, a woman who produced waxwork at the end of the eighteenth century.[44] The participation of women in the production and exhibition of waxwork is astounding. Historical research suggests, in fact, that women dominated the field, in which the reproduction of the corporeal landscape turned the body itself into a "site" of exhibition. The case of Madame Tussaud, enlightened in a study by Marina Warner, is best known but not at all unique.[45] Many other women played essential roles. Often known only as a "Mrs. ...," their first names escaped history. In late eighteenth-century London, there were, in addition to Mrs. Mills, such female wax impresarios as Mrs. Salomon and her successor Mrs. Clarke, Mrs. Sylvester, Mrs. Goldsmith, and Mrs. Patience Wright. Italian and French women engaging in waxwork in the eighteenth-century included Anna Morandi Manzolini and Marie Catherine Bihéron. Wax representation in the form of wax injected into the body of cadavers was in fact pioneered in the early fourteenth century by an Italian woman, Alessandra Giliani of Persiceto, who died in 1326.[46]

Death and wax were joined from the very beginning as a way of envisioning the body in a representation, and women were subjects of this imaging. Before photography and film resculpted physiognomies—seizing, embalming, and transforming their *emotion*—female wax-makers helped to harness the emotion of the body and its temporal history. Like wax, film preserved, displayed, and perpetuated the physicality of the body, materially freezing it as a moment in time. In this respect, it continued the tradition of the *tableau vivant*. This popular spectacle of the eighteenth and nineteenth centuries exhibited mimesis in the form of "living pictures," in which live "actors" adopted immobile poses in imitation of artworks or historical and literary scenes.[47] *Tableaux vivants* essentially turned the principle of waxwork exhibition inside out. Yet, whether live bodies were made to freeze, as in *tableaux vivants*, or frozen flesh was animated in wax models, a spectacle of death was invoked. Death rests at the edge of movement, whether life is mechanically stopped or the flesh is "captured" in motion. Motion pictures came on the scene with the power to do both. Extending the business of the waxwork and the *tableau vivant*, film offered the illusion that (e)moving images could master death.

The deadly line of descendance of moving images from wax models appears clearly in the way waxwork was most commonly advertised throughout the eighteenth and nineteenth centuries: "nothing seems wanting but life and motion." Indeed, with the invention of moving pictures, both conditions were satisfied. It comes as no surprise that meta-films that inquire about representational processes, such as Raúl Ruiz's *L'hypothèse du tableaux volé* (*The Hypothesis of the Stolen Painting*, 1978), Jean-Luc Godard's *Passion* (1982), and *Caravaggio* (1986), by the filmmaker and painter Derek Jarman, exhibit representations of *tableaux vivants*. The lively process of embalming—a picturing of the body that "contains" life and motion—lies at the very heart of image-making and its historical movement toward the motion picture.

TABLEAUX MOUVANTS: BETWEEN ART AND SCIENCE

Filmwork emerged from waxwork by way of automata. From the very beginning there were wax figures mobilized by wind-up clockwork, which created a spectacle of simulated life in motion. Automata made in wax or other media were featured in a form of mechanical theatrical spectacle known as a "moving picture" or "mechanical picture." Such moving mechanical picture shows foregrounded the spectacle of motion pictures, born in the age of the mechanical reproduction of (body) images.

Here, before cinema, spectacle and science collided on the site of the body's animation. It was a "moving" site. The scientific gaze was linked to the cinematic from the days of lantern-slide projections, even before the analytic views of the locomotion studies of Muybridge and Marey. As was often remarked at the time, "picturesque and scientific beauty" went hand in hand. Lantern projections spectacularly scanned the haptic field, often depicting as their subjects human and animal anatomy, as well as natural history, geography, architecture, and other spatial surfaces. From London's Royal Polytechnic, founded in 1838, to the Parisian Salle du Cosmos, Salle du Progrès, and Salle Robin, science and entertainment merged in the nineteenth century as the lantern industrialized both its leisurely and educational components to tour the surface of the world. Thus it was, as historian Vanessa Schwartz discloses in her significant study of fin-de-siècle "spectacular realities," that in 1892, the Musée Grévin in Paris, site of the display of wax models of the

5.8. *He is Free*, a mesmerizing architectural twist on gender in a drawing by Jean-Jacques Lequeu, 1798–99.

human figure, promoted the offerings of the precinematic spectacle of optical the-
ater—Emile Reynaud's *Pantomimes lumineuses*—to public reception.[48] If the wax
museum anticipated and incorporated moving images, in turn, moving pictures, a
scientific invention, were written—waxed—on the body in motion. Even today, the
Musée Grévin exhibits a model of a praxinoscope, "activated" by a wax model. The
spectacle of the "Palais des mirages," moved to the Musée Grévin from the 1900
Paris Exposition and still exhibited there, offers a visual summary of a traveling cor-
poreal mapping. This spectacle of light opens onto garden views and exotic travels
as moving automata are activated, creating a play of moving perspectives.

MOVING PICTURES, MESMERIZING IMAGES

In retracing the cultural history from which the motion picture was fleshed out, we
have described a number of intersecting phenomena that created a bridge between
science and spectacle, including a phantasmagoria of images. The type of spectacle
that employed these images, in many ways, made audiences feel as if they could
touch and, in turn, *be touched by* them. The images were "animated." Ranging from
ghostly apparitions to waxwork creations, this imagery shows the extent to which
phantasmagoria inscribed "phantom" in its spectacularization: vision is indeed con-
nected to visions. Further exploration of this relationship between appearance and
apparition may lead us to an understanding of how the spectacle of film images hap-
pens to transport us or hypnotize us—how film images, that is, "mesmerize" us.

The work of Franz Anton Mesmer (1734–1815), when not relegated to
occultism, is now largely forgotten, while the man himself remains something of a
ghostly shadow, a trace on a linguistic signifier. Although it is not known by most
English-language speakers, there was an actual doctor Mesmer behind the "mesmer-
izing" power.[49] Born at the rise of modern science's great divide, too late in relation
to alchemic thinking and too soon in relation to psychoanalysis, Mesmer bridged
many areas of knowledge, creating a hyphen between science and spectacle.[50] The
Swiss-born Mesmer practiced initially in Vienna and, in later years, in Paris.
Interested in the healing power of suggestion, Mesmer thought he had discovered an
actual force, which he called animal magnetism. According to his theory, there is a
fluid, an energy in which we participate, that can be communicated, or passed, from
person to person. "Transferring" this force from himself to the patient, Mesmer
attempted to prevent and cure forms of hysterical malady. Although isolated and
misunderstood, even at the time, Mesmer's work led to hypnosis and thus to the
birth of psychoanalysis. Connecting the moving power of his gaze and body to the
patient's own, Mesmer thought he could affect symptoms, which were themselves
written on the body. The type of gaze that Mesmer developed could touch people
and heal them. It was, indeed, a tactile eye, which "moved" by moving the forces of
the unconscious. As Mesmer wrote in his memoir, such moving matters were related
to perceptual movement:

It pleases me that the discoveries I have made . . . will extend the boundaries of our knowledge of physics, just as far as the invention of microscopes and telescopes have done. . . . They will make known . . . that man . . . is endowed with a sensibility . . . and that he is capable of taking upon himself a tone of movement by which he is able, just like fire, to transmit to other animate and inanimate bodies; that this movement can be propagated, concentrated, reflected like light, and transmitted by sound.[51]

Writing about this tone of movement, Mesmer dreamt the moving image. Pictures would be animated by motion. Movement and light would be technologically propagated, concentrated, and transmitted as they would come to be reflected on the surface of a movie screen. And thus such motion would turn into an emotion, in a reversible way.

Reconsidering Mesmer's work points us in the direction of the haptic power of images by re-establishing the historical and theoretical place of a "mesmerizing" energy, which includes a traveling, tactile eye. Claiming that such a *transient* sensibility lies at the origins of psychoanalytic thinking allows us to question dominant theories of the gaze and to affirm a different course: a haptic form of site-seeing into the unconscious (optics). To speak of mesmerism is to recognize a visual force that moves and touches within, an eye that affects the space of the interior. Thus understood, Mesmer's discourse touches on the very relation between visuality and the language of emotions. This has tremendous relevance for both film and film theory, for they are deeply implicated in such a relation. By calling attention to Mesmer's discourse, we pinpoint the very archaeology of emotion pictures—the design of intimate architectures.

We know all too well that the birth of the cinema coincides in many ways with the birth of psychoanalysis, for its dream world came into being with Sigmund Freud's *Interpretation of Dreams*, published in 1900. Looking backward into the archaeology of cinema before 1900 confirms this relationship between visual culture and the discourse of emotions, but with a twist: it reveals that a phantasmagoria of transformative images paved the way for, and sustained, the (dream)work that relates psychoanalysis to cinema and psychoanalytic theory to film theory. Taking Mesmer's route—that is, positing a tactile eye and acknowledging the magnetic power of the circulation of images—shows us that there is a physicality in our "projection" into images and our projection by way of images. It shows that the scientific spectacle of imaging is an actual form of "attraction."[52] Positing such magnetism as a force of transfer, it pictures the emotion of a *transito*. Fascinated, we plunge into the discourse of (e)motions and delve into the language of the interior, curious to see memories exhibited and phantasms screened, transported by the display of remnants, carried away by mesmerizing images, mesmerized by the body of images in a "transport" that attracts us to them and to one another.

5.9. The environment as charted in the interior of a botanical garden, in the anonymous engraving *Hortus Botanicus at Leiden*, 17th century.

SPACES OF WANDERING: CABINETS OF CURIOSITY, ROOMS OF DISPLAY

A voracious "curiosity" was at work in the configuration of the moving maps that became implanted in the cinema. Having explored this curiosity as an architectonics of display in our introduction to the Sentimental Museum and observations on Kircher's collection, we turn to the mesmerizing power of a museographic archaeology, a topic that will be developed beyond this chapter and eventually explored in current forms of interface between the cinema and the museum.[53]

We focus first on the cabinets of curiosity and note that in exhibiting fragments, remnants, and sensuously tactile forms, whose images and interrelations excited a private-public curiosity, they built a landscape linked with the opening of new worlds of knowledge.[54] This included the cultivation of the natural world, which gave rise to collections of *naturalia* (as well as *artificialia*) that were related to the fine arts and the natural sciences and incorporated botanical and medical research. The semiotics of their various forms and names (including *cabinets des curieux*, *Wunderkammern*, *Kunstkammern*, *studioli*, and museums) disclose the wonder, the rarity, or the curiosity of the art and science chamber, which fostered a way of thinking linked to an expansive geography of knowledge cumulation and dissemination.[55] Positioned within aesthetic and scientific practices and often serving as a bridge between them, the cabinets explored and exposed vast fields of knowledge, themselves becoming objects of a "curious" and passionate intellectual history. Records of travel and local *savoir*, places of exploration and research, they housed a

variety of experiences, ranging from spiritual meditation to aesthetic and scientific pursuit. Designed as a microcosm of experience, they made manifest the texture of existence in the drift of objecthood.

As the precursors and prototypes of modern museums, these cabinets inaugurated an appetite for exhibition. The complex interface that sustained their eclectic polymathism, which blurred distinctions and overcame the boundaries between art and nature, gradually gave way to a more rigid sense of cultural perimeters and arrangements. Collections changed in time as they came to garner greater public status and consumption. Organizational sensuousness, emotional and aesthetic wander, the restless curiosity that was a constant incitement to push the confines of knowledge—a boundless passion, that is—eventually became translated into a public erotics of voracious taxonomy in the natural history and anatomical museums. Here, physical specimens and the classification of body parts became a perversely sensuous reinvention of corporeal maps for a body of spectatorship. According to Tony Bennett, who usefully describes "the exhibitionary complex," the institution of the museum established a linear direction of viewing in tune with an evolutionary view and prescribed a regulated practice of sequentialized looking.[56] In some cases, as film scholar Alison Griffiths has pointed out, such theatrics of display, when bound up with the ethnographic project and using distinct dramatized scenes and a directed itinerary, created the very narrative of anthropological superiority that would be repeated in the hegemonic structuring of early ethnographic film.[57]

As an architectural "premise," however, the cabinet, like the museum that followed, was conceived, constructed, and traversed in different ways. To avoid limiting the museographic walk strictly to a regulated pattern, we should recognize that this genealogy incorporated diverse geographies of curiosity. It even deregulated them by means of the spectatorial trajectories of wanderers, who could make up their own cultural maps along the way. What came to be mobilized on display was the making of the "interior" itself, with its fluid navigational paths. As in the film theater that ensued, the cabinet of curiosities offered inner spaces for public viewing and exhibited fragments of exteriors in interior spaces. As "interior design," the cabinet of curiosity was home to an architectonics that proleptically led to the cinema and its own private-public spectacle. It was a box/room housing a (re)collection of images that gave shape to, and routed, the modern spectacle reincarnated by the movie "house" and its own permeable interior screens.

Interior design and architecture shaped the precinematic body of images in ways that cannot be confined to voyeurism or visibility alone; a predecessor of the world that would later be projected by lanterns and circulated in the cultural geography of *mondo nuovo*, the cabinet built an architectonics of wander. It is not by chance, for instance, that magic lanterns, as objects, took various architectural forms, revealing that something other than mere voyeuristic optical obsession was at play. Becoming actual "lanterns," they sometimes took the shape of a lamp. The "lampascope" decorated nineteenth-century bourgeois interiors, shedding the light of shadows on their walls. Lanterns were also designed in the shape of exterior

architecture and buildings and were fabricated as itinerant objects that could be packed as luggage for showmen to take on traveling tours. The frontispiece of the 1831 *Almanac*, printed in Turin, Italy, shows that some actually looked like a backpack. Nomadic exhibitors would carry them on their shoulders in tours around the cities and countryside.

From the cabinet of curiosity to the lantern, matters of architecture and design shaped the history of precinema. Framed for viewing and assembled as spectacle, objects in the cabinet of curiosity presented themselves in a protofilmic architectonics, on the threshold of interior and exterior. The items on display in the space were sequentialized and thus made into a narrative trajectory. The stories of the fragments ranged widely, from the curious to the mundane. The shows of rarities did not exclude but, in fact, promoted a curiosity for the ordinary and the everyday and were organized to provoke a distracted viewer's response. As in film, the show was involved in shaping both dominant and deviant views of social customs by way of dialogic montagist processes, to be imaginatively traversed. The cabinet did not simply display but produced responses to socio-sexual and ethnic mappings as it activated spectatorial imagings and architectural promenades. The polymathic curiosity cabinet and, ultimately, the museum created a phantasmagoric relationship between the displayed parts and their viewing public, engaged in peripatetic leisure. The protofilmic framed display—an interior fragment of a world view—was open for browsing in a real sense. It was reassembled by the viewer, who read it in conjunction with her own mental geography as she wandered at leisure around the space, both physically and psychically.

Working at the edge of the image, its dissolution into the next, and the ellipses of the assemblage, the prefilmic montage created by the spectatorial browsing of the collection invites re-collection. The art of memory—displayed as a *theatrum memoriae* in the cabinet—materializes in film's own process of imaginative display. Furthermore, the museographic spectacle of framed views, reframed in spectatorial projections, incorporates a kinesthetic itinerary, a form of "picturesque" voyage. Such was the *emotion*al spectacle—the itinerary of attraction—that was mechanically "re-collected" by motion pictures, which recreated their own kinesthetic travel effects.

This perambulating activity traveled from cabinets to museums to exhibition halls to film. The imaginative peripatetics typical of museum-going and its architecture of transit "translated" into film spectatorship, embodying its inhabited forms of traveling pleasure. This transfer occurred in the architecture itself of the theater. Theaters with lantern shows projecting "dissolving views," such as the one in the Royal Polytechnic Institution in London, looked like gigantic cabinets of curiosity and contained areas for browsing the collections, which included machines of the visible as well as scientific and traveling curiosities. In the theater, a mixed public of "*curieux*" and "*curieuses*" assembled: women strolled and wandered, craving the multifaceted pleasures of spectatorial itineraries, absorbed in sensuous layers of virtual traveling-dwelling.

GEOGRAPHY

The cabinet of curiosity participated in travel culture on many different levels. First of all, the notion of curiosity itself was associated with travel. Not only were virtuosi called "curious" travelers, but, as Krzysztof Pomian shows in his study of collections, the terms were interchangeable: a *curieux* was someone who traveled extensively and had "an inquiring mind" that would engage in the "curious sciences," where the visions of optics met geomancy, cabala, astrology, and magic.[58] In general, curiosity and travel became associated as a mental disposition. Curiosity came to signify a particular desire to know, which, for a period, was encouraged constantly to move, expanding in different directions. Such cognitive desire implies a mobilization that is drift. It is not only implicated in the sensation of wonder, as is often noted, but located in the experience of wander. A passionate drive is set in motion, for one is both moved by curiosity and moves in different ways to respond to it. As one explores a field in constant shift, the "feeling" of the passion of inquiry bears the texture of motion. Thus conceived, curiosity is revealed as a real epistemological passion—an affect that is an *emotion*. It is this "curious" path of the emotions that led from the cabinet of curiosity to the moving image, in a process of re-collecting the traveling curiosity.

Curiosity, as an impulse to wander, led to the discovery of curious things. In this respect, the authorial collecting principle of the curiosity cabinet, as well as

5.10. "Boîte de salon," a French optical box fashioned as an object of interior design, 1750.

the spectatorial itinerary and the textual fragments themselves, displayed several curious travel effects. One was expected to travel to visit the cabinets of curiosity. Moreover, browsing was often directed literally at objects of leisure and specimens of travel. Among these objects was the optical box, a specimen frequently exhibited in the modern cabinet of curiosity and in theaters for magic lantern projections of "dissolving views." In a doubled architectonic effect, framed views, architecturally housed in a box, were reframed and relocated in the cabinets.

Generally looked upon as mere "peep shows" or "perspective boxes"— names by which they are usually known—these optical boxes, as heirs to perspectival representation, have been restricted to the realm of voyeuristic visual pleasure.[59] In arguing for a critical shift from a spectator-*voyeur* to a spectatrix-*voyageuse*, I will rather call attention to the "architectonics" of the box and foreground its "moving" function in site-seeing. Looking at the box in a different way and reclaiming its geographical signifier can reveal other psychic aspects of its viewing pleasures, which do not exclude the female subject. Viewed as site, the box is revealed to be more than a mere toy for the male *voyeur*: it is a powerful machine of (e)motion for the spectator-*voyageuse* as well as for the *voyageur*.

Optical boxes functioned as an imaginative vehicle for travel, and these "traveling homes," in most cases, worked as moving apparatuses of cultural travel. Rather than solitary voyeuristic devices of perspectival origin, they should be seen as sites of a shifting geography. Generated at the intersection of the visual arts, architecture, and urbanism, they circulated this hybrid imagination. Furthermore, not unlike magic lanterns, they were moving maps of itinerant public spectacle. This was especially the case for a traveling optical box named in Italian *mondo nuovo*, literally, "new world." *Mondo nuovo* was a traveling affair and a particularly interesting manifestation of the phenomenon of a "nomadic curiosity." The name itself speaks of the travel effect involved and of the geographical nature of the precinematic form of site-seeing.

Different types of *mondo nuovo* began to appear in European cities in the early eighteenth century as a kind of itinerant curiosity.[60] The device was a viewing box of variable size and shape, often decorated and equipped with openings. As one looked into the box, fitted with devices of varying degrees of sophistication, it was possible to obtain a view or even sequence of views and to become absorbed in the panorama. Sometimes, several people could enjoy the spectacle at the same time through different openings. In the box known as "Italian motions," different

5.11. Sequence of daytime and nighttime city life in an optical view of Piazza San Marco, Venice, 1862.

compartments existed, each inhabited by a moving figure—an automaton—that "acted" out different moments of a narrative sequence.

The spectacle of *mondo nuovo* established a precinematic viewing space, a privately absorbed, public spectacle of narrativized motion. The subjects of this spectacle were often views of cities, depicted in spectacular ways. As in lantern display, a considerable part of *mondo nuovo*'s geography was made up of panoramic views, montage, and travel subjects—all elements that migrated into early film. This geography was a place where the aesthetic met the scientific gaze. Scenic aspects of the cities were particularly enhanced, as were elements of actuality and everyday life. Common subjects ranged from urban panoramas to promenades and various representations of street and garden life. Public and social events such as street or urban-garden festivals and other forms of popular spectacle were also included in the geographic diary. The images were engraved, colored, and animated, thanks to light sources capable of creating the total effect of traveling—of moving through space as well as time. The optical views were also capable of making the observer travel from day to night, establishing the very effects of geographic duration that were later used in early travel-genre films. Such a voyage was a matter of light. The viewer herself could activate time travel by manipulating the simple device (sometimes only a string) that operated the shift from daylight to nocturnal shadows. Holes punctured into the view would simulate lights glittering in the darkness of the cityscape. The spatiotemporal shift affected a peopled landscape. A crowd of city dwellers, a public of strollers, would often appear with the glittering night lights. Their presence transformed the very view of the urban *piazza* and further mobilized this forum. Through *mondo nuovo*'s shifting views, the city was prefilmically conceived as architectural travelogue.

As these descriptions suggest, *vedutismo* and *mondo nuovo* were very closely related. *Vedute* were used as models and were endlessly reproduced in this popular form of entertainment. This was the case, for example, in the famous views of the Venetian region by the painter Antonio Canal, known as Canaletto (1697–1768), which were themselves conceived as touristic souvenirs to incite subsequent voyages. *Mondo nuovo*'s views further popularized the art of view painting before film made it a definite form of popular culture. The views of *mondo nuovo* provided an architectural voyage, just as one experienced the architecture of the city in spatiotemporal motions. In this respect, *mondo nuovo* shows both a contextual and textual relation to the cinema and its space.

The itinerary of precinematic urban viewing taken by *mondo nuovo* engaged the city and travel not only as subject matters but also as geographic sites. The town was an essential "location," for it was the major place of reception for these urban views. As a public viewing spectacle, *mondo nuovo* appeared in the urban *piazza*, at street-corners, or in other sites of social gathering and public life. Like magic lanterns, the viewing boxes were moved around from place to place by itinerant showmen. Wandering entertainers would carry them on their bodies or in carts all over Europe. Small decorative versions were manufactured for home entertainment, in the guise of objects of design. *Mondo nuovo* was a portable pleasure.

The optical boxes were real pieces of urban architecture and interior design as well. Again like lanterns, which engaged the world of architectural tourism in such examples as Louis Aubert's *Lanterne Tour Eiffel*—a lantern built in the form of the Eiffel Tower for the 1889 World Exhibition—some examples of *mondo nuovo* were also fashioned as interior or exterior architecture, designed in the shape of furniture or constructed as buildings. There are a few *mondo nuovo* described as "cabinet" and "armoire" pieces, and some were made to look like a church, a gothic cathedral, or an elaborate medieval castle in scale. *Mondo nuovo* thus traveled a wide spectrum of the spatial emotion, from the privacy of the closet to public architecture. Even the shape of the optical device enhanced the type of site-seeing involved—a "fashioning" of the ways that space contains and unleashes an architectonics of desire.

Architectonically shaped, *mondo nuovo* "took place" in the city and in the interior design of the home, becoming part of its decor and furnishings. A traveling apparatus for city viewing, with its own architecture and located in the inner flow of urban sites, *mondo nuovo* foregrounded film's own architectonics—in particular, the architecture of the movie theater, a private viewing space that houses a form of urban popular spectacle. *Mondo nuovo* was a prototype of the movie "house," for, like the cinema, it was a spectacle of viewing housed in an architectural form that, in turn, inhabited the streets. Traveling was not only the effect of what one saw but of the architectonics of the spectacle. Interestingly, in a series of engravings made from 1753 onward by Gaetano Zompini, *mondo nuovo* was known as one of the *arti che vanno per via nella città*—an art that travels the streets of the city. Whether an armoire on the street or a public building in the home, *mondo nuovo* was private-public viewing. A public cabinet of the curiosities of the everyday, film inherits the very architectonics of this "new world." It is the new art traveling the urban pavement.

Mondo nuovo was a traveling spectacle open to women, as the cinematic promenade itself would be. Engravings from the eighteenth-century that represent *mondo nuovo* traveling European city streets reveal an audience of mixed social classes, genders, and ages, including a large public of women. The collection at the Museo del Cinema in Turin contains numerous examples that show women's involvement and fascination with this "new space."[61] In fact, it is mostly women who are depicted staring into or at *mondo nuovo*, sometimes taking their children along to enjoy the spectacle and to obtain a geography lesson at the same time. From the depictions of Pietro Longhi, Giuseppe Gamberini, and Giovanni Michele Graneri to the abundant series of anonymous representations of *mondo nuovo* in engravings and prints, this is revealed as an urban, womanly affair that cuts across class divisions. Interestingly, most representations that are set outdoors with a female public reproduce in their setting the very mise-en-scène of *vedute* and use the same codes of landscape painting. Large *mondo nuovo* occasionally traveled indoors as well, as seen in an eighteenth-century depiction that portrays the interior of a Venetian palace where ladies enjoy the show of *mondo nuovo* set up in-house. A form of view painting for the urban public, this architectonic medium was placed at

the crossroads of high and popular culture, private and public—the very threshold that produced the cinema and its own socio-sexual crossings.

Mondo nuovo established a practice that traveled all the way to early cinema in various spectatorial and textual architectures. As a traveling curiosity it even anticipated the era of traveling film exhibition in the early years of cinema, when showmen exhibited motion pictures in itinerant ways. Among them, for example, was Lyman H. Howe, who exhibited "moving pictures" in a program called "Lifeorama," hyperbolically billing himself as "America's greatest traveler."[62] The traveling exhibitions addressed motion as topos as well as topic, for many of the films exhibited itinerantly were travel movies. Existing in space and (dis)located in travel space, this practice addressed the making of realism: panoramas were taking shape as "lifeorama." Realism, a life spectacle, was being asserted, in movement, as a question of place. It was the movement of inhabited sites—a matter of lived and habitable space. A physiognomy of place was thus taking shape on the move. Traveling shows of moving pictures were housed in mobile architectures, sometimes actually called "traveling movie palaces." The effect was of "being there"—being, that is, in an elsewhere imaginatively retraversed as "now here." The heterotopia of the traveling movie palace was a traveling home: an inhabitable, mobile map; a nomadic, haptical fantasy; an itinerant atlas of the sense of place.

THE TRAVEL OF TRAVEL FILMS

Viewed both textually and contextually, the architectonics of the early travel genre and the filmic urban panorama—products of the age of panoramic vision—can be seen to have existed earlier in the spatiovisual constructions of the eighteenth century, including the travel effect of *mondo nuovo*'s shifting views and its urban appeal. As we have seen, early cinema expressed a definite topophilic viewpoint, especially in relation to urbanism, for the beginning of film was, generally speaking, an urban affair. The city inhabited it from topic to topos: both film texts and their reception were bound to it. Like *mondo nuovo*, early film was a form of urban voyage and observational geography primarily addressed to urban audiences. Both created a mirroring travel effect: from *mondo nuovo* to film, city views in motion were offered back to city dwellers.

In this way, a travel film such as Porter's *Pan-American Exposition by Night* (Edison, 1901) appears to be a direct continuation, in filmic terms and with the addition of movement, of the spatiotemporal travel effect of *mondo nuovo*. In this film about the turn-of-the-century exposition in Buffalo, New York, the camera pans across the esplanade and surveys the site. Through editing, a shift from a daytime to nighttime view occurs as the camera movement connects two different scenes. The city becomes nothing but a landscape of light as the buildings turn into pure shapes of glittering luminosity.

As the early travel genre attests, urban voyage is a form of imaging that moves between and across cultures, as well as through time. A version of *mondo*

nuovo appears as late as 1955 in a film by the Indian filmmaker Satyajit Ray. In his *Pather Panchali*, a traveling exhibitor arrives in the village where Apu's family lives. With the viewing box, he brings the world of the city to this rural site, attracting to the village square crowds of children who are eager to see views of the great Indian cities of Bombay and Delhi. The same youngsters who long for the "new world" of *mondo nuovo* also love trains and like to watch them crossing the landscape. Views of modernity shape the world of Apu. The desire for modernity—and its sites—is an important agent in this film. Imaged as a drive to travel, to explore space and city views, modernity is represented as moving image. In the world of Apu, modernity is site-seeing, the movement of traveling cultures.

GEOGRAPHY DRESSED IN "-ORAMA"

The nineteenth century witnessed the proliferation of spectacles offering simulated travel experiences, all designated by the suffix "-orama." As Stephan Oettermann argues in his study of panoramas, these devices originated from the discovery and experience of the horizon and from the idea that travel works at broadening one's horizons.[63] Various geographic pleasures were offered to a public that included women, sometimes even exclusively: when the Kineorama, a hybrid of the moving panorama and the diorama, burned in London in 1841, it was found that its public consisted only of women.[64] Through such devices, geography also entered the public sphere and women's daily activities: aquatints often showed women amusing themselves at home with optical instruments, being transported on imaginary grand tours, or using *vues d'optique* to teach geography to children.

The geographical nature of the panoramic curiosity was perhaps best epitomized by the *géorama*, which, standing between science and spectacle, was considered an effective tool for geography lessons. As described in its patent document of 1822: "With the aid of this machine, one could embrace in one single glance the whole surface of the earth: it consists of a sphere of 40 feet in diameter at the center of which the spectator is positioned on a platform of 10 feet in diameter, from which he discovers all parts of the globe."[65] The *géorama* was displayed in Paris beginning in 1823, and a new one, made on the same principle, was exhibited in 1844. A special garden version of the *géorama*, described as a "geographical garden of 4,000 square meters," was manufactured in 1874. Turning site-seeing into a haptic encounter with the environment, this type of geographical garden globe also appeared in Italy in the form of a landscaped globe, equipped with hydrographic and meteorological features for extra sensorial enjoyment.[66]

A version of the *géorama* was displayed in London from 1851 to 1862. The "Great Globe" of James Wyld (1812–87) became a most popular attraction, second only to the Crystal Palace, the famous architecture of iron and glass and the quintessential home of exhibition, which contained geography captured in fluid forms such as the marine landscape of the aquarium.[67] The geographical fantasy expanded further to include the exhibition of a globe of forty meters in circumference at the

Paris World Exhibition of 1889 and the geographer Elisée Reclus's proposal of an even larger globe for the 1900 World Exhibition, which visitors could circumnavigate by cruising its outer circumference on a spiral staircase or tramway.[68]

The Parisian *géorama* created an interesting geographical mutation as it looked ahead to the liminal configuration of cinema. Its interior was covered by a map of the world. Visitors entered the globe from the bottom and traveled upward from Antarctica, experiencing the universe in successive motion. As in a movie theater, "georamic" spectators traveled the world's surface—here, however, *inside* the space of the globe. The *géorama* performed an imaginary inversion and, in so doing, established a prefilmic route: as the world was turned outside in, exterior was made into interior. The *géorama*, a geographical machine, was one of the "-orama" traveling spectacles that preceded the cinema's own spectatorial "embrace" of space and particularly foregrounded the reversible architectonics of film theaters, especially those that played directly on atmospherics.

The geographic traveling aesthetic extended outward by the *géorama* had been previously conceived as an inward journey by the cosmorama. This precinematic space was a direct heir of *mondo nuovo*, whose geography it extended, and a slight variant on the better known panoramas and dioramas.[69] The cosmorama articulated the (e)motional pleasures *mondo nuovo* had envisioned by offering its own grand tour, which was architecturally constructed. It was a glorified, indoor version of the *mondo nuovo*—a *mondo nuovo*, that is, turned inward. Instead of being presented inside a box and traveling through a public space, portable-sized views of cities and landscapes were now exhibited on the interior of an architectural space. The spectator entered a semi-darkened room and, through a series of openings,

5.12. A world turned outside in: sectional view of the interior of James Wyld's "Great Globe," 1851.

5.13. Interior and plan of a cosmorama showing how to voyage in a room, 1821.

would enjoy a spectacle of views. These insets were inserted in the walls of the room and were enlarged by mirrors, lenses, and other perspectival and optical devices.

The cosmorama transformed the concept of architectural "aperture": windows were made into lenses. To enhance the effect of the representational framing, a black border was inserted between the picture and the lens. Sequences of panoramic and dioramic views were thus presented to spectators, who would pay a ticket to enter this public site. The imaging that once took shape by looking into a box could now also be seen by traversing a space, sequentially observing a spectacle of framed views. In the "Cosmorama Room," one was transported "straightway thousands of miles from home."[70]

The cosmorama made its first appearance in Paris in 1808 under the aegis of the *Societé des Voyageurs et d'Artistes* and soon spread to other European and North American cities. Indeed, voyage and art were essential components of its architectonics. The *cosmorama mouvant* was advertised as a "picturesque voyage." In this "reminder of travel memories . . . one would return to deep valleys once traversed, stop in front of waterfalls, cross creeks, climb mountain tops and icelands, descend into grottos and the abyss, without making any effort or incurring any peril."[71] The cosmorama favored topographical and architectural topoi such as landscape views and urban sites. Like other forms of miniature panorama, significantly called "Physical-picturesque Views" and "Voyage in a Room," it proposed this intimate kind of imaginary voyage.

In addition to Paris, the cosmorama was exhibited as the Cosmorama Room in metropolises such as New York, where it opened in 1815, and London, where it opened in 1820. Advertised to please a "cosmopolite society," it was a fashionable meeting place "for Idlers, Lovers, Young Folks, Amusement-seekers,

Ice-eaters &c. &c. &c." According to the publicity: "Here, by looking through a glass, you can see Mont-Blanc as true as reality. . . . From a view of the great Square at Cairo the transition is momentary to a nice little square cake; and from contemplating the ruins at Palmyra in the Desert, the twinkling of an eye transports you to the demolition of jellies in this place of abandon."[72] Indeed, the Cosmorama Room introduced the essential architectonics of film, in which the absorption of images went hand in hand with food consumption. Like the film theater to come, it included a kind of concession stand where refreshments were available to the spectators. Idlers could consume other items as well, such as art objects—images available for show and sale. The Cosmorama Room linked the activity of watching to shopping and eating. The spectator was fundamentally absorbed by images and, in turn, absorbed them. It is not by chance that one of the byproducts of this spectacle was called the Physiorama. Enhancing a prefilmic sense of ingestive pleasure, the cosmorama became an attraction at bazaars: view shopping became an annex to window shopping and thus showed that those two phenomena are connected. The peripatetic form of viewing—indeed, devouring—images established by this "-orama" room included an immobile spectatorship as well; this geographic-architectonic construct thus clearly foreshadows the architecture of film theaters. In Cosmorama Rooms, the itinerant prefilmic spectator could sometimes sit on chairs to take in the view of the "physioramic" picture show, displayed in a prefilmic house of pictures.[73]

HOUSING PICTURES

The design of the Cosmorama Room followed that of another prefilmic space, the Eidophusikon, which had opened thirty years earlier, in 1781, and also inspired nineteenth-century cycloramas. The Eidophusikon, invented by the painter and set designer Philippe Jacques de Loutherbourg (1740–1812), was a mimetic spectacle that added motion, time, and three-dimensionality to pictures, which were presented as a series in movement in a darkened room.[74] Spectators watched moving views of landscapes in a large theatrical stage-box. A *mondo nuovo* with moving pictures, the Eidophusikon presented mobilized views of an ever-changing topography that spanned the globe. One sequence took the spectator-passenger from London to Tangiers and Gibraltar, and then onto Naples, ending with a moonlit night in the Mediterranean disturbed by a storm at sea. North America and Japan featured in other sequences. The spectacular lighting of the show was often accompanied by sound effects, with the aim of giving audio-visual texture to the locations portrayed and adding a "picturesque of sound" to the lighting effects of the mechanical action. Derivative versions of the Eidophusikon, the "Mechanical and Picturesque Cabinet" and "Mechanical and Beautiful Picturesque Representations," made apparent the picturesque nature of the spectacle. The Eidophusikon traveled to America, where it was first known as "Perspective Views with Changeable Effects" and then simply as "Moving Pictures."

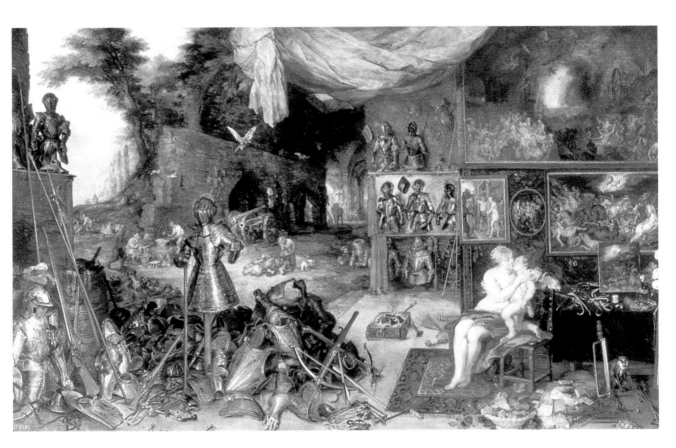

Plate I. Jan Brueghel,
Allegory of Touch, 1618.
Oil on wood.

Plate II. *Emotions*: the
movement of passions painted
on glass for magic lantern
shows, c. 1750–1800.

Plate III. Panoramic wallpaper:
interior decor envisions *Les
Grands Boulevards de Paris*,
c. 1855.

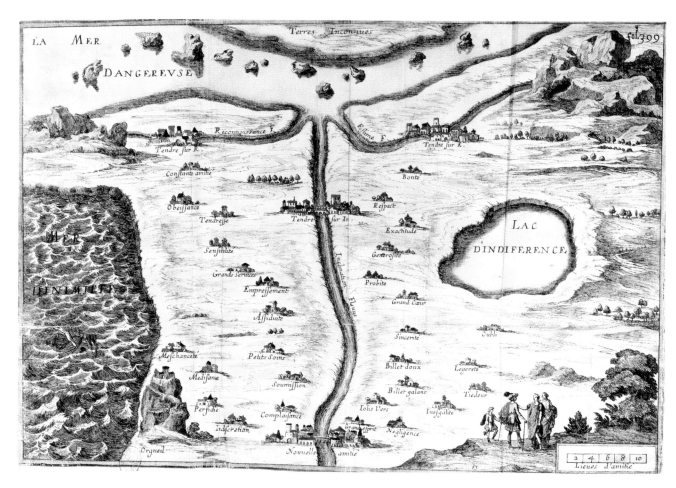

Plate IV. *Carte du pays de Tendre*, the map of tenderness designed by Madeleine de Scudéry in her novel *Clélie*, 1654. Engraving by François Chauveau.

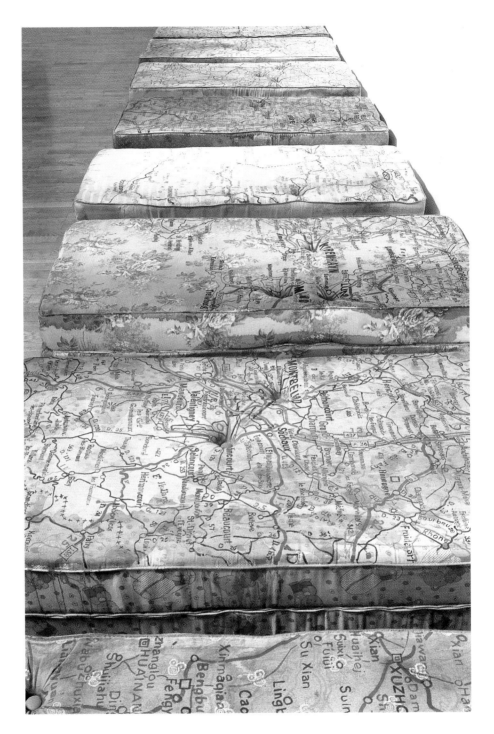

Plate V. Maps of emotion: a
bedroom story in Guillermo
Kuitca's *Untitled*, 1993. Acrylic
on 60 mattresses. Detail of
installation at Whitechapel Art
Gallery, London.

Plate VI. A gallery of *emotion*al
maps in Guillermo Kuitca's
Untitled, 1992. Acrylic on
mattress with wood and bronze
legs, 20 beds.

Plate VII. Screening history
while traversing a "gallery"
of maps: Galleria delle carte
geografiche, Vatican Palace,
Vatican State.

Plate VIII. Jan Brueghel, *The Senses of Touch, Hearing, and Taste*, 1618. Oil on canvas.

Plate IX. A taste of touch in
Peter Greenaway's installation
Watching Water, Venice, 1993.
Interior view.

Plate X. An archive of
habitation: view of Doris
Salcedo's untitled installation
at the Carnegie International,
Pittsburgh, 1995.

Plate XI. Haptic texture in
Gerhard Richter's *Atlas*
(1962–present). Sheet no. 93:
Photograph Sections, 1970.
9 color photographs. Detail.

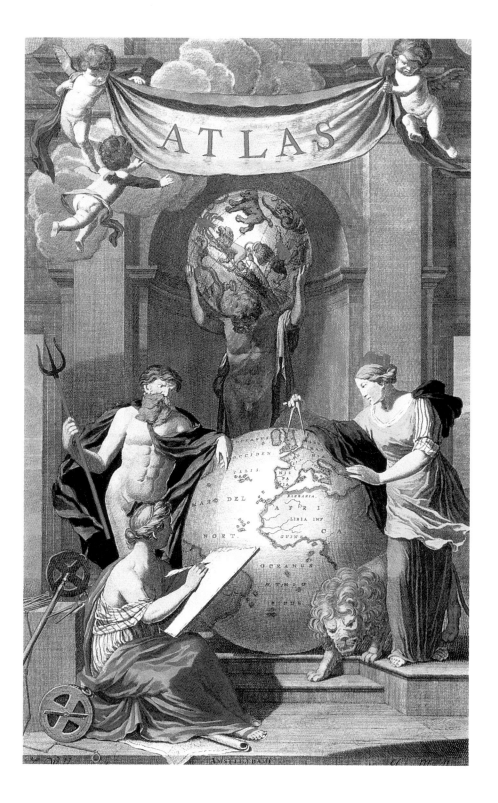

Plate XII. A different kind of "Atlas": Women design the world on the frontispiece of Jan Barend Elwe's *Atlas*, 1792.

Plate XIII. Of flesh and bone:
Guillermo Kuitca, *Untitled*
(Torino), 1993–95. Mixed media
on canvas.

Plate XIV. House as airport in
Guillermo Kuitca's *Coming Home*,
1992. Acrylic on canvas.

Plate XV. Refocusing the journey
of dwelling: Seton Smith,
Curving Windows and Stairs,
1996. Cibachrome print.

Both the homing and the roaming effect of the "movie house" are evident in the Cosmorama Room and the Eidophusikon, architectural homes of the pre-filmic in which the play of traversing interior/exterior takes place. Thus the box of *mondo nuovo*, exhibited in the public city square, is transformed in an interior public architecture—a room with a view—before it becomes the cinematic *camera obscura*—that dark "room" of public privacy that is the cinema. The film spectator takes shape as an inhabitant of a viewing box. A consumer of views, an intimate voyager, she is "moved" by the landscape of traveling cultures.

DRESSING THE INTERIOR: FILM AS PANORAMIC WALLPAPER

Conceived as movement in the architecture of the interior, the genealogy of film draws on a number of such architectural formations and tours. The movie theater, itself a room with a view, is not a singular architecture but one inscribed in the changing histories of the interior. Travel is one of the ways in which the barrier between interior and exterior is broken, as it blurs their rigidly defined architectures. As a liminal space between interior and exterior, cinema is the architecture of an "in-between"—traveling architecture.

The voyage that such moving architectonics enables includes a multiple *transito* between space and the body. Film makes space between architecture and the body; it is about this *emotion*al passage. In this respect, alongside the many forms of moving views and "-orama" spectacles, we should also investigate other "architectures" in search of filmic clues. In particular, interior design, decor, and decoration must be considered when thinking about film and its genealogical scenography, for they helped to "fashion" the cinema as well.

A particularly interesting case of an architecture that fashioned film is the *papier peint panoramique*.[75] Panoramic wallpaper was a design trend that appeared in Europe in the late eighteenth century. At the time, frescoes and tapestries were

5.14. Panoramic wallpaper: interior decor envisions *Les Grands Boulevards de Paris*, c. 1855. Detail.

being superseded by wallpaper that adorned rooms with various imagery, especially landscapes. As the interior preserved in Pompeii's Villa dei Misteri shows, frescoed walls had always provided a form of architectural doubling and a meta-architectural journey. Decorative painting was fashionable in ancient Roman times and resurfaced with an illusionistic touch during the baroque period, when ornamental paintings, often representing architectural elements, covered the ceilings and walls of churches and palaces. *Trompe l'oeil* techniques pervaded interior design as wall painting became fashionable in the decoration of the home. The eighteenth century saw the rise of the garden room, where the boundaries of the covered surface eventually expanded into a total view. Wall decoration in the nineteenth century added a new, comprehensive dimension to ornament. Initiated by Joseph Dufour, Jean Zuber, and others, this new fashion, in which wallpaper panoramically covered all walls of the room with imaging, grew tremendously in popularity, supplanting painting and tapestry.[76] Panoramic wallpaper reframed the inside as an outside. As the sole decorative element of the room, it was an architectural feature by which exterior was made interior.

What took shape in the interior of nineteenth-century homes would later "take place" in the space of the movie theater. The *papier peint panoramique* not only foregrounded the cinematic mode of production but, as a composition structured rhythmically in a series of *tableaux*, exhibited film's new form of spatial representation. Scenes followed one another without repetition, developing a description of a landscape or unfolding a story. Ruptures occurred along the way, for the sequence of images attached to the wall was made of separate panels, each carefully framed. The panels were bound together by structural elements formally conceived to create (dis)juncture and to provide the effect of sequential continuity. Imaginatively sutured, the borders of the depicted scenes were designed so that the wallpaper would appear as a constant flow of images, seamlessly unfolding along the walls. A film before cinema, panoramic wallpaper—a moving chain of views— was the product of edited images: fragments of visible space rendered as panoramic vision. The cinematic framing of shots and the process of their sequential montage was thus architecturally born along the house wall before migrating into the movie "house."

The *papier peint panoramique* fashioned the panoramic drive that film would mechanically reproduce; striving to achieve this vision, it stressed the horizontal dimension of its visual horizon. It invited the gaze to make a tour around the space. The borders of the walls exploded in this form of representation, where images enveloped a viewer's body in space. As in film, here the beholder is the

inhabitant of a space: someone living in a (private) space, who, looking at an interior/exterior, projects her own interior space onto the wall/screen. Like a film viewer, such an inhabitant-spectator is also a passenger. Immobile at the center of the representation, the spectator-passenger is embraced by the composition and transported by the circular flow of images.

The convention of the inhabitant-spectator-passenger was architecturally established before it became a cinematic practice. A body at home was made to travel. Ubiquity inhabited a single room. The drive of the apparatus to journey was enhanced by the subject matter of panoramic wallpaper, which depicted scenes of travel, discovery, and adventure as well as narrative representations of history, mythology, and natural scenes. Particularly popular were views of cities; garden views and other forms of landscape architecture; remakes of exterior architectural styles; and historical revisitations of interiors, with the reframing of architectural elements (such as windows, doors, and passageways) in panoramic form. Landscapes dominated in a design that focused on the description and observation of places. Innumerable Italian scenes were produced, covering aspects of city life and picturesque angles.

The stylistic conceits of such wallpaper ranged from the domestic and the familiar all the way to the exotic. This aspect of the history of wallpaper has been

5.15. Ladies' panoramic interior in Wilhelm Rehlen's *Le Salon des princesses Sophie et Marie de Bavière à Nymphenburg*, c. 1820.

tackled in a compelling architectural installation entitled *Taste Venue* (1994), by the African-American artist Renée Green, who shows how decor intimately takes part in the making and undoing of colonial discourse. A force in the effort to decolonize and rewrite the peripatetics of home as well as peripatetics *at* home, the wallpaper, with its "world tour" (the title of another of the artist's installations, from 1993) functions as one of what Green has called the *Sites of Genealogy* (1990).[77]

With panoramic wallpaper, a wide-ranging invitation to travel, including an anthropological expedition into domination, was extended to the inhabitant-spectator. A prefilmic offer to travel without leaving the room was the prominent message of the panoramic wallpaper, which enacted a domestic form of the *voyage pittoresque*. As a manufacturer of this interior tour wrote in a booklet:

We thought we may inspire gratitude for having assembled, in a clear and comfortable fashion, the multitude of people that the immensity of seas separates from us. This way, without leaving his apartment, with the views brought home and revolving around him, the studious man shall pretend to be in front of characters.[78]

VOYAGE AROUND MY ROOM

Like a library, the room outfitted in panoramic wallpaper contained an imaginary universe. It was itself a library of images, an encyclopedia of traveling images. As the views that featured regularly in this panoramic vogue obsessively depicted sites and their customs, a form of travel report came to tower in the wallpaper library as much as it did in the libraries of the period. Panoramically conceived, location became a site of history, for this prefilmic scenography narrated with space. As spatial narrative, the panoramic wallpaper read the story of a landscape as it read history in the form of a

5.16. Cinema before cinema: moving images unfold from an apparatus used for rolling panoramic wallpaper, 19th century.

location. Like a film, it offered a panorama of history via geography and, in this way, helped forge the shifting narratives of the historical landscape.

The landscape at stake was the very history of private life, for the home was the location of travel. Traces of history were written on the walls of the interior; the world was "at home" in the decorated walls of the house. In turn, the evolving narrative of the interior inscribed itself onto the vast horizon of the panoramic gaze. The spectator of mythological scenes or historical travel was the agent of a family history: the walls contained her history as well, acted out in their interiors and drafted onto their surfaces. An inhabitant-traveler, she was both en route and in place. As living rooms and dining rooms opened themselves outward, panoramically traveling elsewhere, the enclosure of the interior collapsed. Before glass architecture redefined the space of privacy and Le Corbusier's horizontal window opened it to view, decor effected a transformation of the interior. The private became engaged with the public in a mirroring effect that, multiplying and diversifying the terms of the relation, transformed them both.

It was out of this transformation that a new subject emerged, housed in the movie "house." The public panoramic apparatus was produced as domestic space and engendered new forms of private life before it became cinema. In the shape of decor and domestic scenography, such a set "fashioned" the interaction of private and public space and their joint evolution. A screen on which a passage between interior and exterior took place, panoramic wallpaper acted as prefilmic screen, "surfacing" film's own geography of *transito* —the "in-between" of interior and exterior.

Panoramic wallpaper, to an even greater extent than panoramas and dioramas, acted directly on the border of the private in a way that closely resembles filmic space. Both are border geographies, born on the brink of the inscription of the panoramic horizon onto the interior. Appropriating the exterior for interior use, both act out a form of domestication. Their ethnography is everyday life. A subject of insistent investigation in prefilmic forms, the everyday became early film's own anthropology. Actualities and travel films constantly returned to the subjects of nineteenth-century wallpapers and to their sense of being "on location." The familial engaged the foreign. The observation of different ways of life—a history lived as geography—was refashioned as filmic travelogue.

The geography of the interior was reaffirmed and transformed as the voyage around one's own room became cinema. Indeed, panoramic wallpaper was a form of decor—a mise-en-scène—that enabled one to venture outside by staying inside, to be in one's own room and yet, at the same time, in an imaginative elsewhere. Such a heterotopic architectural effect foregrounded the very "transport" of the cinema. A panoramic interior architecture, film is also a wall inscribed with pictures, a wall that is also a window and a screen. Bound to domestic architecture and its forms of travel, the moving image is a contemporary panoramic wallpaper. Its "fashioning" took place at the intersection of architecture and geography, a mapping that traversed various forms of interiorized space. This included the formation of the picturesque imagination in its various traveling incarnations. Let us now turn to this *emotion*al movement.

6.1. Giovanni Paolo
Panini, *Picture Gallery
with Views of Modern
Rome*, 1757. Oil
on canvas.

6 Haptic Routes: View Painting and Garden Narratives

Why couldn't we have the windows of our living room open onto a diorama, representing a beautiful landscape. . . . It would be wonderful to change the view from one's window once a month—to go from Rome to Naples, from Naples to Messina, or wherever we like, without having to move.

Théophile Gautier

What does travel ultimately produce if it is not, by a sort of reversal, 'an exploration of the deserted places of my memory'. . . something like an 'uprooting in one's origins' (Heidegger)?

Michel de Certeau

As a form of panoramic wallpaper, cinema had its spatial roots in the new "fashions" of spatiality that marked the rise of modernity. In pursuing the movement that was taking place in forms of cultural traveling, we traverse a terrain that extended from topographical view painting and cartography to landscape design and, eventually, panoramic vision. As it was located and dislocated, vision was being transformed along the route of mapping. The new pleasure was not the effect of an incorporeal eye, for it was a "matter" of space. The eye/I that was designing—"fashioning"—the new visions was a traveling one, which craved spatial expansion. As space was absorbed and consumed in movement by a spectator, a new architectonics was set in motion: a "picturesque revolution" that was born of setting sites in moving perspectives, expanding outward to incorporate ever larger portions of space. The new sensibility engaged the physicality of the observer, challenging her ability to take in space and more space—a mobilized space.

During the eighteenth century, the production of travel discourse began to grow and took on a variety of forms, from literary to visual and spatial configurations. Journey poems, view paintings, and garden views were among the new forms of shared spatiovisual pleasure. They combined a sensualist theory of the imagination with the touch of physicality. A haptic consciousness was being produced. The broadening of visuality inaugurated at this time was essentially about changing the way desire was positioned: it effectively "located" desire in space and articulated it as a spatial practice. Speaking of the increased yearning for capturing sites in the form of (panoramic) views, the historian Alain Corbin writes:

The debate continued for some time about the sources of this fabulous broadening of vision. . . . The Italian vedute *had learned to take a comprehensive view of their cities, and for ages tourists had rushed to take in the Bay of Naples from the terraces*

overlooking the city. . . . The 'prospect view' offered a pleasure, combined with walking and the ideal day, that gave rise to a new way of seeing.[1]

Scanning sites and cityscapes, moving through and with landscapes, this opening of spatial horizons fashioned spectacular spectatorial pleasures. The "collective attraction for views" was another of the forces that shaped the cultural movement which proleptically led to the cinema.[2] The new mechanisms for spatiovisual (e)motion, that is, expressed the desire for the moving image. It is interesting to note that, without speaking directly of the cinema, Corbin himself partakes of filmic language in describing the new emotion:

Taking in the panorama with a sweeping glance, evaluating its variety, . . . letting the eye slide from distant horizon down to the foreground in a sort of travelling shot *[my emphasis], and learning to expand the depth of field of one's vision were so many new delights for enthusiasts.*[3]

This description of the effects of the eighteenth century's new ways of seeing could easily apply to the cinema, for such mapping of space foregrounds film's own moving views and "traveling shots." Like the tourist confronting a panorama and the viewer addressing a view painting or a panorama painting, the film spectator holds a sweeping glance that is capable of seeing difference. It can slide from the expanse of distant horizons to extreme close-ups. Exploring space from background to foreground, film technique has indeed expanded our "depth of field."

The origins of such observational technique is linguistically apparent. Film language speaks literally of travel space, as the French word for camera movement, *travelling*, attests. It is not by chance that a circular camera movement around an axis is known in French as *panoramique*, in Italian as *panoramica*, and in English as "pan." Train travel is clearly written into Anglo-American film language, which uses the expression "tracking shot" for a type of camera movement that actually incorporates tracks into its physical execution. Along all axes, film moves panoramically.

Such cinematic motion descends genealogically from the traveling history of spatial phenomenology—that is, from the fascination for views and the physical hunger for space that led the subject from vista to vista in an extended search for urban and spatial emotion. Spatial curiosity and the pleasures of site-seeing were consolidated in eighteenth-century travel culture, which designed a route that ranged across topographical views and maps to the architectonics of gardens and led to the opening of travel to more people, the circulation of travel narratives, and the rise of a leisure industry. This included travel to resorts and spas as well as the amusement of peering into cabinets of curiosities and browsing through the composition of natural settings or their depictions. Moving along the path of modernity from view painting to garden views, from travel sketches to itinerant viewing boxes, from panoramas and other geographical "-oramas" to forms of interior/exterior mapping, from the mobile views of train travel to urban streetwalking, the subject was "incorporated" into motion pictures. It is this moving, haptic space that created the (e)motion picture and its spectator—a body who is indeed a "passenger."

RETRACING TRAVELING SHOTS

All bodies that move rapidly appear to inscribe their trajectory with a trace of their own colorful texture.
Leonardo da Vinci

In many ways connected, geography and the body share a tangible territory: the terrain of lived space. Beginning in the eighteenth century, the domain of physicality was designed at the intersection of inside and outside. Links were established, for example, "between the city and the new science of the body," as Richard Sennett shows in his urban history of "flesh and stone": "The Enlightenment planner emphasized the journey. . . . Thus were the words 'artery' and 'veins' applied to city streets by designers who sought to model traffic systems on the blood system of the body."[4] The analogy between the motion of the city and the circulation of bodily fluids was defining a new mobile and haptic mapping.

By the late eighteenth century, the picturesque movement established its own sensuous field of action in landscape design and pictorial views. The picturesque model established a "sense" of space, derived from, among other things, the philosophical tradition of John Locke. At the same time, however, as Barbara Stafford claims, another movement sought a more factual approach to spatiality.[5] This way of picturing landscape culminated in the realistic tradition of the nineteenth century. Both sensibilities intertwined in a plurality of hybrid forms, however. In their different ways, each enhanced the vision of space, calling attention to location—a matter that cinema would make one of its own generative landscapes.

The expansion of spatiality continued in the nineteenth century's mechanized version of the traveling eye and its effects of site-seeing. The passion for traveling, in the words of urban historian Christine Boyer, meant "simultaneously perceiving travel narratives, history books, historical painting, and architectural ruins to be modes of vicarious travel through time and space. . . . Traveling, visiting museums, studying maps, gazing upon architecture, and even observing a city's plan were all optical means by which the beholder organized his mind and his visual memory."[6]

The passion for traveling created a new field of observation that connected diverse spatiotemporal configurations and turned them into a new map. An equally new observer emerged from these moving pictures in the persona of the film spectator. Such a spectatorial body—produced on the cultural map of modernity—had protofilmic roots in the history of spectatorial paradigms, configured of effects from the eighteenth century's visions of space. "The quester after fact" and "the seeker after sensations" found a meeting place in the hybrid realm of the moving image.[7] Motion pictures—the realm of (e)motion—wed the voyage of the analytical imagination to the pursuit of sensual pleasures. The diverse geographic directions of early modernity merged in film's haptic way of picturing and experiencing space. Film established a topographical "sense." It was a geographic attraction turned *emotion*.

CARTOGRAPHIC VIEWING

To understand the origins of the moving image's *emotion*—its analytical "transport"—we must return to the mid-eighteenth century and its aftermath, which witnessed the flourishing of topographical and view painting. The effect of these forms was to carry away—transport—the spectator into the landscape or cityscape depicted, powerfully creating the feeling of simulated travel. The art of viewing sites assumed widely varying forms, from the display of architectural sites as emotional matters, in the tradition of the Neapolitan artist Salvator Rosa (1616–73) and others, to a more descriptive, representational mode that circulated widely as paintings, prints, and illustrations in travel accounts and also as atlases and topographical mappings.

Vedutismo was a particular incarnation of the observational gaze.[8] Foregrounded by a growing interest in architectural forms, paintings of city views were recognized as an autonomous aesthetic category in the late seventeenth century. The *veduta* evolved from a veritable pandemic of urban imaging and *furor geographicus* that, from the fifteenth century onward, had taken the form of book illustrations, drawings, prints, and paintings. Illustrated topographical books, which included histories, travel reports, geographic surveys, and atlases, were instrumental in establishing a taste for viewing sites. The *veduta* itself is inseparable from the history of the grand tour.

The Italian *veduta* used different codes in its description of the city than, say, the Dutch city view.[9] In the *veduta*, the portrait of the city was environmentally shaped in a type of staged representation that transferred the codes of landscape painting to the urban terrain. Masters of this type of representation included Canaletto (1697–1768) and Giovanni Paolo Panini (c. 1691–1765). Working closely with topographical representation, this genre of view painting emphasized the drama of location; the portrait of the city in Italian *vedutismo*, that is, tended toward a narrative dramatization of sites, characterized by a heightened and tactile texture of place.

As they merged the codes of urban topography and landscape painting, city views also incorporated the cartographic drive, creating imaginative representational maps. The city was approached from different viewpoints. These ranged from profile and prospective views to plans, map views, and bird's-eye views, which were often even combined in topographical views. As was often the case even in traditional cartography, factual accuracy was not the aim of these urban views, which exhibited an interest in rendering a mental "image of the city" and proposed not one "cognitive mapping" but diverse observational routes.[10] If imaging a city involves a cluster of diverse maps that are inhabited and carried around by city dwellers within themselves, view painting, in turn, inscribed this moving, inhabited space within its mapping of the city. As the Genovese humanist Antonio Ivani wrote, back in 1473, about a partial view of his city that he sent to a Florentine friend: "[the representation] shows not the whole city, but only parts which meet the need of writers, with the sites [shown] in such a manner as occur [to one] in connection with a

narration."[11] Urban portraits portrayed a haptically lived city and presented it for further *transito* and spectatorial inhabitation, for there is always more than one embedded story in "the naked city."

City views were in many ways an object of the everyday narrative of urban life. As suggested in an eighteenth-century catalogue description for a printed view of London, city views were considered a "cheap and proper ornament for Halls, Rooms and Staircases."[12] In addition to mapping the exterior, city views interestingly participated in the history of the interior, following the "domestic" use that had been made of world maps. From the sixteenth century on, maps were produced in great numbers as objects of display suitable for wall decoration and thus became a feature of domestic interiors, together with other cartographic objects.[13] Atlases brought the world into the domestic space as well, while the globe reduced it to a miniature size, easy to "handle" in one's own home. From wall maps to atlases to globes, ornament and mapping progressed hand in hand.

It follows that city views also became a feature of domestic urban life, participating in the history of exhibition and private life. Urban views even migrated from forms of architectural decor and decoration all the way to the decorative arts where, from the mid-eighteenth century on, they appeared as illustrations on domestic objects. They entered table manners in the form of embellishment on plates, bowls, glasses, cups, and trays and illustrated the tops of dining room tables or were inscribed on their surfaces. They "illuminated" pieces of furniture such as writing desks and decorated ladies' jewelry boxes and fans. City views traveled from the outside to the inside, mapping out the space of the domestic interior and, in so doing, taking part in the liminal passage that marks "domestic" cartography.

Although the realm of city views cannot be collapsed altogether with cartography, which became an independent genre by the seventeenth century, the history of urban views certainly parallels that of artistic maps and interacts with it in many interesting ways. Like mapmaking artists, visual artists who painted views made use of optical instruments such as the camera obscura or the perspective glass, and a cartographic impulse pervaded the form in all its manifestations. Although city views were not necessarily the same as plans, they shared the representational terrain of mapping. Views were often made as prints and published by mapmakers, and thus maintain a direct link to cartography. Even when the artist was not a

6.2. A lady's viewing accoutrement: fan displaying a scene of the Grove at Vauxhall Gardens, London.

cartographer, or the cartographer was not an artist, representations suggest that the metiers were considered interchangeable. Rather than two different domains, the aesthetic and scientific realms were merged in the cartographic art. In general, cartography and the art of viewing, which included landscape painting, interacted in the development of notions of space as well as attitudes toward space. Throughout their history and in their many manifestations, city views established a form of site-seeing: they endeavored to extend the limits, the borders, and the perspective of picturing into an act of mapping.

The art of viewing followed the older touristic drive to survey and embrace a particular terrain: the compulsion to map a territory and position oneself within it that led to the climbing of church towers, mountains, and buildings to take in the panorama. From the beginning, the city view adopted this practice and transcended its real-life limits, as shown, for instance, in the *Bird's-eye View of Venice* attributed to Jacopo de' Barbari, one of the earliest and most significant examples of the panoramic view, produced back in 1500. The all-embracing view was not a totalizing vision in this multi-sheet mapping of the city, which was designed for wall decoration and is speculated even to have served touristic aims. As the art historian Juergen Schulz claims, this was an impressively imaginative enterprise of topographic rendering, for the overall view was assembled from a number of disparate drawings made from different high points throughout the city.[14] There is no clear focal point in this imaginary view, which is rather constructed as a montage of dif-

6.3. Jacopo de'
Barbari, *Bird's-eye
View of Venice*, 1500.
Woodcut.

ferent vanishing points. The observer is not fixed to a position or to a set distance but appears free to wander in and around the space.

Generally speaking, the bird's-eye view was an imaginary perspective, taken from an impossible viewpoint that was neither the actual high point of the real surroundings nor the ground, but above the supposed vantage point and tilted. From Leonardo da Vinci's early attempts to turn earthbound observation into aerial vision—in his oblique map of Milan, anticipated by his panoramic landscape drawings—this cartographic measure was a product of the creative imagination of the artist-cartographer.[15] With a number of possibilities open, the artist-cartographer could take the road suggested by Louis Marin, who claims that "a bird's-eye view gives us a 'snapshot' of the city."[16] But however conceived, the bird's-eye-view was a permeable place of encounters between the map and the landscape, where a number of (im)possible itineraries were inscribed. Often dismissed as a teleological perspective or mistaken for a "cognitive mapping" from a superior eye, the bird's-eye view bears reconsideration: it was not a totalizing perspective but a view from "nowhere" and "now here." This imagined dislocated view, made possible much later by the spatiovisual techniques of cinema, attempted to free vision from a singular, fixed viewpoint, imaginatively mobilizing visual space. The scene of the bird's-eye view staged a fabricated spatial observation that opened the door to narrative space.

Here, the city could become part of a sequence of imaginary surveys, including the traveler's journey. The view described the city as an integral part of cultural travel and inscribed it into the very trajectory of this voyage. A geographical rendering of the imagination, the bird's-eye view was an imaginary map for both those who knew and those who had never seen a city; both spectators found the site described in a mobilized form. The wide vistas of prospect and profile views also functioned in a way that pushed perspectival boundaries. These vistas strove to overcome the limitations of perspective by creating a wider horizontal expanse, often made of aggregate views, that eroded the notion of a single, prioritized perspective.

Thus the image of the Western city expanded, "unlimiting the bounds of painting."[17] Such expansion—rupturing the containability of borders and frames—made it impossible for the ideal city of Renaissance perspective to remain representationally intact, to be captured in a single image. In the eighteenth century, urban *vedute* were produced in several parts, even as different viewpoints. The image of the city underwent an intense process of fragmentation and multiplication before being refigured in the all-embracing views of the panorama, which extended the very borders of the frame. As architectural historian Cesare De Seta suggests, "the urban organism shatters in multiple views."[18] The body of the city is cut into partial views and a fractured montage is set in motion, written on a serialized body-city.

Such montages of views, combined with the panoramic impulse, spoke of things to come: motion pictures. By presenting multiple, mobile perspectives and suggesting a mobilized observer, these urban views exhibited a protocinematic attempt to extend and expand the field of vision itself. It is no wonder that prefilmic apparatuses such as *mondo nuovo* translated *vedutismo* into a popular visual terrain,

*trans*porting it into the realm of shifting streetscapes. It was this cartographic mobilization of perspective, inscribed in the movement of and attraction to urban imaging, that eventually became the "transport" of motion pictures.

MOVING BEYOND PERSPECTIVISM

Thinking by way of such cartography allows us to re-view the place of motion pictures in representational history, moving beyond the confines of classic perspective into a different, mobile architectonics. Advocating architectural representation beyond perspectivism, Alberto Pérez-Gómez and Louise Pelletier have made a brief but significant reference to film in this respect. "The shadow of cinematographic projection re-embodied motion and retrieved tactile space from the perspective frame," they argue. "Film offered a possibility to transcend the limitations of the technological, enframed vision through the juxtaposition of different realities."[19] By adopting an architectural view of film space and investigating the cartographic dimension of this site-seeing, we see that filmic language—a corporeal disruption of static, absolute vision—is a deviation from perspectivism. Vision in film is not fundamentally determined by the distance between the eye and the objects viewed, as in the linear perspective of Albertian Renaissance representation and its model of optics. Cinematic vision bears the destabilizing effect of a shifting, mobilized field. The product of the history of space, filmic space is a terrain of shifting positions—the product of multiple, incorporated, and mobile viewpoints.

First, it must be said that not all perspective drawing was equally constructed to affirm the unity of a body in space. Some artists did not fail to acknowledge a shifting vision or the embodiment of the beholder. A particular case is found in the history of Dutch art, which exhibits, insofar as perspective is concerned, an instance of protofilmic spatiality in the perspective drawings of Jan Vredeman de Vries (1527–c. 1604). The most important Dutch master of perspective, de Vries was an architectural designer as well as a painter and graphic artist who produced a fascinating body of engravings on architecture, ornamental design, and gardens, among other subjects. His book *Perspective* shows a variety of architectural spaces rendered in imaginative ways.[21] De Vries's work was influential and had a particular impact

Film space is not quite the homogeneous space of classical unified central perspective, which has been pictured as if, existing in front of the body, it could be seen "with a single and immobile eye," as Erwin Panofsky put it, relating perspectival to cultural views—an eye external and prior to the representation.[20] As a heterogeneous space comprised of constantly moving centers, the moving image "embraces" the shifting trajectories of psychophysiological space, where the spectator-passenger is mapped within the landscape. To trace the genealogy of such a psychospatial dynamics, we must therefore move away from the Albertian perspectival model and continue to search in different directions for filmic incarnations. This includes exploring different perspectival histories as they correspond to different cultural visions.

6.4. Narratives in moving perspective: the inhabited architecture of Jan Vredeman de Vries's *Perspective*, 1604–5.

on illusionistic architectural imaging. His drawings produced a spatial effect which the art historian Svetlana Alpers, in her foundational work on Dutch art and "the art of describing," calls an "adding-on of views of the moving eye."[22] Mapping the viewer in this cumulative motion, his perspective prefigured filmic scenography.

De Vries's architectonics included the inhabitant or intruder of the space in its representation. In creating such inhabited spaces, he presented diversely embodied perspectives. In one architectural engraving, for example, we discover a naked body lying on a (perhaps anatomical) table, its feet facing the viewer as in Mantegna's *Dead Christ* (1500). The figure, at the center of the vaulted space, narrativizes the architecture, setting it in motion and propelling the tectonics of the building into diegetic movements. We wander as we follow de Vries's corporeal architectural tales, viewing sequential vistas.

In another of de Vries's perspective drawings, an architectural interior is uncannily animated. A body lies on the floor—or is it a corpse? Clothing ornaments draw attention to this mysterious figure while suggesting drops of blood or tears. On the right, a door opens, revealing a person about to enter the space. At the bottom of the room, another door opens wide to let someone else in. The site is spare, unadorned, and marked only by points of entrance and exit. These passageways— including one more door and four windows—have all been opened. As in a film, this arresting drawing communicates the suspense of a spatial narrative. Something has happened. Nothing is static: all is caught in motion, moving in and out, up and down, and around; and it is about to change again. This perspectival space embodies the shifting narrative of inhabitation. The perspectival technique itself shows the dynamics of multiplicity: a complex system of revealed perspectival lines, generated from more than a single viewpoint but asking to be "taken" in the same way, captures the emotion of body space. A moving spectator—herself a body shifting in space—is protofilmically charted inside these architectural views.

If we look beyond perspectivism, and at de Vries in particular, rather than conceiving of film as the direct heir of classic Renaissance perspective (as work that focuses on the cinematic apparatus has done) we can set the invention of film against a different panorama, revisioning its place in the history of perspective.[23] We can see it as a form of mapping, inscribed in a movement in perspectival space that tends away from perspectivism and toward a tactile view of space. "Viewed" as this particular architectonics—a spatial navigation—the motion of moving pictures is revealed as an embodiment of space that approaches the feeling of the haptic.

MOBILE MAPPINGS: VIEWS IN FLUX

The techniques of observing architectural views articulated a relationship between space, movement, and narrative, thus establishing a tradition of spatial storytelling. This geography was not devoid of history. History, for example, occupied the format of view painting insofar as the views often offered an outlook on what was "taking place" in the site. Eighteenth-century views were even accompanied by remarks on the history of the city portrayed. Representing space as inhabited by events and moving with the dynamics of the city, the views exhibited a potential for narrativization. In the eighteenth century, the rectangular space of the view was

6.5. John Rocque, *Garden Plan of Chiswick House, Middlesex*, 1736.

extended to incorporate more narrative space; before the film strip, pictures began to tell stories in long formats. This enlarged perspective extended into the full view of nineteenth-century panoramas, where the subjects of history and narrative realism featured large. Prior to the art of film, CinemaScope picturing was "designed" as a mapping of narrative space.

It was primarily the topographically oriented view painting that established a form of depiction that moved narratively. Until the mid-eighteenth century, spatio-temporal unity appeared to organize the view. The flow of history entered representation when topographical views began to show interest in a kind of diachronic documentation that exceeded perspectival frames and sought to chart a space in time. By representing the life of the site, view painting captured its motion, and, in this way, spatial depiction became historical documentation: the views, which showed real space and time, exhibited the *hic et nunc* of the representation. In such a way, they anticipated the work of pictures brought about by the age of mechanical reproduction. With photography, it became possible to map space at the moment it was captured. Later, with motion pictures, it became possible to map a spatio-temporal flow and thus to fully re-embody a "sense" of space. In the evolution of perspectival practice, an aspect of tactile experience—space that is lived—became charted in descriptive filmic practices.

The cartographic impulse of film derives from a narrative twist on the notion of "the art of describing."[24] Its haptic rendering is particularly indebted to the multiple perspectives of views that illustrated lived space and made landscape inhabited. In depicting places geographically, the explorative drive extensively mapped this terrain and made urban sites into "-scapes."[25] Topographical views of cities frequently expressed the viewpoint of representational documentation, and the techniques of observation themselves mobilized.[26] Drawing distant objects closer and pushing back close ones, the views filmically analyzed space, as if separating it into parts to be read as a whole. Picturing space as an assemblage of partial views— a montage of spatial fragments linked panoramically by a mobile observer—cartographic art pictured (proto)filmic space and its sensational transition from the kinetic to the kinesthetic.

These depictions often borrowed from nautical cartography the experience of the horizon and emulated or recorded the balloon excursion's new experience of mobilized aerial or bird's-eye views, when not prefiguring this phenomenon. The cityscape was expanding as the practice of the urban pavement extended to aerial flotation in a new perspective of shifting corporeal spaces. Haptic wanderings were transferred from the feet to "the wings of desire," well before motion pictures fully enabled their multiple editing.

A terrain of transformations, urban space became documented at the meeting point of city and territory as nautical cartography and fluvial topography merged with urban mapping. Navigational charts of cities often included their natural topography: the margins of cities, their natural borders, were explored; the rivers that crossed them were retraversed; and the edge where sea waves meet the urban flow was redrawn. The resulting representations sought to capture motion with a

moving image, and this search for the status of movement was following a course. It was precisely this passage that the filmic flow of images would haptically materialize, establishing its own cartographic course.

As the views captured and fixed movement, they attempted to make it material and to graft it physically onto the picture surface. Such kinetic embodiment was also exhibited in the mobile cartographic activity that charted the sky and the movements of the waters, viewed in relation to currents and winds. These were forms of mapping that inscribed in their design an "atmospheric" transport. While celestial maps strove to chart a terrain that could not be traversed physically, sea charts aspired to render fluid matter. In astronomical navigation these two motions were linked in maps of the zodiac, for constellations were used as locational aids in navigation. Celestial, marine, and wind charting expressed a desire to map the unmappable before visual technology was able to actualize this drive and incorporate it into its own rendering of the "atmospheric" journey—one that even transferred to the architectural surface of the movie theater.[27]

Capturing the movement of marine landscapes, some maps of seascapes, such as those created by Marshall Islanders, were constructed as elaborate, delicate structures made with sticks.[28] The transient form of these maps suggest their function of giving direction to journey and providing guidance in navigation. Creating a beautiful mobile architectonics at the interstice of land and water, this type of cartography strove to materialize motion, making it not only visible but tangible. Early Western sea charts similarly involved a sense of travel, however figuratively: marine picturing was often haptically constructed from the itineraries of voyages and from travel experience. Insofar as they were navigationally oriented, portolan maps, for example, rendered in chart form the experience of moving across the Mediterranean Sea.[29] In designs drawn and painted on vellum, they reproduced the moving fascination that connected land to sea, often picturing coastal outlines, inland features, and toponymy decoratively for the delight of their viewer-users. Portable maps drawn on skin, these nautical charts were consulted as they unraveled, prefiguring the materiality of the film strip and its own cartographic movement on the cinematic reel.

As we retrace the steps of the moving mapping that leads to film, we travel through a fluid, haptic geography. With respect to this genealogy, it is important to highlight how the landscapes of nautical cartography and fluvial topography, as well as of aerial mapping (including winds), played a role in the prefilmic mapping of cities. Urban representations in view painting often incorporated these moving elements, from literal portrayals of the god Aeolus blowing the winds to a wider mobilization of representational codes. The rigid geometry of picturing was changed by fluvial elements when, in the eighteenth century, the rectangular proportions of pictures expanded widely to accommodate the particular space of river towns, which could be contained neither in the conventional geometry of picturing nor in its framing. Fluvial prospect or profile views literally extended picture borders, elongating their space to create a long format that suited the telling of geohistorical stories and narrative movements, including those that would emerge beyond perspectivism.

The flow of moving images passed by way of numerous fluid mechanical representations before the motion picture was invented. Particularly significant were the hydraulic exhibitions that were popular throughout the eighteenth century. The Water Works, a play of elaborate hydraulic performances, were exhibited in theaters beginning in the early part of the century.[30] Thus even before cinema, spectators came to watch a mechanically produced flow of images. Film's own narrative flow developed at the same time as the Cinéorama, which took spectators on a simulated tour in a hot-air balloon and featured dioramas and movie screens that unfurled actual films of the region to render the world tour.[31] Cinema resonated kinesthetically with maritime versions of the moving panorama as well: the "pleorama" and the Maréorama. Exhibited at the Paris Exposition in 1900, the Maréorama simultaneously unrolled two moving panoramas for the delight of spectators, who were positioned between them to create the illusion of being on the deck of a ship. To enhance the effect, the floor was mechanically agitated to render the sense of navigation.[32] This maritime "-orama" spectacle took up to 1,500 spectators on a simulated cruise through the Mediterranean, beginning in Marseilles and the Riviera, continuing across to Sousse in Tunisia, and then on to Naples and Venice and, finally, Constantinople. It was a sensory voyage in time as well as space. Changes of day and night were represented in a synesthetic form of journey that included smell, sea breeze, and the sound of live music, which accompanied and punctuated the trip. Thus the Maréorama made spectators into "passengers" as it simulated the (e)motion of traveling by sea—the sea of moving images.

Even before the Maréorama, the representations of nautical cartography and, by extension, fluvial topography reproduced the movement of vessels. Viewing an urban space by moving in and out of its bordering sea, one experiences the sensation of approach and detachment in an effect of cinematic telescoping: the physical limit of the city, at the edge of the sea, becomes a frame, which widens into an open visual space. Views of a city that follow the course of a river which traverses its architectural texture also provide a cinematic diversity of perspective and movement: one first views the city from a distance, then moves closer into its heart, and eventually moves away. In the words of architectural historian Renzo Dubbini, as one moves with the flow of the current, "the view is regulated by a continuous but constantly altering flow of images. The point of observation shifts along a succession of the innumerable viewpoints that go to make up a geographical route."[33] It is a filmic route.

A FILMIC FLOW

This geographical route is precisely the one the motion picture took as it created a haptic language of shifting viewpoints. When one rethinks representation by way of nautical and fluvial cartography, it comes as no surprise that early cinema, as an international phenomenon, insistently portrayed urban space by reproducing the

captivating fluvial motion of cities. A film such as *Panorama from Gondola, St. Louis Exposition* (American Mutoscope and Biograph, 1904) incorporated a fluvial perspective into the virtual mobility of the modern exposition by shooting the images from a boat moving along the waterway of the fair. The (e)motion of modernity was also the subject of cinematic views of New York City. Circulation was the generating principle of *Panorama of Riker's Island, N.Y.* (Edison, 1903), a film shot from a fast-moving boat that circumnavigated the island. The film represented the motion of both navigation and urban life as a biorhythm, including in this view the production and recycling of waste that took place around the city's waterways.

Views of New York were mobilized in similar ways in a number of films that showed panoramas of the city's waterfront, its various architectures of motion, and the life of industrial sites. Transitory architectures such as bridges offered occasions for urban portraits, as in *Panorama from the Tower of the Brooklyn Bridge* (American Mutoscope and Biograph, 1903), a film that creates a mobile cityscape as it approaches a bird's-eye view of the city that rises from the water. The bridge commonly served as both view and vantage point in films and sometimes literally became a viaduct, facilitating the transition between the scenic travel genre and narrative cinema, especially when railroad crossings were involved. Urban circulation was often represented as a phenomenon that moved along and with the water. In addition to the fluid views mentioned earlier, travel films of New York included instances such as Porter's *Panorama of Blackwell's Island, N.Y.* (Edison, 1903), which was filmed from a boat that cruised the island and thus presented the streets, land, and architecture from the mobile perspective of the East River. Filmic portrayals of New York showed both cinema and city as bound by mobility. The movie camera (that is, a "moving" camera) linked the motion of the sea and the urban crowd, thus drafting the landscape of modernity.

Urban activities such as architectural construction and excavation were filmically rendered in conjunction with transport and were even characterized *as* transport. *The Skyscrapers of New York City* (Edison, 1903) interestingly adopted a fluvial viewpoint to render the sensation of metropolitan movements, including the rise of modern architecture and means of transportation. An elegy to the city's skyline, the film also ponders New York's railroad tracks, following them all the way to the rivers' terminals. Extending into the city piers, the railway is shown as a dynamic element of the working urban waterfront. A similar urban movement was the driving principle of *Panorama of Water Front and Brooklyn Bridge from East River* (Edison, 1903), a city view that announced to the viewer, as view painting often did, the point of view from which the *veduta* was taken. Cruising the waters to offer moving vistas of New York, the film depicts bustling river activities and houseboat living, climaxing with a sweeping glance across the river from under the bridge. Traveling with its spectatorship through its shifting positions, this travel film created a flowing chart of the city. In such a way—by way, that is, of filmic motion—simulated travelogues met urban mapping and carried us away.

JOURNEYS OF THE HOME BODY

The genealogical territory of the cinema is thus revealed as the *emotion* that accrued to the "transport" of topographical view painting—a haptic terrain shared with the art of cartography, which is itself a form of travel. Maps involve imagined spaces and imaginative spatial exploration. The pleasure in viewing them is a form of journey: viewing maps stimulates, recalls, and substitutes for travel. Like engaging with a map, experiencing film involves being passionately transported through a geography. One is carried away by this imaginary travel just as one is moved when one actually travels or moves (domestically) through architectural ensembles. Maps— like films and architecture—offer the emotion of motion.

Architecture and mapping participated in many ways in the construction of a protofilmic traveling space. City plans and architectural models provide a particular case of the moving spectacle. Throughout the eighteenth and nineteenth centuries, architecture and topography were, quite literally, a form of exhibition. Topographical and architectural models representing single buildings or entire towns or regions were objects of display in Cosmorama Rooms and other sites of exhibition. The aim of these exhibits was to take spectators on a journey. As *The Literary Gazette* explained in 1825, in reference to the exhibit "Switzerland in Piccadilly" at London's Egyptian Hall, this was a form of composite architectural tourism:

The accomplished Tourist may likewise here renew his acquaintance with scenes too splendid and romantic to be evanescent, and explain to inquisitive friends, who have not had the opportunities of seeing the realities, the objects which most attracted his attention on his travels.[34]

As this text makes clear, the function of the topographic and architectural display was not only to induce recollection and desire in the actual tourist but to provide an imaginary voyage for the "homebody." In the display of architectural sites, a body of spectatorship left home by way of topographic journeys. The very equation of body with home and home with body was shattered with the creation of this different kind of voyage—the "traveling domestic" we have seen enacted in other forms of (im)mobile journey. Not just a vicarious type of journey, this was the enactment of a different form of travel: an interior voyage, a journey of the imagination, an experience of heterotopia.

Such an architectural journey, later to be embodied in the moving passion of cinema, began by transporting spectators through various forms of topography and cartography. This popular urban affair, exemplified by the "Switzerland in Piccadilly" exhibition, was a geographic montage in which the confines of the homeland were demolished and opened up to border-crossing imaging. One not only could go to Switzerland without leaving London but experience a new form of voyage, an architectural montage of places. As in topographical view painting, here the spectator was transported to (and by) the city viewed, as the city itself moved toward her. A new geography was constructed that adopted the principle of editing and created an architectural heterotopia—an "elsewhere now here." In this way, a new form of voyage was set in motion, one set in the movie theater.

THE ART OF TRAVEL: SKETCHBOOKS, MAPS, GUIDEBOOKS, AND JOURNALS

This form of "transport," embedded before film in the acts of viewing *vedute* and traveling through maps, plans, and architectural models, was also inscribed in a type of literature: travel writing. Such writing "moved" its readers, taking them along paths known and unknown as it recalled, imagined, incited, and sometimes replaced an actual journey. As narrative trips, travel writing and travel diaries, as we have claimed, formed an important part of the spatiovisual architectonics that led to the cinema and its narrative flow.[35] They were also an integral part of the artistic work of visualization and the mobilization of (narrative) space that film embodied. As forms of voyaging pleasure, they shared the cultural traveling space of both *vedute* and cartographic renderings, a link reinforced by the fact that chroniclers of the grand tour and romantic voyage often took painters along to create landscape views of the narrated sites.

Art took part in the general voyage of discovery as well, for most explorations until the mid-nineteenth century also were accompanied by traveling artists who made pictorial records of the sites. Their depictions document the evolution of representational realism in all its diverse manifestations. The documentary viewpoint that reached cinema by way of early film's obsession for actualities, scenic *dal vero*, and travel films can also be seen as an heir of the global drive for discovery that traversed lands, navigated seas, and ascended to the sky with the aim of measuring, analyzing , and representing the "real."

Conquering space to expand the horizons of knowledge was not necessarily the same as conquest for the sake of domination. But like the more military side of mapping, the scientific drive for discovery was embedded in the discourse of power. "Factual" geographic and cartographic representations of the world are nonetheless world "views," ideological formations like any other representational practice. Although more scientific in nature, the topographical view that flourished with the illustrated travel book was as much a product of imaginings as the *veduta ideata* or *capriccio*, those more emotional creations of the viewing practice. Its descriptive method told its own imaginative story, for it described as well how the world it depicted for us was to be accessed or relived. It was geographical (hi)story-telling.

The observational impulse of modernity—a complex phenomenon that operated at the edge of spatial realism—reframed the codes of realist practice, a process that culminated in film's own mobile remaking of "location." The path that led to the rise of modernity was marked by a multifaceted experience of situations that intertwined both actual and simulated forms of journey. A geographical obsession was acted out in alternative ways of "traveling domestic" that included an entire range of topographic and travel artifacts. Illustrated collections of travel writing containing topographical and architectural scenes were extremely popular from as early as the mid-seventeenth century to beyond the eighteenth century. Volumes devoted solely to the illustration of sites proliferated, eventually leading to virtual picturesque voyages. Maps and prints decorated the walls of those who could not

afford higher forms of travel or its depiction. Travel circulated—this circulation becoming itself another form of journey—and did so in ways that reached beyond the diverse forms of cartographically oriented illustration and publication we have mentioned. Travel diaries and letters circulated widely even in unpublished form, enriching the field of topographical writing with the incorporation of autobiography, for both men and women.

In general, to be knowledgeable meant to be well-traveled. Travel was coming to be conceived as a form of knowledge—a spatial education. The distilled grand tour, as it appeared in Laurence Sterne's *Sentimental Journey*, led to traveling practices that included a greater number of women and members of less-privileged classes.[36] The voyaging craze traversed the picturesque and gave way to a romantic version, which was sensualist, melancholic, and dreamy. With an eye to natural vistas, it searched the landscapes of love and ruins. There, it found both lovable ruins and the ruins of love.

Mapping participated in this curiosity for location as modern voyagers became drawn to cartography. Travelers were advised to acquaint themselves with the techniques of mapping and the tools of measuring time and space, and to bring these along on their journeys. If accompanying professionals were not a possibility, the travelers themselves would often measure and draw. Amateur maps thus frequently illustrate travel accounts and diaries, confirming the curiosity for spatial observation. Rather than a prescriptive enterprise, this mapping was a descriptive tool: drawings mapped travel space; the map was a visual rendering of a practiced itinerary.

Guidebooks functioned in the same way. They were a form of local knowledge and a located *savoir*. Interestingly, they were not used exclusively by foreigners. As Dezallier d'Argenville made clear in his 1778 guide to Paris, *Voyage pittoresque de Paris*, the "description may also be of use to the large numbers of inhabitants of the capital who feel themselves to be strangers in their own city."[37] The guidebook guides us by providing a mode of discovery and rediscovery of place. A precursor of film—itself a form of mapping space—it describes sites, transforming the foreign into the domestic and, conversely, estranging the familiar. In a way, the guidebook remakes the path of the "art of memory."[38] Like films and mapping, guidebooks are haptically conceived: they are spatial tactics, which, reading a site's history, read memory into it. Their strategy of spatial negotiation recreates the tactile use of the space. They advise turning and returning to sites, providing potential itineraries that both anticipate and follow the inhabitant's and the traveler's movement through space—the paths of experiential (e)motion and its his*tory*.

THE NARRATIVE OF DISPLAY

The force that traveled through and across travel culture, reaching out into early cinematic reinventions that mobilized city views, speaks of geographical desire—a drive that is capable of creating historic fiction. This type of fiction is not based on

action or drama but is rather engaged in the narration of space. Protocinematic activity is the narrativization of space itself. Such an impulse, found in the genre of travel writing, was shared by a certain type of *veduta*. A maritime view of the city of Venice by Alessandro Piazza, describing the activities of Francesco Morosini, *doge* of Venice from 1688 to 1694, offers an early example.[39] Here, a series of views is displayed for spectatorial perusal; ordered into a sequence, the multiple view acquires narrative potential and becomes a narrative space. The movement of sequentialization creates a fiction, and thus space, viewed as a progression, is narrativized. Furthering the effect of spatial storytelling, elaborate "intertitles" are added at the bottom of the paintings, linguistically narrating what is pictorially represented by way of a montage of images. In this way, a silent film combining shots and intertitles was born before the moving image could be mechanically reproduced.

This narrative effect of sequentialization was also achieved in evolving forms of artistic display. In this respect, it is important to consider the kind of display that is involved in the exhibition of art: different forms of reception are created not only by the pictures themselves but by the way they are assembled and the way the space of display is organized. This is made clear by the case of the Paris Salon, where, significantly, the public gathered for conversation as much as for looking at pictures.[40] The early modern public that patronized various forms of simulated travel was also an avid consumer of artistic space. Going to an art show was itself a form of leisurely urban voyage, increasingly open to a "public." Illustrations of popular places of art display in early modernity suggest a phantasmagoria of pictures, for a painting in an

6.6. Narrativized space in a sequence by O. B. Bunce depicting New York's *Washington, Madison and Union Squares*, from the 1874 book *Picturesque America*. Woodcut.

exhibition was not a singular image but a fragment of display. It was to be seen in conjunction with a crowd of other images and to be read in the course of spectatorial motion. The assemblage of images, tightly adjoined and made into a sequence, attracted a public of spectators. Such a public traversed a space of prefilmic montage. Sequentialized and assembled, pictures began to move—and create moving stories.

The spatial perusal that developed as a form of narration in the art of viewing was extended in the imaging that guided the spectacle of museum installation. In recording a site, the sequential or panoramic view narrativized space; in sequentializing pictures and transforming objects into images, art exhibition predated the montage of still images in film. Besides the large panoramas and dioramas that created a space of narration, oscillating between topographical and topical views, a protocinematic process was fleshed out in other forms of art display. These included the "peristreptic views" exhibited in theaters as moving panoramas; the "myriorama," where a series of views were cut from a long panoramic strip so that they could be edited together as "matching shots" in different orders of sequencing; and the multiple exhibition of view painting, where events not only "took place" but in many ways unfolded in time and space, suggesting a transportability.

PORTABLE MOVING VIEWS

Interesting cases of viewing (in) motion were scenes designed to be contained in portable drums and rotundas equipped with winding mechanisms for rolling the images in and out of a slot. Alongside J. H. Banks's portable aerial view called *Panorama View of London*, particularly interesting examples are found in the work of the British artist Robert Havell, Jr., who also produced "aeronautical" views such as *Aeronautical View of London* (1831), designed for a portable rotunda and for viewing with a magnifying glass.[41] In 1822 Havell made a fluvial *Panorama of London* that mapped a city tour on the Thames, commencing at Vauxhall. In 1823 he produced a maritime view called *Costa Scena* and in 1824 made *A Coasting View of Brighton*. Each of these colored aquatints was contained in a portable box. The view would "scroll" out of the decorative lacquered case as the viewer physically rolled it in front of his or her eyes. In this way, a horizon of images was set in motion on the horizontal plane. The boxwood drum of *Costa Scena* was decorated with Neptune, god of the sea, who guided the tour. It presented King George embarking on his celebrated Northern Excursion and thus took the viewer-traveler on a simulated trip from England to France through the English Channel. Against the background of inhabited land, a fleet of large and small boats was made to move along the water as the spectator manipulated the view. Along the way, various scenes and events were presented. Havell narrated the space in such a realistic way that the box actually functioned as a moving map. The viewer-traveler could take the moving device on a real trip aboard a steamboat and use the view as a map to establish her position in space, mark the various sites reached on the itinerary, and follow the course of the journey.

This portable form of moving view-map, bound up with the narrative of travel culture, established a form of protofilmic mapping: it not only designed space but charted the movement of bodies in space. Sold as souvenirs and circulated widely, the portable rotundas could even bring moving views home. What unraveled from these "cans of moving images" was a protocinematic space of travel sensations and a tactics of tactile pleasure. Recalling the flow of images of Japanese scroll painting and the unfolding of nautical charts, this narrative form of depiction established the flow of spatial narration before film's own moving storytelling could physically record the architectonics of haptic space and take it, in film cans, back home to the public of the movie house.

One can imagine a journey of return to this phenomenon as an art installation that would exhibit an archive of film rolls. Showing the physical matter of film in this way would remake the cartographic journey of nautical maps, for to display a film without the apparatus is to unravel rolls of celluloid, with series of pictures scrolling out of their house-cans.[42] In an installation proposal that mapped the space needed to do this, Dusan Makavejev once figured that to display his *Sweet Movie* (1974), he would have to wrap the film strip around the entire exterior length of the spiral architecture of New York's Guggenheim Museum. The extensive space that a feature film would require to be physically exposed is a figurative "measure" of the haptic traveling enacted in the movie house.

HAPTIC MEASURES

[I have] anatomized so considerable a tract of land, and given the most
exact representation.
Sir William Hamilton

The haptic measure that is an outcome of the spatiovisual embodiment of travel cul-
ture came into being with the very origins of modernity. Travel was not always a
visual "matter." It was not even always necessarily considered a visual experience.
As Judith Adler has shown, tourism was not originally a form of sightseeing.[43] The
travel experience came to be visualized historically as it evolved from earlier literary
and linguistic models. Between 1600 and 1800, treatises on travel shifted from con-
sidering touring as an opportunity for discourse, even when it involved direct experi-
ence and personal observation, to viewing it, fundamentally, as eyewitness
observation. The tongue gave way to the eye.

Wandering or traveling became a "way" to know, transforming knowledge
itself into a geographical matter. In an interesting travel account from 1642, topog-
raphy was conceived as a way to "anatomize" space, and such anatomical mapping
was called upon to chart the shift to sightseeing:
One should read all the Topographers *that ever writ of, or* anatomized a . . . Country
[my emphasis], and mingle Discourse with the most exact observers. . . . Yet one's
own ocular *view, and personall conversation will still find out something new and*
unpointed at.[44]
Preparation for travel shifted from reading books to observational methods, which
included perusing visual materials as a form of anticipatory voyage or simulated
travel. The travel route incorporated maps, illustrations, and views, and as it
expanded into the nineteenth century, travel lectures that made use of visual aids. It
was a road that, ultimately, led to filmic mappings as the cinema visually and aurally
reinvented the topographic-anatomic route.

Looking from a geographical perspective at the cultural process of visuali-
zation, it appears that such sightseeing was actually turning into site-seeing.
Eyewitness activity implies that the beholder is physically there, a material presence
observing cultural space. Seeing with one's own eyes involves a (dis)placement;
becoming a direct observer, the tourist acknowledges her body in space. A form of
visual absorption of space, tourism establishes a being-in-place that moves through
space. The body is the vehicle of this mobilization. In this sense, modern tourism
shows a tangible link—a haptic bond—to film and its way of making space. Creating
haptic travelogues and a simulated experience of travel, motion pictures partici-
pated in a movement: the cultural transformation of sightseeing into site-seeing.

PICTURESQUE SPACES

*The first amusement of the picturesque traveler is . . . the expectation of
new scenes continually opening, and arising to his view.*
William Gilpin

On the road to site-seeing, the modern traveling eye passed through garden views to
embrace larger environments. The design of the picturesque, in theory and practice,
was an important step in the modern construction of space. Its history intertwines
with the history of tourism and participated in shaping its views. As an essential
moment in the formation of traveling space, the picturesque revolution took part in
the modern making of haptic space and, in so doing, prepared the ground for ele-
ments of traveling space in film.

It is important to articulate the impact of the picturesque on the modern
moving image, especially since the movement has often been marginalized and its
multiplicities reductively flattened.[45] A complex and ultimately elusive notion of taste
in landscape aesthetics and tourism that emerged between classic and romantic art,
the picturesque first appeared as a term used by Alexander Pope to refer to a scene
that would be proper for painting.[46] Hardly a homogeneous notion and inseparable
from assorted philosophical and artistic stances, it was redefined in various theories
and practices. Although the English picturesque, notably elaborated by William
Gilpin, Uvedale Price, Richard Payne Knight, and others, has tended to draw the most

6.8. Anonymous, *A
Perspective View of
the Grand Walk in the
Vauxhall Gardens, and
the Orchestra*, 1765.
Engraving.

A Perspective View of the Grand Walk in Vauxhall Gardens and the Orchestra.

critical attention, the picturesque was actually articulated in the cultural contexts of a number of countries and diverse forms of expression, and thus historically embraces a multifaceted notion of space.[47]

It is often remarked that, as an art of landscaping, the picturesque, initially inspired by the paintings of Claude Lorrain, Nicolas Poussin, and Salvator Rosa, was imaged pictorially—as a series of pictures created for aesthetic enjoyment. Painted landscape was seen as a model for the design of landscape architecture. Nature was to be experienced in the form and shape of a view and, like a picture, was to be viewed as an unfolding visual narration.[48] Here, the garden was a form of museum. Composed of a series of pictures, often joined by way of association, the picturesque was constructed scenographically. Perspectival tricks were used to enhance the composition of the landscape and its mode of reception.

In picturesque journeys, the activity of viewing was sometimes accompanied by touristic gadgets such as the Claude glass, named after the painter.[49] These concave mirrors, made of variously tinted glasses, were used by the viewer to look at, color, "frame," and even modify the view. The Claude glass was an itinerant object, more portable than its ancestor, the camera obscura. This touristic device mediated between an already spectacularized landscape—a set—and the spectator in ways that call to mind the genealogy of viewing apparatuses from which the cinema descends.

In the picturesque design of the garden, nature was not a "natural" landscape but a cultural artifact, the product of a cultivated aesthetic pleasure. An object of mediated views, where views were a desirable objective, the garden was an image-space—a culturally constructed imaginative space. A product of imaging and sequentially assembled, the picturesque garden was thus deployed for viewing as an actual spatiovisual apparatus. Looking at picturesque space in this way, we can begin to see how a relation to the cinematic apparatus can be built on the "grounds" of this space-viewing activity.

Indeed, thinking by way of the moving image about the picturesque unleashes a series of theoretical questions. Considerations of the film image tend to privilege the aesthetics of the sublime and its derivatives over those of the picturesque in defining the cinematic "moment."[50] The often misunderstood, condemned, and even derided concept of the picturesque, however, is currently being re-evaluated in a number of fields and assessed as a modern form of visuality and aesthetics, one also significantly embodied in a modern picturesque.[51] As noted in a previous context, Yve-Alain Bois has predated the "rupture of modernity" to the late eighteenth century in a provocative text on the picturesque in which he also makes reference to film.[52] So does Anthony Vidler, who reconsiders the picturesque in relation to the modern architecture of Le Corbusier.[53] Vincent Scully credits the cerebral and visual picturesque with having impacted the views of modern architecture, especially directing its interest in the visual arts and the notion of place. He also refers to Le Corbusier, who viewed the city as a garden.[54]

As shown earlier, the "montage of views" that unfolds for spectatorial pleasure and the architectural promenade, established by picturesque aesthetics, traveled across modernity all the way to Le Corbusier's and Eisenstein's own versions of this peripatetic practice. Picturesque language was, in fact, based on differential perspectives of views and produced telescoping effects, which were even embedded in the design of the overall view. Effects of parallax drive its representation, creating an apparent displacement of object in relation to a change in the point of observation. The picturesque enacted shifts from vista to vista as its rhythm of montage unraveled along a path of sequential motion. Such picturesque techniques of reassemblage can be recognized as reactivated by film's own image sequencing in motion.

In furthering the affiliation between the picturesque and film, even beyond the discourse of montage, my overall interest is to show the link between the two as a cultural *transito*. The extent of the *transito* cannot be fully understood as mere picturing; nor can it be observed only in terms of visuality, even a multiplied and sequentialized one. There is more than an optical analogy that links cinema to the picturesque, for neither can be reduced to a collage of flat visual planes. According to Renzo Dubbini, the picturesque is "an art of composing scenes and a system for the analysis of the character of place, emerging from the materiality and the cultural matrix of objects."[55] In this respect, the impact of the picturesque can be seen as extending widely, for this advanced reflection on the observation of landscape influenced the urban scene as well and created an expansive reconfiguration of geographic affects. The very act of establishing this particular genealogy for cinema is a way of recognizing both as complex practices of spatial mapping involving an affective design. Both must be investigated historically and theoretically with cartographic tools. We will come to recognize that the montage of the picturesque promenade is a matter of spectatorial *emotion*. This moving picturesque scene, composed to provoke emotional reaction, has traveled to film's own scenic design and is inextricably linked to a landscape of emotions. Before the landscape was mobilized by panoramic vision and the culture of metropolitan movements, the picturesque established the geopsychic possibility of a modern traveling spectator. Along with cartographic representation, this practice lies at the origin of the construction of a modern, gendered psychogeography, which film mechanically reproduces.

To paint this moving picture, let us look more closely at the geography of the picturesque and note, first, that what moved from vista to vista in the landscape was not a traveling eye but a traveling body. Views were set in motion by way of combining real and imaginary movement. In the picturesque, the pictorial composition of the views was actually "mobilized"—not just revealed to the eye or multiplied—as one physically moved through space. The promenade that developed from the root of the picturesque garden was the enactment of a site-seeing.

Before cinema's own picturesque promenade, the architectural and urbane Italian garden, which laid out a narrative sequence for English and French picturesque landscape design, had turned the visitor into an active spectator, one involved in the narrative display of the space. Often conterminous with the geography of the

cabinet of curiosity, these gardens enacted a memory theater.[56] The picturesque inherited in particular the psychological depth of the Italian garden, with its topographic representation of disquieting psychic views.[57] The picturesque garden renewed this emotional fashion of representation in a more pictorial way that was imaged for its client and visitor. The user, embedded in garden design as a spectator-in-the-text, was engaged in the poetics of the architectural deployment of the site. A body was both actor in and spectator of the drama of the space. In such a way, the viewer entered the picture—as a psychosomatic entity. In garden design, as in paintings of anatomy lessons, the spectator was "incorporated" into the very picturing of visual space.

In the garden, especially in the picturesque version, design was anything but static. The placement of objects was a function of the moving absorption of visual space. In the case of some pleasure gardens, displays of objects derived from sixteenth- and seventeenth-century garden design—automata, sculptures, and playful fluid mechanisms (*giochi d'acqua*) that included fountains and watery landscapes—were made into moving views. In the picturesque, the vistas themselves incited the viewer to move into the space. Before filmic close-ups made it possible to approach the image and move into it literally, the picturesque enabled one to physically move into the picture and into the picturing.

Ultimately, the picturesque garden was designed for peripatetic bodies: as in film, the visitor who moved into the picture was asked to travel through its different spaces. The scenery, made of floating images, changed constantly as the spectator's movement remade the garden's own shifting perspectives. Sequences of events unfolded as the visitor passed through. Discoveries were made at every turn. The garden was an affair for spatial wanderers. While it expressed a *genius loci*, it also transformed this "spirit of the place" along its route. The *genius loci* built progressively as locations were physically revisited and the sensation of the site grew in the course of site-seeing.

A physicality was involved at various levels in this site-seeing, engaging the *genius loci*. As the artist Robert Smithson wrote, the picturesque "is based on real land; it precedes the mind in its material external existence. . . . A park [is] a process of ongoing relationships existing in a physical region . . . a 'thing-for-us.'"[58] Adopting a portion of this argument, the construction of the garden can be cinematically read in phenomenological terms. This is a logic of perception that, as film scholar Vivian Sobchack shows, is "embodied" in the language of cinema as an "address of the eye."[59] Merleau-Ponty's understanding of phenomenology suggests that space is not positioned at a distance in front of us but surrounds the body: it is an effect of the lived body's own motility.[60] Seen from this angle, the construction of the modern picturesque is revealed in its physicality, for it implicates a situated existence and a material world.

At stake in the comparison between the picturesque and film expressed through, but also beyond, phenomenology is the delineation of a modern haptic spatiality. In film, as in the picturesque garden, space exists not as a thing-per-se but as a thing-for-us. The movement of a subject creates a sense of place as a series of

unfolding relationships. Like film, picturesque space materializes as practice. It is a user's space. It comes into being as a site for traversal. Inhabited by the passerby and lived as a *transito*, this is the space of the passenger. An intersubjective corporeal mapping, it is nomadically situated.

The picturesque can be reconsidered as a protofilmic practice to the extent that it was a "mode of processing the physical world for our consumption."[61] That is, its spatial construction was used, as that of film would be, to engage the passenger's imagination and incite her (e)motion. The already non-natural nature of sites was "cultivated" further in this traveling practice, which was attracted to the emotion of physical locales that itinerantly revealed themselves in order to be "consumed." This nomadic practice of geopsychic spatial consumption was the very material that was incorporated into filmic *emotion*.

THE PERIPATETICS OF THE PLEASURE GARDEN

Thus understood, the peripatetics of the garden unfolds as the geographic enactment of a heterotopia.[62] Like the cinema, the nomadic garden enacts geopsychic displacements, for it is capable of juxtaposing within a single, real place several (mental) spaces and slices of time. As a traveling space, it is a site whose system of opening and closing renders it both isolated from and penetrable by other sites. As in film, the garden's capacity for fluid geography derives from its ability to house a private, even secretive experience while serving fully as a social space.

As developed in gardens and garden theory, space was a social practice. In its design and use, the garden—particularly, but not exclusively, the French formal garden—was in many ways a theater of public display.[63] Even when strolling alone against the mise-en-scène of the landscape, one engaged in a form of social theater. Many gardens were a site of collective life in the form of gatherings and varied sorts of leisure activity. When they became parks, they decisively became places of public participation.

Organized forms of public leisure—public spectacles of moving images—were set in motion by garden life before the era of cinema. Following the theatrical and preromantic architecture of Italian gardens, the English picturesque produced "pleasure gardens" such as London's Vauxhall and Ranelagh.[64] As Richard Altick shows in his study of exhibition, the various tricks of illusion played on topography in these places, for the pleasure of discovery, were accompanied by other spectacular conceits set in motion for public enjoyment.[65] Masques and *fêtes champêtres*, for example, naturalized in England, turned the gardens into sites of public spectacle.[66] These forms of entertainment, which involved social role playing, were the equivalent of a societal game. The very material of the masques—games of social transformation—paralleled the spatial transformation enacted by the garden's own architectonics. The shifting vistas also included the mixing of social classes and sexes, for the Vauxhall Gardens was a recreational place for all strata of society and a place of sexual intrigue. A composite, moving space of promenade and flirtation,

the pleasure garden was interspersed with a variety of pleasures to be consumed. Besides absorbing vistas, pictures, and spectacles, one could engage in other ingestive activities such as eating and drinking.

The absorbing, fluid geography of pleasure gardens was further enhanced by their use of hydraulic automata and their propensity for water spectacles such as naumachiae—a mechanics of pleasure that was precinematic in its form as well as its object. Pleasure gardens included a number of other prototypical filmic pleasures as well. They displayed large-scale topographical and architectural picture models of sites, for example, which were constructed like filmic set designs.[67] Vauxhall Gardens offered a famous protofilmic show in the form of a lighted landscape scene. This "set" was constructed as a remake of a water mill, a miller's house, and a waterfall and included a number of other animated scenes of mechanized motion. The effect of such mechanized scenes, which foregrounded the workings of the cinematic apparatus and its fabrication of a simulated reality, was also achieved in the pleasure gardens with cinematically conceived *tableaux* that created

6.9. *Jeux de l'amour à Tivoli,* anonymous portrayal of amorous play, 1799.

the illusion of the real. *Trompe l'oeil* paintings, which were positioned in the landscape to interact with the "special effects" of the unfolding garden views, also functioned in this way. Vauxhall Gardens was architecturally shaped as a picture gallery and also exhibited transparent pictures. Protofilmic in texture, transparencies were made with translucent paints and were part of the garden's many "illuminations." They often aided machinery in garden performances, as in the case of the celebrated eruption of the volcano Vesuvius, a favorite protofilmic spectacle, along with the display of sea storms.

The erotics of garden machinery was matched by a machination of landscape aesthetics and the architectonics of lighting. To the extent that it was a theatrical site of sensual pleasures, the garden was, traditionally, an erotic affair and became sensuously noir. It is not by chance that Vauxhall Gardens opened only after five o'clock in the afternoon.[68] The pleasure garden was thus a dark affair that lit up. The night-time entertainment of light spectacles offered by the apparatus of the pleasure garden foregrounded the darkness of the movie theater's own light show.

What unfolded in the garden was the spectacular origin of filmic siteseeing. The mobilized and spectacularized grounds of the picturesque garden eventually gave way to more illusionary moving scenery. Instituting a dreamy mechanics of pleasure, the public spectacles offered by these gardens prepared the grounds for film's own sensuous apparatus and its deployment in the public sphere. This passage from the animated pictures of picturesque views to motion pictures was rendered palpable by the mechanism of the animated "polyorama." This prefilmic "-orama" spectacle of painted views, which was later replaced by photographs, was described in its 1852 patent as "an optical instrument of the phantasmagoric genre. The effect produced by this apparatus is to imitate the movement of nature in picturesque

6.10. A different outlook, as framed in G. M. Towle's *View from Steeple, Boston*, 1874. Woodcut.

views."[69] The moving spectacle of light architectures was being technologically reproduced as motion pictures that would be housed one day in the space of the "atmospheric" movie palace.

The associative journey of the picturesque garden became transformed, by way of pleasure gardens and polyoramas, into the mechanized travel of motion pictures and even formed the basis for some the architectural design that housed it in the theater. An attraction established in 1813 at the Parisian park of Tivoli speaks of this shift. The "Mountains of Tivoli" was a ride that traveled from the hilltop of the park, where one could enjoy a panorama of the city, down through a grotto and onto a site of pedestrian promenade. The design of the park incorporated this voyage into its picturesque setting. Experiencing the landscape from this mobilized perspective prefigured the speedier prefilmic spectatorial journey. Ladies, in particular, were encouraged to mobilize: "The voyage is not dangerous: the perfection of the mechanism (not visible to the naked eye) and the solid construction must reassure the ladies who are timid."[70]

GENDER MOVEMENTS

In speaking of the reception of the gardens and their spatial construction, questions of gender arise. Although the picturesque is intricately and interestingly involved with female subjectivity, it has often been only stereotypically associated with womanliness. As architectural historian Sylvia Lavin effectively shows, the way that the feminine and the picturesque have been codefined has resulted in the marginalization of both.[71] Calling attention to Watelet's *Essai sur les jardins*, a 1770 text of the French picturesque, Lavin argues that the female body is the actual terrain of garden construction, which is imaged as a spatial plenum: a "penetrable space of pleasures" made of "tissues of desire," Watelet's garden, according to her analysis, is "a reclining female body who offers herself to the observer and entices him to enter her."[72] This picturesque garden uses the very definition of the female body to contain the impact of the feminine that was shaping French culture at the time.

Derided because it was perceived as a feminized space and repressed for its analogy with the female body, the picturesque must be reconsidered precisely because it was a space that articulated feminine subjectivity. In this respect, we should review the sensuous aesthetic and psychic "taste" of the French picturesque—which notably included, along with Watelet's work, Nicolas Duchesne's *Traité de la formation des jardins* (1775) and Jean-Marie Morel's *Théorie des jardins* (1776)—and assume its seductions for ourselves.[73] The tools of feminist film theory can be helpful in this regard, for they enable us to turn the body of the picturesque into a subject of revision involving a body of female pleasures.[74] As the picturesque itself shows, a shifting viewpoint changes the object of the picture as well as the picturing. Female spectatorship and its theorizations of desire can change the perspective of the garden from an object of view—a body to be penetrated by a (phallic) eye—into a different geopsychic viewing space, one that does not exclude or

marginalize the feminine but rather affirms it. By acknowledging the force of women in spectatorship and their agency in this position, we reveal another angle of picturesque viewing and its geographic fabrications of shifting (gender) positions.

The activity of pleasure that picturesque space articulated—its texture of affects—was opened to a body of female spectatorship and was fabricated by women as well. Women strolled the gardens' grounds and participated in the public spectacles of the (pleasure) gardens. They were also involved in both actual and virtual picturesque voyages. Illustrations and paintings, as well as texts, document a female presence and show the extent of its participation in garden life and discourse.[75] In these pictures we can see that a female public was being formed on the garden's grounds, a public that turned into a traveling authorship.

As the female characters of Jane Austen's novels testify, the picturesque entered the female universe in many delightful ways.[76] On a picturesque journey through Pemberly Woods, in *Pride and Prejudice*, Elizabeth "saw and admired every remarkable spot and point of view. . . . [She] was delighted."[77] Emma, in the novel named after her, "was glad . . . to look around her; eager to refresh and correct her memories with more particular observation, more exact understanding of a house and grounds which must ever be so interesting to her. . . . Walking some time over the gardens in a scattered, dispersed way . . . led to . . . a sweet view—sweet to the eye and to the mind."[78]

By way of garden strolling, the picturesque opened the emotion of traveling cultures to women. As it participated in the formation of a tactile knowledge of space—of haptic epistemologies—the sense and sensibility of the picturesque paved the road to a new form of spatiality in which the female body was not just a penetrable object but the very subject of an intersubjective spatial mobilization. "Streetwalkers" were positively presituated in nomadic gardens before breaking through to the new spaces of modernity. Their paths redefined modern space itself, as well as the space assigned to gender. Looking from this gendered perspective, the picturesque appears to have made a real impact on modernity, not only as modern vision but as modern spatiality—a form of mobilization that enabled the very affirmation of the female pleasures of *transito*.

GEOGRAPHIC SENSES

It was the eighteenth century that advanced the notion that motion and travel would expand one's sensate universe. Movement was craved as a form of physical stimulation, and sensations were at the basis of this geographical impulse. Geography became the experience of a "sense" of place and of a sentient space. Although garden theory was not the only site of this articulation, the garden was a privileged locus in the pursuit of sensualism, in which women took active part. Diversely shaped by associative philosophies, eighteenth-century landscape design embodied the very idea that motion rules mental activity and generates a "fancying." The

VIRIDARIVM GYMNASII PATAVINI MEDICVM.

Io. Georg. sculps.

6.11. A "global" panorama:
R. R. Reinagle and R. Barker,
Explanation of the View of Rome,
1804. Etching.

6.12. The circular layout of
the Padua Botanic Garden
(est. 1545) as portrayed in
Giacomo Filippo Tomasini's
Gymnasium Patavinum, 1654.

images gathered by the senses were thought to produce "trains" of thought.[79] As Thomas Whately put it in 1770, in his set of *Observations on Modern Gardening*: *Certain dispositions, of the objects of nature, are adapted to excite particular ideas and sensations . . . instantaneously distinguished by our feelings. Beauty alone is not so engaging as this species of character . . . [which] affects our sensibility. . . . The power of such characters is . . . [that they] are connected with others and related . . . by a similitude in the sensation they excite. . . . We follow the track they have begun. . . . The scenes of nature have a power to affect our imagination and our sensibility. . . . The emotion often spreads far beyond the occasion: when the passions are roused, their course is unrestrained.*[80]

This philosophy of space embodied a form of fluid, emotive geography. Sensuously associative in connecting the local and topographic to the personal, it enhanced the passionate voyage of the imagination. "Fancying" was the configuration of a series of relationships created on imaginative tracks. It was the emergence of such sensuous, serial vision (a vision of affects) that made it possible for the serial image in film to make sense and for trains of ideas to inhabit the tracking shots of emotion pictures.

The movement that created filmic (e)motion was an actual "sensing" of space. The picturesque contributed a tactile vision to this scenario and to cartographic imagery. As Christopher Hussey put it back in 1927, the force of the picturesque was "to enable the imagination to form the habit of feeling through the eye."[81] What was fleshed out in the picturesque was not an aesthetics of distance; one was rather taught to *feel* through sight. Here, the eye is epidermic; it is a skin; sight becomes a sense of touch. Picturesque vision is haptic vision. Picturesque aesthetics thus can be said to have had the important function of serving as the vehicle for the shift toward haptic imaging and imagination. It was this *emotional* habit—the fashioning of a haptic movement that is emotive—that was to become embodied in the film sense. In the garden, strolling activated an intersubjective terrain of physical connections and emotional responses. Kinetic journeys across a fragmentary terrain generated kinesthetic feelings. Mobilization, further activated by climbing towers and observatories or tarrying in rooms built in the garden as observational sites, was a form of sensory animation. Sensational movements through the space of the garden "animated" pictures, foregrounding the type of sensing enacted by film's own animated emotion pictures.

Not unlike cinematic space, picturesque space was an aesthetics of fragments and discontinuities. Sometimes, particularly in the case of the French picturesque, architectural fragments contributed to the creation of a microcosmic heterotopia. By way of *fabriques* (garden buildings), one would navigate surprising collections of worlds of knowledge on the set of a garden stroll.[82] Topography was not a totality but an unfolding of variety and disparateness. As architectural scholar Alessandra Ponte claims, in the picturesque there is a varied "character" to the land that corresponds to the way combined features mark the character of a face.[83] Combinatory permutations of feelings are impressed on a landscape of the surface. Picturesque architectonics, creating a drama of changing sets, acted as a medium for emotional landscaping. In the garden, as in the cinema, one could traverse series of

imaginative states of mind in the form of living pictures. A mobilized montage of multiple, asymmetrical views emphasized the diversity and heterogeneity of this representational terrain. The obsession for irregularity led to roughness and dishevelment. Fragments turned into a passion for ruins and debris. Relics punctuated the picturesque map.

A memory theater of sensual pleasures, the garden was an exterior that put the spectator in "touch" with inner space. As one moved through the space of the garden, a constant double movement connected external to internal topographies. The garden was thus an outside turned into an inside; but it was also the projection of an inner world onto the outer geography. In a sensuous mobilization, the exterior of the landscape was transformed into an interior map—the landscape within us—as this inner map was itself culturally mobilized. Along the garden route, the picturesque aesthetic of topography incorporated an actual reading of the skin surface, the very border between inside and outside. Seen in this way—that is, psychophysiologically—picturesque space is inscribed in a gender passage: one that, in anticipation of film, crossed the boundaries between interior and exterior and the border assigned to sexual spaces.

COMING CLOSE: FROM HAPTIC TO INTIMATE SPACE

A scrolling *papier panoramique*, heir to the fragmentary and fluid topographical imagination of the eighteenth century and to the later panoramic culture that followed, film is an imaginative architectural toy—a house of "transports." It is a machine that expands our ability to map the world by extending our sensory apparatus. Making us come to grips with our environment, the moving image offers touching visions as it explores the relation between motion and emotion—the sensuous space of *emotion*.

We now see the moving image emerging out of that particular invention of modernity that is the geography of the interior. This space, which began to take shape during the early part of modernity in the form of garden design and theory, moved along with history as it was linked to the image of the subject's own interiority. A philosophy of the senses and treatises on sensations traveled into the body's sensibility. Medical discourse contributed to this sensing of space as it analyzed passion, along with the shape of the body's own interior. This "finer touch" was "part of a greater movement within the history of perception that sent vision inward bound."[84] The expansion of vision toward the interior opened possibilities for new forms of haptic travel: journeys into emotional space. In the next chapter, let us explore this touching geography in the form of emotional cartography. In many ways linked to garden design, such cartography, charting interior and exterior as passage, activated woman as the very subject of geography. Let us then remap this *Carte de Tendre*, this tender mapping.

ART OF MAPPING

7.1. A different kind of "Atlas": a woman designs the world on the frontispiece of Jan Barend Elwe's *Atlas*, 1792. Detail.

7 An Atlas of Emotions

Geography includes inhabitants and vessels.
Gertrude Stein

I have long, indeed for years, played with the idea of setting out the sphere of life—bios—graphically on a map.
Walter Benjamin

The geography that occupies this atlas includes inhabitants and the forms of their passage through spaces, including the spaces of life. This geography is a terrain of "vessels": that is to say, it is a place that both holds and moves. The notion of vessel incorporates a double image: that of the boat and that of the artery (as in blood vessel); it implies the container of a flux and a system of routing. Such a geography of inhabitants and vessels may be subject to charting. As represented in nautical cartography, the course of an inhabited vessel has imaginary repercussions as well: it can appear graphically on a map in the form of a sequence of *emotion*s. Focusing on this particular mapping impulse, we explore the inner direction of the art of mapping and expose it as a (pre)filmic disposition. In this cartographic view, the moving image itself is theorized, metaphorically, as a vessel—as a means of transportation that carries us away. Film, like an *emotion*al map, here becomes a geographic vessel, a receptacle of imaging that moves, a vehicle for emotions.

By mobilizing this particular form of mapping, we aim to move beyond the critical trend for which the map is a unifying and totalizing concept, produced by a distant eye. Despite postmodern theory's interest in cartography—beginning, notably, with Frederic Jameson's version of "cognitive mapping," which he later applied to his geopolitics of cinema—mapping remains, perhaps because of the problematic nature of the cognitive paradigm, a contested, even negative notion.[1] Maps are the objects of a struggle in many geographic studies;[2] and a number of efforts have been devoted to deconstructing and decolonizing them.[3] Even in works interested in advancing knowledge of sexual difference, the negative persists.[4] All too often, mapping tends to be dismissed as a commanding, hegemonic instrument. Yet to persist in this position is to risk producing a notion of mapping that is restricted, placed wholly in the service of domination. What remains obscured are the nuanced representational edges of cartography, the diversity of cartographic practices, and the varied potentials of different mapping processes, including such tactics as transformative "partial" mappings, which resist a univocal and totalizing vision. The cartographic impulse we will foreground here is the force embodied in the "tender" mapping of Mademoiselle de Scudéry, a cartography that dwells in movement and includes the intimate exploration of difference in gender maps.

As described in the prologue to this volume, Scudéry established a practice of cartography of intimate space that designed a haptic route. Her *Carte de Tendre* was a tender tactics that, tactilely, offered a gendered view. As we will see, this mobile geographic writing has had many incarnations in mappings that relate affects to place—incarnations that exist on the threshold of art, cartography, and politics. As a mapping of *transito*, tender mapping has traveled to, and through, moving pictures as well. As we follow the route of site-seeing opened by Scudéry, we approach the terrain of emotion pictures, for film has reinvented and mobilized this *emotional* map of "transport."

GEOGRAPHICALLY SPEAKING

To locate the geographic route that leads from Scudéry's map to cinema's own modern cartography, we travel with a (blood) vessel—that is, through an embodied terrain. In this view, space is fashioned in a corporeal "vein." As Merleau-Ponty has shown, the relation between bodies and space is such that "our body is not in space like things; it inhabits or haunts space. . . . Through it we have access to space."[5] In the natural world, an actual "mimicry" can exist between organism and environment. For human beings, however, such assimilation to space may involve a loss of perspectival viewpoints. Roger Caillois, in his previously mentioned work on mimicry, which is inflected by insect biology, aesthetics, and theories of sympathy and excess, argues that for subjects captivated by space, it "seems to be a devouring force. Space pursues them, encircles them, digests them. . . . It ends by replacing them. Then the body . . . feels [itself] becoming space."[6]

The primary mimetic force of geography—the flesh itself becoming space—was felt in her own way by Gertrude Stein, who, in 1923, composed a text on the subject:

As Geography return to geography, return geography. Geography. Comes next. . . .

Geography as nice. Comes next geography. Geography as nice comes next geography comes geography.

Geographically, geographical. Geographically to place, geographically in case in case of it.

Looking up under fairly see fairly looking up under as to movement. The movement described. . . .

An interval.

If it needs if it needs if it needs do not move, do not move, do not touch, do not touch. . . . That is what she is looking for. Less. Less threads fairly nearly and geography and water. Descriptive emotion. . . .

Geographically and inundated, geography and inundated. . . .

I stands for . . . Italy. . . . G stands for geographic and geographically. . . .

I touched it.

As through. . . .

Geography includes inhabitants and vessels.[7]

For Stein, *g* stands for geographic thinking. The word *geography*, obsessively and minimally repeated, refers to a way of writing. From her *Geography* to *Geography and Plays* and *The Geographical History of America*, geography becomes an expansion of writerly topoi and connotes a new writerly space—a space that is inhabited.[8] Stein mapped "objects, food, rooms" in a book significantly titled *Tender Buttons*, in which she charted such a lived space.[9] Her type of geography—a "tender" mapping—comprehended both inhabitants and vessels. And like the tender cartography designed by Scudéry, it excluded neither women nor their spaces. It was a terrain that was defined geographically and mapped (geographically speaking) as a "room of one's own."[10]

GEOGRAPHY AS A ROOM OF ONE'S OWN

The movement of tender cartography is a course along which geography itself is made into a room of one's own. This, however, is not an easy process. The construction of this particular room involves making space for what dominant geographical discourse has traditionally excluded: the problem of gender. "The academic discipline of geography has historically been dominated by men," the cultural geographer Gillian Rose has stated.[11] Even the realm of geographic discourse was made into what art historian Rosalyn Deutsche calls a "boys town."[12] Aligning ourselves with the efforts of feminist geography, we wonder what the place of the female subject was in this "boys town."

To address the question, we turn to the domain of "geographical imaginations" and investigate various forms of representation that have intersected with the field of geography proper.[13] The making of geography as a room of one's own is a transdisciplinary process that has traveled an intertextual route. Gertrude Stein's literary-geographic path, for example, shows that not all cartography has been, or need be, a man's world. Stein's geography—a matter of inhabitants and vessels—calls for a different impulse to map. Resisting the urge to make cartography into a "bad object," I am interested rather in reclaiming the realm of mapping as a room of our own. I thus return to Scudéry and her *Carte de Tendre* in order to show that cartography has been inextricably linked with the shaping of female intersubjectivity. This mapping demonstrates, as psychoanalyst Jessica Benjamin has put it, that "what is experientially female is the association of desire with a space."[14] Although particularly involved in such a process, Scudéry's map was not a singular phenomenon. Let us look further into this tender geographical imagination.

A GLOBAL VESSEL

A number of spatial representations do, at the very least, include women in geography. My first choice is an architecture: a room in which to wander and make our own. I have a specific place in mind: the *studiolo* of Isabella d'Este in Mantua. In

1505, Isabella had the terrestrial and celestial globe copied from the library of Pope Julius II and placed in her own cabinet, a contemplative room adjoining a *giardino segreto*. This *studiolo* is our global vessel. Held in her space, carried in it, we can be transported on an imaginative voyage. Sitting in this enveloping house of knowledge—a geographic room of our own—we can look, both literally and figuratively, at the globe. The voyage in this interior enacts a particular global tour. As in film, it is an (im)mobile journey. The room functions like a movie house—a filmic vessel. Carried away with Isabella's celestial and terrestrial globe, we are led to consider the cultural nature of the geographic fascination of which cinema partakes. Passing through her room into the field of cartography, at its intersection with art and architectural history, let us consider the gender mapping of the atlas.

"FASHIONING" G: GENDER AND GEOGRAPHY

Not all atlases excluded women from geography. In fact, in the atlas, an imaging of gender takes place; at a certain level, the very body of woman ends up becoming a map. A politics of gender is pervasive in all mapping and is especially evidenced in the figures that populate the edges of maps. In forms of mapping embedded in colonial discourse, figurative representation assumed a particular political and ethnic significance.[15] The mapping of the West includes somatic decorations as well as designs that end up conflating soma and map. When countries are designed on a woman's very skin, this body politics becomes literalized. This was the case for a map of Europe shaped as a woman: *Europa*, also known as *Europa in forma virginis*, designed in 1537 by John ('Bucius') Putsch, was published widely throughout Europe and circulated in many versions, including those that appeared in various editions of Sebastian Münster's *Cosmography*.[16] As this map shows, the field of geography is particularly useful in illuminating historical gender positioning, for the site of the so-called "geographical oddities" included a sexualized terrain. Maps of the West exhibit sexual difference as their *terra (in)cognita*; the mapping of territory proceeded alongside the very mapping of gender.

Such imaging involved not only the designation of a gendered subject but, also, a particular mode of representation. It is interesting to note that since the sixteenth century, atlases have used the same representational codes as those that depict the body in anatomical books. Geography and the anatomy of Vesalius converge in the way they "figure" the body. This somatic link is confirmed by a semantic one: anatomy books were themselves called atlases. Books with titles like *Geography Anatomiz'ed* (1722) figure the labor that cartography involved.[17] The relationship was furthermore reversible: on the representational level, anatomical figures were actually subject to mapping. This is evident in the way ruled strips appear along the borders of the frame in anatomical drawings, just as in maps drawn in the Ptolemaic tradition.[18] A large field of interaction formed around this double function of the "atlas"—one that would distinctively shape early modern culture in the West.

The expanse of this expanded "atlas" can be visualized, for example, in a 1739 miniature that depicts the rooms of the Institute of Science, in Bologna, Italy.[19] The miniature exhibits the "space" of modern knowledge, composed as an interactive place—an atlas of bodies in space. In the foreground, at the left of the picture, there are globes, compasses, and other measuring instruments for mapping space. On the right, we see people reviewing what appear to be architectural plans. Moving to the back of the picture, in the upper right corner, there is a library. To its left, we find a drawing studio, set up for sketching nudes, which is adjoined to a scientific-anatomical cabinet. Although each of these spaces is defined, the boundaries between them are open. Compositionally, they form an articulate epistemic site of spatiovisual knowledge. We are free to travel in this space and to create our own relations between the rooms, moving from one to the next. Although the epistemic space is constructed sequentially, the sequence is assembled in such a way that the relationship between the rooms in the foreground and background sets out a circuitous path. The assemblage ends up creating a circle that very much resembles the composition of a globe. In this representation of global knowledge, the globe in the foreground relates directly to the anatomical museum in the background, and the architectural plans at the front correspond to the nude figures being drawn in the back. This picture circumscribes the complex representational movement of the "atlas."

In early modern culture, anatomy books—that is, atlases of the body—shared representational modes not only with geographic atlases but with other spatiocorporeal configurations as well. The composite "atlas" that resulted depicts the body in ways that resemble the body map then emerging in fashion and travel culture. A spatiovisual link is thus established between anatomy, apparel, travel, and cartography. Costume books and travel books, for example, were drawn in the manner of somatic and geographic atlases; conversely, illustrations found on European maps involved outfitting the inhabitants and portraying their gender, ethnicity, and class through traditional costumes.[20] An act of "fashioning" was thus taking place in mapping; map decoration became a way of "designing" difference and inscribing it in the geographic terrain. If the cartographer used the representational codes of the costume book to depict the socio-sexual body, so did the costume book borrow from geography and travel culture to "fashion" the body. It is only fitting, then, that the Sala delle carte geografiche, the Map Room, in Florence's Palazzo Vecchio, known as the Guardaroba, would bear a name that at the time designated a geographic "cabinet" and now means closet.[21] This chamber featured a wall atlas, which decorated a room devoted to fashioning a collection of images. At different levels, a semiotics of *habitus* takes place on the map of the atlas. *Habitus* connotes both costume and custom. The habit of *habitus* is the "vein" of cartographic imaging—a bodily connector.

Such an epistemic configuration shows that gender and mapping are explicitly connected. This relationship cannot be reduced to issues of domination, although, in many cases, woman was made into a geographic object, imprisoned in a binary opposition, or simply collapsed with the terrain in a type of representation

7.2. She has the world at her feet in Gian Lorenzo Bernini's *Monument to Pope Alexander VII*, 1672–78, Saint Peter's Cathedral, Rome.

that has feminized the very notion of land itself. But, even at the figurative level, gender has been mapped in other ways. We need to travel further into the spaces between art and cartography—where the map was configured—in order to reconfigure the gender atlas.[22] We especially need to explore the realm in which, as Christian Jacob suggests, the cultural and imaginary empires of mapping were configured together.[23] Here, we will find that the atlas unfolds as a multiform site for the configuration of place, evolving in constant interaction with pictorial imaging and its spatial physiognomy. In this respect, it can be said that allegories and other figures in the visual and plastic arts have constructed a varied, gendered atlas that exists on the threshold of a complex spatial "fashioning."

Take, for example, Gian Lorenzo Bernini's *Monument to Pope Alexander VII* (1672–78), in Saint Peter's Cathedral in Rome, a tomb surrounded by four allegorical figures, including an allegory of Truth that interestingly portrays the church's "global" mission in female form. This is a sculpture of a woman clutching an image of the sun who is sensuously wrapped in a double layer of marble cloth, opened to reveal her foot firmly planted on the globe. The association of woman with the globe

is deeply rooted in allegorical tradition. Curious images of "lady-world" appear in the art of mapping, in which women are depicted with globes in portraits that are often conceived as allegories of vanity.[24] These allegorical images on world maps are an interesting form of exhibition, for they exist at the very intersection of gender, fashion, and geography. In this configuration, fashion joins together with these other elements as a way of imaging. Lady-worlds suggest a female "fashioning" of the geographic terrain as they position the female subject in the atlas of image-making.

ART AND THE GEOGRAPHY LESSON

Art took part in the making of a female subject of geography, even when the subject matter was not directly cartographic. In the age of Enlightenment, for example, women engaged in the pursuit of knowledge were sensuously portrayed with atlases and globes, which designated their "worldly" position or their place of power. This is the case in portraits of Madame de Pompadour, as represented in her interior domain by Boucher or François-Hubert Drouais.[25] In a 1755 portrait by Maurice-Quentin de La Tour, she is represented in a sumptuous flowered robe, striking a seductive pose as she reads a book of music; she has deposited a portfolio of engravings and drawings on the floor. Looking out of frame as if to welcome a visitor—perhaps her lover, the king—she sits attractively near a marble table on which a globe is placed, towering over volume four of the *Encyclopédie* and other weighty tomes.[26] The geographic object, positioned in this architecture, becomes a female accoutrement. It is part of an erotics of knowledge, which locates the passion and power of inquiry in the "cosmetics" of gender.

 The work of the Venetian artist Pietro Longhi (1702–85) offers an articulate example of this cosmetics. Longhi was an interpreter of eighteenth-century life who shared the painterly touch of the female artist Rosalba Carriera (1675–1758).[27] Longhi traveled the architecture of the "interior" and paid attention to the life of the women of the city. He showed their fascination for such things as *mondo nuovo* and produced two paintings completely devoted to the subject, both titled *Il mondo novo* (c. 1756 and 1757), which depict ladies in urban scenes of travel.[28] His work was very influential for "the arts that travel the streets of the city." Longhi created realistic portraits of the everyday life of different classes and was a master of "little scenes." In the realm of the interior, he indulged in "conversation pieces" and "parlour scenes." Among his *topoi* are "the life of a lady," "family life," and "the education of a noble young lady," including eroticized scenes that involve desire and seduction. Longhi portrayed upper-class women in various cosmetic situations—preparing their *toilette*, dressing their hair, choosing a dress—or in scenes of daily life: lounging with their morning cup of chocolate, fainting, reposing, hosting visitors, visiting the library, reading aloud from a book, receiving a letter, or taking lessons in music, singing, dancing, and . . . geography. Positioned in this way—that is, in the realm of the private—geography met dwelling. Indeed, the "geography lesson" was one of Longhi's most striking in-

terior scenes. It portrays the way in which the world comes into the home and enters the inner views of an educated lady. It also publicizes private life, a point evidenced even in the formal construction of the work. The geography-lesson scenario "fits" his other interiors, sharing with them the same composition and construction as well as size and proportion. A form of interior voyage links the geography lesson to the lesson of cosmetics and to the act of traveling through the new world of *mondo nuovo*. The progression from geography to cosmetics to venture was a path: the course of learning how to "fashion" the self in space.

With this in mind, let us take a closer look at Pietro Longhi's most striking painting, *The Geography Lesson* (1752).[29] At the center of the picture is a woman. This feature is common to other representations of the same topic, including Francesco Capella's *Geography Lesson* (c. 1760) and the *Geography Lesson* attributed to Gramiccia (c. 1750).[30] Longhi's woman sits at a small table on which a globe has been placed. She points at the object with one hand and holds a compass over it with the other. An atlas is open on the floor. Her gaze is fixed straight ahead, directed at the beholder. Around her are two men who look in her direction, toward her body as well as the globe. Although she is showing the men (and us) something on the globe, the characters' roles are not clearly defined. The picture is intriguingly ambiguous as to whether she is giving or taking the geography lesson. This ambiguity renders the portrait richly complex: she appears to be doing both. What is nonetheless made clear is her facility with the subject, her knowledge of places, her navigation of space and the world at large. A light shines powerfully over her, as if to suggest her literal "enlightenment." This lighting locates the subject and positions her even more clearly at the center of the geographic picturing. A class dynamics further enriches the portrait: behind the lady, in the background, are two other women who belong to a lower class; they are the maids, who—one may speculate—may be hoping to take a geography lesson and thus to shift the social position they hold. These women have been relegated to holding serving trays rather than the globe.

A similar fashion of portraying women and geography shapes another *Geography Lesson* (c. 1750) by Longhi, where the topos of woman as a subject of geography is also richly and ambiguously portrayed.[31] A lady stands by a globe set on a table. She is bathed in light, holding a compass on the globe with one hand and touching the pages of an atlas with the other. While a man in the background stares at the scene, two other women sit in the foreground. Both look directly at the standing woman and appear to be engaged in the geography lesson. A young girl, seated at the table, holds an atlas. Her gaze is directed with particular intensity at the matronly woman demonstrating geographic knowledge with the globe. Again, this central figure looks out of the painting, as if to include us in her powerful geographic scene.

We can conclude, then, that taking and giving geography lessons were not necessarily male activities: they were part of a woman's "enlightenment," too, as paintings and engravings abundantly document. An eighteenth-century aquatint entitled *L'optique*, by J. F. Casanave after Louis Leopold Boilly, for instance, depicts a woman who uses an optical instrument to show views to a child and impart to him

7.3. The "enlightened" female subject in Pietro Longhi's *The Geography Lesson*, 1752. Oil on canvas.

geographic outlooks.[32] We may recall here how the geography lesson participated in the creation of a "new world" of imaging that led to film, particularly by way of *mondo nuovo*—that place of geographical delight for women and a means for them to teach such pleasure to their children. An engraving also entitled *L'optique*, preserved at the Barnes Museum of Cinematography, synthetically marks a passage to the moving image in its portrayal of a lady who draws an anamorphic image. She is engaged in the picturing impulse that, traveling the history of imaging space, would lead to the very invention of motion pictures.

ATLAS AND THEORIA

Fashioning the history of this protofilmic geographic practice and resuming our exploration of gender picturing in the atlas, we must look further into the realm of

allegory, for in its narrative configuration, it is a particularly fruitful terrain of sexual difference. As mental mappings, allegories both portrayed and promoted the presence of women in the geographic field. Although allegories are generally represented as female images and their stories are often conveyed in the form of a woman, this is not always the case; men are also portrayed in the allegorical position. So the issue at stake is not simply one of iconography. The geographic allegory displays a particular female form, an image we call upon here to investigate the mythological narrative and artistic representation of the atlas. Atlas, a male figure, of course, is the Titan who supports the globe on his shoulders, holding it up for view.[33] But in contrast to this Atlas, there are powerful women, conceived as allegorical figures, whose images have been drawn on maps. These are representations of women in the process of "figuring" knowledge, cartographic and otherwise.

In the 1622 edition of Willem Blaeu's *Atlas*, for example, there is one such interesting geographical allegory, conveyed in the image of a woman who holds a compass in one hand and an easel in the other.[34] This type of representation recurs in a number of geographic enterprises. Jodocus Hondius's 1611 world map, for instance, decorated with Cornelis Drebbel's figure of Geometry, after Hendrik Goltzius, shows an image of a woman who holds a compass on a globe and is surrounded by an array of instruments of knowledge.[35] Nicolas Visscher's map, published in the second half of the seventeenth century, is decorated with a cartouche from the title page of Cornelis Visscher's *Principes Hollandie, Zelandiae et Frisiae.* Taken from Dutch portraits of the 1650s, it positions a woman at the center of geographic picturing, comfortably leaning on the globe.

In Cesare Ripa's *Iconologia*, an influential treatise from 1593, Geometria is a woman who holds measuring instruments in both hands. The nature of her mapping is tactile: in one hand "is represented the movement, the rhythm, and the materiality of the body," while, in the other, its "line, surface, and depth."[36] Geographia and Corographia are also depicted as women, whose cartographic work is distinguished by their representations: one measures the globe and points a compass skyward, while the other points the measuring instrument down to earth, toward the material world. Together they cover the world of knowledge. Allegorical variations include the title page of Maurice Bouguereau's atlas, *Le Théâtre françoys* (1594): here, Geography holds a map to be viewed by an anamorphic process while Geometry—dressed seductively, so that "the folds of her toga," in Tom Conley's words, "reveal her sex"—demonstrates the measuring knowledge of mapping.[37]

In Ripa's *Iconologia*, theory itself becomes a mapping. Theoria, the figure the Greeks associated with vision and contemplation, is pictured architecturally here and redefined in geographic terms. She not only has been "fashioned" with cartographic and architectural accoutrements but has been provided a location for her activity: a set of steps. In Ripa's own words, "Theoria can be aptly represented in the form of a young woman who looks and aims upward, joining her hands together and holding on her head an open compass that points skyward. She is nobly dressed in blue, and is in the process of descending from the summit of a staircase."[38] In this representation of Theoria, a tension is created between two opposing directions. The

woman's body is the seat of this oppositional movement, from which theory is produced. "Dressed" for theory, with her toga holding the torsion of two vectors, this spatial, epistemic tension, in fact, defines her theoretical plight: her figure negotiates a movement between a drive for geographic ascent, which measures, points upward, and aims high; and an architectural descent, which tends downward, toward the material world and perhaps even to the unconscious. In Ripa's picture of Theoria, the geographic ascent takes a haptic form. The compass, literally implanted in her head, becomes a cognitive prosthesis. This epistemic headset is quite spacious, for the compass is wide open to the world. Looking like a set of pointers and receptacles, it becomes, figuratively, her antennae—her "feelers" of space.

A kindred spirit of Theoria is the female geographic allegory contained in Jan Barend Elwe's *Atlas*, published in Amsterdam in 1792. Its prominent display on the frontispiece of the atlas suggests that the image's function is to provide entrée to the field of geography itself. The mythical, male Atlas here is relegated to the background and the representation of geographic knowledge is dominated by two women who are depicted below the title *Atlas*, written in large capital letters on a cloth held by angels. Positioned in front of an extremely large globe, the two female figures appear to be creating geography. One stands, holding a compass over the globe with one hand as she touches the surface of the globe with the other. She is making a map or, rather, charting the globe: "designing" the earth. In this rendition, the land is not feminized; on the contrary, it appears to be subject to a gendered act of mapping. The other woman, in the foreground of the image, sits in front of the globe and draws a picture. The combined activities of the two women cover the vast field of spatial knowledge. Depicting the intersection of chorography and geography, this representation addresses the convergence of art and cartography and, in so doing, portrays the very act of "picturing." The allegory speaks of the making of geographic picturing in terms of gender and depicts the notion of the "atlas" itself as a potentially feminine form of knowledge. The subject of cartographic image making is female: while women are making geographic space, geography, in turn, is making them into subjects of representation. The atlas "fashions" geography with, and as, a female subject. It gives the kind of geography lesson that had been established, in its own way, by Scudéry's *Carte de Tendre*, expanding the geographic borders of her *tact*ics of representation.

"TAKING PLACE": FROM SALONS TO GARDENS

Every Saturday, beginning in 1653, Madeleine de Scudéry opened the salon of her Parisian house in the rue de Beauce, making room for an intellectual enterprise that included mapping. The salon culture Scudéry presided over, which produced the *Carte de Tendre*, was a forum of female affirmation.[39] The salon is an important locale to revisit as we retrace topographic paths, especially because it was a site where the female subject, as it were, "took place." The work of the *précieuses*, satirized by

Molière as "ridiculous" and frequently dismissed or denigrated, turns out to be quite precious, indeed, and in need of critical re-evaluation.

Scudéry's salon was devoted to a collective form of writing that fostered the articulation of intersubjective discourse. Her salon was unique in that it even composed a geographic document such as the *Carte de Tendre* in this way. Insofar as it represented a female writerly space, however, it was not a singular occurrence, for the salon was, generally, a woman's affair. As Joan De Jean, among others, points out, the "salon's writing was always women's writing."[40] In other words, the "*précieuses* are the ancestors of modern feminists."[41] In many ways, this is because they "sought for women what would today be termed control over their bodies."[42] A literary world led by women, devoted to women, and interested in their body politics, salon culture valued interpersonal relations and turned them into forums of female authorship. It did so by fostering collaborative creative ventures that later would become mechanized in such collaborative activities as film authorship.

Produced in the collective atmosphere of the salon, a composite map like the *Carte de Tendre* calls for a reading that can unpack its position within a cultural geography at large. This includes its relation to garden culture of the time. Salons directed by women, such as Scudéry's, were not enclosed sites but open to other worlds, including that of gardens. In fact, Scudéry had a taste for gardens, and her participation in the *fêtes* at Vaux may even explain the foundation of the *Carte de*

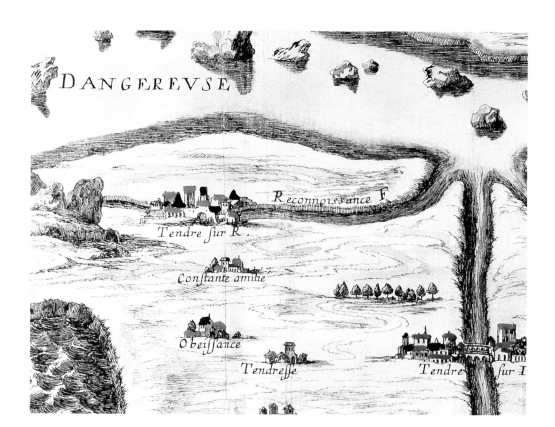

7.4. *Carte du pays de Tendre*, the map of tenderness designed by Madeleine de Scudéry in her novel *Clélie*, 1654. Engraving by François Chauveau. Detail.

Tendre. Insofar as it is landscape design, Scudéry's map and the emotional cartography it inspired are indeed deeply related to garden design. As Michel Conan shows in his study of garden history, a project such as the *Labyrinthe* at Versailles, to which Charles Le Brun contributed artistically, is not only analogous to Scudéry's map but even can be read in conjunction with it.[43] Visitors were taken through the labyrinth on a path that made up a "game," the nature of which recalls the spatial game that a map like the *Carte de Tendre* offered.

Beyond this specific example of intertextuality, which focuses on the idea of play, the garden and the emotional map, considered in the context of a larger epistemological strategy, show an even deeper association. Both the map and the garden are imaginary topographies. As systems of representation, they are organized and shaped as itineraries. As noted previously, the landscape is experienced in a viewing that demands motion. Scudéry's map functions in the same way: it is a site that is meant to be traveled through by the beholder, who becomes inscribed in the map itself. As we have seen, the garden of Scudéry's time embodied motion at different levels, including the mechanics of movement represented in the spectacular moving machines and theatrical spectacles that took place on the garden site and enhanced its special effect of motion.[44] We have also seen how the kinetics of the garden began to produce the type of kinesthetics that picturesque aesthetics made into an ultimate design feature. The sensory experience was driven by the haptic: strolling in the garden, a touching experience of feeling through the eye, was a means of activating the senses in a cumulative sequence of emotional responses. It is precisely on this haptic route that the garden that would become the picturesque met the emotional map. This, too, was designed as a place that evoked emotion in the shape of motion as one traveled through it: Scudéry's map drew a landscape of emotions to be experienced as a series of sensational movements. In this "moving" way, it made "sense" of the place of affects. It also made sense of sentimental displacement. The emotional map produced an e*motion*, and the motion inscribed therein was not only kinetic or kinesthetic. As in garden design, there was a passage that made it possible for the exterior world of the landscape to be transformed into an interior landscape, and vice versa. The garden and the emotional map are "intimately" interconnected along this route, which leads to the inner course of the moving image. Both were sensate discourses that became a new trajectory of vision—a site-seeing that opened the road to prefilmic movement.

Site-seeing was indeed an incipient horizon on the cultural scene that produced Scudéry's emotional mapping in early modern Europe. The geographic activity of the time was so pervasive and engaging that one was truly immersed in different forms of topographic reading, of which the garden represented a major model. As Alain-Marie Bassy explains in his panoramic view of Scudéry's time, a geographic mode of thinking was being set, and set in motion:

Fed from an early age on Cicero and Quintilian, expert on the tactics of artificial memory, familiar with the techniques of ekphrasis, *a glutton with an appetite for travel reports or garden descriptions, and, finally, a reader of Francesco Colonna's* Hypnerotomachia Poliphili—*whose pseudo-archaeological topography organizes*

the sentimental and spiritual itinerary of the hero—the 1650 reader can see a discourse, an argument, an object in a garden, just as he or she, as a good rhetorician, disposes "topographically" the parts of his/her discourse. [45]

A discursive geography was put into place, mobilized by multiple *tactics* of reading space. It was on this haptic terrain that the *Carte de Tendre* was mapped. Transforming *ekphrasis* from a descriptive mode of representation into a narrative mapping of places and people, this map envisaged a geography of "inhabitants and vessels." A subject fed on mnemonic journeys through architectural spaces and hungry for travel discourse, who is also a voracious reader of topographic narratives, an avid observer of garden description, and a glutton for cartographic *ekphrasis*, could indeed turn such tactile tactics into a tender geography.

The protofilmic *tactics* of site-seeing that embodied the cartographic terrain of architectural seduction was established by the 1499 architectural fiction *Hypnerotomachia Poliphili*, whose traces are as tangible in the amorous path of the *Carte de Tendre* as in Ledoux's architectural vision.[46] Let us recall that Poliphilo dreams about waking up in a dark forest and, as if in a memory theater, recounts the architectural marvels he sees as he searches for his love, Polia.[47] The journey of this fiction of automatism leads him (a living machine) to activate his five senses and to visit gardens and sites, for this book was actually made in lieu of architecture. Doors conceal his beloved, but, appropriately, she is eventually found behind the door of *vita voluptuaria*, the voluptuous life of seduction. Despite a journey through the sea of death, the dreamer unites with his lover. In the end, however, as he wakes for the last time, Polia—whose name stands for *polis*, the city so loved by *Poli*philo—is not at his side. Poliphilo has only dreamt a *Carte de Tendre*.

MEMORY IN PLACE: AN ART OF MAPPING

Scudéry's salon was able to produce the *Carte de Tendre* in 1654 because, having absorbed various topographic tactics, including the architectural seduction of Poliphilo's amorous discourse, it had gone on to elaborate a cartographic *sensibility*. The salon knew not only how to see but also how to "set" a discourse in a landscape and how to dispose a discourse topographically. This type of knowledge was made available through the legacy of the art of memory, which enabled the transformation of topographical *savoir* into an art of mapping.

The art of memory had always been a matter of mapping space and was traditionally an architectural affair. In the first century A.D., more than a hundred years after Cicero's version, Quintilian formulated his architectural understanding of the way memory works, which became a cultural landmark.[48] To remember the different parts of a discourse, one would imagine a building and implant the discourse in site as well as in sequence: that is, one would walk around the building and populate each part of the space with an image; then one would mentally retraverse the building, moving around and through the space, revisiting in turn all the rooms that had been "decorated" with imaging. Conceived in this way, memories are motion pic-

tures. As Quintilian has it, memory stems from a narrative, mobile, architectural experience of site:

It is an assistance to the memory if localities are sharply impressed upon the mind, a view the truth of which everyone may realise by practical experiment. For when we return to a place after a considerable absence, we not merely recognise the place itself, but remember things that we did there, and recall the persons whom we met and even the unuttered thoughts which passed through our minds when we were there before. Thus, as in most cases, art originates in experiment. Some place is chosen of the largest possible extent and characterized by the utmost variety, such as a spacious house divided into a number of rooms. Everything of note therein is carefully imprinted on the mind. . . . The first thought is placed, as it were, in the forecourt; the second, let us say, in the living-room; the remainder are placed in due order all round the impluvium, *and entrusted not merely to bedrooms and parlours, but even to the care of statues and the like. This done, when the memory of the facts requires to be revived, all these places are visited in turn. . . . What I have spoken of as being done in a house can equally well be done in connexion with public buildings, a long journey, or going through a city or even with pictures. Or we may even imagine such places to ourselves. We require therefore places, real or imaginary, and images or simulacra which we must, of course, invent for ourselves. . . . As Cicero says, 'we use places as wax.'*[49]

As Frances Yates shows in her seminal study on the subject, the art of memory is an architectonics of inner writing.[50] Such a reading, in fact, can be extended all the way from Plato's "wax block" of memory to the wax slab of mnemonic traces, impressed on celluloid, in Freud's "Mystic Writing Pad."[51] In Cicero and in Quintilian, whose art of memory is particularly relevant to this study, the type of inner writing that is inscribed in wax is architectural. *Places* are used as wax. They bear the layers of a writing that can be effaced and yet written over again, in a constant redrafting. Places are the site of a mnemonic palimpsest. With respect to this rendering of location, the architecture of memory reveals ties to the filmic experience of place. Before motion pictures spatialized and mobilized discourse—substituting for memory, in the end—the art of memory understood recollection spatially. It made room for image collection and, by means of an architectural promenade, enabled this process of image collection to generate recollection. In this way, memory interacts with the haptic experience of place; it is precisely this experience of revisiting sites that the architectural journey of film sets in place, and in motion. Places live in memory and revive in the moving image. It is perhaps because, as the filmmaker Raúl Ruiz puts it, "cinema is a mechanical mirror that has a memory"; or, better yet, because it is in this mirror-screen that the architecture of memory lives.[52] Mechanically made in the image of wax simulacra, the projected strip of celluloid is the modern wax tablet. Not only the form but the very space of this *écriture* is reinvented in film's own spatial writing, decor, and palimpsestic architectonics, as well as in the spectatorial promenade. The loci of the art of memory bear the peculiar wax texture of a filmic "set"—a site of constant redrawing, a place where many stories "take place" and take the place of memory.

The architectural memory system, grafted onto the site of a house or a building, drafted in the form of a long journey or urban travel, or, indeed, drawn in (motion) pictures, continued to grow in scope. It was revived in medieval times, along with the sense that memory is material and spatial and that its visual process is an emotional affair. It became clear, as Mary Carruthers explains in her study of mnemonics, that "a memory-image . . . is 'affective' in nature—that is, it is sensorially derived and emotionally charged. . . . Recollection [is] a re-enactment of experience, which involves . . . imagination and emotion."[53] Physiological processes are involved in the emotions, for memory affects physical organs and engages our somatic being as it responds by way of movement and mental walks. The objects that are architectonically set in place and revisited in the architectural mnemonic include ideas and feelings, which are thus understood as fundaments of decor.

The art of memory that grew out of Quintilian architectonics found a site of development in theater before implanting itself in the movie house. Particularly well known in France and Italy, the theatrical version of this art was offered by Giulio Camillo (1480–1544), a celebrity of the sixteenth century. Camillo worked for the better part of his life at devising his Memory Theater: a collection of everything that could be conceived but not seen with the naked eye. He physically built it in Venice and Paris and wrote something of its foundational ideas.[54] According to his theory, inner images, when collected together in meditation, could be expressed by certain corporeal signs and thus materialize and be made visible to beholders in a theater. As Erasmus put it, "it is because of this corporeal looking that he calls it a theatre."[55] It is also because of this corporeal looking that we may now call this architectonics a movie theater—a house of haptic imaging. An incarnation of the Memory Theater, the movie theater, too, is an architecture of image collection for collective exploration.

Along this road that connects external space to interior geography, through which the art of memory evolved from mnemonic theater and the art of mapping into the movie theater, the work of Giordano Bruno (1548–1600) plays an important role.[56] When the passionate Bruno fled the Dominican monastery in Naples to which he belonged and started wandering through France, England, and Germany, he took his own particular brand of the art of memory with him.[57] Less static than Camillo's Memory Theater, Bruno's art of memory shared the physiognomic and astral tone of the work of his fellow Neapolitan magus Giovan Battista Della Porta. His architectural memory system consists of a sequence of memory rooms in which images are placed according to a complex logic, based on everything from magical geometry to celestial mechanics. In designing a form of "local memory," Bruno constructed a type of knowledge that was mobile. In order to map a great number of memory places, he conceived a flow of movement between them, creating a composite geography. In Bruno's mobile architectonics, one can travel through houses in different parts of the city or even in different cities, assembling disparate places as if connecting the memory sites on a journey (or experiencing a filmic process). His art of memory turns the imagination into an alchemy of the inner senses and imparts associative power to images. As shadows of ideas, memories, for Bruno, must be

affectively charged in order to move us and pass through the doors of the memory archive. Bruno's mobile architectonics thus results in mapping emotionally striking images that are able to "move" the affects as they chart the movement of the living world. The pictures of his memory systems actually look like maps: they dream up that art of mapping imaginary places that became cinematic writing.

In the course of the mapping of inner space that led to filmic mapping, the art and theater of memory interacted closely even with actual theater design. It is well known, for example, that London's celebrated Globe Theatre is related to Robert Fludd's Memory Theater. It was also by way of the theatrical embodiment of memory that, by 1868, Stokes's "mnemonic globe" entered the field of "cartographical curiosity," pointing the way to the mnemonic mapping about to take place in the cinema.[58] It was by way of a "global" theatrical incarnation that the art of memory was revived in the movie theater. It was transformed, in particular, in that mnemonic architectonics that became the mark of the movie palace: the historic and "atmospheric" sensory remake of spaces in which one could walk, once again, in the imaginary garden of memory.

This remake in the architecture of the film theater was motivated, for film itself, like the map-garden, is an "art of memory," a memory map. In its memory theater, the spectator-passenger, sent on an architectural journey, endlessly retraces the itineraries of a geographically localized discourse that "sets" memory in place and reads memories as places. As this architectural art of memory, filmic site-seeing embodies a particularly mobile art of mapping: an *emotio*nal mapping. In film, sites of emotion are mobilized. Schooled in the architectural journey of mnemonic systems, the "moving" image knows the route of Scudéry's emotional cartography. Let us proceed on this route, looking further into her geographical discourse, to advance our understanding of the genealogy of a geographic language that puts affects on the map by placing them on an itinerary. Such is the road to a geography of "inhabitants and vessels."

A CARTOGRAPHY OF *EMOTIONS*

A text aptly called "Discours géographique," published in the *Gazette de tendre* (c. 1654), set the *Carte de Tendre* within the "geographical discourse" of Scudéry's salon. The map was, in fact, the text of an elaborate geographical discourse, pervaded, as we have shown, by the topographical imagination that set discourse in a garden and memory in place and foresaw—by way of this old, sensuous path—an eighteenth-century sensibility. This geographical discourse turned intersubjectivity into a map by which one might navigate interpersonal relations and locate women's position in love and society. The *Carte de Tendre* made a geographic documentation of relational space in the form of a map.

As a collaborative form of writing-as-mapping, the map spatially inscribed the interpersonal bond at many levels into its texture. Designed by Scudéry and first engraved by François Chauveau, the *Carte de Tendre* is part of the fictional making

of lived space. In the course of Scudéry's novel *Clélie*, the map—a narrative plan—is said to be the design of the eponymous character, who draws it to show the way to the land of *Tendre*.[59] Produced by women and also addressed to men, the *Carte de Tendre* was a chart of relational developments that mapped the realm of sexual difference in its intimate space. Although sometimes read only as a map of courtly love, it covered a larger relational terrain.[60] For women it actually mapped, in sequential manner, the terrain of an intellectual and emotional liaison shared among friends, in addition to the bond between lovers. The type of friendship Scudéry mapped out was a social practice developed on the site of the garden and in the salon. It was an emancipatory alternative to the rules that regulated heterosexual conduct and the societal arrangements of relationships in Scudéry's time. In the name of desire, Scudéry, who used the pseudonym Sapho, was opposed to marriage. She did not marry, opting instead for an intense intellectual and emotional rapport with Paul Pellison. The realm of *Tendre* provided an alternative to the inferior position to which marriage, often arranged for reasons other than love, relegated women of her day, excluding them from the amorous geography. The map of *tendresse* offered an uncharted path of productive, rather than reproductive, closeness between a man and a woman, made room for the sharing of intimacy between women, and explored relational magnetism in settings larger than coupling. From a female viewpoint, it promoted the recognition of the subjective inner world of women as a basis for non-objectifying, non-exploitative relations.

Scudéry produced a spatial mapping of emotions, inscribing affects onto an architectonics that was a social map. In this respect, the power of her vision can be inspirational today, not only for the political assertion of desire in its discourse, as has been noted, but because it allows us to remap a politics of affects, by putting affects back on our map, and thus to change our own navigational charts.[61] In a way, I see Scudéry's map as an early symptom of what Julia Kristeva defines, in psychoanalytic terms, as "the intimate revolt."[62] This is a cartographic rendering of intimate experience, a domain that has been explored in psychoanalysis but extends over a much larger terrain. By showing how this tender map works and assuming tender cartography as a methodological vehicle, my intent is to reclaim this intimacy as a place of interpretation and, in the process, to place cinema on the map of the emotional road atlas. A return to emotion is politically essential for cultural movement, for, in feminist terms, politics closely affects the fabric of our intimate space. To my mind, this intimate experience positively includes the world of imaging and the cinematic "vessel" that carries these images across the social landscape.

Taking the image of the map as a means of such "transport," the tender map can become, first of all, a guide to relational politics, stretching interpretive borders that were already stretched in our effort to reposition *emotion* on the cultural scene. In fact, as we are about to see, the most striking feature of the *Carte de Tendre* is the fluidity of its "tender" geography. This is an inhabited place that lacks borders; as such, it offers an affective journey that is uniquely suited to be carried across new frontiers of site-seeing, in a reversible cartographic exchange between its plan and our own geopsychic design.

AN INTIMATE MAP

The map creates an itinerary for the one who travels with it, or who navigates its landscape in the travail of (interpretive) life. As she passes through a variety of terrains, the beholder-inhabitant of the *Carte de Tendre*—a garden stroller, fed on the architectural art of memory—is transformed into a voyager who traverses an inhabited realm of towns and landscapes. Scudéry's map is made up of multiple navigational paths that, in ways that are ultimately protofilmic, can be traveled forward and backward, at accelerated speed, or even in slow motion. One senses that the traveler on this chart can wander around the map as well as off it. The spectator-passenger is even led astray at times in this garden of *emotions*.

The *Carte de Tendre* is part map, part *veduta*. In an image at the bottom of its right side, four people stand leisurely under large trees, as if themselves about to begin a voyage on the map. In another version, from 1659, a woman on the left, in provocative attire that reveals her breast, extends her hand to a man.[63] She seems to be on her way out of the map. Even without this exit, the *Carte de Tendre* does not depict a demarcated, isolated topography but a terrain that keeps spilling over a cartographic "off-screen." As in a filmic frame, the sites on the map are in constant touch with the territory off the map, which is neither closed nor enclosed but continues on all four sides. The "Countries of Tenderness" are not finite but extend over the bottom and left side of the charted terrain. At the top left and right, we see only a portion of the "Dangerous Sea" and can envisage being swept away in it, off the map. At the top center of the plan, beyond the "Dangerous Sea," are the "Countries Undiscovered." These amorous *terrae incognitae* might certainly lure the traveler off in an exploration that would take her well beyond the landscape of the map.

Scudéry's map is a narrative tour (de force). Even if one stays within the map, one confronts a journey that provides the option of roaming. In the map, as in the architectural memory journey, time and discourse are not only understood spatially but are mobilized in imaginative ways. There are no fixed directives for this map tour. In the undetermined itinerary, several movements are possible and encouraged. There are even different destinations. The *Carte de Tendre* is, in many ways, an "open work" of geography.[64] It is an open cartographic text whose many potential touring options produce a cumulative effect. For instance, if one wishes to confine oneself to the goal of reaching the land of *Tendre* and approaching the "Countries Undiscovered," there are three possible itineraries to follow. These routes are a spatialized representation of the stages of love. One can reach "Tender upon Inclination" by way of water, following the direct, rapid route on the "River of Inclination," which then leads into the "Dangerous Sea" and beyond, into the amorous *terrae incognitae*. One can also reach "Tender upon Esteem" via a series of interludes on terra firma, which go from the bridge of the town of "New Friendship" onward, passing by the village of "Great Spirit" and traveling through a series of fragments of inhabited amorous discourse. The map is in this sense Poliphilic: its loving architecture is a cartographic manifestation of an intimate domain. This domain includes love, here understood as a representational field, as Roland Barthes puts it in his own

"lover's discourse."[65] The map travels the terrain that historian Stephen Kern calls "the culture of love," and shapes it architecturally.[66]

An autonomous geographic text, the *Carte de Tendre* is further narrativized architecturally by the character of Celère, who verbally redrafts the map's architectonics in the novel, commenting on the interplay between the natural and architectural settings. Celère notes, for instance, that "Clélie had not placed any villages along the banks of the River of Inclination, which runs with such a rapid course that there can be no lodging along its shore."[67] In other cases, a steadier inhabitation of the *emotion* is possible. Villages and even cities are designed on the map to house this sentiment. They function as resting places on the map tour, places of lodging for the emotional movement.

Scudéry's discursive erotics of love takes place in the seventeenth-century fashion. In a way, however, this fashion is not far from our own amorous mode of address. As in today's virtual reinvention of epistolary love—the contemporary erotic obsession for amorous e-mail—missives are here a major vessel of love. Language and eros are connected on Scudéry's map, which is a literary itinerary of correspondences. This itinerary is composed of the village of "Pleasing Verses," which precedes the sites of "A Gallant Letter" and "An Amorous Letter." One can also employ other venues, visit different sites, and use different servers or carriers. For instance, one can reach "Tender upon Recognizance" by making a series of stops on the terrain of tenderness that includes "Small Cares" and "Great Services" and by using a lot of "Sensibility"—for, as Celère remarks, "we must be lively touched by . . . those we love."[68]

In the unfolding of love, things, of course, may go wrong—that is, go the wrong way. Scudéry's amorous narration includes such doomed paths. One is marked by forms of "Negligence." By way of "Inequality," "Lukewarmness," "Lightness," and "Forgetfulness," this path finally leads into the "Lake of Indifference," which "by its calm waters lively presents, without a doubt, the very thing of which it bears the name in this place."[69] The only enclosed site on the map, this enormous lake is a foreboding "final" destination, a visibly disturbing sign of deadly amorous stillness. The "Lake of Indifference" is a still-life portrait of terminal love. Swimming in it is as lethal as navigating the haptic insensitivity of an ending love affair. In the "Lake of Indifference," there can be no more touching between people.

Scudéry was aware of "fatal attractions" and marked several such deadly paths on her chart of affect. One that traces the sour relationship that may exist between friends or lovers is found to the left of the map. This path leads into the "Sea of Enmity," which is depicted as a giant black hole. We can only imagine the depth and width of this huge mass of dark, rough waters, since it extends beyond the map. To follow this path is to fall out of love and, quite literally, off the map. "Indiscretion," "Perfidiousness," "Obloquy," and "Mischief" all lead into the "Sea of Enmity." You are confined to this view if you dwell in your solitary path, up on the rock of "Pride," which is set on the coast of this sea. But floating at the top of the map is another option, another sea. Compared to the tempestuous "Sea of

Enmity," "where all vessels are shipwreck," this sea is quite different.[70] A boundless fluid that is called "dangerous," it is actually dangerously appealing: a calm expanse of water interspersed with restful islands. It is a top destination on the itinerary that takes one from *tendresse* to the *terrae incognitae* of affect. Driven by amorous "curiosity" and beguiled by the epistemic seduction of swimming in the unknown, one approaches this sea with the sweet danger of navigating a tender geography and reaching beyond it—toward a new form of mapping.

THE FASHION OF EMOTIONAL MAPS

Positioned at the threshold of art, mapping, and the literary salon, Scudéry's *Carte de Tendre* entered the domain of imaginary cartography and changed its course.[71] Prefiguring the *sensibilité* of the eighteenth century, it became a landmark for a new form of mapping that affected the discursive realm of emotions. Reverent or satirical imitations appeared well into the nineteenth century, where sentimental cartography aided the search for (amorous) bliss in maps such as *Carte et jeu allégoriques du bonheur* (1810), or even the pursuit of divine love, as in *Presqu'île de la perfection* (1855). Although others were produced, Scudéry's was the most open of the affective cartographic texts. Nonetheless, the replicas and complementary designs that began where Scudéry left off explored the sensitive terrain of affects well before the film industry made this matter its own "affair."

Despite her own claims of precedence, Scudéry's project may not have been the very first map of affects to be (dis)placed onto a landscape; it was, however, the one that publicly established emotional cartography as a genre. One particularly interesting map of amorous *terrae incognitae* may have preceded hers, but it was not as articulated as the *Carte de Tendre*. Engraved by Jean Sadeler, *Royaume d'Amour en l'isle de Cythère*, a map of the kingdom of love, was further subtitled *Carte descripte par le S. Tristan l'Hermitte*, "1650," although it was more likely composed around 1653–54. In 1659, a *Carte du Royaume d'Amour*, attributed to Tristan l'Hermite, appeared in the first volume of *Recueil de Sercy* by Somaize, who imitated Scudéry's narrative topography and applied it to his descriptions of the *pays de galanterie*. This chart of the kingdom of love describes, as the map explains, love's "main cities, villages and other sites, and the course one must keep to journey there." Like the *Carte de Tendre*, this engraving is also part map, part *veduta*. At the bottom, next to a town view, an erotic scene pictures the banquet of love. Despite this view, however, the map imposes forms of control and containment on the amorous terrain. The realm of love, for instance, is here an enclosed island. From the "Plain of Indifference" to "Amorous Gazing" and "Panting" all the way to "Declaration" and "Satisfaction," one circles this island in search of love. Here, the course of the journey becomes a circuitous path. Cartographic repetition becomes the key to a mastery of sentiments.

Also contemporary with the *Carte de Tendre* was the *Carte du Royaume de Coquetterie* (1654). This map was published in the *Histoire du temps* of the Abbé

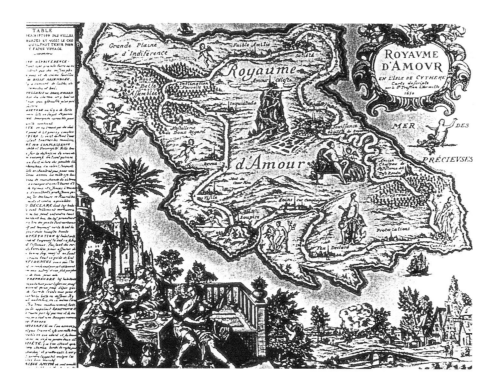

d'Aubignac, who defended himself from the accusation that he had plagiarized Scudéry's *Carte de Tendre* by asserting that his topography allowed for more space than hers. Even if more spacious, his map is not more open, for, in effect, to reach one's emotional goals, one has to travel long and hard between places here. This map is also an enclosed island, accessible only by boats that navigate the surrounding sea. The island houses a walled city, uses trees as demarcations, and accommodates amorous combat. There are several routes between the place of departure, set in the capital, and the destination to be reached. On this itinerary, as befits the inhabitants of the kingdom of coquetry, one encounters La Mode, a figure in charge of "textures, color, and fashions."

Questions of precedence and plagiarism aside, several trends of imaginary cartography initiated by the *Carte de Tendre* flourished in the second half of the seventeenth century, including and surpassing sentimental mapping.[72] By way of Scudéry's cartography, discourse itself became subject to mapping. Discursive strategies and tactics were spatialized, for example, in the *Carte de la bataille des romans* (1659), a map of the "war of novels." Published in Furetière's *Nouvelle allégorique, ou histoire des derniers troubles au royaume d'éloquence*, an account of the "latest troubles in the kingdom of eloquence," this map strove to chart the terrain of history and fiction, mapping such discursive practices as descriptions and allegories. Scudéry's own intellectual realm, the life of the salon, itself became the subject of mapping in Maulévrier's *Carte de l'empire des Précieuses* (1659). A *Carte du Pays de Jansénie* was produced in 1660, while François de Callières's *Histoire*

poétique de la guerre nouvellement déclarée entre les Anciens et les Modernes, which tackled the recurring war between proponents of the "ancient" and the "modern," appeared in 1688.

This mapping of discourse became intertwined with the geographic charting of imaginary places. In 1659, Mademoiselle de Montpensier envisioned an "island of the imagination" belonging to a female character in her *Relation de l'Isle Imaginaire et Histoire de la Princesse de Paphlagonie*, while a map entitled *Royaume de Frisquemore* appeared in Charles Sorel's 1662 history of an imaginary kingdom. It is interesting to note that, in many instances, the mapping of imaginary geographies was directly linked to figuring the place of sexuality and picturing sexual difference. Thus the *Carte du monde de la Lune*, an anonymous engraving of 1662, mapped "the Kingdoms, States, and Republics that women possess on the moon." Charted by "a good friend of women"—who nonetheless gave them power only on the moon—it described in great detail the "properties of women." This feminine lunar landscape was not fully lunatic, but contained a range of attitudes and emotional states. The map was divided into the "Continent of Fierceness" and the "Continent of Vanity, Pride and Gluttony," in the midst of which was positioned the "Lake of Love." The map's assertion that "only women lived in this lunar landscape" serves to confirm the joined cultural mapping of gender and space while significantly constructing this as "outer space."

Maps that drafted the terrain of love in the wake of Scudéry's *Carte de Tendre* include Baudeau de Somaise's *Voyage fortuné dans les Indes du Couchant, ou L'Amant heureux, contenant la découverte des terres inconnues qui sont au delà des trois villes de Tendre* (1662), where the "happy lover" is a fortunate voyager who discovers the *terrae incognitae* beyond the cities of Tenderness; Bussy-Rabutin's *L'Almanach d'amour pour 1663*; E. Pavillon's *De L'Isle des Passions, ce premier*

7.6. Anonymous,
Carte du Royaume de Coquetterie, 1654.
Engraving.

mois d'inclination (1698), a chart of the Island of Passions; and *Le Pays d'Amour*, by Morévi. These maps employ and expand the language of the *Carte de Tendre*, from the "Realm of Inclination" to "Countries Undiscovered," and go beyond the cities of tenderness in search of *jouissance*.

Although most maps of love provide a voyage, they generally present landscape features as if seen from the reader's position, rather than from within the realm depicted. The path of emotions is often circular and thus produces a roundabout voyage that puts the reader on a veritable merry-go-round of love. By documenting an experience and repeating it, these maps would appear to offer a way to master a trauma rather than a way to change the course of emotional events, as in the *Carte de Tendre*. Nevertheless, all amorous maps represent experience as a journey. This is particularly evident in the abbé Tallemant's *Voyages de l'Isle d'Amour*, a map published around 1660 that represents the travails of journeying to the island of love. Even the title makes clear that a map is a voyage and emotional cartography a way to retrace a psychogeography.

An elaborate tactics was deployed in a map entitled *The Attack of Love*, by Matthaeus Seutter (1678–1756), published in his *Atlas novus*, extant in versions from 1720, 1730, and 1745.[73] Here, romantic strategies become a military affair and, in such a way, are drawn onto the landscape. The map offered "a method to

7.7. Matthaeus Seutter, map of *The Attack of Love*, from his *Atlas novus*, 1745.

defend and preserve one's heart against the attacks of love." In a highly decorative way, it charted a varied amorous terrain that included the "Palace of Love," the "Garden of Pleasure," and the "Camp of Love," with its "Masculine Fort" and "Tent of General Cupid," all intent on attacking the "Citadel of Reason," and a heart surrounded by a "Glacial Sea." This map also charted the interaction of sexuality and space. As one of the "geographical oddities" of the *Map Collectors' Series*, its domain was described as follows: "Set in a frozen sea without passion, it is besieged by ships and batteries, attacks of the fair sex. Cannon blasts represent pride, desire, familiarity, and false chagrin."[74]

Seutter's map is an example of the way in which cartography and garden history were intertwined and particularly reveals the extent to which the sentimental map was embedded in the joint views of these endeavors.[75] While the *Carte de Tendre* also exposes the relation between map and garden design, as we have shown, *The Attack of Love* employs a different model and takes an entirely different cartographic route. As Vincent Scully has noted, in French culture, landscape architecture and fortification were linked in such a way that they became a single art.[76] *The Attack of Love* is an outcome of this particular relation. Its shape reprises the *étoile* that characterized the geometrics of French formal gardens and was adopted by military art, especially in the design of the fortification of the citadel. It was the shape that eventually, with the advent of Haussmanization, made modern Paris into an ultimate garden. We thus see that sentimental views come to be designed as cultural views themselves are landscaped and further mapped in place.

Another map of love by Seutter, engraved in four parts, shows the "Empire of Love," the "Empire of Bacchus," "Communion between Love and Wine," and the "Empire of the *Précieuses*." Here, love is articulated into "Hope," "Enjoyment," and "Inconsistency" and features "Gallantry" and "Coquetry" on the outskirts. Most clearly, love shares an affinity—a "communion"—with the intake of wine: both involve incorporation, as Christian representation makes clear. The anonymous *Géographie galante. Description universelle du royaume de galanterie* (1662) describes a comparable situation in a land surrounded by the "Sea of Imprudence" and the "Sea of Perdition." It maps the terrain of love in relation to "Opulence" and "Good Food." Love is positioned between these two luxurious realms, while the "Lake of Amorous Abandonment" shares the same shape and position as "Lake Gourmand." Bodily matters and emotional cartography went hand in hand. The *Carte de l'isle Clerine en Barbaril*, an anonymous map of an island of the imagination, from the end of the seventeenth century, also connected gastronomy and inner itineraries. We find the "Coast of Wines" located not far from the "Sea of Desire," while the "Sea of Trouble" is juxtaposed to such culinary delights as *gigot*. The same form of incorporation is evidenced in *La carte des Estats du Grand Duc D'Osmeos* (c. 1662), an anonymous engraving of an imaginary estate in which the absorption of space and the intake of food are linked. In mapping countries and cuisines, it pictured such things as a "Bacchic Sea" and, by way of describing the "Feminine Part of the World of the Moon," again wrote gender into an imaginary inner voyage.

CARNAL KNOWLEDGE

An anatomist of the human heart, Madeleine de Scudéry fashioned a map of affects that established an imaginative trend for depicting a physiology of passions. In this imaginary cartography of intimate space, where emotions "take place" and are spatially represented in their motion, the map, like the garden, is a sensate yet embodied topography. Its circuitous circulation is reminiscent of the circulation of blood "vessels." Existing somewhere between anatomy and cosmography, this intimate cartography was indeed a carnal form of journey where the body, mapped in space, was mapped *as* space. In some ways, Scudéry's map actualized the physiological link that haunted, from afar, Leonardo's representations: his maps were as alive as his anatomical drawings, to which they are often compared.[77]

In Scudéry's *Carte de Tendre*, this relation between flesh and space is embodied literally in the map's design: as we have mentioned, her emotional chart drafts a landscape that looks strikingly like the inside of a woman's body.[78] The fluid spatial relation of the "Dangerous Sea" and "River of Inclination" to the surrounding land suggests that this is a living map of a woman's reproductive organs and bodily fluids. In fact, the way the two sides of the "Dangerous Sea" flow into the "River of Inclination" duplicates the anatomical relation between the fallopian tubes and the uterus. The course that the "River of Inclination" takes is a literal journey into the space of the uterus, through the cervix, and into the vagina. For Scudéry, the topography of love is sexed. A traveling anatomy retraces carnal affairs. At many levels, Scudéry's *Carte de Tendre* impersonates a play of reversals between the terms

7.8. O. Soglow, *Main Route of Expedition through the Alimentary Canal*, 1930.

7.9. Anonymous,
Map of Matrimony
navigating "the orbit
of affection," n.d.

of "body space." If the landscape becomes a body, the body conversely becomes a site of mapping. In this reversible fashion, emotional cartography is dressed with sexual curiosity. Desiring a body becomes a yearning for space. At the same time, yearning for a place can turn into a bodily desire—a physical matter.

As a trend of carnal knowledge, the physiology of passion that took place around the *Carte de Tendre* continued well into the nineteenth century. Even in the twentieth, the gastronomic itinerary that had been established in seventeenth-century corporeal mapping became a *Main Route of Expedition through the Alimentary Canal*, a 1930 satirical fictional voyage that aimed at "shooting" the body with "gun and camera."[79] When the site of exploration is a body map, one can travel physiologically through the depths of bodily passages. Mapped in the very channel of the body, this epidermic cartographic knowledge maneuvers sexuality; charting sexual difference, cartography depicted both the encounter and the battle between the sexes. Possibly inspired by the seventeenth-century *Carte de mariage* of Sorel, even a *Map of Matrimony* was configured: from the "Bay of Introduction" to the "Gulf of Flirtation" to "Port Hymen," one could navigate the sexual contract. On this chart, the art of mapping is married to the fiction of a heterosexual "sentimental education"—a grand literary fiction, indeed.

THE IMAGINARY ATLAS: A FICTIONAL JOURNEY

*The map . . . presupposes the idea of narration, it is conceived as an
itinerary. It is an Odyssey.*
Italo Calvino

The relationship between imaginary cartography and site-seeing that emerges in the
art of mapping, with its spatial rendering of sequences of affects, is a function of the
fictional imagination. From the itinerary of Scudéry's map to film language, the art
of mapping space exhibits a narrative configuration and, as Pierre Jourde shows in
his study of imaginary geographies, plays an important part in the shaping itself of
narrative space.[80] This goes well beyond the observation that maps have been used
in literature.[81] What it means, as Robert Harbison has delightfully and eccentrically
suggested, is that fictional itineraries can take on imaginative cartographic forms,
while topographical sites and architectural spaces can be invested with a composite
narrative representation.[82]

Literary scholar Franco Moretti maintains, from a different perspective,
that novels are so bound to topography and other forms of socio-spatial mapping
that they can be redrawn on maps—visible analytical tools with which to explore
the interaction of literature and space.[83] In this view, geography is exposed as an
influential discursive practice. It has, in fact, shaped the very narrative configura-
tion of modern European fiction, giving rise to new forms of writerly space.[84]
In cartographic terms, a story can be laid out as an experiential trajectory on an
existing geographic map, as on a palimpsest, and that map will be transformed in
the process. Like cinema and its spatially bound genres, many books are built
around, across, and through a map of specific places and, through their narratives,
reinvent and revisit sites charted by emotional cartography. Thus in spatial forms
of literature, as in film narratives, fiction participates in the architectonics of a
social psychogeography.

The specific type of cultural map considered here is the narrative geogra-
phy of *emotion*s, a transport that attaches eroticism to space and especially engages
the seduction of architecture and topographical architectonics. In the intertextual
course that led to modern site-seeing, many such archi-topographical fictions have
been mobilized. In its sensuous narrative itinerary, which followed the topography
of Poliphilo's own erotic architectural journey, the tender geography of the *Carte de
Tendre* also bonded with erotic architectonics. This was taken further in the story of
the "The Little House," published by Jean-François de Bastide in *Le nouveau spec-
tateur* in 1758.[85] As the architect Rodolphe el-Khoury points out, an architectural
itinerary of sensation and affect is set out in this *petite maison*, or garden pavilion—
a *folie* that was, literally, a lover's asylum.[86] In the physiognomy of place designed by
this novella, architecture stands for a lover's body and its traversal binds romantic
touch to the taste for space. Mélite, lured by Trémicour into his *petite maison*, is in
turn seduced by its architecture and "touched" by the decor. Having spent her life
acquiring taste and knowledge, she is interested in sensing this "body" of work. An

architectural story sensuously unfolds as she travels in, out, and through every corner of the *petite maison*. She "wanted . . . to explore," the story explains. "Curiosity . . . compelled her to linger at every turn," for she "did come here to walk" and "was enchanted."[87] This itinerant narrative, where a woman is subject rather than object of (architectural) seduction, was set in motion after the experience of *emotio*nal cartography and shortly before an architectonics of successive decor became diffused in the picturesque garden. It thus represents another step along the path that made room for a protofilmic site-seeing and the subsequent fiction of film.

While novels can construct forms of imaginary mapping, some are themselves a direct product of the topographic journey set in motion by the art of (imaginary) cartography. Cultural maps are designed by the cartography that is written in fiction as well as in the work of narrative that is produced by cartographic observation. At an epistemic level, as literary scholar Tom Conley decisively demonstrates, cartography can be said actually to have shaped early modern writing: as mapping developed in Renaissance France, a new literary imagination took hold that produced forms of cartographic writing.[88] Cartography has activated a mental imaging of space in Western culture. The explosion of the cartographic impulse, bound up with the very politics of space, has defined the contours of the subject and forms of social organization and, in this way, has largely reshaped the sense of self in its relation to space. The impact of maps on selfhood is even more pronounced in forms of emotional cartography, as epitomized in the *Carte de Tendre*: through narrative forms, cartography has redesigned the very *space* of the subject. By providing a design for her spatial imagination, it has fashioned forms of spatial inner-subjectivity and intersubjectivity.

THE TRAVELING SEDUCTION OF THE ART OF MAPPING

Framed within the design of a moving cartographic imagination, the tender geography established by Madeleine de Scudéry touches the lived space and live place of the subject. Her psychogeography, in this sense, is a living map. Fashioning inner intersubjectivity, the map thus lives an intertextual life. In the cultural journey that reveals cartography to both picture and be pictured as narrative space, the *Carte de Tendre* indeed forms an intertextual trail that reaches all the way to contemporary times. It was refashioned, for example, in the mnemonic design of Marcel Proust, who used it to describe the state of mind of Swann in love as he waits for Odette.[89] By now, the *Carte de Tendre* has entered the very domain of the "lover's discourse": in romance languages, *tendre* still indicates an amorous tie, as in the French *il y a du tendre* or the Italian *c'è del tenero*. A map of this kind forms a link between people.

Scudéry's tender cartography also shapes the art of mapping today, particularly in artistic undertakings. A substantial number of contemporary artworks, in fact, have adopted and reposed the methods of the art of mapping, reinventing its form of geographic expression.[90] Cartography is becoming a central locus of contemporary culture not only because today's artists are making maps but because

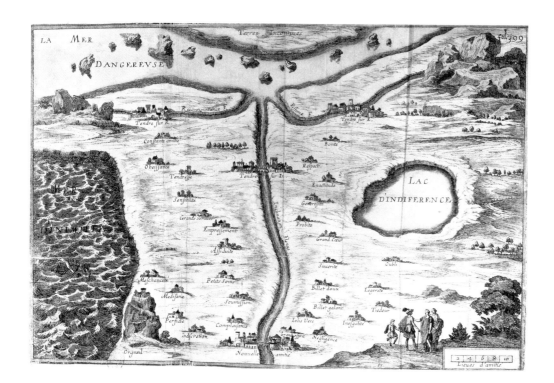

7.10. Madeleine de Scudéry, *Carte du pays de Tendre*, 1654. Engraving by François Chauveau.

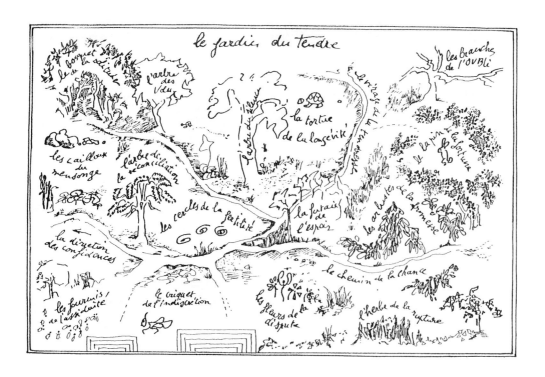

7.11. Annette Messager, *Le jardin du tendre*, 1988. Drawing from the installation at Centre d'art contemporain, Castres, France.

artistic endeavors are curatorially measured and exhibited as maps that chart the trajectory of a movement. An aesthetic form of cartographic expression is taking place in our current world of displacements. Once again, the art of mapping, with its cartographic fiction, is becoming symptomatic of a worldly condition.

One strain of contemporary cartographic art touches on the politics of emotions and even remakes the space of the *Carte de Tendre*. This is especially evident in the work of the Parisian artist Annette Messager, in whose aesthetic world intertextuality becomes a direct genealogy. Messager acknowledges her long-standing debt to Scudéry and the *Carte de Tendre* and makes the connection explicit in the title she chose for a recent exhibition of her work in the United States: "Map of Temper, Map of Tenderness."[91] Calling herself a "love painter," Messager has remade Scudéry's *Carte de Tendre* in many ways.[92] As an artist whose work is produced in the bedroom as well as the studio and is designated the product of "Annette Messager Collectionneuse," she collects and circulates an array of emotional imagery.[93] In 1988, for example, Messager produced a design of "the garden of tender regions," an outright remake of the *Carte de Tendre*. *Le jardin du tendre* (1988) is both a drawing and an actual garden. Various paths depart from "the tree of silence," along which *emotion*al states, in the shape of sites and creatures, appear. Among these are "the winding road to tenderness," "the path of chance," "the way to confidence," "the mountain of assiduity," "the branches of forgetfulness," "the flowers of dispute," "the herbs of rupture," "the tree of reconciliation," and "the fork leading back home." Traveling on this map, one may choose to sojourn at "the lake of temptation"; ponder at "the crossroads of ambition" and "the circles of fertility"; visit "the grove of solitude" and slide into "the slope of sorrows"; or even linger in "the mirage of tears."

This emotional garden was explored again in Messager's contribution to "La Ville, le Jardin, la Mémoire" (1998), a group exhibition at Villa Medici in Rome that included a haptic tour of urban gardens and memory led by artist Janet Cardiff.[94] Besides the gardens, other works by Messager can be read as maps that chart the course of carnal relations. In *My Works* (1987), an installation that actually resembles a map, fragmentary images are connected with strings of words, creating a register of amorous language that strongly recalls that of the *Carte de Tendre*. Other works that grow out of her fascination with Scudéry's map are *My Trophies* (1987), emotional landscapes drawn on body parts, which make feet into illuminated manuscripts; *The Travel Warrant of Annette Messager* (1995–96); and *Anatomy* (1995–96). In all these works, a road map of emotions meets anatomical charting.

This kind of traveling, which the German artist Rebecca Horn called *Journey within the Body* in a piece from 1992, can become a filmic geopsychic affair. It does so not only in the mechanism of Horn's film performances and feature films but especially in her installations.[95] Fashioned as an erotic machinery, these installations take us through the stages of a playful and mournful mechanics of love, as in her *River of the Moon* (1992). In Horn's physiology of love, *stations amoureux* are elaborate psychic sites. Stops on a pilgrimage of passion, her heart chambers are

places of passage: hotel rooms, maps of travel, places where tales of habitation are constantly written and erased on the same bed. For Horn, to enter the rooms of the Hotel Peninsular is to navigate the course of inner space.

Bedroom stories turn into a *Carte de Tendre* in a different way in the work of the New York artist Heide Fasnacht. In *My City Was Gone* (1991–92), a blanket covers geological strata made of cloth and other materials, its plaid pattern standing for geographic coordinates and its contour defining the state border of Ohio. A map of microhistory that reveals the layers of a personal story, this mattress-map, centered by a steel hole, represents a fragment of a stratified memory. This is the map of a hometown left behind, the peculiar souvenir of a home that became a place of departure and cannot be represented as nostalgic return.

Displacements and domestic journeys are the main terrain of mapping for Guillermo Kuitca, an Argentinian artist of Russian Jewish descent whose bedroom stories make up a fascinating errant cartography.[96] In his work, architecture is the visionary matter of Ledoux and Boullée, and mapping is a magnificent obsession. Kuitca travels the domain of the *Carte de Tendre* as well, working delicately and sensuously with architectural methods and geographic imagery that include the floor plan of an apartment and maps. Kuitca's road maps, regional charts, architectural designs, urban plans, blueprints, tables, and genealogical charts radiate from Buenos Aires but speak beyond its borders. The artist has inventively charted space and reworked maps of existing cities or countries, imaginatively exploring their topography. He also has made maps of people in the form of genealogies and family trees, and charted relations and connections between human beings.

In Kuitca's work, the veinal cartographic grid is subject to constant traversal and internal movement. A path may be stained with paint, red as blood, as if to mark a painful passing. Names of cities from different countries may be interpolated on a single road map, creating an imaginary topography. In the fashion of a film spectator, the viewer of Kuitca's maps is asked to remake a trajectory and retrace a spatiotemporal journey. Along this route, uncanny things may happen. The name of a city may be inscribed, again and again, on the same map. Showing how an entire world may be reduced to a single place—the site of unavoidable destiny and inevitable destination—Kuitca reveals the obsessional nature of our emotional geography.

In his mapping of history and loss, the artist "travels domestic." This journey becomes a map in *Coming Home* (1992), a painting in which an apartment plan is designed to look like an airport landing strip. Here, the domestic ground turns into a plane field. In Kuitca's work, we always land in this place of coming and going, as the floor plan of what is essentially the same empty apartment is endlessly refigured. As in *House Plan with Broken Heart* (1990), *House Plan with Teardrops* (1989), or *Shit Disposal House Plan* (1990), for Kuitca, home is a real architectural landscape: a physiology mapped, traversed, and redesigned by the trajectory of emotions. This architecture incorporates and expels. It is a melancholic fragment. Kuitca's homes cry, bleed, secrete, defecate. In *Union Avenue* (1991) this "inner"

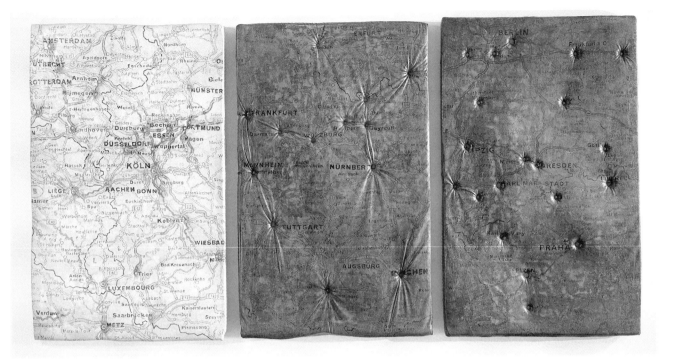

working of urban planning is charted as interior design. Here, the lines that mark city blocks are made of forks, knives, and spoons. In such a way, the map recreates the geometry of the domestic. This is a plan of familial topographies. In his mappings, Kuitca has also used thorns and bones as the delineations of architectural edges to reveal the true "perimeter" of his mapping and to suggest what the "border" actually contains and releases.

Kuitca's architectural views map a world of daily objects. Like the passengers in the films of Antonioni or Akerman, in Kuitca's paintings we move between a bed and a chair. But, most of all in his work, we travel on a mattress. Kuitca's most evocative landscapes are bedroom world-views. These are imprinted in a number of works called *Untitled*, produced mostly in 1992: mattresses upon which road maps of Europe have been designed. In the installation *Untitled* (1993), for example, the sequential layout of the map-inscribed mattresses in an architectural space entices us to share a private bedroom fantasy.[97] Lonely mattresses are scattered on the floor; the space is suspended and frozen, as if something has just taken place or is about to happen; no one is lying on the beds. But the maps speak of a fiction—an arresting architectural tale. This is a story written on a bed, inscribed in the fabric of a room, layered on the geological strata of a used mattress, entangled in the buttons that punctuate its surface like belly buttons. The map haunts the mattress like a stained memory. It is a residue, a trace, a living document. The mattress was a witness. It absorbed a story, some event—perhaps too many events or not quite

7.12. Belly buttons punctuate a life story written on a mattress-map in Guillermo Kuitca's *Untitled*, 1989. Oil on vinyl covered mattress, 3 parts.

enough of them. Now, inevitably, it recounts the tale of what was lived, or unlived, on it.

Like a film, the bedroom map retains and explores "folds" of experience. It charts the private inner fabric of our mental landscape. The mattress-map is a complex narrative: a nocturnal chronicle, an erotic fantasy, an account of the flesh. A road map of cities designed on a bed is a chart of our phantasmatic life. It belongs to the realm of dreams and their interpretations. Reproducing the immobility that allows us to travel the unconscious, it traces the very itinerary of our unconscious journeys. The mattress-map portrays the motion of the emotions. It is our life map. As an anatomy of life, this is a relational chart, an inhabited "vessel" with roads that are "veins" and places that are "tender buttons." Such a map, in which land is skin, retraces the layers of people that populate our space and draws the places that populate our peopled landscapes. It tells us, in a kind of "mimicry," that people themselves become places, marks and markers of our living map, just as our faces, decorated with the lines of memory, become the map of our passing—the very landscape recorded by film.

Positioned in this private architecture, Kuitca's residual cartography touches the living house of memory and dreams—the very cartographic debris that is the "fabric" of motion pictures. It charts the haptic space that fashioned the *emotion*al space of the moving image: a mnemonic cultural journey, as we have seen, of genealogic "measure." The filmic connection of Kuitca's cultural mapping is even made textually explicit in his work. Eisenstein's Odessa steps are cited in *El mar dulce* (1984 and 1986) and *Odessa* (1987). In *Coming* (1989), a story is mapped filmically in twelve frames, each containing a different angle of view. Somewhere in a city, there is a dining room, a bathroom, and an empty bed. While apartment views appear in axonometric projection and ground plan, a diagram of street plans and regional maps resides in other frames of the painting, (dis)locating us. The whole scene is stained by bodily fluids. Corporeal marks leave their impression on an empty, deserted bed, intractably painting a vacant apartment with the liquidity of love.

The cinematic range that exists in Kuitca's maps extends from a filmic form of storytelling to the architecture of filmic space itself. In the series of gigantic miniatures called *DeTablada Suite* (1991–93), for example, his art of memory becomes an architecture, which takes a spectacular form: the shape of "*puro teatro.*"[98] It becomes pure theater space, a site where, quite suitably, the archive and the cemetery are placed next to other theatrical sites of collection, which are recollection. As they chart in this way the geography of imaging—the site of public intimacy and collective dreaming—Kuitca's maps touch the very texture that has produced the space of the unconscious optics of film and its own memory theater. Narrating the architecture of social space, the maps inhabit the very room of filmic matter: the house of moving pictures; the home of emotion pictures. Gigantic miniatures, indeed, in the cartography of recollection.

A MAPPING OF FILMIC EMOTIONS

The "mapping impulse," as the art historian Svetlana Alpers shows, has been a major force in the history of the visual arts, shaping, in particular, Dutch art in the seventeenth century, where picturing and mapping coincided and expressed a common notion of knowledge.[99] As we have seen, the historical link between art and cartography—where mapping itself took place—now has been revived in a different form, marking our postcolonial age of diasporas. In its contemporary incarnation, the art of mapping is rerouted to picture a geography of transits. It is interesting to note that, rather than constituting itself solely as a descriptive art, mapping, in general, appears to be fleshing out its narrative impulse and new psychogeographic paths. An impulse, after all, is a force that both impels and is impelled by waves of feeling and states of mind.

Along this particular route of mapping we have encountered the observational space of the moving image and its way of charting emotion pictures. As we have seen, a form of mapping, tender to gender, has shaped the genealogy of filmic site-seeing on the *emotion*al terrain that ranged from the peripatetics of the (memory) garden to the relational strolling of sentimental mapping. An architectural mobilization of affect and memory has taken place along this haptic way. The (dis)placement of affect onto space has given way to a passage, as the exterior world of the landscape has become protofilmically transformed into an interior landscape. This tender site-seeing not only configures the mode of protofilmic representation but pervades the subject of cinematic representation. Let us, then, turn to a consideration of the textual narrative of the tender geography as it presents itself in filmic narrative. As a map of emotions, Scudéry's *Carte de Tendre* has made direct filmic appearances, and, in many indirect ways, has shaped an intertextual language of emotion in film.

The *Carte de Tendre* appears as a textual reference, for example, in the opening sequence of Louis Malle's *Les Amants* (*Lovers*, 1958), framing the opening scene of its narration. As such an aperture, the map creates an entrance to the film and shapes its narrative development. As T. Jefferson Kline suggests, "at the level alluded to by *La carte de tendre*, Malle's film addresses the very possibility of feminine subjectivity and feminine discourse."[100] In so doing, the borderless map of tenderness serves as more than a simple introduction to the film. It functions as a diagram of the film's own sexual politics and discourse of affects. But the *Carte de Tendre* "touches" film architectonics in ways that go even beyond direct reference, for it opens the way to a geography in which space is the place of *emotion*al interplay. Cinema is bound to tender mapping on this terrain of intertextuality, which is itself a geography "moving" in history—as shown by the films included in this book, from the intimate plans of Antonioni and Akerman, treated earlier, to the voyages of Rossellini and Greenaway, which we have yet to traverse.

As a passage into this cartographic intertextuality, we pause momentarily to revisit Alain Resnais and Marguerite Duras's *Hiroshima mon amour* and its cine-city travelogue, for it steps openly into Scudéry's terrain.[101] Although the map is

neither referenced nor depicted in this film, *Hiroshima mon amour* can be read as an actual cinematic remake of the *Carte de Tendre*. Like Scudéry's map, it designs intimate space as it enacts a narrative detour of emotional "transport." *Hiroshima mon amour* creates a tender map in which a lover's body stands for a city, while, conversely, the city itself is imagined as a corporeal affair. Let us recall that the city, as the female protagonist tells us, was made to the measure of love, just as her lover was made to the measure of her body. Here, taking us beyond mimesis to the edge of "mimicry," a body map is lived and even explored as a site as, in turn, a city is tailored to a body—one's own and that of loved ones. Her city fits (and "fashions") a body of love. It is an intimate geography, a body-city on a tender map. As in Scudéry's map, where exterior landscape reads as interior, emotions are architecturally rendered and spatialized along a course. Different topographies merge on this filmic map of love, incorporating one another. As in the *Carte de Tendre*, architecture becomes a body of experience, lived and loved. It becomes a metaphor—a means of transportation—for passionate traversals. Indeed, this mapping charts a journey: the way space designs intersubjectivity. Ultimately, one desires a site as one does a person. Bodies and cities involve the same seduction, give rise to the same tales of love. We absorb them with the same passion: one can literally fall in love with a place.

As *Hiroshima mon amour* shows, crossing the borders of a foreign body— the body of another touched for the first time—can compare to the cluster of emotions involved in approaching an unknown landscape. A libidinal drive moves us toward a place and lets us absorb it. It is the same drive that makes us cling to the body of another. The beginnings of the exploration are thrilling, and fearful. The desire for the embrace is mingled with the anxiety of losing boundaries. One may get lost in the new geography; one may pleasurably wander in the *Carte de Tendre*. A

7.13. Amorous superimpositions in *Hiroshima mon amour* (Alain Resnais, 1959). Frame enlargement.

danger, however, is that with the loving incorporation comes expulsion. This might involve digestion. A slow process of incorporation may end up consuming desire itself and lead to the death of the story. And what about indigestion? Too much, too soon, too close. Then, incorporation leads to ejection. Scudéry shows the course for taking someone into our emotional geography and offers some advice for erasing their place inside of us. Longing can endlessly inhabit the heart. Yet this seemingly infinite route may turn into the "Lake of Indifference," that place of still life frozen on the map.

Love affairs with places and people are sought out, lived, and sometimes even end in the same way. We "consume" them. They wear out. Taking it all in, becoming the other, as the woman in *Hiroshima mon amour* does, is a transformation measuring up to that assimilation. If incorporation is the rule of this game, you can play until the drive wears out or until expulsion arrives in the guise of rejection. In the end, looming on the horizon, there is always a "Sea of Enmity," for amorous ingestion can be a way of devouring, another form of consumption. Indeed, the same emotional "consumption" affects both bodies and places. One falls in love. One also, alas, falls out of love. One, then, simply falls. Off the map.

A lover's journey has many paths. Tracing them, the narrative itinerary of *Hiroshima mon amour* enacts a filmic game of tender mapping. A loved body turns into the woman's own geography. It marks her place of origin and her transits through cities, charting her motion from town to town, from country to country. First, it encounters the German soldier. The loving chart touches foreignness and madness as it maps her escape from her native town of Nevers to her happy exile in Paris. It is a map that follows her "until the end of the world": to Hiroshima, where, fourteen years later, the name of her beloved Japanese architect becomes Hiroshima and she, completing a voyage of displacement and condensation, becomes Nevers.

In this film, as in Scudéry's *Carte de Tendre*, different temporalities are spatially mapped as different sites are revisited in different bodies. Although there is a spatial movement, there is no chronological order to the journey of love. In *Hiroshima mon amour*, the journey, like a psychoanalytic tour, spirals backward. It begins and ends with a woman's geography. First, we see her body embracing the Japanese architect, whose image has been superimposed on a scene that is the body of the city of Hiroshima. The camera is on a moving vehicle, traveling the city in the fashion of the panorama films of early film history. "I met you here," the story begins, as we cross a bridge.[102] "I remember you. Who are you? You destroy me. . . . You are good for me. How could I know that this city was made to the measure of love? How could I know that you were made to the measure of my body?" As these words bridge an emotional distance, we traverse an arcade. The journey of love takes shape as we travel the city streets. "Please . . . devour me. . . . Deform me to the point of ugliness. . . . Why not you, in this city, in this night . . . so like the others, they can hardly be told apart?" By way of such incorporation, Nevers and Hiroshima begin to merge on the map of love, as the story of the impossible love with the German soldier becomes a *tale* of love—a narrative that can only be told and mapped, for it has already been devoured and consumed.

It is nighttime. She walks out of the hotel room. She sits down, looking out at the empty street. Car lights go by. Out of the darkness, he walks in, toward her. They look at each other. They're in the same frame. How long can they be together, like this, in the same space? He begs her to stay in Hiroshima. "Of course, I will stay in Hiroshima . . . with you. . . . Go away. It is impossible to leave you." He turns away and the camera follows him as he begins to walk. Time seems to have gone by as the film cuts to a shot of her walking a few steps ahead of him. "Stay in Hiroshima with me," he repeats softly. She continues to walk as she thinks to herself, hoping and longing in fear: "He'll come toward me. . . . He'll take me by the shoulders. . . . He'll embrace me. He'll kiss me, and then I'll be lost." But he does not take her by the shoulders. He does not kiss her. He walks slower. Stops. Then exits her frame.

She is now alone, walking the streets of her beloved's city. Through this tale of love, Hiroshima becomes her own city. It turns into Nevers, the city of another passion and the site of another death. The horror of Hiroshima turns into the horror of her German lover being killed, the shame of her unspeakable liaison, the public humiliation of being shaved, the memory of going mad. This is her side of the war, a war of love. As she now walks through the streets of postwar Hiroshima, the architecture of the empty arcade gives way to the empty piazza of that other town. Repeated intercutting takes us between distant moments and places far apart. As we cross time and continents, the consistent rhythm of the camera movement links them together. It is a motion that ensures an emotional continuity. The changes are only apparent, for we are moving through a single mental location. We are in the same site. We follow her traveling through Hiroshima-Nevers—a composite city, an imagined topography. We are with her as she walks through this *Carte de Tendre*, her own emotionally imaged geography.

On this composite map, the film's end meets its beginning. With cross-cutting reconnecting emotional places, we can now see this city, the imagined geography of her tender mapping, as the condensed, displaced city of filmic montage. Made to the measure of love, it is a cinematic creature—a cine city. It is a geography that turns out to be a screen, a screen of memory. As she walks the map of this imaginary place—finally able to return, recount, and relive—the scene, filled with memories, becomes empty. It is fated that no one else be on the streets of her city, the city made to the measure of love and his body. The peopled landscape begins to fade just as it was recalled to life.

As the urban bodies unite in recollection, the bodies of her lovers also become collected as one, addressed as "you." And now that her city has been fleshed out, fit to the measure of this amorous transmutation, she begs again: "Devour me. . . . Deform me to your likeness . . . so that no one after you will ever understand the reason for so much desire." But all this can only lead to finality: "We shall mourn for the dead departed day. . . . A time will come . . . when we can no longer name the thing that unites us. . . . The name will gradually fade. Then one day it will vanish." In the end, she speaks of amorous consumption, ultimately recognizing its devouring force, able to name the fear of ejection and the desire for forgetting. As

she charts the double movement of letting go, the work of mourning—itself a work of incorporation and removal—is consumed. Her geography of "inhabitants and vessels" is now void. She begins to exit her *Carte de Tendre*, putting away the faded map of her devouring love. She enters a building. For the first time, the camera makes a movement independent of her. At faster speed, it traverses the block and ends up on the other side of the street. The sequence is over. It is all over. She is off the loving map.

THE MAP TOUR: THE COURSE OF EMOTIONS

In Scudéry's art of mapping, as in the art of film, narrative is spatially configured, and its mapping, in turn, makes more room for lived space and its movement. In its many narrative configurations, as we have recounted them in this chapter, tender mapping does not reproduce the ordering principle of analytic knowledge but rather tries to chart a movement. In this sense, it refutes the cartographic binarism of Michel de Certeau, which creates a false opposition between the categories of "maps" and "tours."[103] In Scudéry's form of cartographic narration, as in film's own, there is no distinction between map and tour. Both are a form of architectural narration. Cinematic description, like emotional cartography and its landscape design, does not oscillate between the alternatives given by de Certeau: "seeing" or "going." It does not present a "tableau" or organize "movements." As shown earlier, and especially in the chapter "A Geography of the Moving Image," the motion picture does precisely what its name announces: like Scudéry's map, it is the very synthesis of seeing and going—a place where seeing *is* going. It is a tableau that organizes movements: a *tableau mouvant*.

What is mobilized in film's own emotional mapping is the plan of an unconscious topography in which emotions can "move" us, for they are themselves organized as a course. In film, as in the emotional course mapped by Scudéry, sentiments come to be mapped as physical transformations, written as moving physiognomy. Indeed, emotional cartography is about an itinerary, the carnal knowledge by which one comes to know beings. It is the kind of cosmography whose compositional lines touch the most tender filaments of our inner cells—a cosmography that draws the universe in the manner of an intimate landscape. This is a drawing whose texture is the very system of our interior, the text of our inner fabric: a place where pictures become a space, an architecture.

8.1. An archive of habitation:
view of Doris Salcedo's untitled
installation at the Carnegie
International, Pittsburgh,
1995. Detail.

8 An Archive of Emotion Pictures

Motion is emotion.
Douglas Sirk

I think we could arrive at a Cinema . . . in which the feelings would have
free play in the way [of] a contemporary canvas.
Alain Resnais

Our consideration of the art of mapping, with its representation of life in motion, has taken us to the subject of the motion of emotion. We now turn to the construction of an archive of emotion pictures, reflecting as we do so on art. The cultural interplay between art and film has come to the fore in our research. In the hope of furthering an interdisciplinary project in which art and film theory may develop concurrently, we wish to readdress and clarify the notion of the haptic here, for it is essential in reinforcing this interaction. Looking at the role the haptic has played in art and its theorization, and considering its potential effects on film theory, we take into account past and future incarnations of the "touch of space." In this investigation we will focus on the realm of psychogeography and its historical dislocations in various maps in which the motion of emotion reemerges as an intimate geography. Taking the measure of our current geopsychic situation vis-à-vis shifting forms of (intimate) habitation, we question the "sense" that mapping can make of charting our moving place in history. As we dwell on the archive of emotion pictures, we continue to work in that interface between the map, the wall, and the screen.

HAPTIC THEORIES: ART AND FILM

Let us begin by addressing the issue of the haptic in the realm of art and film, noting an historical coincidence that set a haptic intersection in motion. Cinema emerged alongside a reformulation of spatiality in art theory, proposed most notably by Alois Riegl (1858–1905), who developed a notion of the haptic.[1] Riegl was curator of textiles at the Museum of Art and Industry in Vienna during most of his professional life. Work on the haptic was thus, significantly, produced by an art historian whose curatorial considerations put him in touch with matters of texture and tactile practices. One may assume that Riegl's concern with surface decoration and his engagement with the history of ornament were inscribed in a textural practice.

Riegl's work influenced Walter Benjamin, and his foregrounding of the haptic shaped Benjamin's pioneering theorization of the cinematic art form. Benjamin, however, put a twist on Riegl's theory: he subverted the separation of touch and vision and, by extension, the distinction between haptic and optic that

8.2. Jan Brueghel, *The Senses of Touch, Hearing, and Taste*, 1618. Oil on canvas. Detail.

8.3. A taste of touch in Peter
Greenaway's installation
Watching Water, Venice, 1993.
Detail of interior view.

Riegl had established by way of Egyptian art; he also objected to the teleological vision that saw art moving toward an optic mode of representation in modern forms. As Margaret Iversen writes in her volume on Riegl's work, for Benjamin, "the modern 'tactile' mode of perception involves a challenge to the senses. . . . Benjamin's appreciation of Riegl's theory did not prevent him from turning it upside down, that is by making modern perception tactile or haptic rather than optic."[2]

In contemporary film theory, there is a limited history to the use of the term *haptic* with regard to cinema.[3] Noël Burch first employed it as a way to account for film's spatial illusion: as access, that is, to a believable deep space, which he saw growing out of the surface of early film in a gradual way.[4] Burch has been criticized by Antonia Lant for using the term haptic in a confusing way that runs counter to Riegl's conception and actually ends up defining the optical mode.[5] Although appreciative of Benjamin's approach, Lant does not work from his vantage point (which might provide a different perspective on reading Burch); rather she elaborates a different understanding of haptical cinema. Invoking Egyptian art and referring to early cinema's Egyptomania, she presents the view that, for Riegl, the haptic implied the presence of representational flatness and planarity. Reinforcing her assumptions about the bipolarity of flatness/depth in filmic terms, she develops an historically grounded theoretical model of film based on the plane of a non-perspectival space. The "early screen," for Lant, is "utterly haptic, a surface of clearly delimited height and width with no visual suggestion of an inside, of any depth."[6] While we share with Lant an interest in art and its theorization, and the project of linking the haptic to the genealogy of film, we nonetheless begin our investigation of the haptic with different "premises." Her notion suits the account of an Egyptianate phase in early cinema, in tension between flatness and depth, but is distinct from my own conception, which is concerned with a different range of filmic phenomena.

In investing the moving image with haptic appeal, I have mobilized the notion of the field screen, understood as habitable geographic space. Speaking of the haptic as a way to describe cinema's modernity and approaching the problem of site-seeing architecturally, I have taken as my starting point Benjamin's reversal of Riegl: namely, that it is the haptic that defines the modern impact of the moving image. In this respect, let me reconsider Burch's use of the notion of a haptical cinema apart from its application to an interpretation of spatial illusion, for there is an incipient element of theorization in his work that nonetheless deserves attention: reinterpreted in the context of what Burch calls film's "motionless voyage," haptic implies "habitable."[7] Proceeding from Benjamin's logic, whereby film—to the extent that it, too, is tactilely apperceived by way of habit—joins architecture as this form of habitation, I have conceived the haptic space of cinema as habitable space.

In this sense, I understand *habitation* (in which *habit* is inscribed) to be a component of a notion of the haptic, particularly if the haptic is placed in the realm of spatiality and set in motion in an investigation of traveling cultures. Here, the haptic nature of cinema involves an architectural itinerary, related to motion and texture rather than flatness. It takes the haptic to be the measure of our tactile apprehension of space, an apprehension that is an effect of our movement in space.

We have shown how, from the art of memory to the art of emotional mapping to garden strolling, a genealogy of haptic motion marks protofilmic space. Film provided the modern subject with a new *tactics* for orienting herself in space and for making "sense" of this motion, which includes the motion of emotions. By way of its site-seeing, it offered a sensuous orientation to cognitive mapping, creating a spatial architectonics for mobile, *emotio*nal mapping. As a house of moving pictures, film is as habitable as the house we live in. Its "architexture," in fact, designs the realm of bio-history—a map of *bios*, or life-mode. It draws on its *emotion* to circulate this history. And does so tangibly.

A TOUCH OF SPACE

The tactile aspect of spatial tactics, engaged thus far primarily through the strategies of emotional cartography, permeates the construction of haptic perception. We have revisited many archival incarnations of this *tactics* and given room to the cultural map of the eighteenth century, for its obsession with the relationship of touch to sight is particularly relevant to our discussion of haptic imaging. In a Western culture that privileged sight, touch had often been positioned at the bottom of the hierarchy of the senses; in the eighteenth century, however, a renewed and extensive interest in touch came about. Writing on "plasticity" in 1778, Johann Gottfried Herder, for example, made a case for haptic perception and reversed the conventional hierarchy by arguing that touch even generated sight: learning to see involves "seeing figures in space as the letters of earlier physical feeling."[8]

It was Etienne Bonnot de Condillac's 1754 *Treatise on the Sensations* that, in the philosophical tradition of John Locke, wrote sentient aesthetics onto the mechanics of a body by envisioning a statue that is progressively "animated."[9] In Condillac's plan, the statue's senses are sequentially activated, one by one, and then combined until full sensation (and thus knowledge) is achieved. As the cognitive process unfolds, connecting sense to sensibility, an interesting construction of the haptic emerges, together with a theory that understands emotions as a transformation of sensations.

Condillac proposes that "we are led to attribute to sight ideas that we owe to touch alone."[10] Considering the case of a person "limited to the sense of sight," he suggests that "the eye in itself is incapable of seeing space outside itself."[11] Touch projects us outward:

When considering the properties of touch I came to the conclusion that it was capable of discovering space and also of instructing the other senses to relate their sensations to bodies extended in space. . . . With the aid of touch, [the eyes] come to judge objects which are in space.[12]

Designing a haptic field, Condillac demonstrates the interaction of touch, space, and movement. Touch teaches the eyes to see beyond themselves. It is "the only sense which of itself can judge of externality," for we "learn to touch through movements . . . spreading over all parts, extending enjoyment to the whole body."[13] The sense of

touch, then, makes the discovery and exploration of space possible in every way: recognizing other presences in space can make disparate objects into "collections." This sense not only implements desire but fosters curiosity, taking us from place to place in pursuit of pleasures that touch the sphere of imagination and reflection. Condillac concludes that, through access to this movement, touch also opens up for us the experience of duration. The haptic sense thus ultimately maps the deployment of historical space.

In Condillac's activation of sensory perception he performed a sequence of actions on his inanimate simulacrum of a human body as, in turn, he sculpted the human body in its simulated image. The mechanics of this epistemic operation, marginalized in optically driven theories, has, by now, been achieved technologically and inhabits our visual culture pervasively: it has become the representational technique of the cinema. In Condillac's manner, the cinema, a corporeal mechanics, produces body doubles and keeps them running. As Annette Michelson shows, this history of simulacra began in the realm of precinema, "on the eve of the future," with the literary creation of Edison's Hadaly, an android that was itself a prototypical remake of Condillac's statue and the "Eve" of our cinematic future.[14] Over the course of its history, the cinema has created a great number of these "skin-jobs."

It is not by chance that the sensory machinery we know as cinema, itself bound to a prosthetic image of kinesthetics, has a penchant for activating these lovely, tactile "replicants," for the cinematic apparatus is the very type of sentient automaton that Condillac "sensationally" constructed. His mechanism, like our apparatus, not only could be "sequentially" activated in a "succession of feelings" but was entrusted with memory, in order to recollect "sensations in succession."[15] This construction could sense space "automatically," moving "mechanically" to "discover, by means of movement . . . a body," which is "a continuum, formed by the contiguity of other extended bodies."[16] In mnemonic imprint, it intimately embodied, just as film does, the principle of its own (e)motion, *animating* it.

From Condillac's sensate statue to film's own sentient cyborg, the sense of space is confirmed as more than the product of the eye alone. Let us also recall that Diderot, who posited a reciprocal assistance between the senses, physiologically described the memory of sight together with touch, hearing, and taste as a "sequence of automated movements" and showed that it is "habit that links together a long sequence of sensations and words, of successive and connected organic movements."[17] The distant gaze cannot explain space by itself. From the start, it is the tactile sense that extends surface into space. The senses not only work together in this enterprise but, in a series of traversals, interact in their function of fashioning space. This view does not, therefore, consider sight and touch to be in opposition. The eye itself can caress, and be caressed. Thinking of the haptic as inseparable from the optic was the basis for a modern incarnation of this notion, in which an actual reciprocity is operative. In Benjaminian fashion, with awareness of the "sense" of the cinematic experience, this construction took the mechanical habit of a tactile vision and an optical touch.[18] This included the understanding that technology interacted with the sensorium and touched the sphere of other histories, including a natural history.[19]

In a geographic convergence, touch engages the other senses to cognitively "sense" body surfaces extended in space. Let us recall the sentient accoutrement that was the intrinsic component of Cesare Ripa's image of Theoria, fashioned as a geographic woman: a compass, open like antennae, was implanted in her head as a cognitive "feeler" of space.[20] In geographic terms, we may say that a "touching" interface creates emotional space by projecting us outward with other people, objects, and machines moving in space: it mobilizes the human body and its representational prosthetics in a vast, sentient expanse. The geographic path is profoundly haptic and relational. Site-seeing is, indeed, a tender mapping.

HAPTIC GEOGRAPHIES, GEOPSYCHIC AFFAIRS

The interaction of touch with the sensing of space is part of an historical development that engages the impulse to map psychocorporeal space and its intimate mechanics. As we have developed the notion of the haptic, it has been mobilized primarily in the field of this geographic history. Investigating the atlas, it has led us to a search for cartographic designs capable of developing a tactics of intimate space. Moving inside and outside, in the trajectory of a psychogeography, we have looked into the geopsychic terrain that has been left out by theories of the gaze. This terrain—which comprehends haptic "space"—is also the place where a tactile eye and a visual touch develop, for this way of looking is inscribed in the movement of psychogeography. It is found in the representational space that, both as spatial practice and the representation of space, progressed from early modernity and, passing through a series of "situations," caressed film's own version of the motion of emotion.

In this passage our sense of place, which is also our sense of history, has been mapped haptically onto the field screen of "moving" images. The field screen that animates the city and the cine city, for instance, makes these sites conterminous, and in this "projection" history itself is mobilized. As we have seen, the streetscape is a product of both architecture and the moving image, habitually conjoined in history and now evermore melded in screen-space. The cine city is an architecture of the real, a place where social geography and psychic paths are written together in a phantasmatic construction of the present, where the future lives in traces of the past. Thus conceived on the field screen of moving images, geography is not a place without a history; nor is it a discipline of the exterior that relegates psychic traces to a separate interior—assigning them to a psychoanalysis that, presumably, is not concerned with space. In psychogeographic terms, a merging of historic and psychic space is enacted, in recognition of the public course of interior vision that takes place in the intimate space the cinema represents.

This view of geopsychic space can be further advanced, even physiologically, by employing a notion of the haptic that circulates in cultural geography. When we turn to geographic studies that pertain to the physiology of the senses, we find substantiation of Condillac's early findings on spatial sensations. In Paul Rodaway's recent study of "sensuous geographies," for instance, a physiologic

notion of the haptic is used to explain the interaction between sense and place.[21] Although Rodaway's account of haptic geography is introductory and falls particularly short in addressing problems of cultural space and delineating cultural differences, some of its insights are nonetheless useful. The work confirms that touch is a sense actively involved with the locomotive capacity of the body and with its kinesthetic perception. Because the haptic realm is not simply inclusive but "comprehensive" of this motile touch and its kinesthetics, the haptic, in a way, becomes an actual geographic sense. In our haptic experience of reaching, an extended, imagined, and even global touch is achieved. Hence contact, exploration, and communication are to be considered haptic activities. Although Rodaway himself does not mention the cinema as part of these communicative activities or acknowledge the haptic experience of film, it is easy to see how his description almost demands that this recognition be made. From my perspective, placing the cinema in this "mediatic" haptic realm has involved, in terms of methodology, launching an exploration of representation that is sensitive to cultural travel. The recognition of this connection has taken the very form of a geographic navigation. We can also extend this reading of haptic geographies to consider the intersection of spatiality with other fields of sentience. To the extent that it combines tactile and locomotive properties, the haptic experience, in geographic terms, involves a knowledge of surface, geometry, material, location, energy, and dynamics. All these are the mesmerizing properties of the cinema, and they are mobilized in the sensorium of the movie house to implement, augment, transform, and reinvent, by technological means, our sensory cognition and our sense of space.

A participatory aspect is at work in this kine(sthe)tics, for the haptic involves a sense of reciprocity. The haptic, as its etymological root suggests, allows us to come into contact with people and the surface of things. Thus, while the basis of touch is a reaching out—for an object, a place, or a person (including oneself)— it also implies the reverse: that is, being touched in return. This reciprocal condition can be extended to a representational object as well; indeed, it invests the very process of film reception, for we are moved by the moving image. Furthermore, we should consider that, as a receptive function of skin, touch is not solely a prerogative of the hand. It covers the entire body, including the eye itself, and the feet, which establish our contact with the ground. Conceived as such a pervasive enterprise, the haptic sense actually can be understood as a geographic sense in a global way: it "measures," "interfaces," and "borders" our relation to the world, and does so habitually. It is no wonder, then, that the cinema, as a haptic affair, would play emotionally at this very threshold: its geographic machine came into being as a way to access, interface, border, and map such a relation between us and the world, implementing a geography of passage.

The transitive, corporeal mapping that informs the cinema is also a psychoanalytic passage: it borders on the intimate terrain of the self as charted in psychoanalysis, particularly with respect to the idea of an "inside out." As Elizabeth Grosz points out in her claims for a corporeal feminism, the inside out is a psychic topography: it is an outcome of Freud's notion of the "skin ego," a mental projection—

or, rather, a map—of the surface of the body.[22] It is a reversible map of surfaces. If we consider the haptic as this terrain of crossings, where spatial theories may encounter psychoanalysis, the work of Henri Lefebvre provides further reinforcement of such surface-screen contact, but only if read against the grain, for Lefebvre was not particularly tender to psychoanalysis. His version of the production of space, however, especially the aspect that has inspired my cartographic reading of haptic space, is not too far from a psychoanalytic perspective.[23] His notion of a "lived space," imagined in a triadic relation with "perceived" and "conceived" space, certainly leaves more than enough room for analytic thinking. This is evident when Lefebvre speaks of the relation between space and the body, extending one into the other, even conflating the two, and mapping their web of intersections.[24] This interaction evokes the very reversibility of the flesh, where touching also means being touched; the idea thus approaches the tactile self mapped in psychoanalysis as an inside out. Furthermore, Lefebvre's view of the production of space is fundamentally relational. In his intersections of bodies and spaces, we may recognize intersubjectivity taking part in the making of intimate space. As psychoanalyst Jessica Benjamin defines it, intersubjectivity relates to the erotics of the "bonds of love" and is located in the very interaction of space and desire.[25] It is a reciprocal place, both physically and culturally—an "in-between."

TACTILISM IN EARLY FILM THEORY

Projecting this tactile landscape onto the realm of film, let us now consider how "tactilism" may have affected its discursive history and the process of its theorization. We have established that the haptic is a vast, distinct relational space and should not be restricted to tactility alone or merely assigned to vision. Nevertheless, this component of the haptic, in the limited form of a corporeal vision, circulated in film theory before our times and affected the very formulation of film theorization. Later erased in the theory of the gaze, an embodied vision has reemerged and underwrites, for example, Vivian Sobchack's phenomenology of film experience.[26] To further restore the tactile and reinforce a haptic cinema at the threshold of intimate space, we return to early film theory, moving beyond the matter of the architectural voyage outlined earlier and turning to another version of the "film sense" in order to foreground the material expression of the motion of emotions.[27]

Insofar as this materiality involves a play of surfaces, it can be said that a route was established by Ricciotto Canudo, who "animated" the very surface of the screen. An Italian émigré active in Paris from 1902 to 1923, Canudo played an important role in Robert Mallet-Stevens's architectural experience in film.[28] His film theory integrated cinema into the spatiovisual arts and was particularly sensitive to the living presence of space on the screen, which he theorized as a visible manifestation of the liminal relation of the unconscious to consciousness.[29] Binding all filmic elements onto the landscape that paints the relation of people to environment, Canudo saw cinema as a plastic art in motion. Joining science and

art, cinema, in his view, makes the rhythms of spatiotemporality into a modern dance of expression. As he wrote in 1911, cinema "achieves the greatest mobility in the representation of life. . . . [It] heightens the basic psychic condition of western life, which manifests itself in action."[30]

Working on the surface of things, Béla Balázs outlined the "character" of cinema by understanding the film screen as pervaded by physiognomy.[31] In this way, he enacted a theoretical shift, rejecting the primacy of the eye for a notion of visual life and calling for the "incorporation" of psychosomatic features such as the visage. Balázs utilized the notion of *stimmung*—which, as we have seen, encompasses state of mind, sentiment, mood, tonality, and atmosphere—to speak of film's expressive qualities and "atmospheric" play. Recognizing the physiognomic impact of cinema, Balázs's work was invested with a topography of the surface and designed such psychic contours as the filmic landscape of the face. In this view, the close-up became a microphysiognomic form of contact with interiority.

Moving beyond physiognomy to make an inner world visible, Jean Epstein, the French medical doctor turned filmmaker and theorist, constructed a tactile vision for the film machine, claiming for it a prosthetic ability to extend the range of our corporeal way of seeing.[32] Epstein's vision of a corporeal cinematic eye imparted physicality and intimacy and was conceived in sensuous proximity to the phenomenological world. He embodied this cinematic eye in many ways, particularly in terms of its ability to capture time—a feature that recently has attracted interest in film theory.[33] But if Epstein is called upon here, it is especially to highlight a theory that was tuned to the labor of emotion expressed in film, even to the physiology of passions of an amorous discourse.[34] Recognizing the flux that resides in the cinema in the sensual moment of "photogénie," he accessed the dynamics of the emotion. In Epstein's view, cinema has the power to engage the affective life of human subjects and to envision the emotional impact of the environment and objects that surround them.

In advancing the mechanics of this landscape, we have engaged the architectonics of projection and incorporation that underwrites the haptic as an (e)motional absorption of images. We have also addressed the transformative side of a haptic cinema, embedded in Epstein's emotion pictures, and will continue to examine it as we investigate the filmic intakes of Peter Greenaway and other emotive morphings. For now, however, let us remain with the notion of reciprocity outlined above, which proposes that absorption impacts a tactile optics. In anthropologist Michael Taussig's mimetic version of tactile optics, which is sensitive to physiognomic manifestations of visual worlds, we recognize the very form of habitual knowledge that cinema actualizes in its double movement of absorption.[35] This is a haptic route that can push mimesis to the edge of mimicry, taking us into the image as the image, in turn, is ingested. In this "transport" of acculturation, we travel across terrains and between cultures.

As it turns optic into haptic, site-seeing reveals that theories of the gaze, applied to film theory, left much "room" unexplored and regrettably ignored even the psychoanalytic investigations that construct our sense of space, including emotional space. Some aspects of this construction have emerged in our mapping of habitable

space. We might note that the type of map that was established in emotional cartography, which we navigated in the previous chapter, was the very sensitive terrain on which psychoanalysis trod. As the psychoanalyst Paul Schilder recognized back in 1935, "space . . . is in close relation to instincts, drives, emotions and actions."[36] Viewed from this perspective, the interaction of psychoanalysis and space can be seen to reside in the very production of lived space. More specifically, it involves a way of locating affects in space, mobilizing them, and maneuvering the place that they, in turn, affect. To explore this tactics, we must continue the voyage initiated in the emotional art of mapping and consider the extension of one particular route of psychogeography: the impulse to map that, wishing to place *bios* on a map, ends up mapping our bio-history.

A MAP OF BIO-HISTORY

If it is in a fashioning of space that tactilism "resides," then such a place passes through the writings of Walter Benjamin, a recurring source of inspiration for thinking haptically and mimetically by way of architecture and visual mapping. As we traverse his well-traveled *One Way Street*, for instance, we encounter a tactile, lived space. This street is inhabited. The book, as Victor Burgin remarks, "has the appearance of a city plan."[37] Above all, it is occupied by Asja Lacis, the Bolshevik director and actress with whom Benjamin had fallen in love while traveling in Italy, with whom he co-authored an essay on "porous" Naples, and who took him down the Marxist road.[38]

In speaking of this road, his dedication of *One Way Street* to her becomes relevant here again, for its emotional life extends into film's own. Let us recall that if "this street is named Asja Lacis Street after her who as an engineer cut it through the author," it is not so named because she simply showed him the way.[39] In a haptic conception, the author envisioned the Marxist, writerly street as if cut through the skin of his own body. This architectural anatomy lesson, performed by a woman, is quite a powerful image of the transformative impact of love on both biographical and intellectual life. This representation of space not only functions cinematically but plays a part in Benjamin's discourse on film, for it marks the passage between exterior and interior. It shows a way in which Benjamin understood the street—an understanding that applies to his notion that filmic energy itself is "of the street." In a sense, it "engineers" the very idea of haptic cinematic vision, for one way in which Benjamin rendered the haptic impact of cinema was to compare the cameraman's eye to the hands of a surgeon who cuts into the body, thus impressing on celluloid the force of a vision that "operates" a transformation with touch.[40] Unfolded as a filmic map, this inscription reads as an *emotion* picture, of which we "sense" all the engineering.

An architectonic engineering also resonates in the other haptic routes Benjamin traveled in film theory, albeit more reciprocally. As discussed earlier, for Benjamin, the mode of absorption by which we apprehend architecture abides in the cinema as well: buildings and films—artworks appropriated by the kind of touch

accomplished by habit—are creatures of our sensate habitation.[41] Their haptic routes habitually connect space with desire on a communal map. As tales of inhabitation, film and architecture map the sphere of daily life, lodging traces of biography as they, in turn, are "moved" by stories of the flesh. In his articulation of a physiognomy of the interior, Benjamin remarked that "the traces of objects of everyday use are imprinted. The traces of the occupant also leave their impression on the interior."[42] The birth of the cinema has made it possible to record these traces, mobilizing this landscape and reproducing in motion the very movement of inhabitation. It is an imprint. A tactile passing.

This tangible passage constructed by film and architecture belongs to the sensory sphere of emotional mapping and includes the architectonics of memory. As Benjamin put it, "memory is not an instrument for exploring the past but its theatre. He who seeks to approach his own buried past must conduct himself like a man digging. . . . He must not be afraid to return again and again to the same matter. . . . For the matter itself is only a deposit, a stratum. . . . For successful excavations a plan is needed."[43] In such an archaeological mapping, a haptic space is designed, theatrically, with the architectonics of the mnemonic theater. This form is invoked when Benjamin, in chronicling Berlin, reveals his desire for charting *bios* on a map. Here is his personal chart of memory life:

I have long, indeed for years, played with the idea of setting out the sphere of life— bios—*graphically on a map. . . . I have evolved a system of signs, and on the grey background of such maps they would make a colorful show if I clearly marked in the houses of my friends and girlfriends, the assembly halls of various collectives, from the 'debating chambers' of the Youth Movement to the gathering place of the Communist Youth, the hotel and brothel rooms that I knew for one night, the deci-*

8.4. "Lived Berlin" as mapped in *Wings of Desire* (Wim Wenders, 1987). Frame enlargement.

sive benches in the Tiergarten, the ways to different schools and the graves that I saw filled, the sites of prestigious cafés whose long-forgotten names daily cross our lips, the tennis courts where empty apartment blocks stand today. . . . 'Lived Berlin.'[44]

As in Scudéry's own *Carte de Tendre*, Benjamin draws a moving map of affects. For him, transitory moments of a life can be designed in the grand scheme of History. This map of the lived city is the place where history is charted as a story, developing both narratively and geographically. Interestingly, it is not time alone that creates such history. Dates do not create the memory that this history recalls. History, and one's microhistory, "take place" in places. This his*tory* is not chronologically punctuated but spatially bound to duration. Mnemonic life abides in space and can, indeed, be mapped. One's past resides not in the mere presence of time but in the spaces where time was lived: in the schools frequented, in the landscape of the chambers occupied and visited, in the park benches used as seats. The past lives in the public life of streets, cafés, gyms, and gathering halls. It is reinvented in the houses one inhabited, in the hotels and brothels traversed for a night. It awaits us in the geometry of the grave, our body's final resting place—a terminal home for ourselves and our loved ones.

SCIENCE AND THE MEASURE OF OUR EMOTIONS

Benjamin's map can illustrate for us the relation of emotions to motion, for it translates, in the form of a map, the same affective mimicry the motion picture itself mobilizes. It was Hugo Münsterberg, the psychologist and early film theorist, who scientifically pursued this relation of motion to emotion and made it a field of cinematic inquiry from a psychological viewpoint. His film theory confirms that measuring motion is a matter of the genealogy of cinema; he advances this idea by taking it beyond the sphere of Muybridge's motion studies, their impact on Marey, and the contribution this work made to the cinema, as well as to the pictorial disruption of modern art.[45] Münsterberg's interest in physiological psychology enabled him to recognize subjective agency and therefore to access the measure of filmic emotion. For Münsterberg, "motion is to a high degree the product of our own reaction. Depth and movement come to us in the moving picture world. . . . We invest the impressions with them."[46] According to Münsterberg, what we see in movies, including motion, is produced in a mental process of binding. Speaking of this spectatorial "performance," Münsterberg claims that "the objective world of outer events . . . [is] adjusted to the subjective movements of the mind. The mind develops memory ideas and imaginative ideas; in the moving pictures they become reality."[47] In spectatorship, a range of inner movements binds the pictures together with plastic and emotional life.

This is the foundational idea of *The Photoplay: A Psychological Study*, published the year Münsterberg died, in 1916. Although this thin pamphlet, republished in 1970, was read by my generation of film scholars, our gaze was rather directed at Althusserian and Lacanian cinematic apparatuses. Münsterberg was

dismissed, despite his involvement in developing a filmic apparatus that, although apparently less refined, can be very useful when read in a specific way: the *dispositif* of knowledge he deployed can only be understood, and rediscovered, in cultural history. In fact, Münsterberg reads differently now, in the face of historical work that approaches his area of "attention." We are now interested in exhibiting the conjunction of the invention of cinema with the formation of a vast epistemic apparatus, including scientific knowledge—while not exclusively focused, however, on the experimentation in optical devices.

Advancing film genealogy in site-seeing, we may thus bypass the blind spots of Münsterberg's philosophy and aesthetics and appreciate the insights of a research that illuminated cinematic depth and movement, focused on attention, traced the work of memory and imagination, and tackled the emotions. This is, at least, how I have encountered Münsterberg again, aided by one of those biographical coincidences that Benjamin thought eminently mappable. It was while teaching at the university where Münsterberg conceived his book that I realized his film work must be seen in relation to the "laboratory" of ideas and instruments this émigré developed at Harvard. Münsterberg's film theory, in fact, came out of an actual laboratory. The lab was attached to the Department of Philosophy, where Gertrude Stein became his "ideal student" and engrossed herself in experiments that made use of his psychological technology.[48] It is the collection of his instruments to measure the registry of emotion that gave me the "measure" of historical reconsideration needed to embark on an address of film genealogy and its theorization in relation to the inscription of emotions in time-space.

In my effort to map this archive of (re)collection—here, at the place of the motion of emotions—Münsterberg comes fully into place. To grasp his tiny 1916 book one must see it positioned in the "gallery" of his measuring instruments, for they impart something about the impact of cinematic technology; they illustrate, that is, how cinema takes part in the technology of emotion. One might imagine this entire apparatus, including the filmic one, displayed in the context of an exhibition of Münsterberg's laboratory, mobilized again in conjunction with film. Reinvented in the form of this imaginary art installation, the joint emotional machinery would be able to convey not only the disciplinary side of measuring but the measure of fascination mobilized in *emotion*, a force that can confound even scientific disciplining.

If we were to imagine Münsterberg's film theory this way, surrounded by all his machines, animated and moving around us in an art installation, the ideas themselves might appear to spin, for it was this emotive apparatus that sustained his vision of film theory and constituted a part of its very genealogy. The intellectual laboratory that became Münsterberg's cinematic apparatus offers us a haptic understanding of the cinema and invests it with the physiological movement of *emotion*s. Münsterberg observed, first, that the kinesthetic properties of our cinematic machine result in a transport—that is, they carry us away, and around. In his words, in film, "not more than one-sixteenth of a second is needed to carry us from one corner of the globe to the other, from a jubilant setting to a mourning scene. The whole key-

board of the imagination may be used to serve this emotionalizing of nature."[49] The venture described here bears the trace of geographic exploration and the imprint of scientific imaging and thus creates, with microscope and moving images, a different access to the natural world. But above all, the type of inner venture that Münsterberg describes is an intimate "transport." It corresponds to what I like to call a "tourism of the emotions."

Münsterberg's vision of the cinema is charged with the moving power of *emotion*. To account for the mnemonic, attentive, imaginative, and emotional impact of the moving image, Münsterberg pushed the psychophysiological direction in his scientific approach. Film makes an impression, which first comes into our visual field in the form of sensation; this bodily defined sensation is the very basis of an emotional knowledge. As he puts it:

Impressions which come to our eye at first awaken only sensations. But it is well known that in the view of modern physiological psychology our consciousness of the emotion itself is shaped and marked by the sensations which arise from our bodily organs. As soon as such abnormal visual impressions stream into our consciousness, our whole background of fusing bodily sensations becomes altered and new emotions seem to take hold of us.[50]

Münsterberg understood the cinema to be a vehicle of physiological activity and placed emotions in this moving realm. In the way it explained the relation of the film sense to emotion, his modern physiological psychology followed the ancient sentient path paved by Condillac. In this view, not only do sensations arise from corporeal matters, but it is out of bodily sensations that emotions and passions are formed. The realm of filmic emotion is mobilized as the very transformation of sensations. Although this is a partial view of the intimate space mobilized in the cinema, it nonetheless enables us to grasp how filmic emotions "take hold of" our bodies in the space of the movie house. This is the direct route to filmic tears and the stomach crunch. It speaks to the material base of cinematic pathos. As an approach to the physical impact of emotion pictures on a spectatorial body, this understanding represents an important entry into the physiology of spectatorial life.

Münsterberg claims that the moving image participates in the transformation of sensations and emotions, for, being itself a form of "transport," it acts as a passage. In his words, "The photoplay tells the human story by overcoming the forms of the outer world, namely space, time, and causality, and by adjusting the events to the forms of the inner world, namely, attention, memory, imagination, and emotion."[51] Münsterberg's film theory recognized the threshold that the moving image activated in its tactile passage from the outer to the inner world, which includes the very course of psychic energy. The borderline art form of cinema, thus placed at the very perimeter of optical unconsciousness, was being shaped as a haptic geography. An apparatus was applied to "measure" film's psychophysiological interaction with the inner life of imaging, remembering, and feeling. In Münsterberg's hands, spectatorship began to be conceived as a cell of affective life.

For Münsterberg, writing in 1916, this way of seeing was a program in need of a style: "to picture emotions must be the central aim of the photoplay," he wrote.[52] Wishing for this to happen, he became concerned with the kinesthetic expression of emotional picturing. He worried about the work of acting in this sense: "The photoactors may carefully go through the movements and imitate the contractions and relaxations of the muscles, and yet may be unable to produce those processes which are most essential for the true life emotions, namely those in the glands, blood vessels, and involuntary muscles."[53]

Münsterberg's hope that an emotional kinesthetics would materialize in film theoretically touches on the muscular effort that accompanies voluntary motion on the screen and the faculty by which this sensation is perceived. It also bears on the involuntary body of emotions. Intersecting with the language of the unconscious, albeit from a different perspective than that of psychoanalysis, his theory contributed in its own way to the composite discourse that was mapping intimate space. It revealed aspects of the emotional range and infused the cinema with the sentient circulation of emotions. In mapping *emotion*s from the perspective of a psychophysiological inquiry, we may find ourselves carried away—"transported"—even if not to the absolute edge of intimate space. We can feel the "motor" of the filmic passion. We can sense the material fiber of that passion to reimagine, remember, and reinvent experience which we have been exploring and have sought to put back on the (pre)filmic map. By way of Münsterberg's "life emotions," which reside in the "blood vessels," we have been taken on a tour that leads all the way back to the future: to that very vessel—the "vein" of moving thoughts—from whence we began our historical navigation of an intimate geography in the form of an atlas of *emotion*s.

EMOTION

It is not surprising to conclude, then, that the museum of emotion pictures, as it repictures fragments of an intimate geography, ferries across a reversible "transport." Emotion, as we have shown, reveals itself to be a matter of voyage: a moving form of epistemological passion and historic force. Its Latin root suggests the route this motion will take: a moving out, a migration, a transference from place to place. The physical effect of the pull of emotion is inscribed in the very experience of spatial transfer and dislocation and, in such a way, underwrites the fabrication of cultural travel. It is here, in this very *emotion*, that the moving image was fashioned, with its own psychogeographic version of the *transito* of *emovere*.

One source of this type of dislocated emotion, as we have seen, is the moving architectonics represented in the art of memory. Some contemporary views of art and science subscribe to the movement of emotion proposed by the old architectonic art of memory and represent this map of *emovere* by technological means. By way of image technology, we are still playing with the moving images placed on revolving wheels by Ramon Lull, who, back in the thirteenth century, introduced

such movement into memory.[54] This type of mechanics, and the automated motion that includes repetition, constitute an essential "wheel" that drives our imaginative processes and forges representational history a spinning continuum of subjectivity, mnemonics, and imagination that marked the prefilmic history of the mechanics of imaging implanted, eventually, in the movie house.

This type of "wheel," inscribed on the cinematic "reel," returns as a motif in contemporary art installations that deal with technology and architecture. It is inscribed in Daniel Libeskind's transformation, in exhibitions and set designs he created in 1994, of the "machine for living" into an emotive machine, in which "spinning" propels "a dynamically expanding spiral dance."[55] It lives, cinematically, in the three machines Libeskind designed for an installation at the Venice Biennale in 1985: two wheeling mechanisms for reading and writing that resonate with a machine for memory, turning the memory theater into an erotic site of projection.[56] The wheel has turned into the reel of image technology in different ways. By way of Buddhist itineraries and prayer wheels, for example, it shapes the form of Bill Viola's *Slowly Turning Narrative* (1992), in which the landscape of a video self is meditatively observed in projection on a constantly moving wheel with repetitive sound. Motion, activated in the palimpsestic writing of emotions onto images, informs the subjective representational histories that extend from the waxed mnemonic images of earlier centuries all the way to our digital screen, impressing itself into the transparent layers of Viola's *The Veiling* (1995).[57]

We are still coupling motion with emotion, in science as in art. Contemporary neuroscience reproposes this relation as our basic epistemic mapping. As Israel Rosenfield shows in *The Invention of Memory*, there is a "deep relation between movement and memory."[58] Neuronal groups, for instance, are organized into maps and in such form communicate with one another, speaking back and forth to produce notions of things and events. Maps, in this sense, constitute our very fabric. Rosenfield furthermore claims that "all acts of recognition, all acts of recollection, require some kind of motor activity. We come to perceive and understand the physical world by exploring it with our hands, our eyes, and the movements of our bodies; our recollections and recognitions of the world are intimately related to those very movements we use to explore it. . . . In fact, we are all 'redoing' the past."[59] It is in redoing the past, indeed, that we turn to cinema to record experience and further remap its *emotion*. Film becomes the reproducible memory of our kinesthetic view of space, and of the tactile exploration that makes up the intimate history of our emotional range.

It is along this sequential path—a "sequence" that started with the art of memory and led to emotional cartography (including garden architecture) and maps of bio-history all the way to the contemporary view of *emotion*s in art and neuroscience—that a haptic design takes place, making room for our historic memory. This cultural map engineers a dynamics—the relation of motion to emotion—and in this way "touches" the very relational matter that makes up the moving image, the screen of emotion pictures.

SITUATIONIST PSYCHOGEOGRAPHY

With the aid of old maps . . . one can draw up hitherto lacking maps of . . . changing architecture and urbanism.
Guy Debord

The voyage of emotion traced by way of Madeleine de Scudéry's *Carte de Tendre*, which has moved us through various representational histories, inspired an art of mapping that eventually came to inhabit the very fabric of the conjoined urban and filmic screen of emotions. Locating the e*motion* in this psychogeography, we turn to the map of the lived city designed by the situationists in order to propose the geopolitical substance of "transport" across mapping and film. As mentioned, both tender mapping and cinema played important roles in the situationists' mapping of psychogeography. The group reprinted the *Carte de Tendre* in the *Internationale situationniste*.[60] It also reinvented it in two maps, one of which is named after a film. Both of these maps, attributed to Guy Debord and Asger Jorn, were modeled after Scudéry's chart and, in tracing the drift of a city dweller's own psychospatial negotiation, redraft its investment in intersubjective social space.

The recent critical focus on situationism, as exemplified in the work of Thomas McDonough, reveals that a most crucial legacy of this movement lies in its conception of space, previously underplayed in the critique of visual spectacle, even though space was central to the group's project.[61] This critical revision of situationism includes specific attention to the movement's articulate views on architecture and "unitary urbanism," enlightening their practice of atmosphere and ambiance and their geopolitics of the city, built on a new architecture of social space with nomadic forms of transformation.[62] My own contribution to this discourse lies in approaching the issue of a mobile architecture of living; here, I take the group's construction of situations, in terms of lived ambiances and lived experiences, as a place of research on the relationship between spaces and emotions. Exploring geopsychic space from the perspective of film criticism, I focus on their cartographic thinking, tracing the way in which situationist mapping converges with the area of my specific cartographic concern: the intersection of filmic space and Scudéry's map.[63] To foreground the tender extension of psychogeography, my observations focus on the interplay between the film *The Naked City* (Jules Dassin, 1948) and the situationist map that bears its name.

The *Naked City* map is an assemblage of fragments, whose montage playfully remakes an urban topography into a social and affective landscape. It was constructed from nineteen segments of a map of Paris that, having undergone a process of *détournement* in a creative intervention that forms new relations among the city's parts and their inhabitant-passengers, is then reconfigured with red directional arrows that link the cutouts. These arrows are referred to as *plaques tournantes* because they function as "turntables" (like those used to rotate trains) that describe the subject's reorientation as he or she passes through various psychogeographic realms and "unities of atmosphere." An actual "locomotive" reinstatement of what

was, in effect, a "wheel," the *plaques tournantes* mark the dweller's way of living the city in its intensity as a psychogeographic recreation of new (e)motions. Considering this cartographic configuration, we may recognize in its fractured, sequential archi tectonics, its montagist derailing, and its narrative of "locomotive" geography an imprint of a mapping practice that is "e-mobilized" in filmic language. In the con struction of the map, film appears to be much more than a citation or a passing ref erence. In addition to the inscription of a filmic title, the situationist map effectively grafts a filmic itinerary onto the very space of its design. In this respect, let us also recall the form that psychogeography took in Ralph Rumney's *Psychogeographic Map of Venice* (1957), a rare document of the practice of psychogeographic drift.[64] The map is a sequential photographic collage of street views, opening with a bird's-eye view and accompanied by "intertitles." It is an attempt to render the urban drift in filmic writing, creating, as it were, a shot-by-shot analysis of filmic montage. This map, a city travelogue, is a sequence of film narrative laid bare.

 As we further trace the cartographic threads of film's *emotion* in intertextual terms, we find the graph of a narrative itinerary in *The Naked City* map, which may be exposed through comparison with the film in an interpretive game that claims no intent or influence. The *Naked City*, an American detective film that inspired a tele vision series of the same name, was made in 1948 and has been considered a film noir, with some stretching of the definition.[65] Made at the time of the neorealist city walks,

8.5. Frames of mind: Ralph Rumney, *Psychogeographic Map of Venice*, 1957. Detail.

The Naked City is itself a city walk of its own sort. The film opens with an aerial vista of New York City as the film's producer, Mark Hellinger, comments in voice-over on the history of the streetscape in the cinema. He proclaims, without the shadow of a doubt, that this is the first (*sic*) physical appearance of New York City on screen—replete with hot pavements, naked stones, and cosmetic-free faces. Warning spectators that the city known to them is the studio-lot New York—thus laying bare the city as a fabrication, a fictional set, a celluloid place—he reclaims location as a narrative strategy for the detective genre at the very moment Italian neorealism would claim it in a different aesthetic context.

The city becomes the protagonist of the story in a filmic promenade of kinesthetic dimensions. To solve a murder case, a detective and his assistant undertake an assignment involving extensive "leg work." The film takes great pains to observe and describe the number of blocks the investigators must travel in their search for clues that will piece together the deadly puzzle. *The Naked City* fits the "detective paradigm" described by the historian Carlo Ginzburg as the analytic approach that was taken by Sherlock Holmes, that colored the symptoms of Sigmund Freud, and that was explored in art by the Italian art historian Giovanni Morelli, who identified artworks representationally by piecing together morphologies of body parts.[66] In such a noirish, corporeal way, this detective film pieces together a narrative of identifying clues in kinesthetic segments, foreshadowing the strategic game that would be played by the situationists on the space of the city. Through its fragmentary technique, *The Naked City* reconstructs a mobile map of the city, reclaiming location as a tactic. As we follow the detectives around (literally, in their footsteps), the landscape of a crime is sequentially retraversed and then recomposed on the landscape of the city as experienced by its inhabitants. Space becomes psychic space, taking shape in the stories of the city dwellers and reflecting their representation of its contours. "The naked city," in a corollary to the film's famous last line, inhabits millions of stories, including that of the future situationist map of "pedestrian" *dérive*. It is the narrative of a navigated, lived space, of segments retraced—exactly as they would be on the map by the red arrows and "cardinal" threads of peoples' movements in geopsychic space. An urban detective film thus gave rise to a theoretical tactic: a filmic narrative was the graph upon which the situationist narrative was built.

If a cinematic promenade formed the basis of situationist cartography, it also made it possible for it to exist as psychogeographic "transport": that is, cinematic language made possible the very transfer of mapping strategies from the inspirational *Carte de Tendre* to a situationist enactment. If we consider a version of the situationist map that is printed as a large plan, to be folded and circulated like a travel map, the psychogeographic link of this "transport" becomes clear. The *Guide psychogéographique de Paris* (1957) is similar to the map of *The Naked City*, and both played a significant role in the development of situationist architectural ideas.[67] Also signed by Debord and Jorn, the map is subtitled *Discours sur les passions de l'amour*. This psychogeographic map of a city constitutes an amorous discourse and thus relates to Scudéry's tender map in ways that are more than referential or inspi-

8.6. Psychic turns of events in Guy Debord and Asger Jorn's *Guide psychogéographique de Paris*, 1957. Detail.

rational. It is actually made in the image of her particular fluid language of love. A geographical "discourse on the passions of love," the map engages with the emotion of *dérive*, described as bearing a psychogeographic *pente*—an "inclination." In this way, the map reinscribes, in "socio-ecological" and geographic terms, the very passionate motion of the *Carte de Tendre*, reinventing the bent of Scudéry's own amorous navigation through the "River of Inclination."[68]

In the situationist view, "*psychogeography* could set for itself the study of the precise laws and specific effects of the geographical environment, consciously organized or not, on the emotions and behavior of individuals. The adjective *psychogeographical* . . . reflect[s] the same spirit of discovery."[69] In its exploration of the emotional edge of lived space as an affective traversal of the street, situationist mapping constituted itself as a socio-political psychoanalysis of urban space. "Putting the psychoanalytic couch in the street, transforming the city into an immense divan," as one commentator put it, the movement proposed that the subjective practice of intimate reinvention be a motor that drives urban transformation and social revolt.[70] In Debord's words, "spatial development must take into account the emotional effects. . . . New, free architecture . . . will primarily be based on . . . the atmospheric effects of rooms, hallways, streets, atmospheres linked to the gestures they contain. . . . Architecture must advance by taking emotionally moving situations . . . as the material it works with."[71]

With this geopolitics laid bare on a map, situationist psychocartography reenergized a particular impulse to map, taking new directions in the process of events that, at certain historic junctures, had rethought cartography in relation to a bio-history. The map of *The Naked City* played cinematically with the idea of setting out the sphere of urban life on a map in graphic terms; the red vectors, marking the lived psychogeographic itinerary of the map, write filmically. In a way, they cinematically reinvent that "colorful show" that Benjamin, in a different cultural context, had also wanted to design cartographically. "Refashioning" them as locomotive turntables, they set out the inhabited segments, vectors, and "colored markers" against a grey mapping that Benjamin previously dreamt of mobilizing in the graphic design of his own map of *bios* in the lived city.[72]

Closely bound up with historicity, a form of psychogeographic mapping may periodically return to reinvent the measure of spatiotemporal configuration itself. This mapping represented a field of concern for Henri Lefebvre, who admitted to having been "touche[d] . . . intimately" in a troubled "love story" with the situationists.[73] It charts the field Lefebvre theorized as the act of inhabiting a social space. In Lefebvre's spatial design, love and its history were recognized as an example of new situations of urban living and a force in their transformation.[74] Here, there is a political understanding that to observe, and change, the architecture of social space means to engage with how this space is "intimately" inhabited, without shying away from such things as the culture of love. For emotional force does create, in many ways, new forms of habitation. This geography of lived situations—a *tactic*s we have located in that space between the map, the wall, and the screen—

"comprehends" casual encounters with emotion pictures, with their own intimate ways of habitation.

In remapping the textual articulation of a film onto a map, we are able to observe the considerable extent to which cinematic "transport" played a role in mediating between tender cartography and the situationist notion of atmospheric drift, for, negotiating passage in the city, situationist space was mapped with, and through, the wandering, filmic tactics of site-seeing. The situationist tactics, imaged cartographically, involved the *dérive*—the "nautical" drift—experienced in geopsychic navigation. This transient passage was aware of the ambiance and affect of dislocation and the effect of *dépaysement* in the geopolitics of space. Seen in this way—that is, from the genealogy of its filmic, tactically fractured perspective—the situationists' psychogeographical practice of mapping emerges as an alternative model to the totalizing, regulative ideal of a cognitively defined mapping. In the situational bond of *The Naked City*, the *tacti*cs that exposes social bio-history is relived. In this inspirational binding, a laying bare of the open, relational, "navigational" narrative of a mapping that is fundamentally *emotio*nal comes to be nautically reinvented in psychosocial currents.

A SITUATION BEYOND SITUATIONIST CARTOGRAPHY

Although domination is one aspect of cartography, situationist cartography demonstrates that cartographic thinking need not always be colored by the impulse to conquer or by the language of power and its tendency to unify. As we have seen in the development of *emotio*nal cartography across time, cartography can be an essential tool in the exploration of moving subjects and their differences. We have shown the ways in which the texture of this cartographic thought was tender to gender and can be used in remapping the female subject as a subject of geography. A tender mapping is not only an important step in recharting the field of gender mapping but a vehicle for other measures we may take in navigating the current state of our *emotion*.

This involves taking the meaning of emotion in its historical sense as a "moving out"—a sense, as we have claimed, that includes migration and transference from place to place—and thus confronting the affective component of this dislocation in history: confronting, that is, the itinerary of the "space-affect." Facing the cultural movement of *emotion* inscribed in the history of traveling space, we have mapped the very space from which the moving image emerged as *kinema*, fostering its own psychogeography of *transito*. In the concluding chapters of this book, which address problematic notions of "home," I will continue to work with the migratory sense of emotional passion. For it is in the cartographic *emotion*, where the moving image was activated, that we can try to rework our own psychogeographic mapping in the face of hybrid, nomadic histories. Certainly, as Edward Soja rightly remarks, "loving maps is not enough," but it can provide a starting point for addressing the demonization of cartography as a totalizing view and for rethinking some critical issues from the perspective of a spatialized historicism.[75]

Moving beyond the idea of cognitive mapping, contemporary theory can "mobilize" the impulse to map in order to advocate practices of intersubjective mapping and thereby tame certain anxieties and resistances that have pertained to cartography. As we have seen, the impulse to map has indeed been set in motion for some scholars of the literary imagination and for other thinkers who, like Bruno Latour in the sociology of science, are interested in the mobilization of worlds through cartographic practices.[76] It is at play, for example, in the work of Rosi Braidotti, a theorist whose intellectual biography spans Italy-Australia-Paris-the Netherlands, and who knows that "the nomad and the cartographer proceed hand in hand because they share a situational need."[77] However different, these geographic itineraries are among those that elicit my own cartographic sympathy—or perhaps, one might say, pathos. They—along with others revisited throughout this book or, regrettably, not explored (an atlas is not an encyclopedia!)—mark the path of an intellectual migrancy often related to, if not generated by, the bio-cultural experience of nomadism, wandering, or diaspora.[78] They represent that generative cartographic matrix which defines the self as an authorial subject (dis)placed between diverse cultures and languages, where writing is "moved" by a mobile, cartographic experience of dwelling.

It has been all too evident to this "resident alien" that, as Celeste Olalquiaga, a Venezuelan cultural critic living in New York, claims: "bodies are . . . like cities, their temporal coordinates transformed into spatial ones. . . . History has been replaced by geography, stories by maps."[79] Confronting this landscape, the art of mapping has returned in artistic practices—as it does at specific historical junctures—with an open question about our geopsychic state. The migrant architectonics of memory that is materialized, for instance, in the urban public artwork of Krzysztof Wodiczko (a Polish artist residing in the United States) is a shared condition that forces us to confront the issue of mapping in relation to history.[80] All this remapping of identity is a psychogeographic affair that, on the threshold of space and time, engages our sense of spatial duration and temporal placement.

Taking the measure of our displacement, it has become necessary to "refigure" the labor of mapping in relation to a state of residual history. Out of the postmodernist and deconstructive shattering of the teleological historical narrative, some reconfigurations are emerging that evince at times (as in my own case) the drive to voyage of archaeological excavation or environmental cultural history. However different these routes may be, "negotiating metaphoric travel," as Donna Haraway has put it, "is an important and dangerous work."[81] Rather than dismissing or demonizing it, we might aspire to engage a theory and practice of mapping for "traveling cultures": a cartography beyond the cognitive, open to webs of ethno-cultural movements in a way that accounts for the motion of emotion embodied therein.[82] To think of filmic cartography as a vehicle of cultural mapping may be one way of accessing the shifting geography of intimate space and questioning, on psychogeographical terrain, the function of an archive of images in cultural remapping. As a form of site-seeing, film has historically reshaped (as it continues to do) the very *emotion* of these phenomena, along with our sense of space and time.

Incorporating the moving image into an examination of discursive remapping is not simply a matter of phenomenological orientation but of incorporating intersubjective, relational dimensions that mobilize mapping itself within the fragmented segments of a historical trajectory. With the invention of cinema, the very territory of geopsychic representation itself has shifted, creating a different measure of time-space. Film's site-seeing inaugurated modern cartography, for its map of fragmentary e-movements opened the way to a new geographical imagination of temporal traces. As Paul Virilio puts it, writing across architecture and film, "measurement is . . . displacement. One not only displaces oneself, in order to take the measure, but one also displaces the territory in its representation, in its geometric or cartographic reduction."[83] It is in this representational respect that the moving image plays a role, for it is a measure of the reconfiguration mapping has undergone in time, affecting, in turn, our imaginative place in history. The measure of our geopsychic situation vis-à-vis shifting forms of (intimate) habitation invests the archive of emotion pictures with its very sense. In our effort to "reimage" residual history out of our current cartographic scene, motion pictures and their archaeology constitute both an instrument and a route.

8.7. The fabric of residual history in the architectural and fashion remnants of *Re Construction*, a store installation by J. Morgan Puett and Shack Inc., New York, 1998.

ESTABLISHING SHOTS: A CARTOGRAPHIC FILM PRACTICE

The need to establish spatial parameters and to (dis)locate one's own body along with them—a need found, in reversible forms, in cartographic culture—is indeed an *emotional* obsession of film. A clear example of cartographic transference is the cinematic convention of the "establishing" shot. Here, a travel practice is quite materially transformed into filmic mapping. The establishing shot, a fundamental feature of the dominant film language, makes manifest a particular form of mapping: it exerts the pressure of a regulatory measure against the practice of border crossing. The drawing of place established by the establishing shot reveals a geographic phenomenon at work in film that we can recognize as cartographic anxiety and its release.

At the beginning of a film, just as at the start of a traveler's visit to a city, the spectator is thought to confront a geographic emotion. This may be a simple desire to know the location or, more commonly, a fear that develops into the need to be reassured of one's whereabouts. The establishing shot is the conventional response to this destabilizing "space-affect." It is a way of securely mapping the viewer in space. Responding to film's various effects of displacement, the recurring establishing shot appears to compensate for the fear of dislocation and the resistance of the filmic fragment to represent a totality. Conventional editing techniques such as the analytic editing style try to address this situational dislocation by stressing continuity and reaffirming placement. Other less conventional techniques allow the viewer to float freely on the filmic chart. Generally speaking, editing engages in a dialogue with directional disorientation of the body. Even when conventionally trying to diffuse such disorientation, editing can serve to underscore it, and often does so. The work of editing aims to navigate the course of the filmic emotional route, interacting with its various phenomenological and cultural trespassings.

Taken to an elsewhere now here and constantly transported through (un)familiar terrains, the spectator-passenger periodically can be rescued from getting lost. From time to time, she can be put back in place or discouraged from doing that to which she is attracted—namely, becoming dangerously curious or going off the road—through the establishment of filmic-cartographic conventions for her trip. In the spatial dialogue of film language, these exist to be confounded and defied. Points and pointers certainly are marked on the filmic map, but only to be constantly shifted, twisted, and refashioned. In the drift of the spectatorial voyage in the space of the movie house, the filmic chart moves, continually refigured by the filmic (e)motion. Thus configured, even cartographic anxiety is a sign—a "measure"—of the force of the psychogeographic flux in film.

THE MAP, THE WALL, AND THE SCREEN: PART I

A double haptic process conjoins mapping and film: this process involves mobilizing mapping by way of the moving image, while at the same time redesigning film theory by way of cartographic theories. Rudolf Arnheim's research in the visual arts

represents an important contribution to the understanding of this process. Arnheim's interest in art and visual perception from the viewpoint of visual psychology extended to the cinema as well, an art form he investigated and theorized from 1933 onward.[84] But it is not for his work on film that Arnheim is relevant to our mode of theory. Rather, it is his thinking about maps that helps us along in our endeavor to flesh out the interface of the map with the wall and the screen—the wall, in this case, being the wall as it functions in art and in the gallery.

In an essay entitled "The Perception of Maps," Arnheim furthered the aesthetic understanding he had developed in his theory of art, which insisted on the cumulative function of perception.[85] For Arnheim, a perceptual act is never isolated but occurs in a series; this movement incorporates the past and is recorded in memory. Arnheim proposed that the work of art and the work of mapping share this particular imaginative function. Although he never mentions the cinema in his account of cultural cartography, from our position, this understanding speaks precisely to the haptic texture of cinematic perception.

According to Arnheim, the map—a graphic analogue—shares further perceptual properties with the artwork, to which it is linked by way of its historical conjunction with artistic practices of mapping. The map is a configuration of forces, transformed into a play of corresponding forces in the psychic act of reception. It takes part in the cumulative process that shapes, for example, depth and figure-ground phenomena. Sharing properties with the object it represents, the map "can arouse visual images in the mind" that have been conjured up "from the reservoirs of the viewer's memory. It takes imagination, fed by experience, to generate visual imagery."[86] Indeed, it does, in the art of mapping as on the gallery wall or on the wall-screen in the house of pictures.

THE MAP, THE WALL, AND THE SCREEN: PART II

Along the route of cartographic exploration, in the process of conjuring reciprocal, transitive intersections between film and mapping, the work of Gilles Deleuze cannot be bypassed, however engaged we may be in critical revision.[87] It is perhaps ironic that a contribution to the discourse on filmic cartography does not come directly from Deleuze's philosophical involvement with the language of cinema, although some ideas on cinematic mapping can be derived from this work. At times, Deleuze recognizes film's potential to measure, as when he states that "the screen, as the frame of frames, gives a common standard of measurement to things which do not have one—long shots of countryside and close-up of the face, an astronomical system and a single drop of water. . . . In all these senses the frame ensures a deterritorialization of the image."[88] When it comes to discussing the potential play of the haptic and of the "affection-image" in film, however, the view that he offers is inadequate and unsatisfactorily literal.[89] Rather than in his work on film, a theoretical contribution to the mapping of a haptic "movement-image" is more productively found in Deleuze and Guattari's notion of "geo-philosophy."[90] It is especially in

place in their idea of nomadology. Although abused and criticized, this notion may still hold a radical place in the theorization of space by virtue of its proclaimed appropriation, admiring critique, and admitted "free use" of Riegl's and Worringer's notions of haptic—a position that led to the forceful claim of haptic space for a nomad art.[91] In this view, the map itself assumes haptic tones:

The map does not reproduce an unconscious closed in upon itself; it constructs the unconscious. It fosters connections between fields, the removal of blockage of bodies without organs onto a plane of consistency. It is itself a part of the rhizome. The map is open and connectable in all of its dimensions; it is detachable, reversible, susceptible to constant modification. It can be torn, reversed, adapted to any kind of mounting, reworked by an individual, group, or social formation. It can be drawn on a wall, conceived as a work of art, constructed as a political action or as a meditation. . . . A map has multiple entryways.[92]

To connect this map to the cinema, we have to read Deleuze and Guattari architecturally and play an architectural game of interpretation. The map in question constructs the unconscious, fostering all kinds of links between fields. Such a map is drawn on a wall. Like panoramic wallpaper, it is removable, open, connectable, adaptable, and implies reversibility. It is similarly susceptible to change and can be shaped to different kinds of mounting. Like wallpaper, it can also be torn and replaced, and is subject to the aesthetic and political taste of an individual or social group. As decor, it is readable from multiple viewpoints and penetrable from several entryways. This map can easily be redesigned on a white screen—indeed, *as* a film screen. It is the type of wall-screen materialized in Robert Irwin's installation *Excursus: Homage to the Square*[3] (1998): a transparent, geometric site of light that may be traversed by multiple presences, a place where others can turn into reflections of the self. It is a wall that is constantly redesigned by passages and the passage of light images. This map, in fact, is a moving image. It is cinema—a contemporary wallpaper. A wall atlas.

THE MAP ROOM OF MOVING PICTURES

We have found that from the very beginning of cartography, even before it was etched onto our mobile wallpaper—that is, onto the white film screen—mapping was a transitory activity. The terrain of ephemeral maps that has occupied us includes not only the stick-charts of nautical activity but also maps drawn on transient materials: scratched in sand, drawn on earth, carved on wood or stone, drafted on walls, designed on glass and parchment, impressed on fabric and painted on the body.[93] Like the film body's own remapping of space, mapping has been a haptic activity. Body tattooing, as a form of decoration, has long been a design activity that "fashions" not only the body but its surrounding space. Body maps of space move with the body's own "temporal" state. They trace a displacement that, in turn, incites further time travel.

As Joan Blaeu wrote in the introduction to his famous *Atlas Maior* (1663): "Geography is . . . the light of history. . . . Maps enable us to contemplate at home and right before our eyes things that are far away."[94] We have seen how, by the seventeenth century, the map was inhabiting the walls of European domestic interiors, competing for wall space alongside painting, especially landscape painting.[95] We have seen also how maps were collected into atlases for domestic use; like the cabinet of curiosity and the botanic garden, atlases started to bring the world into view at home, turning it into an object to peruse, finger, and handle. In this way, people began to "touch" the world and explore it haptically. The map opened the way to film, for it enabled people to experience in their private ways the public itinerary of the various journeys of time and space that its planar form condenses for viewing. Here, layers of different travel discourses become virtually touchable, brought tactilely close on a textured surface and inside for our intimate travel.

8.8. Traversing a "gallery" of maps: Galleria delle carte geografiche, Vatican Palace, Vatican State.

We must furthermore recall that atlases were also pictured on the wall; in fact, as the art historian Juergen Schulz shows, the first atlas of modern times was a map room.[96] Map rooms can offer a geographic narrative tour, as in the Galleria delle carte geografiche at the Vatican Palace, in Rome; or let us take part in the inner voyage of a *studiolo*, as in the Sala delle carte geografiche (Guardaroba) in the Palazzo Vecchio, in Florence; or make us passengers, as in the Sala del mappamondo at the Palazzo Farnese, in Caprarola. These map rooms, produced between the mid-1560s and the mid-1580s, have an appeal that redesigns decoration. Wall maps appearing as atlases expose an elaborate cultural architectonics, and not only when they feature city views or include *mappaemundi* that rehearse a history fictionally. The wall atlas was never there to display exact geographic information. Generally, the map room conflates and assembles in one place new knowledge of the physical world, "so that one can see and measure [these phenomena] together and by themselves."[97] Sometimes, this constellation traverses land, sea, and sky, extending from geography to cosmography, from earth to the zodiac as it approaches celestial matters, reaching beyond the strict conceptual terrain and border of the map.

Standing there now, revisiting these map rooms, we can sense the force of their transport and read the appeal of this decor as an *emovere*. With poetic license that reaches across history, we may even venture to see in the map room (or, at least, experience in its architectural embrace of transport) the architectonics we now know as art installation. An imaginary itinerary may take us from the map room to its domestic appearance in the form of panoramic wallpaper, whence it is transferred to the cinematic wall screen and, later, retraversed on the walls of the contemporary art gallery, in installations that are themselves decorated with maps and ornate with moving images.[98]

Standing in the old map rooms, one realizes, in any case, that a map is a particular kind of decoration. Maps on a wall transform the wall itself, turning it into a permeable surface that can be entered in different ways and traveled through. In the map room, the wall becomes a screen—a place of "projections." The wall of the map room is a porous site, loaded with the multiple layers of public fantasies and the strata of history projected onto it. This transitory, architectural feel of the map "room" is the very texture of the movie "house." There also, the wall is a screen—the filter of a private, public voyage.

THE MAP, THE WALL, THE SCREEN: GENEALOGICAL PANORAMA

A map visualizes our experience of sites, records and measures a place in time in order to transport it to the viewer. The binding activity of filmic site-seeing produces the same cartographic effect. There is even a further, textural resemblance. Like a map, which is a surface that can hold the assemblage of a world, a film is a two-dimensional text that can create the illusion of other spatial dimensions, including depth. It collapses time and space, mapping out diachronies and spatialities, known and unknown, for the viewer to traverse virtually. Transitorily fixed on the texture

8.9. Screening history in a room: wall maps and globe in the Sala delle carte geografiche (Guardaroba), Palazzo Vecchio, Florence.

of the screen, as sequentially and cumulatively assembled in an atlas, these spatial impressions can travel and bring to us, right where we are, records of even the most remote places and distant intimacies. The cinema, like an atlas, offers the dislocating pleasure of such imaginary explorations.

The cinema serves a cartographic function, for it documents cultural sites and makes renderings of imagined geographies that are bound up in the physiology of spectatorial life. Its archival renderings are transported to the viewer, who, in turn, is transported by them. Cinema carries with it the mapping impulse and the "transport" inscribed in emotive cartography, which charts the motion of emotion. The motion picture has turned this particular landscape into an art of mapping, charting the collapse of mnemonic time on the surface of spatiovisual "architextures." Now the fabric—the screen—can emove.

The historical development of mapping, with its spatial renderings of affects, is film archaeology, for cinema descends, as we have seen, from the art of memory and the emotional mapping that were transformed into the shifting view-sensing of picturesque gardens, as well as from the view-tracking of topographical paintings and from the cabinets of curiosity, whose transport created new travels of the room. As the wall atlas gave way to the panoramic wall painting, the nineteenth century further mobilized this topographical situation, transformed in prefilmic

panoramic vision. In its various transmutations, from world exhibitions to architectural transits and cityscape design all the way to mass tourism, the cartographic impulse led to the reinvention of *emotion* in the moving image.

Film's own cartography corresponds to a geographic condition: a shifting "space-affect" that accompanies the fragmentation of space itself—especially city space—and the making of the interior, both of which were born of the age of modernity that generated film. Multiple views of the metropolis, the montage of pedestrian experience, aerial flights: these are all present in a new mapping of the city—the cine city. The invention of film embodies interior renderings of urban settings, reinventing them in mobile, fragmented, haptic emotion pictures. Such movement, observed at the beginning of this book, can now be recognized as an emotion: it resides in lived space. It is a form of "rhythmanalysis."[99] Lefebvre's urban notion, which developed from his observation of geographic rhythm, defines yet another zone of geopsychic site-seeing: the place of emotion pictures. A psychogeographic "rhythmanalysis" is housed in the movie house—the dual location of the emotion of motion. This field screen is home to a heterotopia of reinvented geographic rhythms. It is a permeable, reversible site, where the geopsychic fragments of an inner world not only take shape, but make room. Exhibited inside out, exposed to light in the darkness, they are, reversibly, turned outside in.

MAPS OF *EMOTION*, LANDSCAPES OF HISTORY

In the emotional cartography we have mapped, a history is written on the physiognomy of space and mobilized in its geopsychic rhythm. It is written between the flesh and the map—on that map which is our face, and on the filmic facade, which is our map of history and screen of memory. Considering the psychogeographic map and the map room, in particular, as stories in history, the map turns out to be not only a geographic space but an historical vehicle, engaging, in the fashion of contemporary histories, in both microhistory and narrative.

As Louis Marin suggested in his theoretical observations on art, the geographic map, which he confined to the structural limits of a utopia, contains a history in its "spatial play" and, indeed, cannot even resist this condition, for "as the direct transposition of an itinerary, the map constitutes the text of a possible narrative discourse."[100] There, as in cinema, one travels on anterior traces. The space of the map, like the space of the journey that precedes it, is the *blank* page of a cultural palimpsest; like the film screen, it takes shape as one reads between the strata of multiple voids. Read as it is traversed, a map, like a film, is a fragment that can unravel the culture of its time as it positions us in a plurality of places and non-places. It connects to film insofar as it offers a mnemotechnical apparatus to "travel" a library. In this sense, the map, as a performative site of memory, remains a form of historical travelogue. Collected cumulatively in an atlas, mapping creates an archive of emotion pictures, bound to the architectural wall and the film screen.

8.10. An archive in motion: the traveling library of Sir Thomas Egerton, 1615.

8.11. An archive of e*motion*: Rachel Whiteread, *Untitled (Book Corridors)*, 1997–98. Plaster, polystyrene, steel, and wood.

In *L'Empire des cartes*, a theoretical study of the history of cartography pervaded by an intellectual nomadism, Christian Jacob shows that "to read the toponymy of a map is to travel in space as much as it is to turn back in time. . . . The reading invites a genealogy, even an archaeology. . . . The globe is a palimpsest, a cemetery of toponymy."[101] Now, as we bind filmic places to such a cemetery of cartographic toponymy, the narrative territory of the map can expand in history. Adjoined to the geopsychic narrative of film and its genealogy, the map, by nature interdisciplinary and interactive, reveals even more conflated historical layers, deposited and exhibited on the contour of a surface-screen. This archival representational field may turn out to be a vehicle for reimaging a sense of space. Perhaps it can even become a tool for remapping a form of residual historiographic narrative out of the psychogeographic debris that we inhabit, *hic et nunc*, at those moments of time-space meltdown, when passions cannot possibly be contained in any map of rigid geometries. Let us then hold on to our navigational *Carte de Tendre* and carry it with us as we follow the course of passions in the cartographic world of Peter Greenaway, and as we travel from *cine*res to *cine*mas with Gerhard Richter's *Atlas* in hand.

DESIGN

9.1. A touch of love in *The Cook,*
The Thief, His Wife, and Her
Lover (Peter Greenaway, 1989).
Frame enlargement.

9 M Is for Mapping: Art, Apparel, Architecture Is for Peter Greenaway

Recollection is a discarded garment.
Repetition is an imperishable garment.
Søren Kierkegaard

I remember the story. They met in a "travelling history of architecture."[1] They met in a movie. She was the wife. He was the lover. It was the architectural odyssey of The Cook, The Thief, His Wife, and Her Lover. A Greenaway affair. The "date," 1989.

She spotted him.

Michael was alone. He always sat by himself in the restaurant. He preferred the company of his books to that of people. A bachelor, he lived in a library; or rather he had turned a book depository into a home. His private set was an endless stack of books, a bed, and a view of the city outside. There were no signs of domesticity here, for Michael always ate out at the restaurant. Never wanting to separate from his book-keeping, he had a habit of eating with his volumes. He devoured the written page, so engrossed was he in reading. In the same way, he ingested his meals meticulously.

Michael, in fact, consumed everything in this way. He practiced the pleasure of the archivist: the quiet, avid, obsessive passion that is a private love of surface, texture, and the imaginary. Michael was indeed an archivist, even though he would lie about his way of life and, later in the story, tell her that he was a gynecologist. He did not see a difference. Archivist and gynecologist: both travel interiors.

She watched him.

Why would she be attracted to this pale-skinned loner, a member of that particular species the French appropriately call rat de bibliothèque? Perhaps it was because it took just one glance to know that he could touch her with the same delicacy with which he handled the pages of his books. He could caress her skin like the feather of a quill pen moves across the surface of a parchment. Parchment, after all, is a matter of skin—flesh on which to write. She fancied feathers. You could tell if you took note of her outfits.

Michael noticed her stare. Or was it her hair? She went to a good hairdresser. She liked to "wear" herself out in public, to design the map of her body. Fashion and good cuisine were her somatic obsessions. They touched her yearning to consume, as well as her manner of consumption. Clothes, a real passion for her, were fabrics of fabrication: excessive constructions, textures of seduction.

She wore beautiful things. In true eighties' style, extravagant, lavish apparel fashioned her image, shaped her figure. Her dresses were hyperbolic, ironic voyages into femininity. They accentuated her bodily "architecture": corsetlike structures framed shapes, doubled skin, marked curves, rounded breasts. She put herself together with care, composing a sequence of successively revealed parts. Her outfits were assemblages, luxuriant montages with

seductive inner mechanisms. The ensemble was always open to ready deconstruction—was there to be unfolded at the drop of a hand. It craved a lover's hand. Her attire roared desire.

Jean-Paul Gaultier was, of course, her designer. She favored this couture outlaw who twisted good taste, winked at historicity, and, in his Metropolis vogue, even turned Madonna into a False Maria. A fashion addict, she spent four hundred pounds a week on clothes. She also ate in the best restaurants. The food, exquisitely assembled on her plate, mirrored her clothes: it was a spectacle of consumable compositions. Eating and clothing went together, bonded on her map like bodily supplements. Aesthetic matters of the flesh, they were fibers—specular sides of the same material.

No wonder she nourished her gateways of incorporation. All passages and orifices—the doors of intersubjectivity—were lovingly nursed. She went to a good dentist and to a good gynecologist. So she told Michael, later in the story, adding that it was unlikely she would ever have a child. Her insides, she said, were ruined. Come and see me, he said then.

But this only happened much later. At first, and for a while, they did not talk. This was a "story of the eye."[2]

Her eyes devoured him.

Michael looked up from his meal. Would he return that hungry look, give himself up to it, allow himself to be "taken" in the erotic game? In the age of female desire, one no longer assumes a positive answer to this query. The usual navigational maps have been superseded by new practices of heterosexual love, and the rules of the game have changed. Woman is no longer game: no longer prey but, also, not always allowed to play. Now that she is the subject of desire she ends up subjected to new forms of denial. She maneuvers the boat of seduction and he becomes frightened: as if confronting the ghost of Cleopatra, he jumps ship and descends into the Nile. Denial equals power in the current flow of amorous positions the male gets to navigate. Scudéry's "River of Inclination" runs a different course. Rerouted by the new currents of seduction—and the male's attempt to regain control by way of negation— it becomes a journey into the Nile of denial.

And what of the fear of the loss of self, of the loss of power, that accompanies immersion in the sea of passion? In the Carte de Tendre, "Countries Undiscovered" appeared on the horizon of the map of tenderness, lurking behind the "Dangerous Sea" of love. Was Michael afraid of the waters? Would he remain castled up in the left corner of the map, nestled in that remote house of "Pride"? This dwelling, a safe haven, sat up high, overlooking a desperately lonely cliff.

Would he take the plunge?

A voyage to the sea has its advantages. Michael might indeed consider it. Perhaps he will not fear navigating the dangerous waters, will let himself be transported by their (e)motion. But he will have to travel far. Many obstacles stand in the way. He may be tempted to stop along the road. What if he chooses to stay at the lakeshore? The dead calm may be appealing to him. Indeed, the "Lake of Indifference" has its attractions. No mermaids. None of those oceanic creatures that made Ulysses drift away from the oikos. Here, there is only ataraxia. Or is it "still life"?

The "Lake of Indifference" stands there, still, a large and seductive spot on the map. Michael may never get out of it. But who knows? He may want to ride the waves of passion. Perhaps —she wondered—this man knows how to swim.

Michael reached for her famished eyes. He left his food and book behind and went after her. Perhaps he figured that a woman, too, could be eaten up: absorbed, consumed, expended, depleted. No, that was not what Michael thought. Leaving his table to absorb her—leaving the smell of his meal behind to follow hers—sweet Michael had a sensuous thought. He thought that she would taste good. Yes, she would taste real good. She was real food for thought.

She craved Michael.

Michael craved her.

They swallowed each other.

It had to end badly.

THE GEOMETRY OF PASSION

In turning, by way of a fictional appropriation, to the work of Peter Greenaway—a film director and artist trained as a painter and obsessed by architecture, the fashioning of space, and the cartographic enterprise—the cultural mapping we have genealogically traced is exposed in a contemporary filmic incarnation. Here, we sense the changes that have occurred in the domain that the Italian philosopher Remo Bodei calls "the geometry of passions."[3] One of the most accomplished cultural travelers in our cinematic century, Greenaway engages with some fundamental topoi of Western culture. His work leads us to question the current status of an emotional cartography in a world in which, according to Bodei, "no etics is any longer capable of circumscribing, measuring, and cataloguing desire *more geometrico*, as happened earlier with other passions, [for] 'the geometry of passion' itself has come to an end."[4]

Greenaway compels us to think about mapping cultural space after the demise of such a geometry of passion. He is obsessed with measuring and cataloguing—modes of organization used in systematizing anatomy and the organic world, natural history, letters, and cartography. For Greenaway, as for Godard, however, the return to taxonomy is absurdist and minimalist, and capsizes the meanings set on this scale.[5] In Greenaway's carefully constructed world, whose foundation rests on distancing and detachment, this elaborate architectonics tends to break around the edges of a passion. This suggests that when it comes to sentiments—including the intellectual passion, and especially the cartographic impulse—geometry was perhaps always a fiction. It also suggests that the geometry of passion has been keeping something at bay: the shifting design of an *emotio*nal cartography. The predominant order of geometry has been obscuring other ways of facing, and even measuring, our passions.

This said, I do not mean to identify Greenaway with my mode of tender mapping. For with respect to mapping space, Greenaway, despite the various representational directions he sets into tension, generally maintains the observational stance of the Dutch descriptive tradition.[6] This mode of representation nevertheless had its own passionate investment in describing the surface of the world, which was directly engaged in cartography and in charting the narrative of interior life. In the end, we may not be as far here from a tender mapping as it would at first seem, nor as decisively encamped in opposing territories. In my fictive, interpretive game, I purposely stretch Greenaway's cartographic borders, smuggling some of my mapping into his world. What follows, then, is a selective treatment of his work that

engages only with those of the many aspects of his enterprise that intersect with the concerns of this book.

Greenaway's recent work, from his curatorial endeavors and art installations to his recent film *The Pillow Book* (1995), challenges, with precision, the mores of a *more geometrico* of passion, adopting a softer approach—one that resonates, perhaps, with the tone of Emmanuel Levinas's reading of obsession in terms of a proximity of consciousness and sensibility. Here, in contact with the face of the other, in the writing of the face—where the caress of the visible takes place—"consciousness, in caressing, is obsessed."[7] Greenaway's obsessive aesthetic measures labor in hybrid forms that venture beyond the traditional territory of film, reaching for that intersection of the map, the wall, and the screen. Beginning with *A TV Dante* (1989), made in collaboration with the painter Tom Phillips, and *Prospero's Books* (1991), Greenaway furthermore has produced a new mode of imaging, incorporating recent technologies such as Graphic Paintbox, which, as its name suggests, refashions painterly tools and ways of picturing for the digital domain.[8] The texture of the resulting image no longer contains the geometry of passion. In an elaborate visual mapping that assumes the touch of a caress, *The Pillow Book* even provides a new cinematic screen. This consists of an assemblage of three screen ratios: one widescreen and color; one of smaller dimensions in black and white; and the last a tiny videographic window-screen—all coalesced into several superimposed configurations that work together with the eighteen languages of the film as multiple calligraphies. The frame, constantly refigured, explodes in favor of a simultaneous yet cumulative spatial flux. This screen, in dialogue with the reinvention of old representational techniques such as the filmic writing of intertitles, is composed of layers of passages that *emove*.

Peter Greenaway engages with the shifting place of a geometry of passion, as well as its aesthetic closure, by working with multiple mobile screens, thus collapsing borders between the cultural work he undertakes as a filmmaker, visual artist, and curator. With his conflated layers of imaging, he produces new formal means for cinema, in interface with the history of art and architecture and sensitive to fashion. In its shifting textural materiality, its digital calligraphy, Greenaway's work is building a newly mobilized cinematic "architexture" for us to inhabit. His work propels a cross-pollination between cinema and the museum as it circulates together their various archives of imaging. In this way, Greenaway becomes a barometer of historical changes that have beset spatiovisuality in our time as he offers, in turn, a measure of our intellectual passion.

INCORPORATION: THE LABOR OF MOURNING

Let us consider the metamorphoses exposed on Greenaway's screen, beginning with the act of incorporation. Occasionally in the artist's visual map, the tactile eye becomes a devouring eye: thus the narrative events of *The Cook, The Thief, His Wife, and Her Lover*, etched palpably on a template of culinary-sartorial seduction,

end up escalating into cannibalism. In the end, Michael dies by the hand of Georgina's husband, who makes him eat one of his beloved books. After force-feeding him the pages of Pascal Astruc-Latelle's *History of the French Revolution*, the cuckolded husband proceeds to turn him into a cadaveric double of Rembrandt's *Anatomy Lesson of Dr. Joan Deyman* (1656). In the wake of this atrocity, Georgina asks the chef at her favorite restaurant to cook her dead lover. Whatever for?

Perhaps Georgina makes a gesture of love: that is, makes her lover, quite literally, into potential nourishment. Insofar as love may be understood as such a form of incorporation, this is indeed an act of love. As the cook suggests to her, eating her lover would make him remain part of her; they could always be together. But love, as a form of nourishing and nurturing, can also turn abject, for it rests on a primary generative scene of horror that implies sucking and devouring. On the topography of the mother's breast, as Melanie Klein shows, milk and blood are intimately connected.[9] In this scenario, Georgina may want a meal of her lover, for love travels the whole metabolic range: it feeds, kills, and dies.

It is not for the purpose of embalming that Georgina wants her lover cooked. It is rather perhaps to enable the work of mourning to take place. Since Freud, the work of mourning has come to be understood as a process of incorporating the dead.[10] Grieving is an architecture of swallowing. For mourning to occur, death must be metabolized. We have to take the deceased inside—interiorize the person—in order to allow ourselves to overcome the horror of death. The fricaseeing of Georgina's dead lover is a gesture that connotes the habitual way we come to terms with death. It may actually enrage some spectators, for it enacts a horror that society knows well but prefers to cover up. Greenaway thus lays bare our daily affairs. This cooking of the dead is the actual abject condition we all experience: ingestion is only an act of love in the labor of mourning.

The act of devouring configured in *The Cook* might be further interpreted in the context of Jacques Derrida's reading of the work of mourning, which involves memory and interiorization, and is dependent on an *emotion*. Derrida describes the

9.2. A tear moves down the surface-screen of Georgina's face in *The Cook, The Thief, His Wife, and Her Lover*. Frame enlargement.

movement involved in interiorizing the physical persona—remembering the voice and the visage of the deceased—as "quasi-literally devouring them." In his conception, "this mimetic interiorization is not fictive; it is the origin of fiction. . . . It takes place in a body. Or rather it makes a place for a body."[11] This is the metabolic process that eventually lets us digest a death, expelling the corpse that has been living within us. It is only when the other becomes mnemonically interiorized as flesh—becomes a part of us, borne in us like a fetus—that a "tender rejection" can take place, and the labor of mourning is over. The dead can be finally left there, outside of us.

Georgina herself goes through a process of mourning. Only after she has spent the night lying next to her lover's cadaver, taking in his death in tender closeness with his body, does she have him made into a nourishing meal. For this occasion, Greenaway prepares an exquisite shot for an exquisitely loved corpse. At daybreak, we are presented with an extreme close-up of her face, which fills the frame horizontally. A tear, becoming palpable on the large screen of her visage, gently glides down the skin's surface. The shot sweats the labor of her pain as she intimately joins Michael, telling him of her horror. But the tender moment passes. . . .

Although Michael is finally prepared into a meal, in the end Georgina does not eat him. She vindictively offers his corpse up as culinary fodder for her husband, starting with the private parts that had lovingly nurtured her. He is delivered by a procession of all the people the brutish husband has badly hurt. Michael is arranged on a plate as though on an anatomical table in a scene from Rembrandt, laid out like Holbein's *The Body of the Dead Christ in the Tomb* (1522), and, finally, turned around as in Mantegna's *Dead Christ* to be offered to the carving knife.[12]

9.3. Dead Michael in *The Cook, The Thief, His Wife, and Her Lover*. Frame enlargement.

9.4. *Dead Christ*
by Andrea Mantegna,
c. 1500. Oil on
canvas.

EATING WITH THE EYES

The film's ending, not easy to stomach, hardly comes as a surprise. Antivision and cannibalism, as art historian Rosalind Krauss has theorized, are bound up with one another.[13] The dictionary entry for "Eye" in Georges Bataille's journal *Documents* is subtitled "Cannibal Delicacy":

On the subject of vision, it appears impossible to pronounce any other word but seduction. . . . But the extreme seduction probably borders on horror.

In this respect vision can be related to cutting. . . .

The eye, cannibal delicacy, after the exquisite expression of Stevenson, is an uncanny object. . . .

There is a common saying "eating with the eyes.". . . Looking at an object with desire is an act of appropriation and enjoyment. To desire is to contaminate; to desire is to take.[14]

Bataille's writing on visuality as cannibal delicacy is accompanied by the photograph of a woman whose wide-open eyes are prominently displayed. It is a filmic fabrication: Joan Crawford, the star of such fashion-ruled, absorbing melodramas as *Mildred Pierce* (1945). Bataille's illustration of seduction is no less than a portrayal of cinematic taste itself, rendered in female performance. Through this theoretical lens, with its cutting visions of contamination, female antivision becomes the site of cannibal delicacy. As the eye reaches for the mouth and the mouth envisions itself, seeing becomes philosophically bound to taste.[15] Vision is no longer pictured as the sight of distance but as a digestive, contaminating closeness. Seductive trails of gastronomy emanate from this metabolic scene.

THE DELICACIES OF ALIMENTARY PHILOSOPHY

In Greenaway's world, we always reach a wall—the skin of a material resistance. We travel a sphere of experience that is visceral. In this domain, epitomized by *The Cook*, eating becomes a form of knowledge. An eye-mouth maps space, ingesting it; sensuality is a pervasive form of nourishment; sexuality is experienced as food that is consumed. Bound together as incorporation, eating and knowing make for a gastric philosophy.

The alimentary side of knowledge, coupled with the epistemological edge of food, was illuminated by Jean-Paul Sartre in a text from 1939, which speaks of cannibal delicacies in its opening passage:

'His eyes devoured her.' The expression provides one of many hints of the illusion, common to both realism and idealism, that knowing is a sort of eating. This is where French philosophy is still mired. . . . We've all imagined a spider-Mind drawing things into its web, covering them with white saliva and slowly ingesting them, reducing them to its own substance. . . . O, alimentary philosophy! But what could be clearer:

Isn't the table the current content of my perceptions, and my perception the present state of my consciousness? Nutrition, assimilation. The assimilation, as Lalande used to say, of things to ideas, of ideas to one another, and of one mind to another.[16]

What does this gastric landscape represent? For an answer, let us turn to some metabolic spiders pictured in women's art. In *The Spider* (1994), a sculpture and series of drawings by Louise Bourgeois, the image of a "spider-Mind drawing things into its web" stands for alimentary knowledge, which, as Bourgeois sees it, is not too far from the complex nourishing emotion that defines femininity in the maternal topos.[17] This web of knowledge is constructed by way of "weaving" thoughts onto the picture surface in the textural work of Elaine Reichek. In her *Sampler (A Spider)* (1997), a web, inscribed in the cultural labor that produces a "room of one's own," is actually woven onto the fabric of a canvas in the form of this absorbing passage from Virginia Woolf: "fiction is like a spider's web . . . attached to life at four corners. . . . These webs are not spun in midair by incorporeal creatures. They are . . . attached to grossly material things like . . . the houses we live in." Such webs of metabolic knowledge are inscribed in the house of moving pictures as well and, in the form of intellectual "intakes," define the way Greenaway gastrically inhabits it.

In his analysis of alimentary philosophy, Sartre sought to transform the "moist gastric inwardness" of digestive philosophy and turn it outward.[18] He insisted that in order to succeed in this theoretical transformation, one must "break out" in the Husserlian sense, fly out beyond oneself, *be* outside oneself. In this epistemic flight, to "be" is to break into the world, for in a Heideggerian sense, "being-in" is fundamentally a movement. Such an epistemological break is attempted by way of amorous transformation in *The Cook*, in the scenes of love-making between Georgina and Michael in the kitchen of the restaurant, a series of amorous tableaux composed as culinary portraits, in the fashion of a typical Dutch *nature morte*. In the kitchen setting, these "still lifes" become erotic living, in a twist on the notion of *tableau vivant*. The e*motion* of the film is also housed in the book depository, in that library/archive/home of transformative amorous knowledge. However, overall, and despite the extremely seductive choreography of camera movements in the restaurant, *The Cook* does not progress entirely in the direction of mapping being-in as motion. There is movement across and within, but ultimately not outside an essentially gastric inwardness, which includes a fixation on the sentiment of revenge.

A potential journey outward occurs when the film takes the spectators and the bonded lovers, who are in a sealed refrigerator truck, from the claustrophilic interior of the restaurant to the interior world of Michael's book depository. But this journey represents a particular kind of exit. It is an expulsion. It develops in descent. Discovered by the enraged husband, the lovers leave the Edenic delights of the restaurant and enter the enclosed truck, which is filled with rotten food. Expulsion, the other side of ingestion, is visually mapped in a sequence that has strong hagiographic and art-historical references. The lovers incarnate the image of Adam and Eve expelled from the Garden of Eden, where, with the eating of the forbidden apple, eroticism and gastronomy were first connected. The scene reeks of many

painterly representations of the subject and particularly echoes the composition of Masaccio's *Expulsion of Adam and Eve* (1425).

Expulsion from the place of Edenic pleasures is one of the many Christian metaphors of incorporation employed in the film, culminating with the final act of cannibalism. Michael is offered up to be eaten just as the body of Christ is swallowed and ingested in the form of the Host. This reminds us how, in eucharistic terms, one becomes a cannibal by eating the body of Christ.[19] Like any cannibalistic action, this one creates matter. It is a transformative act of the externalized psyche. In this sense, cannibalism performs the same kind of transformation that is enacted in alchemic knowledge.[20]

Formally orchestrated, as all Greenaway's features are, *The Cook* constructs the escalation of cannibalistic activity with a minimal opulence that is beautifully perverse.[21] Its visual mannerism is underscored by the music of Michael Nyman, a former frequent collaborator in the director's neo-baroque enterprise.[22] The pleasure of cannibalism is enacted on many levels, including that of an authorial ingestion—an intellectual voracity. In Greenaway's opus, cannibalism involves the assimilation of painterly, architectural, literary, musical, and sartorial figures, all ruled by "taste." The pleasure of watching this cinema involves sampling and digesting such food and unpacking it for one's own gourmand delight. A taste for Greenaway involves an omnivorous appetite for its intertextuality: it is a dissemination of architectures remade into a traveling body of texts, reinvented in endless *mise en cadre*.

9.6. The museum as an interior (re)collection, from the title page of Olaus Worm's *Museum Wormianum seu Historia rerum rariorum*, 1655.

APPETIZING ROOMS

In Greenaway's films we are taken on appetizing tours through his mental library, where we are made to feel as if we are sitting in the study of Saint Jerome itself, or in extensions of his rooms. One such room is the study presented in his film *Darwin* (1992), a single set depicted in eighteen *tableaux* that constructs an actual museum for the cinema. Another of these museographic rooms is the scenography of *Prospero's Books*, which travels the topoi of library and archive.

For this film, Greenaway executed twenty-four imaginary books, exquisite objects of graphic design that parallel the film's architectural sets (designed by Jan Roelfs and Ben van Os, who have collaborated on the art direction for all Greenaway's films since 1985). This traveling library becomes the subject of the short film *A Walk through Prospero's Library* (1992), where it is exhibited as if it were an art installation. It features *A Harsh Book of Geometry*, "a thick, brown, leather-covered book" whose diagrams rise up out of pages that flicker with measuring instruments activated by magnets.[23] There is also *A Book of Universal Cosmography*, with concentric rings that circle and countercircle; and *The Book of Colours*, in which "the colour so strongly evokes a place, an object, a location or a situation that the associated sensory sensation is directly experienced."[24] Set next to a garden encyclopedia, *An Atlas Belonging to Orpheus* appears as an enormous volume "full of large maps of the travel and usage of music in the classical world [and] of maps of Hell . . . scorched and charred by Hellfire." This geographic volume has

9.7. The book depository, another place of intimate (re)collection, in *The Cook, The Thief, His Wife, and Her Lover*. Frame enlargement.

a particularly dramatic configuration: "When the atlas is opened the maps bubble with pitch. Avalanches of hot, loose gravel and molten sand fall out of the book to scorch the library floor."[25] If this atlas contains ruined maps, another volume, *Love of Ruins*, has maps of ruins and plans of archaeological sites: its architectural *vedute* represent "an essential volume for the melancholic historian."[26] *An Alphabetical Inventory of the Dead* is funereal in nature, while the macabre *Vesalius's Last Anatomy of Birth* is "full of descriptive drawings of the workings of the human body which, when the pages open, move, throb and bleed."[27] A Leonardesque dream produces a veritable wet dream in *The Book of Water*, which is discolored by contact with water and full of animated, agitated explorative drawings of various fluid maps and hydraulic matters, from seas to tears. Also ruined by use is *A Book of Traveller's Tales*, which illustrates amazing stories of faraway places with bearded women and cities of purple ice. Similar architectural stories are echoed in the city plans and diagrams of *A Memoria Technica Called Architecture and Other Music*, where facades, perspectives, and architectural models of buildings pop up in the moving shadows of mnemonic techniques; piazzas become crowded; and lights flicker in nocturnal urban landscapes. *A Book of Motion* "describes how laughter changes the face . . . how ideas chase one another in the memory, and where thought goes when it is finished with."[28] This book of animated drawings "drums against its bookcase shelf and, because it is always bursting of its own volition," must be bound and held down, for it might go off to court *The Book of Love*, a "scented volume" bound in red and gold, "with knotted crimson ribbons for page markers."[29]

Examining the "installation" of this library, we realize that in Greenaway's archive we revisit Jerome's architecture constantly and diversely, in depictions that range from Caravaggio to Georges de La Tour. In particular, we inhabit the version of *St. Jerome in his Study* (c. 1475) that was produced in a Neapolitan art studio, deeply steeped in Dutch painterly culture, by Antonello da Messina (c. 1430–79). This study space is the main model for all of Greenaway's libraries, including Prospero's and the book depository in *The Cook*. In each, beautifully composed traveling shots construct the space of intellectual consumption. With the erotic, gastric force of a spider-mind drawing things into her web, ideas are assimilated into one another in a comprehensive mapping fashioned by omnivorous taste.

EYE-MOUTH

This itinerary of contaminations begins with the film script, "a structure," in the words of the equally metabolic filmmaker Pier Paolo Pasolini, that is "morphologically in movement."[30] A fellow traveler on the route of incorporative contamination, Pasolini wrote of his own passion for devouring and of the cannibalistic power of film.[31] In the essay "Res sunt Nomina," he noted that the Italian word for movie camera, *macchina da presa*, suggests film is a machine that captures, enraptures, and devours. The "kino-eye" is renamed *occhio-bocca*, or "eye-mouth."[32] For Pasolini, film is a "reality eater." From the script to the images captured, the cannibalistic

delight of inward transformation molds film space and, eventually, digests it with the "eye-mouth."

Greenaway shares with Pasolini this vision, as well as the polemical tone of a ravenous intellectual passion that encompasses diverse creative fields, perhaps heir to some forms of Renaissance expression. Both filmmakers incorporate painterly compositions in filmic reinvention. Both, moreover, work in the specific tradition of Western representation—Enlightenment included—that, despite its ocularcentricism, engaged haptics through touch and taste. Particularly attracted to scatological morsels, they share an obsession for orifices, constantly meditating on the body's points of entry and exit and on the digestive tract.[33] Within this exchange on taste and its tactility, they expose the taste of love-making, and take this liminality as a threshold of scenographic representation.

Lingering on the places of intake and outtake, filling the screen with food, sex, and excrement, Greenaway and Pasolini understand the orifice as a passage—a transitional site of dialogue between exterior and interior. Ultimately, the orifice is the place of contact with, and access to, intersubjectivity and the social world. In the face of death, the mouth modifies its habitual intake to leave space for the incorporation of mourning, which in many cultures directly involves gastronomic rituals. In my own culture, for example, there are always restaurants near cemeteries, to properly prepare for the work of mourning. For the survivor who confronts the death of a loved one, death is accompanied by a physiological experience: it affects the stomach's regular cravings until the labor of mourning is done. Physiologically conceived, it is gastrically configured.

THE PHYSIOLOGY OF DEATH

The restaurant in *The Cook*, a site of cadaveric experience, is dominated by a painting about social eating: *The Banquet of the Officers and Sergeants of the St. George Civic Guard Company* (1616), by Frans Hals. This Dutch painting, composed in the fashion of the "supper painting" genre and close in form to Leonardo's *The Last Supper* (1495–97), is set in dialogue with the filmic banquet that takes place in the foreground. As Alois Riegl has shown, Hals's painting, in its public binding of eating and social relations, incorporates an implied spectator. In this way, it functions much like such depictions of the anatomy lesson as Rembrandt's *The Anatomy Lesson of Doctor Nicolaes Tulp* (1632), which delivers its own haptic construction of an implied public.[34]

The anatomy of death returns obsessively to Greenaway's screen. The anatomical theater is the epistemic location, for example, of *M Is for Man, Music and Mozart* (1991), a film set in a remake of a sixteenth-century medical amphitheater. Here, the human body is dissected by the camera, which composes physiognomic portraits in the fashion of Giuseppe Arcimboldo (c. 1530–93) and anatomical drawings à la Andreas Vesalius (1514–64), in which "bodies are like complicated urban maps of the future."[35] The dissected human body is then set in motion, for *m* is also

9.8. *The Anatomical Theatre of Leiden*, illustrated by Willem Swanenburgh after J. C. Woudanus, 1616.

for "movement." This analytic gesture speaks of cinema's genealogical connection to anatomical panoramas and their performative theatrics.[36] The spectatorial architectonics of the anatomical amphitheater, as we have shown, translates to the movie theater, where cinematic technology generates the film body. The mechanics that emerges from this analytic scene engages the mimetic reproduction of the body, which is at the root of film's genealogy. In Greenaway, it carries the obsessive analytic repetitiveness of Muybridge's locomotion studies—a scene that is obscene.[37]

The physiology of death haunts Greenaway's representational space as it does the work of many contemporary artists. Like Andres Serrano, Greenaway composes a haptic scene of the morgue in his *Death in the Seine* (1989).[38] Following the codes of the Western representation of death—in which, as Philippe Ariès has shown, cadavers can be exquisite—he extends a cinematic embrace over both cadavers and books.[39] The film examines signs of life found on corpses dragged from the Seine, as noted by two morgue assistants between 1795 and 1801 whose work was reconstructed from records stored in a mortuary archive at the Bibliothèque Nationale.[40] As historian Vanessa Schwartz shows, at the end of the nineteenth century, the Paris morgue became one of the catalogued curiosities to attend and—as a public spectacle of the real, displayed in flesh and blood—took part in the "spectacular realities" that contributed to the birth of the cinema.[41] In Greenaway's film of the morgue, the cinematic touch is a caress that sweeps over the cadavers, which face us, feet to the foreground, once more like the body in Mantegna's *Dead Christ*. Again and again, this repetitive camera movement places us back in the morgue and the archive to explore the skin surface of the dead. Such cinematic

9.9. The theater of anatomy in a still from *M Is for Man, Music and Mozart* (Peter Greenaway, 1991).

caresses trace the story of the corpses as it is written on wounds and in the contents of pockets, on jewels and bandages, scars and haircuts, skin texture, and the fabric of garments.

METABOLIC ARCHITECTURE

In this anatomy of pathos, affects are expressed as spatial cravings: fragments of places, like the landscapes of the dead, are the subject of yearning and longing. Here, architectural hunger defines a cinema driven by the delicacies of architecture and represented as a spatial art form "fashioned" upon the body. *The Belly of an Architect* (1986), in particular, renders architecture's metabolic projections as it develops the story of an American architect's fixation on matters of the belly alongside the story of an exhibition in Rome on the architect Etienne-Louis Boullée (1728–99). In this double articulation, it creates the hyphen that connects the body to built space.

The mechanics of this link, as Henri Lefebvre has explained it, rests on the fact that bodies produce space and produce themselves in architectural form.[42] Richard Sennett shows that throughout the history of Western architecture, traces of this bond between "flesh and stone" have taken different representational forms.[43] According to Anthony Vidler, architecture has moved successively from the assumption that the building *is* a body to the idea that it embodies states of mind or bodily sensations, toward a conception of the environment at large as itself organic,

and, finally, to a sense of the loss of the body and its reappearance in morcelated form.[44] From analogon to metaphor to actual constituent, and in biomorphic disintegration or even dismemberment, the history of architecture has bonded with the house of the body, even if only by way of its repression.[45] In fact, in feminist architectural terms, this architectural body reflects historicity in a gendered domain.[46] For Greenaway, "architectural anthropomorphism can conceivably be extended to the interior anatomy. Vesalius, the anatomist . . . said that 'the body is like a palace set in water and kept alive by air.'"[47] If we think historically about this architectural landscape designed by Greenaway, we are reminded of Athanasius Kircher, the seventeenth-century polymath who dreamt of cinema's light and shadows and for whom architecture was mingled with biology and home economics—the place of production for the gendering of the belly.[48]

9.10. Dome, *domus*, and belly in *The Belly of an Architect* (Peter Greenaway, 1986), with remnants of Etienne-Louis Boullée's own design. Frame enlargements.

To further locate a genealogy for the belly of architecture, beyond the direct reference to Boullée, one may also turn to Humbert de Superville (1770–1849), author of *Essai sur les signes inconditionnels dans l'art*, published in 1832.[49] In precinematic times, de Superville wrote about aesthetics and corporeality, exploring the presence of the body in art and architecture. Most distinctively, he argued that physiognomy inhabits the architectural field. De Superville's method engages in physiognomy to form a link between bodyscape and cityscape, and especially between face and facade. As its etymology indicates, the face is inscribed in the facade. The terms are connected as signifiers insofar as both are sur*faces*. Rather than simply collapsing body and architecture, de Superville, focusing on an ethics of passion, introduced an element of change: the human face, like the architectural facade, is haptically moved. Rather than a given, the body—in his physiognomic sense—is affected by emotional states, which reflect and create a range of diverse representations on the surface of the skin. For de Superville, this evolution—that is to say, this *emotion*—and especially the range of calm, joy, and pain, finds an analogue in architectural style as metamorphosis. Palpable signs, engaging textures, color and shape, are mapped on a facade as they are on the face in the form of a haptic communication, read on the surface by those who come into contact with them.

De Superville's precinematic approach involves the inscription of an observer-inhabitant in the field of passion and architectonics. It makes clear that architectural movements shape, and are shaped by, changing physiological landscapes. As we have seen, film itself was born out of this emotive landscape, with its haptic architectural promenade. In this (e)motional cartography, and in the liminal binding of spectatorship, moving physiognomies and the space of emotions "take place," architecturally, on the surface-screen. Reciprocally, the haptic mapping of film mobilizes the belly of architecture in an emotive interchange, in which affects dialogue with place. As Greenaway ultimately puts it, "for architecture, write film; for architect, write filmmaker."[50]

GASTRIC CITY

The Belly of an Architect reinforces the representation of the architectural belly as conceived through emotive passion by de Superville. It operates on this terrain, in particular, by absorbing sculpture into the body of architecture and thus demonstrating the physiological passion that links face to facade. Figurative sculpture is a monument to the body, physically close to architecture when this is conceived anthropomorphically. Physiological shapes are the link between architectural, sculptural registers and the design of somatic contours. The film assembles these together in its composition, building a classical symmetry between nudes and unclothed architectonics in observations of both the city and the architect, and in the framing of lovemaking scenes.

Thus the belly of the architect Kracklite becomes a sculptural object in the film, particularly in the scenes in which he is at the doctor's office or is identified by the police against an archive of sculptural body parts at the Capitoline Museum. This belly is a partial copy of the sculpture of Augustus, whose mausoleum the architect worships, as well as a fragment of Agnolo Bronzino's portrait of *Andrea Doria as Neptune* (1556). It is always identified with Boullée's passion for the dome. In this geometry of volumes, Greenaway joins sculpture, etching, painting, photography, and architecture, constructing as well an architectural itinerary for the Roman belly that extends from arch to cupola and from Hadrian's Pantheon to EUR's Palazzo della Civiltà (1942).

An understanding of the physiological "nature" of this filmic architectural belly depends on one's viewpoint. For David Wills, the belly of the film is conceived *a tergo*, in the rounded shape of buttocks that stand in for an eye; the story is about digestive disorder, sexual penetration, and an ultimate male craving to return to the womb.[51] Such a reading exposes the fact that, when it comes to the belly, the critical viewpoint tends to incorporate gender difference, as does *The Belly of an Architect*. In fact, there are two bellies in the film: his and hers, which, over the course of the couple's "Voyage in Italy," come progressively apart. Kracklite's belly, first exhibited in the train as it arrives in Italy, happily entering "the home of the dome, arch, and good food," will grow a cancer. Louisa's belly is from a different "sphere" and, encountering sexuality in the Italian terrain, ends up containing a child. The gendered shaping of the belly dwells on the opposition between dome and *domus*. This dichotomy, once again, confines her sphere of action to the realm of the *oikos*—the ultimate fantasy container—and thus locks sexual difference into the architectural domain.

In working against this binary opposition, it is important to note that the dome can also be a home. Just as the sculptural belly is a figurative home for the dead, so the dome is itself a *domus*. This is how Boullée envisioned the spherics of the dome and gave sense to geometrical shapes and volumes. Boullée produced well-known paper architecture bound to his theoretical production.[52] His designs, in keeping with his ideas about a museum of architecture, favored public monuments

for the dead. As large-scale funerary architectures for the mind, they turned body into building, at the point of the burial, as the very site of mourning itself. The project entitled *Cenotaph for Isaac Newton* (1784) was one of these memorials and sits center-stage in the exhibition of Boullée's work produced by Kracklite in the film. Here, the *Cenotaph* is reproduced as a cake and is metabolically ingested into the dying belly of the architect. This huge, perfect, melancholic sphere, a funereal planetarium, serves as the model for Greenaway's architectural belly. Following the path of this particular topographical fiction, the belly can be redesigned as the domain of a dome that might house a different type of *domus*.

In fashioning the remnants of a "geometry of passion," Greenaway (who, in 1985, made *Inside Rooms—26 Bathrooms*) addresses the plumbing of the architectural belly in all aspects of its technology and design, thereby creating an architectural body that is not an organic whole. Read through Greenaway, idealized body space has a pain, located right in the geometry of the belly and in its specular oppositions. In a modernity that is both heightened and dying, this cinema measures the architectural passion with an anatomy of space that is obsessive, excessive, decomposed, morcelated, and diseased, and with the same gastric perspective *The Cook* inscribed into the fabric of costumes and the fibers of its customs.

ROMAN VIEWS AND PICTURE-POSTCARDS

Greenaway suggests that "every film needs to have a location, a sense of place, whether found or invented, and when found, then usually re-invented."[53] In *The Belly of an Architect*, a sense of place is established in the Vittoriano, the memorial building chosen for the exhibition of Boullée. A filmic reinvent of the art of viewing takes place in this monument, known to Romans, in the feminine, as "the Emmanuella," or else, "the typewriter." As the Italian architect Costantino Dardi, the film's consultant, explains: in "the highest point of the building, we realized a series of . . . 'machines to read Rome' that enabled one to frame the sites, in the guise of the *camera lucida* (drawing from Barthes) or of the instrument used by Canaletto to observe the views of Venice. . . . Greenaway loved this operation, affirming that knowledge means sectioning views, and this applies to cinema."[54]

The same architectural logic used to frame the views from the Vittoriano applied to the techniques of shooting the city. Greenaway and Sacha Vierny, the talented director of photography of most of his films, "paced and re-paced . . . to find the exact required emphasis of man and building." Afterward, as Greenaway describes it, "the whole film . . . was photographed as though the cameraman himself was a classical architect."[55] Rome's monumentality offered a degree of resistance to the perfect view, and, in the end, the film appears to contain its urban motion in static shots. City views are framed as in a sequence of frozen picture postcards. This postcard city is not "a walk through Rome."[56] Rather, as Greenaway puts it, the picture postcards "conduct you, building by building, street by street . . . each postcard

photograph containing in the background a detail of the main view in the next post-card."[57] The film takes us on a site-seeing tour of *vedute* through a representational juxtaposition of city views, filmic views, and touristic postcards. Actual postcards are filmed as Kracklite uses them to write imaginary letters to Boullée, creating an intimate, urban diary. Threaded through this emotive landscape, the fragmented vistas of postcards expose the mental map of an architect.

ARCHITECTURE IS ONLY A MOVIE

In the architect's view, noted on a postcard, "the colours of Rome are the colours of human flesh and hair."[58] The film's tones cosmetically adjust to the skin tone of Roman facades, sculpting a view of architecture. In this way, Greenaway's film takes a portrait of the architect to represent an architectural position. *The Belly of an Architect* does for anthropomorphic architecture what *The Fountainhead* (King Vidor, 1949) did for high modernist design in the film version of Ayn Rand's novel.[59] Inspired by Frank Lloyd Wright, the novel combined architecture and love and was perversely eloquent—more so than the film—on the interplay of woman, seduction, and modernist design.

Greenaway joins architectural and filmic design in a search for a cinematic language that not only features architecture but makes it the fabric of a corresponding filmic architectonics. In this respect, his work parallels the inventive building of space created by Jacques Tati, especially in *Playtime* (1967), although their views on architecture differ. Tati, who built his filmic city in the fashion of an architect, turned sets into movements.[60] Filmed in 70mm, in deep-focus long shots and long takes, "Tativille" was a panoramic commentary on the International Style of modern architecture and left a range of observational movements open to spectatorial wanderings in the frame. Directing with sound more than sight, turning places into one another and everything into an airport, designing clothes and objects alike, Tati ultimately spent his "playtime" toying with transparency, building a world between glass and screen.

Despite their different representational positions, Greenaway and Tati converge on one level, for both portray the relation of architecture to the photographic image, suggesting their interplay on the surface of the screen and the perimeter of the frame. In the way it photographs architecture, *The Belly of an Architect* owes something to Michelangelo Antonioni. This is particularly evident at the end of the film, where, in a citation from Antonioni's *Blow-Up* (1966), architecture becomes a movie as memory is revealed to be an archive of images. In Antonioni's film, a fashion photographer builds a plot by sequencing pictures, turning photography into cinema. In the same fashion, Kracklite comes to confront a sequence of pictures on the wall in a photographer's studio and realizes how a film narrative was constructed out of his own architectural belly.

CAMERA MOVEMENTS, MOVEMENTS OF THE ROOM

Greenaway uses camera movement to construct scenography, in traversals that often enable spectators to touch different historicities of architecture. In the restaurant scenes facing the Pantheon in *The Belly of an Architect*, camera movement conveys the epistemic emotion of an architectural odyssey. This epistemic sentiment becomes a curatorial tactic in *The Cook*, where the change of room colors orchestrated in motion creates an entire history of architecture. As the director explains in his essay "Photographing Architecture":

Delightfully, you can prefabricate . . . architectural excitements in cinema. . . . Architecture built solely for the camera. . . . In the huge spaces of this extended restaurant, [one sees] a travelling history of architecture. From left to right, the camera on rails moved from the blue Stonehenge exterior to green Piranesi 'Krak des Chevaliers' medievalism to a vulgar Beaux-Arts Baroque to a Modernist bathroom complete with Bauhaus fittings. Only possible at the movies? Not necessarily so. For in any capital city in Europe, walking down the once-ancient and now-modern main street, you may very well observe that chronological change.[61]

This architectural *capriccio* built by the cinema corresponds to the practice of living the historical layers of cities as they unravel on the urban pavement. The architectural palimpsest is traversed equally by the city dweller and the camera. This epistemic approach to camera movement takes hold of the *emotion* of habitation and encompasses, in this idea of habitat, even the clothes that Helen Mirren wears: her attire changes tone with that of the architecture, shifting from green to red to white. With this tourism of architectural sentiments, Greenaway projects us into a moving odyssey of art history and design.

This approach parallels the epistemic force of the space odyssey, different in form yet just as daring, traveled by Stanley Kubrick, a master of movement. In *The Shining* (1980), Kubrick exposed pathology with elaborate camera movements in and out of the space of a hotel: through the salons, halls, and kitchen, and in the labyrinth of a maze. He fashioned an epistemic odyssey in *2001: A Space Odyssey* (1968), a film that makes a movie theater into a traveling vessel. Opening with the boldest historiographic and architectural shift in film history, it turned the dawn of mankind into a spaceship of the future, sending us on this voyage in a single cut. Moving between history and timelessness, Kubrick's film articulates the very experience of space and its navigation as it meditates on vehicles, environments, and decor. Appropriately, the monolith from the film's opening finally reappears in a hotel room, lit up by the luminous floor beneath. As Annette Michelson described it, Kubrick constructed "'an architecture of movement,'" offering "an Idea of a Room . . . the notion of Idea and Ideality as Dwelling."[62]

H IS FOR HOUSE, M IS FOR MAPPING

Architectural dwelling is a form of mapping for Greenaway, a filmmaker who is fascinated with cartography, collects maps, and has made some three hundred artworks that engage in charting. Greenaway works with the map's potential for traveling different historic tenses. *A Walk through H* (1978) is one such labor, in which mapmaking and filmmaking are co-articulated. This film takes an ornithologist through his last journey, guiding him through a succession of landscapes, from city to wilderness, by way of maps. At the beginning of the film, we visit an art gallery where a series of works, produced somewhere between the codes of art and cartography, hangs on the wall.[63] The ninety-two maps were made by Greenaway; the film is their extended exhibition. *A Walk through H* animates the space of the maps, taking us through the fictive cultural voyage that mapping, like cinema, is capable of condensing in its texture. The map tour returns us back to the gallery at the end of the film.

The archivist who organized the maps is a recurring fictive character of Greenaway's named Tulse Luper, a man who packs a suitcase with maps of

9.11. A filmic map: narrative paths in Peter Greenaway's *The Duchess of Berry Map*, 1976–78. Mixed media on paper.

9.12. *The Home of the Roadrunner Map*, from the film *A Walk through H* (Peter Greenaway, 1978). Frame enlargements.

Herculaneum and always represents the filmmaker's double. Learning of the ornithologist's illness, Luper has collated the maps to enable him to take a walk through the country of H. These maps "wcrc in the ornithologist's possession already—either found, bought or stolen on his travels. . . . In some cases, the ornithologist, though he had not realized it, had possessed the maps since childhood."[64] As he ponders the cartographic journey, the narrator considers that "perhaps the country only existed in its maps, in which case the traveller created the territory as he walked through it."

We travel through the maps in a cartographic itinerary that outlines the experience of architecture, landscape design, and other surface-spaces as they are used, lived, and traversed. There are maps "before use" and "after use." We travel, for example, through the city plan of *The Amsterdam Map*, which invites the collector to look for a map in everything he possesses. We traverse the interior design of *The Duchess of Berry Map*, made from a French engraving that shows an inside view and plan of the attic in which the lady was arrested. Here, the filmmaker-mapmaker has marked possible routes in white, creating an itinerary that crawls the walls and attempts a rooftop exit. In *Two Small Cities*, cartographic conventions are reinvented as they reprise the flattened and figurative medieval representation of towns. Maps are ironically made from every possible material: paper for wrapping X rays becomes a map, as does cloth in *The Laundry Map*; you can touch the skin of *The Cowshide Map* and handle the texture of *Sandpaper*; by way of mapping, even *Thin Cloud over the Airport* becomes palpable; reading between the lines, "the geological cracks . . . of [an] older and more monumental message" are visible in *Red Correspondence*;[65] cartographic missives can travel in the used envelope of *The Last Map*.

The itineraries of the maps, themselves filmic in nature, are further mobilized by camera movement, which explores and articulates their trajectory. Accessing, traversing, and analyzing the space of the cinematic maps as it intercuts documentary footage of birds in their natural habitat with increasing rapidity, *A Walk through H* allows us to wander in all cardinal directions through, onto, and inside the surface of the maps, with the awareness that "the time allowance of each map stretches forwards as well as backwards."[66] Along the way, the painterly frame gives way to a unified haptic navigation of filmic and cartographic time-space. The film meditates on cartography as a form of epistemic inquiry and inventory, conjoining filmic travel and mapped itineraries with the traveling of the archive.

Greenaway regularly constructs a gallery—an architectonics—of paintings in his films. Here, he delivers a film that, as an art of mapping, offers a museological promenade. *A Walk through H* delves into that particular archive that constitutes the work of natural history. The itinerary of the film is cartographically built as cinematic flight, modeled on the flight of birds. Flying and an envy of birds has been a central object of Greenaway's artistic and curatorial fascination. In 1997 he curated an exhibition/installation in Barcelona entitled "Flying over Water," which presented "encyclopedias" of water and air.[67] Since no concept of historic water exists, Greenaway bottled water from various urban sites, such as laundromats, and labeled the jars, cataloguing them museographically and placing them in a setting

that purported to await the return of Icarus. In 1992 the filmmaker curated a show entitled "Le Bruit des Nuages" at the Louvre, selecting from the museum's collection ninety-one works that illustrate the longing for flight. Included in this display was Atlas, who, under the weight of the globe, conceived a different way to escape his earthbound condition. In a veritable flight of fancy, Greenaway created a companion volume of representational flights aptly called *Flying Out of This World*.[68]

Greenaway's father was a passionate amateur ornithologist; thus the landscape of flight is an *intimate* mapping for the filmmaker. This paternal landscape engineers *A Walk through H*, whose ornithological display is a sentimental museum. Insofar as it is an archaeological–cartographic navigation along a gallery wall, *A Walk through H* resonates with the cinematics of Gerhard Richter's *Atlas* (1962–present), which we will address at length in the next chapter. Using different means of representation but the same cartographic slant, Greenaway's sense of mapping is both personal and melancholic. As in Richter's project, the landscape and movement that define the work of mapping expose what is, fundamentally, a work of mourning. Greenaway makes no mystery of the fact that his father had recently "flown out of this world"; he had died of stomach cancer before the film was made.[69] The ornithologist had amassed an extraordinary archive of bird-study materials. With his death, this archive stood in peril—as is the archive of any life upon death. Thus the son took on the museographic project of mobilizing this life-work, filmically incorporating the memory of his father's archive in his own gastric attempt to metabolize death. *A Walk through H*, which is subtitled *The Reincarnation of an Ornithologist*, tracks the actual archival journey of incorporation, which, as we have seen, defines the labor of mourning. It is quite literally "a walk through H" because, as the title of another of Greenaway's films attests, for this director, "H is for House." There, in the belly of architecture, from Hadrian to Boullée-Kracklite, the stomach is always quite painfully diseased. Which is yet another way of saying that cartography is never too far from charting the particular terrain that is the land of affects.

ATMOSPHERIC INSTALLATION: THE CITY AS MOVIE THEATER

Traveling the map as an art exhibit, Greenaway is admittedly "curious about the possibilities of taking cinema out of cinema . . . presenting cinema as a three-dimensional exhibition" in order to question "what constitutes a vocabulary of cinema."[70] One such project of expanded cinema, extending the mode of installation portrayed in *The Belly of an Architect*, was the 1996 *Cosmology at the Piazza del Popolo: A History of the Piazza from Nero to Fellini Using Light and Sound*.[71] Here, the piazza was animated with the language of film in order to make manifest its urban history, which includes the cinema as part of its fabric. For film is itself a trace of the historical passages that take place "on location." Reflecting on the performative aspect of architecture, Greenaway has asked: "can you applaud an urban square, a flight of stairs, a statue in the shade of a tree . . . a city? Is this in fact what we do when we watch a film?"[72] Recognizing that this joint performance involves

9.13. The city as movie theater in Greenaway's *The Stairs 2: Projection*, Munich, 1995. View of one site of the city-wide installation.

social participation, he considered that this condition might also be "available in the proposition of an exhibition—and isn't cinema an exhibition of sorts, maybe, where the audience moves and not the exhibits? Perhaps we can imagine a cinema where both audience and exhibits move."[73]

This interplay of cinema, exhibition, and the city was fully articulated in *The Stairs 2: Projection*, a city-wide installation created in Munich, in 1995, for the one-hundredth anniversary of film's invention. One hundred screens were created in different locations in the city, each representing one of the one hundred years of film history. The sites were marked and connected on the city map, creating an itinerary that could be covered by a passenger-spectator in the course of an evening's stroll. Lighted frames were projected onto the city's own architectonics, their surfaces interacting with the grain and texture of the facades. These filmic screens overlapped with windows and cornices, architectural structures and ornaments, turning building, street pavement, and urban fountain into film screens. Wandering in this scenography, drifting from screen to screen and from palace to palace, the city itself became a giant movie palace, close in shape to the "atmospherics" of an open-air theater. In this public-private movie theater for the urban dweller, the city itself became a film archive.

This was a peculiar archive, for no films were projected at all. The subject of the installation was the pure space of screen projection, in clear avoidance of figurative elements. As Greenaway explains, "The one hundred projections in Munich are deliberately non-figurative, since this city installation specifically refers to the essential act of light projection which is the basic premise of cinema."[74] Although there was no figuration, the work of the filmic text was exposed nonetheless through the display of the cinematic mechanism—its movement—in space. In this sense, Greenaway's installation resonates with Hiroshi Sugimoto's own minimal representation of cinema as architectural projection. As in Sugimoto's photographs of film theaters, cinema is a white-light "screen-space," an archive of screens.[75] In Greenaway's words:

Cinema is nothing if not a beam of projected light striking a surface with a framed rectangle of brightness. . . . This, therefore, is to be an installation of screens. . . . The strong beam of projected light with its moving shadows is to be the predominant image of the screen-space.[76]

Traveling the texture of this filmic palimpsest composed of light, the many stories of the "naked city," as held in each participant's personal archive of filmic memory, were projected onto the naked screen. The screen-space holds these stories, for they are always written and erased in this way: on the white, filmic canvas of light. Visiting this city-turned-cinema gave the passenger-spectator the opportunity to remake the assemblage of the cinematic archive on her own screen.

VIEW-SENSING

Greenaway's meditations on architecture, cinema, and painting rely on view-sensing. In the film *The Draughtsman's Contract* (1982), a draughtsman, commissioned to make drawings of a mansion in an English garden in exchange for sex, sets himself up in different locations, using a viewfinder to frame the landscape.[77] Although the practices of topographical survey and garden view are central to the history of the English country house, the film takes liberties in this representational field. Simon Watney has argued that although the film is set in 1694, it is deliberately inaccurate with respect to English society and the practice of landscape gardening of the period, and that its allegories extend to contemporary times.[78]

The viewfinder in the film is a hybrid instrument, loosely based on the device used by Canaletto and Dürer and endowed with observational powers of astronomical and astrological proportions.[79] This expanded mode of picturing is to be equated with the viewfinder of the movie camera, for it is even equipped with its grid. The history of these two viewing practices is presented in a conterminous representation of their mode of picturing landscape. Both the execution of the plot and the fact that Greenaway did the drawings himself reinforce the parallel between draftsmanship and filmmaking. As the draughtsman draws, the history of landscape painting and design unfolds filmically. Here, the landscape, composed through the

9.14. Film as art installation: view-sensing in *The Belly of an Architect*. Frame enlargement.

viewfinder, is constructed in a montage of different views. The static composition, with little camera movement allowed, sustains the adherence of film to the painterly frame that viewed the landscape. By means of this joint representation, *The Draughtsman's Contract* touches on the space of film genealogy, offering a textual manifestation of the archaeology of cinema mapped earlier in this book.[80] The conterminous relation Greenaway establishes cinematically demonstrates, in a viewfinder, that the origin of cinema is representationally linked to the space of the *veduta* and the act of viewing the landscape, and to all the instrumental accoutrements used to construct this site-seeing.

Greenaway, who admits to enjoying the experience of landscape above all, once had the ambition of becoming a landscape painter. He was influenced by the history of landscape design and art and showed interest in "land art" in his early experimental films, including *H is for House* (1971), which features his wife, Carol, and daughter, Hannah.[81] In *The Draughtsman's Contract*, he pays homage to the Dutch topographic tradition as well as the English passion for landscapes, viewed through the mobilizing device of the Claude glass. He uses "the ratio of the film frame . . . 1 to 1.66" to encompass these views because it is "the preferred ratio of those books of drawings by Claude Lorrain of artificially realized landscapes."[82] Greenaway reworks the English garden just as Alain Resnais had reworked the French formal garden in *Last Year at Marienbad*.[83] As a mode of landscape design, the composition and assemblage resonate with the representation of the picturesque in visual art. In *The Draughtsman's Contract*, this framed view adjoins the filmic view, produced by a representational apparatus stationed in the landscape and assembled in traversal by way of an imaginative spectatorial peripatetics. A sense of place joins these aesthetics.

9.15. A sense of place: site for view-sensing in Greenaway's city installation *The Stairs 1: The Location*, Geneva, 1994.

If cinema, insofar as it is a geography, is about a shifting sense of place, for Greenaway this is specifically related to Western outlooks on architectonics and landscape design. Describing his installation *The Stairs 1: The Location*, produced in Geneva in 1994, he returns to the *genius loci*:

I have always been fascinated by the particular excitements aroused by a sense of place, the distinction of a particular genius loci. *This is true if the place, space or location is a real one but it is certainly also true if the location has been invented in words, in a painting or in the cinema.*[84]

This sense of place is "an amalgam not just of geographical placing in architecture or landscape, but of a sense . . . of history."[85] Framing this history of site-seeing, the Geneva exhibition of *The Stairs* offered the passenger-spectator the opportunity to revisit a *genius loci*. This city-wide installation devoted to location investigated a

sense of place by means of an architectural element, constructed in the guise of a viewing device. One hundred wooden staircases, painted white, were built to offer elevated viewing platforms and were placed around the city in alleyways and avenues, on crossroads and bridges, in parks and museums, and surrounding the lake. Participants would take a short journey to the top of the staircase to find a view-finder that enabled them to observe different framings of the city, which were composed, filmically, as medium shots, wide shots, and close-ups. At night, the sites were cinematographically lit to achieve further architectural drama, enhancing each view's specific sense of place.

The framed views were built to "question the dogma of the frame, if only, in the first instance, to demonstrate its persistence."[86] To exhibit cinema's relation to painting —particularly to view painting—and to provoke a response to the tyranny of the frame, the aspect ratio of the "shot" was often changed, and the customary horizontal lines were at times substituted by a diagonal axis. The variety of impertinent frames led to reassessment, fragmentation, expansion, and even explosion of the frame itself. The cutting and cropping of views was designed to engage in dialogue with the design of the city and with the unscripted drama of each urban location. The views noticed, heightened, or elided aspects of the lived city and of the landscaped sites. The variety of viewpoints "did not neglect the denigrated viewpoint of the tourist, for the tourist seeks the definite view, the economic identifying viewpoint with the maximum amount of sensory gratification."[87]

This project grew out of a specific fascination for stairs, the subject of an unrealized film that eventually became the urban installation. Greenaway chose the staircase as "a suitable enough metaphor for ascent and descent, rise and fall, growth and aspiration, Heaven and Hell."[88] The composition of the installation thus referenced "stairness": reflexively elaborating on how stairs function in a city, it offered a narrative of site-seeing to the urban public. In its many configurations, the staircase is a powerful architectural threshold. It links the exterior to the interior of a building and connects different living zones. It can offer a place for loitering and lingering. In European cities, the staircase publicizes the private and privatizes a public architecture: it is often a public place that houses intimate individual and collective histories. In Rome—the paradigmatic city of steps—one finds at Aracoeli that "the staircase was once frequented by spinsters looking for husbands, and barren married women, climbing the stairs on their knees, hoping to conceive a child."[89] Stairs are public monuments on which histories are recorded and inscribed in flesh and stone.

The urban staircase is a place of exhibitory exchange, a socio-sexual observatory. Because of its relation to architecture and topography, the staircase is, in itself, an observational platform. Greenaway's urban installation enhanced the descriptive function inscribed in the architecture of the stairs and, deploying their narrative potential, generated the activity of re-viewing the city. Staircases that unwind onto courtyards were redoubled as observatories of the history of communal building life. The stairs channeled urban sentiment. As the panoramic view embraced the city, one could capture lovers embracing on the steps. Every place has

a story set on a staircase. Painting has made a habit of describing these stories, and cinema itself has known the power of the (Odessa) steps.

The Stairs explicitly acknowledged this cinematic passage. It was made "in the spirit of sequence that governs the construction of a film," with "its concern to make as many multiple connections between viewpoints as possible."[90] Through their frames, the viewing platforms of the staircases delivered imaginary films of multiple locations. "It was credible that here were one hundred separate hundred-day long films with no film in the camera."[91] The city, viewed at the junction of topography and painting, was transformed into a "picture palace." Architecturally produced viewing positions created filmic views in a perambulatory kind of cinema. The audience of this city cinema would move, migrating from site to site, as it does imaginatively in a movie house. To experience such a cinema, one walked the city. On the landscape of view-sensing and site-seeing, where a sense of place was filmically reframed, cinema became a painterly museum of places, to be inhabited and revisited in emotive steps.

FILM AS ART GALLERY, THE MUSEUM AS CINEMA

> *Creating an encyclopedia is like constructing a great city.*
> Denis Diderot

> *Cinematography is the best art gallery.*
> Ernst Bloch

In Greenaway's encyclopedic world, as we have shown, filmmaking is a curatorial activity and, reversibly, film viewing is conterminous with view-sensing, architectural living, and gallery-going. In a constant exchange, the city of cinema becomes an art gallery. Although a painterly sense and architectural taste are examined here as generative spaces, to exhaust the art historical references of the films is not the point of this study. Greenaway exposes them in extended interviews, published with long-awaited scholarly commentary on his topics.[92] David Pascoe, in particular, effectively shows how Vermeer drives Greenaway's narrative space and points to other phenomena, different from the pool of visual sources mapped here, including optical mechanisms, voyeurism, artificiality, and structural grids.[93]

However one approaches Greenaway's art gallery, it is evident that the attachment to art goes beyond citation. Greenaway does not just quote art or even work with film *as* art. His engagement with art and film resonates with that of a few artist-filmmakers of his generation, most notably Derek Jarman.[94] But moving beyond Jarman's film art, Greenaway's museum posits a genealogical relationship between art and film, working across their architectonics. Here is a telling example, supporting the generative geography traced earlier across the field of architecture, art, and landscape design:

Joseph Wright, in keeping with . . . his reputation as an 'industrial tenebrist' . . . painted a version of The Origin of Painting: *a young woman of Corinth, anxious about the departure of her lover, traces the silhouette of his shadow on a wall as a remembrance of his true likeness. A shadow on the wall. A true likeness. The fixing of shadows. A remembrance. Perhaps there could not be a more suitable iconography to begin the history of cinema as well as the history of painting.*[95]

Because of its narrative component and its theatrics of excess, Greenaway's insistent visual play has been interpreted by Bridget Elliot and Anthony Purdy as a neo-baroque remake of the allegory.[96] This reading can elucidate Greenaway's penchant for the decayed, ripped-apart body—for, in Benjamin's reading of allegory, the body is turned into a corpse of the cultural past so that it can enter the homeland of representation.[97] It also suggests the kind of "slaughterhouse" that Greenaway's "museum" can represent, especially when associated with Georges Bataille's critical dictionary. The authors frame their allegorical reading, however, on the assumption that Greenaway's filmography consists of two distinct kinds of text: "museum" films and theatrical films. Greenaway's research in film and engagement with multiple terrains challenges this assumption, for it is the theatrics of urban life and curatorial display that he makes into cinema, as cinema's own theatrics becomes the object of his museographic exhibition.

This exchange touches on the panoramic culture of the museum, which constitutes the archaeology of cinema. As Greenaway has noted in reference to his museum exhibitions: "In intimate fashion . . . they, the audience, were included in the lighting panorama which was frequently sensitized by their presence."[98] This lighting panorama is the actual museographic scenography that translates into cinema's own spectatorial theatrics, set in a house of pictures. What emerges from this landscape is not only film's relation to art-historical stances on representation but an actual cross-pollination of art and film. Establishing a relationship between art exhibition and film reception, Greenaway proposes to "use a contemplation of the phenomenon of the exhibition to improve the status of cinema. . . . Cinema as exhibition? Exhibition as cinema? Soon I suspect such a proposition will be commonplace."[99] In fact, as we will see in the next chapter, this proposition has become a crucial part of the fabric of contemporary practice in the visual arts. In many generative ways, Greenaway's opus exhibits this interplay between the activities of film-going and museum-going. In this exchange, the place of cinema in the spatiovisual arts is mapped out by way of a convergence of languages and exhibitionary trajectories. Whether inhabiting an installation or visiting film, either in the city square or in the movie house, Greenaway's cosmology has set a hyphen between the cinema, the city, and the museum.

This configuration is built on the notion of archiving. An art collection is displayed in Greenaway's filmic archive, just as a filmic collection molds the archival structure of the curatorial and exhibitionary work of his urban gallery. As Walter Benjamin put it, the collection—a production of one's intellectual *Carte de Tendre*—

9.16. Museographic exhibition as
cinema: Greenaway's treatment
of the art collection of Mariano
Fortuny in *Watching Water*,
Venice, 1993. Interior view of
the installation.

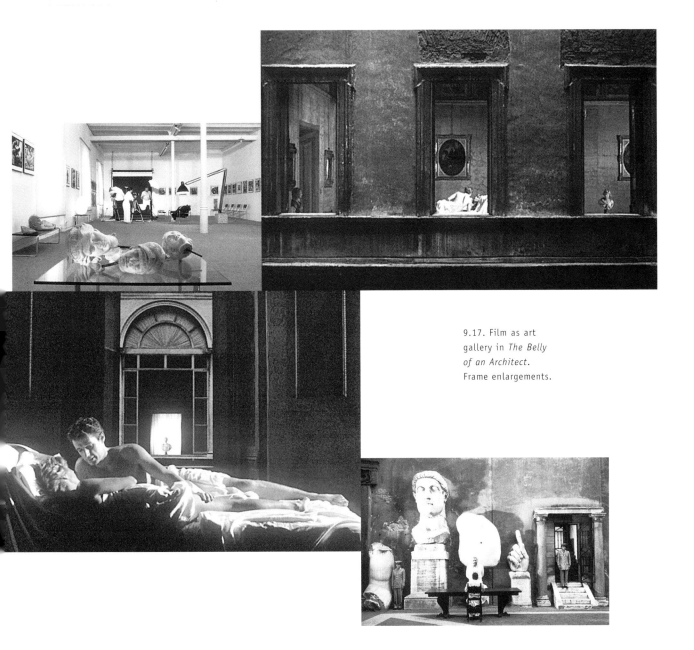

9.17. Film as art
gallery in *The Belly
of an Architect*.
Frame enlargements.

is an urban memory archive. Joining the physiognomy of objects with that of cities, Benjamin understood collection as an architectonics ruled by tactilism:

Collectors are the physiognomists of the world of objects . . . people with a tactile instinct; their experience teaches them that when they capture a strange city, the smallest antique shop can be a fortress. . . . How many cities have revealed themselves to me in the marches I undertook in the pursuit of books![100]

Greenaway's art gallery is a library that corresponds to this world of collecting. This was exemplified in his exhibition "The Physical Self," assembled from the collection of the Boymans-van Beuningen Museum, in Rotterdam, in 1991–92.[101] Objects, collected in the course of intellectual wanderings through the museum and its deposi-

tory, were treated as extensions of the physical self, in touch with traces of the body. Here, design and art met prosthetics: a seated body, in the flesh, adjoined the touch of a naked glove, a worn shoe, a writing tool, a knife on a table setting, a cut on the painting of Agatha's breasts, the roundness of a vase, a painterly embrace, the wheel of the bicycle, the dial of a phone, the platen of a typewriter, a sequence of Muybridge, and a reel of film—for all, in the end, are experienced on spectatorial chairs. The design objects design us, "from the car to the cinema, the aircraft to the bathroom, the restaurant to the classroom."[102]

In "The Physical Self," the museum was treated as a kitchen of combinatory ingredients that make up the material of cinema. This kitchen-laboratory was also the setting for *In the Dark*, Greenaway's contribution to the 1996 London group show "Spellbound: Art and Film." This work of "exploded cinema," as Thomas Elsaesser notes, was based on "antinomies around removal and unpacking, storage and retrieval."[103] Here, the elements of cinema were decomposed and offered to the spectator–gallery goer, who had the opportunity to make his or her own movie out of them, as if preparing a meal. Again, storage and unpacking stand for the metabolic design of the archive of emotion pictures.

In reconfiguring the museum/gallery as a cinematic kitchen and making use of numerical play and an ironic, subjective taxonomy that lies beyond the orthodoxy of museum culture, Greenaway's exhibitions/installations have created some playful encyclopedic archives, in which cataloguing meets collating and cinematic sequencing becomes the organizing principle for reading an exhibition. Here is one description of the way in which Greenaway perceives his accumulation of assemblage—his own *caméra-stylo*—to work:

The fountain-pen inside my pocket is a machine that can represent all machinery; it is made of metal and plastic which could be said to represent the whole metallurgy industry from drawing-pins to battleships, and the whole plastic industry from the intra-uterine device to inflatables. It has a clip for attaching it to my inside jacket pocket and thus acknowledges the clothing industry. It is designed to write, thus representing all literature, belles lettres *and journalism. It has the name Parker inscribed on its lid, revealing the presence of words, designer-significance, advertising, identity.*[104]

With this associative logic, Greenaway examines the polyvalent status of the art object in both museum and film culture. It is the logic that ruled the filmically lit exhibition "100 Objects to Represent the World" (1992), which gathered together objects from the world of art as well as from medical, criminal, and scientific collections.[105] The show was a variation on a shopping list, tactilely conscious of object and property and focused on the inanimate matter that activates the drama of cinema as it traditionally activated that of Western painting. In a cinematic way, Greenaway's project is a memory theater, itself a sort of *mise en cadre* that utilizes the history of art and the place of architecture in life, including all the life debris that generates from table, bed, coffin, column, staircase, window, wall, and map. A chart, according to Greenaway, "can tell you where you have been, where you are and where you are going—three tenses in one."[106] To this we may add a fourth tense, or,

rather, a mood: the subjunctive, which tells you where you might have been or could be or might wish to go. In this subjunctive fashion, body parts join items of clothing and objects of design as modes of inhabiting flesh, travel, writing, film, and music, and thus, in general, "make room" for lived space. Inverting the tradition of collections such as those displayed in Marès's Sentimental Museum, Greenaway makes a public collection a cinematic "unsentimental" museum.

THE FABRIC OF FILMIC INSTALLATION

In creating the fabric of art exhibition, Greenaway met his match in Mariano Fortuny, Jr. (1871–1947), whose Venetian palace formed the setting for one of his installations, in 1993.[107] Fortuny, son of the Spanish painter, was a designer and manufacturer of clothes and textiles. He was also a passionate collector, an enthusiast of technological novelties—including electrical and photographic items—and a bibliophile who had a habit of making books of everything: photographs, drawings, texts, postcards, and ephemera. He lived in Venice most of his life, in a restored Gothic palace for which he designed the furniture and lighting. There he kept his textile collection along with all his other acquisitions.

Greenaway's palazzo installation, entitled *Watching Water*, was an homage to the Venetian lagoon; it treated his beloved topos of water allusively and metonymically, creating it mostly with light.[108] Sited within the topography of the lagoon, the palace represented a central anatomy and, as such, was clothed—dressed for exhibit. As Greenaway put it, "Palazzo Fortuny can be appreciated as a building of female architecture, and it is our intention to clothe it . . . front and back, vulva, anus, navel, and the heraldic architectural clitoris above the front door."[109] In the Venetian tradition of Carpaccio, the exterior was hung with drapes.

Both the entrance to the anatomy of the clothed palazzo and the journey that the installation invited the spectator to take were filmic, for according to Greenaway, "the start of a film is like a gateway, a formal entrance-point. . . . The start of this exhibition begins with a gateway."[110] Once inside the building, one would traverse the rooms of Fortuny's House of Memory—as if he had just left it—and encounter some of Greenaway's own related work, including eight books from Prospero's library. Greenaway chose not to rearrange Fortuny's collections, but to reilluminate the display of artifacts, inventions, books, paintings, clothing, and textiles, animating the objects of the collection with changing light and shadows. This was in keeping with Fortuny's interest in the magic of electricity and his excitement about its transformative power—particularly the translation of light into movement. This, of course, is the actual magic of cinema's historical invention and the current condition of its projection. The journey of the installation, constructed as a filmic trajectory of site-seeing—with shifting light perspectives and varying navigations through frames of exhibition—traversed the material history of the medium of cinema.

9.18. The fabric of art fabrication: the clothed Palazzo Fortuny in Greenaway's *Watching Water*, Venice, 1993. Exterior view of the installation.

9.19. The fluid architecture of imaging in Greenaway's *Watching Water*, Venice, 1993. Interior view of the installation.

The textured journey through Fortuny's House of Memory involved layers of fabric, and it touched on the work of mourning. When his beloved mother died, Fortuny kept her corpse in his studio, wrapping her in fabric he had designed himself. Noting this gesture, Greenaway worked with Fortuny's fabric, showing care for all textures of his design, including the "text" of the funerary textile. Meditating on design and arguing that all art—especially portraiture—is about costume design and the history of fashion, Greenaway has stated that "our fascination with the style with which a body covers its nakedness or indicates its employment or its wealth or its ambition runs very deep."[111] Cinema absorbs the artistic heritage of fashion design: "The cinema employs such a large army of costume designers, fitters, wardrobe mistresses, cosmeticians, wig-makers, that some may feel the cinema should be considered an adjunct of the fashion industry. Some indeed are convinced that the cinema is the fashion industry."[112] I, for one, do hold this conviction: in many ways, cinema is textural design.

FASHIONING SPACE

The fashioning of space is a predicament of architecture, art, design, and cinema. Fashion itself resides somewhere between a corpus and the architectural ensemble of film. In his fashioning of space, Greenaway plays with the visual codes of apparel, for he is aware of the fact that design designs characters. Cutting-edge haute-couture rebels have contributed to the fabric of his films: Jean-Paul Gaultier, as mentioned, costumed *The Cook*, while Martin Margiela, his former assistant, designed the fashion world portrayed in *The Pillow Book*. Margiela created a filmic fabric that enables the central character to bedeck herself in the sensuous, amorous, and literary texture of Sei Shōnagon's tenth-century book of the same title and, eventually, to write her own.

On one level, the clothes in Greenaway's films serve to create socio-historical textures. Gaultier's clothes in *The Cook* oscillate between the seventeenth-century Dutch sartorial tradition and contemporary fashion, and they shape, in Nita Rollins's view, the film's critique of late capitalism.[113] But the social component, although essential to any reading of fashion, is not the only level on which fashion performs in the cinema. Just as the relation of architecture to film cannot be limited to the depiction of architecture in film, the interplay of fashion and cinema supersedes a sociology of costume design.[114]

Greenaway's work offers a "location" for this expanded sartorial inquiry. His fascination with fashion is articulated through the camera movement in his films, which, reversibly, fashions space by way of attire. Like Wim Wenders in *Notebooks on Cities and Clothes* (1989), Greenaway plays with the performative nuances of fashion in relation to architecture. Moving beyond mere sartorial cinema, both directors have contributed to the discourse of fashion and film as they interweave the two languages in their making of spatial texture. In this way, their work constructs a

relationship between design, film, and architecture: here, the fields of fashion and cinema connect at the level of *factio* and thus, as acts of making, inform the actual fabrication of space. Let us take a closer look at this architectural fashioning.

FILM, FASHION, ARCHITECTURE

Thinking of fashion in terms of space brings into question the nature of texture, surface, and appearance and, as we have seen, exerts pressure on contemporary architectural theory.[115] Coming to grips with the notion of surface in his book *White Walls, Designer Dresses*, Mark Wigley argues for modern architecture as an art of clothing. In an elaborate analysis that potentially converges with our view of the haptic, he shows how Gottfried Semper's view of decoration as clothing infiltrated the discourse of Alois Riegl, as well as that of modern architecture.[116] According to Wigley, Semper's understanding of the structural role of surface—the matter that creates modern architecture—brought about a transformation in the very status of surface, which ultimately informed the construction of the white wall. This white wall is neither flat nor naked but is dressed with a modern "coat" of paint that "suited" then-contemporary reforms in dress design and the new athletics it promoted. The white wall is thus stitched together with the psychosexual economy of fashion. Claiming that modern architecture is about this sartorial surface, Wigley

9.20. Fashioning the self and space in *The Cook, The Thief, His Wife, and Her Lover*. Frame enlargement.

articulates a sensuous play between fashion and built structures, stressing the Semperian claim that "to wear a building . . . is to feel its weave. . . . To occupy it is to wrap yourself in the sensuous surface."[117] Wigley teases out the seductive exposure of surface that the white wall bears as a suspended and mobile texture, which is as physiognomic as clothing. In the caress of light, the white wall is sensitive to a psychic play of diverse spatial possibilities.

Similarly obsessed with the white surface, I cannot help seeing in this modern white wall the white film screen, which itself came to be invented in the shadow of Semper's mid-nineteenth century idea of space: a habitation woven of texture, fabric, and surface. Wigley's modern wall—a skin of light; a mobile, sensuous surface that is "an active mechanism for reorganizing space"—corresponds to the translucent physiognomic coat the white film screen wears, making space and making room for us to inhabit.[118] It is this white surface, a site of residual exposure, that Sugimoto revealed in his *Theatres* and Greenaway exhibited in *The Stairs 2: Projection*, in which he represented the history of cinema in the guise of a sheer installation of screens, aware of textural surface. Here, in actual *mise en abyme*, the surface-screen space of modern architecture came to be projected onto the surface of the city as a film.

As modern site-seeing, cinema partakes of the residual fashioning of space that is written on the white wall. The architectural fashioning of psychogeographic space, that is, extends to the cinema, where it is radically shaped by the way film makes space on the surface. Dressing the wall with new forms of mobile spatiality, film, like fashion and the modernist wall, can be seen as nothing but a screen. Like the white wall, the white filmic screen absorbs many different geopsychic textures and holds all colors within its surface. It is a texture that continues to acquire depth as the geopsychic design passes through it. Film is both the mise-en-scène and the off-screen space of everyday life dressed up in an architectonics of diverse socio-sexual shapes that become, as in fashion, a haptic landscape of absorption. These inhabited screens all live in the power of the moving form, in the liminality of the ingestion and digestion of images of ourselves, traced on the map of the house wall, the movie house, and the dress we live in.

TACTILE SURFACES

On the moving screen of modernity, fashion, city, and film were all theorized together by the Italian Futurists. As Giacomo Balla wrote in 1913, setting out "The Futurist Manifesto on Men's Clothing" and announcing an unrealized "Futurist Manifesto on Women's Clothing":

WE MUST INVENT FUTURIST CLOTHES. . . . They must be simple . . . to provide constant and novel enjoyment for our bodies. Use material with forceful MUSCULAR colours . . . and SKELETON tones. . . . The consequent merry dazzle

produced by our clothes in the noisy streets which we shall have transformed into our FUTURIST architecture will mean that everything will begin to sparkle.[119]

In Balla's conception, clothes exist in the realm of architecture, for they participate in the architectonics of city streets. Clothes and architecture are cut from the same cloth and share a specific mobility: they are actions that develop in space as lived emotion. Futurist apparel partakes of modernity precisely because of this dynamic ability to provoke imaginative emotionality. In Futurist terms, fashion is also a way of building a new tactilism. Reinforcing the tone of the manifesto on clothes in a text entitled "Tactilism" (1924), F. T. Marinetti wrote of a "tactile art" as a "spiritual communication among human beings through epidermics."[120] Linking X-ray vision to the realization that all senses are a modification of touch, he considered this matter "a harmony of electronic systems."[121] In his 1921 "tactile tables" (described as "voyages of hands"), he listed among the endeavors related to this haptic mode the design of rooms, furniture, clothes, roads, and theaters.[122] And to make clothes even more like rooms, Balla invented *modificanti*: elements of variable decor to be used, creatively, to change the shape of one's dress by pneumatic application, so that one might invent a new outfit at any time, according to mood.[123]

ADDRESS TO DRESS: HABITATION, *HABITUS*, *ABITO*

When the scope of surface tactilism is extended, clothes, architecture, interior design, cosmetics, and the moving image appear as conterminous spaces of inhabitation. As the mutable skin of a social body, they are all part of a shared interactive experience. In defining our way of living space, they tailor our own contours. They shape our passage as moving surfaces in space and mark the traces we make along the way, for "to live is to leave traces."[124]

To further articulate this *habitus* of living, let us return to Henri Lefebvre, who, commenting on Panofsky's work on architecture, suggested that one might consider the connection of *habitus* "as a 'mode of being,' implying a 'power of use and enjoyment' . . . with *habere* and *habitare*."[125] Although Lefebvre does not develop this point, the opportunity is there. Considering the inscription of *habitus* in inhabitation, one might extend his paradigm by adding another element to this equation: fashion. A peculiarity of Italian usage makes this both possible and apparent. If *habitus* and *habitare* are semantically bound, *abito*, which means dress, is an element of their connection, for it comes from the same Latin root. A semiotic bond links sheltering to clothing the body, just as the German *wand*, which connotes both wall and screen, is connected to *gewand*, meaning garment or clothing.[126] In Italian, this goes a step further. Not only is *abito* a dress but, in verbal form, it is the first person of *abitare*, which means "to live" and is used to define one's address.

It is seductive to think of the reversibility of the terms *address* and *dress*—like two sides of a reversible fabric—in an interplay of *habitus* and *habere* that incorporates the cinema. For, indeed, *habere*, as a mode of use and enjoyable

appropriation, defines both fashion and architecture as well as film—for they are all about consumption. Once purchased, each continues to be consumed as we "put" ourselves into them: we step into a dress, just as we enter a house or a movie house. In fashion as in architecture, one "suits" oneself to space. A dress, like a house or a film, is both lived and loved. Clothes exhibit the consumption of living: like the furniture we use, they "wear" the marks of life. As in*habit*ations, they bear our imprints, enabling us to become known permeably and to acquire knowledge through passageways. As socio-sexual surface and skin, dress and address are filters and membranes of our carnal knowledge. House, attire, and the film body inscribe the experiential narrative on their tangible surfaces. They are haptic fashions of habit, habitat, habitation.

Extending these considerations even further, we may say that a dress is eaten up by continual "wear" just as architecture is: architectural walls crumble; clothes decompose or deteriorate. This wearing out signals, with the passage of time, our markings in space. In the extreme, fashion is a terminal sign, for when we cease to inhabit a dress it becomes an empty address, a coffin. An empty dress is a specter, bearing in its terminality the same sign—*terminus*, the edge of things—that marks the railway hub and the airport, which, as "terminal" places, signal boundaries. Upon our passing, our attire is what is left of our bodies. As leftovers, they even smell of our smells. In the architecture of memory and loss, clothes, as our habitat, hold the traces of our passage through the space of life, imprinted as on a white film screen. Ultimately, architecture and apparel join the cinema as mobile archives of imaging.

IN THE HOUSE OF DESIGN

The link between *abito*, *habitus*, and *habitare* is predicated on a traveling historicity. Design, architecture, and cinema all combine social history with personal story as they dig foundations into the emotive terrain. Traveling in this emotional texture, fashion, architecture, and film are all subject to trend, for one moves with the mood of one's history. Liminally conveying our affective apparel, clothes come alive in (e)motion. They are physically moved as we are, activated by our persona: hanging still, they make only funerary sense; livened by kinesthetics, they travel with us as envelopes of our history. As emotional fabrications, they are part of our emotive fabric and screen.

In a way, through a touch of the haptic, a dress may even be understood as a "translation." As Hélène Cixous described it, recounting a visit to her designer: "I go to Sonya Rykiel as one goes to a woman, as one goes home . . . which is to say . . . with my hands, with my eyes in my hands, with my eyes groping like hands. . . . I enter the dress as I enter the water which envelops me, and without effacing me, hides me transparently. And here I am, dressed at the closest point to myself. Almost in myself. . . . The dress does not separate the inside from the outside, it translates."[127]

Let us recall that Maya Deren herself wrote of dress in this way, not as a byproduct of the gaze, not as fetish, but as manifestation and metaphor—that is, as a means of transport. In this filmic sense, Maya Deren gave good fashion tips. A number of years and many trends later, her fashion manifesto gives us a valuable lesson on fashion: "The closer the outward appearance to the inner state of mind, the better dressed."[128] Fashion is an interior map in reverse, a trace of the emotional *habitus* left on the *abito* in a two-fold projection. A chart in the negative, it is an affect that is projected outward as if onto a screen and, in such a way, written on the skin of the world. In the transport of dress and address, a passage to closeness takes place. This mapping of intimacy is liminally designed on the surface of the address/dress—on the wall, the skin, and the screen. Nagiko, in the *Pillow Book*, was aware of this mapping. She actually wore it. Hers was a map of self-fashioning, drawn between "the flesh and the writing table."

9.21. Benoît-Louis Prévost, *Art of Writing: Position of the Body for Writing, and the Holding of the Pen*, illustration from Charles Paillason's *L'Art d'écrire*, 1763.

Art d'Écrire.

It is 1995. She has given up on the book depository but holds on tight to her Pillow Book.

She has changed her designer, too. She finds Margiela's clothes more suitable than Gaultier's to her effort to suit herself in the mind-set of The Pillow Book. *Sei Shōnagon, who wrote it, combined the delights of literature with those of the flesh and understood that black ink is lacquered hair. She knew about textures, as Margiela's fabrications do. Sei Shōnagon thought "the smell of paper was like the scent of the skin of a new lover who just paid a surprise visit out of a rainy garden"; but she actually preferred a lover on his second visit.*[129] *A sad thought about Michael occurs. He does not visit her anymore.*

Perhaps what happened in The Cook *had been Gaultier's fault. With all those excessive assemblages, what, if not tragedy, could she have expected? She does not fancy them anymore, despite the witty references of the "appetitive" ensembles. Naturally, she had been seduced by those epaulets with knives and by the rows of forks plunged into the bustiers of the waitresses' costumes. A great metonymy and, en plus, a potential tool for revenge. But Michael is dead. Dead, passed, and past. The fork did not help that. Not even plunging it into his corpse.*

So she is in Hong Kong now, working the runway, having left Kyoto to don those exquisite Margiela outfits for her own pleasure and that of the crowd. She is a fashion model and has her own mode of doing things. Margiela fits her well. His colors and textures, the white label he uses as a signature, the minimal, elegant design even suit the tones, shapes, and mood of the restaurant she now frequents. She can hardly remember that Frans Hals painting in Le Hollandais, although she still favors the light of the kitchen area in that

9.22. Between the flesh and the writing table: *The Pillow Book* (Peter Greenaway, 1995). Frame enlargement.

special restaurant. After all, it was not called Le Hollandais for nothing. It had a touch of the Dutch, and that painterly stroke had given her pleasure in the kitchen-bedroom. But she has had to leave all that behind, although she finds herself always in same place. She still practices intimacy in the public space. She still turns a restaurant into a boudoir. She still merges fashion and cuisine. Well, of course, they are both matters of taste.

In the restaurant-bedroom there is talk about her. Not everyone agrees with her way of mixing digestion with an archive of love. Some do not like how she fashions things and even object to her penchant for Margiela, whose unmarked, white strip of a label only speaks to those in the know. They think it snobbish for a griffe *not to sign his clothes. Perhaps they were never seduced by a sign under erasure. But a white strip of cloth is all you need. Margiela's label inspires you to write on it, to write your own story. That is becoming important to her now. Textures always were, but texts had only been the province of her lovers. First Michael, the keeper of the book depository, and now a translator. Her father was an author. He used to write on her face with ink. Every year, a face-poem marked her birthday. But he is dead now. Terminally dead.*

She is seeking to replace him with the best calligrapher-lover in town. Someone who can write on her body as well as her father did. So, turning the amorous script of the Letter from an Unknown Woman *into an open call, she remakes* La Ronde.[130] *In the roundabout of amorous calligraphy, Jerome, the translator, comes along. He is sharp, handsome, and knows many languages. But he has no touch for drawing them. This is a problem. She needs him to do precisely that. Calligraphy, a parent of cartography, is fundamentally a matter of drafting. She who has traveled the map to become her own "model" of design knows this through her love of maps; she can appreciate their material language.*

The tactics of these writings are dear to those who are attracted to them. Someone named "Jerome" should know this matter of study. How could he, of all people, have forgotten the etched inscription of mapping? As she scans her mental library, a screen of writing materializes—as if projected in a film—with white letters of light that adorn the stark walls of her house and the skin of her flesh, like maps. She thinks of Gerardus Mercator, who showed how to hold a pen in his calligraphic manual, On the Lettering of Maps *(1549): a hand with a drafting tool glides across the texture of the map, marking place names or designing cartouches. The calligrapher, like the cartographer, relies on this tactile etching, this palpable incision, which returns the delights of its physicality to those who come into contact with it. Ultimately, this haptic surface-writing, pursued in calligraphy, is a cartography.*

She knows this, intimately, from the bookish air she breathed as a child and, especially, from the pictograms that were etched annually onto her forehead, cheeks, and lips. Now, as an adult, she follows the hand that draws the letters on her body as she would read a map. The haptic path of this map is etched in the navigational route her eyes take, allowing her to internalize its course in her own geography. In this way, the map lets her project her unconscious design onto its own. But that is only possible if one gets really close to the map and if one fancies the calligraphy—that is, appreciates the pictographic design and handles the fabric of the representation with its subtleties of tones, patterns, and shapes: its texture. In the end, she senses, the haptics of maps is a textural fashioning, an impression of the cartographic fiber. It is a play of surfaces that engages the various layers of the design fabric, for the physi-

cal touch, like her father's writings on the flesh, permits the architexture of an exchange. The geopsychic design between herself and the map is this kind of imaginary game, played on the surface-screen of a design.

If for this fashion model the matter of surface is key, her Western lover does not really appear to understand it. And no wonder. Unlike her father, he was neither born with nor trained in pictographic language. He knows nothing of this writing that is itself painting, and even a sort of prefilmic montage.[131] But he is a translator. He knows about transfers. What he does, in essence, is ferry things across. A translator practices transport, that "ferrying across" that Diotima of Mantineia claimed love is really about.[132] A lover-translator is a real treat. And he will learn, for he knows already.

Someone named Jerome could always turn for help to the calligraphic manuals he has collected in his library. They would remind him that Western alphabets were also decorative arts, drawn and physically labored over—like painting and architecture—on a textured surface. Writing, like drafting, was the kind of hand-work whose "touch" was taught. Someone like Benoît-Louis Prévost, who etched this haptics, provided instruction for it in the Art of Writing (1763), illustrating the "position of the body for writing, and the holding of the pen."[133] The manuals would remind Jerome that the art of calligraphy at one time met up with alchemy and the ars combinatoria, as applied to the art of mapping. If he had read Henry Noel Humphreys's The Origin and Progress of the Art of Writing, it would be clear to him that "the historian, the mathematician, the astronomer, can do nothing without letters."[134] He might notice that it was written in 1853, when the screen surface of cinema was about to be invented. Jerome would then feel less nostalgic about the caress of writing. No need to be literal about the quill pen and the parchment: from the surface of the skin, he could move right to the screen. The white film screen shares the fabric of the wall of light that is Jerome's current writing desk, "digitally" joined to the drafting table. A digit, after all, is also a finger.

From these lessons, Jerome learns quickly how to write on her flesh. She notes in her diary: "His writing in so many languages made me a signpost to point East, West, North and South. I had shoes in German, stockings in French, gloves in Hebrew, and a hat with a veil in Italian. He only kept me naked where I was most accustomed to wear clothes."[135] She enjoys being turned into a map and is well suited to the design he has drawn for her to wear, which merges objects of clothing and borders of countries on her skin. But why should she rely on someone else to do the picturing for her? She ought to try it herself, for she might enjoy the tender labor of mapping. She starts by writing on herself, but does better at applying the scriptural tools to the skin of her translator-lover. Jerome offers his body up to use like the pages of a book—her book. He is the first chapter.

But the happiness is short lived. Jerome fakes suicide to become her Romeo, but ends up dying. Finding herself once more composing a corpse, mourning the loss of a lover—his feet turned the same way as Michael's—she again seeks terrible revenge. But this time, something changes for her. Adopting the fetal position as she bathes in the tub that had held their lovemaking, she manages to interiorize his love and conceive his child. She reaches for The Pillow Book and internalizes from Sei Shōnagon the sense that she should make her own anatomical "list of things that make the heart beat faster: love in the afternoon in imitation of history, love before and love after, writing of love and finding it."[136]

Sei Shōnagon teaches her that "writing is an ordinary enough occupation—yet how precious it is. If it did not exist what terrible depressions we should suffer."[137] *And so she continues to write her opus. She composes the remaining twelve volumes, including a book of silence, on the skin of men, choosing their epidermic texture with care. As a model, she can discern fabric. Jerome had provided a good one. It was so good that his other lover, the male publisher who had also been her father's lover, abducts his corpse and makes a loving book out of him, flaying his skin. The folds of Jerome's skin are turned literally into pages to be unfolded. She offers the publisher her own work of skin-books in order to retrieve this tome of flesh for herself, to keep in the* makura, *near the folds of her bedding, as befits such a novel pillow book. Jerome, who had been food for thought, might thus continue to nourish her as she nurses his child. In the end, she stores him under a plant, and even it grows.*

Looking back, she reflects on the fact that Jerome, dressed in her writing, had represented an abito *for her scriptural pursuits—a location fabricated as cloth. She had designed a scriptural* habitus *as if it were a dress to wear, had "modeled" a way of writing on him. This had been evident when Jerome first went to the publisher to show him the chapter of her book mapped on his skin: he had been accompanied by the same music that played for her on the modeling runway. Each subsequent writing subject had similarly become a model for her designs. In fashioning a writing of the flesh, designing a language of her own as an amorous habitation, she had not strayed too far from matters of fashion. The textures of fabrics returned obsessively on her screen.*

As she joined calligraphy and cartography in her own way, she also drew an etymological chart. Jerome had made her sensitive to the mapping of languages, and she had worn his chart like a dress. So she looks up the use of the word: the English chart, *like the French* carte *or Italian* carta, *comes from the late Latin* carta, *a derivative of the Greek* chartès.[138] *The term refers to a flexible, supple, adaptable support on which one can write. The map, she reflects, carried with it the support that produced it, and this shaped the language of cartography. It became the world of paper, but, once, it had been about engraving on leather and wood; it involved animal skin, parchment, vellum, and fabric. Her epidermic writing and her lover's skin flayed into a book may turn some spectatorial stomachs. But this abject, erotic subject matter represents nothing more than the generative scene of mapping. Her model of inscription is etched in the very history of cartography: it is the material support of the map. As a model, she senses that this is the same support that fashion makes use of, for identical materials, including the epidermic tissues that once composed maps, are employed in the fabrication of clothes. The fabric is not only produced but exhibited, inhabited, and worn in incredible proximity to skin.* Abito *is a map.*

To select a dress to wear she had used the same touch she would later apply to choosing a sample of skin to write on, for she knew what would render. The skin had to be just right: not too sweaty, to avoid blotching, but permeable enough to absorb the ink, like the texture of her beloved maps. The kind of cartography she fancied belonged to a permeable, fragile, perishable practice of mapping. She preferred nautical cartography, which had navigated from the oceans to the sea of love of tender mapping. Drawn and painted on vellum, the portolans had been portable maps. Flexible as skin, they could be folded, like the folds of fabric used to make clothes.[139] *These maps, like attire, were transient: they were made to travel, not to last. They could handle wear-and-tear and some water. She considered this factor when*

choosing her skin models for writing. The skin sweats. Sea maps also got wet. Like skin, they eventually deteriorated from environmental exposure. Like our skin and the clothes we wear, the maps ultimately decayed, wore out, and perished.

Maps, she concluded, wear the same abito *of our habitation. Drawn on fabric, they wear the life of the fiber and the imprint of what Vesalius called the* humani corporis fabrica.[140] *Once again, excavating the depths of a word provides a key for reading the fashion of her skin-mapping. The English word* map, *like the Italian* mappa, *comes from the Latin* mappa, *which defines a piece of fabric. In her drafting, she had addressed this issue, "dressing" the texture of skin. In writing what was a mapping, she had actually been "modeling." This became even clearer when she realized that the inscription would wash off with rain and water. In fact, it was made to be washable. The mapping would wear like a dress, could even be washed out like the cloth of clothes. No wonder.* Mappa *contains another fabric in its etymological texture: it is also a napkin, itself a washable table design. So, there she was again, back in the fabric of table manners, in a fabrication that fashioned—modeled—the writing of her own map.*

10.1. Pictures become an
architecture in Gerhard Richter's
Atlas (1962–present). Sheet
no. 234: *Rooms*, 1971.
11 sections of drawing and
watercolor on paper, mounted
in a sketch of a room.

10 Film and Museum Architexture: Excursus with Gerhard Richter's *Atlas*

Pictures will become an environment, an architecture.
Gerhard Richter

Moving pictures can still do what they were invented to do a hundred years ago. Move.
Phil Winter, in Wim Wenders's *Lisbon Story*

In the folds of space fashioned by Peter Greenaway between the flesh and the drafting table we have seen an architexture emerge from the interchange between the visual arts and film, and we have observed an archive of emotion pictures built between the cinema and the museum. To sense the texture of this geopsychic cultural design, we move on to inhabit this habitat, closing in on that field screen of projections that occurs between the map, the wall, and the screen. In doing so, our aim is to foreground the architecture of (re)collection that binds the itinerary of the cinema to that of the museum. Building our own archive of moving pictures, we approach the cinema as a kind of unstable museum as, conversely, we take the museum's narrative, cinematic promenade. These archival connections and shared functions are further explored in current museographic practices that link art and film in renewed convergence and hybrid forms.

To approach the particular fashioning of space that constitutes a shifting architexture of recollection, we will travel with Gerhard Richter's *Atlas* in hand. This excursus has no pretense of providing a competent art-historical reading of this opus. It simply proposes to take a cinematic walk through one incarnation of *Atlas*. We focus more on the intimate geography of the later pictures in this ongoing work than on the earlier historical and reportage elements. By traversing an installation of Richter's later *Atlas* with a strictly filmic point of view, we may come to grasp the space of *emotion* that binds us to the moving image and feel its mnemonic flux. Let us open this atlas, which, in its own way, is a *Carte de Tendre*, a tender map. Its geography of "inhabitants and vessels," built on the threshold of photography, may unfold a map of *kinema* for us.

A WALL *ATLAS*, AN ALBUM OF PICTURES

Gerhard Richter's *Atlas* is an ongoing work consisting of photographs, collages, and sketches.[1] The project began in 1962, when the artist started assembling a variety of

10.2. A wall of pictures to travel through: view of Richter's *Atlas* at the Dia Center for the Arts, New York, 1995–96.

images (including snapshots, newspaper clippings, and press photos) that he had been collecting over time, sometimes as sources for his painterly work, and mounting them onto panels. He then began to make this intimate process public through exhibition. In its 1998 incarnation, the work comprised some five thousand images assembled on more than 630 panels.[2] Richter once suggested that he had a "dream" in mind for his artistic enterprise: "that the pictures will become an environment or become an architecture."[3] *Atlas* realizes this dream, even beyond the limits of still photography and the painterly frame, for in this atlas, pictures dissolve into an architecture as they are sited in exhibition and experienced through time and space.[4]

In *Atlas* a "wall of pictures" is presented to us literally. Landscapes, vistas of paint, city plans, touristic snapshots, urban views, images of train travel, peopled places, bodyscapes, objects, and interiors populate the walls of the room, creating an overwhelming architectural effect. Inside this architecture of images, viewing becomes a topographical affair, for the installation asks the spectator to sense a place, to be both in site and inside. As we are called upon to inhabit these walls of pictures, *Atlas* produces a cumulative effect. Drawn ever more deeply into the architecture of the space created by the picture-walls, we access the layers of a map.

Traveling through the strata of Richter's *Atlas* is an experience that produces a *moving* effect. In this architecture of sequenced pictures, a haptic narrative evolves as the spectator traverses the images, makes them her own, and creates a personal atlas along the way. In this respect, *Atlas* displays the building of narrative

space itself. To enter the exhibition is to enter a geography—the makings of a filmic-architectural dream whose mapping is made available to us through the very design of the installation. Here, as the photographic image becomes an architecture and pictures turn into an environment, the ensemble creates further space. The assembled images make room for us to inhabit just as architecture does, creating a space for living—an intersubjective site of transfer for stories of the flesh.

AN ARCHIVE OF INTIMATE SPACE

The installation makes pictures into architecture because, like architecture, it inhabits the everyday: *Atlas*, made by an artist who speaks of "the daily practice" of art making, is a map of quotidian space.[5] The majority of the later pictures exhibited in the show even look like everyone's pictures and, in this sense, portray everyone's story. These images, offered for our assimilation, share with the work's historical photo-portraits (which form a part of its earlier portions) a process of incorporation that engages common habits, including our way of internalizing such life events as death.

In one way, as art historian Benjamin Buchloh shows in a segment of his extensive reflections on Richter's production, *Atlas* refers to and involves the work of mourning.[6] Buchloh's demonstration of how the fictitious pantheon of historical figures of the early *Atlas* (a study for Richter's *48 Portraits of Famous Men*) includes a work of mourning may be extended to, and tested against, the collection of the later *Atlas*, which conveys a different sense of mourning by virtue of its very different shape.[7] This shape corresponds to a different notion of the archive as well. The configuration of the later *Atlas* eschews the categorical inventory of the normative photo archive, whose disciplining method has been exposed by Allan Sekula.[8] This archival form had been present in the historical portions of the *Atlas* but, as Buchloh convincingly argues, the sort of mourning for the past such an archive implies was overturned here by an unconscious reworking that dismantles the monumentality and credibility of the historical pantheon itself.

The work of mourning exhibited in the later *Atlas*, made into a spectatorial journey, departs even further from this type of archival mourning, for it engages a different "fabric" of grieving and comes closer to expressing the representation of memory that was incipient even in the historical *Atlas*. According to Gertrud Koch, Richter's way of collating, which resulted in the fictitious "museum" of *Atlas*, achieves an actual decomposition of history, for it blurs reference to a specific time and space.[9] Such a process of blurring (very dear to this artist, in general) parallels the haziness of our memory. The play of distance and proximity in the later *Atlas* engages with this particular process of haziness as the archive makes manifest the emotional process deployed in daily geography.

Along mnemonic lines, Richter's daily pictures also suggest the kind of mourning and melancholia that was mobilized in some historical instances of the

"sentimental journey": the kind mapped in, and around, the *Carte de Tendre*. In particular, *Atlas* provides a modified version of the melancholic chronicle enacted in environments such as Marès's Sentimental Museum, for it is a site of collection of moving images propelled into spectatorial existence by the motion of emotion. Here, as in the Museu Marès, the visitor is confronted with a spectacle of images whose force lies not their aesthetic value but in their emotional power. Taken singularly, most of the pictures, unclassified and unclassifiable, are apparently banal, routine, and disposable. These pictures are snapshots—intimate souvenirs.

As in some forms of sentimental collection, the pictures are transformed into narratives by way of emotive mobilization. The chart of this narrative movement—an atlas of one's private geography—reinvents a specific type of sentimental voyage: the voyage through one's "own room." This form of travel, as we may recall, was launched in Xavier de Maistre's late eighteenth-century *Voyage around My Room*, in which the author travels the perimeter of his house as a way of negotiating his interior.[10] Here, the architectonics of the house, which incorporates a range of design and fashion elements, becomes a narrative that is transformed into fictional autobiography. De Maistre moves from the folds of his traveling coat, to which he devotes a whole chapter, to his writing table; from the armchair to the bed; from the prints and paintings displayed on his walls to the mirrors adorning them. He then proceeds to the books of his library, of which he notes: "*Cook*'s voyages, and the observations of his traveling companions, doctors *Banks* and *Solander*, are nothing compared to my adventures in this single region."[11] The voyage encompasses a great deal more than the perimeter of his room, for the narrative of the room moves, both literally and metaphorically, in all directions and "follow[s] every line possible in geometry."[12]

Like de Maistre, Richter becomes a traveler of the interior in the later *Atlas*. But he travels it in a different way, exploding the geometry of that earlier room, which had contained, in all senses, the borders of a nonetheless "roomy" voyage. Richter reinvents the architecture of an inner geography by allowing it to seep out of the shape of a touristic snapshot, where place is made into space. The act of photographic appropriation and the practice of assimilative display transform place into personal space. The same is true for the portraits exhibited and incorporated: in *Atlas*, people are sites.

Richter's *Atlas* goes beyond the limits of the sentimental collection as well, and differs from most remakes of the sentimental museum that have reemerged in contemporary art.[13] Here the objects of the collection are spatial subjects—pictures turned into architecture. Furthermore, while it shares with other contemporary archival projects a propensity for narrative, deployed in the sequencing of pictures, this *Atlas* is distinguished from most of these endeavors through its lack of attachment to a fetishism of the object or the process of cataloguing. In this mnemonic archive we find neither a drive to monumentalize nor an obsession to control through taxonomic ordering. Richter's later *Atlas* even resists classification as an archival work in the strict sense of the term. Its random pictures have not been

selected, organized, or categorized according to a logic of enclosure; the material is not forced into fixed schemes of memorization; nor is it conducive to preservation or driven to exhaustion. This is not a collection striving to exhaust its own subject. By the same token, *Atlas* is not an encyclopedia. It does not wish to be all-encompassing. It gives no definite form to the knowledge it presents. These are fragments set in motion in an orderly fashion but with no systematic or systematizing logic. The work is boundless, and yet bound. New images are constantly incorporated; and they can change the form—the territory—of the ever-growing atlas.

CARTE DE TENDRE IN EMOTION

This type of (re)collection—an atlas of memory—is as borderless as a *Carte de Tendre*. Its emotional mapping moves in the fashion of Scudéry's own architectural archive: as in a *Carte de Tendre*, exploration reversibly incorporates exterior landscape as an interior. In *Atlas*, landscapes of light take us across skies and ocean, fog and snow, sunsets and clouds, icebergs and flowers, lakes and rivers, mountains and plains, grassy fields and trees, waterfalls and gardens, houses and cities, terraces and rooms.[14] These views are never static, for they appear to be "tracked" by the railway travel Richter at times records in his archive. They exist as if seen from a train traversing their landscapes, like views from a framed, moving window.

The logic of this topophilic picturing is "moving" also because it does not produce hierarchies or distinguish between categories; it rather interfaces the views. In many ways, a landscape, a building, a canvas here equal a candle, a vase, or a skull. A bottle on a table resonates with a skyscraper in a landscape. An apple on a window seat exudes colors in the way Richter's paintings do. Landscape, building, canvas, picture all equal themselves, for, ultimately, they are all equal to an architecture of love. In *Atlas*, all bodies of work are tenderly exposed in their intimate structure and interconnected. Richter's own artistic process is also exhibited this way. Its painterly, photographic, and architectural fabric is laid bare next to, and with, the naked bodies of his loved ones.

Cities feature large in the topophilic *Atlas*, becoming cityscapes when mapped in Richter's aerial perspectives. But, here, the city plan is taken inside a room: the urban, bird's-eye view appears to be drawn as part of an interior and is positioned in the place of a wall in the room. Substituting in this way for a window-wall, the map turns into an interior panorama. The same process of architectural drafting is applied to landscape and to the landscape of Richter's own work. Sunsets, clouds, oceans, and textured images of paint are paradigmatically inserted, drafted, and grafted in the place of the window-wall, sometimes sequenced in multiple imaging. Any of these pictures may take the place of the map-panorama, and thus in the architectural drawings of *Atlas*, the map-wall-window becomes a screen. A filmic screen. In Richter's architexture, the fabric of the screen shows. And so the house turns into the movie house.

10.3. An archive of emotion
pictures in Richter's *Atlas*.
Above, sheet no. 394: *Betty
Richter*, 1978. 3 color photo-
graphs, partly painted over and
pasted up, individually mounted.
Below, sheet no. 397: *Candles*,
1983. 3 color photographs,
1 collage, partly pasted up,
with small sketches, individu-
ally mounted.

10.4. A sea of tangible images
in Richter's *Atlas*. Sheet no. 184:
Seascapes, 1969. 9 collages,
each from 2 color photographs
individually mounted with
adhesive tape.

10.5. In the liminal architecture of Richter's *Atlas*, the wall is a screen. Sheet no. 222: *Rooms*, 1970. 5 color photographs, mounted in perspective in sketches of rooms.

10.6. Making room in Richter's *Atlas*. Sheet no. 227: *Rooms*, 1970. 4 color photographs, mounted in sketches of rooms.

AN *ATLAS* OF BIO-HISTORY

Gerhard Richter's *Atlas* tells the history of private life in an architectural way, making this history an art of mapping: the labor of mourning begets a shifting architectonics of lived space. Here, cadres are *cadres de vie*.[15] In this respect, Richter's project realizes the dream of mapping that remained only a dream for Walter Benjamin: that dream in which pictures, turning into an architecture, could resolve a work of microhistorical mourning. We recall how Benjamin longed for quite some time to make this map of bio-history, "setting out the sphere of life—*bios*—graphically on a map."[16] As it turns the chronicle of *bios* into a map, *Atlas* reads like a diary. Like a journal, architecture shows how one maps oneself. A diary, after all, is a private architecture and an intimate plan. A journal is a room of one's own. *Atlas*, like a filmic journal, enables this subjective space to become visible. Through such exposure, it makes it possible for us not only to inhabit this narrative space but to take part in it. Like a film, this *Atlas* manages to make a very personal architecture into an intersubjective matter that can be shared.

Richter's later *Atlas* even turns history into such a story, for it is a chronology of quotidian architecture—a microhistory of site—where sequencing is as important as architectural picturing and airy rooms. To walk around *Atlas* is to perambulate an architecture of the interior, deployed in an emotional itinerary that unfolds "filmically" as everyone's possession. Depicting places visited and sites inhabited, the snapshot photos, which possess an everyday, touristic quality, expose with the ritual precision of habit the architecture of nothingness. They are not only banal but even bad pictures, leftover moments of non-action, still life turned into *emotion*. This is a communal archive where places and faces are (re)collected in memory, conjoined for assimilation, and displayed for the viewer to author-ize: to appropriate for her own mnemonic journey of overcoming death and negotiating life.

Walking through Richter's *Atlas* affords the rare chance to walk through someone's mind. As we enter this mental landscape we experience an actual topography—an intimate geography as it "takes place" and becomes mapped. The exposure of the pictures ranges widely. Intellectual, emotional, and artistic processes are combined in atlas form and handed out to us. Pictures touched, framed, reworked in order to be repainted. Landscapes re-viewed. A table stained. Moments suspended. Rooms opened to the sky. Drawings of a room. Drafted spaces. Architectures that come into place. People pictured in order that they may continue to be loved. With such "exposure" comes a binding. We not only travel in intimate geography but travel as if we could be held in a person's mind. *Atlas* holds us in that particular place and carries us right into the space of emotion pictures. In this journey of emotions we revisit the corporeal architecture of things. Bodies in space. Still lifes. Faces. Breasts. Shoulders. Children. Their landscapes also turn into our landscapes. A moving house of pictures. Cityscapes, interiors, trains tracking. Amorous journeys of a moving *Carte de Tendre*. Images framed, then reframed, retouched, blurred, set in motion. Gertrude Stein's "geography of inhabitants and vessels" sails off into a liminal place of "transport."

In this landscape, architecturally drawn, Richter's touch is still palpable. Architexture reveals itself as the textural fabric of the artist's own labor. In *Atlas*, we can touch the work of picturing as much as the work of mourning, for the artist lets us feel the very making of their architextures. Sometimes the architecture of the image is haptically changed. A piece of tape applied to a snapshot offers a new perspective. Pencil marks lovingly contour a facial landscape. The images, reframed by the tape, reshaped by a stain, or redefined by a scratch, end up changing in front of us, take on a different geometry. They turn into a place of picturing—a lived space. This intervention into the frame, transforming cadre into *cadre de vie*, tells a series of stories. Among them, there may even be a film. Even our own movie.

INSTALLATION AND FILM EXHIBITION

Atlas—a picture album mounted on walls—is a geographic book that bespeaks the architectonics of the moving image in both its generative and exhibitionary processes. Retracing our steps to consider the form of Richter's reassemblage and look at its pattern up close makes this even more apparent. A picture book—a lived atlas—is exhibited for a spectator in the moving work of pictures that unfolds in a perambulating act of editing. The installation displays several series of images, organized in a sequence; the sequence of photographic sheets is grouped on a panel, and a series of panels is assembled together. Each picture is generally only slightly different than the next one in the series. The montage accentuates visual similarity as well as distinction. The nature of the images, as well as their positioning and architecture, suggests the seriality of the mechanically reproduced image.

At a photographic exhibition, one is generally impelled to establish relations among the pictures and to consider them as a developing (dis)continuum. Because one moves along a space when reading pictures, a photo installation may contain a cinematics: a spectacle of display enacting kinetic and spatial-corporeal affairs. In Richter's *Atlas*, this process is pushed to the limit, both authorially and spectatorially, as it drives the construction of the show. While it reveals the photographic bent of Richter's work as a painter, the exhibition fundamentally questions still photography and pushes the boundaries of the medium. By presenting an overwhelmingly cumulative "series," *Atlas* ultimately asks us to reflect on still photography's relationship to the moving image. Photography, investigated here, is transformed on the grounds of the cinematics exposed.

The serialization and *mise en sequence* of images drive the space of still photography into that of motion pictures. Here, the pictures cannot exist as individual images to be read singularly; they are unreadable as anything other than serial montage. The sequential form of picturing reveals a cinematic process, a film-in-progress laid bare on the wall. In this *Atlas*, as in film, a story resides in the architectural montage of pictures—a narrative space that is exposed in order to be retraversed. Furthermore, the juxtaposition of the countless, slightly different pictures makes them function as filmic shots or, at times, even as filmic frames. After

all, film, at its base level, is a series of still images, printed one after the next on a strip of celluloid. As in the panels of Richter's *Atlas*, in film each image is normally only slightly different from the one that precedes and follows it. It is this slight diffraction that makes possible the illusion of movement as the serial frames are projected at a given speed. In this way—that is, by way of difference—photography turns into cinema. Positioning us in the space of this diffraction, Richter's *Atlas* locates us within the very historical transformation that, at the turn of the last century, turned photography into film. We are right there, where the frame came into motion, where the picture came into *emotion*.

In watching this process take place we also experience the materiality of cinema—the texture of the film strip. Richter takes us on a genealogical site-seeing tour: he has us watch an assemblage of (film) stills mounted on the wall so that, as spectators, we may remake the variously outlined dimensions of the filmic journey ourselves. The effect of the exhibition is to convey a physicality of image display. In this sense, the experience is not dissimilar to the physical display Dusan Makavejev imagined for his feature *Sweet Movie* (1974), which Peter Kubelka actually carried out in the late 1950s, though in a different way.[17] This avant-garde filmmaker, who engaged very closely with the filmic frame, used to exhibit his works of framing by making literal installations of his films in art galleries and museums. Kubelka would pin the film strip to an inside wall and unravel the celluloid thread across a window or drape it around a room. Wrapped around space this way, film shows its connection to both architectural and photographic frames. The viewer can read this bond, experiencing the work frame by frame, shot by shot, in the same elliptical way the film editor—herself a seamstress—labors over the celluloid, fabricating the filmic assemblage with cuts and seams.

From the viewpoint of cinematics, the construction of *Atlas* can also be related to the way the French filmmaker Chris Marker constructed his film *La Jetée* (*The Jetty*, 1964). Marker made this film years before producing his archival project *Silent Movie* (1994–95), which remakes film history in a multiple-video installation.[18] *La Jetée* was a work of memory that was produced almost completely of still photographs. Almost. For it was the apparent stillness of the pictures that created an emotion. And, at some point, something actually did move, for a second: eyelids moved, imperceptibly. We similarly sense the *emotion* in Richter's moving installation of still pictures, which both contains and offers that particular affect of (im)mobility: the suspended emotion. Richter's *Atlas* is a map that comes to move. To emove.

This peculiar atlas-album of lived landscape develops, as architecture and film do, as we inhabit space, in architectural itineraries that track the sequence of living pictures. In connecting the series mounted on panels and constructing a film of them, the moving observer of *Atlas*, like a film spectator, reads emotion pictures in motion on the wall. Pictures become an architecture; architecture becomes a film. In the cumulative effect of *Atlas*, a moving cartography progressively builds out of this architectural-filmic (e)motion. In this sense, Richter's installation of *Atlas* is more than an architectural journey that reveals a filmic itinerary. It actually designs the chart of film's relation to architecture. As this *Atlas* confirms, cinema is indeed

our kind of atlas—a mapping out that is architecturally displayed on the wall, etched on the screen. It is a mapping of *emotion*, suspended on the threshold of the wall and the screen in a transport that embraces us.

AN *ATLAS* OF EMOTION PICTURES

In naming his work *Atlas*, Gerhard Richter identified it as a cartography. The casual gallery goer, however, may question the name of the exhibition. It may not be immediately apparent how this peculiar work is at all an atlas. It is not even strictly a map-driven work. But *Atlas* is, indeed, a work of mapping, an "atlas" in the full meaning of the form. As we consider it at this point in our exploration, Richter's installation can be fully understood as an expression of that diverse practice of knowledge we have traced and historically considered as taking shape in the form of the atlas. It embodies such historical geography, a form of thinking that, as we have shown, used both the name and form of "atlas" to mold a vast field of experiential knowledge—ranging from geography all the way to anatomy and reaching out to embrace an anatomy of sentiments. Richter's *Atlas*, in fact, "takes place" within the realm of mapping this book has foregrounded primarily, for in its formidable scope and presentation it charts that particularly difficult terrain we have called a subtle geography, a tender mapping. *Atlas* lets us touch, traverse, and be held in the geography of affects and intimate space, fostering a form of mapping that exhibits, within the layers of its architexture, the labor of memory.

In this respect, we must call forth one specific shape and function the "atlas" assumed in the history of art. In the special space an "atlas" such as Richter's inhabits, one finds precedence in the important work of the art and cultural historian Aby Warburg (1866–1929).[19] Warburg, most notably, developed a theory of social memory. As Carlo Ginzburg has shown, the particularity of Warburg's iconology resided in its sensitivity to the symptoms of the changing emotional orientations of society.[20] In his work, Warburg used a heterogeneous form of documentation to articulate different societal voices, often stressing the word "life." He went in search of "pathos formulas." In this way, his work strove to become a testimonial to the relationship between states of mind and corporeal expression, for this, he claimed, is the matter that physically turns into images and underlies their cultural transferal. For Warburg, images do, indeed, travel. They move, culturally, in relation to social sensibilities, especially in the embodied form of gestural expression.

For his final project, Warburg set out to image an actual place for "the archive of memory" he had worked with in critical form throughout his life. He produced the unfinished *Mnemosyne*, a work of mnemonic imagination that, significantly, he called an *Atlas*. This, too, was a peculiar atlas. It was actually an album—or, rather, an atlas that took the form of an album.[21] Its intention was to trace and then map in visual form a genealogy of the types of socio-historical memory that make up Western culture. The album was composed of diverse screens of pictures that ranged in subject from art to science to the everyday.[22] Warburg's

"atlas" was a geographic history of visual expression, analytically and materially constructed as tables that mapped its persistence and various movements. Photographs and series of art reproductions accompanied pictures of daily life, including those that were technologically produced for mass consumption, such as travel images. These were assembled together on sheets to show, as Warburg himself put it, that the enduring "images of the Mnemosyne atlas are . . . the representation of life in motion."[23] In his introduction to the *Mnemosyne Atlas*, Warburg insisted on this idea, affirming that "the atlas, in its material base of images, wants, first of all, to be an inventory of the classic configurations that inform the stylistic development of the representation of life in motion."[24] Paying particular attention to "the engrams of affective experience" and "including the entire range of vital kinetic manifestations," he pictured on panels "the dynamics of exchange of expressive values in relation to the techniques of their means of transport."[25] This included the design of a room, the physical movement of a person, and the flow of a dress. Concluding that "the figurative language of gestures . . . compels one to relive the experience of human emotion," he mapped "the movement of life" with his "pathos formulas" in atlas form.[26]

Richter's *Atlas* is a version of the cultural mapping of (e)motions that, as we have seen, has taken many cartographic forms throughout history, including that of Warburg's *Mnemosyne Atlas*. Like that work, Richter's project is also an atlas-album. It is made up of photographs, collages, and sketches and is mobilized by the consistent presence of travel images, all organized into panels. Substantial historical changes have taken place with regard to the nature, methodologies, and techniques of the representational mnemonic archive, and the supporting foundation used to build and hold together Warburg's *Mnemosyne Atlas* cannot now be sustained in the same way. Richter's *Atlas* thus invents another form of atlas-album, offering with it not only new engrams but a new screen for (re)collection and a different vessel for affective imaging. Nevertheless, with enduring fragility, the images of Richter's own mnemosyne *Atlas* take hold of a matter that is none other than "the representation of life in motion." *Atlas* enables us to experience the very assemblage of *kinema*, to inhabit the filmic *emotion*—to take hold, that is, of the representation of the movement of life, with life in motion. Moving through this fascinating artwork—traveling with this atlas—we are transported into the very haptic space of (re)collection, where the filmic-architectural bond is pictured and figured as a map.

FILM ITINERARIES AND MUSEUM WALKS

Navigating the installation of Richter's *Atlas*, we have come to foreground the interaction between film's imaginative route and the museum walk and, recognizing a reversible process at work, to link their (e)motion along the experiential path that includes acts of memory and the labor of mourning. This discourse could be extended even further. Considerations of exhibition are the focus of a current reconfiguration of art history and curatorship as well as art production. Among the many

artists who have worked in this area is Christian Boltanski, who has created his own fascinating field of (re)collection in works of mourning related to Jewish history.[27] This oeuvre includes ventures into cinematic territory and is even rooted in film, for Boltanski had his first public exhibition in a Parisian movie theater in 1968 and made experimental films between 1968 and 1976.[28] He also has incorporated film into the "fabric" of a recent set-design installation. Creating an artwork that dialogues with Schubert's *Die Winterreise*, Boltanski portrayed absence, as he recurrently does, by mobilizing a set made of the fabric of clothes no longer inhabited, bound to a network of dim lighting. The unoccupied apparel was set against a panoramic film of moving landscapes, seen from a train, with tracking shots that resonate with those of Claude Lanzmann's *Shoah* (1985) projected onto the textured wall of the stage.[29]

In its many compelling forms, exhibition has become a locus of serious practice as well as a site for the study of the design politics of artistic space.[30] The resonance between art and architecture is a particularly compelling issue in the reconfiguration of exhibition, which might include the work of film.[31] Film theory, however, despite its interest in exhibition, has yet to engage fully with this discourse. This remains the case even though film has encountered art on the terrain of exhibition in ways that go far beyond the scope of this book. The intent here has been to open the doors of the movie house and to show that the motor-force of cinema extends beyond the borders of film's own venues of circulation. The affective life of cinema has a vast range of effects and, in general, its representational and cultural itineraries are productive outside the film theater. They are implanted, among other places, in the performative space of the art gallery, as evidenced by way of Richter's *Atlas* and Greenaway's work. The reflections on this interaction here, expanded in the following pages, reflect my desire for a cross-pollination of film and art theory while suggesting further encounters between film and art at the interface of the map, the wall, and the screen.

I have developed the idea of this interface in different ways over the course of this book. At its outset, I let Hiroshi Sugimoto's photographs of film theaters guide us through a genealogical reconfiguration of the haptic dwelling of site-seeing. In the course of this journey, we discovered the interface in the geography of history and developed the genealogy of an interactive geovisual culture. Tracing cinema's relation to the history of exhibition tactics, we examined, in particular, how a tableau of early museographic spectacles and practices of curiosity came to affect the architecture of interior design. The interface was also approached by placing film exhibition within the history of a mobilized architectonics of scenic space, in an aesthetics of fractured, sequential, and shifting views. Now, this zone in which the visual arts have interacted with (pre)cinema can be signaled as the very matter of cinematics that attracts art to the moving image in a contemporary hybrid exchange. As we represented filmmakers who reconfigure the labor of film architecture, taking along a number of artists as their imaginary fellow travelers, we pointed to an intersection that goes beyond textuality. In this respect, walking through the installation of *Atlas*, where cinema does not "show" in an obvious form, is a way of furthering

the cultural mapping initiated with the cartographies of Guillermo Kuitca and Annette Messager—a discourse that exposes, architecturally, the relation between emotion pictures and art in new forms of dwelling.

The work of Lewis Mumford provides insights that may take us a step further into the subject of this archive of emotion pictures. It was Mumford who, early on, articulated an interaction between cinema and the museum in architectural terms by assigning a museographic function to film. In his view, film becomes a modern way of documenting the memorials of culture by offering for viewing different modes of life and past existences. In this way, it allows us to cope with—to have "intercourse" with—other historical periods. According to Mumford:

Starting itself as a chance accumulation of relics, with no more rhyme or reason than the city itself, the museum at last presents itself to use as a means of selectively preserving the memorials of culture. . . . What cannot be kept in existence in material form we may now measure, photograph in still and moving pictures.[32]

For Mumford, the cinema intervenes in museographic culture by providing a measure of what cannot be kept in existence. As it relates to preservation, Mumford's discourse offers a version of the process of embalming that the reproduction of life on film is taken to represent—the mummification complex we discussed earlier as being activated, at some level, in film genealogy and archaeology.[33] Going beyond the notion of cinema as a death mask, however, Mumford's words provide a different angle from which to view this question, for they enable us to recognize cinema as a moving imprint and an active mnemonic "measure": that is, as a mapping of an archive of images. Taking this route of mapping a step further (and further away from preservation), we can recognize the random accumulation, the rhyme and rhythm of relic collection that is mobilized in exhibitionary discourse when it is intersubjectively shared in intimate "intercourse." This is precisely the geographic narrative of Richter's *Atlas*, the effects of which are felt as cinematic rhythm—that is, as random, cumulative assemblage mobilized in *emotion*al traversal. On this field screen, let us then continue to dwell on the rhythm and rhyme of the celluloid archive and consider further the possibility of mapping intersections between wall and screen.

A DETOUR THROUGH THE GALLERY'S FILM ARCHIVE

Gerhard Richter's *Atlas* leads us to ask how the urban rhyme and rhythm of museographic display, mapped earlier as a prefilmic site-seeing, affects us today in the current space of the museum and the gallery.[34] The convergence of the museum and the cinema, established before as a constituent of film genealogy, has become a newly articulated strain in contemporary visual culture and is especially vital in the realm of art installation. This exchange has taken place in many ways on the field screen of visual archives.

In a concrete sense, it has led filmmakers—including Chantal Akerman, Isaac Julien, Chris Marker, and Raúl Ruiz—to produce installations and filmmaking projects that reformulate cinematic space. Conversely, many notable contemporary

artists have turned to filmmaking. Although this is hardly a new phenomenon, since the language of twentieth-century art has variously intersected with film, the recent incarnation of the exchange engages more directly in the work of narrative and has, at times, a greater predilection for popular culture. Sophie Calle, for instance, who works narratively in photography and is concerned with detecting and investigating intimate space, created with Gregory Shephard *Double Blind* (1992), a road movie that records, from their different viewpoints, the disintegrating course of their relationship on a car trip across country in the United States.[35] Larry Clark, Robert Longo, David Salle, Julian Schnabel, and Cindy Sherman have all worked in feature film formats, making fiction films that do not fit the rubric of the so-called art film.[36] Rebecca Horn also has creatively navigated the language of fiction, working to a considerable extent in film performance and feature film formats for a number of years.[37] Matthew Barney has created his own "mutant" *Cremaster* film form, working in the interstices of sculpture, photography, video, and cinema to compose anatomical hybrids that challenge distinctions of species and gender and drive them into new, intricate designs.[38]

Shifting grounds on a large scale, moving images have made their way into the art gallery and the museum, both in terms of production and distribution, returning spectatorship to "exhibition." This trajectory is reciprocal and is articulated spatially. Looking at how the art installation has established itself as a crucial nexus in the museum, one cannot help thinking of the cinema. In many ways, the form of this aesthetic—in which art melts into architecture—is reminiscent of the space occupied by cinema itself, that other architectural art form. In even more graphic terms, one might say that the rooms of an installation often become a literal projection room, transforming themselves into actual filmic space.

In its combined screening process, the deconstruction, decomposition, and remaking of cinematics that is taking place in the museum and gallery space at times resonates with the researches into film language made by an earlier film avant-garde, especially in the cinematic genealogies of Ken Jacobs or Bruce Conner.[39] Many contemporary artists have come to engage with the language of film, analyzing specific film texts, retraversing film history, or breaking down film movement and duration. They have deployed in their artistic practice the use of slow motion and such techniques as the freeze frame, looping, and the reworking of found footage. Particularly notable in this respect are the installations of the Canadian artist Stan Douglas, whose media work refashions time and duration in the face of history and in the guise of historical memory, thereby propelling a cultural remapping of imaging and space.[40] As Kerry Brougher claims (and demonstrated in a recent exhibition), in many ways "the cinematic is alive and well within . . . the network of images and sounds" mobilized in art.[41] A 1996 London exhibition, in which the relationship between art and films was staged, proved that such crossovers can, indeed, hold one "Spellbound."[42] Without pretending to assess the state of the art, and aware of the limits of such an excursus, these partial observations are meant to point out that the genealogical life of film is being extended—perhaps even distended—in the space of the contemporary gallery.

One aspect of this phenomenon has taken place in the intersection between the still and the moving-image archives. Here, we find the practice of Cindy Sherman, whose groundbreaking series of *Untitled Film Stills* (1977–80), analyzed by Laura Mulvey and Rosalind Krauss, have been enacted further in her rear-screen projections (1980) and historical tableaux (1988–90).[43] The work of Victor Burgin offers a reflection, in both theory and artistic practice, on actual reversals occurring between film space and gallery space. Burgin is especially attentive to the differences in the movements and passages within these spaces and intertwines filmic and art-historical ways of seeing.[44] Another view of interface is offered by the artist, curator, and writer Douglas Blau, who has sequentially assembled on the gallery wall a photo archive of imagery that ranges from the art historical to the cinematic; he turns these still pictures, through narrative, into moving images.[45] The artist, writer, photographer, and filmmaker Alain Fleischer, again both in criticism and practice, has reworked and exhibited the medium of film culture in conjunction with art-historical picturing.[46] His rules of exchange display the seduction of the screen—in all its fragmentation and dissolution—at the "nerve centers" of viewing positions, creating possibilities for exploring points of montage, narrative links, and the art of framing.

At one level, what apparently has occurred in the exhibition space is something that resembles a drive to access the work of the film apparatus itself in relation to modes of picturing. Having gained this access, the installation space then contributes to a remapping of the cultural space of the cinema, as well as the cultural space of art. Sometimes, the discourses of art and film intertwine in this archive of film genealogy. Let me offer as a different example an installation by the Scottish artist Douglas Gordon, whose manipulation of cinematic material has included extending Alfred Hitchcock's *Psycho* into a *24 Hour Psycho* (1993) installation event.[47] Gordon's specifically genealogical work, entitled *Hysterical* (1995), is a video installation that rereads the familiar relationship between hysteria and representation. It projects onto two screens footage from an unnamed silent film, making two loops—one moving at normal speed, the other in slow motion—whose rhythms occasionally and casually meet up. The archival source of the installation (a filmed medical experiment made by the Italian doctor Camillo Negro) resonates on the reel of film history that has occupied my own cinematic imagination. As I have argued elsewhere, when Negro filmed *La neuropatologia* (Neuropathology) with Roberto Omegna in 1908, he exhibited the supposed "female malady" as the theatrics of the "seen" itself.[48] When the film was first shown, a reviewer aptly remarked that "the white film screen was transformed into an anatomical table."[49] The comment points to the sort of genealogy Gordon exposes as, reworking the film, he exhibits the very representational grounds upon which the filmic bodyscape itself was built and mobilized. Gordon's loops furthermore expose and accentuate the "wheeling" motion that we have seen to be a motor-force of emotion pictures. The loop especially reminds us that this wheel constitutes the very materiality of the filmic "reel." As an intervention on the matter of duration, this work resonates with Andy Warhol's filmic experiments of "reel" time.[50]

In the gallery or the museum, one has the recurring sense of taking a walk through—or even into—a film and of being asked to reexperience the movement of cinema in different ways as one refigures its cultural ground of site-seeing. Entering and exiting an installation increasingly recalls the process of inhabiting a movie house, where forms of emotional displacement, cultural habitation, and liminality are experienced. Given the history of the "installations" that gave rise to film, it is only appropriate that the cinema and the museum should renew their convergence in ways that foster greater hybridization.

An editing splice and a loop thus connect the turn of the century and the dawn of the millennium. In revisiting the genealogy of cinema, we see that it was marked by a prefilmic theatrics of image collection, active in forms of spectacular array that enacted recollection.[51] The composite museographic genealogy of film that we traversed in diverse georhythms of site-seeing—cabinets of curiosity, *tableaux vivants*, wax museums, fluid and automated spectacular motions, cosmorama rooms, panoramic and dioramic stages, georamic display, urban *mondo nuovo*, and view painting—occurred in and around public viewing sites. Fragments that were crystallized, serialized, and automated in an art of viewing developed as an "-oramic" architecture of the interior that represents "installation" *avant la lettre*. Cinema descends from this travel of the room—a waxed, fluid geography of exhibition that came of age in the nineteenth century and molded the following one.

What turned into cinema was an imaginative trajectory that required physical habitation and liminal traversal of the sites of display. The establishment of a public in this historical itinerary made art exhibition cross over into film exhibition. The age that saw the birth of the public was marked in the realm of art by the establishment of such institutions as the Paris Salon, where art was exhibited for public consumption.[52] Cinema, an intimate geography born with the emergence of such a public, is architecturally attached to this notion, for the movie house signals the mobilization of public space with its architectonics of display and architectural promenade, experientially implanted in the binding of imaging to spectatorial life.[53] Thus generated out of modernity's itineraries, film movement has included in its cultural space the trajectory of public exhibition itself: an exhibitionary itinerary became a filmic architectonics of traveling-dwelling.

Now, back in the museum and in the gallery space, this moving topography once again can be physically and imaginatively traversed in more hybrid forms, where the genealogy of cinema is displayed on the walls to be walked through, grasped, and reworked. The moving geography that fabricates the cultural mapping of cinema has come to be exposed, analyzed, even remade—at crucial nerve points— on the field screen of the gallery. This artistic process extends the refiguring of the cinematic work of cultural imaging, and of the space of image circulation, as it forces art to reconfigure itself. Along the way, something important is set in motion. The installation space becomes a renewed theater of image (re)collection, which both takes the place of and interfaces with that performative space the movie theater has represented for the last century and continues to embody. An archive of moving images comes to be displaced in hybrid, residual interfacing.

10.7. An archive of urban landscapes in Richter's *Atlas*. Sheet no. 120: *Cities*, 1968. 12 black-and-white cuttings, aerial photographs from books, marked up cuttings. Detail.

10.8. The architecture of memory: traces of cities in a (screening) room in Richter's *Atlas*. Sheet no. 123: *Cities*, 1968. 4 black-and-white cuttings, aerial photographs mounted in sketches of rooms. Detail.

10.9. The landscape of an atlas-album in Richter's *Atlas*. Sheet no. 312: *Capri*, 1975. 16 color photographs. Detail.

10.10. The imprint of topo-philia in Richter's *Atlas*. Sheet no. 213: *Clouds*, 1970. 2 color photographs, marked into divisions and individually mounted. Detail.

INTERFACADE: CINEMA AND THE MUSEUM

The renewed convergence of moving images and the museum has also engaged the domain of design. This conflated geography informs the geography of intimate space itself, as well as its forms of liminal navigation. Thus the passage between interior and exterior not only is enacted on the walls of the museum but is staged in the very structure of its architectural premise. In an age where—from Los Angeles to Seattle, Bilbao to Berlin, and beyond—new architecture is mobilized with, and as, museographic exhibition, the challenge may involve the task of refiguring spatial cinematics and geopsychic paths of navigation on the screen of the architectural site itself. In his plan for Berlin's Jewish Museum, Daniel Libeskind inscribes subjective cartography by slashing windows into the building's surface that correspond to places on the map of Benjamin's "Lived Berlin." In the architect's words, the building itself, an architectonics of lacunae, emerges out of "the openness of what remains of those glimpses across the terrain—glimpses, views and glances . . . belonging to a projection of addresses traversing the addressee."[54]

We already have witnessed a cultural center/museum such as the Institut du Monde Arabe, designed by Jean Nouvel, in Paris, challenge the permeability of the facade with windows that converge with the mechanics of light-sensitive photographic shutters.[55] Now one of Frank Gehry's proposed designs for a new Guggenheim Museum, stretched out by the water and floating with New York City's harbor life, looks like an unraveled film strip. Given Gehry's well-known propensity for oceanic creatures, one wonders if this "fish" may not be seeing a sea of images. As Gehry tells Michael Sorkin in an interview about his recent work, he "dream[s] of brick melting into metal, a kind of alchemy . . . [that tries] to get more liquid, to put feeling, passion and emotion into . . . building through motion."[56] This alchemy, as we have claimed, is the matter of celluloid imaging itself—that fluid place where motion becomes emotion. The motion picture, with its fabric of moving images, circulates a passionate architexture: *emotion* comes into place in fluctuating cultural geography. In the face of new image-network meltdowns, then, one might envisage further hybridized geographies, such as those found in the work of architect Hani Rashid. His studio project *220 Minute Museum* (1998) is a timed sequence of eleven virtual museums that was projected onto several movable fabric scrims suspended from pivots on and around the facade of the Storefront for Art and Architecture in New York.[57] Thinking of this pivotal movement as we watch the wheel of museographic debris potentially melting into cinema in the art gallery, it may seem that we are beginning to confront an interfaced reconfiguration of the residual pieces of a nomadic visual archive.

CINERES AND CINEMAS

Another dimension of the collision of architexture with filmic texture is elaborated in the work of the visual artist Judith Barry, who explores inhabited, imaginary

spaces in post-perspectival ways, investing cities and travel with whirling history. Here, the museum, the cinema, and the department store share a common architectural form, insofar as all are showcases of cultural design.[58] In her installation *Dépense: A Museum of Irrevocable Loss* (1990), for example, set in an abandoned nineteenth-century marketplace in Glasgow, vitrines of the sort used in history museums become a screen on which to project early silent films of city life. In revisiting this interaction in contemporary installation, we might recall the genealogy mapped earlier in this book, for the three exhibitionary sites were, historically, visited the same way: in fluid intersection, passing from space to space, in joined trends of public consumption. This relationship extended to the shape of the interior design itself of these spaces, and to commonalities in lighting and spatial layout.[59]

Such convergences have not appealed to critics concerned with the demise of spectacle, who have maintained that the museum is the cemetery of the artwork. By the same token, the cinema has been declared dead (or deadly) more than once. An appreciation of the department store analogy, however, need not become a celebration of the museum (as) store. We might alternatively think of the fashioning of cultural space as an actual matter of fashion—that is, as texture. The museum, the cinema, and the department store all represent textural places: emoving archives of imaging. To reclaim the museum and the cinema from the land of the dead is to "refashion" them together in this archival interface, connecting their exhibition and spectatorship on the level of *habitus*. After all, *habitus*, as shown in the previous chapter, is a matter of habitation and in its very semiotic texture is dressed with the sign of apparel—the *abito*.

Such a fabrication may also take into account the fact that an *habitus*, in the definition of Pierre Bourdieu, is not only a cultural design but cultural baggage.[60] This understanding of design does not reject the past but, indeed, enables us to conceive of it as a "suitcase" with which we may return to the cemetery—for it may contain something we need today or something we desire for the future. We might wish to concede to the cemetery a certain heterotopic liveliness insofar as it displays a conflated geography and historicity.[61] The city of the dead is not frozen in time. It does not simply hold or arrest but extends life, for it is a geography of accumulating duration offered to a public. This permeable site is capable of inhabiting multiple points in time and of collapsing multiple (body) spaces into a single place. This cumulative view of the cemetery may enable us to look differently at the conjoined histories of topoi like the cinema and the museum, which fashion, like the cemetery itself, a mnemonic archive of images. Moving in this way from *cine*res to *cine*mas, from the ashes of the necropolis to the residual cine city, something of this heterotopic force may be opened up in more hybrid forms of reinvention.

Traversing the interface of *cine*mas and *cine*res is an archaeological project—one which exposes the conflation of images in the present as a way of looking at their future. There might be in store for us an altogether new configuration of the architectonics of moving images which should proceed along with the funereal project, for both are woven into the fabric of the spectatorial *habitus*. After all,

museographic sites are, to some extent, consumer versions of the architectonics of memory theaters. Museums, like memory theaters, have offered to cinema the heterotopic dimension of compressed, connected sites. A movie house provides a version of the spatial work of memory, requiring the labor of search and the accumulation of imaging; it furnishes a fictional itinerary that traverses historical materialities and bridges the path from producer to consumer.

In some way, then, the cumulating fictions of the cinema and the architecture of film theaters have come to reinvent—however transformed in heterologies—some of the imaginative process that, in 1947, André Malraux called the *musée imaginaire*: a boundless notion of imaginative production that, in English translation, even becomes a "museum without walls."[62] As art historian Denis Hollier notes, Malraux's imaginary museum was itself "a museum conceived in terms of cinema."[63] This interaction has invested the architectural premise with an interface of passage. Historically, the museum has been experienced through a practice of perambulation in a trajectory that, in the age of modernism, is laid out as a spiral—most notably literalized in Frank Lloyd Wright's design for the Guggenheim Museum in New York City.[64] In the cinema, another product of modernity, the perambulating activity takes place as an imaginary process, also interfacing exterior and interior. One practice has not substituted for the other, although at times one has taken the other's place and, in so doing, has changed the very nature of that place. The stories written on the mobilized figures of the transparent wall that is the screen, and on the space that surrounds it, are there to be retraversed by the film/museumgoer, for the fluid collection of imaging in both invites a shifting form of recollection. The interface between the exhibition wall and the film screen, as mapped in this book, is thus both reversible and reciprocal, even in the process of transhistorical imagination. A work of mutual historical "resonance," to use Stephen Greenblatt's notion, is set in motion as the cultural force of the interface.[65] Here, memory places are searched and inhabited throughout time in interconnected visual geographies, thus rendering, through cumulation and scanning, our fragile place in history. As in Richter's *Atlas*, this architexture is an absorbing screen, breathing in the passage and the conflated layers of materially lived space in motion.

Ways of experiencing cinema also inform the imaginative space of the museum inasmuch as both are public-private affairs that are constantly mutating. If, in evolving form, the museum serves as "counter-hegemonic memory," in the apt words of Andreas Huyssen, such a function travels in other media as well, for when our feelings about temporality and subjectivity change, they also change cultural locations.[66] For example, the architecture of the movie palace, with its recurrent memorial decor, temple motifs, and funerary design, and of the atmospheric theater, with its penchant for architectural mnemonics, suggests that cinema is the kind of museum that may even act as a secular place of mourning. In the range of its offerings, it houses a variety of liminal experiences, including an inner search that is publicly shared and exhibited. The museum, according to Carol Duncan, also publicly houses the performance of such private voyage, inscribed in the ritual history and dramas that constitute museographic spectatorship.[67] In the narrative habitation of the installation space, as

in the liminal movie house, personal experiences and geopsychic transformations are transiently lived in the presence of a community of strangers.

Over time, the itinerary of public privacy has built its own museographic architectures, changing and exchanging, renewing and reinventing the rhyme and rhythm of social mnemonics in an architextural trajectory that transforms *cine*res into *cine*mas. If, as the French historian Pierre Nora puts it, there are now only *lieux de mémoire*—sites of memory generated in the interplay of history—which are "fundamentally remains," then "modern memory is, above all, archival."[68] Cinema, as constructed here, is the unstable site that, against monumentalization, affirms a transmigrating documentation of memory: itself a trace, it is an essential part of a museographic archive of *cineres*. The modern experience of memory is, quite simply, a moving representational archive. Such a museum of emotion pictures has been built along the retrospective route that has taken us to and from cabinets and *studioli*, museums and exhibition halls, houses and movie houses. The atlas of memory consists of this kind of textural exposure, which travels in different public rooms (of one's own) in reversible routes, in passage on a field screen that interfaces cultural itineraries. Mnemosyne—the mythological figure of memory who, according to legend, was the mother of knowledge—became an "atlas" in Aby Warburg's hands, at the threshold of the cinematic age. Mapped in visual space, the mnemosyne atlas did not simply take up a new place in this realm but became space: a multi-screened theater of (re)collection. A peculiar atlas. A movie theater. The perambulating affair proper to museum-going and its architectures of transit transferred in reciprocal ways into imaginative film spectatorship and, thus mobilized and interfaced, became the circulation of an album of views—the "atlas" that is our own museum. A Richter *Atlas*.

AN ALBUM OF VIEWS, AN ARCHIVE OF IMAGING

Inscribed on transparent celluloid and scripted in its mechanical history, the cultural journey of images projected onto the white screen surface has become a museum of *emotion* pictures. But this museographic function of the moving image was acknowledged as a traveling affair from the time of precinema. Speaking of the daguerreotype and its future in 1838, a critic interestingly observed the relation of the photographic image to a potential atlas-album:

How satisfying the possession of this machine must be to a traveler, or to a lady who, wishing to make an album of the finest views that have ever struck her eyes, can compel Nature to reproduce them as perfectly as She herself has created them.[69]

The imaginative passion—the drive to design an imagined geography, to circulate a collection of one's "views"—ventured forth into filmic traveling as film intersected with travel and museographic culture in the act of documenting space, which issued from the desire to make a private "album" of moving views for public consumption.

Think of Esther Lyons, the travel lecturer we encountered some chapters back, who published her book of landscape pictures with her own self-portrait. On the eve of the invention of cinema, as the motion picture was being fashioned from

the landscape of travel culture, Lyons held a mirror up to her own face. A special kind of landscape picturing emerged from that mirror—a place of transient self-reflection. The mirror turned into a filmic screen. Sally Potter would pick up the mirror-screen in the streets of London and Paris and take it to the dancing halls of Buenos Aires. She would hold it right up to her face on the mirror-screen of auto-biographical fiction, turning motion pictures into her own album of views.

In an archival way, the culture of travel, formed in relation to imaging, has engaged the moving image as a site of domestic exploration—a screen that interfaces both intimate and social, private and public narratives. The ultimate residual incarnation of modernity's trajectory created an imaginary mobilization of the traveling room. As with any travel effect, cinema, a nomadic archive of images, became a touching map of personal views. A museum of emotion pictures. A haptic architexture. A topophilic affair. A place for the love of place. A site of close picturing for undistanced *emotion*.

THE EMOTION OF TOPOPHILIA

Moving in this way through the realm of *emotion*, we find ourselves constantly returning to the site of topophilia. A crucial core of my atlas of emotion, the notion of topophilia derives, as we have seen, from the field of geography. In 1974 the geographer Yi-Fu Tuan, in a book on environmental perception and attitudes that deals, albeit problematically, with the love of place, proposed that human beings are affected by what he ingeniously named topophilia.[70] Although I have found inspiration in this work, my engagement with the notion of topophilia stems from a very different premise. In order to explain the love of place, Yi-Fu Tuan ended up establishing a system of values for places, ultimately making claims for ideals of landscape in an evaluative structure based on binary oppositions and harmonious wholes. By contrast, I have used the term *topophilia* to describe that form of cinematic discourse that exposes the labor of intimate geography—a love of place that works together with the residual texture of *cineres*. Such work is driven by a passion for mapping that is itself topophilically routed not on wholeness but on the fabric of lacunae. This "exposure" of remnants has been made visible from the opening gesture of my site-seeing: Sugimoto's "exposed" white film screen, which, like the screen-space of Greenaway's installation *The Stairs 2: Projection*, is the texture of a palimpsestic writing of place. This is the site of (in)visible traces, inscribed and laid bare, enduring yet erasable on the white fabric of the screen. In this sense, the white film screen morphs into the blank surface exposed by Ann Hamilton in her *Crying Wall*, where, according to my story, the moving tear etched on the wall surface there becomes a tear moving down the facial landscape of the film screen in a woman's filmic work of mourning. In the world of emotion pictures, there are no monuments but only documents, for ashes make up the work of memory or the place of mourning, where people are sites.

The mnemonic landscape of Richter's *Atlas* is one such topophilic place, where *emotion* rests on diffraction and moves in passage. Here, the particular love of place produced by his work is quite distinct from the centric view of a nesting drive. Far from it, for topophilia is also not to be collapsed with nostalgia, especially when the latter is used to advocate univocal attachment to one's land of origin. Looking in previous chapters at the type of topophilia enacted in tender forms of mapping, we have seen that a "philic" drive is inscribed at multiple levels in maps that reroute and mobilize an amorous discourse in relation to moving landscapes. This topophilia is inscribed in the emotional maps we considered that reinvent a *Carte de Tendre* and a geography of affects, and finds a place in Richter's own *Atlas* of emotion pictures.

As we further explore mental geographies, we might pause here to consider that maps have been called by Robert Harbison "the mind's miniatures."[71] And as Simon Schama argues, the landscape is also a work of the mind.[72] In this vein, a landscape, broadly conceived, can be regarded in many ways as a trace of the memories, the attention, and the imagination of those inhabitant-passengers who have traversed it at different times. It is an intertextural terrain of passage which carries its own representation in the threads of its fabric, weaving it on intersecting screens.

To grasp the lack of plenitude and the lacunar interiority of this topophilic scenario, we might recall the way in which the architectural artist Rachel Whiteread works her textures, compiling an inventory of design objects and spaces of domestic life.[73] To build her museum of private life, Whiteread works from inside out and outside in. She usually casts the interior void of architectural space in liquid substances that become hardened, and then puts the bare, hollow volume of a mattress, bathtub, table, room, house, or book back onto the landscape. In this way, the emotional texture of a work like *House* (1993–94) is palpably offered back to us, rendered in a negative that, like film's own negative, contains the impressions of those who have, and will, come into contact with its particular interior landscape. The mnemonic imprint of a house corridor contains an archive of stories just as the materialized interior library of *Untitled (Book Corridors)* (1997–98) does. Cast and exposed in the negative by Whiteread, inner space can actually "take place." As in the negative spaces cast by Bruce Nauman, it reveals haptic texture and the fabric of its architectonics. In Whiteread's *Water Tower* (1998), mounted on a New York City rooftop in the Soho gallery district, the object is the inverse of the contained fluid substance. A "lacunar" metonymy for the city of New York, whose cityscape is a map of water towers, this texture is a filmic screen for the projected stories of "the naked city." Visiting Whiteread's translucent architecture, we sense the passage of people through a brief moment in space in the tense materiality of suspended historicity.

The story of the landscape is told as a palpable imprint in the moving landscape of its representation: in its folds, gaps, and layers, geography holds remnants of what has been projected onto it at every *transito*, including the *emotion*s. Imaged in this way, landscape is an archaeology of the present. Emotional cartographies, to which Richter's *Atlas* belongs, make this particularly evident, showing how *topos* is attuned to *philia* in the historicity of sentient encounters. From the art of memory to

emotional maps to film viewing, such cartography joins, on topophilic grounds, with an architecture of inner voyage, a geography of intimate space. In this landscape, filmic site-seeing is immersed in the geopsychic act of interfacing affect and place that has driven the architectonics of memory, from Quintilian to Richter, as an art of mapping place. Cinematically, the affect is rewritten on the land as on a palimpsest, and the moving landscape returns a sign of affect. Residing in this way as an "in-between," in a pause of movement, permanence turns into permeability as intimacy becomes publicly shared in the museum-movie house.

Space—including cinematic space—emoves because, charged with layers of topophilic *emotion*s, it is invested with the ability to nourish the self.[74] This psychic process involves making claims and demands on the landscape. Cultures and individuals fixate on specific landscapes for different reasons and reactively pursue them. A traveler seeking a particular landscape may go there, even filmically, to be replenished, restored, held, and fed. For example, in the history of landscape, the sea and the seashore have functioned as lures.[75] Mutable marine landscapes have offered varied topophilic pleasures as they have expanded imaginative horizons. In the hub of traveling and dwelling, their coastal borders have embraced the stream of *emotion*s and exerted the pull of an embracing "transport." Richter's *Atlas*—a psychogeographic landscape—is likewise one of these topophilic places that can hold us in its design and navigate our story. In the "film" of landscapes, moving trains, and people-sites it sets out, our own unconscious comes to be housed.

People are drawn to places—museums included—for psychic reasons, just as they may find themselves emotionally engaged in a literary "site" or attracted to a place of moving pictures. This includes revisiting affective sites of trauma, as the wounded architectural work of the artist Doris Salcedo reminds us.[76] Her passage into counter-memorial is a kind of mourning, a process that works, as we have claimed, by way of incorporation. Such passage can make textural exposure something that binds. Salcedo holds us there, in the material site of loss, in the traces of the fabric remnants that leak out of the concrete contained in her dead armoire. But it is precisely this intimate holding in affective vicinity, in the architexture of loss, that can become a form of sustenance and a way of moving on with life. It is in this way that *cine*res turn into *cine*ma.

As they are materially traversed in representation—in itineraries of affective reality that include motion pictures—places change shape. Sometimes, a site speaks only of passage and revisitation, for when we absorb places as they absorb what is laid out on them, geography exhibits itself in iterative mappings. On this terrain, cartography encounters psychoanalysis, for, as we learned long ago from Gaston Bachelard, "the unconscious is housed," and in the poetics of space "a voyage unreels a film of houses."[77] Now, having passed through the various incarnations of the *Carte de Tendre* and visited its extension in Richter's *Atlas*, we might see that cartography—a charting of the subject in space—is fundamentally a (psycho)analytic residue. In the act of drawing, it excavates one's archaeology: the fragments and relics of one's *terrae incognitae*, sometimes traveled so much by way of habit and habitation that they have become unknown. Such is the ruined map that Richter's *Atlas* presents to us.

Such is the ruined map exposed in the cinema. Wandering with the imaginary atlas, the fabric of this fabrication—an architexture—shows.

In the course of the motionless journey of film, we are held, as with Richter's *Atlas*, in an intimate binding that can even "transport" us backward. Now, at the end of our map zone, we may find ourselves back where we started, back in the global vessel in which, some chapters back, we began drifting through the art of mapping. We had positioned ourselves in a *studiolo*, one of the very places that, in time, would become a museum. Perhaps the *studiolo* of Isabella d'Este—a place of immobile voyage furnished with a globe, a geographic study room where the world existed as interior decor—was indeed an analytic room, dreaming ahead to Richter's *Atlas*. This is the place of "projections," where the voyage of the unconscious works itself into stories and dreams that end up populating the walls of the room; it is a house of pictures, like film's own movie "house." Evanescent and fugitive, emotion pictures fix themselves on the analytic movie screen, reflective and translucent. Layered on the white texture of an erasable palimpsest, films can be the wallpaper of a room, the peeling layers of painted and inhabited stories, the fanciful decor of a *studiolo*, the traces of analytic debris. Housed in spectatorship, the cinematics of *emotion*—the very *tact*ics mobilized in *Atlas*—reinvents a *Voyage around My Room*. This exploration of the room is held in the "room" of the camera obscura/lucida, attached to the room of one's own. It makes a mattress-map and is bound to a spectatorial seat, a couch, or a desk chair. It is a "furnished" wall dream. In this residual sense, the emotional voyage is, indeed, an architectural affair. It is an actual matter of "interior design"—that place topophilically mapped in Richter's *Atlas*.

HOUSE

11.1. A personal view from a
fan that opens to vistas of
the landscape. Naples, late
18th century.

11 Views from Home

In the world in which I travel, I am endlessly creating myself.
Frantz Fanon

Naples [is] the ideal place for a landscape painter.
Johann Wolfgang von Goethe

The mixture of generations and epochs, social classes and narratives is particularly amazing in Naples, . . . a porous, transient city.
Ernst Bloch

In closing this book, allow me to take you site-seeing, on a "Voyage in Italy"—to Naples, that is, with Roberto Rossellini's *Voyage in Italy,* a filmic visit to my home town. This film, a woman's travel diary, deals with the geopsychic relation between affect and place we have been exploring, which includes topophilia. It exposes the physical affect of (e)motion and will enable us to take part in the intimate experience mobilized in the process of cultural travel, in which one's very form of dwelling is remapped. Asking what kind of love of place is mobilized in this voyage, we will uncover a strain of its representation. Sensing the philic drive that historically has attracted artistic, literary, and film voyagers to this land, we will take the grand tour to Italy, turning it into a tour of the cine city. Here, I will test the grounds of my hyphenated history and continue to root out the migratory sense of the emotional passion—that "moving out" which is a transference from one place to another. Finally, with this cartographic *emotion* in mind, I will rethink the idea of psychogeographic mapping through the movement of my own topophilic history.

Thus we return to the fabric of the cine city, that "fashioned" space from which, chapters ago, we first embarked on our site-seeing tour. In so doing, we link the history of film more to palimpsestic sites than to discrete points in time. Conventional film history, in general, is more time- than space-bound. It moves diachronically, progressing from period to period, and provides an essentially temporal history of the medium. Space emerges, for the most part, only in accounts of national cinemas, and in a reductive way that tends to confine itself within the borders of particular states. Interesting relations emerge, however, when one tries to break the teleology of time and the cartography of nationhood and to organize filmic movements instead around travel through the durational layers of space and spatiotemporal fragments of dwelling. A spatial history of film could, for example, construct an inventive collage of cine cities, for cities are "made" in the cinema and recreated in different historical periods by filmmakers of different national backgrounds. Cities in film do not have strict walls or borders. However situated, they are a transcultural affair. Making a geographical journey of this kind, one might

draft a segment of landscape and traverse it, retracing its intertextual markings on an imaginary chart. Taking Naples as the site of such a representational exploration, we approach a fragment of lived film space as we unfold a panorama of the city in history.

A RAPID DIORAMA

The most filmed city in the history of Italian film next to Rome, Naples already had been widely painted, photographed, and variously represented when the motion picture encountered its peculiar topography and made it into a *cinecittà*. Images of Naples (both before and after cinema) have been marked out on the threshold between high and low, where the city's own cultural hyphen is situated. In film, the geography of the city has become the thread of a diverse visual architectonics and a fragment in the mosaic of traveling geovisual cultures. Hence, to understand the relation of Naples to the cinema, one must engage the visual history of the city in relation to the culture of travel. It was one of the subjects most frequently portrayed in the geography of *vedutismo*, and the practice of view painting, conversely, shaped the city's very imaging.[1] The bird's-eye view of the city was made famous by such artists as Pieter Brueghel, who painted *Bay of Naples* in 1556. Many topographic views were produced, including those by Alessandro Baratta (1583–after 1629), who made *Plan of Naples* in 1629, and Didier Barra (c. 1590–?), who executed the stunning *Bird's-eye View of Naples* in 1647. Internationally celebrated, the city generated an entire cartographic history. A view of Naples by Francesco Rosselli, *Tavola Strozzi*, appeared as early as 1472 and was the first large-scale portrait of a European city ever to be made.[2] In 1750, Giovanni Carafa, duke of Noja, conceived a multi-sheet *Topographical Map of the City of Naples and Its Surroundings*.[3] Completed in 1775 and comprising thirty-five sheets, this embracing sequential view composed of framed picture-shots made for a very cinematic map. From subject to form, the geography of the city, in painting as in film, is forever linked to the *veduta* and to the representational codes of mapping.

A moving portrait, the map of the city was also a product of the *voyage pittoresque* and its cultural developments:

We are bound for Naples! How picturesque the great crags and points of rock overhanging to-morrow's narrow road . . . ; and in the morning, just at daybreak, the prospect suddenly becomes expanded, as if by a miracle, reveals—in the far distance, across the sea there!—Naples with the islands and Vesuvius spouting fire.[4]

"A Rapid Diorama" is the title that Charles Dickens gave to this description of his voyage to Naples in his *Pictures from Italy*. It is an aptly chosen title, for the diorama—the spatiovisual device that presented changing panoramic scenes—created for the viewer the very dimension of voyage, proleptically pointing toward cinema's own power to transport. But, as Dickens's text suggests, the diorama and the panorama form only a fraction of cinematic site-seeing, for as we have argued, the entire representational archive of traveling images contributes to this "transport."

On this chart, Naples has been revisited endlessly since the era of the grand tourist and the romantic traveler. Indeed, it was one of the grand tour's last stops—the southern edge in the "descent" of the northern voyagers across Europe.⁵ A major site of representational as well as actual travel, Naples was one of the spaces where the traveling eye literally "came into place." In addition to view painting, this passage included the spectacle of moving pictures produced by the Eidophusikon, the cyclorama, the cosmorama, *mondo nuovo*, and other panoramic spectacles. All of them regularly offered views of the city and of the volcano that overlooks it. At London's Vauxhall Gardens, an eighty-foot-high view of the Bay of Naples was illuminated by fireworks every night during 1823, while the gardens offered a panoramic model "al fresco" of the site.⁶ In the pleasure garden, a displaced Naples featured large.

Interior design participated in the travel of city imaging as well. Among the views of Italy that were frequent subjects of *papiers peints panoramiques*, the Bay of Naples was often favored. One particular design of panoramic wallpaper, produced in Paris in the early 1820s, reproduced Constant Bourgeois's *View of Vesuvius and a Part of the City of Naples* and was perhaps also inspired by a *Bay of Naples* on view at the Panoramas of the boulevard Montmartre.⁷ Cementing the link between traveling culture and domestic life, such decor drafted new notions of the interior at the doorstep of the exterior, constructing the geography of the city as a journey.

VIEWS OF A CINE CITY

One wonders whether the Bay of Naples, set against Vesuvius, was actually made to be pictured. In 1861, when a panorama of Naples opened at the Burford establishment in London, it was proposed that Naples existed perhaps best as a picture, for the city's panorama was "even more pleasant to look upon in Leicester Square, than is the reality with all its abominations."⁸ Naples, in fact, has been looked at so much that it runs the risk of being worn out by overrepresentation. As the writer Thomas Bernhard once said: "To see Vesuvius is, for me, a catastrophe: millions, billions of people have already seen it."⁹

Overrepresentation and the touristic picture of Naples become real issues when we consider the city's portrayal in film, especially in view of what it has been made to stand for in the cinema.¹⁰ This has included the idea that love is tied to topography. Indeed, as one film from 1960 put it, "It Started in Naples." Here, in this captivating city, Clark Gable was lured into love and, falling for local girl Sophia Loren, went "native." Lina Wertmuller also adopted a formula that typecasts the "native" culture, helping to turn the city into both a frozen and a serial image. Better to try and start from scratch, as Massimo Troisi would claim in *Ricomincio da tre* (1980).

This touristic city, which has attracted film images like a magnet, was itself one of the earliest and most productive film centers. It was home to Etienne-Jules Marey, who in 1870 bought a villa there. Marey traveled south from Paris every year to spend his winters in Naples, where he made some prefilmic experiments with his photographic gun. A number of period photographs testify to Marey's work in

11.2. Panoramic wallpaper wrapping the house with *Views of Italy*, c. 1820–25, parts 1–5, *The Bay of Naples*. Manufactured by Dufour, Paris; designer anonymous.

Naples, showing him "shooting" such subjects as the Bay of Naples and its floating ships. In the words of François Dagognet, Naples "was to mark his work as his work would mark its period."[11]

Naples, a cinematic city from the very inception of film history and even in prefilmic times, was also the subject of illustrated travel lectures. They celebrated its beauty and its misery and this image migrated from there into the genre of travel films that grew out of these slide talks. From the very beginning, the films produced in Naples manifested themselves as ways of imaging and touring the city: early Neapolitan cinema participated intensely in the construction of "city views." The Italian version of the panorama film devoted to viewing the city—significantly called *dal vero*—emphasized the view "shot from real life on location." The first filmmakers, including local ones, widely practiced this *dal vero*, making short films that addressed location with street views or vistas of the city and its scenic surroundings. Since *dal vero* were internationally produced, Naples became a well-traveled subject of this genre. An extension of the nineteenth-century practice of painting *en plein air*, *dal vero* articulated a kind of cinematic site-seeing that transformed the city into cityscape.

After the Second World War, the *dal vero* of Naples were reinvented by neorealism as city travelogues were remade into fiction. Enhancing the sense of location, neorealism placed narrative in the space of a present historicity. From there, a number of films documented Naples both as a situation and a site of history. Cinematic histories set in Naples include Vittorio De Sica's *L'oro di Napoli* (*The Gold of Naples*, 1954) and, in more recent times, Liliana Cavani's *La pelle* (1981).[12] The most powerful contribution to this geography of history, however, was Roberto Rossellini's *Paisà* (*Paisan*, 1946), an episodic filmed history that travels through Naples as it moves across the space of different Italian cities, assembling a fragmentary, moving portrait of a country in ruins. This "motion" picture travels from south to north, making a composite map of cultural differences within the Italian nation and exploring its marked regional diversity. Ultimately, *Paisan* would undo national identity with its traveling eye and create a filmic rendering of the multiple "location of culture," including Naples' own situated (popular) knowledge.[13] After the neorealist period, Rossellini did not abandon this propensity for site and continued to be driven by geography even when, in *Voyage in Italy*, historical weight gave way to fictional minimalism and he moved from exterior to interior, toward a modernist narrative space. This was the space, as we have seen, that Michelangelo Antonioni ventured to inhabit: on the rarefied terrain of the interior voyage, *Voyage in Italy* met *L'avventura*, connecting landscape with the female landscape and its erotics.

A series of adventures without adventure, *Voyage in Italy* travels through Naples and to the attractive outskirts of town. Insofar as it is a tribute to the surroundings of the city and to the Mediterranean landscape, it is intertextually linked with Godard's *Contempt* and René Clément's *Plein soleil* (*Purple Noon*, 1960).[14] In *Purple Noon* the sensuality of the land is written on the body of Alain Delon, while in *Contempt* idle eroticism, conjoined with filmmaking, is housed at Casa Malaparte, that house of views suspended on a promontory over the sea of Capri.

Godard, who admits to having remade *Voyage in Italy*, filmically reinterprets a most seductive twentieth-century Mediterranean architecture: the house, where architecture is engaged in dialogue with topography, becomes the place in which characters disconnect from the landscape of their lives.[15]

As location, Naples is a constructed geography; collected in representational fragments, its mapping is an effect of the cultural imaginary. Naples is a place displaced and fabricated, which can even be "set" miles away from the city itself. The Naples of Hollywood, more Naples than Naples itself, embodies a paradox: in order to make its architecture appear real, overfabrication is required. The hyperreal city of Frank Borzage's *Street Angel* (1928) is such a fiction: the city of Naples too perfectly reconstructed in a film studio. From baroque churches to alleyways, Hollywood's Naples is a city imaged by people who may never have been there and who therefore have tried to match the reality of a fiction. More real than the original, this is *real* fantasy. Here the real city meets the reel city; it is a replicant, which is never just a copy of the original. The city remade in a film studio is a geography in its own right. It is a cine city—a lived city, traversable and habitable on its own geopsychic terms, both visually and aurally.

The audio track is an important part of this urban construction. As Wim Wenders demonstrates in his *Lisbon Story* (1994), soundscapes define cities: they construct urban spaces and make them into specific places and sites of memory. As inhabitant-spectators of the haptic architectural journey, we are deeply affected by the sounds of a city. Naples has a particular sound. With its penchant for musicality, it has been the setting of many musical film stories. The sounds of Naples include the local *sceneggiata*. These musical melodramas endured from the "silent" 1920s, when there was actually live accompaniment, through the sound period. Some aspects survived and were reinvented over the course of the development of the post–World War II popular cinema, from the films of Roberto Amoroso to the recent movies of Nino D'Angelo.

Musicality, noise, and body language defined the cine city that gave birth to Elvira Notari (1875–1946), Italy's first and most prolific woman filmmaker, for whom Naples was a permeable and transient city-body.[16] This "located" physiognomy later resounded in the work of the actor Totò and in that of the playwright-actor Eduardo De Filippo, who adapted and directed many of his own plays for the screen.[17] This Naples was envisaged as a "plebeian metropolis," to use the expression of Pier Paolo Pasolini, who, also working with situated physiognomy, offered poignant visions of the city as a film body.[18]

The musical corporeality of Naples has lent itself to filmic representations of popular culture and street life. These views were not always produced locally, and they always functioned in *transito*. A most interesting case is the cinema fabricated for and by Neapolitan immigrants in the United States. In the immigrant film *Memories of Naples* (1931), for example, the city itself emigrated, functioning as a displaced home for those whose own sense of home had been complicated by emigration. In the immigrant cinema, the reinvention of Neapolitan *dal vero* acted as an imaginary journey: the impossible voyage of a return home.

On the city map, the immigrant cine city met other traveling versions of a popular Naples. Views that portray a city of the poor span the history of sound film, from Alessandro Blasetti's 1932 *La tavola dei poveri* (*The Table of the Poor*), a film version of the trenchant play by Raffaele Viviani, to Werner Schroeter's *Neapolitanische Geschwister* (*Kingdom of Naples*, 1978), which follows the postwar story of a poor Neapolitan family over the course of thirty years. Over time, the image of Naples as a plebeian metropolis—not always innovative and marred by overrepresentation—has teetered on the verge of stereotype. The musicality and street life of the city ultimately have been transformed into an internationally constructed folklore.

A situated critique of such a vision is offered by Francesco Rosi, who claims to portray the city "from within the position of a city dweller."[19] His film *Le mani sulla città* (1963) denounced the corrupt "hands over the city" long before this corruption reached public exposure. Here, Rosi eschews the folkloric version of Naples for quite a different image. In establishing shots and frequently inserted panoramas that make use of tracking, the film documents the building of a new city. The bombed city of neorealism here becomes the city of the "economic miracle," a huge new construction site. Naples, like most West European cities, was subjected to radical urban shifts in the 1960s. Building by building and condominium by condominium, the periphery of the city expanded, creating new notions of metropolitan living. Unlike Antonioni, Rosi criticizes the politics of postwar architecture—as Godard would do for Paris in *Deux ou trois choses que je sais d'elle* (*Two or Three Things I Know about Her*, 1967). Godard, like Rosi, exposed the weak links between capitalism and modernization as he turned the new Paris of "the exterior boulevards" into an *Alphaville* (1965). Rosi's own architectural critique is a specific political analysis denouncing corruption and the role of the local mafia, the *camorra*, in the building of the new Naples.

The cine city has rendered shifting architectural forms of living—in postwar to contemporary incarnations—that dwell on the threshold of narrative and lived space. A film such as Mario Martone's *L'amore molesto* (*Wounded Love*, 1995) extends the trajectory of Rosi's *Hands over the City* as it sketches a new urban narrative alongside an architectural commentary. The city Martone narrativizes here is not the baroque public sphere of his previous city film, *Morte di un matematico napoletano* (*Death of a Neapolitan Mathematician*, 1992). *L'amore molesto* rather documents a radical urban change, as does his *Teatro di guerra* (*Rehearsals for War*, 1998).[20] Naples, "the only true Italian metropolis," is shown undergoing an interesting postindustrial phase.[21] A seat of urban movements, this new-old Naples has become a productive site of the "New New Italian Film," which has effected a Renaissance of Italian cinema in the 1990s.[22]

The new wave of Italian filmmaking, of which Martone and Pappi Corsicato are leading figures, in fact has its center in Naples, where "Vesuvian" filmmakers such as Antonietta De Lillo (*Matilda*, 1991, and *Una casa in bilico*, 1986, both co-directed with Giorgio Magliulo; and *Racconti di Vittoria*, 1996), Antonio Capuano (*Vito e gli altri*, 1991; *Pianese Nunzio 14 anni a maggio*, 1996; *Polvere di*

Napoli, 1998), and Stefano Incerti (*Il verificatore*, 1995) are creating a "situated" cinematic image of the city.[23] A composite map of this geography is designed in *I Vesuviani* (1997), an omnibus film authored by all five filmmakers, who confront diverse aspects of their urban genealogy. Contributing to the filmic map of the area are also Giuseppe Gaudino, screenwriter of Gianni Amelio's *Il ladro di bambini* (*The Stolen Children*, 1991) and *Lamerica* (1994) and author of the "volcanic" *Giro di lune tra terra e mare* (*Moon Spins Between Land and Sea*, 1997); and Edoardo Winspeare, who as a distant observer made *Pizzicata* (1996). This regional urban cinema was preceded in the 1980s by the work of Salvatore Piscicelli, whose filmography, deserving more attention than it has received, includes *Immacolata e Concetta* (1979), his study of lesbian love in the city; *Le occasioni di Rosa* (1981); *Blues metropolitano* (1985); and *Baby Gang* (1992).

An agent of evolving metropolitan textures, Neapolitan cinema is exploring new as well as ancient locations, prominent among which is "downtown" Naples. Next to the baroque and rococo architecture in the piazze and alleyways of the plebeian historic center, an actual downtown has been erected. It is the first of its kind in Italy, where the phenomenon of downtown, until now, has had no equivalent. The central skyline that defines so many American cities does not exist at all in Italy, and the Vesuvian incarnation is a unique urban experiment. Naples' "downtown" is an imported city in many ways, for the web of skyscrapers was planned by the Japanese architect Kenzo Tange. Called *centro direzionale*, it was designed to house a combination of businesses and residences, creating an alternative administrative center and relieving the overcrowded *centro storico*, the historic center of town. A somewhat aseptic cityscape, this polished downtown has never really taken off. The area remains scarcely inhabited and is progressively closing in on itself. Walled in for security reasons, it is surrounded by bustling metropolitan circulation. The desolate, high-tech downtown, partially burned down before it was even finished, is set between the train station and the industrial area, next to popular and overcrowded old neighborhoods, the debris of the city's fruit market, and the relics of a notorious "hot" junkyard. It is here that Naples truly appears as sequel to *Blade Runner*.

This fabricated city—a displaced Japanese urban map—is the frequent setting for Pappi Corsicato's local yet transnational filmmaking and plays a major role in his *Libera* (1993). From his first feature, the director of *I buchi neri* (*Black Holes*, 1995) has been enamored with the edges of the metropolis. The recognizable geography he often depicts could, nevertheless, be elsewhere. It is almost always a cinematic elsewhere: Corsicato's queer cinema represents urban, hybrid socio-sexual margins with an ironic, topocinephilic touch. He can make the landscape of Naples into a global or morphed space, as when he films a local resort area as if it were the site of a 1970's American road movie. *Libera* depicts life in a downtown skyscraper in the same parodic way and makes it ecologically incorrect. Here, apartments are equipped with such essential domestic accessories as the "eco-light," a policing device that detects unnatural fabrics and lights them up. Activating polyester attire in this way, it transforms the outfits into amazingly seductive glowing textures as it offers a tour of new fashions in the newly designed city of micro fibers.

These are the novel pictures (and picturesque) from Italy: a continuing "rapid diorama" of a city that resists control and reinvents itself on the margins. *A suivre.*

A FILMIC GRAND TOUR

Against this panorama of the city cinema, let us now restage Roberto Rossellini's *Voyage in Italy*, critically remapping a film that also has been known as *Strangers*.[24] In this context, *Voyage in Italy* appears as a fragment of a larger map drawn for touring the (cine) city. If, as Michel de Certeau claims, "every story is a travel story— a spatial practice," this is particularly the case for *Voyage in Italy*, a film in which, as André Bazin put it, the city is drafted as "mental landscape."[25] A cinematic voyage of this kind, the movie virtually defines architectural tourism.

The story concerns a house. An uncle—significantly named Homer—who had left his British motherland and made a home for himself in the famed Mediterranean bay, has passed away. A wealthy English businessman and his wife travel to Naples to deal with the aftermath of his death and claim the house he has left them. While Alex wants only to liquidate the situation and sell the house, Katherine embraces the trip and its deadly trajectory. On the road and in the house they progressively grow apart, becoming strangers to themselves and to one another.

In its presentation of topophilia, the film seems almost entirely an excuse to construct an architectonic view in motion of the city and its surroundings.[26] Constructed as a showcase for the sites, it barely has an actual plot, in fact; in the conventional sense, one could say that nothing happens. We follow the couple as they journey down to Naples, accompany Katherine on her Neapolitan tours, and travel with Alex as he visits the island of Capri. As Ingrid Bergman recalled, Rossellini "was only looking for a story into which he could put Pompeii and the museums and Naples and all that Naples stands for, which he was always fascinated with. . . . He wanted to show all those grottoes with the relics and the bones and the museums and the laziness of the statues."[27]

In this sense, *Voyage in Italy* further develops Rossellini's narrative style, often so descriptive and topophilic that the story, produced from this love of place, comes to "suit" itself to the landscape. *Stromboli* (1949), for example, another work from the director's "Bergman period," is constructed literally around elements of geology and topography. The story is generated from—indeed, made possible by— the harsh landscape of the island, dominated by an insurmountable volcano that radically separates the two villages located there. Insurmountable also is the emotional and cultural difference that separates the heroine, a "stranger" in town, from her husband, a native of the island. Her difficulty in communicating across cultures and her dreams of escape are inscribed in the landscape and mapped onto the topography of the land. In the end, she will literalize her flight from the restrictive socio-sexual customs of the village by climbing the volcano in an attempt to reach the other side and freedom. Similarly, the fictional deployment of *Voyage in Italy* is

overwhelmingly determined by site and carried by the topography of the land and its geological fiber, in sheer travelogue fashion.

ILLUSTRATED VOYAGES

Following the well-known script of the picturesque voyage, *Voyage in Italy* takes us on a grand literary tour. A step-by-step reconstruction of this long traveled path, the film, intertextually bound to the visual imaging of travel culture, is particularly attuned to the art of describing of travel writing. We have seen how traveling artists often accompanied writers on their journeys, creating travelogues that combined city views, landscape paintings, field glasses, compasses, topographic material, and maps.[28] *Voyage in Italy* represents a film version of this composite traveling pleasure. In fact, the film's text has observational antecedents in travel diaries such as *Beaten Tracks, or Pen and Pencil Sketches in Italy by the Authoress of a 'Voyage en Zigzag'*.[29] What Katherine chooses to do in Naples, the sites she decides to visit, and the ways in which she tours the country correspond to the practices established in these accounts. Although she has substituted a camera for the easel, the film takes the same road to "picturing" that British traveling followed well before the invention of cinema: the classic tradition of the grand tour taken by northern Europeans and avidly recounted in writing. It is this "Voyage in Italy" that provides historic documentation for our female traveler, who follows literally in its footsteps.

11.3. A sketch of Naples sent from *The Sisters Abroad: or, An Italian Journey* by Barbara H. Channing, 1856.

NAPLES.　　　　　　Page 39.

Voyage in Italy is in many ways an archaeological dig. Like the grand tour, Rossellini's filmic version is consonant with antiquity and surveys the land with a painter's eyes. The Latin writers still inhabited the land that the grand tourist and later travelers visited during their voyages in Italy. When this classic journey ended in Naples, voyagers lingered there to absorb its beauty and history.[30] Admiring the landscape, they searched for "the qualities that they appreciated in the most fancied landscape painters: a Poussin, a Claude Lorrain, a Salvator Rosa. The Neapolitan region was considered the most beautiful in the world."[31] The traveler to Italy thus searched for the emotion of a painted, cultured landscape and remapped that particular experiential site that is the painterly imaginary. "Framed" by painterly contours and writerly profiles, this was a voyage of the geographical imagination; traveling to Italy was another way of fashioning landscape imaging.

TRAVEL LECTURES

As it follows the grand tour and various forms of picturesque voyage, Voyage in Italy offers an historic travel lecture in the most literal sense—a lecture of the kind that was fashionable in those prefilmic times that gave rise to the travel film. In its characterization of sites, the film in fact reproduces the actual scenography of the illustrated travel lecture. Looking backward into the history of travel culture, it thus reinvents the very genealogical discourse that produced the cinema. We have shown how, at the inception of film history, the desire for travel lectures anticipated the establishment of filmic spectatorial pleasures that were geographic in nature. John L. Stoddard was one of the most prominent lecturers, who gave illustrated talks on Naples and published their contents and images. His lectures reveal the historical construction of topophilia in the form of a traveling mosaic:

The Bay of Naples holds within its curving arms the history and legends of two thousand years. Few spots on earth awaken such absorbing interest. Not one surpasses it in beauty. Even in this prosaic age it still remains a copious fountain of romance. Year after year, and century after century, the worshipers of Nature from all lands have come to its . . . bay.[32]

The narrative of Stoddard's travel lecture and the pictures that accompany it "illustrate" Naples in the same way Katherine and Alex show it to us. He notes how "the tourist . . . feast(s) his eyes only on the grand, incomparable view," but "in the heart of the city . . . noise, rags, dirt, . . . torrents of humanity" inhabit the streets.[33] He takes us also to Pompeii, which "places the historian and the thoughtless tourist upon practically the same ground."[34] This landscape of ruins, together with the famed island of Capri, offer "enchanting scenery. . . . [One] can hardly imagine a more picturesque situation."[35] Moving from the aerial views of the bay to street scenes and the sites of Capri and Pompeii, Voyage in Italy offers a similar narrative tour of the city; in so doing, it creates a late filmic version of the travel genre that constructed the very scene of film narrative and its language and evokes the form's implicit ideological perspectives.

EAST OF EDEN/SOUTH OF THE WEST

Alex, in particular, appears to share a number of Stoddard's views of travel in Italy. Both display an attitude that at times makes Naples as "exotic" as any destination in the Far East might seem, especially when they observe the Neapolitan's relationship to food. Stoddard writes in his travel lectures:

One night, in driving through a market-place, we saw a vender of spaghetti. Stopping the carriage, I paid him to distribute twenty platefuls to the people, that we might watch them eat it. . . . In three minutes our cab was like an island in the sea of roaring, struggling humanity. . . . The instant that one wretched man received a plate a dozen others jumped for it; and four or five black fists grabbed handfuls of the steaming mass, and thrust the almost scalding mixture down their throats. I had expected to be amused, but this mad eagerness for common food denoted actual hunger.[36]

Watching Neapolitans eat as if on display at a zoo is a "curiosity" that traveled intact from Stoddard's travel lectures to the travel-film genre. *Eating Macaroni in the Streets of Naples* (Edison, 1903) cinematically recreates Stoddard's verbal and photographic scenario in a frontal medium-shot that solicits an identical gustatorial show from the "natives": a "roaring, struggling humanity" manually thrusting down their throats those funny noodles that one finds south of the West.[37]

Approaching the south, Alex, too, appears uneasy. The male protagonist of *Voyage in Italy* begins to fear an explosion of the flesh. As a British traveler, he may be in danger there. His coolness, alas, may be disturbed. Too much body heat. Not to speak of the spicy food. That sunny southern European land is said to be inhabited by noisy people and plenty of insects. He may even be in danger of catching malaria. The "Continent" is full of surprises for Alex, and being in a foreign land provokes in him the anxiety of the hegemonic viewpoint: a part of Europe becomes *terra incognita* on his cultural map.

In *Voyage in Italy*, Western culture emerges as a mosaic of diversified imagings, out of compliance with the unified and unifying concept it is sometimes imagined to be. The monolithic view of Eurocentricism fails to explain a number of multilayered historical phenomena and cultural geographies that make up the West. Difference and the "dangers" of otherness reign on the cartography of "-ism," which is not a unitary view but an extremely fragmented map. As recent European history sadly suggests, Eurocentricism, like Orientalism, is a complex projection.[38] Otherness and sameness inhabit this discursive house of mirrors.

In many ways, the voyage to Italy has been a participant in the (touristic) colonization of the West. Italy was the site to which northern Europeans went in order to acquire the cultural sensibility to establish power back home and to affirm the superiority of their nationalities.[39] Thus propelled by voyage, a phenomenon of "orientalization" has shaped sections of the European land and become part of the internal history of Europe. The resulting cultural map shows that geography is not a science: its cardinal points are not always objectively fixed. In the cultural geography to which the history of travel belongs, there is a "South" of the West, which is actually an East.

This geographical descent has affected the history of Naples in particular. In the literary imagination that over the centuries constructed it as a traveled topos, Naples has been "viewed" as a non Western Western city. At times, it is seen as a "porous" version of "the African kraal," as Walter Benjamin and Asja Lacis put it in their reflections on the city.[40] Naples is also often represented as an Oriental city. In this process of displacement, the British perspective has played an important role by magnifying its un-Westernness. Norman Lewis, a British writer and intelligence officer who authored a book of memoirs entitled *Naples '44*, observed, for example, that: "Naples is extraordinary in every way. At the end of the last century, Scarfoglio, leading Italian journalist of his day, wrote, 'This is the only Eastern city where there is no residential European quarter,' and the witticism still seems to hold good."[41] Through Alex's eyes, *Voyage in Italy* recapitulates the classic voyage of the British traveler to Naples. Here, the voyage in Italy may as well be "a passage to India." Alex holds good the idea that Naples is even more Eastern than the East. There is no sign of European quarters in this uncolonized, rather uncolonizable city of exotic habits. Driven by leisure and lust, the place somehow manages "to mix noise and boredom," in Alex's words. "This country poisons you with laziness," he says.

Alex's filmic voyage in Italy bears the scent of many tourist guidebooks. At the time the film was made, the *Blue Guide* described the voyage to Naples as it would a voyage to Bombay, especially alerting travelers to beware of beggars, *scugnizzi*, and *lazzaroni*: "In Naples the persistent attention of small boys, rarely innocent whatever their age, should be firmly but kindly discouraged."[42] A creation of "types" has taken place in such travel discourse, which as Roland Barthes has pointed out, closely involves geography—itself constructed as any other cultural landscape. As he writes: "The *Blue Guide* hardly knows the existence of scenery except under the guise of the picturesque. The picturesque is found any time the ground is uneven. . . . Just as hilliness is overstressed to such an extent as to eliminate all other types of scenery . . . for the *Blue Guide*, men exist only as types."[43]

THE VOYAGE IN ITALY FROM A WOMAN'S TRAVELING DESK

In Rossellini's version of the voyage in Italy, Alex's orientalizing view is not entirely shared by Katherine, who tries to see the country through a different set of glasses, to venture beyond her husband's typological perspective. As a female traveler to Italy, Katherine steps into a complex social history of travel. With some exceptions, the grand tour in the seventeenth and eighteenth centuries had been the domain of mostly upper-class northern males. But the beginning of the nineteenth century saw more and more women undertaking the voyage in Italy and establishing their own set itinerary. In 1802, Mariana Starke published the letters she had written during trips she made between 1792 and 1798; her *Travels in Italy* paved the way to a number of female publications describing women's travels.[44] The voyage in Italy was fictionalized by Germaine de Staël in her 1807 book *Corinne, or Italy*.[45] It fascinated women

like Mary Shelley, who wrote of her travels in *Rambles in Germany and Italy*, as well as many "anonymous" authors of letters, memoirs, diaries, and reports.[46]

Surveying this "minor" literature, we observe the making of a gendered voice. Women's travel reports on Italy pay attention to areas of existence that are not much explored in the male literature. Their curiosity touches on various aspects of Italian daily life: they report on people's habits and behaviors, commenting on the different ways social and private lives are organized, and include copious details on domestic life and the *space* it occupies. Here, the status of women and the forms of their existence are given "room" for consideration in a type of writing that appears concerned with space in all of its expressions.

In women's versions of the voyage in Italy, a visit to Naples' archaeological museum (where Pompeiian statues, frescoes, and artifacts are displayed) or to Pompeii itself is often accompanied by observations on the life in this ancient site and the ways in which it compares with current modes of living. Diary entries such as the following are much concerned with the "design" of everyday life:

We entered Pompeii by the streets of the tombs: near them are the semicircular seats, so admirably adapted for conversation that I wonder we have not sofas on a similar plan, and similar scale. . . .

The streets of Pompeii are narrow, the houses are very small, and the rooms, though often decorated with exquisite taste, are . . . dark, confined and seldom communicate with each other, but have a general communication with a portico. . . . It is evident that the ancient inhabitants of this lovely country lived like their descendants mostly in the open air, and met together in their public walks, or in the forums and

11.4. A voyageuse at her traveling desk: portable table and library designed by Louis Vuitton, Paris.

Modèles de Louis Vuitton.

Malle secrétaire

theatres. . . . The houses seem constructed on the same principle as birds construct their nests; as places of retreat and shelter, rather than of assemblage and recreation.[47] Female travelers to Italy comment on architecture and interior design as well as food and fashion as part of their concern for the history of habitual matters. Indeed, these diaries show how profoundly linked these spaces are as forms of habitation. This is evident, for example, in Mrs. G. Gretton's *Impressions of Life* (an account of *The Englishwoman in Italy*) or in Mrs. Ashton Yates's *Winter in Italy in a Series of Letters to a Friend.*[48] This latter female traveler focused her eye on display and incorporated its wearable and digestible pleasures into her life. As we browse with her through a cultural archive, it comes alive—as when her visit to Naples' museum becomes a type of urban shopping trip:

Though tea may have been unknown at Pompeii, fruits were not; for a dessert found there is laid out, consisting of walnuts and other nuts, prunes or plums, figs and currants. . . . I must not forget, whilst on this subject, to notice a full set of the paste-cutters, such as confectioners of the present day employ in the manufacture of ornamental pastry. . . .

We saw a glass-covered table in the middle of the room, which displayed necklaces, pins, bracelets, earrings & c., composed of coloured stones and gold finely wrought, all apparently of the most modern description, though fabricated there is no saying how much more than eighteen centuries ago. . . .

We could no longer remain at the Museo; the doors were closed; so whilst our impressions were recent as to bracelets and other ornaments worn by the belles of Pompeii, we repaired to our jeweller's to see if he was executing some we had ordered in strict accordance with the antique models we had been examining.[49]

As we pointed out earlier, women travelers often employed fashion in their writing as the basis for creative and cultural analysis.[50] Travelers to Italy were no exception. They widely discussed clothing and fashions of space as signs of cultural difference bound up with gender difference. Travel in Italy also turned women from fashion critics into fashion designers: affected by the strictures of costumes that were not designed for venturing, female travelers sometimes designed their own traveling attire, shaping their image on the road.

LUGGING AROUND CULTURAL BAGGAGE: FASHIONS OF TRAVEL

The sartorial concerns of female travelers included the luggage that contained their garments, which is often pictured in the sketches that accompany their travel reports. Indeed, one can read the entire history of travel by looking at baggage and considering its contents and transformations. In reading women's diaries of travel in Italy and in roaming through a private museum of voyage such as Louis Vuitton's, it becomes clear that a gendered history of social mobilization molds the history of design.[51] Acquiring "a room of one's own" implies a fundamental movement, for to own such a space one must gain mobility; the room itself must move. The diversification of means of transportation in the age of modernity and women's impact on

this aspect of modern life is written on the very "fashioning" of traveling objects. Traveling wardrobes as well as traveling beds and traveling desks in many ways mobilized our lady travelers and their space. Equipped with traveling desks, women could write their reports and journals on the road. Prefilmically, observations could be constructed as the travelers moved along a changing terrain.

This mobilization becomes particularly important if we continue to understand it in relation to a concomitant "interior" movement, for landscape is not only a matter of exteriority: the impact of landscape extends inward, into one's own interior landscape. The mobilization of one potentially impacts the expansion of the other. This is possible because, as Madeleine de Scudéry's *Carte de Tendre* shows,

exterior and interior are representationally connected: the geographical imagination includes and traverses both. This is especially manifest in women's travel culture. Here, one is drawn to topography: the land provokes an emotional response; geography is a way to express one's feelings. It becomes a vehicle for emotions that may not surface otherwise. From early travel diaries all the way to *Voyage in Italy* and *L'amore molesto*, geography has drawn on psychic paths. Women's self-portraits become pictured on the "face" of the earth. Physiognomy—from the unclothed surface of the skin to the earth's surface—appears to guide the tour.

On the face of geography, the history of women's travel reveals itself as a voyage of self-discovery. In this type of exploration, the Italian landscape was a favored site: a land much dreamt of and especially desired by female travelers.[52] With its picturesque qualities, teeming with historic memories, the Italian landscape particularly lent itself as a vehicle for women's subjective, psychic voyages. Loaded with mnemonic ties, the voyage in Italy provoked a personal response from women. It connected history with their own stories, memories with their pasts. Traveling in Italy was this *emotion*.

A CARTOGRAPHIC ACCOUTREMENT: THE TRAVEL DIARY

As if hearing voices from the female voyagers who preceded her in self-discovery, Katherine composes her own filmic version of the voyage in Italy. Like Charlotte Vale, the protagonist of *Now, Voyager*, she, too, embarks on a voyage of transformation—a "refashioning" of the self. In order to picture Katherine's journey, we must unravel an entire montage of transhistorical traveling images and look at the city composed in these journeys as a traveling map. In doing so, we will invent a topography. Here, pictures, maps, and citations unfold like a map from a travel guide. Like most travel writing, this will be a personalized guide.

In preparation for the montage of travel writing that accompanies Katherine's voyage in Italy, we might call again on Anna Jameson, author of the semi-autobiographical and semi-fictional *Diary of an Ennuyée*, who introduces us to the tactile pleasure of opening a travel diary, that essential accoutrement of cultural mapping, for the first time. It is 1826. With a diary in hand as her cartographic tool, she sits at her traveling desk and begins her travel/writing:

What young lady, travelling for the first time on the continent, does not write a "Diary?" No sooner have we stept on the shores of France—no sooner are we seated in the gay salon at Dessin's, than we call, like Biddy Fudge, for "French pens and French ink," and forth steps from its case the morocco-bound diary, regularly ruled and paged, with its patent Bramah lock and key, wherein we are to record and preserve all the striking, profound, and original observations—the classical reminiscences—the thread-bare ruptures—the poetical effusions—in short, all the never-sufficiently-to-be-exhausted topics of sentiment and enthusiasm, which must necessarily suggest themselves while posting from Paris to Naples.[53]

GRAND TOURS OF EMOTION

February 28

We spent today in ecstasies over the most astonishing sights. I can forgive anyone for going off his head about Naples. . . . One . . . could never be really unhappy because his thoughts could always return to Naples. . . . My eyes pop out of my head.

March 1. Evening

Who has not had the experience of being swept off his feet . . .? How shall I describe a day like today? —a boat trip; some short drives in a carriage; walks on foot on some of the most astonishing landscape in the world; treacherous ground under a pure sky; ruins of unimaginable luxury, abominable and sad; seething waters; caves exhaling sulphur fumes. . . .

The map I made on the spot for our use and a quick sketch of Tischbein's will be of great help. . . .

March 11

As Tischbein and I drove to Pompeii, we saw on every hand many views which we knew well from drawings, but now they were fitted together into one splendid landscape. . . .

The mummified city left us with a curious, rather disagreeable impression.
Johann Wolfgang von Goethe[54]

11.6. A moving map: Giovanni Carafa, duke of Noja, *Topographical Map of the City of Naples and Its Surroundings,* 1775, folio 8. Engraving.

As a foreigner in Italy, Katherine is more motivated than her husband, Alex, to travel the city and visit the sites. Museums, as he puts it, bore him. He would rather seek fun in Capri or pick up a prostitute than go on her "pilgrimages." Over the course of the film, Katherine makes five canonical touristic journeys, following the animated path of Goethe's famed *Italian Journey* and its various offshoots. In the first, she pays a visit to the museum of Greek and Roman antiquity. The Museo Nazionale has long been a must-see for the cultivated traveler, and in this famed archaeological museum, Katherine, too, admires the beauty of the statues. From there she travels to the grotto of the Cumaean Sibyl, the ancient sanctuary where, as Virgil recounts, Aeneas went to consult the prophetess. As we learn from women's travel reports, the Sibyl had particularly fascinated female travelers, for she was a "modern" woman *ante litteram*, "fond of traveling" and so skilled at dealing with money that, had she been able, she would have enjoyed playing the stock market:

The Cumaean Sibyl . . . offered for sale to Tarquin, king of Rome, the books of the oracles; he at first declined the acquisition, upon which she burned several . . . [and] demanded still more for the few that remained. . . . He, like a paltry customer, was obliged to submit. . . . There was no putting in the funds, nor purchasing of railroad shares in those days; so what investment she made of her money, history does not inform us. . . .

Like modern ladies, it seems she was fond of travelling, and often left home.[55]

After the visit to Sibyl's cave, Katherine continues her descent into the depths of the region, traveling to see the sulfurous vapors that rise from the volcanic soil of the earth at Solfatara. A visit to the catacombs follows, where she finds a morbid display of skeletons. Finally, she makes the essential trip to the dead city of Pompeii, thus completing her "picturesque" voyage in Italy.

The purpose of Katherine's tour, as it was in the tradition of the picturesque voyage, is to feed the intellect with intense aesthetic sentiment. Katherine emotionally revisits an ancient body of work in her pilgrimage to the various sites that house traces of Roman and Greek culture. In a geography marked by the depth of history, her terrain becomes the ruins of the past. Traveling this picturesque topography, from caves to volcanoes, it is Virgil who still guides her trip. And it is view painting which she adopts as the lens through which to frame her views and guide her picturing.

Voyage in Italy consists primarily of Katherine's journey and "chronicles" the series of outlooks she has on the land. As it offers this record, an intimate report of her tour, the film is conceived as a diary, like many women's travel books. It unfolds as a montage of observations and reflections made by a woman to herself, which, in travel writing, also become letters written to friends and postcards sent to distant viewers. The filmic architectonics follows this diaristic model. How many times does one read in female travel diaries entries beginning with phrases such as "we have been today to . . ." and "then we went to . . . " and "next came . . ."? Description by description, the tourist site-sees in the very way the filmic tourist observes. Sequence by sequence, in the style of a travel report, the film moves us from site to site. From outside in, and inside out.

11.7. The e*motion* of mapping continues in Carafa's *Topographical Map of the City of Naples*, 1775, folio 9. Engraving.

AN UNSETTLED URBAN MAP

Naples' surroundings are the most beautiful in the world. The destruction and the chaos of the volcano drives our souls to imitate nature's criminal hand.
Marquis de Sade[56]

Naples is a city that has the structure of a novel. The streets are full of stories that ask to be transcribed. But Naples' narrative can only be a baroque and surrealist novel, unfinished, unresolved, contradictory.
Tahar Ben Jelloun[57]

Naples, like Paris, is a great capital city.
Stendhal[58]

Katherine enters the ex-capital by car and, in so doing, commences her own mobilized travel story. Her baroque, unfinished, unsettling novel unfolds at the speed of modern travel. The town's ruinous air immediately affects her. The volcano's destructive hands take hold of her, beginning to tear both her and her marriage apart. She can feel that this city has quite a shaky history. It is written onto its soil. Through the frame of the car's window, Katherine looks, puzzled, at its "moving panorama."

11.8. The makeup of a woman's voyage: panorama from the dashboard of *Voyage in Italy* (Roberto Rossellini, 1953). Frame enlargements.

A MOVING PANORAMA

Now they were in the much longed-for Bay of Naples, and Helen's heart beat faster as she tried to remember how she used at home to think it would look, before she ever dreamed of seeing it with her own eyes. . . .

Our travellers held their breath, as their eyes caught, one after the other, the different points of this wondrous panorama. . . .

They drove through the long, narrow streets, which intersect continually. Crowds of priests, women, children, donkeys, vehicles of wonderful shapes, cooking operations, selling, boot-cleaning, and everything else imaginable, form this moving panorama. . . . Naples . . . appeared both idle and gay in its bustle.

[Barbara H. Channing], *The Sisters Abroad*[59]

11.9. A panoramic *veduta* in Carafa's *Topographical Map of the City of Naples*, 1775, folio 27. Engraving.

11.10. A panoramic *veduta* from *Voyage in Italy*. Frame enlargement.

Katherine has arrived in Naples with a guidebook in her hand. Like many earlier female travelers on their voyage to Italy, she too has expectations about the city, and has nurtured them through reading. She thinks she is prepared. Yes, there is the famous bay, laid out as a moving cinematic picture postcard. She takes in the panorama but, like the anonymous "sisters abroad," is more attracted to the "moving panorama" of the metropolis.

She drives herself through the city, through the long and narrow streets, which intersect continually. At every crossroads she looks through the window at all that composes the city's moving geography. Priests walking under Communist party posters, women, children, animals, vehicles of all kinds, cooking operations, processions, and everything else imaginable form the moving panorama of this (un)picturesque city.

(UN)PICTURESQUE CITY

Lovers and hunters of the picturesque, let us not keep too studiously out of view, the miserable depravity, degradation and wretchedness, with which this gay Neapolitan life is inseparably associated! . . . Painting and poetising for ever, if you will, the beauty of this most beautiful and lovely spot on earth, let us, as our duty, try to associate a new picturesque with some faint recognition of man's destiny and capabilities.
Charles Dickens[60]

The moving panorama that Katherine pictures for us as she drives through the streets of Naples, looking through the frame of her car window as if through the framed view of a *mondo nuovo* box, is indeed a "new picturesque." Her gaze does not block from view the depravity, degradation, and wretchedness—that dark side which is inseparably associated with gay Neapolitan life. Unlike Alex, she is not horrified by it. She becomes topophilically attracted to it. She moves closer to the city-body.

11.11. Soundscape: "the orgiastic cult of noise" in an (un)picturesque city, from *Voyage in Italy*. Frame enlargements.

CITY-BODY

*Naples is not, like Venice, Florence, and Rome, one of the cities of the
soul. You are too constantly deafened; reverie and contemplation are per-
petually interrupted; you . . . must shut yourself up with the silent com-
pany of the statues; you cannot live in the past; you are too much jostled;
you are overcome by the continual fever, the sterile activity, the indefati-
gable and idle curiosity which stir so many thousands of beings.*
Auguste Laugel[61]

Naples is not a city of the soul; it is a city of the body. Or rather, its body is always
in the way of rarefied emotions. Cinematic at heart, the corporeal Naples defeats any
attempt at contemplation. It shows itself only in constant (e)motion. Katherine is
astounded at the continual fever that drives it, the indefatigable and idle curiosity
that stirs the population. One is constantly deafened here by the incessant clamor.
And all that music. An "orgiastic cult of noise."

SOUNDSCAPE: AN ORGIASTIC CULT OF NOISE

*Why not talk about the orgiastic cult of noise? . . . When the Neapolitan
fulfills his utmost desire and goes to buy a motorcycle, he will systemati-
cally try them all out in order to keep the one that makes the most noise.
I will never forget the opening of the underground railway, which was
inaccessible for days, for all the ticket counters were besieged by street
kids whose screaming was louder than all the noise made by the train and
who, during the trip, filled the gallery with piercing cries.*
Walter Benjamin[62]

If sound builds the urban landscape in movement, this is particularly true for Naples:
it is not only a musical city, as we have seen, but a noisy one. Filmic city tours such
as Rossellini's *Voyage in Italy* and Martone's *L'amore molesto* have interestingly
"pictured" the Neapolitan cityscape through its sound. In this latter film, the city's
soundscape stands out for its loudness and for its maddening quality—the silencing

effect of its noise. While human cries and the clamor of traffic today combine to drive everyone happily mad, *Voyage in Italy* was made before machines had significantly added to the human propensity for the "orgiastic cult of noise." Here, then, the orgy of human sounds becomes even more pronounced and is an essential element of the filmic voyage. Sound is everywhere in the film: from the credit sequence on, it is a continuous presence that has an existence of its own, even outside of narrative motivations. From the very moment Katherine and Alex arrive at the dead uncle's house, the streets of the region appear to be inhabited by the interactive sound of objects, voices, and singing. This nondiegetic sound track is not at all a musical accompaniment, secondary to the picture. It is the picture—the very portrait of the city.

RHYTHMANALYSIS OF A MEDITERRANEAN CITY

> *Rhythms: music of the City, a picture which listens to itself, image in the present of a discontinuous sum. Rhythms perceived from the invisible window, pierced in the wall of the facade. . . .*
>
> *This analysis of rhythms, in all their magnitude 'from particles to galaxies,' has a transdisciplinary character. Moreover, it gives itself as aim the least possible separation between the scientific and the poetic.*
>
> *In this manner we can try to draw the portrait of an enigmatic personage wandering the streets of a large Mediterranean city. . . .*
>
> *Venice . . . Syracuse, Barcelona, Palermo, Naples and Marseilles. . . . Cities given over to tourism who fiercely resist homogenization, linearity, rhythms of the 'other'.*
>
> Henri Lefebvre[63]

Voyage in Italy demonstrates that the creation of a cityscape is a multifaceted affair of the senses. Making sense of a city requires an *emotional* lens, that sweeping view that Henri Lefebvre called a "rhythmanalysis." Lefebvre developed this view while looking out the window of his apartment onto the streets and thinking in particular about the geography and history of Mediterranean cities. A transdisciplinary perspective encompassing the theory of measure, music history, and chronobiology as well as other geographies and cosmological theories, rhythmanalysis, "seen from the window," writes the city filmically—screens it.

Seen from an apartment window, as Lefebvre viewed it, or from a car window, as Katherine does—from a viewpoint that is a body double for the framed, mobile view of the film screen itself—a Mediterranean city unfolds its rhythmic map. The sea-bordering view of Naples frames a heterogeneous city that moves with the connecting rhythm of waves. The mediation of the sea unites it with other solar Mediterranean cities. All marked by tourism, these unruly cities are linked by a tra-

11.12. Intimate views from the car to the streetscape in *Voyage in Italy*. Frame enlargements.

dition of sea voyage that dates to the time of Homer's *Odyssey*. In the rhythms of these metropolitan waves, sound plays a crucial role as one of the tangible ways in which public space is acted out and privacy is articulated.

Indeed, a number of emotional layers make up a landscape. Geographically speaking, these include homescape, bodyscape, deathscape, and smellscape, as well as soundscape.[64] As a component of the cityscape, the soundscape of Naples closely interacts with its pronounced deathscape and bodyscape. Naples' musical body-city is constantly courting death. Here, Katherine feels surrounded by the rhythms of passionate excess and decay that are pierced in the walls. Listening to the city's pronounced sound, perspiring from the belly of the city, she is affected by an overwhelming body heat.

BODY HEAT

> *I had never yet had such an impression of what the summer could be in the south or the south in the summer. . . . The Bay of Naples in June might still seem quite final. That picture struck me . . . as the last word. . . .*
>
> *The place is at the best wild and weird and sinister. . . . I seemed, under the blaze of summer, the only stranger—though the blaze of summer itself was, for that matter, everywhere. . . .*
>
> *I wander wild . . .; my intention having been only to let my sense of the merciless June beauty of Naples Bay at sunset hour and on the island terrace associate itself with . . . [a] feast of scenery. . . .*
>
> *There had been this morning . . . the image of one of those human figures on which our perception of the romantic so often pounces in Italy as on the genius of the scene personified; . . . so the physiognomic representative, standing for it all, and with an animation, a complexion, an expression, a fineness of humanity that appears to have gathered it in it and to sum it up, becomes beautiful. . . .*
>
> *We stayed no long time . . . yet we communicated to intensity, we lay at our ease in the bosom of the past, we practiced intimacy.*
> Henry James[65]

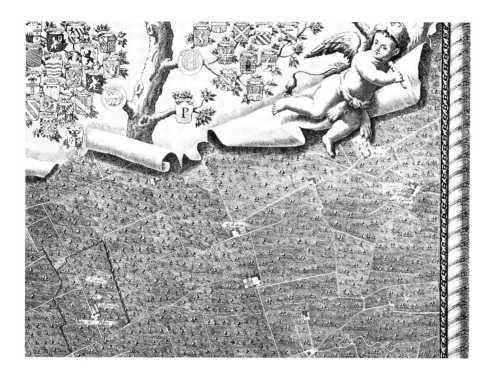

11.13. Flaying the layers of mapping reveals a tangible view of the history of place in Carafa's *Topographical Map of the City of Naples*, 1775, folio 14. Engraving.

It's hot. The volcanic land at Solfatara is hot. People are hot. Heat is everywhere. It overcomes you. Katherine surrenders to the blaze of the summer. Struck by this body heat, she stands motionless. There is nothing to do but give into it. She lies around on the terrace's lounge chairs. Absorbing the sun, she lets her senses run wild, transported by this feast of scenery that is the house's vista. She comes into contact with the *genius loci*. At ease in the bosom of the past, she begins to grasp what it is to practice intimacy. Pondering on the spirit of the place, one can hardly escape the realm of the senses. Camille experienced it in *Contempt*, reclining naked with a book on her buttocks, soaking up the sun on the panoramic rooftop of Casa Malaparte. The genius of the place is the physiognomy of site. An idle affair.

THE IDLER IN ITALY

> *My senses and my imagination have been so enchanted. . . . To stand upon my balcony, looking out upon the sunshine, and the glorious bay; the blue sea and the pure skies—and to feel that indefinite sensation of excitement, that* superflu de vie, *quickening every pulse and thrilling through every nerve, is a pleasure peculiar to this climate, where the mere consciousness of existence is happiness enough.*
>
> Mrs. [Anna] Jameson[66]

For a British traveler, the voyage in Italy can be an imaginative, corporeal descent down into the sensuous depth of existence. No wonder the response to this land has been so emotional: it provides, as Anna Jameson put it, an enchantment of the senses and the imagination. Like many of her predecessors who had ventured south to Naples, into the land of sunshine, Katherine discovers this warm landscape and learns how to make space for herself in the essential ephemeral, with the "indefinite sensation" of pleasure "thrilling through every nerve." She confronts the publicly lived, private space that the female author of *The Diary of an Ennuyée* so aptly called a *superflu de vie*.

Indeed, the *genius loci* reeks of an historical relation to a *superflu de vie* that goes all the way back to the ancient notion of *otium*. A long-lasting historic practice, *otium* might be defined as a form of cultivated leisure. Antique *otium* was philosophically conceived and practiced here by the Romans, and it helped to shape the landscape that would later be offered to travelers. This region was the site of a collective form of leisurely existence: a relaxation that opened the play of the mind, enabling thoughts to wander.[67] As the body and the mind were allowed to roam freely, intellectual paths were forged along the trajectory formed by promenading through, contemplating, or conversing about the scenery. This included regularly immersing oneself in the restorative landscape of the *thermae*—the baths—where taking the waters was the vehicle for an entirely sensuous approach to life, which encompassed one's mental life. The *thermae*, housed in spectacular architectural and natural settings, were places where the spiritual, corporeal, and social life was mindfully cultivated.[68] The *otium* of the *thermae* enabled physical, cultural, and intellectual pursuits to be pleasurably combined into a refined art of living.

Sensing this *genius loci*, Katherine wanders motionlessly. On the terrace of a villa located in this Roman land, she practices a modern sort of *otium*. Moving across the centuries, Roman *otium*—however transformed—has entered modern life in various forms of cultivated leisure. Indeed, *otium* is now lodged in the movie house: it has been turned into the still movement of cinematic spectatorship. Having been transmuted through the ages, however, *otium* is now viewed differently as well: it is considered synonymous with idleness. Embodied momentarily in the twentieth century first in the notion of *flânerie* and then as the drifting

11.14. The idler in Italy: *otium* sinks in during the *Voyage in Italy*. Frame enlargements.

psychogeography of *dérive*, the sense of idleness eventually acquired a negative connotation. It is now wrongly perceived as a state void of intellectual purpose by a society that has turned even the production of thought into a managerial enterprise, applying to the intellectual life the same mode of pressure that rules its myopic view of managerial work itself. This society does not know how to pursue intellectual paths and ideas by way of respite, which includes sensory enjoyment. Compulsively, one either works or works out, even at the day spa—that post-Calvinist remake of the ancient Roman baths.

Allergic to puritanisms, Italy has somehow managed to sustain a healthier perspective. The tourist senses that there is less confusion here between a capitalist notion of the use of private space, on the one hand, and the production of a subjective sense of relational intimacy, on the other, which comprehends intellectual space as part of a "room of one's own." What is most apparent is that Italian culture has managed forms of resistance by bringing into postmodernity (and beyond it) the ancient practice of *otium*, a tender sense of *dolce far niente*, and the historic penchant for the idle perambulations of *passeggiata* as a navigational tactics of daily life—attracting, for this reason, the modern and the cyber tourist.

From the grand tour to *Voyage in Italy*, in the imagination of northern travelers Italy has enlivened the perception of that cultivated leisure ascribed to forms of *otium* and their itinerant, cultured erotics. Katherine is not alone in her search for these sensations, which are written on the body of the Italian land. They affected Claudia's own erotic wanderings in the southern landscape of *L'avventura*, which transpired on a path not driven but let loose. Searching the landscape of this interior state, many female travelers have traversed "idle" matters in Italy.

We may recall how a tradition of idleness was established by Marguerite, Countess of Blessington, who published *The Idler in Italy* in 1839.[69] Others followed. Frances Elliot, who wrote *Diary of an Idle Woman in Italy*, explained her own state of mind:

When I call these volumes "The Diary of an Idle Woman," I do so because I went to Italy with a perfect disengaged mind. . . . I was idle in that I went where fancy or accident led me. . . .

I am at Siena, on my way to Rome, enjoying those idle days where one learns so much.[70]

Frances Elliot let herself go wandering, aware of the difference between her reinvented *otium* and the nothingness in which she, like many modern women, was trapped at home:

And here my diary ends. I am suddenly called back to England, and the "Idle Woman" . . . lays down her pen and becomes "the woman of the period," with really nothing to do.[71]

Before closing her filmic diary, Katherine, too, discovers the roots of *otium* drifting into the cultural depository of that *superflu de vie* that touches her every nerve. Feeling the seduction of the flesh, which lazily exposes itself to view, she allows her idle travels to take her to a place designed for it: a museum.

MONUMENTS OF THE FLESH

Naples, Museo Nazionale. —*Archaic statues offer in their smiles the consciousness of their bodies to the onlooker.*
Walter Benjamin[72]

Museo Borbonico. Paintings. . . . *In the gallery of the Prince of Salerno, we find . . . Ribera.* The Drunken Silenus, *lying on the ground and surrounded by satyrs. —Very beautiful, all naked.*
Gustave Flaubert[73]

Three friends who were traveling in Italy together visited last year the Studj Museum at Naples, where the various antique objects exhumed from the ruins of Pompeii and Herculaneum are collected. . . . The youngest . . . [was] absorbed in profound contemplation. The object that he was examining so closely was . . . a fragment of the mould of a statue, broken in the casting. The trained eye of an artist would easily have recognised the curve of a beautiful breast The commonest traveller's guides will tell you that the lava, cooling about a woman's body, had perpetuated its charming contours. Thanks to the caprice of an eruption which destroyed four cities, that noble form has come down to us; the rounded outline of a breast has lived through ages.
Théophile Gautier[74]

The Museo Nazionale in Naples is a monument erected for the body. Sculpture always has a physical impact, and it often explores a monumentality that is carnal. Remakes of the flesh, ancient figurative sculptures can act as corporeal shrines, or rather body doubles. But these statues are figures of the absent body. Fragments of its fragile historicity, they are live memorials to the deceased. Naples' archaeological museum is a site where ancient figures are preserved only to be freshly encountered. There, archaic statues expose the "consciousness of their bodies to the onlooker." They exhibit the roundness of their contours, marks of their physicality that have traversed the centuries. Moving through the museum's space, the onlooker is drawn toward this sculpted flesh as she seeks to grasp what it has to convey. Here, in contact with such a "body" of art, looking becomes a form of touching, a visual caress. The onlooker accesses a haptic sense of the sculpted work as it offers itself up to be apprehended in the embrace of motion. As monuments to the flesh, these sculptures have imparted the realm of the haptic to many visitor-voyagers, including our filmic Katherine. In the Museo Nazionale, Katherine is made aware of physicality. She cannot avoid feeling what the archaic statues are "exhibiting." She is uncomfortable. But she continues to look and moves closer. These statues seem to be flaunting something she is not "in touch" with. Something that her marriage lacks. Something she yearns for. These ancient bodies turn her on to something she craves. Indeed, they simply turn her on.

11.15. Statues offer "the consciousness of their body to the onlooker": the museum as haptic monument in *Voyage in Italy*. Frame enlargements.

Careful framing and camera logistics shape the making of this carnal scene. Katherine's walk through the museum is constructed in an extraordinary choreography of camera movements. Entering into her curious gaze, the motion of the camera haptically shows us her "approach" to the bodies. As she moves into a wing of the museum, Katherine encounters the nude form of a young man and ponders the harmonious movements of a group of female dancers. A pagan divinity shows her the dangers of the flesh, as does a drunken statue. Katherine moves closer and closer to it. The subjective camera dances around this man, making an exploration of his abandoned, debauched, and naked body.

As she moves through the museum space, Katherine appears further captivated. At first, we cannot see the object of her fascination. We are with her as she moves toward it. A reverse shot shows us that she has been captured by a male nude, a sculpture of a beautiful young man. The reversible movement of approach continues unaltered so that this naked body, which seemed frozen in the act of leaning forward, now seems actually to be reaching toward her. His arm extends to grab her. She turns away, only to confront more physiognomies. Surveying the faces of dead Roman emperors, she eventually lands on a nude statue of Venus, her thighs wrapped erotically in a cloth and her sex exposed. Katherine's guide, whose commentary attempts to render the statues familiar, remarks that this Venus is not as young as others. It resembles a more mature woman. Asked for her opinion, Katherine responds, "Perhaps. I would not know."

The language of the body is a foreign tongue for Katherine. This carnal knowledge is not her own. Not until she becomes a museum passenger. In the idle itineraries of museum-going that remake, in their way, the cultivated leisure of *otium*, Katherine gets close to its seductive offerings. Here, in the very museum devoted to this Roman affair, she senses tactile matters and through sculpture accesses the openness of the haptic. The camera makes this sculptural-haptic not only visible but palpable and obtainable, ultimately revealing how a sculpture is spectatorially experienced in a haptic way, with movement that emoves.

The "pull" that Katherine experiences is morbid. Approaching the nude monuments to the dead, she repeatedly caresses them with her moving gaze. In the face of these simulated corpses, the movement of the camera extends a veritable "reach" for what the dead bodies can bring to life. Near the end of the sequence, the camera circles a corpulent male nude as if embracing it, and in this way the monu-

mental, ten-foot body of Hercules comes to stand in front of Katherine, fully exposed to her desire. From behind the naked statue, we see her figure below, staring up at the excessive flesh laid bare. She exclaims that it is wonderful.

A final exploration of sculptural (e)motion that shows the Farnese bull surrounded by a group of male and female nudes closes the museum sequence. Reporting later about her experience, Katherine remarks that the immodestly exposed statues of men who lived thousands of years ago are just like those of flesh and bones. Initiated into the realm of the senses by statues that haptically communicate the consciousness of their bodies to her, Katherine can now access her own haptics, can activate her emotions. She can attempt to live the physiology of love. And of death.

A PHYSIOLOGY OF LOVE

> *I left Paris. I went through the streets of Marseilles, the waterfront of Tangier, the* basso porto *of Naples. In the narrow streets of Naples, ivies and flowers were growing over the broken down walls. Under enormous staircases, rising open to the streets, beggars lay sleeping beside images of St. Gennaro; girls going into the churches to pray were calling out to boys in the squares. . . . In one room that lay open to the alley, before a bed covered with a cheap heavy satin comforter, in the semi-darkness, a young girl sat on a chair Looking from her to the Madonna behind the candles, I knew that the image, to her, was what I had been to Robin, not a saint at all, but a fixed dismay, the space between the human and the holy head, the arena of the 'indecent eternal'. At that moment I stood in the center of eroticism and death, death that makes the dead smaller, as a lover we are beginning to forget dwindles and wastes; for love and life are a bulk of which the body and heart can be drained, and I knew in that bed Robin should have put me down. In that bed we would have forgotten our lives in the extremity of memory, moulted our parts, as figures in the waxworks.*
>
> Djuna Barnes[75]

11.16. "Death . . . makes the dead smaller, as a lover we are beginning to forget dwindles and wastes": the deathscape of *Voyage in Italy*. Frame enlargements.

In the belly of Naples, city of a *basso porto*, Katherine goes down below, down into the excavation of her own physicality. Memories surface from this archaeological dig, shaped like figures in the waxworks. Places speak of the people who once inhabited them or who have left, for geography, as we recall from Stein, "includes inhabitants and vessels." Unknowingly, one returns to find them. Remaining in Naples to deal with the death of her uncle and the house he has left behind, Katherine Joyce remembers another "dead" man. Reminiscent of Michael in James Joyce's *The Dead*, he had been stationed during the war right there where she stands.[76] His name was Charles and he was a poet. He was different from Alex. He was a romantic spirit, one of those figures of the literary imagination that she could fall for. A figure of waxwork, Charles was evanescent. Consumed by a malady, he had been dying of consumption since the war. He finally expired before his work could be published. But Katherine remembered his poems. His verses described the museum of the dead bodies. He used to read them to her. She was able to recite them still, in front of the place his feet once touched.

She recalls the last time they had seen each other, on the eve of her wedding to Alex. Charles had come to see her. He was desperately ill, but there he stood, drenched in the heavy rain. Maybe he wanted to prove that, despite his high fever, he would brave the elements to see her. Maybe he wanted to die. In that moment of reminiscence, reawakened in Naples, Katherine stood between eroticism and death, death that consumes the body just as love does. The lover one is beginning to forget can waste away. For love is a bulk of which the body can be drained. In the extremity of memory, the lover's body parts molt. Just like figures in the waxworks. Or bodies "cast" by the lava in the dead city of Pompeii.

AMOROUS FOLLIES

> *Death! Yet nothing somber exudes from this word into my thoughts. . . .*
> *I have sometimes dreamt that it awaited for me, smiling, at the bedside of a loved woman, after the happiness, after the inebriation. . . .*
>
> > *But where had this image offered itself to me already? Ah! I told you, it was in Naples.*
>
> Gérard de Nerval[77]

In Nerval's *Les Filles du feu*, Naples drives a lover mad. Here, as in Rossellini's film, a city produces a ghost—makes a body out of memory or fantasy. The dead can produce apparitions in this city, as Charles does for Katherine. His specter is awakened once more for her in the cave where the Cumaean Sibyl spoke the oracle. The dead can materialize in Naples, for the dead are indeed incarnate there, alive in a culture that maintains an ongoing dialogue with them. The dead do not only inhabit archaeological sites here: the heads of skeletons literally punctuate street corners. In the city of Naples, one encounters death as a daily matter.[78]

On her deadly tour, Katherine is taken by her Italian host, Natalia, to visit the catacombs of Fontanelle. The place, she assures her, is not dismal at all. Quite the contrary. Many people go there to visit the skeleton of someone who died two, three, or even four hundred years ago. Some even adopt a skeleton, take care of it lovingly, assemble it properly, bring fresh flowers to it every so often. These dead have real lives. And thus, in the house of the dead, Natalia admits her desire to create a life in her belly. Touched by this morbid body of life, Katherine listens to this language of the stomach.

STOMACHICALLY SPEAKING

We wished, stomachically.
Henry James [79]

Walking down a street in Naples, we pass a clump of people sitting outside, busy doing in public everything the French do in private. . . . The image forced me to feel the generosity and organic obscenity of the streets of Naples, where thousands of families turn their stomachs inside out (and even their intestines). Everything is outside, you understand, but everything remains contiguous, interlinked, organically connected to the inside. . . . [People] go to bed, marinating in that atmosphere of musty smells. At that moment, contact with the outside is broken off, the body has reingested its stomach: from the outside you can no longer see all the breathing and all the digesting going on in the dark. . . . Naples' stomach . . . is everywhere.
Jean-Paul Sartre[80]

11.17. "Stomachically" speaking in *Voyage in Italy*. Frame enlargements.

In the streets of Naples, Katherine watches people constantly "turn their stomachs inside out." Although everything is outside, she notices how it is all "contiguous, interlinked, organically connected to the inside." An aspect of this "organic obscenity" is an intimacy practiced publicly, which includes sex and dying. Not even death is a private affair here. It, too, is turned inside out.

Naples' stomach is ubiquitous, indeed.[81] It lives in those pregnant bellies that seem to be everywhere and keep appearing in Katherine's path. Perhaps they remind her of the children she has not had. She chose not to have any children. Could it be that she is now troubled by her choice? All those pregnant bellies. Are they disturbing or attractive? She can't really admit to being fond of children.

More bellies. Two, three, four, five. Then couples making love out in broad daylight. Everything speaks openly of sex. Facing those bellies as signs of a lived sexuality, her own bears the texture of a new emotion. Throughout her filmic journey through the city, Katherine has been slowly digesting this abdominal image of the place. Watching the city flaunting its belly, she incorporates the image. She learns how to live with her body, how to be in it. How to let it utter gutter emotions. How to feel her flesh and bones.

OF FLESH AND BONES

I discovered in Naples the foul link between love and nourishment. . . . I asked myself: Am I in Naples? Does Naples exist? I have known cities— false cities, like Milan—that crumble to pieces as one enters them. . . . Neapolitans, who hide their bodies in lightly colored clothing, feed on textiles and wallpaper. And window shopping. I stopped in front of a pastry shop that looked like a jewelry store. Sweets are human, anthropomorphic, they look like faces. . . . One felt like putting them on display as porcelains. I tell myself: "Well, time to go to the movies." . . .

I wandered about, I went left, turned right, then left again; all the alleyways looked alike. I was taken by the skin of the Neapolitans . . . the alleyway seemed to have digested their cheekbones. . . . Surrounded by nourishment, live food, waste, morsels, obscene flesh, decayed fruit, they enjoyed with sensuous indolence their own organic life. . . . I felt digested myself. . . . What to do? To eat? To caress, to vomit?

Jean-Paul Sartre[82]

Discovering "the foul link between love and nourishment" and surrounded by "live food, waste, morsels, obscene flesh," Katherine feels digested herself. People here, feeding on textures and window shopping, appear to consume, ingest, waste even their body image. Everything is about physiognomy in this town. The city has a face: a fading makeup. All it produces is anthropomorphic. Including the food. The shape of the landscape. Even the dead.

One not only can see dead bodies in flesh and bone here; at the excavations in Pompeii, one can even touch the bodies of the dead. The lava has made an image of death that supersedes waxwork. Congealed around the bodies, it has perfectly cast the corpora of the dead. During an archaeological dig into the soil of Pompeii, covered by volcanic ash, Katherine watches this process take shape. Body parts emerge. Here is an arm, a leg, then another leg. A man's head is revealed, its teeth remarkably well preserved. His daily activities, arrested by death, sculpted by the lava, are palpable after two thousand years.

Pompeii shows life in freeze frame. It shows that archaeology was filmic even before cinema took over its function, melded with it in a hybridized form by "casting" live motion and exhibiting the (e)motion of everyday life. In Pompeii, as in film, bodies are caught dead in the act of living. People there were surprised by death just at the moment, perhaps, that they were eating, drinking, defecating, or making love. The man Katherine watches being uncovered was lying near a woman. Two people just as they were two thousand years ago found death together. Perhaps they are husband and wife. Katherine is moved. She bursts into tears. She feels her own volcanic eruption. In the landscape of a ruinous city, she has reached the bottom of her archaeological excavation. What to do? To eat? To caress? To vomit?

VOLCANIC EXCAVATIONS

11.18. Erupting emotions in *Voyage in Italy*. Frame enlargement.

The volcanic air breathed in this region might conceivably provoke ferocity when the passions are aroused. . . .

 The heart beats wildly at the phenomenon that is Vesuvius.
Madame de Staël[83]

A place to see in Naples, after the customary visits to the archaeological sites, the Zolfatara, and, if one has the time, the crater of the Vesuvius, is the III and IV Granili, . . . a temporary housing for the homeless. . . .

 Profoundly diseased from within, Naples tolerates decay without any distress.
Anna Maria Ortese[84]

Katherine experiences the destructive danger of an eruptive, diseased city of decay, which is essentially geologically defined. Built at the edge of an active volcano and moved by the waves of the sea, this city of ruins is strongly marked by a topography linked to an unstable underground. The "picturesque" Bay of Naples is, in fact, ruinous. The restless city is used to all forms of erosion and bears strata of moving interiors. Will the volcano—dangerous, warm, passionate—drive Katherine to the very brink, shattering her marriage to Alex? Will this destructive geography shake them into a final breakup? On this critical volcanic terrain, Katherine meets Lady Hamilton, together with the literature and films she inspired, and enters a trail of Vesuvian narrative that leads all the way to Susan Sontag's *The Volcano Lover*.[85] As a voyage of passion, Katherine's *Voyage in Italy* is indeed a geological narrative. It is an excavation.

A GEOGRAPHY OF PASSION: EMOTIVE MORPHING

Prompted and underscored by death, *Voyage in Italy* has retraced a cartographic itinerary: a filmic tour of geopsychic excavations. The voyage in Italy has functioned for Katherine as it did for many female travelers before her, whose diaries testify to a rite of passage by way of geographic motion. The voyage in Italy—*l'avventura* of the female wanderer—confirms that sites can be the object of a yearning that is not dissimilar to amorous longing. The traveler may cling to a place or long for a site as

11.19. This city of ruins is ruinous: geological history as mapped in Carafa's *Topographical Map of the City of Naples*, 1775, folio 28. Engraving.

11.20. Katherine is driven to and from the city and herself during her *Voyage in Italy*. Frame enlargements.

if wishing to be embraced by it, but may also turn away from it, seeking separation. For a place can either nurture or starve. Sometimes, the desire for place manifests itself as lust. As the traveler is driven to Italy, craving it like a lover's body, the surface of its earth becomes as soft and as hard as skin. Described with a great intensity that is almost sexual in nature, the Italian landscape has fashioned a history of interior voyages that have changed socio-sexual visions. As travel culture shows, geography, never separate from the topography of the I/eye, was never too far from sexual difference either.

By way of site-seeing, a mobile map of differences has taken shape, for in their experience of site-seeing, women who traveled to Italy and wrote about their voyages built a new map of the self. This is what Dorothy Carrington, among others, tells us. A female scholar and collector of travel literature who, in 1947, wrote *The Traveller's Eye*, Carrington spoke about Lady Anne Miller (1741–81), who traveled to Italy and published her *Letters from Italy* in 1776:

Like so many English people before and since, Lady Miller was transformed by Italy; "Alas" wrote Horace Walpole . . . "Mrs. Miller returned a beauty, a genius, a Sappho, a tenth Muse, as romantic as Mademoiselle Scudéry."[86]

There are places where one allows geography to speak history; places where one's trajectory is somehow shaped by the feelings left by the arrivals and departures of others, even if imaginary—or filmic. Italy is one of them. Like Katherine, many have traveled Italy with a map that others as well have used, and have transformed themselves en route.

This map of travel—as Carrington notes, citing the renowned garden theorist Horace Walpole (1717–97)—is that of Mademoiselle de Scudéry.[87] As in her map, the voyage through landscape pictures the paths of emotion: the exterior terrain is the vehicle for an interior journey which, reversibly, can be pictured on the land. It is in this sense that Italy has played such an important part in women's (travel) history as a place of transformation. Traveling to Italy on a voyage of self-recollection, a woman can reanimate her map.

This is precisely what Katherine does. Nothing really happens in *Voyage in Italy* (or, for that matter, in *L'avventura*) according to conventional proairetic codes, yet an emotional narrative unfolds as Katherine (or Claudia) traverses the archival fiber of the landscape, sculpting it into her own erotic space in a tourism of emotions. Topophilically driven by the porous geology of the site, Katherine has

11.21. Emotive morphing: picturing the inner space of a new self in *Voyage in Italy*. Frame enlargements.

embarked on a "volcanic" interior journey. Moving from the cave of the Cumaean Sibyl into the warm sulphur vapors of the Solfatara and down into the excavations of Pompeii, she has voyaged closer and closer to an inner space. Cruising the land, she has plumbed geological depths. Moving into the warm abyss of the Neapolitan region, descending further into the belly of the city, she has reached her own underground. Digging the earth, she has descended into her body. Unconscious desires have erupted with this archaeological excavation. Geography has produced sensational changes. She is now in touch with her senses. Picturing sites, Katherine has designed her own landscape, a new *Carte de Tendre*.

The voyage down south to sunny shores—site of geopsychic regeneration— can open up its own route of emotive morphing. For Claudia in *L'avventura*, too, this journey promises to rewrite a map that is "tender." From the "River of Inclination" to the "Dangerous Sea," one can reach "Countries Undiscovered."

11.22. An archaeology of knowledge in Carafa's *Topographical Map of the City of Naples*, 1775, folio 35. Engraving.

Traversing "Countries Undiscovered" may lead to passion; or become an avenue of physicality; or serve as transport to a venue of the senses. It can touch the terrain of death as the very border of the skin. This voyage explores, even expands, a sentient horizon, for in many ways it haptically attunes space with the desire for change. And thus it truly "touches" Scudéry's domain. Ultimately, this "Voyage in Italy" is an *emotion*. It leads to intimate reinvention. Traveling the terrain of affects, a completely new map can be designed. It is a reciprocal *Carte de Tendre*: a transformative, intersubjective map of emotional dwelling. A place with no "Lake of Indifference." A loving geography.

12.1. House as airport in
Guillermo Kuitca's *Coming Home*,
1992. Acrylic on canvas. Detail.

12 *My "Voyage in Italy"*

En pèlerin et en étranger.
Marguerite Yourcenar

Should one recognize that one becomes a foreigner in another country because one is already a foreigner from within?
Julia Kristeva

To theorize, one leaves home.
James Clifford

A car is driving down the road. A man and a woman are traveling, going south. She is driving. The Italian landscape is mobilized as the car and the camera rapidly traverse it. The British couple is on the road to Naples when he gets behind the wheel—and on her nerves. He keeps fretting about the dangers of their voyage in Italy. She holds a tourist guide in her hand and has a different vision of the ruinous site. She has read her Baedeker *in her own way and, aware that anything may erupt here, is open to the journey. The land of molestation has not molested her.*

Yet, as we have seen, several disturbing elements have underwritten their voyage in Italy. The journey, an architectural tour prompted by a house inhabited by death, is a geopsychic voyage that connects travel—via death—with the vicissitudes of cultural and sexual identity. A final form of absentation, death is the Proppian propeller for this narrative itinerary, not only because, as Freud puts it, "a journey is one of the commonest and best authenticated symbols of death," but because the deadly journey of cultural transits knows how to excavate the affective terrain.[1]

A cab is driving down the road. The passengers are making a journey to Naples. The death of their mother is calling the daughters back to the city. Two of the sisters cannot wait to return to their families, to forget Naples and liquidate the whole affair. But Delia will stay, will embark on the deadly voyage and confront her mother's "place."

Like Katherine, Delia has inherited a house and, with it, the story that every domestic site contains. Delia has inherited the narrative of her mother's "space" and must return to the home to confront it. Will this family house be a cell of memory, with a guillotine poised to descend, as in Louise Bourgeois's Cell (Choisy) *(1990–93)?*[2] *Possibly, but Delia must enter the physical and mental space of her mother anyway, must arrange her things. It is a difficult task. Nobody else will do it. Something awaits her in the house. Perhaps a secret. Perhaps a "family secret."*

The cab stops at Piazza Carlo III, in front of the Albergo dei Poveri, a monumental city landmark. Delia gets out. A woman in her late thirties, she has a creative career. Her demeanor and apparel state clearly that she has been marked by feminism. Delia had left

Naples some years before and looks a little out of place here now. She has apparently lost her accent, perhaps in the attempt to lose a memory. Delia is a double for Elena Ferrante, the author of L'amore molesto, *who also left the city only to revisit it fictionally.*[3] *The filmmaker Mario Martone did so too, creatively returning to his home town to film* Death of a Neapolitan Mathematician *in 1992 and, after, to transform Ferrante's novel into a film about a "love molested." Watching* L'amore molesto *puts one constantly in mind of* Voyage in Italy. *The two films travel the same road, for, as Martone himself acknowledges, "*Voyage in Italy *touches the same topic as* L'amore molesto—*a woman's collision with the city and the ancient popular culture of Naples. Both films speak of strangers in the city."*[4]

A stranger in search of herself, Katherine in Voyage in Italy *was performed by a Swedish actress who had made English her creative and professional home and then moved to Italy to act and live with Rossellini. Ingrid Bergman was not merely the actress of Rossellini's so-called "Bergman era." In a way, she acted out the films from life. From* Stromboli *to* Voyage in Italy, *Bergman the "stranger" was the very text of the narrative. In much the same way, the character of Delia in* L'amore molesto, *a stranger in her own city, is also an author-in-the-text. Like Katherine, she endlessly travels the city in a tour of the emotions. For both women this voyage, prompted by death, will turn out to be a sentient return. The intertextual itinerary drawn on this filmic* Carte de Tendre *extends the moving relationship between affect and place, further designing a cross-cultural* transito.

A cab is driving down the road. A man and a woman are making a journey to Naples. Their voyage to Italy is prompted by a death. The dialogue is in English. Words of anxiety are being exchanged as the couple approaches the center of town. The cityscape is closing in on them. No longer a distant shape on the horizon, it is becoming "touchy" material: stories written on the street pavement, feet walking over stones. The woman speaks with an accent. English is her second language, her creative and professional home. This is her voyage. My voyage.

My cab also stops at Piazza Carlo III, in front of the Albergo dei Poveri. This huge, ancient building used to be home to the urban poor and marked the entrance to the city: "Naples, 9th February [1817]. Grandiose approach to the city: . . . first building— l'Albergo de' Poveri; deeply impressive—no comparison with that over-rated bit of sham baroque, that chocolate-box effect that Rome is pleased to call Porta del Popolo."[5]
The door to the city greatly impressed Stendhal, a writer sensitive to the observation of site who considered Naples "the most beautiful city in the world." The passage into Naples, the poor house, is now a mere facade, an empty shell, a ghostly monument to itself. An architectural ruin, it stands as a grand stage set, a document of passing urban decay; a perverse tourist sign, it is an advertisement that screams Naples unequivocally, despite all the gentrification that has occurred there. This piece of urban archaeology draws a hyphen on my map, connecting the memory of dystopic (cine) cities. It reminds me how in postmodern times it used to say: Naples—just like New York—just like Blade Runner. *My territories. Places I have lived, loved, absorbed, traversed. I negotiated myself in them, wrote myself in them, wrote about them.*[6] *I have called them home. The "accelerated decrepitude" of the metropolis has linked together these cities and cine cities of my imaginary and lived turf. Home is a hyphen. Hyphen is my home. An imaginative geography.*

12.2. Cells of memory: the family house in Louise Bourgeois's *Cell (Choisy)*, 1990–93. Marble, metal, and glass.

I look fondly at the ruinscape now. It inspires a sort of topographical ease that, in my cartography, creates a heterotopic landscape—a "door to the city" that opens onto a vista of the Flatiron or the Bradbury Building. Sensing this urban archaeological hyphen, I remap myself in one of my eroding harbor towns. Here I am, in Naples. I must surrender myself to the city. So I get out of the cab and begin to walk in front of my ruin. This is exactly where Delia, with her baggage of death in tow, begins her filmic journey in L'amore molesto. *A stranger in her molesting city she is bound, like myself, to confront house and home—and loss. It is hardly a coincidence.*

The longa manus *is taking me back to Naples. My father's place is near Delia's mother's. He died suddenly, unexpectedly. I am back to mourn in his house. Entering his private space and going through the difficult task of arranging his affairs gives way to an intense "archival" journey that maps the geography of a life's history for me. I am pulled back to the city in which I grew up, to the sites of* Voyage in Italy. *Katherine's touristic journey marks*

many points on my map. City views, including the corpulent statues at the Museo Archeologico Nazionale with its Greek and Roman culture, Sibyl's grotto, Solfatara, the catacombs, and Pompeii, were significant sites in my "bio-cultural" itinerary—strata of my own archaeology that are brought back to life by the death of my father.

RETURNS

I left Naples in 1980 for the voluntary exile in New York that enabled me to reinvent the topos of "home town." As New York became home and a foreign language turned into a new house of language, I designed the home-hyphen. I have returned to Naples several times and in several ways, with an awareness that the *emotion* of the migratory sense—a moving out from within—would change the sentiment of cultural identity. Unlike the exiles or the immigrants, who couldn't or wouldn't return, a different horizon—a moving vista—is open in the postcolonial era to the generation of intellectual nomads to which I belong, less affected by origins and connected to place in a way that is neither nostalgic nor fixed. We have felt all the tensions of displacement and the grief of separation but we have also enjoyed pushing the limits of national cultures and making new borders of identity. Situated, with feet planted and eyes wandering, in a traveling space that exists between the local and the international, we have had the privilege of choosing and multiplying our cultural hyphens, making identity detours within the sense of situatedness that was our point of departure. In revisiting this shifting landscape of origins, writing becomes one such form of return. Working within my own archaeology, Naples had come and gone—from topos to topic—and I was coming to believe that I had somehow worked it through. I thought that I was done thinking about genealogies and cultural transits. I was wrong.

A remarkable coincidence took place during this voyage in Italy: I encountered Delia in a Neapolitan café. She was becoming a filmic character just as I was making my voyage back to Naples for my own family death. My conversation with Mario Martone, who was creating her filmic persona, turned out to reveal a shared set of experiential ties—ties that had led up to this uncanny encounter between myself and Delia.[7] The nature of our connection was cartographic. Martone, who thinks cartographically, sees filmmaking as a "journey of knowledge" made of encounters, of which "the screenplay is a map . . . a map which enables us to move freely; the more a map is defined, the more our journey through a terrain will be open."[8] This cartographic experience was part of a cultural map that was being drawn, like the separate pieces of a mosaic, by a number of intellectuals in voluntary exile—all strangers (from within), according to Julia Kristeva's autobiographical definition.[9] It was the sign of an "intimate revolt" that was leading, even in etymological terms, to both "return" and "volume."[10] Strangers were linked together in intimate revolt by the "silence of polyglots" and by separations from the body of the city and its language; they were making cultural journeys of return to the city of origin with volumes of thoughts. A number of writers who were neither completely for-

eigners nor natives, including Maria Antonietta Macciocchi and Jean-Noël Schifano, were furthermore chronicling the city's dense history.[11] This was happening just as Iain Chambers was launching from Naples his "border dialogues" on "migrancy, culture, and identity"—a "journey without maps" that embraced the idea of "cities without maps" and found Naples to correspond nicely to this notion.[12] In the "sympathy" of intimate reinvention, the silence of polyglots linked together these diverse traveling eyes and cartographic viewpoints, laid bare on a displaced city map.

Martone's association with an expatriate female writer like Elena Ferrante had been preceded by another imprint of female displacement: his *Death of a Neapolitan Mathematician* was written with Fabrizia Ramondino, whose own nomadic existence is inscribed in a fascinating body of writing that returns constantly to themes of voyage and home(lessness). Her hybrid style, particularly evident in *In viaggio* and *Star di casa*, turns the language of the essay into autobiography and fiction.[13] "Feeling like a stranger in my country," she claims, "I have no choice but to transform the long time I have spent in Naples into my own geographic space. But isn't every work—cities as well as books—the transformation of time into space?"[14] Charting metropolitan nomadisms and the voyage around her own room, Ramondino draws a picture of her passages in and out of her city as if remaking its map.

Ramondino's own dislodged map is echoed in Ermanno Rea's *Mistero napoletano*, a hybrid book that ventures from (travel) diary to fiction as it draws a panorama of Naples and documents its radical history. The displaced author's

12.3. A personal "state" of unrest: Heide Fasnacht, *My City Was Gone*, 1991–92. Plywood, silicon, rubber belting, latex, cotton batting, wool blanket, Dacron, and steel.

voyage back to uncover the mystery of the death of Francesca Spada (a member of the Communist party who killed herself in 1961) forms the basis of the book, which reflects on the relationship between the city and its inhabitants, who are strangers to themselves. He speaks of Renato Caccioppoli, the mathematician related to Bakunin and fictionalized in Martone's film as "a splinter of Europe transplanted at the feet of Vesuvius."[15] Noting that "Naples and Caccioppoli loved each other because they did not resemble each other at all," he goes on to query: "But what does it mean to resemble a city? What is the actual identity of a city other than the drawing that each of the inhabitants makes inside himself?"[16]

Casting a self-analytic glance at this panorama—a veritable *Carte de Tendre*—enables us to challenge further the notion of "cognitive mapping" we investigated earlier: there is hybridity as well as displacement in the mental map that constitutes a city's interior drawing.[17] Here, the pieces of the cultural experiential mosaic, including my own, appear hyphenated, and the map of the city itself comes together as a shifting terrain. This *Carte de Tendre* is essentially being drawn elsewhere (yet now here)—as a distant map, a map of distance within. Strangers in their own towns are making the drawing. Tangible separations and journeys of remapping emerge in the work. Tactile maps of the city—woven like the patterns of wandering through a fragmentary cartography—are the desirous outcome of an intersubjectivity that is designed as the city's own lived cartography. Traveling maps are being drafted by native tourists. This type of journey, made by the displaced writer, demands a special suit (and suitcase). One must pack e*motion*al baggage. Death (or other forms of absence and loss) seems to haunt this moving map.

A few years back, as I traced the removal—the historical death—of a woman filmmaker in *Streetwalking on a Ruined Map* with an archaeology of lacunae, I tried to picture a *transito*ry mapping for my city of origin. Now, back again, but in a different way, I found myself blurring itineraries on Madeleine de Scudéry's *Carte de Tendre*, where I had displaced "the voyage in Italy." On the tangible itinerary of an emotional cartography, Katherine's grand tour of identities was turning into Delia's nomadic subjectivity. As I moved along this imaginary filmic map, reading signs, tracing trajectories, remaking itineraries through the city, their stories revealed mine. I was carrying notes on *Voyage in Italy* when my father died, and writing about the voyage in Italy began to take a different shape: it exposed *my* "Voyage in Italy."

Katherine is driving her car through town. Sunglasses filter the site. As she drives, she looks out the car window and allows us to catch a glimpse of the city. This is how we passenger-spectators get to know the streets of Naples—through her subjective viewpoint. The camera is not allowed any autonomous freedom of movement. It only looks as she looks. It sees what, and how, she sees: through the dark frame of her sunglasses, the geometry of the moving car's window, and the screen's own frame. In this way, the stranger looks out at the city and into herself. She is "screening" something out.

Delia is walking through her home town. She is also wearing a body screen. As she looks out at the city and into herself, her outfit and her acquired northern accent—signs that read for-eigner—filter an overwhelming presence. The cacophonous soundscape of Naples, matched by the film's intense sound track, speaks of the city's corporeal presence and makes her confront something of her own that she keeps hiding from view. Delia needs her screen.

I am walking in Naples, wearing my dark shades and ordinary New York attire. The armor of this period was a minimalist exercise, which often resorted to monochromatic landscapes with textured variations on noir. For an urban uniform, my generation had not quite retired the old favorite, basic black, for while the dark city made detours into color it kept a penchant for sen-suously somber fashions: the more subtle the more daring. Back in Naples, then, with my transplanted apparel, I see some people staring at my body screen. Although I do not seem to recognize them, they act as if they know me. A woman questions me, pointing at my black ensemble: "Per lutto o per lusso?" The inadvertent wordplay asks if the color written on my skin is for mourning or elegance. They've heard my father died, she said, and have a bet going. She says it is mourning; her daughter bets vogue. A stranger in my own town, as I always was, accustomed to travel far distances and speak foreign tongues to feel close, I rest on my hyphen. I tell them it is both. Like the film screen, fashion is a twofold affair. It writes the hyphen on the map. Sometimes off *screen.*

CRITICAL JOURNEYS

An authorial subject off screen, like the female travel writers who have occupied such a large imaginative space in this book, I worked with and against the implica-tions of *my* voyage in Italy, perceived my self-representation as a site of writerly ten-sion. Esther Lyons's self-portrait, to which I have dedicated substantial critical room, had revealed to me all the complexities of picturing oneself in the genre. In speaking of *Voyage in Italy* in relation to travel culture and especially to women's travel diaries, the very diarylike, episodic structure of the film had come into question. In their travel journals, women had written insistently of *my* travel, *my* voyage, *my* excursion, only to realize how difficult it was to map oneself into the picture. To state the *I* of the eye was to allow one's subjectivity to write the space of observa-tion. Immersed in the hybrid language of travel writing—where, traditionally, the scholarly joins the autobiographical in discourse—I was designing my displaced map across this difficult, hybrid horizon.

Trying out different voices of critical self-representation, I wrestled with the temptation to disclose hints of *my* "Voyage in Italy," to reveal my own emo-tional bond to the films. I kept asking myself questions, and most of all wondered: why write about it at all? Forays into known theoretical territory were not of tremendous help here. Much has been written about spectatorial identification with the filmic text. We also know something about the phantasmatic structure that links the filmmaker to her text. I have done my share of thinking about these issues. But what of the *theorist's* relationship to a set of texts? What drives the analyst to an

12.4. M. A. Palairet, self-portrait from her travel diary, 1843.

12.5. Ann Hamilton, *tropos*, 1993. Detail of the installation at Dia Center for the Arts, New York.

object choice? What navigates it? In what ways is the film an object of desire, a site of the bonds of love or domination, an emotional fabrication? What "architexture" does this relationship dwell upon? How does one's own position as subject, and the changes it undergoes, affect the reading of a film? Is there a historicity in this trajectory? What is the geography of this critical history? Does it have a place in writing? In short, what should or can we say about a critical journey?

Film theory generally has backed away from analyzing this subject, especially at the point when, in order to reach out and grasp the sense of the lived subject, one would have to plunge into the subjective realm. In scholarly speculation, the subjective, when not treated with suspicion, is at best constructed as indirect speech or as an off-screen presence—that is, as a figure absent yet present. I have often found myself evoked in the margins, fictionally inscribed at the edge of the frame: a projected shadow on the screen of writing which, like the off-screen in my beloved film noirs, is a place of traction and attraction. Engaging the tension between subjective and objective presentation in travel writing, I wondered about mapping the self as something more than the implied fiction of an off-screen space, readable only to those familiar with one's history.

In contrast to the situation in film theory, the realm of the "I" is practiced widely in film criticism, sometimes shamelessly so. The film critic acts precisely like the food critic: she regularly involves herself in the circumstances of selecting the film menu and then of sharing the appetizing experience with others. Film and food thus metaphorically conjoined, both critics write about personal position and state of mind, and speak in the first person. The film theorist generally has a tremendous resistance to this way of doing things and, even more importantly, has trouble imagining the subjective as a possible site of investigation—perhaps with good reason. Does the practice of directly addressing the subject of speech—or calling it into question—with her own lived experience add anything to the reading of a text? "What matter who's speaking?"[18] Or put more bluntly, should we care?

Yet the very resistance of film theory to acknowledging this matter—the speaking subject as a speaking geography—may tell us something. As Michel Foucault, among others, has shown, what really matters is the position from which one speaks. I find that this issue—shall we call it the cartography of the subjective?—has implications for rethinking the placement of analytic knowledge. In the end, this is a question of geography, of the "location" of knowledge. It pertains to the historicity of discursive settings and the location of discursive historicities. The issue may thus be tackled more productively if viewed within the broad parameters of a cultural topography and recast as a question of the pronouncement of lived space in discourse. As Henri Lefebvre perceptively envisioned it, "the space of speech . . . is forever insinuating itself 'in between'. . . between bodily space and bodies-in-space." To ask "Who speaks? And where from?" in terms of this mapping is crucial for understanding transcultural sites, both in theoretical and political terms.[19]

The "situatedness" of knowledge has, in fact, become an important site of contemporary investigation and shapes cultural writing in many different ways.[20] As we have pointed out, spatial metaphors have been used increasingly in theoretical discourse, often to signal a widening interest in location and positioning, including social and gender displacements.[21] This trend is important, for, as Donna Haraway remarks, "epistemologies of location, positioning, and situating . . . are claims on people's lives."[22] For herself, she adds, "these are lessons which I learned in part walking with my dogs . . . and wondering how the world looks . . . with . . . sensory areas for smells."[23] Wandering the hybrid territory of projections between home and the world, I find myself incessantly in that terrain of "unhomely" displacements and "border existence" that Homi Bhabha calls an "in-between," a zone of cultural intersections where signification is marked by hybridity.[24] From this location, as James Clifford has put it, discourse appears as a production of "traveling cultures," and from the chronotope of the hotel, cultural knowledge itself appears as a work of traveling-in-dwelling and dwelling-in-traveling.[25] Speaking for many writers, including this one, Clifford claims that "to theorize, one leaves home."[26] Having taken this very route and journeyed along its path for a long time, I also discovered that to theorize one cannot really leave home behind. Ultimately, one must accept the risks, theoretical and otherwise, involved not only in leaving but in attempting a return.

THEORETICAL EMOTIONS

However one defines and lives it, situatedness is, in any case, the outcome of a radical change in cultural focus and suggests a shift in viewpoint. It can be produced only through mobilization and by way of using a different interpretive lens: a traveling lens. It is the *emotion* of this traveling lens—the attraction for a traveling theory—that, questioning boundaries and forcing borders, enables one to envision a knowledge that is situated in lived space. This is precisely where we connect with the cinema, for, as I have argued, this located space, mobilized in *emotion*, is the actual cultural "place" of the moving image. Emotion pictures fabricate this situated viewpoint with their multiple traveling lenses. Geographically speaking, the moving image is sculpted as a *Scultura da passeggio*: that is, as a haptic "traveling globe" that one may go strolling with, as in the sculpture of that title (1966–68) by the Italian artist Michelangelo Pistoletto. A home to cultural voyage and a housing of traveling cultures, film is a tender mapping of intimate space: in mobile cartographic ways, it dwells in psychospatial journeys, in a situatedness that incorporates the world of affects, sexuality, and the subjectivity of subjects. Through and with the work of film, critical theory should be able to enhance such "moving" design, and to account for its various trajectories.

Yet when the dynamics of the emotional sphere—an important ingredient of this haptic situated knowledge—is at stake for the critic, the work comes to a halt. There are no theoretical means with which to speak about it. Contemporary film

12.6. A peripatetic globe: Michelangelo Pistoletto, *Scultura da passeggio*, 1966–68. Newspapers and iron.

theory has generally not considered "emotions" to be a part of its "motion." As Annette Kuhn puts it:

Any feeling response to a film—and indeed recollections of such a response even more so—threaten to elude our attempt to explain or intellectualize . . . because each category memory/feeling as against explanation/analysis seems to inhabit an altogether distinct register. Emotion and memory bring into play a category with which film theory—and cultural theory more generally—are ill equipped to deal: experience. Indeed they have been wary of making any attempt to tackle it, and quite rightly so. . . . Nevertheless . . . my memories, my feelings . . . are important. Must they be consigned to a compartment separate from the part of me that thinks and analyses? Can the idea of experience not be taken on board—if with a degree of caution?[27]

Wrestling with this categorical dichotomy, Kuhn dares to go the "wrong way": she ventures into questioning her own emotional response to moving pictures and puts herself into the picture of "family secrets." Her preliminary words reveal a measure of the hardship involved in undoing the foundational binary system of critical vision.

Can we recognize now that this disembodied theoretical "eye" trapped the cinema in a similar specular, optical model? What, then, of this model of critical distance? Why insist on writing experience out of our analytical screen? Emotions are very much a part of our ability to analyze—that is to say, to mobilize—a text. If we wipe them away or compartmentalize them, we end up reproducing the view from above and from nowhere. Speaking of cultural hybridization and feminism, Trinh T. Minh-ha writes that "thought is as much a product of the eye, the finger, or the foot as it is of the brain."[28] In handling film, I might add the heart to the archive of haptic tools for analysis that includes the foot—essential, indeed, for the historian-voyager mapping a sense of space.

One may choose a favorite body part with which to design one's own map of knowledge, and it does make a difference. But, whatever the body part, knowledge is indeed connected to the body of *emotion* and to the fabric of affects. It belongs to a tender cartography. Theoria, as we have shown, can be (indeed, has been) imaged in a sentient "fashion," equipped with all the "accoutrements" for feeling.[29] At the very least, it participates in the design of "the geometry of passions."[30] Even when the object is not passion itself, there is always a desire to know, which has all sorts of passionate implications, including resistance and rejection. When knowledge is set in motion, one senses a critical sympathy shared with a body of texts and with human subjects. This sympathy may lead to absorption and drive knowledge on its path, sculpting the itinerary of its multiple positioning.

Analysis is about passage, about the complex erotics of intersubjectivity, about the *transito* of intertextural incorporation. The traveling motion of dwelling, theory is a partial perspective: it is located, produced, and seen from a subjective angle. The work of theory is indeed quite bodily driven and very *emotion*al. Its traveling lens is, in a way, a prosthesis. An antenna—an intellectual feeler—is planted on the critic's head just as it was in Ripa's sixteenth-century portrait of Theoria. It is an implement for our intimate exploration of inhabited cultural sites. Our *vissuto*—the ever-changing space of our lived experience—is an essential part of this critical architectonics. In sensing cultural movements, the lived space of theory (a fragment, a view from our map) becomes a "moving" view.

A VIEW FROM MY MAP

These wanderings, of course, go back and forth, weaving in and out of *my* "Voyage in Italy," for a film like *Voyage in Italy* acts on that Lefebvrian transformation by which a social subject turns the urban space into a bodily lived experience—a transformation that occurs for the tourist as for the native.[31] To traverse this text is to unfold some of the theoretical and *emotion*al threads of the narrativized architecture of lived space. As I rewind back to the film, I am reminded of Walter Benjamin's words: "If lived experience and lived knowledge are the conditions of all writings of travel, where can one find in Europe an object as good as Naples, where the traveler is just like the native?"[32] *Voyage in Italy* showed me that cultural travel—a form of

remapping—has to do with one's affective topography, just as motion connects with emotion. The same could be said for the act of writing, when it is topographically driven and experienced as a travel of the room. Alfred Döblin described his own process:

I could not rest until I sat down in front of the blank page. . . . I had to open a secret door and enter a quiet room that belonged only to me. . . .

I see myself placed before backdrops, pushed into landscapes and situations that surfaced in me. . . . The words that entered my room . . . wore a kind of ghostly attire. They were not permitted to come in otherwise. . . . It is an odd thing, writing. I never began until my ideas . . . appeared clothed in language. Once I possessed this image, I set out on it, my pilot boat, from the harbor, and I would soon see a ship, a great ocean liner, and boarded and continued sailing and was in my element, I traveled and made great discoveries and only months later did I return home. . . . My journeys behind closed doors took me to China, India, Greenland, to other eras, and out of time as well. . . .

What could be brought back from such travels? In the end, a book.[33]

Both traveler and native, I voyaged in Italy in the end to know my geography. Doing so has allowed me to hear Benjamin again, citing from a diary: "the journey to discover my geography" is what I write.[34]

As I write I am redrawing a map, perhaps *my* map. I constantly picture myself in the scene of Annette Lemieux's installation *Portable World* (1986), where a mapping scrolls through the screen of writing. Writing, like cartography, is a "transport"; it has always been a form of mapping for me, and this material charting, like cartography itself, has essentially to do with its etymological root: *grapho*. *Grapho* is writing, drawing, recording. Geography, topography, and, indeed, cinematography are all connected, for they are all "graphic" arts of space. A suffix links them, a type of *grapho*. Geography, topography, and cinematography are forms of *écriture* obsessed with sites, even the site itself of topophilia. They "graph" space with the love of place. Their common terrain is mapping, and graphing room (the room of one's own).

But what lies behind this "graphic" sensibility, this impulse to map? What drives my own critical impulse to map? Looking back at the origins of cartography, one may find clues to explain this cartographic obsession. The great explosion of geographical desire—the drive to discovery, exploration, domination—that took place in the sixteenth century was marked, as Svetlana Alpers points out, by "the trust to maps as a form of knowledge and an interest in the particular kinds of knowledge to be gained from maps."[35] This kind of knowledge was indeed particular: it was located, situated, and diffused among a range of individual scholars in different fields. Among the cartographers was Cornelis Drebbel, an experimenter in natural knowledge who devised a machine of perpetual motion and, early in his career, mapped his home town of Alkmaar, in the Netherlands. There was also Comenius, author of *Orbis Sensualium Pictus* (1658) and texts on gardening, painting, and building, who made the first map of Bohemia before he was forced to leave. "Each man made only a single map in a lifetime," Alpers tells us. Mapping "seems

12.8. Views from the keyboard of Annette Lemieux in *The Ascension*, 1986. Typewriter and gelatin silver prints. Detail.

to have been an accepted way to pay one's respect to one's home while contributing to the knowledge of it."[36] Rather than the description of an elsewhere, mapping turns out to be a domestic enterprise. The cartographer travels domestic, so to speak, as she maps her own territory. Cartography, a public form of knowledge, is actually a private journey, a mapping of one's own—a drawing of one's home. No wonder only one map was drawn in a lifetime. Perhaps, in the end, one can aspire only to chart a single graphic design and expect to spend a lifetime drawing it: the one imaginative map, the map of one's home.

Vermeer's impulse to map may be one imaginary model for this type of critical cartography, for this painter of interiors and domestic scenes produced only a single landscape in his career: *View of Delft* (c. 1660–61), a view of his home town. He moved inward from this panoramic view of the city only so far as *The Little Street* (c. 1657–58), a "close-up" of one of its alleys. His interiors were mostly populated by women in a room, who often look out of the frame from their position by the window, behind a desk, or in a corner. Recurrently, as, for instance, in *Woman in Blue Reading a Letter* (c. 1663–64), *Young Woman with a Water Pitcher* (c. 1664–65), or *The Art of Painting* (c. 1666–67), his female subjects are juxtaposed with wall maps. The interiors include only two men, *The Geographer* (c. 1668–69) and *The Astronomer* (c. 1668).[37] They are alone, absorbed in the same representational space the women occupy. One wonders if this similar epistemic placement makes the geographer and the astronomer "honorary women," as Svetlana Alpers has suggested; or, in the reverse postulation, if the women are honorary cartographers.[38]

Whichever the case, this reciprocal epistemic interplay renders a sense of intimate geographic space. It even suggests that cartography is itself an intimate drafting—a liminal passage from private to social history. To reinforce this metabolic picturing in filmic terms, let us recall the pictures of Hiroshi Sugimoto, who works "like an astronomer" and "calculate[s] the passage of the moon" and the speed of light in photographs that "themselves function like paintings" and are drawn as maps.[39] Sugimoto invokes the labor of the geographer and the astronomer in picturing an inner cosmology that includes the residual landscape of the cinema in its texture, geographically rendering that intimate setting of the emotional binding that constructs the movie house itself. However one looks at these connective representational spaces—from Vermeer's geographic observations of the interior and his *View of Delft* to the various liminal cartographies mapped in this book—mapping is exposed as a venture into one's local archive. Mapping is, indeed, a topophilic *emotion*—that "journey to discover my geography."

VIEWS FROM HOME

Mapping one's home town, drawing a room of one's own: for me, such a *camera*— and the camera, the "room," that generates film—is a room with a view. As I wander around my home town with *Voyage in Italy*, I wonder if my critical obsession for mapping and views, and for inscribing cinema in their representational history, has a direct link with the topography of this place. As we have seen, Naples is a city of great views and a visceral maze of street life; this well-traveled, transient city, porous as skin, was a founding topos in the geography of view painting—that "in-between" painting and mapping—which we claimed was a predecessor to cinema's own mobile *vedute*. Drafted in countless etchings, Naples is a site of cartographic imaging. As a mental mapping, this urban imaging is perhaps "etched" so strongly that it may lead a critical subject like myself to follow its very topographic paths.

But can a critical map resemble a city map? Does location thus affect the way to knowledge? What of the mimesis of such (dis)placements? Are there critical cases of that "mimicry" between subject and space envisaged by Roger Caillois?[40] Is our form of knowledge—our own cartographic impulse—somehow drafted out of and grafted onto "the image of the city"? Is one to look for such spatial clues back in the topography of one's home (town)? Is the map this intimate? Is it always drawn upon a mattress? Recall the emotional maps of Guillermo Kuitca: maps where places are multiplied and displaced; maps that turn home into an airport; maps charted in the interior, suited to our beds.[41]

What also comes to mind is the "tender" geography exhibited in the series of paintings and drawings made by Louise Bourgeois beginning in the early 1940s called *Femme-Maison*, which represent women in the shape of houses, joining the architecture of the body and the house in the itinerary of dwelling.[42] In exposing this link through the many stories of the house that we have revisited in film, art, and architecture, a haptic map of inhabitation is designed, where *domus* is not confused

12.9. Louise Bourgeois, *Femme-Maison*, 1947. Ink on paper.

with domesticity and location is the ground of departure. This "traveling domestic" is the retrospective voyage of culturally hybrid subjects. It is not by chance that Louise Bourgeois, a French artist transplanted in New York who, for sixty years, has mapped the architecture of the interior, included a map of her home town in her autobiographical book of pictures, marking in red the itinerary of her travels within.[43] In inscribing a colored path on her map, she used the same form of cartographic writing that, as we have seen, colors most maps of bio-history and marks the process of their emotional construction. In this affective mapping, home can indeed turn into a voyage.

MY "VOYAGE IN ITALY"

Views from home. *News from Home. My* "Voyage in Italy." A retrospective voyage. I rewind back through filmic archives, for "the nomad's identity is a map of where s/he has already been; s/he can always reconstruct it a posteriori, as a set of steps in an itinerary."[44] Unavoidably, my cultural fabric leads me to travel *à rebours* into a future past, filmically "rewinding": revisiting places known or unknown, left, found, hyphenated on the filmic reel to be projected forward. In this cartographic mobilization of historical grounds, histories and stories are planted on the experiential chart, reinvented on the map of *bios* as we readdress or redress them in the imaginative process that takes the measure of our emotions.

In mapping, we draw (in) the past, not to conserve bygone images but to grasp their conflation with the present and assess if it is really offering us something new. In so doing, we open our eyes to what we could not before see of our present, which may become a barrier to our future. Like the replicants of *Blade Runner*, we still scan the map of our lived space, not to find what we have lost but to search for clues of our finite historicity, to measure what pleasures of discovery may lie ahead. Photographic and filmic memories—fragile yet enduring—are fragments of this archival process, porously embedded in our lacunar path, part of our own shifting cartography. As moving documents of history and fractions of our personal stories, films act as traces, vehicles, and passages of our retrospective subjectivity. It is to represent this relational place that we draw maps of the intimate spaces we have inhabited. The history of film is the story of this habitation. It is quite a porous story of reversible *emotion*al access and interface.

In this specific cartographic sense, cinema shares a course with psychoanalysis, which is itself a cartography: its analytic path is also a charting-screening of the subject's relational space. Such an intersubjective path leads one back into the presence of one's history on a composite screen of cultural memory. It digs into sites in ways that recall those of archaeology and contemporary art restoration, for their methodologies also enable the mobile observer to perceive the palpable textures of analytic intervention and to trace the effects of duration in representation. This process of archaeological excavation affected the way my stories of cultural history

12.10. A pedestrian archive: Annette Messager, *My Trophies*, 1987. Acrylic, charcoal, and pastel on gelatin silver prints, framed in wood.

were retraced and mapped. *My* "Voyage in Italy" was another attempt at a dig in intimate space: a personal journey on my *Carte de Tendre*. My archaeology—a geopsychic landscape—surfaced as I traveled with Katherine on a city map, down into the catacombs and out to the excavation sites of Pompeii. Traveling with a motion picture that is nothing but this architectural tour, house turned into voyage and the fibers of my own emotional cartography were "moved," for film is, indeed, a traveling dwelling for one's history and geography: a reciprocal, emobile mapping of transformative sites.

POSTSCRIPT

In closing the account of my return to Italy with this last intended *error*, should I dig any further? Should I uncover the Italian root of my "emobile" thinking? You probably know the pun. *Mobile*, in Italian, stands for a domestic object, a piece of furniture. It is an armoire. "Mobile" is, indeed, an interior design. Quite an emobile mapping.

12.11. The fabric of an intimate archaeology in the armoire of Doris Salcedo's *Untitled*, 1995. Wood, cement, cloth, glass, and steel. Detail.

P.S. TO THE POSTSCRIPT

Was there anything left for me to see in this *mobile*?

> *To write in order to close*
> *To write the letter to the father . . .*
> *I went, then I wrote . . .*
> *Visions in passing . . .*
> *Travels . . .*
> *On the way I still passed [the place]*

where my mother comes from. . . .
And slowly you realize that
it is always the same thing
that is revealed,
a little like the primal scene. . . .
There is nothing to do;
it is obsessive
and I am obsessed. . . .
Despite cinema.
Once [it] was finished,
I said to myself,
so that's *what it was:*
that, *again.*
—Chantal Akerman[45]

Circular returns. Spinning backward. Back to my own archaeology. Back to filmic genealogy. Visions in passing. Travels. On the Italian tour, a tarnished memory resurfaces from beyond the pleasure principle. Going back to Naples for the death of my father, I revisited the house that he had inhabited and left behind. There was a *mobile*. And inside this *mobile* there was a round cookie box inscribed with pictures that could be constantly (re)turned. There were no more cookies. They were long gone. But the box still fed me.

This box with pictures was a regular feature at breakfast time in our house. Spinning the round box, my father used to "animate" the pictures. Absorbing views and a landscape of captivating stories habitually unfolded for me from the moving box. The cookie box turned into a magic box. It opened a "new world." A domestic version of an optical box, the empty cookie box was, indeed, my own *boîte à curiosité*, my first *mondo nuovo*. It affectively navigated a way of thinking for me. And so I ate. Pictures. Motion pictures. Stories of the I/eye, amorously spun out of a kino-box-mouth. Emotion pictures. A digestible landscape. A moving place of "sustenance."

Once the book is finished, I can say to myself, so *that's* the archaeological turn I was after. Reinventing that loving, moving box. Rewind, and it will spin. A reel of moving landscapes. The obsessively returning graphic design of the emotion. Genealogic turns of the memory path. Haptic maps of affective localities. An intimate geography of vicinity. That fragile topophilia. A Richter *Atlas*. An atlas tenderly fashioned as a *Carte de Tendre*. A history of one's moving pictures. A graph of my own emotion pictures. *Kinema*, indeed.

Prologue

1 Madeleine de Scudéry, *Clélie, histoire romaine*, 10 vols., Paris: Augustin Courbé, 1654 60.

2 Giuliana Bruno, *Streetwalking on a Ruined Map*, Princeton: Princeton University Press, 1993.

3 Walter Benjamin thus dedicated his book *One Way Street*: "This street is named Asja Lacis Street after her who as an engineer cut it through the author." See Benjamin, *One Way Street*, trans. Edmund Jephcott and Kingsley Shorter, London: Verso, 1979, p. 45.

4 *Oxford English Dictionary*, vol. 5, Oxford: Clarendon Press, 1989, p. 183.

1 Site-Seeing: The Cine City

1 For the Latin root of the word *error*, see P. G. W. Glare, ed., *Oxford Latin Dictionary*, Oxford: Clarendon Press, 1982, p. 618.

2 Although the notion of the haptic permeates the entire construction of this book, for a discussion that addresses specific uses of the notion, see chapter 8.

3 To understand the notion of the gaze in film theory within the larger context of a history of ocularcentric discourse, see Martin Jay, *Downcast Eyes: The Denigration of Vision in Twentieth-Century French Thought*, Los Angeles: University of California Press, 1994; and Rosalind Krauss, *The Optical Unconscious*, Cambridge: MIT Press, 1993.

4 Throughout this book, I use the term *genealogy* in the Foucauldian sense, not to mean a search for origins, but to designate a set of circumstances defining the production of a discourse or series of discourses. See Michel Foucault, "Nietzsche, Genealogy, History," in *Language, Counter-Memory, Practice: Selected Essays and Interviews*, ed. Donald F. Bouchard, trans. Bouchard and Sherry Simon, Ithaca, N.Y.: Cornell University Press, 1977.

5 For an introduction to the rich field of research on early film space, see Thomas Elsaesser, ed., with Adam Barker, *Early Cinema: Space, Frame, Narrative*, London: British Film Institute, 1990.

6 On this subject, see (along with works cited later) Leo Charney, *Empty Moments: Cinema, Modernity, and Drift*, Durham, N.C.: Duke University Press, 1998; Charney and Vanessa R. Schwartz, eds., *Cinema and the Invention of Modern Life*, Los Angeles: University of California Press, 1995; Edward Dimendberg, "The Will to Motorization: Cinema, Highways, and Modernity," *October*, no. 73, Summer 1995, pp. 91–137; James Donald, "The City, The Cinema, Modern Spaces," in Chris Jenks, ed., *Visual Culture*, London: Routledge, 1995; and Mary Ann Doane, "Technology's Body: Cinematic Vision in Modernity," *Difference*, vol. 5, no. 2, Summer 1993, pp. 1–23.

7 Jonathan Crary, *Techniques of the Observer: On Vision and Modernity in the Nineteenth Century*, Cambridge: MIT Press, 1990.

8 See Wolfgang Schivelbusch, *The Railway Journey: The Industrialization of Time and Space in the 19th Century*, Los Angeles: University of California Press, 1986.

9 See Anne Friedberg, *Window-Shopping: Cinema and the Postmodern*, Los Angeles: University of California Press, 1993.

10 See Giuliana Bruno, *Streetwalking on a Ruined Map*, Princeton: Princeton University Press, 1993; and Bruno, "Bodily Architectures," *Assemblage*, no. 19, 1992, pp. 106–11.

11 Committed to a Foucauldian awareness of "the position from which one speaks," I have restricted myself mostly to Western views, with occasional contaminations, in order to avoid the risk of attempting a world encyclopedia. This includes refraining from comment on the private life of cultures about which I do not feel qualified to speak, for this is a critical dialogue that draws (and draws on) the geography and viewpoints I have inhabited, both in my skin and on the screen.

12 Paul Virilio, *The Lost Dimension*, trans. Daniel Moshenberg, New York: Semiotext(e), 1991, p. 25.

13 Tom Gunning, "From the Kaleidoscope to the X-Ray: Urban Spectatorship, Poe, Benjamin, and *Traffic in Souls* (1913)," *Wide Angle*, vol. 19. no. 4, 1997, p. 33.

14 After a few examples dated 1896, the genre took off in 1897. By 1907, the number of titles thinned, but the genre continued through the mid-twenties. The teens do not appear to have brought substantial innovations in style, nor to have brought about a real exploration of editing potential.

15 See, in particular, chapters 2 and 6 for a discussion of these ideas.

16 Not many of the balloon films appear to have survived. Among them are *Bird's Eye View of San Francisco from a Balloon* (Edison, 1902) and *Panoramic View of Electric Tower from a Balloon* (Edison, 1901). The latter is misleading, for the representation results from the up-and-down motion of the camera and, despite the film's title, it is not clear that it was shot from a balloon. Sometimes, rather than strictly aerial photography, one finds lateral tracks. There are also pans of the city below, from the relatively static position of the balloon.

17 On the culture of the railroad film, see Lynne Kirby, *Parallel Tracks: The Railroad and Silent Cinema*, Durham, N.C.: Duke University Press, 1997.

18 Given the camera's position in these train films, one is transported not only along but into the landscape. It is interesting that instead of offering lateral views—the ones that a passenger would see from the train's windows—these films offer the frontal views that the person who operates the train would see. The frontal view is developed, for example, in *Panoramic View of the Gorge Railroad* (Edison, 1901); *Panoramic View of the White Pass Railroad* (Edison, 1901); *Panoramic View of the Golden Gate* (Edison, 1902); *Panorama from Incline Railway* (AM&B, Robert K. Bonine, 1902); *Panorama from Running Incline Railway* (AM&B, Robert K. Bonine, 1902); *Panorama of Great Gorge Route over Lewinston Bridge* (Edison, 1901); *Panoramic View, Horseshoe Curve From Penna R.R.* (Edison, 1899); *Panoramic View, Kicking Horse Canyon* (Edison, 1901); *Panoramic View, Lower Kicking Horse Canyon* (Edison, 1901); *Panoramic View of the White Pass Railroad* (Edison, 1901); and *Panoramic View, Albert Canyon* (Edison, 1901).

19 Specific bibliographical reference on the city films analyzed is provided over the course of the chapter. The following exhibition catalogues and special issues of journals offer a descriptive survey of the city in film: *Cités-Cinés*, La Villette: Editions Ramsay, 1987 (exhibition catalogue); *Architecture: récits, figures, fictions*, Cahiers du CCI, no. 1, Paris: Editions du Centre Pompidou/CCI, 1986; *Images et imaginaires d'architecture*, Paris: Editions du Centre Pompidou, 1984 (exhibition catalogue); and *Architectural Design*, special issue

"Architecture and Film," no. 112, 1994. Italian sources include Fanny Moro and Paolo Romano, eds., *Lampi metropolitani*, Verona: Cierre Edizioni, 1994; Gian Piero Brunetta and Antonio Costa, eds., *La città che sale*, Trento: Manfrini Editori, 1990 (exhibition catalogue); Marisa Galbiati, ed., *Proiezioni urbane*, Milan: Tranchida, 1989; Donatella Mazzoleni, ed., *La città e l'immaginario*, Rome: Officina, 1985; Antonella Licata and Elisa Mariani Travi, *La città e il cinema*, Bari: Dedalo, 1985; and Alessandro Cappabianca and Michele Mancini, *Ombre urbane*, Rome: Edizioni Kappa, 1981.

20 For a survey of the city film, see Helmut Weismann, "The City in Twilight: Charting the Genre of the City Film, 1900–1930," in François Penz and Maureen Thomas, eds., *Cinema and Architecture: Méliès, Mallet-Stevens, Multimedia*, London: British Film Institute, 1997. For a survey of later periods, see Larry Ford, "Sunshine and Shadow: Lighting and Color in the Depiction of Cities on Film," in Stuart C. Aitken and Leo E. Zonn, eds., *Place, Power, Situation, and Spectacle: A Geography of Film*, London: Rowman and Littlefield, 1994.

21 On the city films of Germany, see Patrice Petro, *Joyless Streets: Women and Melodramatic Representation in Weimar Germany*, Princeton: Princeton University Press, 1989; and Katharina Von Ankum, ed., *Women in the Metropolis: Gender and Modernity in Weimar Culture*, Los Angeles: University of California Press, 1997. On *Berlin, Symphony of the Big City*, see Anke Gleber, "Female Flânerie and the *Symphony of the City*," in Von Ankum, ed., *Women in the Metropolis*; and Wolfgang Natter, "The City as Cinematic Space: Modernism and Place in *Berlin, Symphony of a City*," in Aitken and Zonn, eds., *Place, Power, Situation, and Spectacle*. On Italian city films, see my *Streetwalking on a Ruined Map*.

22 The theoretical outlook that interfaces film and architecture is a field in the making. A growing number of conferences and publications are addressing this issue, fostering a creative synergy that awaits fuller articulation. Important publications that have promoted the dialogue between architecture and film include: Penz and Thomas, eds., *Cinema and Architecture*; David B. Clarke, ed., *The Cinematic City*, New York: Routledge, 1997; and Dietrich Neumann, ed., *Film Architecture: Set Designs from Metropolis to Blade Runner*, New York: Prestel, 1996. See also *Wide Angle*, special issue "Cityscapes I," ed. Clark Arnwine and Jesse Lerner, vol. 19, no. 4, October 1997; and *Iris*, special issue "Cinema and Architecture," ed. Paolo Cherchi Usai and Frank Kessler, no. 12, 1991.

An essential intervention on the cine city was made at the conference and film retrospective "Cine-City: Film and Perceptions of Urban Space, 1895–1995," held at the Getty Center in Los Angeles, 25 March–7 April 1994, where chapters 1 and 2 of this book were presented in an earlier, combined version. See also the proceedings of the conference "(In)Visible Cities: From the Postmodern Metropolis to the City of the Future," New York, 3–6 October 1996, ed. Pellegrino D'Acierno, forthcoming from Monacelli Press, where an essay adapted from this book was also presented.

The international biennial film+arc.graz, directed by Charlotte Pöchhacker in Graz, Austria, which had its third edition 12–16 November 1997, is an ongoing site of exchange between architecture and film. Recent exhibition catalogues published include *Film+arc.graz 3. Internationale Biennale*, Graz: 1997; and *Film+arc.graz 2. Internationale Biennale Film und Architektur*, Graz, 1995.

23 See, for example, P. Morton Shand, *Modern Picture-Houses and Theatres*, Philadelphia: J. B. Lippincott, 1930.

24 On *Metropolis* and modernity, see Anton Kaes, "Metropolis: City, Cinema, Modernity," in Timothy Benson, ed., *Expressionist*

Utopia, Los Angeles: County Museum of Art, 1993 (exhibition catalogue); Dietrich Neumann, "Before and After *Metropolis*: Film and Architecture in Search of the Modern City," in Neumann, ed., *Film Architecture*; and Paola Antonelli and Romana Schneider, "Metropolis in Vitro," *Domus*, no. 717, June 1990, pp. 74–80.

25 On this subject, see Janet Lungstrum, "*Metropolis* and the Technosexual Woman of German Modernity," in Von Ankum, ed., *Women in the Metropolis*; Peter Wollen, "Cinema/Americanism/the Robot," *New Formations*, no. 8, Summer 1989, pp. 7–34; Andreas Huyssen, "The Vamp and the Machine," in *After the Great Divide: Modernism, Mass Culture, Postmodernism*, Bloomington: Indiana University Press, 1986; Roger Dadoun, "*Metropolis*: Mother-City—'Mittler'—Hitler," *Camera Obscura*, no. 15, 1986, pp. 136–63; Patricia Mellencamp, "Oedipus and the Robot in *Metropolis*," *Enclitic*, no. 5, Spring 1981, pp. 20–42; and Stephen Jenkins, "Lang: Fear and Desire," in Jenkins, ed., *Fritz Lang: The Image and the Look*, London: British Film Institute, 1981.

26 On the notion of cyborg, see Donna J. Haraway, *Simians, Cyborgs, and Women: The Reinvention of Nature*, New York: Routledge, 1991, especially chapter 8.

27 In *Metropolis*, the android is made to the image of the human and is a perfect copy. However, a distinction between copy and original is retained somewhat at the ethical level. The android may look like a human but it is still proven to be a fake, for the "False Maria" is not as good as the original. By the time *Blade Runner* came to be made, the blur between original and copy was further eroded in favor of the cyborg, and the replicants have no originals. They are not remakes and furthermore exist on their own terms.

28 Annette Michelson, "Dr. Crase and Mr. Clair," *October*, no. 11, Winter 1979, p. 44.

29 See Lisa Cartwright, *Screening the Body: Tracing Medicine's Visual Culture*, Minneapolis: University of Minnesota Press, 1995.

30 The film's script was written by H. G. Wells, based on his book *The Shape of Things to Come* (1933). On this film, see, among others, Christopher Frayling, *Things to Come*, London: British Film Institute, 1995.

31 László Moholy-Nagy, *Painting, Photography, Film*, trans. Janet Seligman, Cambridge: MIT Press, 1969. This originally appeared as Bauhaus Book, no. 8, in 1925.

32 On this film and urban modernity, see Annette Michelson, "*The Man with a Movie Camera*: From Magician to Epistemologist," *Artforum*, vol. 10, no. 7, 1972, pp. 62–72, in which *Paris qui dort* is also discussed in relation to epistemic approaches of montage.

33 See Vlada Petrić, *Constructivism in Film: The Man with the Movie Camera: A Cinematic Analysis*, Cambridge: Cambridge University Press, 1987.

34 See Vertov, *Kino-Eye: The Writings of Dziga Vertov*, ed. and with an introduction by Annette Michelson, trans. Kevin O'Brien, Los Angeles: University of California Press, 1984.

35 André Bazin called attention to the "mummy complex" of the plastic arts in his "The Ontology of the Photographic Image," in *What is Cinema?*, vol. 1, ed. and trans. Hugh Gray, Los Angeles: University of California Press, 1967.

36 On *L'Inhumaine*, see Odile Vaillant, "Robert Mallet-Stevens: Architecture, Cinema and Poetics," in Penz and Thomas, eds.,

Cinema and Architecture; Luc Wouters, "Cinema and Architecture," in Jean François Pinchon, ed., *Robert Mallet-Stevens, Architecture, Furniture, Interior Design*, Cambridge: MIT Press, 1990; Michel Louis, "Mallet-Stevens and the Cinema 1919–1929," in Hubert Jeanneau and Dominique Deshoulières, eds., *Robert Mallet-Stevens, Architecte*, Brussels: Editions des Archives d'Architecture Moderne, 1980; Donald Albrecht, *Designing Dreams*, New York: Harper and Row, 1986, pp. 43–51; and Antonio Costa, "Cinema, avanguardie storiche e koiné modernista: *L'Inhumaine* di Marcel l'Herbier," in Brunetta and Costa, eds., *La città che sale*.

37 In addition, Pierre Chareau and Michel Dufet designed the furniture; Raymond Templier, the jewels; Lalique, Puiforcat, and Jean Luce, glassware and carpets. The musical score was composed by Darius Milhaud.

38 Mallet-Stevens, "Le décor" (1929), in *Iris*, no. 12, 1991, pp. 129–37; and Mallet-Stevens, *Le Décor moderne au cinéma*, Paris: Massin, 1928.

39 See Adolf Loos, "*L'Inhumaine*: Histoire féerique," *Neue Freie Presse*, 29 July 1924.

40 See chapters 5 and 10 for a treatment of the relation of the cabinet of curiosity to (pre)cinematic culture.

41 The literature on *Sunrise* includes Lotte Eisner, *Murnau*, Berkeley: University of California Press, 1973; Robin Wood, "Murnau II, *Sunrise*," *Film Comment*, May–June 1976, pp. 10–12; Mary Ann Doane, "Desire in *Sunrise*," *Film Reader*, no. 2, 1977, pp. 71–77; and Dudley Andrew, *Film in the Aura of Art*, Princeton: Princeton University Press, 1984, pp. 28–58.

42 The set was designed by Rochus Gliese.

43 René Clair's statement is cited by Paul Virilio in *The Lost Dimension*, p. 69.

44 Set design is a crucial aspect of cinema which, regrettably, has been the focus of too little critical investigation. The field has opened up with such important scholarly contributions as Albrecht, *Designing Dreams*; and Charles Affron and Mirella Jona Affron, *Sets in Motion: Art Direction and Film Narrative*, New Brunswick: Rutgers University Press, 1995. In Spanish, see Juan Antonio Ramirez, *La arquitectura en el cine: Hollywood, la edad de oro*, Madrid: Hermann Blume, 1986. In Italian, see Alessandro Cappabianca, Michele Mancini, and Umberto Silva, *La costruzione del labirinto*, Milan: Mazzotta Editore, 1974.

45 For a survey of this cine city, see Donald Albrecht, "New York, Olde York: The Rise and Fall of a Celluloid City," in Neumann, ed., *Film Architecture*.

46 See Edward Dimendberg, "From Berlin to Bunker Hill: Urban Space, Late Modernity, and Film Noir in Fritz Lang's and Joseph Losey's *M*," *Wide Angle*, vol. 19, no. 4, October 1997, pp. 62–93, a part of his forthcoming book, *Film Noir and The Spaces of Modernity*; Joan Copjec, ed., *Shades of Noir: A Reader*, New York: Verso, 1993; Rosalyn Deutsche, "*Chinatown*, Part Four? What Jake Forgets about Downtown," in *Evictions: Art and Spatial Politics*, Cambridge: MIT Press, 1996; Frank Krutnik, "Something More than Night: Tales of the *Noir* City," in Clarke, ed., *The Cinematic City*; and Paul Arthur, *Shadows on the Mirror: Film Noir and Cold War America*, Ph.D. dissertation, New York University, 1985.

47 The film, directed by De Sica, was written by his collaborator, the writer and critic Cesare Zavattini, with Truman Capote, from a treatment by Zavattini. For the debate that it stirred, see Umberto Barbaro, *Servitù e grandezza del cinema*, Rome: Editori Riuniti, 1962, pp. 223–27.

48 See chapter 8 for a treatment of *The Naked City* in relation to the situationist map named after it and for a discussion of the workings of psychogeography in the film.

49 This is the definition of the city given by Emile Zola in *The Belly of Paris*, trans. Ernest Alfred Vizetelly, Los Angeles: Sun and Moon Press, 1996.

50 André Bazin, *What is Cinema?*, vol. 2, ed. and trans. Hugh Gray, Los Angeles: University of California Press, 1971, p. 55. The film is known in English as *Bicycle Thief*, although the Italian title underscores clearly the plurality of the situation: many are led by social conditions to become "Bicycle Thieves." The wrong translation seriously obscures the film's social commentary.

51 Henri Lefebvre, *The Production of Space*, trans. Donald Nicholson-Smith, Oxford: Blackwell, 1991, p. 137.

52 Gilles Deleuze, *Cinema 1: The Movement-Image*, trans. Hugh Tomlinson and Barbara Habberjam, Minneapolis: University of Minnesota Press, 1986, p. 12.

53 See Maurizio Viano, "Mamma Roma Città Aperta," in *A Certain Realism: Making Use of Pasolini's Film Theory and Practice*, Los Angeles: University of California Press, 1993, pp. 87–93. Viano treats the film's ending, remarking on its two different views and reading it, in a different way, as the director's point of view—that is, as an affirmation of Pasolini's "free indirect subjective" style.

54 For an architectural commentary on this and other Roman films, see David Bass, "Insiders and Outsiders: Latent Urban Thinking in Movies of Modern Rome," in Penz and Thomas, eds., *Cinema and Architecture*.

55 Homi K. Bhabha, *The Location of Culture*, New York: Routledge, 1994, p. 9.

56 Wim Wenders, "Impossible Stories," in Roger F. Cook and Gerd Gemünden, *The Cinema of Wim Wenders: Image, Narrative, and the Postmodern Condition*, Detroit: Wayne State University Press, 1997, p. 33.

57 See Yi-Fu Tuan, *Topophilia: A Study of Environmental Perception, Attitudes, and Values*, New York: Columbia University Press, 1990. The notion of topophilia is addressed more fully in the present book in chapters 10, 11, and 12.

58 Wenders as interviewed in *Cahiers du CCI*, no. 1, 1986, pp. 104–7.

59 Wenders, "An Attempted Description of an Indescribable Film: From the First Treatment of *Wings of Desire*," in *The Logic of Images: Essays and Conversations*, trans. Michael Hofman, London: Faber and Faber, 1991, p. 77. For a reading of the angels as angels of history, see Cesare Casarino, "Fragments on *Wings of Desire* (Or, Fragmentary Representation as Historical Necessity)," *Social Text*, no. 24, 1990, pp. 167–81; Roger F. Cook, "Angels, Fiction and History in Berlin: *Wings of Desire*," in Cook and Gemünden, *The Cinema of Wim Wenders*; and Robert Phillip Kolker and Peter Beicken, *The Films of Wim Wenders*, Cambridge: Cambridge University Press, 1993, chapter 6.

60 Wenders, "An Attempted Description of an Indescribable Film," p. 81.

61 On Ledoux, see Anthony Vidler, *Claude-Nicolas Ledoux: Architecture and Social Reform at the End of the Ancien Regime*, Cambridge: MIT Press, 1990.

62 See, in particular, chapters 9 and 10.

63 *Contempt* was adapted from Alberto Moravia's novel *A Ghost at Noon*, trans. Angus Davidson, New York: Farrar Straus and Young, 1955.

64 *The Waxen Venus* (1782), made by Clemente Susini and Giuseppe Ferrini, was a celebrated anatomical model that fashioned an entire genre.

65 I refer to the method of Abram Room's *Bed and Sofa* (1926), a film that took place entirely in between the two objects of love and design in its title.

66 See chapter 11. Rossellini's *Viaggio in Italia* has been distributed in English under many different names, including *Journey to Italy*, *Voyage to Italy*, *Strangers*, *The Lonely Woman*, *Love is the Strongest*, and *The Greatest Love*. According to Adriano Aprà, the original English title is *Journey to Italy*, a title given to the film by critics. The Italian title, however, actually means "voyage in Italy." This last translation is not only correct but actually corresponds to the sense of the narrative: this is a voyage in, and not to, Italy.

On the influence of Rossellini's film on *Contempt*, see Jean-Luc Godard, "Le mépris," in *Jean-Luc Godard par Jean Luc Godard*, ed. Alain Bergala, Paris: Cahiers du Cinéma—Editions de l'Etoile, 1985. Readings that also compare *Contempt* to *Voyage in Italy* include Kaja Silverman and Harun Farocki, *Speaking about Godard*, New York: New York University Press, 1998, chapter 2; Michel Marie, *Le Mépris: Jean-Luc Godard, étude critique*, Paris: Nathan, 1990; and Jacques Aumont, "The Fall of the Gods: Jean-Luc Godard's *Le mépris*," in Susan Hayward and Ginette Vincendeau, eds., *French Films: Texts and Contexts*, New York: Routledge, 1990.

67 On this house, see Marida Talamona, *Casa Malaparte*, New York: Princeton Architectural Press, 1992; and Richard Flood, "Curzio Malaparte: Casa Malaparte, 1938," *Artforum*, Summer 1997; pp. 122–23.

68 See Frank Kessler, "Les architectes-peintres du cinéma allemand muet," *Iris*, no. 12, 1991, pp. 46–54.

69 Marguerite Duras, *The Lover*, trans. Barbara Brey, New York: Pantheon Books, 1985; and Duras, *The North China Lover*, trans. Leigh Hafrey, New York: New Press, 1992. On Duras's work in relation to mental architectural space, see Yann Beauvais, "Remembrances—Visible Cities," in *film+arc.graz 3. Internationale Biennale*, 1997 (exhibition catalogue). For further treatment of *Hiroshima mon amour*, see chapter 7.

70 On the subject of love and estrangement, see Julia Kristeva, *Tales of Love*, trans. Leon S. Roudiez, New York: Columbia University Press, 1987; and Kristeva, *Strangers to Ourselves*, trans. Leon S. Roudiez, New York: Columbia University Press, 1991. See also Stephen Kern, *The Culture of Love: Victorians to Moderns*, Cambridge: Harvard University Press, 1992.

71 On the etymology of *metaphor*, see Michel de Certeau, *The Practice of Everyday Life*, trans. Steven Rendall, Los Angeles: University of California Press, 1984, p. 115.

72 Plato, *Symposium*, ed. Eric H. Warmington and Philip G. Rouse, New York: Mentor Books, 1956, especially pp. 97–98.

73 Roger Caillois, "Mimicry and Legendary Psychasthenia," *October*, no. 31, Winter 1984, pp. 17–32.

74 See Marc Augé, *Non-places: Introduction to an Anthropology of Supermodernity*, trans. John Howe, London: Verso, 1995.

75 Siegfried Kracauer, "Farewell to the Linden Arcade" (1930), in *The Mass Ornament: Weimar Essays*, ed. and trans. Thomas Y. Levins, Cambridge: Harvard University Press, 1995, p. 342.

76 See Kracauer, "The Hotel Lobby," "Analysis of a City Map," "Travel and Dance," and other Weimar-era essays in *The Mass Ornament*.

77 Kracauer, *Theory of Film: The Redemption of Physical Reality*, New York: Oxford University Press, 1960, p. 98.

78 Miriam Hansen, "'With Skin and Hair': Kracauer's Theory of Film, Marseille 1940," *Critical Inquiry*, no. 19, Spring 1993, pp. 437–69. See also Heide Schlupmann, "Phenomenology of Film: On Siegfried Kracauer's Writings of the 1920s," *New German Critique*, no. 40, Winter 1987, pp. 97–114; and Petro, *Joyless Streets*.

79 Kracauer, *From Caligari to Hitler: A Psychological History of the German Film*, Princeton: Princeton University Press, 1947, especially pp. 157–60.

80 Kracauer, *Theory of Film*, especially p. 52.

81 Kracauer, "Farewell to the Linden Arcade."

82 Kracauer, "Cult of Distraction: On Berlin's Picture Palaces," in *The Mass Ornament*, p. 325.

83 For a chronicle of film theaters of the modern era, see Shand, *Modern Picture-Houses and Theatres*. On the design context of the American picture house, see also Richard Guy Wilson, Dianne H. Pilgrim, and Dickran Tashjian, *The Machine Age in America 1818–1941*, New York: Harry N. Abrams, in association with the Brooklyn Museum, 1986; and Maggie Valentine, *The Show Starts on the Sidewalk: An Architectural History of the Movie Theatre, Starring S. Charles Lee*, New Haven: Yale University Press, 1994.

84 Essential information on Kiesler's design has been drawn from the Kiesler fund at the Harvard Theatre Collection. On Kiesler, see *Frederick Kiesler, Artiste-architecte*, Paris: Centre Georges Pompidou, 1996 (exhibition catalogue), and in particular the essay by Richard Becherer, "Le Film Guild Cinema"; Maria Bottero, *Frederick Kiesler: Arte Architettura Ambiente*, Milan: Electa, 1995; and Lisa Phillips, ed., *Frederick Kiesler*, New York: Whitney Museum of American Art, 1989 (exhibition catalogue).

85 The theater was featured in the famous "Modern Architecture: International Exhibition," organized in 1932 at the Museum of Modern Art in New York by Philip Johnson and Henry-Russell Hitchcock.

86 Frederick Kiesler, "Building a Cinema Theater," *New York Evening Post*, 2 February 1929, n.p.

87 On this subject, see Annette Michelson, "Gnosis and Iconoclasm: A Case Study of Cinephilia," *October*, no. 83, Winter 1998, pp. 3–18.

88 Ben M. Hall, *The Best Remaining Seats: The Golden Age of the Movie Palace*, New York: Crown, 1961, p. 76.

89 Lloyd Lewis, in the *New Republic* (1929), as cited by Robert A. M. Stern, "Prologue: The Way They Were: The Twenties," in Jane

Preddy, *Glamour, Glitz and Sparkle: The Deco Theatres of John Eberson*, publication of the Theatre Historical Society of America, no. 16, 1989, p. 6.

90 These were places for parents to take their children when they could not remain silent during the show.

91 William Paul, "Screening Space: Architecture, Technology, and the Motion Picture Screen," *Michigan Quarterly Review*, special issue "The Movies: A Centennial Issue," ed. Laurence Goldstein and Ira Konigsberg, vol. 35, no. 1, 1996, pp. 143–73; and Paul, "Staging the Screen," paper presented at the Columbia University Seminar for Cinema and Interdisciplinary Interpretation, Museum of Modern Art, New York, 12 December 1996.

92 Eberson built more than forty atmospheric movie palaces, the majority of which have been destroyed, and altogether about three hundred movie theaters, including streamlined, art-deco versions. For useful information on Eberson's atmospheric career, see Richard Stapleford, "The Architectural Significance of the Atmospheric Theater," and Jane Preddy, "John Eberson and the Atmospheric Theatre," in *Temples of Illusion: The Atmospheric Theaters of John Eberson*, New York: Bertha and Karl Leubsdorf Art Gallery of Hunter College, 1988 (exhibition catalogue).

93 Kessler, "Les architectes-peintres du cinéma allemand muet," pp. 51–52.

94 Eberson's daughters and son also collaborated with the father.

95 Stern, "Prologue: The Way They Were," p. 6.

96 Drew Eberson, son and partner of John Eberson, recalls that teachers brought classes to the movie theater to learn from the precise celestial map. See Drew Eberson, foreword to Michael Miller, "Paradise in the Bronx," *Marquee*, publication of the Theatre Historical Society of America, 1975, n.p.

97 See chapter 6 for this genealogy of cinema.

98 See Miller, "Paradise in the Bronx"; and Lloyd Ultan with the Bronx Historical Society, *The Beautiful Bronx 1920–1950*, New York: Harmony Books, 1979.

99 See chapters 7 and 10 for an analysis of this genealogy.

100 "Interview with Hiroshi Sugimoto" by Thomas Kellein, in *Hiroshi Sugimoto: Time Exposed*, New York: Thames and Hudson, 1995 (exhibition catalogue), pp. 92–93. See also *Sugimoto*, Madrid: Fundació "La Caixa," 1998 (exhibition catalogue); Ralph Rugoff, "Half Dead," *Parkett*, no. 46, 1996, pp. 132–37; *Motion Picture*: Milan: Skira Editore, 1995; Russell Ferguson, ed., *Sugimoto*, Los Angeles: Museum of Contemporary Art, 1993 (exhibition catalogue), with an essay by Kerry Brougher; and *Photographs by Hiroshi Sugimoto: Dioramas, Theatres, Seascapes*, New York: Sonnabend Gallery, 1988.

101 Bazin, *What is Cinema?*, vol. 2, p. 60.

102 Norman Bryson, "Hiroshi Sugimoto's Metabolic Photography," *Parkett*, no. 46, 1996, pp. 121–22.

103 Sugimoto's statement is cited from the wall text of his exhibition at the Metropolitan Museum of Art, New York, 21 November 1995–14 January 1996.

2 A Geography of the Moving Image

1 See, in particular, chapter 8.

2 Sergei M. Eisenstein, "Montage and Architecture" (c. 1937), *Assemblage*, no. 10, 1989, with an introduction by Yve-Alain Bois, pp. 111–31. The text was originally to have been inserted in a book-length work.

3 Ibid., p. 116.

4 Eisenstein, "'El Greco y el cine,'" (1937–41), in *Cinématisme: Peinture et cinéma*, ed. François Albera, trans. Anne Zouboff, Brussels: Editions complexe, 1980, pp. 16–17.

5 This phenomenon can also be explored in different contexts, as Annette Michelson shows when she considers Eisenstein's claims for subjectivity. See Michelson, "Reading Eisenstein Reading *Ulysses*: Montage and the Claims of Subjectivity," *Art and Text*, no. 34, Spring 1989, pp. 64–78.

6 Eisenstein, "Montage and Architecture," p. 117.

7 See Auguste Choisy, *Histoire de l'architecture*, vol. 1, Paris: Gauthiers-Villars, 1889, p. 413. For a reading of the Acropolis as a sequence of views, see also C. A. Doxiadis, *Architectural Space in Ancient Greece* (1937), ed. and trans. Jaqueline Tywhitt, Cambridge: MIT Press, 1972.

8 Eisenstein, "Montage and Architecture," p. 117.

9 It was Walter Benjamin's belief that every epoch dreams the following, an idea expressed in his "Fourier or the Arcades," in *Charles Baudelaire: A Lyric Poet in the Era of High Capitalism*, trans. Harry Zohn, London: Verso, 1973.

10 Bernard Tschumi, *The Manhattan Transcripts*, New York: St. Martin's Press, 1981, p. 7.

11 Ibid., p. 11.

12 See Tschumi, *Cinégramme folie: Le Parc de La Villette, Paris Nineteenth Arrondissement*, Princeton: Princeton Architectural Press, 1987. Defining the cinematic promenade as analogous to the film strip, Tschumi notes that "in the cinema the relations between frames or between sequences can be manipulated through devices such as flashbacks, jumpcuts, dissolves and so on. Why not in architecture?" (p. 12)

13 See the development of Tschumi's work, especially with the Glass Video gallery (1990), in Groningen, the Netherlands; and Le Fresnoy National Studio for the Contemporary Arts, Tourcoing, France. The latter, a center for leisure activities housed in an industrial warehouse, was ingeniously transformed by Tschumi into a cultural center that promotes interaction among the arts, including film.

14 Michel de Certeau, *The Practice of Everyday Life*, trans. Steven Rendall, Los Angeles: University of California Press, 1984.

15 Choisy, *Histoire de l'architecture*, vol. 1, p. 413, cited by Eisenstein in "Montage and Architecture," p. 118.

16 Eisenstein, "Montage and Architecture," p. 120.

17 Le Corbusier and Pierre Jeanneret, *Oeuvre complète*, vol. 1, ed. Willi Boesiger, Zurich: Editions Girsberger, 1964, p. 60. Here, Le Corbusier speaks of the Maison La Roche (1922).

18 Anthony Vidler, "The Explosion of Space: Architecture and the Filmic Imaginary," in Dietrich Neumann, ed., *Film Architecture: Set Designs from Metropolis to Blade Runner*, New York: Prestel, 1996. On Eisenstein and architectural history, see Yve-Alain Bois's introduction to Eisenstein's "Montage and Architecture." On Choisy and Le Corbusier, see Richard A. Etlin, "Le Corbusier, Choisy, and French Hellenism: The Search for a New Architecture," *Art Bulletin*, no. 2, June 1987, pp. 264–78; and Stan Allen, "Le Corbusier and Modernist Movement," *ANY*, no. 5, March–April 1994, pp. 42–47.

19 This interview, the only one that Le Corbusier gave during his stay in Moscow in 1928, is cited in Jean-Louis Cohen, *Le Corbusier and the Mystique of the USSR*, trans. Kenneth Hylton, Princeton: Princeton University Press, 1992, p. 49.

20 See Beatriz Colomina, *Privacy and Publicity: Modern Architecture as Mass Media*, Cambridge: MIT Press, 1994.

21 Le Corbusier, *Oeuvre complète*, vol. 2, p. 24. Here, Le Corbusier develops the idea of the architectural promenade by reading the itinerary of Villa Savoye (1929–31) in relation to the movement of Arabic architecture.

22 Eisenstein, "Piranesi, or the Fluidity of Forms," *Oppositions*, no. 11, Winter 1977, p. 98. The essay, written c. 1947 and published first in 1964, focuses on Piranesi's *Prisons* and begins with *Carcere Oscura* (c. 1745), from the series *Opere varie di architettura*.

23 Anne Hollander, *Moving Pictures*, Cambridge: Harvard University Press, 1991.

24 On cinema's pictorialism, see Jacques Aumont, *L'oeil interminable: cinéma et peinture*, Paris: Librarie Séguier, 1989; Angela Dalle Vacche, *Cinema and Painting: How Art is Used in Film*, Austin: University of Texas Press, 1996; Brigitte Peucker, *Incorporating Images: Film and the Rival Arts*, Princeton: Princeton University Press, 1995; Pascal Bonitzer, *Décadrage: Cinéma et peinture*, Paris: Editions de l'Etoile, 1985. On American nineteenth-century landscape painting and film language, see Scott MacDonald, "Voyages of Life," *Wide Angle*, vol. 18, no. 2, April 1996, pp. 101–26; and Iris Cahn, "The Changing Landscape of Modernity: Early Film and America's 'Great Picture' Tradition," *Wide Angle*, vol. 18, no. 3, July 1996, pp. 85–100. Both issues are devoted to "Movies Before Cinema" and are edited by Scott MacDonald. For an early account, see André Bazin, "Painting and Cinema," in *What is Cinema?*, vol. 1, ed. and trans. Hugh Gray, Los Angeles: University of California Press, 1967.

The interdisciplinary study of art and film, which for some time has interested scholars such as Annette Michelson and Peter Wollen, is being forged as a discipline and becoming a site of exhibition. See, for example, the collection of essays by Michelson, *On the Eve of the Future*, Cambridge: MIT Press, forthcoming; Peter Wollen, *Raiding the Icebox: Reflections on Twentieth-Century Culture*, Bloomington: Indiana University Press, 1993; and Antonia Lant, "Haptical Cinema," *October*, no. 74, 1995, pp. 45–73. On the exhibition of art and film, see Russell Ferguson, ed., *Art and Film since 1945: Hall of Mirrors*, New York: Monacelli Press, and Los Angeles: Museum of Contemporary Art, 1996 (exhibition catalogue); Philip Dodd and Ian Christie, eds., *Spellbound: Art and Film*, London: British Film Institute and Hayward Gallery, 1996 (exhibition catalogue). See also, *A.D., Art and Design*, special issue "Art and Film," no. 49, 1996.

25 The bond between art and film, a concern throughout the book, is especially developed in chapters 6 through 10.

26 For an extended treatment of and bibliographical reference on the picturesque, see chapter 6.

27 On this view and map, see Louis Marin, *Utopics: Spatial Plays*, trans. Robert A. Vollrath, New Jersey: Humanities, 1984, chapter 10.

28 Eisenstein, "Synchronization of Senses," in *The Film Sense*, ed. and trans. Jay Leyda, New York: Harcourt, 1942, p. 103.

29 The literature on view painting, a subject that will be explored more closely in chapter 6, is vast. For bibliographic reference, see the proceedings of the conference "Archéologie du paysage" published in *Caesarodunum*, vol. 1, no. 13, 1978, bibliography compiled by Elisabeth Chevallier, pp. 579–613.

30 For the inception of a traveling theory see Edward Said, "Traveling Theory," in *The World, the Text and the Critic*, London: Faber and Faber, 1984, pp. 226–47.

31 Before modern tourism, organized forms of travel emerged in medieval times in connection with religious pilgrimage. See Maxine Feifer, *Going Places: The Ways of the Tourist from Imperial Rome to the Present Day*, London: Macmillan, 1985.

32 Bois, introduction to Eisenstein's "Montage and Architecture," p. 115.

33 See Giuliana Bruno, *Streetwalking on a Ruined Map*, Princeton: Princeton University Press, 1993, especially chapters 4 and 15, for a treatment of the film theater as anatomical theater. On anatomy, gender, and film genealogy, see also Annette Michelson, "On the Eve of the Future: The Reasonable Facsimile and the Philosophical Toy," *October*, no. 29, 1984, pp. 1–22; Lisa Cartwright, *Screening the Body: Tracing Medicine's Visual Culture*, Minneapolis: University of Minnesota Press, 1995; and Vanessa R. Schwartz, *Spectacular Realities: Early Mass Culture in Fin-de-Siècle Paris*, Los Angeles: University of California Press, 1998.

34 On this notion see Ludmilla Jordanova's *Sexual Visions: Images of Gender in Science and Medicine Between the Eighteenth and Twentieth Centuries*, Madison: University of Wisconsin Press, 1989.

35 Henri Lefebvre, *The Production of Space*, trans. Donald Nicholson-Smith, Oxford: Blackwell, 1991, p. 184. For a spatial reading of Lefebvre, see Edward W. Soja, *Thirdspace*, Oxford: Blackwell, 1996, especially the chapters "The Extraordinary Voyages of Henri Lefebvre" and "The Trialectics of Spatiality"; and Victor Burgin, *In/different Spaces: Place and Memory in Visual Culture*, Los Angeles: University of California Press, 1996.

36 Although in this book I develop this notion architecturally and geographically, and in Lefebvrian terms, the phenomenology of Merleau-Ponty provides a basis for understanding the primary level of the lived body in lived space. See especially Maurice Merleau-Ponty, *Phenomenology of Perception*, trans. Colin Smith, London: Routledge, 1962; and *The Visible and the Invisible*, trans. A. Lingis, Evanston: Northwestern University Press, 1968. For a philosophical reassessment of place that treats the phenomenological way of the body, see Edward S. Casey, *The Fate of Place: A Philosophical History*, Berkeley: University of California Press, 1997, especially chapter 10. For a film phenomenology, see Vivian Sobchack, *The Address of the Eye: A Phenomenology of Film Experience*, Princeton: Princeton University Press, 1992.

37 Water Benjamin, "The Work of Art in the Age of Mechanical Reproduction," in *Illuminations*, ed. and with an introduction by Hannah Arendt, trans. Harry Zohn, New York: Schocken Books, 1969, p. 239. The link between the city and film engages the inhabi-

tant-spectator, extended in space in a process of perceptive enrich-ment: "The film corresponds to profound changes in the appercep-tive apparatus—changes that are experienced on an individual scale by the man in the street in big-city traffic, on a historical scale by every present-day citizen." (p. 250) See also Benjamin, *Immagini di città*, Turin: Einaudi, 1977. On the subject of Benjamin's view of film's radical potential for spatiocorporeal expansion, see Gertrud Koch, "Cosmos in Film: On the Concept of Space in Walter Benjamin's 'Work of Art' Essay," trans. Nancy Nenno, in Andrew Benjamin and Peter Osborne, eds., *Walter Benjamin's Philosophy: Destruction and Experience*, New York: Routledge, 1994.

38 Benjamin, "The Work of Art," p. 240.

39 This notion originated in Kevin Lynch, *The Image of the City*, Cambridge: MIT Press, 1960.

40 Georg Simmel, "The Metropolis and Mental Life," in *On Individuality and Social Forms: Selected Writings*, ed. Donald N. Levine, Chicago: University of Chicago Press, 1971, pp. 325–35.

41 See Thomas McDonough, "Situationist Space," *October*, no. 67, Winter 1994, pp. 58–77, in which the relationship of *The Naked City* to the *Carte de Tendre* is addressed. This topic is addressed further in chapter 8.

42 James Clifford, *Routes*, Cambridge: Harvard University Press, 1997, p. 30.

43 Robert Mallet-Stevens, "Le Cinéma et les arts, l'architecture," *Les Cahiers du Mois*, nos. 16–17, 1925, p. 96.

44 See, for example, Jeffrey Kipnis and Thomas Leeser, eds., *Chora L works: Jacques Derrida and Peter Eisenman*, New York: Monacelli Press, 1997. A multidisciplinary mobilization of the architectural field has been promoted by the Anyone Corporation through a series of annual conferences starting in 1991, the publication of books, and the magazine *ANY*.

45 For a theoretical narration of film's vision machine, see, in particu-lar, Paul Virilio, *The Aesthetics of Disappearance*, trans. Philip Beitchman, New York: Semiotext(e), 1991; and Virilio, *The Lost Dimension*, trans. Daniel Moshenberg, New York: Semiotext(e), 1991. Also relevant are Virilio, *The Vision Machine*, trans. Julie Rose, London: British Film Institute, 1994; Virilio, *The Art of the Motor*, trans. Julie Rose, Minneapolis: University of Minnesota Press, 1994; and Virilio, *Open Sky*, trans. Julie Rose, London: Verso, 1997.

46 For recent developments, see Bernard Tschumi, *Architecture and Disjunction*, Cambridge: MIT Press, 1994; and Tschumi, *Event-Cities*, Cambridge: MIT Press, 1994.

47 See Rem Koolhaas, *Delirious New York*, New York: Monacelli Press, 1994; and Koolhaas, *S,M,L,XL*, New York: Monacelli Press, 1995.

48 Koolhaas's statement is cited in the editorial by Maggy Toy in *A.D.*, *Architectural Design*, special issue "Architecture and Film," no. 112, 1994, p. 7.

49 For a comparison of Koolhaas's work to that of filmmakers, including Jean-Luc Godard, see Roemer Van Toorn, "Architecture Against Architecture: Radical Criticism Within the Society of the Spectacle," in *film+arc.graz 2. Internationale Biennale Film und Architektur*, 1995.

50 Jean Nouvel, "Les cinéastes? Sur des choses certaines ils m'ont ouvert les yeux," in *Cités-Cinés*, Paris: Editions Ramsay, 1987 (exhibition catalogue), p. 23 (my translation).

51 Nouvel's statement is cited in Kester Rattenbury, "Echo and Narcissus," *A.D.*, *Architectural Design*, special issue "Architecture and Film," no. 112, 1994, p. 35.

52 Nouvel as cited in Odile Fillion, "Life Into Art, Art Into Life: Fusions in Film, Video and Architecture," in François Penz and Maureen Thomas, eds., *Cinema and Architecture: Méliès, Mallet-Stevens, Multimedia*, London: British Film Institute, 1997, p. 119.

53 Diana I. Agrest, *Architecture from Without*, Cambridge: MIT Press, 1993, pp. 62–63.

54 See Elizabeth Diller and Ricardo Scofidio, *Tourisms: suitCase Studies*, in *Semiotext(e)*, special issue "Architecture," 1992. See also, Diller + Scofidio, eds., *Back to the Front: Tourisms of War*, Basse-Normandie: F.R.A.C., 1994; and Diller + Scofidio, *Flesh*, with an essay by Georges Teyssot, New York: Princeton Architectural Press, 1994. On *BAD Press*, see Zvi Efrat, "Diller + Scofidio's 'BAD Press': Unseemliness of the Fashionable"; and Diller + Scofidio, "BAD Press: Housework Series," in Deborah Fausch, Paulette Singley, Rodolphe El-Khoury, and Zvi Efrat, eds., *Architecture in Fashion*, New York: Princeton Architectural Press, 1994.

55 Diller and Scofidio, *Tourisms: suitCase Studies*, p. 11.

56 Erwin Panofsky, "Style and Medium in the Motion Picture" (1934, revised 1947), in Gerald Mast, Marshall Cohen, and Leo Braudy, eds., *Film Theory and Criticism*, New York: Oxford University Press, 1992, p. 234.

57 Pier Paolo Pasolini, "The Codes of Codes," in *Heretical Empiricism*, trans. Ben Lawton and Luise K. Barnett, Bloomington: Indiana University Press, 1988, p. 280.

58 Steven Shaviro, *The Cinematic Body*, Minneapolis: University of Minnesota Press, 1993, p. 52. Shaviro offers his version of the cine-matic body, drawing on the work of Deleuze and Guattari.

59 On this subject, see, among others, Beatriz Colomina, ed., *Sexuality and Space*, Princeton: Princeton Architectural Press, 1992; Diana Agrest, Patricia Conway, and Leslie Kanes Weisman, eds., *The Sex of Architecture*, Cambridge: MIT Press, 1996. I return to architec-tural discourse at different points in the book, developing the cine-matic link outlined earlier in my own "Bodily Architectures," *Assemblage*, no. 19, 1992, pp. 106–11.

60 Michael Dear, "Between Architecture and Film," *A.D.*, *Architectural Design*, special issue "Architecture and Film," no. 112, 1994, p. 9.

61 I am borrowing and developing the notion of *transito* from Italian philosophy. See Mario Perniola, *Transiti: Come si va dallo stesso allo stesso*, Bologna: Cappelli, 1985. See also Franco Rella, *Limina: il pensiero e le cose*, Milan: Feltrinelli, 1987.

3 Traveling Domestic: The Movie "House"

1 See Philip Rosen, "Disjunction and Ideology in a Preclassical Film: A Policeman's Tour of the World," *Wide Angle*, vol. 12, no. 3, 1990, pp. 20–36.

2 Charles Musser first turned historical attention to travel films in his "The Travel Genre in 1903–04: Moving Toward Fictional Narrative," in Thomas Elsaesser, ed., with Adam Barker, *Early Cinema: Space, Frame, Narrative*, London: British Film Institute, 1990. He expanded the subject in *The Emergence of Cinema: The American Screen to 1907*, New York: Macmillan, 1990; and (in collaboration with Carol Nelson) in *High-Class Moving Pictures: Lyman H. Howe and the Forgotten Era of Traveling Exhibition, 1880–1920*, Princeton: Princeton University Press, 1991.

3 On "touristic consciousness," see Lynne Kirby, *Parallel Tracks: The Railroad and Silent Cinema*, Durham, N.C.: Duke University Press, 1996, p. 42. For a theoretical introduction to film's "touristic" vision, see, among others, Anne Friedberg, *Window Shopping: Cinema and the Postmodern*, Los Angeles: University of California Press, 1993; Giuliana Bruno, *Streetwalking on a Ruined Map*, Princeton: Princeton University Press, 1993; Jacques Aumont, "Migrations," *Cinémathèque*, no. 7, 1993, pp. 35–47; Tom Gunning, "'The Whole World Within Reach': Travel Images without Borders," in Roland Cosandey and François Albera, eds., *Cinéma sans frontières, 1896–1918: Images Across Borders*, Lausanne: Editions Payot Lausanne, 1992; and Annette Michelson, "Track Records, Trains of Events: The Limits of Cinematic Representation," in *Junction and Journey: Trains and Film*, New York: Museum of Modern Art, 1991 (exhibition catalogue).

4 P. Morton Shand, *Modern Picture-Houses and Theatres*, Philadelphia: J. B. Lippincott, 1930, p. 11.

5 Wolfgang Schivelbusch, *Disenchanted Night: The Industrialization of Light in the Nineteenth Century*, trans. Angela Davies, Berkeley: University of California Press, 1988, pp. 213–19.

6 Shand, *Modern Picture-Houses and Theatres*, p. 11.

7 I thank my student Naghmeh Sohrabi for adding a Persian twist to my site-seeing tour with the spectator-passenger.

8 Anthony Vidler, "The Scenes of the Street: Transformations in Ideal and Reality, 1750–1871," in Stanford Anderson, ed., *On Streets*, Cambridge: MIT Press, 1986, p. 81.

9 Paul Virilio, *The Aesthetics of Disappearance*, trans. Philip Beitchman, New York: Semiotext(e), 1991, p. 65.

10 These effects of the travel genre continue in television and video. On this subject, see Yosefa Loshitzky, "Travelling Culture, Travelling Television," *Screen*, vol. 37, no. 4, Winter 1996, pp. 323–35; and John Welchman, "Moving Images: On Travelling Film and Video," *Screen*, vol. 37, no. 4, pp. 336–50.

11 See Ella Shohat, "Imaging Terra Incognita: The Disciplinary Gaze of Empire," *Public Culture*, vol. 3, no. 2, Spring 1991, pp. 41–70; Shohat, "Gender and Culture of Empire: Toward a Feminist Ethnography of the Cinema," *Quarterly Review of Film and Video*, no. 13, 1991, pp. 45–84; Shohat and Robert Stam, *Unthinking Eurocentrism: Multiculturalism and the Media*, New York: Routledge, 1994; Rey Chow, "Media, Matter, Migrants," in *Writing Diaspora: Tactics of Intervention in Contemporary Cultural Studies*, Bloomington: Indiana University Press, 1993; and Fatimah Tobing Rony, *The Third Eye: Race, Cinema and Ethnographic Spectacle*, Durham, N.C.: Duke University Press, 1996.

12 Paul Virilio, *War and Cinema: The Logistics of Perception*, trans. Patrick Camiller, London: Verso, 1984.

13 Diller + Scofidio, eds., *Back to The Front: Tourisms of War*, New York: Princeton Architectural Press, 1994.

14 On this subject, see, among others, Marta Braun, *Picturing Time: The Work of Etienne-Jules Marey (1830–1904)*, Chicago: University of Chicago Press, 1992.

15 Filmmakers often compare making a film to being at war. The comparison stands in many ways, including the fact that managing and directing a crew involves a highly structured, hierarchical system. It makes use of organizational tactics and strategic movements that duplicate the maneuvering of an army. It also includes feeding the army-crew. The constant rituals of nourishment that occur on a film set, as on a battlefield, span from actual food consumption to affective need fulfillment.

16 See Robert Stam, *Reflexivity in Film and Literature: From Don Quixote to Jean-Luc Godard*, New York: Columbia University Press, 1992.

17 Friedberg, *Window Shopping*.

18 Peter Greenaway in an interview published in Jonathan Hacker and David Price, *Take Ten: Contemporary British Film Directors*, Oxford: Clarendon Press, 1991, p. 191. He often refers to *Les Carabiniers*, speaking of the influence of Godard on his work.

19 Mary Louise Pratt, *Imperial Eyes: Travel Writing and Transculturation*, New York: Routledge, 1992, p. 38.

20 See Paul Bowles, *The Sheltering Sky*, New York: Ecco Press, 1978, especially pp. 13–14.

21 On Jane Bowles's travel story, see Lidia Curti, "Alterity and the Female Traveller: Jane Bowles," in *Female Stories, Female Bodies: Narrative, Identity and Representation*, New York: New York University Press, 1998.

22 Trinh T. Minh-ha, *Woman Native Other: Writing Postcoloniality and Feminism*, Bloomington: Indiana University Press, 1989, p. 39.

23 Meaghan Morris, "At Henry Parkes Motel," *Cultural Studies*, vol. 2, no. 1, 1988, pp. 1–47.

24 This film has produced literature on sexual difference. See Lea Jacobs, "*Now Voyager*: Some Problems of Enunciation and Sexual Difference," *Camera Obscura*, no. 7, 1981, pp. 89–109; Elizabeth Cowie, "Fantasia," *m/f*, 1984, pp. 70–105; Stanley Cavell, "Ugly Duckling, Funny Butterfly: Bette Davis and *Now, Voyager*, Followed by Postscript (1989): To Whom It May Concern," *Critical Inquiry*, no. 16, Winter 1990, pp. 213–89; and Teresa de Lauretis, "On the Subject of Fantasy," in Laura Pietropaolo and Ada Testaferri, eds., *Feminisms in the Cinema*, Bloomington: Indiana University Press, 1995.

25 Mabel Sharman Crawford, "A Plea for Lady Tourists," in *Through Algeria*, London: Richard Bentley, 1863, pp. xi–xii.

26 This phenomenon is discussed and referenced further in chapter 4. See, among others, Sara Mills, *Discourses of Difference: An Analysis of Women's Travel Writing and Colonialism*, New York: Routledge, 1993.

27 Ella W. Thompson, *Beaten Paths; or, A Woman's Vacation*, Boston: Lee and Sheperd, 1874, pp. 9–10, cited in Mary Suzanne Schriber, ed., *Telling Travels: Selected Writings by Nineteenth-Century American Women Abroad*, DeKalb: Northern Illinois University Press, 1995, p. xvii.

28 On this subject, see Miriam Hansen, "Early Cinema, Late Cinema: Transformations of the Public Sphere," in Linda Williams, ed.,

Viewing Positions: Ways of Seeing Film, New Brunswick: Routledge, 1995.

29 John Urry, *The Tourist Gaze. Leisure and Travel in Contemporary Societies*, London: Sage, 1990.

30 Derek Gregory, "Between the Book and the Lamp: Imaginative Geographies of Egypt, 1849–1850," *Transactions of the Institute of British Geographers*, vol. 20, 1995, pp. 29–57.

31 Florence Nightingale, *Letters from Egypt: A Journey on the Nile 1848–1850*, New York: Weidenfeld and Nicholson, 1987, p. 200, cited in Gregory, "Between the Book and the Lamp."

32 This idea is further explored in chapters 4 and 11.

33 Marguerite, Countess of Blessington, *The Idler in Italy*, vol. 1, London, 1839, p. 311, cited in Shirley Foster, *Across New Worlds: Nineteenth-Century Women Travellers and Their Writings*, New York: Harvester Wheatsheaf, 1990, p. 39.

34 Sarah Rogers Haight, *Letters from the Old World. By a Lady of New York*, 1840, anthologized in Schriber, ed., *Telling Travels*, p. 57.

35 Edith Wharton, "Joy in the House," in *Human Nature*, New York: D. Appleton and Company, 1933, p. 180.

36 See James Clifford, *Routes: Travel and Translation in the Late Twentieth Century*, Cambridge: Harvard University Press, 1997.

37 See Rosalyn Deutsche, "Men in Space" and "Boys Town," in *Evictions: Art and Spatial Politics*, Cambridge: MIT Press, 1996.

38 See Kevin Lynch, *The Image of the City*, Cambridge: MIT Press, 1960; and Fredric Jameson, "Cognitive Mapping," in Cary Nelson and Lawrence Grossberg, eds., *Marxism and the Interpretation of Culture*, Chicago: University of Illinois Press, 1988; and Jameson, *Postmodernism, or the Cultural Logic of Late Capitalism*, Durham, N.C.: Duke University Press, 1991, especially pp. 51–52.

39 This point is made by Mark Wigley in "Lost in Space," in Michael Speaks, ed., *The Critical Landscape*, Rotterdam: 010 Publishers, 1996.

40 On this subject, see Caren Kaplan, *Questions of Travel: Postmodern Discourses of Displacement*, Durham, N.C.: Duke University Press, 1996; and Janet Wolff, "On the Road Again: Metaphors of Travel in Cultural Criticism," *Cultural Studies*, vol. 7, no. 2, 1992, pp. 224–39.

41 Morris, "At Henry Parkes Motel."

42 Georges Van Den Abbeele, *Travel as Metaphor*, Minneapolis: University of Minnesota Press, 1992, p. xviii.

43 Paola Melchiori, "Un sentimento senza oggetto," *Lapis*, no. 19, September 1993, p. 22.

44 Rosi Braidotti, *Nomadic Subjects: Embodiment and Sexual Difference in Contemporary Feminist Thought*, New York: Columbia University Press, 1994, pp. 35–36.

45 See *Toba Khedoori*, Los Angeles: Museum of Contemporary Art, 1997 (exhibition catalogue).

46 An exhibition of Gary Hill's *Liminal Objects* (1995–present) was presented at Barbara Gladstone Gallery in New York, 5 December 1998–23 January 1999.

47 Seton Smith's work is very sensitive to forms of architectural inhabitation. She photographs landscapes, produces architectural models, designs furniture, and makes architectural installations, all on the threshold between private and public space. See *Seton Smith*, Milan: Electa, 1995 (exhibition catalogue); and *Seton Smith*, Nantes: Musée des Beaux-Arts de Nantes, 1994 (exhibition catalogue).

48 Elaine Scarry, *The Body in Pain: The Making and Unmaking of the World*, New York: Oxford University Press, 1985.

49 The film was based on a Pulitzer Prize–winning play by George Kelly. It was remade in 1950 in a less interesting film version called *Harriet Craig*, directed by Vincent Sherman and starring Joan Crawford. An art exhibition inspired by this latter film and entitled "Harriet Craig" was presented at Apex Art in New York, 19 November–19 December 1998. It included the work of Alex Bag, Martha Rosler, and John Boskovich.

50 Claire Johnston, "Dorothy Arzner: Critical Strategies," in Constance Penley, ed., *Feminism and Film Theory*, New York: Routledge, 1988, p. 36. In this same volume, see also Pam Cook, "Approaching the Work of Dorothy Arzner"; and Jacquelyn Suter, "Feminine Discourse in *Christopher Strong*."

51 Judith Mayne, *Directed by Dorothy Arzner*, Bloomington: Indiana University Press, 1994.

52 On the place of home in historical studies, see, for example, Philippe Ariès and Georges Duby, eds., *A History of Private Life*, and in particular, on home and modernity, volume four of the series, *A History of Private Life: From the Fires of Revolution to the Great War*, ed. Michelle Perrot, trans. Arthur Goldhammer, Cambridge: Harvard University Press, 1990.

53 Wim Wenders, *Emotion Pictures: Reflections on the Camera*, London: Faber and Faber, 1986, p. 112.

54 See Georges Teyssot, ed., *Il progetto domestico. La casa dell'uomo: archetipi e prototipi*, 2 vols., Milan: Electa, 1986; Teyssot, ed., *Paesaggio d'interni = Interior Landscapes*, Milan: Electa, 1987; and Teyssot, "The Disease of the Domicile," *Assemblage*, no. 6, 1988, pp. 72–97. For an historical precedent, see, among others, Eugène-Emmanuel Viollet-le-Duc, *Histoire d'une maison*, Paris: Hetzel, 1873.

55 Mark Wigley, "Untitled: The Housing of Gender," in Beatriz Colomina, ed., *Sexuality and Space*, Princeton: Princeton Architectural Press, 1992, p. 331.

56 In the field of "sexuality and space," see also Diana Agrest, Patricia Conway, and Leslie Kanes Weisman, eds., *The Sex of Architecture*, New York: Abrams, 1996; Debra Coleman, Elizabeth Danze, and Carol Henderson, *Architecture and Feminism*, Princeton: Princeton Architectural Press, 1996; and Francesca Hughes, ed., *The Architect: Reconstructing Her Practice*, Cambridge: MIT Press, 1996.

57 Ann Bergren, "The (Re)Marriage of Penelope and Odysseus: Architecture, Gender, Philosophy," *Assemblage*, no. 21, 1993, pp. 6–23.

58 Mikhaïl Iampolski, "Le cinéma de l'architecture utopique," in *Iris*, special issue "Cinema and Architecture," ed. Paolo Cherchi Usai and Frank Kessler, 1991, pp. 39–46. The films were *Die Galoschen des Glücks* and *Der Weltbaumeister*.

59 See Mark Wigley, *White Walls, Designer Dresses: The Fashioning of Modern Architecture*, Cambridge: MIT Press, 1995.

60 Bruno Taut, *Die Neue Wohnung: Die Frau als Schöpferin*, Leipzig: Bei Klinkhardt and Biermann, 1924.

61 Witold Rybczynski, *Home: A Short History of an Idea*, New York: Penguin Books, 1986, p. 88. On the subject of interior decoration, see also Mario Praz, *An Illustrated History of Interior Decoration: From Pompeii to Art Nouveau*, trans. William Weaver, New York: Thames and Hudson, 1982.

62 Edith Wharton and Ogden Codman, *The Decoration of Houses*, New York: Charles Scribner's Sons, 1897. On this subject, see Vanessa Chase, "Edith Wharton, The Decoration of Houses, and Gender in Turn-of-the-Century America," in Coleman, et al., *Architecture and Feminism*.

63 This citation is taken from the Italian edition of Bruno Taut's book, entitled *La nuova abitazione: la donna come creatrice*, Rome: Gangemi editore, 1986, pp. 84–85 (my translation).

64 On Antonioni, in English, see Peter Brunette, *The Films of Michelangelo Antonioni*, New York: Cambridge University Press, 1998; William Arrowsmith, *Antonioni: The Poet of Images*, ed. Ted Perry, New York: Oxford University Press, 1995; Sam Rodhie, *Antonioni*, London: British Film Institute, 1990; Seymour Chatman, *Antonioni, or, The Surface of the World*, Berkeley: University of California Press, 1985; and Frank P. Tomasulo, "The Architectonics of Alienation: Antonioni's Edifice Complex," *Wide Angle*, vol. 15, no. 3, July 1993, pp. 3–20. In Italian, see Michele Mancini and Giuseppe Perrella, *Michelangelo Antonioni: Architetture della visione*, 2 vols., Rome: Coneditor, 1986; Carlo di Carlo, ed., *Michelangelo Antonioni: Identificazione di un autore*, Parma: Pratiche, 1983–85; Giorgio Tinazzi, *Michelangelo Antonioni*, Florence: la Nuova Italia, 1974; Lorenzo Cuccu, *La visione come problema: Forme e svolgimento del cinema di Antonioni*, Rome: Bulzoni, 1973.

65 Roland Barthes, "Dear Antonioni...," published in English in Geoffrey Nowell-Smith, *L'Avventura*, London: British Film Institute, 1997, p. 167.

66 I understand drift not as a textual matter but as a geopsychic experience of living. In this respect, I agree with Leo Charney's reading of modernity's drift. However, Charney considers drift in relation to time and the loss of presence, while my reading, especially in chapter 8, is primarily spatial and sustained in cartographic terms in relation to psychogeography. See Leo Charney, *Empty Moments: Cinema, Modernity, and Drift*, Durham, N.C.: Duke University Press, 1998.

67 Martin Scorsese's comment is from a speech he made honoring Antonioni's film career, New York, Walter Reade Theater, October 1992. Antonioni's remark to Rothko is reported in Chatman, *Antonioni*, p. 54. See also Richard Gilman, "About Nothing—With Precision," *Theater Arts*, vol. 46, no. 7, 1962, pp. 10–12.

68 To consider this further from the filmmaker's viewpoint, see the film criticism he published from 1939 onward in the journal *Cinema*; and, in English, Antonioni, *The Architecture of Vision: Writings and Interviews on Cinema*, ed. Carlo di Carlo and Giorgio Tinazzi, with Marga Cottino-Jones, New York: Marsilio, 1996.

69 The first American exhibition of Antonioni's paintings, "The Enchanted Mountains," was organized by Robert Haller at the Staten Island Institute of Arts and Sciences, Staten Island, New York, December 1988–January 1989. The first Italian show took place in Rome at the Galleria Nazionale d'Arte Moderna, 8 October–27 November 1983.

70 Michael Fried, "Art and Objecthood," in Gregory Battcock, ed., *Minimal Art: A Critical Anthology*, New York: Dutton, 1968, p. 117.

71 On this film, see also George Amberg and Robert Hughes, eds., *L'avventura*, New York: Grove Press, 1969; and Seymour Chatman and Guido Fink, *L'avventura*, New Brunswick, N.J.: Rutgers University Press, 1989.

72 See P. Adams Sitney, *Vital Crisis in Italian Cinema*, Austin: Texas University Press, 1995, p. 145. While *Voyage in Italy* explores the Neapolitan region, *L'Avventura* moves from Rome to Sicily, touching Lisca Bianca, Bagheria, Messina, Taormina, Troina, Santa Panagia, and Noto.

73 On this film's "subjective" itinerary, see Pier Paolo Pasolini, "The Cinema of Poetry," in *Heretical Empiricism*, ed. Louise K. Barnett, trans. Ben Lawton and Louise K. Barnett, Bloomington: Indiana University Press, 1972. See also Angela Dalle Vacche, *Cinema and Painting: How Art is Used in Film*, Austin: University of Texas Press, 1996, chapter 2.

74 On this subject, see Ian Wiblin, "The Space Between: Photography, Architecture and the Presence of Absence," in François Penz and Maureen Thomas, eds., *Cinema and Architecture: Méliès, Mallet-Stevens, Multimedia*, London: British Film Institute, 1997.

75 Pellegrino D'Acierno's lecture on *La notte* was delivered at the conference "(In)visible Cities: From the Postmodern Metropolis to the Cities of the Future," New York, 3–6 October 1996 (unpublished paper).

76 See Therese Grisham, "An Interview with Ulrike Ottinger," *Wide Angle*, vol. 14, no. 2, April 1992, pp. 31 and 33. On the film, see also Grisham, "Twentieth Century Theatrum Mundi: Ulrike Ottinger's *Johanna d'Arc of Mongolia*," *Wide Angle*, vol. 14, no. 2, April 1992, pp. 22–27; Brenda Longfellow, "Lesbian Phantasy and the Other Woman in Ottinger's *Johanna d'Arc of Mongolia*," *Screen*, vol. 34, no. 2, 1993; and Kristen Whissel, "Racialized Spectacle, Exchange Relations and the Western in *Johanna d'Arc of Mongolia*," *Screen*, vol. 37, no. 1, Spring 1996, pp. 41–67.

77 For a reading of Akerman's work in terms of the revisitation of Jewish sites and forms of wandering, see, in particular, Janet Bergstrom, "Invented Memories," and Ivone Margulies, "Echo and Voice in *Meetings with Anna*," both in Gwendolyn Audrey Foster, ed., *Identity and Memory: The Films of Chantal Akerman*, London: Flicks Books, forthcoming. See also Margulies, *Nothing Happens: Chantal Akerman's Hyperrealist Everyday*, Durham, N.C.: Duke University Press, 1996.

78 The text was displayed on the wall of the exhibition and is published in *Bordering on Fiction: Chantal Akerman's "D'Est,"* Minneapolis: Walker Art Center, 1995 (exhibition catalogue), pp. 17–18. The exhibition originated at the Walker Art Center in Minneapolis and was on view at the Jewish Museum in New York, 23 February–27 May 1997.

79 Chantal Akerman, unpublished text for *Of the Middle East*, 1998, p. 4. I thank her for offering me this text.

80 Ibid.

81 Beatriz Colomina, "Battle Lines: E.1027," in Agrest, Conway, and Kanes Weisman, eds., *The Sex of Architecture*. For other gendered architectural studies that revise the notion of house, see, for example, Jennifer Bloomer, "The Matter of Matter: A Longing for Gravity," in Agrest, et al., *The Sex of Architecture*; and Cathrine Ingraham, *Architecture and the Burdens of Linearity*, New Haven: Yale University Press, 1998.

82 Colomina, "The Exhibitionist House," in Russell Ferguson, ed., *At The End of the Century: One Hundred Years of Architecture*, New York: Abrams, and Los Angeles: Museum of Contemporary Art, 1998 (exhibition catalogue), p. 127.

83 The Gardner Museum is located in Boston.

84 For an introduction to projects of domestic dwelling in movement, see Georges Teyssot, ed., *Il Progetto domestico*. See also John Hejduk, *Mask of Medusa: Works 1947–1985*, ed. Kim Shkapich, New York: Rizzoli, 1985; Hejduk, *Architectures in Love*, New York: Rizzoli, 1995; and Zaha Hadid, *Zaha Hadid: The Complete Works*, New York: Rizzoli, 1998. Examples of filmic architectures are abundant. See chapters 2 and 10 for further reference to this topic.

85 The citation is from Andrea Zittel's sales brochure. See Andrea Zittel, *Andrea Zittel, Living Units: Interviews With the Owners of the Living Units*, Basel: Museum fur Gegenwartskunst, 1996 (exhibition catalogue).

86 See Steven Holl, *Anchoring*, New York: Princeton Architectural Press, 1991; Holl, *Stretto House: Steven Holl Architects*, New York: Monacelli Press, 1996; and Holl, *Intertwining*, New York: Princeton Architectural Press, 1996.

87 Ann Hamilton's *Crying Wall* is an on-site installation that was produced at the P.S.1 Contemporary Art Center, Long Island City, New York, and exhibited there 29 October 1997–26 April 1998. On Hamilton's work, see *Ann Hamilton: Present-Past 1984–1997*, Milan: Skira, 1998; *The Body and the Object: Ann Hamilton 1984–1996*, Columbus, Ohio: Wexner Center for the Arts, 1996 (exhibition catalogue and CD-ROM); Lynne Cooke and Karen Kelly, eds., *Ann Hamilton: Tropos*, New York: DIA Center for the Arts, 1995 (exhibition catalogue); Judith Nesbitt, ed., *Ann Hamilton: Mneme*, Liverpool: Tate Gallery, 1994 (exhibition catalogue); *Ann Hamilton: Sao Paulo/Seattle*, Seattle: Henry Art Gallery, University of Washington, 1992; and Susan Stewart, *Ann Hamilton*, La Jolla, Cal.: San Diego Museum of Contemporary Art, 1992 (exhibition catalogue).

88 On Rachel Whiteread, see the issue of *Parkett* devoted to her work, no. 42, 1994, with essays by Neville Wakefield, Trevor Fairbrother, Rudolph Schmitz, and Simon Watney. See also, *Rachel Whiteread: Gouaches*, Stuttgart: Cantz Verlag, 1993; *Rachel Whiteread*, Boston: ICA, 1995; *Rachel Whiteread, with "Music for Torching,"* a story by A. M. Homes, London: Anthony D'Offay Gallery, 1998.

89 See James Lingwood, ed., *Rachel Whiteread: House*, London: Phaidon Press, 1995.

90 On Hatoum, see Michael Archer, Guy Brett, and Catherine de Zegher, eds., *Mona Hatoum*, London: Phaidon Press, 1997, which contains bibliographical information. See also Johanna Drucker, "Sense and Sensibility: Women Artists and Minimalism in the Nineties," *Third Text*, no. 27, Summer 1994; and Nadia Tazi, *Mona Hatoum*, Paris: Centre Georges Pompidou, 1994 (exhibition catalogue). On Hatoum's video work, see Ewa Lajer-Burcharth, "Real Bodies: Video in the 1990s," *Art History*, vol. 20, no. 2, June 1997, pp. 185–213.

91 See *Doris Salcedo*, New York: New Museum of Contemporary Art, 1998 (exhibition catalogue).

92 The architectural projects of Laura Kurgan question virtual mapping. See, for example, Reneé Green and Laura Kurgan's project *Browsing*, in *Architectures of Display*, Architectural League of New York and Minetta Brook, 1995; and Kurgan's installation piece *You Are Here: Information Drift*, exhibited at the Storefront for Art and Architecture, New York, 12 March–16 April 1994. A larger exhibition of the latter work was held in Barcelona. See Laura Kurgan and Xavier Costa, eds., *You Are Here: Architecture and Information Flows*, Barcelona: Museu d'Art Contemporani, 1995 (exhibition catalogue).

93 Derek Gregory, *Geographical Imaginations*, Cambridge, Mass.: Blackwell, 1994.

94 On this film, see Nobert Grob, "Life Sneaks out of Stories: *Until the End of the World*," in Roger F. Cook and Gerd Gemünden, eds., *The Cinema of Wim Wenders: Image, Narrative, and the Postmodern Condition*, Detroit: Wayne State University, 1997.

95 Mikhail Bakhtin, *The Dialogic Imagination*, ed. Michael Holquist, trans. Caryl Emerson and Michael Holquist, Austin: University of Texas Press, 1981, p. 244.

96 See Jameson, "Cognitive Mapping."

4 Fashioning Travel Space

1 The simile that likens travel to film is proposed by Paul Virilio in his *The Aesthetics of Disappearance*, trans. Philip Beitchman, New York: Semiotext(e), 1991, p. 60.

2 Charles Musser, *The Emergence of Cinema: The American Screen to 1907*, New York: Charles Scribner's Sons, 1990, pp. 39–41. See also Musser, "The Travel Genre in 1903–1904: Moving Towards Fictional Narrative," in Thomas Elsaesser, ed., with Adam Barker, *Early Cinema: Space, Frame, Narrative*, London: British Film Institute, 1990.

3 Ethnographic cinema is a specific case of the merging of film and travel, one in which the gaze of exploration turns into explicit forms of domination. A field in itself (and one that intersects in many ways with my own topic), it is the subject of serious emerging research. See, among others, Fatimah Tobing Rony, *The Third Eye: Race, Cinema and Ethnographic Spectacle*, Durham, N.C.: Duke University Press, 1996; Alison Griffiths, "Science and Spectacle: Native American Representation in Early Cinema," in Elizabeth Bird, ed., *Dressing in Feathers: The Construction of the Indian in American Public Culture*, Boulder, Col.: Westview, 1996; Ellen Strain, "Exotic Bodies, Distant Landscapes: Touristic Viewing and Popularized Anthropology in the Nineteenth Century," *Wide Angle*, special issue "Movies Before Cinema Part II," ed. Scott MacDonald, vol. 18, no. 2, 1996, pp. 71–100; and Paula Rabinowitz, *They Must be Represented*, London: Verso, 1995.

On Osa Johnson, Delia Akeley, and Mary Jobe Akeley, see also Donna Haraway, *Primate Visions: Gender, Race and Nature in the World of Modern Science*, New York: Routledge, 1989. All three women worked with the men to whom they were married. On the Johnsons' production, see also Erik Barnouw, *Documentary: A History of the Non-Fiction Film*, Oxford: Oxford University Press, 1974, pp. 50–51; and James and Eleanor M. Imperato, *They Married Adventure: The Wandering Lives of Martin and Osa Johnson*, New Brunswick, N.J.: Rutgers University Press, 1992.

4 Writing on "voyeurs or walkers," Michel de Certeau speaks of the erotics of knowledge involved in the ecstasy of reading. See de Certeau, *The Practice of Everyday Life*, trans. Steven Rendall, Los Angeles: University of California Press, 1984, especially pp. 92–93.

5 See Charles Musser, in collaboration with Carol Nelson, *High-Class Moving Pictures: Lyman H. Howe and the Forgotten Era of*

Traveling Exhibition, 1880–1920, Princeton: Princeton University Press, 1991, p. 80.

6 Esther Lyons, ed., *Esther Lyons' Glimpses of Alaska: A Collection of Views of the Interior of Alaska and the Klondike District, from Photographs by Veazie Wilson, Compiled by Miss Esther Lyons*, Chicago: Rand, McNally, 1897.

7 On the masquerade and the female subject, see Joan Riviere, "Womanliness as Masquerade" (1929), in Victor Burgin, James Donald, and Cora Kaplan, eds., *Formations of Fantasy*, London: Methuen, 1986.

8 Read this way, Esther Lyons's self-portrait is aligned with the many filmic reinventions of the "masquerade" and reaffirms the impact that this imaging has had on the development of film theory, beginning with Mary Ann Doane's use of Riviere's 1929 essay to theorize female spectatorship. See Mary Ann Doane, *Femmes Fatales: Feminism, Film Theory, Psychoanalysis*, New York: Routledge, 1991, especially chapters 1 and 2.

9 Michel Foucault, "Of Other Spaces," *Diacritics*, vol. 16, no. 1, 1986, p. 24.

10 Rosi Braidotti, *Nomadic Subjects*, New York: Columbia University Press, 1994, p. 5.

11 See, among others, Shirley Foster, *Across New Worlds: Nineteenth-Century Women Travellers and their Writings*, New York: Harvester Wheatsheaf, 1990; Sara Mills, *Discourses of Difference: An Analysis of Women's Travel Writing and Colonialism*, New York: Routledge, 1991; Mary Louise Pratt, *Imperial Eyes: Travel Writing and Transculturation*, New York: Routledge, 1992; Alison Blunt, *Travel, Gender, and Imperialism: Mary Kingsley and West Africa*, New York: Guilford Press, 1994; Karen R. Lawrence, *Penelope Voyages: Women and Travel in the British Literary Tradition*, Ithaca, N.Y.: Cornell University Press, 1994.

12 On this subject, see, among others, Gillian Rose, *Feminism and Geography: The Limits of Geographical Knowledge*, Minneapolis: University of Minnesota Press, 1993; Allison Blunt and Gillian Rose, eds., *Writing Women and Space: Colonial and Postcolonial Geographies*, New York: Guilford Press, 1994; Doreen Massey, *Space, Place, and Gender*, Minneapolis: University of Minnesota Press, 1994; Nancy Duncan, ed., *Body Space: Destabilizing Geographies of Gender and Sexuality*, New York: Routledge, 1996; and Linda McDowell and Joanne P. Sharp, eds., *Space, Gender, Knowledge: Feminist Readings*, New York: John Wiley, 1997.

13 John Urry, *The Tourist Gaze*, London: Sage, 1990, p. 24.

14 Bénédicte Monicat, "Autobiography and Women's Travel Writings in Nineteenth-century France: Journeys through Self-representation," *Gender, Place and Culture*, vol. 1, no. 1, 1994, p. 65.

15 See Richard D. Altick, *The Shows of London*, Cambridge: Harvard University Press, 1978, pp. 473–78.

16 Remarking on the Egyptian roots of the filmic spectacle, Antonia Lant points out that the Egyptian Hall became a cinema on 19 March 1896. See her "The Curse of the Pharaoh, or How Cinema Contracted Egyptomania," *October*, no. 59, Winter 1992, pp. 87–112.

17 See Harold Smith, ed., *American Travelers Abroad: A Bibliography of Accounts Published Before 1900*, Carbondale: The Library, Southern Illinois University, 1969. This account lists approximately 1,600 books published by men.

18 See Mary Suzanne Schriber, ed., *Telling Travels: Selected Writings by Nineteenth-Century American Women Abroad*, DeKalb: Northern Illinois Press, 1995. In her introduction, Schriber offers a commentary on the race and class issue in American travel writing and provides the statistical information cited here.

19 See Ronald J. Zboray, *A Fictive People: Antebellum Economic Development and the American Reading Public*, New York: Oxford University Press, 1993.

20 On (post)colonialism, women's discourse, and film, see Ella Shohat, "Gender and Culture of Empire: Toward a Feminist Ethnography of the Cinema," *Quarterly Review of Film and Video*, vol. 13, nos. 1–3, pp. 45–84; and Shohat, "Imaging Terra Incognita: The Disciplinary Gaze of Empire," *Public Culture*, vol. 3, no. 2, Spring 1991, pp. 41–70.

21 An anxiety of authorship can also be read in the presentation of the book itself. Although Lyons did not take the photographs (she selected and edited the pictures of Veazie Wilson), her name appears twice and is emphasized in the title. These are *her* views. The book is "Esther Lyons's Glimpses of Alaska." Furthermore, as the subtitle insists, the "Collection of Views of the Interior of Alaska" is "Compiled by Miss Esther Lyons."

22 Pratt, *Imperial Eyes*, p. 160.

23 Georg Simmel, "Fashion," in *On Individuality and Social Forms*, ed. Donald N. Levine, Chicago: University of Chicago Press, 1971, p. 297.

24 Ibid., p. 320.

25 Ibid., pp. 321–22.

26 Ibid., p. 309.

27 See Roland Barthes, *The Fashion System*, trans. Matthew Ward and Richard Howard, Los Angeles: University of California Press, 1963. For an early account of the psychology of attire, see J. C. Flügel, *The Psychology of Clothes*, New York: International University Press, 1971. For a sociological approach, see, for example, Joanne Finkelstein, *The Fashioned Self*, Philadelphia: Temple University Press, 1991.

28 For the beginning of this work in cultural studies, see Dick Hebdige, *Subculture: The Meaning of Style*, London: Methuen, 1979. Additional recent studies that are especially concerned with gender construct the discourse of fashion in relation to socio-sexual modes. See, among others, Elizabeth Wilson, *Adorned in Dreams: Fashion and Modernity*, Berkeley: University of California Press, 1985; Juliet Ash and Elizabeth Wilson, eds., *Chic Thrills: A Fashion Reader*, Los Angeles: University of California Press, 1992; Marjorie Garber, *Vested Interests: Cross-Dressing and Cultural Identity*, New York: Routledge, 1992; Jennifer Craik, *The Face of Fashion: Cultural Studies on Fashion*, New York: Routledge, 1994; and Valerie Steele, *Fetish: Fashion, Sex and Power*, New York: Oxford University Press, 1996.

29 For an historical approach to fashion, see Anne Hollander, *Seeing Through Clothes*, Los Angeles: University of California Press, 1993, first published in 1975; Hollander, *Sex and Suits: The Evolution of Modern Dress*, New York: Alfred A. Knopf, 1994; Philippe Perrot, *Fashioning the Bourgeoisie: A History of Clothing in the Nineteenth Century*, trans. Richard Bienvenu, Princeton: Princeton University Press, 1994; Christopher Breward, *The Culture of Fashion*, Manchester: Manchester University Press, 1995; and Anne Higonnet, "Real Fashions: Clothes Unmake the Working Woman,"

in Margaret Cohen and Christopher Prendergast, eds., *Spectacles of Realism: Gender, Body, Genre*, Minneapolis: University of Minnesota Press, 1995.

30 On film fashions and modern spectacles, see Jane Gaines and Charlotte Herzog, eds., *Fabrications: Costume and the Female Body*, New York: Routledge, 1990; Maureen Turim, "Seduction and Elegance: The New Woman of Fashion in Silent Cinema," and Kaja Silverman, "Fragments of a Fashionable Discourse," both in Shari Benstock and Suzanne Ferris, eds., *On Fashion*, New Brunswick: Rutgers University Press, 1994; Peter Wollen, "Strike a Pose," *Sight and Sound*, vol. 5, no. 3, March 1995, pp. 13–15; Pam Cook, *Fashioning the Nation: Costume and Identity in British Cinema*, London: British Film Institute, 1996; Sabine Hake, "In the Mirror of Fashion," in Katharina Von Ankum, ed., *Women in the Metropolis: Gender and Modernity in Weimar Culture*, Los Angeles: University of California Press, 1997; and Stella Bruzzi, *Undressing Cinema: Clothing and Identity in the Movies*, New York: Routledge, 1997.

31 Mary McLeod, "Undressing Architecture: Fashion, Gender, and Modernity," in Deborah Fausch, Paulette Singley, Rodolphe El-Khoury, and Zvi Efrat, eds., *Architecture: In Fashion*, Princeton, Princeton Architectural Press, 1994, p. 92.

32 Mark Wigley, *White Walls, Designer Dresses: The Fashioning of Modern Architecture*, Cambridge: MIT Press, 1995. For further discussion of this work, see chapter 9. See also Gottfried Semper, *The Four Elements of Architecture and Other Writings*, trans. Harry Francis Mallgrave and Wolfgang Herrmann, Cambridge: Cambridge University Press, 1989.

33 Mark Wigley, "Untitled: The Housing of Gender," in Beatriz Colomina, ed., *Sexuality and Space*, Princeton: Princeton Architectural Press, 1992, p. 368. On modern architecture and fashion, in the same volume, see also Colomina, "The Split Wall: Domestic Voyeurism." For a reading of subject and cloth in the work of Clérambault, see Joan Copjec, "The Sartorial Superego," *October*, no. 50, Fall 1989, pp. 57–95.

34 Wigley, *White Walls, Designer Dresses*, p. 23.

35 See Foster, *Across New Worlds*, especially chapter 1.

36 Lady Mary Wortley Montagu, from *Embassy to Constantinople*, letter to Lady Mar-, Adrianopole, 1 April 1717, anthologized in Mary Morris, ed., *Maiden Voyages: Writings of Women Travelers*, New York: Vintage Books, 1993, p. 4.

37 Ibid., pp. 5–6.

38 See Nelly Bly (Elizabeth Cochrane Seaman), *Nellie Bly's Book: Around the World in Seventy-Two Days*, New York: Pictorial Weeklies Company, 1890.

39 Simmel, "Fashion," p. 320.

40 Maya Deren's unpublished manuscript "Psychology of Fashion" has been printed in Vèvè A. Clark, Millicent Hodson, and Catrina Neiman, eds., *The Legend of Maya Deren: A Documentary Biography and Collected Works*, vol. 1, part two, New York: Anthology Film Archives, 1988.

41 See Bernard Rudofsky, *Are Clothes Modern? An Essay on Contemporary Apparel*, Chicago: P. Theobald, 1947.

42 Hollander, *Seeing Through Clothes*, pp. xv–xvi.

43 Ibid., pp. 349–50.

44 Deren, "Psychology of Fashion," p. 436.

45 Ibid., p. 435.

5 The Architecture of the Interior

1 Xavier de Maistre, *Voyage around My Room*, trans. Stephen Sartarelli, New York: New Directions Books, 1994. The book was first published in 1794 and was followed in 1825 by a sequel called *Nocturnal Expeditions around My Room*. A fad of the eighteenth century, the "sentimental" matter had been taken to new levels by Laurence Sterne in his *A Sentimental Journey through France and Italy*, London: Penguin, 1986. The book, which distilled the experience of the grand tour, was first published in 1768. In 1884, the voyage in one's room became the "decadent" journey of Des Esseintes in *A Rebours*. See J.-K. Huysmans, *Against Nature*, trans. Robert Baldrick, London: Penguin Books, 1959. I thank Leslie Cahmi, who, understanding my passion for such "sentimental" matters, encouraged me to visit the Museu Marès.

2 Susan Stewart, "Death and Life, in that Order, in the Works of Charles Willson Peale," in Lynne Cooke and Peter Wollen, eds., *Visual Display: Culture Beyond Appearances*, Seattle: Bay Press, 1995, pp. 39–40. The entire volume is relevant to the topic of my discussion, especially Stephen Bann, "Shrines, Curiosities, and the Rhetoric of Display." See also Susan Stewart, *On Longing: Narratives of the Miniature, the Gigantic, the Souvenir, the Collection*, Durham, N.C.: Duke University Press, 1993; and Susan Pearce, ed., *On Collecting: An Investigation into Collecting in the European Tradition*, New York: Routledge, 1995.

3 See Jean-Claude Beaune, "The Classical Age of Automata: An Impressionistic Survey from the Sixteenth to the Nineteenth Century," *Zone*, special issue "Fragments for a History of the Human Body, Part I," ed. Michel Feher, with Ramona Nadaff and Nadia Tazi, 1989, pp. 431–37.

4 On the history of precinema, see, among others, Laurent Mannoni, *Le grand art de la lumière et de l'ombre: archéologie du cinéma*, Paris: Nathan, 1995; Laurent Mannoni, Donata Pesenti Campagnoni, and David Robinson, *Light and Movement: Incunabula of the Motion Picture*, Pordenone: Le Giornate del Cinema Muto, 1995; Pesenti Campagnoni, *Verso il cinema: macchine, spettacoli e mirabili visioni*, Turin: Utet, 1995; *Geografia del precinema: percorsi della visione dalla camera oscura alla luce dei Lumière*, Bologna: Grafis Edizioni, 1994 (exhibition catalogue); Gian Piero Brunetta, *Il viaggio dell'icononauta: dalla camera oscura di Leonardo alla luce dei Lumière*, Venice: Marsilio, 1997; Brunetta, "Il Pre-cinema," in *Cinema and Film*, Rome: Armando Curcio Editore, 1986; Carlo Alberto Zotti Minici, ed., *Prima del cinema: le lanterne magiche*, Venice: Marsilio, 1988 (exhibition catalogue); and C. W. Ceram, *Archaeology of the Cinema*, New York: Harcourt, Brace and World, 1965. See also *Wide Angle*, special issues "Movies Before Cinema," parts 1 and 2, ed. Scott MacDonald, vol. 18, nos. 2 and 3, July 1996. For bibliographical reference, see Herman Hecht, *Pre-Cinema History: An Encyclopedia and Annotated Bibliography of the Moving Image before 1896*, ed. Ann Hecht, London: Bowker, Saur, in association with the British Film Institute, 1993. The recent historiographic work covers areas that often overlap with my research.

5 For insights in this area, see, among others, Lisa Cartwright, *Screening the Body: Tracing Medicine's Visual Culture*, Minneapolis:

University of Minnesota Press, 1995; Mary Ann Doane, "Temporality, Storage, Legibility: Freud, Marey, and the Cinema," *Critical Inquiry*, vol. 22, no. 2, 1996, pp. 313–43; François Dagognet, *Etienne-Jules Marey: A Passion for the Trace*, trans. Robert Galeta and Jeanine Herman, New York: Zone Books, 1992; Marta Braun, *Picturing Time: The Work of Etienne-Jules Marey*, Chicago: University of Chicago Press, 1992; Linda Williams, "Film Body: An Implantation of Perversions," in Philip Rosen, ed., *Narrative, Apparatus, Ideology*, New York: Columbia University Press, 1986; Williams, *Hard Core: Power, Pleasure, and the "Frenzy of the Visible,"* Berkeley: University of California Press, 1989; Hollis Frampton, "Eadweard Muybridge: Fragments of a Tesseract," in *Circles of Confusion*, Rochester: Visual Studies Workshop Press, 1983.

6 The archaeological paradigm evoked here is that of Michel Foucault's *The Archaeology of Knowledge*, trans. A. M. Sheridan Smith, New York: Pantheon Books, 1972.

7 Jonathan Crary, *Techniques of the Observer: On Vision and Modernity in the Nineteenth Century*, Cambridge: MIT Press, 1990. See also Joel Snyder, "Picturing Vision," *Critical Inquiry*, no. 6, Spring 1980, pp. 499–526.

8 Gilles Deleuze, *Cinema 1: The Movement-Image*, trans. Hugh Tomlinson and Barbara Habberjam, Minneapolis: University of Minnesota Press, 1986, p. 4.

9 Yve-Alain Bois backdates the "rupture of modernity" in a provocative essay on the picturesque, "A Picturesque Stroll around *Clara-Clara*," *October*, no. 29, 1984, pp. 32–62.

10 Walter Benjamin expresses this opinion, citing from Michelet's "Avenir! Avenir!," in "Fourier or the Arcades," *Charles Baudelaire: A Lyric Poet in the Era of High Capitalism*, trans. Harry Zohn, London: Verso, 1983, p. 159.

11 See Jean-Louis Baudry, "The Apparatus: Metapsychological Approaches to the Impression of Reality in the Cinema," in Rosen, ed., *Narrative, Apparatus, Ideology*.

12 Robert Treat Paine and Alexander Soper, *The Art and Architecture of Japan*, London: Penguin Books, 1990.

13 Ibid., p. 133.

14 Peter Greenaway, *Watching Water*, Milan: Electa, 1993, p. 30.

15 See, among others, Stephen Heath, *Questions of Cinema*, Bloomington: Indiana University Press, 1981; Christian Metz, *The Imaginary Signifier: Psychoanalysis and the Cinema*, trans. Celia Britton, Annwyl Williams, Ben Brewster, and Alfred Guzzetti, Bloomington: Indiana University Press, 1977; Jean Louis Comolli, "Machines of the Visible," in Teresa de Lauretis and Stephen Heath, eds., *The Cinematic Apparatus*, New York: St. Martin's Press, 1980; Comolli, "Technique and Ideology: Camera, Perspective and Depth of Field," *Film Reader*, no. 2, 1977, pp. 132–38; Comolli, "Technique and Ideology: Camera Perspective and Depth of Field" [parts 3 and 4], in Rosen, ed., *Narrative, Apparatus, Ideology*.

16 Giovan Battista Della Porta, *Magiae Naturalis, libri XX. Ab ipso authore expurgati, et superaucti, in quibus scientiarum Naturalium divitiae et delitiae demonstrantur*, Apud Horatium Salvianum, Naples, 1589. Following the Latin edition, a revised edition in Italian (*volgare*) was subsequently published as *Della Magia Naturale del signor Gio: Battista Della Porta napolitano, libri XX.*

Tradotti da latino in volgare, e dall'istesso Autore accresciuti, sotto nome di Gio: De Rosa V.I.P. con l'aggiunta d'infiniti altri secreti, e con la dichiaratione di molti, che prima non s'intendevano, Naples: Antonio Bulifon, 1677.

17 On Della Porta, see Luisa Muraro, *Giambattista Della Porta mago e scienziato*, Milan: Feltrinelli, 1978. On his work in physiognomy, see Patrizia Magli, *Il volto e l'anima: Fisiognomica e passioni*, Milan: Bompiani, 1995.

18 Della Porta, *De humana physiognomonia*, 4 vols., Vico Equense, 1586. The first edition, in Latin, was translated into Italian by Della Porta himself and published as *Della fisonomia dell'huomo*, Naples, 1598. It was subsequently revised and enlarged to 6 vols. in the 1610 Neapolitan edition and all subsequent editions.

19 Della Porta, *Magiae Naturalis*, p. 486 of the 1677 edition (my translation). On this subject, see Pesenti Campagnoni, *Verso il cinema.*

20 This singular philosophical position allowed Della Porta to speak about perfumes and women's ornaments in the same relational terms he used to address the material shapes of plants, animals, humans, and astral correlations.

21 Charles Le Brun, *Conférence sur l'expression générale et particulière des passions*, Paris: Picart, 1698. On Le Brun, see Norman Bryson, *Word and Image: French Painting of the Ancien Régime*, Cambridge: Cambridge University Press, 1981, pp. 29–57.

22 See Graeme Tytler, *Physiognomy in the European Novel: Faces and Fortunes*, Princeton: Princeton University Press, 1982, especially pp. 35–81.

23 See Magli, *Il volto e l'anima*, chapter 9.

24 See Philippe Duboy, *Lequeu: An Architectural Enigma*, Cambridge: MIT Press, 1986; and Anthony Vidler, *The Writing of the Walls: Architectural Theory in the Late Enlightenment*, Princeton: Princeton Architectural Press, 1987, chapter 7.

25 See chapter 9 for a discussion of de Superville.

26 Guillaume-Benjamin Duchenne de Boulogne, *Mécanisme de la physionomie humaine; ou, Analyse électro-physiologique de l'expression des passions applicable à la pratique des arts plastiques*, Paris: Jules Renouard, 1862; published in English under the title *The Mechanism of Human Facial Expression*, ed. and trans. R. Andrew Cuthbertson, Cambridge: Cambridge University Press, 1990. See also Charles Darwin, *The Expression of the Emotions in Man and Animals*, London: John Murray, 1872, which, significantly, contains some of Duchenne's images.

27 See, for example, William Cheselden, *Osteographia or the Anatomy of the Bones*, London, 1733.

28 These emotional lantern strips, preserved at the Museo del Cinema, are part of the series of 46 slides for the magic lantern "Veronese," measuring 20.3 x 5.4 cm. each.

29 On Kircher and precinema, see Brunetta, *Il viaggio dell'icononauta*, pp. 90–101.

30 See Athanasius Kircher, *Romani Collegii Societatis Jesu Museum Celeberrimum*, Amsterdam: Jassinio-Waesbergiana, 1678; and Filippo Buonanni, *Museum Kircherianum; sive, musaeum a padre Athanasio Kircherio in Collegio Romano Societatis Jesu*, Rome, 1709. See also Riccardo García Villoslada, *Storia del Collegio*

Romano dal suo inizio (1551) alla soppressione della Compagnia di Gesù (1773), Rome: Universitatis Gregorianae, 1954; and Maristella Casciato, Maria Grazia Ianniello, and Maria Vitale, eds., *Enciclopedismo in Roma Barocca: Athanasius Kircher e il Collegio Romano tra wunderkammern e museo scientifico*, Venice: Marsilio, 1986, especially the essays by Silvio Bedini and Adalgisa Lugli.

31 Kircher, *Mundus subterraneus*, Amsterdam, 1665. On this subject, see Barbara Maria Stafford, *Voyage into Substance: Art, Science, Nature and the Illustrated Travel Account, 1760–1840*, Cambridge: MIT Press, 1984.

32 Athanasius Kircher, *Ars magna lucis et umbrae in decem libros digesta. Quibus admirandae lucis et umbrae in mundo, atque adeo universa natura, vire effectusq. uti nova, ita varia novorum reconditiorumq. speciminum exhibitione, ad varios mortalium usus, pandatur.*, Rome: Sumptibus Hermanni Scheus, 1646.

33 In *Le grand art de la lumière et de l'ombre*, Mannoni argues for the precedence of Huygens over Kircher, and appears to agree with Pesenti Campagnoni on the importance of Della Porta. See Mannoni, Pesenti Campagnoni, and Robinson, *Light and Movement*; and Pesenti Campagnoni, *Verso il cinema*.

34 See, among others, Françoise Levie, *Etienne-Gaspard Robertson: La vie d'un fantasmagore*, Brussels: La Préamble, 1990; and Max Milner, *La fantasmagorie: essai sur l'optique fantastique*, Paris: Presses Universitaires de France, 1982.

35 See Antonia Lant, "The Curse of the Pharaoh, or How Cinema Contracted Egyptomania," *October*, no. 59, Winter 1992, pp. 87–112.

36 According to Sir David Brewster, *Letters on Natural Magic*, London, 1832, p. 80.

37 For an interpretation of phantasmagoria, see Terry Castle, *The Female Termometer: Eighteenth-Century Culture and the Invention of the Uncanny*, New York: Oxford University Press, 1995, especially chapter 9; and Crary, *Techniques of the Observer*, pp. 132–36.

38 See Tom Gunning, "Phantom Images and Modern Manifestations: Spirit Photography, Magic Theatre, Trick Films, and Photography's Uncanny," in Patrice Petro, ed., *Fugitive Images: From Photography to Video*, Bloomington: Indiana University Press, 1995. See also Paul Hammond, *Marvellous Méliès*, London: Gordon Fraser Gallery, 1974; and Stanley Cavell, "What Becomes of Things on Film," in *Themes Out of School: Effects and Causes*, San Francisco: North Point Press, 1984, pp. 173–83.

39 André Bazin, *What is Cinema?*, vol. 1, trans. Hugh Gray, Berkeley: University of California Press, 1967, p. 9.

40 The concept of heterotopia was the subject of a lecture by Michel Foucault in March 1967, published as "Des espaces autres" in the French architectural journal *Architectures–Movement–Continuité*, October 1984. It is translated into English under the title "Of Other Spaces" and published in *Diacritic*, vol. 1, Spring 1986, pp. 22–27. I thank my student Eric R. Keune for an exchange of ideas that inspired this reading.

41 Walter Benjamin, *Das Passagen-Werk*, vol. 5 of *Gesammelte Schriften*, ed. Rolf Tiedemann and Hermann Schweppenhauser, Frankfurt am Main: Suhrkamp Verlag, 1972–, pp. 111 and 118, as cited in Susan Buck-Morss, *The Dialectics of Seeing: Walter Benjamin and the Arcades Project*, Cambridge: MIT Press, 1989, p. 101.

42 See Barbara Stafford, *Artful Science: Enlightenment Entertainment and the Eclipse of Visual Education*, Cambridge: MIT Press, 1994; and Stafford, *Body Criticism: Imaging the Unseen in Enlightenment Art and Medicine*, Cambridge: MIT Press, 1989.

43 For a history of waxwork, see, among others, Michel Lemire, *Artistes et mortels*, Paris: Chabaud, 1990. For an earlier account of the relation of waxwork to early cinema, see Giuliana Bruno, *Streetwalking on a Ruined Map*, Princeton: Princeton University Press, 1993.

44 The handbill advertising Mrs. Mills's Waxwork is reprinted in Richard D. Altick, *The Shows of London*, Cambridge: Harvard University Press, 1978, p. 51. Altick mentions other women involved in waxwork in London at the time.

45 On Tussaud's work, see Marina Warner, "Waxworks and Wonderlands," in Cooke and Wollen, eds., *Visual Display*.

46 Information on wax-makers in Italy and France is given in Thomas N. Haviland and Lawrence Charles Parish, "A Brief Account of the Use of Wax Models in the Study of Medicine," *Journal of the History of Medicine*, vol. 25, 1970, pp. 52–75.

47 A particularly interesting prefilmic description of a *tableau vivant* is offered by Edith Wharton in her novel *The House of Mirth*. On the subject of women and *tableaux vivants*, see Mary Chapman, "'Living Pictures': Women and *Tableaux Vivants* in Nineteenth-Century American Fiction and Culture," *Wide Angle*, vol. 18, no. 3, July 1996, pp. 22–52.

48 Vanessa R. Schwartz, *Spectacular Realities: Early Mass Culture in Fin-de-Siècle Paris*, Los Angeles: University of California Press, 1998.

49 Mesmer left little published work, but he did produce a memoir.

50 See Stefan Zweig's reading of Mesmer's position in his *Mental Healers: Mesmer, Eddy, Freud*, New York: Viking Press, 1932, especially p. 4.

51 Franz Anton Mesmer, *Memoir of F. A. Mesmer, Doctor of Medicine on His Discoveries*, 1799, trans. Jerome Eden, Mount Vernon, N.Y.: Eden Press, 1957, pp. 3–4.

52 Although using the notion of attraction in a different sense, I refer to Tom Gunning's founding definition of a cinema of attraction in his "The Cinema of Attractions: Early Film, Its Spectator, and the Avant-Garde," in Thomas Elsaesser, ed., with Adam Barker, *Early Cinema: Face, Frame, Narrative*, London: British Film Institute, 1990.

53 See, in particular, chapters 9 and 10.

54 For an introduction to the world of curiosity cabinets, see Olive Impey and Arthur MacGregor, eds., *The Origins of Museums: The Cabinet of Curiosities in Sixteenth- and Seventeenth-Century Europe*, Oxford: Clarendon Press, 1985; Krzysztof Pomian, *Collectors and Curiosities: Paris and Venice, 1500–1800*, trans. Elizabeth Wiles-Portier, Cambridge, Mass.: Basil Blackwell, 1990; Adalgisa Lugli, *Naturalia e mirabilia: Il collezionismo enciclopedico nelle Wunderkammern d'Europa*, Milan: Gabriele Mazzotta, 1983; and Lorraine Daston and Katharine Park, *Wonder and the Order of Nature 1150–1750*, New York: Zone Books, 1998.

55 On the relation between a sense of wonder, the experience of the marvelous, and the new world, see Stephen Greenblatt, *Marvelous Possessions: The Wonder of the New World*, Chicago: University of

Chicago Press, 1991. On cabinets and wonder, see Greenblatt, "Resonance and Wonder," in Ivan Karp and Steven D. Lavine, eds., *Exhibiting Cultures: The Poetics and Politics of Museum Display*, Washington, D.C.: Smithsonian Institution Press, 1991.

56 See Tony Bennett, "The Exhibitionary Complex," in Reesa Greenberg, Bruce W. Ferguson, and Sandy Nairne, eds., *Thinking about Exhibitions*, New York: Routledge, 1997; and Bennett, *The Birth of the Museum*, London: Routledge, 1995.

57 Alison Griffiths, "'Journeys for Those Who Can Not Travel': Promenade Cinema and the Museum Life Group," in *Wide Angle*, special issue "Movies Before Cinema: Part II," ed. Scott MacDonald, vol. 18, no. 3, July 1996, pp. 53–84.

58 Pomian, *Collectors and Curiosities*, chapter 2.

59 There were a number of variations on the viewing box. Despite their differences, their history is linked to the camera obscura and the magic lantern, although no projection is involved here. Interestingly, they were known by different names in different languages. The English "perspective box" and the French "*optique*" are names that emphasize the optical component, while the English "peepshow" and German "*Guckkasten*" speak of the voyeurism involved. I prefer to use the Italian name, *mondo nuovo*, for it foregrounds the travel effect of the viewing box, obscured by the other names and in the criticism that emphasizes the visuality and voyeurism of perspective devices. *Mondo nuovo* is also known as *mondo niovo* or *mondo novo*.

60 On this subject, see, among others, Carlo Alberto Zotti Minici, ed., *Il mondo nuovo: Le meraviglie della visione dal '700 alla nascita del cinema*, Milan: Mazzotta, 1988, in particular the essays by Zotti Minici, Alberto Milano, and Gian Piero Brunetta. Brunetta elaborates here on the impact of *mondo nuovo* on the expansion of vision and interprets the public itinerant character of the device as a precursor of televisual modes (pp. 28–29). He expands this topic in chapter 8 of his *Il viaggio dell'icononauta*, devoted to *mondo nuovo*.

61 See Maria Adriana Prolo and Luigi Carluccio, eds., *Il Museo Nazionale del Cinema di Torino*, Turin: Cassa di Risparmio, 1978; and Paolo Bertetto and Donata Pesenti Campagnoni, eds., *La magia dell'immagine: macchine e spettacoli prima dei Lumière nelle collezioni del Museo Nazionale del Cinema*, Milan: Electa, 1997 (exhibition catalogue).

62 See Charles Musser, in collaboration with Carol Nelson, *High Class Moving Pictures: Lyman H. Howe and the Forgotten Era of Traveling Exhibition, 1880–1920*, Princeton: Princeton University Press, 1991.

63 Stephan Oettermann, *The Panorama: History of a Mass Medium*, trans. Deborah Lucas Schneider, New York: Zone Books, 1997.

64 See Ralph Hyde, *Panoramania!: The Art and Entertainment of the 'All-Embracing View'*, London: Trefoil, in association with the Barbican Art Gallery, 1988, p. 40. On panoramas, see also Dolf Stenberger, "Panorama of the Nineteenth Century," *October*, no. 4, Fall 1977, pp. 3–20; and Silvia Bordini, *Storia del panorama: La visione totale nella pittura del XIX secolo*, Rome: Officina, 1984.

65 From the patent document deposited on 25 March 1822 by the inventor of the *géorama*, Charles-François-Paul Delanglard. Reprinted in Mannoni, *Le grand art*, p. 176, in a discussion in which panoramas and dioramas are also treated as prefilmic spectacles.

66 On these geographical garden globes, see Christian Jacob, *L'Empire des cartes: approche théorique de la cartographie à travers l'histoire*, Paris: Editions Albin Michel, 1992, pp. 61–66.

67 On the Crystal Palace and its own crystallization of images, see Celeste Olalquiaga, *The Artificial Kingdom: A Treasury of the Kitsch Experience*, New York: Pantheon Books, 1998. Olalquiaga interestingly presents this landmark as a manifestation of the modern landscape of memory and loss, which creates the underworld as a topography of the unconscious.

68 See Derek Gregory, *Geographical Imaginations*, Cambridge, Mass.: Blackwell, 1994, pp. 38–39.

69 Unlike other "-oramic" geographies, panoramas and dioramas have been given more scholarly attention as prefilmic apparatuses. See, for example, Wolfgang Schivelbusch, *Disenchanted Night: The Industrialization of Light in the Nineteenth Century*, trans. Angela Davies, Los Angeles: University of California Press, 1988; Anne Friedberg, *Window Shopping: Cinema and the Postmodern*, Los Angeles: University of California Press, 1993; Schwartz, *Spectacular Realities*; Jacques Aumont, *L'oeil interminable: Cinéma et peinture*, Paris: Nouvelles Editions Séguier, 1995; and Angela Miller, "The Panorama, the Cinema and the Emergence of the Spectacular," *Wide Angle*, no. 2, April 1996, pp. 34–69.

70 From the *Albion*, as cited in Hyde, *Panoramania!*, p. 126.

71 From the program notes accompanying the *cosmorama mouvant* by Cuvelier, preserved in the Museo del Cinema in Turin, Italy, as reprinted in Pesenti Campagnoni, *Verso il cinema*, pp. 87 and 93 (my translation).

72 *Literary Gazette*, London, 10 May 1823, p. 301, cited in Altick, *The Shows of London*, pp. 211–12.

73 This was the case at Hubert Sattler's permanent rotunda for cosmoramas in Salzburg.

74 See Altick, *The Shows of London*, chapter 9.

75 On this subject, see Odile Nouvel-Kammerer, ed., *Papiers peints panoramiques*, Paris: Flammarion, 1990 (exhibition catalogue of the Musée des Arts Décoratifs); *Trois siècles de papiers peints*, Paris: Musée des Arts Décoratifs, 1967 (exhibition catalogue); *Wallpapers of France, 1800–1850*, with an introduction by Jean-Pierre Seguin, trans. Margaret Timmers, New York: Rizzoli, 1981.

76 Tapestries, such as the "panoramic" one on rollers displayed in the Bayeux Cathedral as decoration for feasts, also acted as a forerunner of moving panoramas.

77 Renée Green's *Taste Venue* (1994) was exhibited at Pat Hearn Gallery in New York. It is part of the artist's genealogical quest and of her project of invented museography. Her site-specific exhibition *Sites of Genealogy* was part of the exhibition "Out of Site," at P.S.1 Museum/Institute of Contemporary Art, Long Island City, New York, 1990. *World Tour* (1993) was shown at the Museum of Contemporary Art, Los Angeles. See Renée Green, *Certain Miscellanies: Some Documents*, Amsterdam: De Appel Foundation, 1996 (exhibition catalogue); Green, *After the Ten Thousand Things*, The Hague: Seventh Museum, 1994; and Green, *World Tour*: Los Angeles: Museum of Contemporary Art, 1993 (exhibition catalogue).

78 From Joseph Dufour's introductory text to *Sauvages de la mer Pacifique*, p. 11, cited in Nouvel-Kammerer, ed., *Papiers peints panoramiques*, p. 122.

6 Haptic Routes: View Painting and Garden Narratives

1 Alain Corbin, *The Lure of the Sea: The Discovery of the Seaside 1750–1840*, trans. Jocelyn Phelps, New York: Penguin Books, 1995, pp. 137–38.

2 The quoted phrase is Corbin's, ibid., p. 138.

3 Ibid.

4 Richard Sennett, *Flesh and Stone: The Body and the City in Western Civilization*, New York: W. W. Norton, 1994, pp. 261–64.

5 Barbara Maria Stafford, *Voyage into Substance: Art, Science, Nature, and the Illustrated Travel Account, 1760–1840*, Cambridge: MIT Press, 1984. See also Kenneth Clark, *Landscape into Art*, London: Murray, 1976.

6 M. Christine Boyer, *The City of Collective Memory: Its Historical Imagery and Architectural Entertainments*, Cambridge: MIT Press, 1994, p. 228–30.

7 Stafford, *Voyage into Substance*, p. 2.

8 On this subject, see, among others, Cesare de Seta, ed., *Città d'Europa: Iconografia e vedutismo dal XV al XIX secolo*, Naples: Electa, 1996; de Seta, "Topografia urbana e vedutismo nel Seicento: a proposito di alcuni disegni di Alessandro Baratta," *Prospettiva*, no. 2, July 1980, pp. 46–60; de Seta, "Bernardo Bellotto vedutista e storiografo della civiltà urbana europea," *Quaderni dell'Istituto di Storia dell'Architettura*, nos. 15–20, 1990–92, pp. 813–18; de Seta, *L'Italia del Grand Tour da Montaigne a Goethe*, Naples: Electa, 1992; Giuliano Briganti, *The View Painters of Europe*, trans. Pamela Waley, London: Phaidon, 1970; and *The Origins of the Italian Veduta*, Providence, R.I.: Brown University, 1978 (exhibition catalogue). A bibliography on view painting was compiled by Elisabeth Chevallier and published in the proceedings of the conference "Archéologie du paysage," *Caesarodunum*, vol. 1, no. 13, 1978, pp. 579–613.

9 On Dutch methods of description and mapping, see Svetlana Alpers, *The Art of Describing: Dutch Art in the Seventeenth Century*, Chicago: University of Chicago Press, 1983.

10 On the notion of the mental image of the city, see Kevin Lynch, *The Image of the City*, Cambridge: MIT Press, 1960. On cognitive mapping as developed from Lynch, see Fredric Jameson, "Cognitive Mapping," in Cary Nelson and Lawrence Grossberg, eds., *Marxism and the Interpretation of Culture*, Chicago: University of Illinois Press, 1988; and Jameson, *Postmodernism, or the Cultural Logic of Late Capitalism*, Durham, N.C.: Duke University Press, 1991, especially pp. 51–52.

11 The letter is cited in Juergen Schulz, "Jacopo de' Barbari's View of Venice: Map Making, City Views, and Moralized Geography Before the Year 1500," *The Art Bulletin*, vol. 60, no. 3, September 1978, p. 458.

12 *The East Prospect of London Southwark and Bridge* and *The West Prospect of London Southwark and Bridge* (c. 1734) are so described in John Bowles's 1731 and 1736 catalogues of *London Printed and Sold*. Cited in Ralph Hyde, *Gilded Scenes and Shining Prospects: Panoramic Views of British Towns, 1575–1900*, New Haven: Yale Center for British Art, 1985 (exhibition catalogue), p. 88.

13 See Christian Jacob, *L'Empire des cartes: approche théorique de la cartographie à travers l'histoire*, Paris: Éditions Albin Michel, 1992,

especially chapter 1; and Joy Kenseth, ed., *The Age of the Marvelous*, Hanover, N.H.: Hood Museum of Art, Dartmouth College, 1991 (exhibition catalogue).

14 See Schulz, "Jacopo de' Barbari's View of Venice."

15 See Ronald Rees, "Historical Links between Cartography and Art," *Geographical Review*, no. 70, 1980, pp. 61–78.

16 Louis Marin, *Utopics: Spatial Plays*, trans. Robert A. Vollrath, Atlantic Highlands, N.J.: Humanities, 1984, p. 208.

17 On prospect views as precursors of panoramic vision, see Ralph Hyde, *Panoramania!: The Art and Entertainment of the 'All-Embracing View'*, London: Trefoil, in association with the Barbican Art Gallery, 1988. The expression cited is the title of the book's introduction.

18 Cesare de Seta, "L'iconografia urbana in Europa dal XV al XVIII secolo," in de Seta, ed., *Città d'Europa*, p. 46.

19 Alberto Pérez-Gómez and Louise Pelletier, "Architectural Representation Beyond Perspectivism," *Perspecta*, no. 27, 1992, p. 36.

20 Erwin Panofsky, *Perspective as Symbolic Form*, trans. Christopher S. Wood, New York: Zone Books, p. 29. Panofsky, while connecting perspectival to cultural changes, recognized the mobile gaze of film in his "Style and Medium in the Motion Pictures," *Bulletin of the Department of Art and Archaeology*, Princeton University, 1934, reprinted in Gerald Mast, Marshall Cohen, and Leo Braudy, eds., *Film Theory and Criticism*, New York: Oxford University Press, 1992.

21 Jan Vredeman de Vries, *Perspective*, New York: Dover Publications, 1968. The book was first published by Hondius in The Hague and Leiden in 1604–5.

22 Alpers, *The Art of Describing*, p. 58.

23 On the apparatus and classical perspective, see, for example, Stephen Heath, *Questions of Cinema*, Bloomington: Indiana University Press, 1981; and Christian Metz, *The Imaginary Signifier: Psychoanalysis and the Cinema*, trans. Celia Britton, Annwyl Williams, Ben Brewster, and Alfred Guzzetti, Bloomington: Indiana University Press, 1977.

24 The nature of the twist on this landscape of mapping has to do with what I consider to be a possibility: a cartographic rendering of narrative space in haptic terms, which will be addressed further in subsequent chapters on the art of mapping.

25 On the architectonic imaginary of painting, beyond *vedutismo* and cartographic art, see Giuliana Massobrio and Paolo Portoghesi, *L'immaginario architettonico nella pittura*, Bari: Laterza, 1988.

26 Art historian Anne Hollander significantly refers to painterly scenic designs as "moving pictures." See Anne Hollander, *Moving Pictures*, Cambridge: Harvard University Press, 1991, especially chapter 8.

27 On atmospheric movie theaters, see chapter 1.

28 See P. D. A. Harvey, *The History of Topographical Maps: Symbols, Pictures and Surveys*, London: Thames and Hudson, 1980, pp. 29–36.

29 See J. B. Harley and David Woodward, *The History of Cartography*, vol. 1, Chicago: University of Chicago Press, 1987,

especially chapter 19 on "Portolan Charts from the Late Thirteenth Century to 1500"; and Jacob, *L'empire des cartes*, chapter 1.

30 See Richard D. Altick, *The Shows of London*, Cambridge: Harvard University Press, 1978.

31 See Rhonda Garelick, "*Bayadères, Stéréorama*, and *Vahat-Loukoum*: Technological Realism in the Age of Empire," in Margaret Cohen and Christopher Prendergast, eds., *Spectacles of Realism: Gender, Body, Genre*, Minneapolis: University of Minnesota Press, 1995. On this and other moving panoramas, see Stephan Oettermann, *The Panorama: History of a Mass Medium*, trans. Deborah Lucas Schneider, New York: Zone Books, 1997; and Vanessa Schwartz, *Spectacular Realities: Early Mass Culture in Fin-de-Siècle Paris*, Los Angeles: University of California Press, 1998.

32 See, among others, Jim Bennett, Robert Brain, Simon Schaffer, Heinz Otto Sibum, and Richard Staley, *1900: The New Age*, Cambridge, England: Whipple Museum of the History of Science, 1994 (exhibition catalogue). Another moving panorama shown at the Paris Exposition was the *Trans-Siberian Express*, which simulated the celebrated railway journey in a forty-five-minute tour.

33 Renzo Dubbini, "Views and Panoramas: Representations of Landscapes and Towns," *Lotus International*, no. 52, 1987, p. 105. See also Dubbini, *Geografie dello sguardo: visione e paesaggio in età moderna*, Turin: Einaudi, 1994, especially chapters 2 and 6.

34 *Literary Gazette*, 16 April 1825, p. 255. Cited in Altick, *The Shows of London*, p. 395.

35 See chapters 3, 4, and 11.

36 See Laurence Sterne, *A Sentimental Journey Through France and Italy*, London: Penguin, 1986, first published in 1768.

37 Dezallier d'Argenville, *Voyage pittoresque de Paris*, Paris, 1778, "Préface," p. iii, cited in Dubbini, "Views and Panoramas," p. 105.

38 On the art of memory, see Frances A. Yates, *The Art of Memory*, Chicago: University of Chicago Press, 1966. For further discussion of the art of mapping and memory, see chapter 7.

39 Alessandro Piazza's multiple views are preserved at the Museo Correr in Venice, Italy.

40 On the Salon, see Patricia Mainardi, *The End of the Salon: Art and the State in the Early Third Republic*, New York: Cambridge University Press, 1993. For further discussion of exhibition practices, see chapter 10.

41 On Havell's work, see Hyde, *Gilded Scenes*. The portable strip panoramas were an extensive European phenomenon, quite popular in the nineteenth century. The most celebrated ones were produced in England by Havell, in Switzerland by Heinrich Keller, and in Germany by Friedrich Delleskamp.

42 See chapter 10 for further discussion of this possibility, as embodied, for example, in the experimental installations of the filmmaker Peter Kubelka.

43 Judith Adler, "Origins of Sightseeing," *Annals of Tourism Research*, vol. 16, 1989, pp. 7–29.

44 J. Howell, *Instructions for Forrein Travell*, London: Humphrey Mosele, 1642, pp. 2–3, cited in Adler, "Origins of Sightseeing," pp. 12–13.

45 For a discussion of the misunderstandings surrounding the picturesque, see Kim Ian Michasiw, "Nine Revisionist Theses on the Picturesque," *Representations*, no. 38, Spring 1992, pp. 76–100.

46 On the picturesque as a landscape aesthetic, see, among others, John Dixon Hunt, *Gardens and the Picturesque: Studies in the History of Landscape Architecture*, Cambridge: MIT Press, 1992; Malcolm Andrews, *The Search for the Picturesque: Landscape Aesthetics and Tourism in Britain, 1760–1800*, Stanford, Cal.: Stanford University Press, 1989; Sidney Robinson, *Inquiry into the Picturesque*, Chicago: University of Chicago Press, 1991; David Watkin, *The English Vision: The Picturesque in Architecture, Landscape and Garden Design*, London: Murray, 1982; and Monique Mosser and Georges Teyssot, eds., *The Architecture of Western Gardens: A Design History from the Renaissance to the Present Day*, Cambridge: MIT Press, 1991. The notion of "picturesque" was first used by Alexander Pope in relation to the narrative impact of history painting and originally referred to a scene that would be apt for painting.

47 See William Gilpin, *Three Essays: On Picturesque Beauty; On Picturesque Travel; and on Sketching Landscape*, London, 1792; Uvedale Price, *Essays on the Picturesque*, 3 vols., London, 1810; Richard Payne Knight, *The Landscape: A Didactic Poem in Three Books Addressed to Uvedale Price, Esq.*, London, 1795; and Knight, *Analytical Inquiry into the Principles of Taste*, London, 1805.

48 My study focuses in particular on the architectonics of view painting, picturesque aesthetics, garden strolling, and other topographic or cartographic practices; but other cases for the relation of landscape to precinema could be made. For a case study that links nineteenth-century American landscape painting and film language, see Scott MacDonald's "Voyages of Life," on the cinematism of Thomas Cole's *The Voyage of Life* and avant-garde film, in *Wide Angle*, vol. 18, no. 2, April 1996, pp. 101–26; and Iris Cahn, "The Changing Landscape of Modernity: Early Film and America's 'Great Picture' Tradition," *Wide Angle*, vol. 18, no. 3, July 1996, pp. 85–100. Both issues are devoted to "Movies Before Cinema" and were edited by Scott MacDonald.

49 On this and other viewing apparatuses, see Jonathan Crary, *Techniques of the Observer*, Cambridge: MIT Press, 1990.

50 Anne Hollander, for example, prefers to highlight the filmic sublime in her discussion of "moving images." Focusing on visual composition rather than on moving spectatorial culture, Hollander sees the picturesque as "essentially static" and "jarringly anti-cinematic." She furthermore states that "picturesqueness remains an enemy of serious film drama; but sublime landscape can be its best servant" (Hollander, *Moving Pictures*, pp. 263–64). See also Scott Bukatman, "The Artificial Infinite," in Lynne Cooke and Peter Wollen, eds., *Visual Display: Culture Beyond Appearances*, Seattle: Bay Press, 1995.

51 On the picturesque and questions of modernity see, among others, Rosalind Krauss, *The Originality of the Avant-Garde and Other Modernist Myths*, Cambridge: MIT Press, 1985, especially pp. 162–70; Caroline Constant, "The Barcelona Pavilion as Landscape Garden: Modernity and the Picturesque," *AA Files*, no. 20, 1990, pp. 47–54; as well as other works discussed below.

52 Yve-Alain Bois, "A Picturesque Stroll around *Clara-Clara*," *October*, no. 29, 1984, pp. 32–62; and Bois, introduction to Sergei Eisenstein's "Montage and Architecture," *Assemblage*, no. 10, December 1989, pp. 111–31.

53 Anthony Vidler, "The Explosion of Space: Architecture and the Filmic Imaginary," in Dietrich Neumann, ed., *Film Architecture: Set Designs from Metropolis to Blade Runner*, New York: Prestel, 1996.

54 Vincent Scully, *Architecture: The Natural and the Man Made*, New York: St. Martin's, 1991, chapter 11.

55 Dubbini, *Geografie dello sguardo*, p. xxi.

56 See John Dixon Hunt, "'*Curiosities* To Adorn *Cabinets* and *Gardens*,'" in Oliver Impey and Arthur MacGregor, eds., *The Origins of Museums: The Cabinet of Curiosities in Sixteenth- and Seventeenth-Century Europe*, Oxford: Clarendon, 1985.

57 Scully, *Architecture*, chapters 8 and 11.

58 Robert Smithson, "Frederick Law Olmstead and the Dialectical Landscape," in *The Writings of Robert Smithson*, ed. Nancy Holt, New York: New York University Press, 1979, p. 119.

59 See Vivian Sobchack, *The Address of the Eye: A Phenomenology of the Film Experience*, Princeton: Princeton University Press, 1992.

60 See, in particular, Maurice Merleau-Ponty, *The Visible and the Invisible*, ed. Claude Lefort, trans. Alphonso Lingis, Evanston, Ill.: Northwestern University Press, 1968; Merleau-Ponty, *Phenomenology of Perception*, trans. Colin Smith, London: Routledge, 1962; Merleau-Ponty, "Eye and Mind" (1961), in *The Primacy of Perception*, ed. James M. Edie, trans. Carleton Dallery, Evanston, Ill.: Northwestern University Press, 1964.

61 Dixon Hunt, *Gardens and the Picturesque*, p. 4.

62 Foucault's concept of heterotopia was discussed in chapter 5.

63 See Allen S. Weiss, *Mirrors of Infinity: The French Formal Garden and 17th-century Metaphysics*, Princeton: Princeton Architectural Press, 1995. On the politics of French gardens, see also Scully, *Architecture*, chapters 9 and 10.

64 Opened in 1661, Vauxhall Gardens took the form for which it is now best known in the 1730s. See Dixon Hunt, *Gardens and the Picturesque*, particularly chapter 2.

65 See Altick, *The Shows of London*, particularly chapters 7 and 23. The treatment of Vauxhall Gardens that follows in this section is based for the most part on this work. I have interpreted it, however, in ways that advance my hypothesis that the garden constitutes protofilmic space.

66 On the role of the fête in eighteenth-century French cultural life, see Thomas E. Crow, *Painters and Public Life in Eighteenth-Century Paris*, New Haven: Yale University Press, 1985, especially chapter 2.

67 These architectural entertainments were developed particularly in London's Surrey Gardens.

68 This was the convention until the mid-1830s, when the garden's decline prompted the management to open during the day. This was not unrelated to the perception of Vauxhall as a "licentious" space.

69 The description of Séguin's patent for the polyorama, dated 20 September 1852, is cited in Laurent Mannoni, *Le grand art de la lumière et de l'ombre: archéologie du cinéma*, Paris: Nathan, 1995, p. 237 (my translation).

70 This advertisement, dated 1817, is cited in Gilles-Antoine Langois, *Folies, Tivolis et Attractions*, Paris: Délégations à L'Action Artistique, 1990, p. 8 (my translation).

71 See Sylvia Lavin, "Sacrifice and the Garden: Watelet's *Essai sur les jardins* and the Space of the Picturesque," *Assemblage*, no. 28, December 1995, pp. 17–33.

72 Ibid., pp. 22–23. See also Claude-Henri Watelet, *Essai sur les jardins*, Paris, 1770.

73 Nicolas Duchesne, *Traité de la formation des jardins*, Paris, 1775; and Jean-Marie Morel, *Théorie des jardins*, Paris, 1776.

74 Scholarship on female spectatorship has played an important role in the definition of feminist film theory. For an orientational map of the initial discourse, see the special issue of *Camera Obscura* on "The Spectatrix," edited by Janet Bergstrom and Mary Ann Doane, nos. 20–21, May–September 1989. From the early claim of bisexuality in feminist film theory to more recent theorizations of the "performance" of gender elaborated by queer theory, feminist scholars have been calling attention to shifting positions in the gender realm. For an array of theorizations of spectatorship, see Linda Williams, ed., *Viewing Positions: Ways of Seeing Film*, New Brunswick, N.J.: Rutgers University Press, 1995.

75 There are many visual documents of female strollers and onlookers. See, as an example, the illustrations in *History of Vauxhall Gardens*, 1890; and in Paul Sandby, *Roslin Castle, Midlothian*, c. 1770, where ladies in a park amuse themselves with a camera obscura.

76 The recent spate of filmic revivals of Austen's novels is interesting in this respect, as it may be read as a sign of a revival of the picturesque in the context of revisiting turn-of-the-century notions of the interior.

77 Jane Austen, *Pride and Prejudice*, in *The Novels of Jane Austen*, 3rd ed., vol. 3, ed. R. W. Chapman, Oxford: Oxford University Press, 1932–34, chapter 1, p. 245. The novel was originally published in 1813.

78 Austen, *Emma*, in *The Novels of Jane Austen*, vol. 3, chapter 6, p. 357. The novel was originally published in 1816.

79 Stafford, *Voyage into Substance*, p. 4.

80 Thomas Whately, *Observations on Modern Gardening* (1770), anthologized in John Dixon Hunt and Peter Willis, eds., *The Genius of the Place: The English Landscape Garden 1620–1820*, Cambridge: MIT Press, 1992, pp. 306–7. The French translation of this text was influential in French visions of the garden.

81 Christopher Hussey, *The Picturesque: Studies in a Point of View*, London and New York, 1927, p. 4.

82 See Monique Mosser, "Paradox in the Garden: A Brief Account of *Fabriques*," in Mosser and Teyssot, eds., *The Architecture of Western Gardens*.

83 Alessandra Ponte, "The Character of a Tree: From Alexander Cozens to Richard Payne Knight," in Mosser and Teyssot, eds., *The Architecture of Western Gardens*. See also Ponte, "Architecture and Phallocentricism in Richard Payne Knight's Theory," in Beatriz Colomina, ed., *Sexuality and Space*, New York: Princeton Architectural Press, 1992.

84 Barbara Maria Stafford, *Body Criticism: Imaging the Unseen in Enlightenment Art and Medicine*, Cambridge: MIT Press, 1991, p. 413.

7 An Atlas of Emotions

1 The notion of cognitive mapping, as developed by Lynch and further thered by Jameson, was introduced in chapter 3 and further discussed in chapter 6. On geopolitics and film, see Jameson, *The Geopolitical Aesthetic: Cinema and Space in the World Systems*, Bloomington: Indiana University Press, 1992.

2 See for example Trevor Barnes and Derek Gregory, eds., *Reading Human Geography*, London: Routledge, 1997; Denis Wood, *The Power of Maps*, New York: Guilford Press, 1992; M. H. Matthews, *Making Sense of Place*, Hemel Hempstead, Hertfordshire: Harvester Wheatsheaf, 1992; Stephen S. Hall, *Mapping the Next Millennium*, New York: Random House, 1992; Mark Monmonier, *How to Lie with Maps*, Chicago: University of Chicago Press, 1991; and David Turnbull, *Maps are Territories*, Chicago: University of Chicago Press, 1989.

3 See, among others, J. B. Harley, "Deconstructing the Map," and John Pickles, "Texts, Hermeneutics and Propaganda Maps," both in Trevor J. Barnes and James S. Duncan, eds., *Writing Worlds: Discourse, Text and Metaphor in the Representation of Landscape*, New York: Routledge, 1992; Graham Huggan, "Decolonizing the Map: Post-Colonialism, Post-Structuralism and the Cartographic Connection," *Ariel*, vol. 20, no. 4, October 1989, pp. 115–31; Richard Helgerson, "The Land Speaks: Cartography, Chorography and Subversion in Renaissance England," *Representations*, no. 16, Fall 1986, pp. 51-85; and Kathleen Kirby, *Indifferent Boundaries: Spatial Concepts of Human Subjectivity*, New York: Guilford Press, 1996, especially "Lost in Space."

4 See Janet Wolff, "On the Road Again: Metaphors of Travel in Cultural Criticism," *Cultural Studies*, no. 7, 1993, pp. 224–39; and Caren Kaplan, *Questions of Travel: Postmodern Discourses of Displacement*, Durham, N.C.: Duke University Press, 1996.

5 Maurice Merleau-Ponty, *The Primacy of Perception*, ed. James M. Edie, trans. Carleton Dallery, Evanston, Ill.: Northwestern University Press, 1964, p. 5.

6 Roger Caillois, "Mimicry and Legendary Psychasthenia," *October*, no. 31, Winter 1984, p. 30. The essay was originally published in the Surrealist journal *Minotaure* in 1935.

7 Gertrude Stein, *Geography* (1923), in *Printed Lace and Other Pieces* (1914–37), *The Yale Edition of the Unpublished Work of Gertrude Stein*, vol. 5, New Haven: Yale University Press, 1955, reprinted in *A Stein Reader*, ed. Ulla E. Dydo, Evanston, Ill.: Northwestern University Press, 1993, pp. 467–70.

8 See Stein, *Geography and Plays*, Boston: Four Seas Company, 1922; and Stein, *The Geographical History of America*, New York: Random House, 1936.

9 Stein, *Tender Buttons: Objects, Food, Rooms* (1914), in *Selected Writings of Gertrude Stein*, ed. Carl Van Vechten, New York: Vintage Books, 1990.

10 The expression comes from Virginia Woolf, *A Room of One's Own*, London: Hogarth Press, 1929. I am not using the phrase, however, strictly in the way Woolf defined it.

11 Gillian Rose, *Feminism and Geography: The Limits of Geographical Knowledge*, Minneapolis: University of Minnesota Press, 1993, p. 1. Rose participates in a movement that incorporates feminism into the project of geography, as discussed in chapter 4.

12 See Rosalyn Deutsche, *Evictions: Art and Spatial Politics*, Cambridge: MIT Press, 1996, in particular the chapters "Men in Space" and "Boys Town."

13 See Derek Gregory, *Geographical Imaginations*, Oxford: Blackwell, 1994.

14 Jessica Benjamin, "A Desire of One's Own: Psychoanalytic Feminism and Intersubjective Space," in Teresa de Lauretis, ed., *Feminist Studies/Critical Studies*, Bloomington: Indiana University Press, 1986, p. 97.

15 For the relatively limited scholarship that addresses this issue, see Valerie Traub, "Mapping the Global Body: Gender, Eroticism, and Race in Seventeenth-Century European Cartography," unpublished paper, read at the Humanities Center, Seminar on Women and Culture in Early Modern Europe, Harvard University, 16 April 1998.

16 This map appears simplified in the 1580, 1588, 1598, 1614, and 1628 editions of Münster's *Cosmography*. Another version appeared in 1548 and 1587. See Map Collectors' Circle, *Map Collectors' Series: no. 1, Geographical Oddities*, described by R. V. Tooley, London: Robert Stockwell, 1963.

17 See Patrick Gordon, *Geography Anatomiz'ed*, London, 1722.

18 An example is the anatomical figure designed in 1552 that appears in Bartolomeo Eustachio's *Tabulae anatomicae clarissimi viri*, 1714. As discussed by Samuel Y. Edgerton, "From Mental Matrix to *Mappamundi* to Christian Empire: The Heritage of Ptolemaic Cartography in the Renaissance," in David Woodward, ed., *Art and Cartography*, Chicago: University of Chicago Press, 1987.

19 The miniature of Bologna's Istituto delle Scienze in Palazzo Poggi, showing its laboratories and rooms as well as the school of life drawing in the Accademia Clementina, is preserved in the Archivio di Stato, *Insignia degli Anziani*, vol. 13.

20 An example of the spatial creation of gender dichotomy (and, hence, gender domination) is found in Claes Jansz. Visscher's map of *Gallia* (1650). Here, views of cities are featured at the bottom of the map, while the left and right sides play out socio-sexual difference. On the left, men of different social classes are outfitted; on the right, women, defined solely in terms of their familial role (as "wives of") and in relation to male social types, are depicted in their costumes and customs.

21 On this map room, see Juergen Schulz, "Maps as Metaphors: Mural Map Cycles of the Italian Renaissance," in Woodward, ed., *Art and Cartography*.

22 On the relationship between cartography and art, see Christine Buci-Glucksmann, *L'Oeil cartographique de l'art*, Paris: Editions Galilée, 1996; Svetlana Alpers, *The Art of Describing: Dutch Art in the Seventeenth Century*, Chicago: University of Chicago Press, 1983; Woodward, ed., *Art and Cartography*; P. D. A. Harvey, *The History of Topographical Maps: Symbols, Pictures and Surveys*, London: Thames and Hudson, 1980; and Ronald Rees, "Historical Links Between Cartography and Art," *Geographical Review*, no. 70, 1980, pp. 60–78.

23 In addition to the sources mentioned above, for a theoretical approach to cartographic imagination in history, see Christian Jacob, *L'Empire des cartes: approche théorique de la cartographie à travers l'histoire*, Paris: Editions Albin Michel, 1992. See also Louis Marin, *Utopics: Spatial Play*, trans. Robert A. Vollrath, Atlantic Highlands, N.J.: Humanities Press International, 1984.

24 See James A. Welu, "Vermeer and Cartography," Ph.D. dissertation, Boston University, 1977, pp. 98–102.

25 On Pompadour and issues of representation, see Ewa Lajer-Burcharth, "Pompadour's Touch: Patronage, Art and Sexuality in Eighteenth Century France," unpublished paper, read at the Humanities Center, Seminar on Women and Culture in Early Modern Europe, Harvard University, 31 March 1998.

26 For a reading of this portrait that looks at Pompadour's objects of knowledge, see Charles-Augustin Sainte-Beuve, *Causeries du Lundi*, vol. 2, Paris, 1851–52.

27 On Longhi, see Terisio Pignatti, *Pietro Longhi: Paintings and Drawings, Complete Edition*, trans. Pamela Waley, London: Phaidon, 1969.

28 The 1756 painting of *Il Mondo Novo* is part of the collection of the Fondazione Scientifica Querini Stampalia, in Venice. The 1757 *Il Mondo Novo* belongs to Banca Cattolica del Veneto, in Vicenza, Italy.

29 Longhi's *Geography Lesson* (1752) is in the collection of the Fondazione Scientifica Querini Stampalia, in Venice.

30 Francesco Capella's *Geography Lesson* (c. 1760) is in a private collection in Bergamo, Italy. The *Geography Lesson* attributed to Gramiccia (c. 1750) is in Venice, Ca' d'Oro.

31 Longhi's *Geography Lesson* (c. 1750) is in Padua's Museo Civico.

32 She is thought to be Louise Sebastienne Gely, who later married Danton. It is his younger son to whom she is showing views in this print.

33 One of the oldest figurative examples of the myth of Atlas is *Atlante farnesiano*, a Roman copy of a Greek statue of Atlas, who supports a celestial globe on his shoulders. It is displayed at the Museo Archeologico Nazionale, in Naples.

34 The image appears in the edition of Blaeu's *Atlas* preserved in the Bibliothèque Nationale in Paris.

35 This and the Visscher image discussed below are treated, albeit with no reference to gender mapping, in James A. Welu, "The Sources and Development of Cartographic Ornamentation in the Netherlands," in Woodward, ed., *Art and Cartography*.

36 Cesare Ripa, *Iconologia*, Rome: Heredi di Gio. Gigliotti, 1593. The citation on Geometria is taken from a contemporary Italian edition, Turin: Fogola Editore, 1986, vol. 1, p. 184 (my translation).

37 Tom Conley, *The Self-Made Map: Cartographic Writing in Early Modern France*, Minneapolis: University of Minnesota Press, 1996, p. 210.

38 Ripa, *Iconologia*, vol. 2, p. 294.

39 For a reading of Scudéry and her salon in these terms, see, among others, Joan De Jean, *Tender Geographies: Women and the Origins of the Novel in France*, New York: Columbia University Press, 1991; Elaine Showalter, *The Evolution of the French Novel (1641–1782)*, Princeton: Princeton University Press, 1972; Joanne Davis, *Mademoiselle de Scudéry and the Looking-Glass Self*, New York: Peter Lang, 1993; Nicole Aronson, *Mademoiselle de Scudéry ou le voyage au pays de tendre*, Paris: Fayard, 1986; Aronson, *Mademoiselle de Scudéry*, Boston: Twayne, 1978; and Georges

Mongrédien, *Madeleine de Scudéry et son salon*, Paris: Editions Tallendier, 1946.

40 De Jean, *Tender Geographies*, p. 73.

41 Rita Santa Celoria, introduction to Madeleine de Scudéry, *Clélie, histoire romaine*, Turin: Giappichelli Editore, 1973, p. xxxiii.

42 Joan De Jean, "The Salons, 'Preciosity,' and the Sphere of Women's Influence," in Denis Hollier, ed., *A New History of French Literature*, Cambridge: Harvard University Press, 1989, p. 303. On this subject, see also Dena Goodman, *The Republic of Letters: A Cultural History of the French Enlightenment*, Ithaca, N.Y.: Cornell University Press, 1994; Donna Stanton, "The Fiction of Préciosité and the Fear of Women," *Yale French Studies*, no. 62, 1981, pp. 107–34; Carolyn Lougee, *Le Paradis des femmes: Women, Salons, and Social Stratification in Seventeenth-Century France*, Princeton: Princeton University Press, 1976; and Dorothy Anne Liot Backer, *Precious Women: A Feminist Phenomenon in the Age of Louis XIV*, New York: Basic Books, 1974.

43 Michel Conan, "The Conundrum of Le Nôtre's *Labyrinthe*," in John Dixon Hunt, ed., *Garden History: Issues, Approaches, Methods*, Washington, D.C.: Dumbarton Oaks Research Library and Collection, 1992.

44 See Mark S. Weil, "Love, Monsters, Movement, and Machines: The Marvelous in Theatres, Festivals, and Gardens," in Joy Kenseth, ed., *The Age of the Marvelous*, Hanover, N.H.: Hood Museum of Art, Dartmouth College, 1991 (exhibition catalogue); and Monique Mosser and Georges Teyssot, eds., *The Architecture of Western Gardens: A Design History from the Renaissance to the Present Day*, Cambridge: MIT Press, 1991.

45 Alain-Marie Bassy, "Supplément au voyage de Tendre," *Bulletin du bibliophile*, no. 1, 1982, p. 17 (my translation). Although aware of the relation between garden topography, the art of memory, and the *Carte de Tendre*, Bassy ultimately chooses to read Scudéry's map as an appropriation of twelfth-century military cartography, whose "rules of the game," in this view, are transformed into a societal game.

46 Francesco Colonna, *Hypnerotomachia Poliphili*, Venice: Aldus Manutius, 1499. Although it is not certain that Colonna was the author of this work, this is the most accepted hypothesis.

47 For an architectural revisitation of Poliphilo's journey, see Alberto Pérez-Gómez, *Polyphilo or The Dark Forest Revisited: An Erotic Epiphany of Architecture*, Cambridge: MIT Press, 1992; and Robert Harbison, *Eccentric Spaces*, New York: Avon Books, 1977, chapter 5.

48 Marcus Tullius Cicero's version of the art of memory is outlined in his *De Oratore*, trans. E. W. Sutton and Harris Rackman, London: Loeb Classical Library, 1942. Marcus Fabius Quintilianus' rendition of the subject is laid out in his *Institutio oratoria*, vol. 4, trans. H. E. Butler, New York: G. P. Putnam's Sons, 1922.

49 Quintilian, *Institutio oratoria*, vol. 4, pp. 221–23.

50 See Frances A. Yates, *The Art of Memory*, Chicago: University of Chicago Press, 1966; and Yates, "Architecture and the Art of Memory," *Architectural Design*, vol. 38, no. 12, December 1968, pp. 573–78.

51 See Plato, *Theaetetus*, trans. Harold N. Fowler, London: Loeb Classical Library, 1921; and Sigmund Freud, "A Note on the Mystic Writing Pad," in *Complete Psychological Works*, vol. 9, London: Standard Edition, 1956.

52 Raúl Ruiz, "Miroirs du cinéma," *Parachute*, no. 67, Summer 1992, p. 18.

53 Mary Carruthers, *The Book of Memory: A Study of Memory in Medieval Culture*, New York: Cambridge University Press, 1992, pp. 59–60.

54 See Giulio Camillo, *L'idea del teatro*, ed. Lina Bolzoni, Palermo: Sellerio, 1991.

55 Erasmus, *Opus Epistolarum*, vol. 9, ed. P. S. Allen, et al., Oxonii, in typographeo Clarendoniano, 1906–58, p. 479. Cited in Yates, *The Art of Memory*, p. 132.

56 Frances Yates dedicates most of her study of the art of memory to Giordano Bruno's fascinating work. See also Yates, *Giordano Bruno and the Hermetic Tradition*, Chicago: University of Chicago Press, 1964.

57 See, in particular, Giordano Bruno, *L'arte della memoria: le ombre delle idee*, Milan: Mimesis, 1996.

58 On such cartographical curiosities, see, for example, "Curiosa," in John Goss, *The Mapmaker's Art*, Rand McNally, 1993.

59 In the novel, the map plays a role in the fiction, as a step in the developing relationship between Aronce and Clélie, who also has been pursued by Horace. The making of the map is prompted by the arrival on this seduction scene of Herminius, who asks Clélie to show him the way to *Tendre*. She does so by producing the map.

60 On this subject, see Claude Filteau, "Le Pays de Tendre: l'enjeu d'une carte," *Littérature*, no. 36, 1979, pp. 37–60; and James S. Munro, *Mademoiselle de Scudéry and the Carte de Tendre*, Durham, England: University of Durham, 1986.

61 On the discourse of desire, see Karen Atkinson and Andrea Liss, *Remapping Tales of Desires: Writings Across the Abyss*, Santa Monica, Cal.: Side Street Press, 1992; and Linda S. Kauffman, *Discourses of Desire: Gender, Genre and Epistolary Fictions*, Ithaca, N.Y.: Cornell University Press, 1986.

62 See Julia Kristeva, *La révolte intime: Pouvoirs et limites de la psychanalyse II*, Paris: Fayard, 1997. I find the intimate revolt to be a crucial issue today, certainly in the psychoanalytic realm, but I do not share Kristeva's view of intimate revolt as being enacted against the stereotypes of modern society, dominated by technology and the media, and do not subscribe to her reading of the cinema in this context, with respect to phantasm. Transcending the worn-out notion of a cinematic apparatus based on phantasmatic structures, the "atlas of emotion" intends to picture a cartographic writing of intimate space, with the cinema set affectively in this place.

63 In the 1659 engraving of the *Carte de Tendre* by Jacques Destrevaulx, the scene is also enriched with an enlarged view of a town, at the bottom right of the map.

64 On this notion, see Umberto Eco, *The Open Work*, trans. Anna Cancogni, Cambridge: Harvard University Press, 1989.

65 Roland Barthes, *A Lover's Discourse: Fragments*, trans. Richard Howard, New York: Hill and Wang, 1978.

66 Stephen Kern, *The Culture of Love: Victorians to Moderns*, Cambridge: Harvard University Press, 1992. See also Julia Kristeva, *Tales of Love*, trans. Leon S. Roudiez, New York: Columbia University Press, 1987.

67 All citations are taken from a contemporary French edition of the novel. Scudéry, *Clélie*, Turin: Giappichelli, 1973, vol. 1, p. 309 (my translation).

68 Ibid., p. 310.

69 Ibid.

70 Ibid.

71 Publications that illustrate the general relationship between art and imaginary cartography include J. B. Harley and David Woodward, *The History of Cartography*, vol. 1, Chicago: University of Chicago Press, 1987; Kenseth, ed., *The Age of the Marvelous*; *Cartes et figures de la terre*, Paris: Centre Georges Pompidou, 1980 (exhibition catalogue); *Il disegno del mondo*, Milan: Electa, 1983 (exhibition catalogue); and J. B. Post, *An Atlas of Fantasy*, New York: Ballantine Books, 1979.

72 An excellent source of information on this topic is E. P. Mayberry Senter, "Les cartes allégoriques romanesque du XVII siècle," *Gazette des Beaux Arts*, no. 89, 1977, pp. 134–44. Many of the maps analyzed here are reproduced in this survey, which lists allegorical charts from the seventeenth century.

73 Matthaeus Seutter, *Atlas novus sive tabulae geographicae totius orbis faciem*, Augsburg: In Verlag des Autoris, 1720.

74 Map Collectors' Circle, *Map Collectors' Series*, p. 14.

75 For an approach to this relationship, which is yet to be fully explored, see François Boudon, "Garden History and Cartography," in Mosser and Teyssot, eds., *The Architecture of Western Gardens*.

76 Vincent Scully, *Architecture: The Natural and the Manmade*, New York: St. Martin's Press, 1991, chapter 10.

77 See, for example, Robert Payne, *Leonardo*, Garden City, N.J.: Doubleday, 1978.

78 The inner fluidity of the map is such that its design offers multiple interpretations. Claude Filteau, for example, in "Le Pays de Tendre," reads the map's representation as the hepatic channel and argues that its paths are geometrically structured. Taking this cartographic position and projecting an elaborate perspectival and anamorphic design onto the borderless map, his interpretation manages to enclose the map itself into fifteen concentric circles. These different readings also may be explained by recalling a point made by Christian Jacob in *L'Empire des cartes* (p. 398), in which he aptly notes that a reader projects his/her "unconscious geometry" onto the strategy of appropriation of a map. In this case, my reading of the map projects even a different reading of the unconscious, resisting the very idea of an "unconscious geometry" and reaching for a nongeometric, geopsychic design. A starting point for this is the psychoanalytic understanding that there is no "no" in the unconscious, a difficult point, indeed, for geometry to swallow.

79 The map was made by O. Soglow and published in George S. Chappell, *Through the Alimentary Canal with Gun and Camera*, New York: Stokes, 1930. It is reproduced, along with the *Map of Matrimony*, discussed below, in Post, *An Atlas of Fantasy*.

80 For an approach to fictional geographies, including some accounts of cartography, see Pierre Jourde, *Géographies imaginaires*, Paris: José Corti, 1991. Jourde's imaginary geographies include an account of cartographic representation in Tolkien (chapter 7), which touches on the subject of the *Carte de Tendre*.

81 This observation is made, for example, in Juliana O. Muehrcke and Phillip C. Muehrcke, "Maps in Literature," *The Geographical Review*, vol. 64, no. 3, July 1974, pp. 317–38. See also Malcolm Bradbury, ed., *The Atlas of Literature*, London: De Agostini, 1996.

82 Harbison, *Eccentric Spaces*, especially chapter 7 on maps, which the author aptly calls "the mind's miniatures."

83 Franco Moretti, *Atlas of The European Novel 1800–1900*, New York: Verso, 1998.

84 On the subject of literary topography, see also John Gillies, *Shakespeare and the Geography of Difference*, Cambridge: Cambridge University Press, 1994; J. Hillis Miller, *Topographies*, Stanford, Cal.: Stanford University Press, 1995; and Ann McClintock, *Imperial Leather*, London: Routledge, 1995.

85 Jean-François de Bastide, *The Little House: An Architectural Seduction*, trans. Rodolphe el-Khoury, Princeton: Princeton Architectural Press, 1996. Originally published as "La Petite Maison," *Le nouveau spectateur*, no. 2, 1758, pp. 361–412.

86 See Rodolphe el-Khoury, introduction to Bastide, *The Little House*; and el-Khoury, "Taste and Spectacle," in Allen S. Weiss, ed., *Taste Nostalgia*, New York: Lusitania Press, 1997.

87 Bastide, *The Little House*, pp. 59–88.

88 Conley, *The Self-Made Map*.

89 Marcel Proust, *Swann's Way*, trans. C. K. Scott Moncrieff, New York: Vintage Books, 1970.

90 An emblematic group show held at the Museum of Modern Art, in New York, exemplifies this trend. See Robert Storr, *Mapping*, New York: Museum of Modern Art, 1994 (exhibition catalogue).

91 The exhibition was on view at the David Winton Bell Gallery of Brown University, Providence, R.I., 31 January–15 March 1998. Jo-Ann Conklin explains the author's reference to the *Carte de Tendre* in her introduction to *Annette Messager: Map of Temper, Map of Tenderness*, Providence, R.I.: David Winton Bell Gallery, Brown University, 1998 (exhibition catalogue).

92 Messager used this phrase in an interview with Bernard Marcadé, "Annette Messager or the Taxidermy of Desire," in *Annette Messager, comédie tragédie, 1971–1989*, Grenoble: Musée de Grenoble, 1989 (exhibition catalogue), p. 171.

93 See, for example, Sheryl Conkelton and Carol S. Eliel, *Annette Messager*, New York: Museum of Modern Art, and Los Angeles: Los Angeles County Museum of Art, distributed by Harry N. Abrams, 1995 (exhibition catalogue); Messager, *Faire parade 1971–1995*, Paris: Musée d'Art Moderne de la Ville de Paris, 1995 (exhibition catalogue), with an interview by Robert Storr and texts by Elizabeth Lebovici and Jean-Noël Vuarnet; and Messager, "All the Parts of One's Life, All the Hopes, are in One's Clothes," *Aperture*, Winter 1993, pp. 48–53.

94 "La Ville, le Jardin, la Mémoire" took place in Villa Medici, Rome, 28 May—30 August 1998.

95 See Giuliana Bruno, "Interiors: Anatomies of the Bride Machine," in *Rebecca Horn*, New York: Guggenheim Museum, 1993 (exhibition catalogue).

96 See, among others, *Guillermo Kuitca—Burning Beds: A Survey 1982–1994*, Amsterdam: Contemporary Art Foundation, 1994 (exhibition catalogue); *A Book Based on Guillermo Kuitca*, Amsterdam: Contemporary Art Foundation, 1993; *Guillermo Kuitca*, Newport Beach: Newport Harbor Art Museum, 1992 (exhibition catalogue); and *Guillermo Kuitca*, New York: Annina Nosei, 1991 (exhibition catalogue).

97 *Untitled* was installed at IVAM Centre del Carme, Valencia, Spain, 1993.

98 See *Guillermo Kuitca: "Puro teatro,"* New York: Sperone Westwater, 1995 (exhibition catalogue).

99 Alpers, *The Art of Describing*.

100 T. Jefferson Kline, "Remapping Tenderness: Louis Malle's *Lovers with No Tomorrow*," in *Screening the Text: Intertextuality in New Wave French Cinema*, Baltimore: Johns Hopkins University Press, 1992, p. 37.

101 See chapter 1 for an introductory treatment of this film.

102 This and the following quotes are taken from dialogue on the film's sound track. The dialogue is published in a slightly different version in *Hiroshima Mon Amour*, text by Marguerite Duras for the film by Alain Resnais, trans. Richard Seaver, New York: Grove Press, 1961.

103 Michel de Certeau, *The Practice of Everyday Life*, trans. Steven Rendall, Los Angeles: University of California Press, 1984, especially pp. 118–22. All citations in this paragraph are from this work.

8 An Archive of Emotion Pictures

1 See Alois Riegl, *Problems of Style: Foundations for a History of Ornament* (1893), trans. Evelyn Kain, Princeton: Princeton University Press, 1993; and Riegl, *Late Roman Art Industry* (1901), trans. Rolf Winkes, Rome: Giorgio Bretschneider Editore, 1985.

2 Margaret Iversen, *Alois Riegl: Art History and Theory*, Cambridge: MIT Press, 1993, p. 16. See also, Michael Podro, *The Critical Historians of Art*, New Haven: Yale University Press, 1982, especially chapter 5.

3 For a survey of the use of this notion in film, see David B. Clarke, "Introduction: Previewing the Cinematic City," in Clarke, ed., *The Cinematic City*, New York: Routledge, 1997. On the use of the haptic in video practices, see Laura U. Marks, "Video Haptics and Erotics," *Screen*, vol. 39, no. 4, Winter 1998, pp. 331–48.

4 Noël Burch, *Life to Those Shadows*, ed. and trans. Ben Brewster, Los Angeles: University of California Press, 1990.

5 Antonia Lant, "Haptical Cinema," *October*, no. 74, Fall 1995, pp. 45–73.

6 Ibid., p. 72.

7 This point is derived from looking at the different versions of Burch's *Life to Those Shadows*. In the French version of the book (Burch is an American transplanted in Paris, whose work is translated into English), in the chapter corresponding to "Building a Haptic Space," haptic becomes "habitable."

8 Johann Gottfried Herder, "Plastik" (1778), in *Sämtliche Werke*, Stuttgart and Tübingen, 1853, p. 134. Cited in Gert Mattenklott, "The Touching Eye," *Daidalos*, special issue "Provocation of the Senses," no. 41, September 1991, p. 106.

9 Etienne Bonnot de Condillac, *Treatise on the Sensations*, trans. Geraldine Carr, Los Angeles: University of Southern California, 1930.

10 Ibid., pp. 167–71.

11 Ibid., p. 58.

12 Ibid., pp. 59–60.

13 Ibid., pp. 73, 90–91.

14 Annette Michelson, "On the Eve of the Future: The Reasonable Facsimile and the Philosophical Toy," *October*, no. 29, Summer 1984, pp. 3–22.

15 Condillac, *Treatise on the Sensations*, p. 228.

16 Ibid., pp. 84–85 and p. 81.

17 Denis Diderot, *Elements de Physiologie*, in *Oeuvres complètes*, vol. 9, Paris, 1875, p. 371.

18 On Benjamin and experience, see Miriam Hansen, "Benjamin, Cinema and Experience: 'The Blue Flower in the Land of Technology,'" *New German Critique*, no. 40, 1987, pp. 179–224.

19 On Benjamin, neurology, and the impact of technology on the "sensorium," see Susan Buck-Morss, "Aesthetics and Anaesthetics: Walter Benjamin's Artwork Essay Reconsidered," *October*, no. 62, Fall 1992, pp. 3–41. See also Buck-Morss, *The Dialectics of Seeing: Walter Benjamin and the Arcades Project*, Cambridge: MIT Press, 1989. On the interaction of technology and natural history, see Beatrice Hanssen, *Walter Benjamin's Other Histories: Of Stones, Animals, Human Beings and Angels*, Berkeley: University of California Press, 1998.

20 Cesare Ripa, *Iconologia*, Rome: Heredi di Gio. Gigliotti, 1593. This image was discussed in chapter 7.

21 Paul Rodaway, *Sensuous Geographies: Body, Sense and Place*, New York: Routledge, 1994.

22 See Elizabeth Grosz, *Volatile Bodies: Toward a Corporeal Feminism*, Bloomington: Indiana University Press, 1994, especially p. 34. See also, Grosz, *Space, Time, and Perversion*, London: Routledge, 1995.

23 See in particular Henri Lefebvre, *The Production of Space*, trans. Donald Nicholson-Smith, Oxford: Blackwell, 1991.

24 Ibid., especially the passage on corporeal interactions on p. 182, which we developed into "a geography of the moving image" in chapter 2.

25 Jessica Benjamin, *The Bonds of Love: Psychoanalysis, Feminism and the Problem of Domination*, New York: Pantheon, 1988; and Benjamin, *Like Subjects, Love Objects: Essays on Recognition and Sexual Difference*, New Haven: Yale University Press, 1995.

26 Vivian Sobchack, *The Address of the Eye: A Phenomenology of Film Experience*, Princeton: Princeton University Press, 1992. For a different perspective on embodiment, see Steven Shaviro, *The Cinematic Body*, Minneapolis: University of Minnesota Press, 1993.

27 Although I have preferred to foreground the architectural aspect of this Eisensteinian matter, there are other pertinent perspectives offered by Eisenstein in this regard, especially in his pursuit of synesthesia and in his remarks on the sensual base and inner tonalities of color. See Sergei Eisenstein, *The Film Sense*, ed. and trans. Jay Leyda, New York: Harcourt, Brace and World, 1947.

28 See Michel Louis, "Mallet-Stevens and the Cinema, 1919–1929," in Hubert Jeanneau and Dominique Deshoulière, eds., *Rob Mallet-Stevens: Architecte*, Brussels: Editions des Archives d'Architecture Moderne, 1980, p. 147.

29 See in particular Ricciotto Canudo, "Reflections on the Seventh Art" (1923), trans. Claudia Gorbman, in Richard Abel, ed., vol. 1 of *French Film Theory and Criticism: A History/Anthology 1907–1939*, 2 vols., Princeton: Princeton University Press, 1988.

30 Canudo, "The Birth of a Sixth Art" (1911), in Abel, ed., *French Film Theory and Criticism*, vol. 1, p. 61.

31 See in particular Béla Balázs, *Theory of the Film: Character and Growth of a New Art*, trans. Edith Bone, New York: Dover, 1970, especially chapter 8, "The Face of Man"; and Balázs, *Der sichtbare Mensch, oder Die Kultur des Film*, Vienna: Deutsch Osterreichischer Verlag, 1924.

32 Jean Epstein, *Ecrits sur le cinéma, 1921–1953*, Paris: Seghers, 1974. For some English translations, see Abel, ed., *French Film Theory and Criticism*; and P. Adams Sitney, ed., *The Avant-Garde Film: A Reader of Theory and Criticism*, New York: New York University Press, 1978.

33 For a recent recasting of Epstein's form of temporality, see Gilles Deleuze, *Cinema 1: The Movement-Image*, trans. Hugh Tomlinson and Barbara Habberjam, Minneapolis: University of Minnesota Press, 1986, chapter 6; and Leo Charney, *Empty Moments: Cinema, Modernity, and Drift*, Durham, N.C.: Duke University Press, 1998, pp. 150–56. The current theoretical recasting of Epstein's work was pioneered by Stuart Liebman in his *Jean Epstein's Early Film Theory, 1920–1922*, Ph.D. dissertation, New York University, 1980. For a psychoanalytic reading, see Paul Willemen, "Photogénie and Epstein," in *Looks and Frictions: Essays in Cultural Studies and Film Theory*, London: British Film Institute, 1994. An interesting interpretation that discloses the closeness of Epstein's cinematic epistemology to Wittgenstein's articulation of "aspect-dawning" is offered by Malcolm Turvey in "Jean Epstein's Cinema of Immanence: The Rehabilitation of the Corporeal Eye," *October*, no. 83, Winter 1998, pp. 25–50.

34 See Epstein, "Magnification" (1921), in Abel, ed., *French Film Theory and Criticism*, vol. 1.

35 See Michael Taussig, *Mimesis and Alterity: A Particular History of the Senses*, New York: Routledge, 1993; and Taussig, "Tactility and Distraction," in G. E. Marcus, ed., *Rereading Cultural Anthropology*, Durham, N.C.: Duke University Press, 1990.

36 Paul Schilder, "Psycho-analysis of Space," *The International Journal of Psychoanalysis*, vol. 16, part 3, July 1935, p. 21.

37 Victor Burgin, *In/different Spaces: Place and Memory in Visual Culture*, Los Angeles: University of California Press, 1996, p. 139.

38 Walter Benjamin and Asja Lacis, "Naples," in *Reflections*, ed. Peter Demetz, trans. Edmund Jephcott, New York: Harcourt Brace Jovanovich, 1978.

39 Walter Benjamin, *One Way Street and Other Writings*, trans. Edmund Jephcott and Kingsley Shorter, London: Verso, 1979, p. 45.

40 See Giuliana Bruno, *Streetwalking on a Ruined Map*, Princeton: Princeton University Press, 1993, especially pp. 271–72.

41 See chapter 2 for an architectural anatomy of Benjamin's "The Work of Art in the Age of Mechanical Reproduction," in *Illuminations*, ed. Hannah Arendt, trans. Harry Zohn, New York: Schocken Books, 1969.

42 Benjamin, "Paris, the Capital of the Nineteenth Century," in *Reflections*, p. 155. A number of critics speak of Benjaminian physiognomy, although not necessarily architecturally, including Jacques Derrida, in *The Truth of Painting*, trans. Geoff Bennington and Ian McLeod, Chicago: University of Chicago Press, 1987. For Benjamin's material physiognomy and the landscape of the face, see Rolf Tiederman, "Dialectics at a Standstill: Approaches to the *Passagen-Werk*," in Gary Smith, ed., *On Walter Benjamin: Critical Essays and Recollection*, Cambridge: MIT Press, 1988.

43 Benjamin, "A Berlin Chronicle," in *One Way Street*, p. 314.

44 Ibid., p. 295.

45 For the impact on modern art of this research, see in particular Marta Braun, *Picturing Time: The Work of Etienne-Jules Marey (1830–1904)*, Chicago: University of Chicago Press, 1992.

46 Hugo Münsterberg, *The Film: A Psychological Study: The Silent Photoplay in 1916*, New York: Dover, 1970, p. 30. This edition is enriched by a preface by Richard Griffith. It is the republication, unaltered except for the title, of *The Photoplay: A Psychological Study*, New York: D. Appleton, 1916.

47 Ibid., p. 58. Münsterberg was so convinced that a spectatorial mental activity moved and bound moving pictures that he took this stand: "The photoplay is therefore poorly characterized if the flatness of the pictorial view is presented as an essential feature. That flatness is . . . not a feature of that which we really see in the performance of the photoplay. We are there in the midst of a three-dimensional world, and the movement of the persons or of the animals or even of the lifeless things, like the streaming of the water in the brook or the movements of the leaves in the wind, strongly maintain our immediate impression of depth." (p. 22)

48 I thank my colleague Robert Brain, in the Department of History of Science, for this information on Gertrude Stein and for helpful discussion of Münsterberg's laboratory, whose instruments are now in the Collection of Historical Scientific Instruments at Harvard University. See also Coventry Edwards-Pitts, *Sonnets to the Psyche: Gertrude Stein, the Harvard Psychology Laboratory, and Literary Modernism*, Senior Honor's Thesis, Harvard University, Department of History of Science, 1998.

49 Münsterberg, *The Film*, pp. 51–52.

50 Ibid., pp. 55–56.

51 Ibid., p. 74.

52 Ibid., p. 48.

53 Ibid., p. 49.

54 In addition to the architectural line of representation for *emotion* that runs from Cicero to Quintilian and Giordano Bruno, treated in chapter 7, we must recall here the moving images placed on revolving wheels by the Catalán poet and mystic Ramon Lull. See Frances A. Yates, *The Art of Memory*, Chicago: University of Chicago Press, 1966, especially chapter 8; and Paolo Rossi, *Clavis Universalis: Arti mnemoniche e logica combinatoria da Lullo a Leibniz*, Milan: Riccardi, 1960.

55 Daniel Libeskind, "Exhibition and Set Designs," *Architectural Design*, special issue, "Architecture and Film," no. 112, 1994, p. 43.

56 On this installation, see, among others, Alain Pélissier, "Microcosmos," in *Architecture: récits, figures, fictions, Cahiers du CCI*, no. 1, Paris: Editions du Centre Georges Pompidou/CCI, 1986; pp. 42–50.

57 See *Bill Viola*, Paris: Flammarion, and New York: Whitney Museum of American Art, 1998 (exhibition catalogue).

58 Israel Rosenfield, *The Invention of Memory: A New View of the Brain*, New York: Basic Books, 1988, p. 79. See also, Rosenfield, *The Strange, Familiar, and Forgotten: An Anatomy of Consciousness*, New York: Alfred Knopf, 1992, especially p. 6, where Rosenfield explains the dynamic sense of consciousness and the flow of perception by comparing it to motion pictures, using film as more than a metaphor. I thank Rachel Zerner for encouraging me to pursue the path of neuroscience in this study.

59 Rosenfield, *The Invention of Memory*, pp. 79–80.

60 The *Carte de Tendre* was published as illustration for the anonymous "Urbanisme unitaire à la fin des année 50," *Internationale situationniste*, no. 3, 1959. It was juxtaposed with an aerial photograph of Amsterdam, a city of situationist drift. The montage suggests a joining of aerial and navigational practices in traversing space, affirming an intimacy with the city.

61 Thomas F. McDonough, "Situationist Space," *October*, Winter 1994, pp. 59–77. In his discussion of the conception of space in situationism, McDonough mentions the relation of *The Naked City* to the *Carte de Tendre*. On situationist space, see also Elisabeth Sussman, ed., *On the Passage of a Few People Through a Rather Brief Moment in Time: The Situationist International 1957–1972*, Cambridge: MIT Press, 1989 (exhibition catalogue), with a selection of situationist texts on space; Christel Hollevoet, "Wandering in the City, *Flânerie* to *Dérive* and After: The Cognitive Mapping of Urban Space," in *The Power of the City/The City of Power*, New York: Whitney Museum of American Art, 1992 (exhibition catalogue); D. Pinder, "Subverting Cartography: The Situationists and Maps of the City," *Environment and Planning A*, vol. 28, no. 3, March 1996, pp. 405–27.

For some English translations of situationist texts on space, see Ken Knabb, ed. and trans., *Situationist International Anthology*, Berkeley: Bureau of Public Secrets, 1989; and Selected Situationist Texts on Visual Culture and Urbanism, published in *October*, special issue "Guy Debord and the *Internationale situationniste*," ed. Thomas F. McDonough, no. 79, Winter 1997. Situationism has also been given room in recent exhibitions; see *Premises: Invested Spaces in Arts, Architecture, and Design from France 1958–1998*, New York: Guggenheim Museum, 1998 (exhibition catalogue).

62 See Mark Wigley, *Constant's New Babylon: The Hyper-Architecture of Desire*, Rotterdam: Witte de Witte Center for Contemporary Art/010 Publishers, 1998, especially pp. 13–20 for a psychogeography of atmosphere; Simon Sadler, *The Situationist City*, Cambridge: MIT Press, 1998, which addresses in its discourse on urbanism the situationist passion for maps; Libero Andreotti and Xavier Costa, eds., *Situationists: Art, Politics, Urbanism*, Barcelona: Museu d'Art Contemporani and Actar, 1996, especially the essay by Thomas Y. Levin, "Geopolitics of Hibernation: The Drift of Situationist Urbanism"; and Andreotti and Costa, eds., *Theory of the Dérive*

and Other Situationist Writings on the City, Barcelona: Museu d'Art Contemporani and Actar, 1996.

63 The cinematics of the map of *The Naked City* is more relevant to my critical discourse on filmic site-seeing than the situationists' direct intervention in film criticism or filmmaking, for it is more eloquent in elaborating a psychogeographic perspective. The film work, including Guy Debord's own films, made between 1952 and 1978, is enmeshed in a critique of visual spectacle, of which much has been made in critical studies over the years. The result has been to obscure other potential "spaces." I prefer to shift the focus toward situationist mapping and away from the visual stance "against cinema" (the significant title of one Debord's film books) that informs, for instance, Debord's film *Society of the Spectacle* (1973) and others, such as René Viénet's *Can Dialectics Break Bricks*. On situationist film practice, see Thomas Y. Levin, "Dismantling the Spectacle: The Cinema of Guy Debord," in Sussman, ed., *On the Passage of a Few People*. Rendered invisible in 1984 after Debord refused permission to screen it any longer, his film work is now recirculating. The six screenplays are published in Guy Debord, *Oeuvres cinématographiques complètes, 1952–1978*, Paris: Editions Champ Libre, 1978.

64 First published in *Ark*, no. 24, 1958.

65 The association of *The Naked City* with film noir is evidenced in its listing in Alain Silver and Elizabeth Ward, eds., *Film Noir: An Encyclopedic Reference to the American Style*, Woodstock, N.Y.: Overlook Press, 1979, a comprehensive reference on the subject.

66 Carlo Ginzburg, "Clues: Morelli, Freud, and Sherlock Holmes," in Umberto Eco and Thomas A. Sebeok, eds., *The Sign of the Three: Dupin, Holmes, Pierce*, Bloomington: Indiana University Press, 1983. On the relevance of this paradigm to film history and theory, see Giuliana Bruno, "Towards a Theorization of Film History," *Iris*, vol. 2, no. 2, September 1984, pp. 41–55; and Tom Gunning, "Tracing the Individual Body: Photography, Detectives, and Early Cinema," in Charney and Schwartz, eds., *Cinema and the Invention of Modern Life*.

67 On this influence, see Wigley, *Constant's New Babylon*, p. 18. Other versions of the urban psychogeographic map include the one published in Guy Debord and Asger Jorn, *Mémoires*, Copenhagen: Permild and Resengreen, 1959; and Debord, *Life Continues to be Free and Easy* (1959), a collage of figures, text, and stamps over a section of Debord and Jorn's *The Naked City*.

68 For a discussion of "socio-ecological" geography, see Guy Debord, "Theory of the Dérive," in Knabb, ed., *Situationist International Anthology*, where, on p. 50, he claims that "ecological analysis . . . must be utilized and completed with psychogeographical methods . . . and with its relations to social morphology."

69 Guy Debord, "Introduction to a Critique of Urban Geography," in Knabb, ed., *Situationist International Anthology*, p. 5. See also Abdelhafid Khatib, "Essai de description psychogéographique des Halles," *Internationale situationniste*, no. 2, December 1958, pp. 13–17.

70 Vincent Kaufmann, "Angels of Purity," *October*, no. 79, Winter 1997, p. 58.

71 Guy Debord, "Report on the Construction of Situations and on the International Situationist Tendency's Conditions of Organization and Action" (excerpts), in Knabb, ed., *Situationist International Anthology*, p. 23.

72 Here, I am only reading across map designs, stretching interpretive borders to make room for cartographic practices that inscribe a moving psychogeography, albeit in different terms and from different perspectives. Exposing textual connections and speaking only of the maps' configurations, I do not intend to erase the patent and well-documented historical and epistemic differences that exist between *flânerie* and *dérive*. In a process that marks the very changing modalities of urban traversal, the latter, defining this traversal in its own terms, has come to be situated in the place the former used to occupy. Moreover, although the situationists still walked the city, they did so in a way that diverged "from classical notions of the journey and the stroll," as Guy Debord put it in his "Theory of the Dérive," p. 50.

73 See the interview by Kristin Ross with Henri Lefebvre on the situationists, *October*, no. 79, Winter 1997, for insights into an intellectual and conceptual relationship on which scholarship is scarce. Lefebvre describes his thinking on the city as parallel to the situationists' and outlines differences in the exchange. The language he uses to describe his association and conflict with the movement tells of an amorous relationship: "It touches me in some ways very intimately. . . . In the end it was a love story that ended badly." (p. 69) In *Le temps des mépris* (Paris: Editions Stock, 1975, p. 10), Lefebvre had also invoked love, citing an unfinished love affair with the situationists.

74 Speaking about love in the *October* interview with Kristin Ross (p. 73), Lefebvre outlines his conceptual differences with situationism and points out that love was his example of new situations. This involved urban practice, for the historical transformations of love impacted modes of living and changed the shape of urbanism. Although Lefebvre claims that the situationists would have nothing to do with love as an example, one should also consider that it was Scudéry's map of love that materially inspired their map of the city "laid bare."

75 Edward W. Soja, *Third Space: Journeys to Los Angeles and Other Real-and-Imagined Places*, Cambridge, Mass.: Blackwell, 1996, especially pp. 174–78.

76 See chapter 7 for reference to cartographic work in literature and art, including the writings of Christian Jacob, Tom Conley, and Franco Moretti. See also Bruno Latour, *Science in Action: How to Follow Scientists and Engineers Through Society*, Cambridge: Harvard University Press, 1987, especially pp. 215–57.

77 Rosi Braidotti, *Nomadic Subjects: Embodiment and Sexual Difference in Contemporary Feminist Thought*, New York: Columbia University Press, 1994, p. 17.

78 For an indication of the sort of bio-cultural diasporic map formed by the work of these contemporary intellectuals, see, among others, Homi Bhabha, *The Location of Culture*, New York: Routledge, 1994; Iain Chambers, *Migrancy, Culture, Identity*, London: Routledge, 1994; Gayatri Chakravorty Spivak, *The Postcolonial Critic: Interviews, Strategies, Dialogues*, ed. Sarah Harasym, New York: Routledge, 1990; Trinh T. Minh-ha, *Woman, Native, Other*, Bloomington: Indiana University Press, 1989; and Trinh, "An Acoustic Journey," in John Welchman, ed., *Rethinking Borders*, Minneapolis: University of Minnesota Press, 1996. Edward Said approaches this discourse from the position of an exile in, for example, "Intellectuals in the Post-colonial World," *Salmagundi*, no. 70-71, Summer 1986, pp. 44–64.

79 Celeste Olalquiaga, *Megalopolis: Contemporary Cultural Sensibilities*, Minneapolis: University of Minnesota Press, 1992, p. 93.

80 See Krzysztof Wodiczko, *Critical Vehicles: Writings, Projects, Interviews*, Cambridge: MIT Press, 1998. On Wodiczko's work, see Rosalyn Deutsche, *Evictions: Art and Spatial Politics*, Cambridge: MIT Press, 1996, especially chapter 1, "Krzysztof Wodiczko's *Homeless Projection* and the Site of Urban Revitalization," and chapter 2, "Uneven Development: Public Art in New York City." In a different way, the work of Martha Rosler also provides a powerful commentary on urban space, politics, and artistic practices. See, among others, Brian Wallis, ed., *If You Lived Here/The City in Art, Theory, and Social Activism: A Project by Martha Rosler*, Dia Art Foundation, Discussions in Contemporary Culture, no. 6, Seattle: Bay Press, 1991.

81 Donna Haraway, *Modest Witness*, New York: Routledge, 1996, p. 139.

82 On "traveling cultures," see James Clifford, *Routes: Travel and Translation in the Late Twentieth Century*, Cambridge: Harvard University Press, 1997.

83 Paul Virilio, *The Lost Dimension*, trans. Daniel Moshenberg, New York: Semiotext(e), 1991, pp. 56–57. I take this comment without subscribing to a teleological vision of technological doom, but wary also of an uncritical celebration of this situation.

84 See Rudolf Arnheim, *Film as Art*, Los Angeles: University of California Press, 1957, an updated version of *Film*, first published in 1933.

85 Rudolf Arnheim, "The Perception of Maps," *The American Cartographer*, vol. 3, no. 1, April 1976, pp. 5–10. On cartographic matters, see also Arnheim, "Tracés urbains: La conduite piétonnière et sa métaphore cartographique," in *Cartes et figures de la terre*, Paris: Centre Georges Pompidou, 1980 (exhibition catalogue). For his theory of art, see Arnheim, *Visual Thinking*, Los Angeles: University of California Press, 1969; and Arnheim, *Art and Visual Perception: A Psychology of the Creative Eye*, Los Angeles: University of California Press, 1954.

86 Arnheim, "The Perception of Maps," p. 5.

87 See Deleuze, *Cinema 1*; and Deleuze, *Cinema 2: The Time-Image*, trans. Hugh Tomlinson and Robert Galeta, Minneapolis: University of Minnesota Press, 1989. For a contextualization of Deleuze's film theory, see D. N. Rodowick, *Gilles Deleuze's Time Machine*, Durham, N.C.: Duke University Press, 1997.

88 Deleuze, *Cinema 1*, pp. 14–15.

89 See, for example, *Cinema 2*, pp. 12–13, and *Cinema 1*, pp. 87–122.

90 Gilles Deleuze and Félix Guattari, "Géophilosophie," in *Qu'est-ce que la philosophie?*, Paris: Editions de Minuit, 1991. For another political-philosophical perspective on "geophilosophy," see Massimo Cacciari, *Geo-filosofia dell'Europa*, Milan: Adelphi, 1994.

91 Gilles Deleuze and Félix Guattari, *A Thousand Plateaus: Capitalism and Schizophrenia*, trans. Brian Massumi, Minneapolis: University of Minnesota Press, 1987, in particular "The Aesthetic Model: Nomad Art," pp. 492–500. Here, the authors point to the ambiguities of Riegl's and Worringer's analyses of the haptic. Approaching haptic space "under the imperial conditions of Egyptian art," the haptic, for them, became "the presence of a horizon-background; the reduction of space to the plane (vertical and horizontal, height and width); and the rectilinear outline enclosing individuality and withdrawing it from change." (p. 495)

92 Ibid., p. 12.

93 See P. D. Harvey, *The History of Topographical Maps: Symbols, Pictures and Surveys*, London: Thames and Hudson, 1980, pp. 29–31; and Christian Jacob, *L'Empire des cartes: approche théorique de la cartographie a travers l'histoire*, Paris: Editions Albin Michel, 1992, especially chapter 1.

94 Joan Blaeu, *Atlas Maior*, Amsterdam, 1663.

95 See, among others, Ronald Rees, "Historical Links Between Cartography and Art," *Geographical Review*, no. 70, 1980, pp. 60–78.

96 See Juergen Schulz, "Maps as Metaphors: Mural Map Cycles of the Italian Renaissance," in David Woodward, ed., *Art and Cartography*, Chicago: University of Chicago Press, 1987.

97 So reports Vasari, as cited in ibid., p. 99.

98 See chapter 7 for a treatment of the contemporary art of mapping, and chapter 10 for the discourse of cinema taking place in the art gallery.

99 See Henri Lefebvre, *Writings on Cities*, ed. and trans. Eleonore Kofman and Elizabeth Lebas, Oxford: Blackwell, 1996.

100 Louis Marin, *Utopics: Spatial Play*, trans. Robert A. Vollrath, Atlantic Highlands, N.J.: Humanities Press International, 1984, p. 205.

101 Jacob, *L'Empire des cartes*, p. 309 (my translation).

9 M Is for Mapping: Art, Apparel, Architecture Is for Peter Greenaway

1 This is how Peter Greenaway describes his film *The Cook, The Thief, His Wife, and Her Lover* in his "Photographing Architecture," in Martin Caiger Smith and David Chandler, eds., *Site-Work: Architecture in Photography Since Early Modernism*, London: Photographers' Gallery, 1991 (exhibition catalogue), p. 85.

2 I refer to Georges Bataille's *Story of the Eye* (trans. Joachim Neugroschel, New York: Urizen Books, 1997) to suggest an affinity between antivision, eroticism, excess, and incorporation in Greenaway's film.

3 Remo Bodei, *Geometria delle passioni. Paura, speranza, felicità: filosofia e uso politico*, Milan: Feltrinelli, 1991.

4 Ibid., p. 23 (my translation).

5 See chapter 3 for a discussion of the taxonomic impulse in Godard and Greenaway. On geometrical breakdowns of taxonomic orders, see the discussion of Borges's famous twist on taxonomy in Michel Foucault, *The Order of Things: An Archaeology of the Human Sciences*, trans. Alan Sheridan, London: Tavistock, 1970, p. xv.

6 I refer here to the foundational interpretation of Dutch art, cited earlier in connection to other issues, provided by Svetlana Alpers in her *The Art of Describing: Dutch Art in the Seventeenth-Century*, Chicago: University of Chicago Press, 1983. My argument, however, works at undoing the radical distinction she makes between description and narrative, observation and history.

7 Paul Davies, "The Face and The Caress: Levinas's Ethical Alterations of Sensibility," in David Michael Levin, ed., *Modernity and the Hegemony of Vision*, Los Angeles: University of California

Press, 1992, p. 258. See Emmanuel Levinas, *Collected Philosophical Papers*, Dordrecht: Martinus Nijhoff, 1987; and Levinas, *Totality and Infinity*, Pittsburgh: Duquesne University Press, 1969.

8 See Tom Phillips, "*A TV Dante*: Making the Pilot Canto," in *Tom Phillips: Works and Texts*, New York: Thames and Hudson, 1992. See also Bridget Elliott and Anthony Purdy, "Peter Greenaway and the Technology of Representation," *A.D., Art and Design*, no. 49, special issue "Art and Film," 1996, pp. 16–23.

9 Melanie Klein, *Love, Guilt and Reparation and Other Works 1921–1945*, New York: Delta, 1975.

10 Sigmund Freud, "Mourning and Melancholia" (1917) in Freud, *General Psychological Theory: Papers on Metapsychology*, ed. Philip Rieff, New York: Macmillan, 1963.

11 Jacques Derrida, *Memoires: For Paul de Man*, trans. Cecile Lindsay, Jonathan Culler, and Eduardo Cadava, New York: Columbia University Press, 1986, p. 34.

12 On Holbein's painting and melancholia, see Julia Kristeva, *Black Sun: Depression and Melancholia*, trans. Leon S. Roudiez, New York: Columbia University Press, 1989.

13 Rosalind E. Krauss, "Antivision," *October*, special issue on Georges Bataille, no. 36, Spring 1986, pp. 147–54. See also, Krauss, *The Optical Unconscious*, Cambridge: MIT Press, 1993.

14 Georges Bataille, "Dictionnaire," *Documents*, no. 4, September 1929, pp. 216–18 (my translation). On Bataille, see Denis Hollier, *Against Architecture: The Writings of Georges Bataille*, trans. Betsy Wing, Cambridge: MIT Press, 1992.

15 On vision and taste, see Allen S. Weiss, ed., *Taste Nostalgia*, New York: Lusitania Press, 1997.

16 Jean-Paul Sartre, "Intentionality," *Zone*, no. 6, special issue "Incorporations," ed. Jonathan Crary and Sanford Kwinter, 1992, p. 387.

17 As Bourgeois puts it, in a statement accompanying the exhibition "Louise Bourgeois: The Locus of Memory, Works 1982–1993," Brooklyn Museum, 22 April–31 July 1994: "The spider—why the spider? Because my best friend was my mother and she was as delicate, discreet, clever, patient, soothing, reasonable, dainty, neat, and useful as a spider, simply indispensable. She could defend herself and me. . . . I will never be tired of representing her. . . . [It is] a remedy for fear." As her artwork suggests, the spider is the image of the mother: she who feeds, teaches, incorporates; a good and bad object, whose embrace both gives and kills as it inevitably absorbs the child.

18 Sartre, "Intentionality," p. 388.

19 For this reading of cannibalism, see Maggie Kilgour, *From Communion to Cannibalism: An Anatomy of Metaphors of Incorporation*, Princeton: Princeton University Press, 1990.

20 On cannibalism and alchemy, see Peggy Reeves Sanday, *Divine Hunger: Cannibalism as a Cultural System*, Cambridge: Cambridge University Press, 1986, especially pp. 95–101.

21 The cannibalism, with its layered metaphors, resonates significantly as well with contemporary readings of social politics. On the politics of late capitalism in Greenaway's work, see Michael Walsh, "Allegories of Thatcherism: The Films of Peter Greenaway," in Lester Friedman, ed., *Fires Were Started: British Cinema and Thatcherism*, Minneapolis: University of Minnesota Press, 1993.

22 On the role of music in Greenaway's films, see Domenico De Gaetano, *Il cinema di Peter Greenaway*, Turin: Lindau, 1995; and, on visual music, Daniel Caux, Michael Field, Florence de Meredieu, and Philippe Pilard, *Peter Greenaway*, Paris: Dis Voir, 1992, with an interview with Michael Nyman.

23 The description of *A Harsh Book of Geometry* is taken from Prospero's description of his library in the film *Prospero's Books*.

24 Greenaway, *Prospero's Books: A Film of Shakespeare's 'The Tempest'*, London: Chatto and Windus, 1991, p. 20.

25 Ibid.

26 From Prospero's description of his library in the film.

27 Ibid.

28 Ibid.

29 Ibid.

30 Pier Paolo Pasolini, "The Screenplay as a 'Structure that Wants to Be Another Structure,'" in *Heretical Empiricism*, ed. Louise K. Barnett, trans. Ben Lawton and Louise K. Barnett, Bloomington: Indiana University Press, 1988, p. 193. The erotic and violent script for *The Cook*, for example, transforms classic revenge tragedy, turning English Jacobean theater into film. On the Jacobean connection, see Laura Denham, *The Films of Peter Greenaway*, London: Minerva Press, 1993, chapter 4.

31 See Giuliana Bruno, "Heresies: The Body of Pasolini's Semiotics," in Patrick Rumble and Bart Testa, eds., *Pier Paolo Pasolini: Contemporary Perspectives*, Toronto: University of Toronto Press, 1994; and Maurizio Viano, "The Reality Eater," unpublished paper, presented at the Society for Cinema Studies Conference, New Orleans, 11–14 February 1993.

32 Pasolini, "Res sunt Nomina," in *Heretical Empiricism*, p. 255.

33 As Greenaway has remarked, *The Cook*, for example, emerges out of "'the theatre of the blood' with its obsession for human corporeality—eating, drinking, defecating, copulating, belching, vomiting, nakedness and blood." See Greenaway, introduction to *The Cook, The Thief, His Wife and Her Lover*, Paris: Editions Dis Voir, 1989, p. 7.

34 Alois Riegl, *Das hollandische Gruppenportrat*, Vienna, 1902. On this subject, see Margaret Iversen, *Alois Riegl: Art History and Theory*, Cambridge: MIT Press, 1993, chapter 6.

35 From a postcard sent by the architect Stourley Kracklite to Etienne-Louis Boullée in *The Belly of an Architect*. See Greenaway, *The Belly of an Architect*, London: Faber and Faber, 1988, p. 119.

36 This mise-en-scène, described in the prologue, is developed in chapters 2, 5, and 8.

37 On this interpretation of Muybridge, see Linda Williams, *Hard Core: Power, Pleasure and the 'Frenzy of the Visible'*, Berkeley: University of California Press, 1989, chapter 2.

38 On Serrano, see, among others, Brian Wallis, ed., *Body and Soul: Andres Serrano*, New York: Tekarajima Books, 1995; and *Andres Serrano, Works 1983–1993*, Philadelphia: Philadelphia Institute of Contemporary Art, 1994 (exhibition catalogue).

39 Philippe Ariès, *The Hours of Our Death*, trans. Helen Weaver, New York: Vintage Books, 1981; Ariès, *Western Attitudes Towards Death: From the Middle Ages to the Present*, trans. Patricia M. Ranum, Baltimore: Johns Hopkins University Press, 1974; Ariès, *Images de l'homme devant la mort*, Paris: Seuil, 1977. For a gendered perspective, see Elisabeth Bronfen, *Over Her Dead Body: Death, Femininity and the Aesthetic*, New York: Routledge, 1992.

40 For a history of the body in this period, see Antoine de Baecque, *The Body Politic: Corporeal Metaphor in Revolutionary France 1770–1800*, trans. Charlotte Mandell, Stanford: Stanford University Press, 1997.

41 Vanessa R. Schwartz, *Spectacular Realities: Early Mass Culture in Fin-de-Siècle Paris*, Los Angeles: University of California Press, 1998, especially chapter 2.

42 Henri Lefebvre, *The Production of Space*, trans. Donald Nicholson-Smith, Oxford: Blackwell, 1991, especially p. 137.

43 Richard Sennett, *Flesh and Stone: The Body and the City in Western Civilization*, New York: Norton, 1994.

44 Anthony Vidler, "Architecture Dismembered," in *The Architectural Uncanny: Essays in the Modern Unhomely*, Cambridge: MIT Press, 1992, pp. 69–82.

45 On the body and architecture, see also the special project of *Precis*, the Columbia architectural journal, entitled *Architecture and Body*, New York: Rizzoli, 1988; and Georges Teyssot, "The Mutant Body of Architecture," in Diller + Scofidio, *Flesh: Architectural Probes*, New York: Princeton Architectural Press, 1994. For an early commentary on this issue, see Kent C. Bloomer and Charles W. Moore, *Body, Memory, and Architecture*, New Haven: Yale University Press, 1977.

46 For reference to this work, see chapters 2 and 3.

47 Greenaway, *Watching Water*, Milan: Electa, 1993 (exhibition catalogue), p. 11.

48 See chapter 5 for a discussion of Kircher and precinema.

49 D. P. G. Humbert de Superville, *Essai sur les signes inconditionnels dans l'art*, Leiden, 1832. On de Superville, see Barbara Maria Stafford, *Symbol and Myth: Humbert de Superville's Essay on Absolute Signs in Art*, London: Associated University Presses, 1979; Anna Ottani Cavina, *I paesaggi della ragione*, Turin: Einaudi, 1994; and Patrizia Magli, *Il volto e l'anima: fisiognomica e passioni*, Milan: Bompiani, 1995. I am grateful to Patrizia Magli for encouraging me to pursue a study of de Superville.

50 Greenaway interviewed by Marcia Pally, "Cinema as the Total Art Form," *Cineaste*, vol. 18, no. 3, 1991, p. 9.

51 David Wills, *Prosthesis*, Stanford, Cal.: Stanford University Press, 1995, chapter 6.

52 On Boullée, see Emile Kaufmann, *Three Revolutionary Architects: Boullée, Ledoux, and Lequeu*, Philadelphia: American Philosophical Society, 1952; Jean Marie Pérouse de Montclos, *Etienne-Louis Boullée: Theoretician of Revolutionary Architecture*, trans. James Emmons, New York: Braziller, 1974; Helen Rosenau, *Boulleé and Visionary Architecture*, New York: Harmony Books, 1976; Anthony Vidler, *The Writings of the Walls: Architectural Theory in the Late Enlightenment*, New York: Princeton Architectural Press, 1987, pp. 165–73; Vidler, *The Architectural Uncanny*, pp. 169–72; and Sennett, *Flesh and Stone*, pp. 292–96.

53 Greenaway, *Watching Water*, p. 7.

54 Costantino Dardi interviewed by Stefano della Casa in "Una macchina per leggere Roma: intervista inedita a Costantino Dardi," *Cinema e Cinema*, special issue on cinema and architecture, vol. 20, no. 66, January–April 1993, p. 105 (my translation).

55 Greenaway, "Photographing Architecture," pp. 84–85.

56 As discussed in chapter 1, this is how Bazin defined *Bicycle Thieves*. See André Bazin, *What is Cinema?*, vol. 2, ed. and trans. Hugh Gray, Los Angeles: University of California Press, 1971, p. 55. For a survey of the representation of Rome in film (not including Greenaway), see David Bass, "Insiders and Outsiders: Latent Urban Thinking in Movies of Modern Rome," in François Penz and Maureen Thomas, eds., *Cinema and Architecture: Méliès, Mallet-Stevens, Multimedia*, London: British Film Institute, 1997.

57 Greenaway, *Papers*, Paris: Editions Dis Voir, 1990, p. 26.

58 Greenaway, *The Belly of an Architect*, p. 135. All postcards used to conceive the work, even those not appearing in the film, are reproduced in this book.

59 On the sets of *The Fountainhead*, see Donald Albrecht, *Designing Dreams: Modern Architecture in the Movies*, New York: Harper and Row, with the Museum of Modern Art, 1986, pp. 168–74. See also John A. Walker, *Art and Artists on Screen*, Manchester, England: Manchester University Press, 1993, including a separate survey of the depiction of the artist in *The Draughtsman's Contract* and *The Belly of an Architect*.

60 On *Playtime* and architecture, see, among others, Andrea Kahn, "Playtime with Architects," *Design Book Review*, no. 24, 1992, pp. 22–29; and François Penz, "Architecture in the Films of Jacques Tati," in Penz and Thomas, eds., *Cinema and Architecture*.

61 Greenaway, "Photographing Architecture," p. 85.

62 Annette Michelson, "Bodies in Space: Film as 'Carnal Knowledge,'" *Artforum*, no. 7, February 1969, pp. 55–60.

63 On the maps, see Paul Melia, "Frames of Reference," in Melia and Alan Woods, *Peter Greenaway: Artworks 63–98*, Manchester, England: Manchester University Press, 1998.

64 Ibid., p. 58.

65 Greenaway, *Papers*, p. 62.

66 So says the narrator of the film.

67 Greenaway, *Flying over Water*, London: Merrell Holberton, 1997 (exhibition catalogue). The curated exhibition/installation was on view at Fundació Joan Miró, Barcelona, 6 March–25 May 1997.

68 Greenaway, *Flying Out of This World*, Chicago: University of Chicago Press, 1994 (exhibition catalogue). The exhibition "Le Bruit des nuages—Flying Out of This World" took place at the Louvre, Paris, 3 November–1 February 1993.

69 Greenaway provides this information in Leon Steinmetz and Greenaway, *The World of Peter Greenaway*, Boston: Journey Editions, 1995, p. 17.

70 Greenaway, *The Stairs 2: Munich, Projection*, London: Merrell Holberton, 1995, p. 9. This city-wide installation was held in Munich, 29 October–19 November 1995.

71 This installation was mounted in Rome, Piazza del Popolo, 23–30 June 1996.

72 Greenaway, *The Stairs 2: Munich, Projection*, p. 23.

73 Ibid., p. 24.

74 Ibid., p. 97. The catalogue of the exhibition, however, contains a cross-section of film history: a list of ten films selected for each year of the century runs as a continuous frieze under the photographs of the installation.

75 On Sugimoto, see chapter 1.

76 Greenaway, *The Stairs 2: Munich, Projection*, pp. 39–51.

77 For a discussion of the sexual nature of this film, see Brigitte Peucker, *Incorporating Images: Film and the Rival Arts*, Princeton: Princeton University Press, 1995, pp. 156–59.

78 Simon Watney, "Gardens of Speculation: Landscape in *The Draughtsman's Contract*," in Philip Hayward, ed., *Picture This: Media Representations of Visual Art and Artists*, London: John Libbey, 1988. For a reading of allegory as a structuring device in this film, see also Bridget Elliot and Anthony Purdy, *Peter Greenaway: Architecture and Allegory*, Chichester, England: Academy Editions, 1997, chapter 1.

79 This information is provided by Greenaway in an interview with Waldemar Januszczak, *The Studio 999*, April–May 1983, p. 23. He makes clear that this is not a period film; its point was not to be historically correct but to offer a mode of picturing that spans time.

80 See, in particular, chapter 6.

81 Other of Greenaway's landscape films are *Tree* (1966), *Water Wrackets* (1975), and *Vertical Feature Remakes* (1978). On this subject, see Steinmetz and Greenaway, *The World of Peter Greenaway*, chapters 1 and 4; and Greenaway's interview with Jonathan Hacker and David Price, in their *Take Ten: Contemporary British Film Directors*, Oxford: Clarendon Press, 1991, p. 212. On Greenaway's early work, see L. Redish, ed., *The Early Films of Peter Greenaway*, London: British Film Institute, 1992; and for its relation to the cinema of Hollis Frampton, see P. Adams Sitney, "The Falls," *Persistence of Vision*, no. 8, 1990, pp. 45–51.

82 Greenaway interviewed by Alan Woods, *Being Naked Playing Dead: The Art of Peter Greenaway*, Manchester, England: Manchester University Press, 1996, p. 228.

83 See Amy Lawrence, *The Films of Peter Greenaway*, Cambridge: Cambridge University Press, 1997, chapter 2.

84 Greenaway, *The Stairs 1: Geneva, the Location*, London: Merrell Holberton, 1994, p. 79 (exhibition catalogue). The city-wide installation took place in Geneva, 30 April–1 August 1994.

85 Greenaway, *The Stairs 2: Munich, Projection*, p. 16.

86 Ibid., p. 20.

87 Greenaway, *The Stairs 1: Geneva, the Location*, p. 85.

88 Ibid., p. 53.

89 Ibid., p. 54.

90 Ibid., p. 85.

91 Greenaway, *The Stairs 2: Munich, Projection*, p. 27.

92 For topics and sources, see, among others, Woods, *Being Naked Playing Dead*; and Alessandro Bencivenni and Anna Samueli, *Peter Greenaway: Il cinema delle idee*, Genoa: Le Mani, 1996. For an inventory of citations in *The Cook*, including Vermeer, Rembrandt, Hals, Van Eyck, and several Dutch still-life painters, see William F. Van Wert, "Reviews: *The Cook, The Thief, His Wife and Her Lover*," *Film Quarterly*, vol. 44, no. 2, Winter 1990–91, pp. 42–50.

93 David Pascoe, *Peter Greenaway: Museums and Moving Images*, London: Reaktion Books, 1997. Pascoe discusses *A Zed and Two Noughts* (1986), in which a surgeon tries to remake a woman into *The Art of Painting* (c. 1666–67), and elucidates the role Piero della Francesca's *Flagellation of Christ* (1455–60) plays in *The Belly of an Architect*. Among Greenaway's other art-historical citations, Pascoe points to Titian, Giorgione, and the later Bellini for *Prospero's Books*; Crevalcore, Desiderio, and Bellini for *The Baby of Mâcon* (1993); the Pre-Raphaelites for *Drowning by Numbers* (1988); Januarius Zick and Georges de La Tour's *The Penitent Magdalene* (c. 1616) for *The Draughtsman's Contract*; and, discussing Greenaway's early work, considers his continued indebtedness to R. B. Kitaj. On the influence of Kitaj, see also Peter Wollen, "The Last New Wave: Modernism in the British Films of the Thatcher Era," in Friedman, ed., *British Cinema and Thatcherism*. On *A Zed and Two Noughts*, see also David Wills and Alec McHoul, "Zoo-logics: Questions of Analysis in a Film by Peter Greenaway," *Textual Practice*, vol. 5, no. 1, 1991.

94 See Paul Wells, "Compare and Contrast: Derek Jarman, Peter Greenaway and Film Art," *A.D.*, Art and Design Profile, no. 49, 1996, pp. 24–31.

95 Greenaway, *The Stairs 2: Munich, Projection*, p. 43.

96 Elliot and Purdy, *Peter Greenaway*.

97 Walter Benjamin, *The Origin of German Tragic Drama*, trans. John Osborne, London: NLB, 1977.

98 Greenaway, *The Stairs 1: Geneva, the Location*, p. 23. He refers to the exhibition *Some Organizing Principles*, Swansea, Glynn Vivian Art Gallery, 2 October–21 November 1993.

99 Greenaway, *Watching Water*, pp. 14, 44.

100 Walter Benjamin, "Unpacking My Library: A Talk about Book Collecting," in *Illuminations*, ed. Hannah Arendt, trans. Harry Zorn, New York: Schocken Books, 1969, pp. 60–63.

101 See Greenaway, *The Physical Self*, Rotterdam: Boymans-van Beuningen Museum, 1991 (exhibition catalogue). The exhibition was on view 27 October 1991–1 December 1992.

102 Greenaway, *The Stairs 2: Munich, Projection*, p. 31.

103 Thomas Elsaesser, "Peter Greenaway," in Philip Dodd and Ian Christie, eds., *Spellbound: Art and Film*, London: British Film Institute and Hayward Gallery, 1996 (exhibition catalogue), p. 81. The exhibition took place in London, at the Hayward Gallery, February 1996.

104 Greenaway, *The Stairs 1: Geneva, the Location*, p. 15.

105 See Greenaway, *100 Objects to Represent the World*, Stuttgart: Verlag Gerd Hatje, 1992 (exhibition catalogue). The curated exhibition/installation was on view 1 October–8 November 1992 at the Academy of Fine Arts, Vienna.

106 Ibid., p. 72.

107 *Watching Water* took place at Palazzo Fortuny, Venice, 12 June–12 September 1993.

108 Water is physically present in most of Greenaway's filmic and curatorial work (with the notable exception of his 1969 film on Venice, *Intervals*). His films that make prominent use of the idea of water include *Water* (1975), *The Sea in Their Blood* (1983), *Making a Splash* (1984), *Inside Rooms—26 Bathrooms* (1985), *Drowning by Numbers* (1988), and *Death in the Seine* (1988).

109 Greenaway, *Watching Water*, p. 11.

110 Ibid., p. 16.

111 Ibid., p. 18.

112 Ibid.

113 Nita Rollins, "Greenaway-Gaultier: Old Masters, Fashion Slaves," *Cinema Journal*, vol. 35, no. 1, Fall 1995, pp. 65–80.

114 The interplay of fashion and film has received limited scholarly attention. Some existing studies are referenced in chapter 4. Stella Bruzzi discusses fashion with respect to Greenaway's work in her *Undressing Cinema: Clothing and Identity in the Movies*, New York: Routledge, 1997, pp. 9–10. For a visual document of film fashions, see Regine and Peter W. Engelmeier, eds., *Fashion in Film*, Munich: Prestel Verlag, 1990 (exhibition catalogue).

115 See chapter 4. For the debate on fashion and architecture, see Deborah Fausch, Paulette Singley, Rodolphe el-Khoury, Zvi Efrat, eds., *Architecture: In Fashion*, Princeton, Princeton Architectural Press, 1994.

116 Mark Wigley, *White Walls, Designer Dresses: The Fashioning of Modern Architecture*, Cambridge: MIT Press, 1995.

117 Ibid., p. 25.

118 Ibid., p. 242.

119 Giacomo Balla, "The Futurist Manifesto on Men's Clothing," (1913), in Umbro Apollonio, ed., *Futurist Manifestos*, London: Thames and Hudson, 1973, p. 132. On Futurist fashion, see *Balla: Futurismo tra arte e moda*, Milan: Leonardo Editore, 1998 (exhibition catalogue, Opere della Fondazione Biagiotti Cigna); and Enrico Crispolti, *Il Futurismo e la moda: Balla e gli altri*, Venice: Marsilio, 1986.

120 F. T. Marinetti, "Tactilism" (1924), in *Let's Murder the Moon Shine: Selected Writings*, ed. and trans. R. W. Flint, Los Angeles: Sun and Moon Classics, 1991, p. 119.

121 Ibid., p. 120.

122 F. T. Marinetti, "Tactilism," text dated 11 January 1921.

123 Giacomo Balla, "Il vestito antineutrale," text dated 11 September 1914, a slightly modified version of the 1913 "Futurist Manifesto of Men's Clothing."

124 Walter Benjamin, "Paris, Capital of the Nineteenth Century," in *Reflections*, ed. Peter Demetz, trans. Edmund Jephcott, New York: Harcourt Brace Jovanovich, 1978, p. 155.

125 Lefebvre, *The Production of Space*, p. 259.

126 Gottfried Semper, "Style in the Technical and Tectonic Arts or Practical Aesthetics" (1860), in *The Four Elements of Architecture and Other Writings*, trans. Harry Francis Mallgrave and Wolfgang Herrmann, Cambridge: Cambridge University Press, 1989. Wigley remarks on this in *White Walls, Designer Dresses*, p. 12.

127 Hélène Cixous, "Sonya Rykiel in Translation," trans. Deborah Jenson, in Shari Benstock and Suzanne Ferriss, eds., *On Fashion*, New Brunswick, N.J.: Rutgers University Press, 1994, pp. 96–98. For a reading of fashion in psychoanalytic terms that illustrates the shape of the ego in the act of seeing and being seen, see, in the same volume, Kaja Silverman, "Fragments of a Fashionable Discourse."

128 Maya Deren, "Psychology of Fashion," in Vèvè A. Clark, Millicent Hodson, and Catrina Neiman, eds., *The Legend of Maya Deren: A Documentary Biography and Collected Works*, vol. 1, part 2, New York: Anthology Film Archives, 1988, p. 435.

129 The quotation from Sei Shōnagon is cited in the film.

130 *Letter from an Unknown Woman* (Max Ophüls, 1948) was adapted from Stefan Zweig's novella of the same title (trans. Eden and Cedar Paul, New York: Viking Press, 1932). *La Ronde* (Ophüls, 1950) was adapted from Arthur Schnitzler's *Hands Around* (trans. Keene Wallis, Julian Press, 1929).

131 See Sergei Eisenstein, "The Cinematographic Principle and the Ideogram," in *Film Form*, ed. and trans. Jay Leyda, New York: Harcourt, Brace and World, 1949.

132 Plato, *Symposium*, ed. Eric H. Warmigton and Philip G. Rouse, New York: Mentor Books, 1956, especially pp. 97–98.

133 Benoît-Louis Prévost's *Art of Writing: Position of the Body for Writing, and the Holding of the Pen* is an illustration from Charles Paillason's *L'Art d'écrire*, Paris, 1763. See David Becker, ed., *The Practice of Letters: The Hofer Collection of Writing Manuals 1514–1800*, Cambridge: Harvard College Library, 1997 (exhibition catalogue).

134 Henry Noel Humphreys, *The Origin and Progress of the Art of Writing* (1853), as cited in Johanna Drucker, *The Alphabetic Labyrinth: The Letters in History and Imagination*, London: Thames and Hudson, 1995, p. 9.

135 Cited from the film's diaristic register.

136 Cited from the film's verbal and written text.

137 Nagiko, reading from Sei Shōnagon's book.

138 On the etymology of chart and map and the material support of maps, see Christian Jacob, *L'Empire des cartes: approche théorique de la cartographie à travers l'histoire*, Paris: Albin Michel, 1992, pp. 37, 54–56, and 71–79.

139 This idea about the folds of space might be further stretched to explain Greenaway's neo-baroque bent, along the lines of Gilles Deleuze's understanding of baroque philosophy in his *The Fold: Leibnitz and the Baroque*, trans. Tom Conley, Minneapolis: University of Minnesota Press, 1993.

140 Andreas Vesalius, *De humani corporis fabrica. Epitome*, Amsterdam, 1642, with a woman anatomized on the title page.

10 Film and Museum Architexture: Excursus with Gerhard Richter's *Atlas*

1 The ever-growing work of *Atlas* is documented in exhibition catalogues. The complete opus to date is presented in Helmut Friedel and Ulrich Wilmes, eds., *Gerhard Richter: Atlas of the Photographs, Collages and Sketches*, New York: D.A.P./Distributed Art Publishers, in association with London: Anthony d'Offay, and New York: Marian Goodman Gallery, 1997 (exhibition catalogue, Lenbachhaus, Munich), which features a catalogue raisonné of the panels. See also Fred Jahn, ed., *Gerhard Richter: Atlas*, Munich: Städtische Galerie Lenbachhaus, 1989 (exhibition catalogue), with an essay by Armin Zweite; and Massimo Martino, ed., *Gerhard Richter: Selected Works 1963–1987*, Milan: Skira Editore, 1995 (exhibition catalogue), containing the sections of *Atlas* shown at Luhring Augustine gallery, New York, 4 November 1995–13 January 1996.

2 The latest exhibition of Richter's opus, called *Der Atlas und seine Bilder*, at Kunstbau/Lenbachhaus, Munich, 8 April 8–21 June 1998, contained the complete *Atlas* from 1962 to 1997 and presented 633 panels. Previous exhibitions of the work include an installation at documenta X, Kassel, Germany, 20 June–28 September 1997; and *Atlas, 1964–1995*, at the Dia Center for the Arts, New York, 27 April 1995–3 March 1996, where it comprised 583 panels.

3 Dorotea Dietrich, "Gerhard Richter: An Interview," *The Print Collector's Newsletter*, vol. 16, no. 4, September–October 1985, p. 130.

4 The exhibition of *Atlas* at the Dia Center for the Arts, New York, 1995–1996, was accompanied by a pamphlet, with a critical text by Lynne Cooke, who mentions the fulfillment of this dream.

5 For the painter's perspective, see Gerhard Richter, *The Daily Practice of Painting: Writings, 1962–1993*, Cambridge: MIT Press, 1995.

6 See Benjamin H. D. Buchloh, *Gerhard Richter: Painting After the Subject of History*, Ph.D. Dissertation, City University of New York, 1994; *Gerhard Richter*, New York: Marion Goodman Gallery, 1993 (exhibition catalogue for documenta IX, Kassel, 1992, and Marion Goodman Gallery) with an essay by Buchloh; *Gerhard Richter 1988/89*, Rotterdam: Museum Boymans-van Beuningen, 1989 (exhibition catalogue), with an essay by Buchloh; Buchloh, "Richter's Fracture: Between the Synecdoche and the Spectacle," in *Gerhard Richter*, New York: Marian Goodman and Sperone Westwater, 1985 (exhibition catalogue); Buchloh, "Ready-Made, photographie et peinture dans la peinture de Gerhard Richter," in *Gerhard Richter*, Paris: Centre nationale d'art et de culture Georges Pompidou, 1977; and *Gerhard Richter*, Paris: Musée de l'Art Moderne de la Ville de Paris, 3 vols., Stuttgart: Ed. Cantz, 1996, with essays by Buchloh, Peter Gidal, and Birgit Pelzer.

7 See Benjamin Buchloh, "Divided Memory and Post-Traditional Identity: Gerhard Richter's Work of Mourning," *October*, no. 75, Winter 1996, pp. 61–82.

8 Allan Sekula, "The Body and the Archive," *October*, no. 39, Winter 1986, pp. 3–64.

9 Gertrud Koch, "The Richter-Scale of Blur," in *October*, no. 62, 1992, pp. 133–42. On Richter's work in general, see also Koch, "The Open Secret: Gerhard Richter and the Surface of Modernity," in Jean-Philippe Antoine, Gertrud Koch, and Luc Lang, *Gerhard Richter*, Paris: Dis Voir, 1995; and Koch, "Sequence of Time," in *Parkett*, no. 35, 1993. In this issue of *Parkett*, see also Peter Gidal, "Endless Finalities"; and Dave Hickey, "Richter in Tahiti." See also

Gidal, "The Polemics of Paint," in *Gerhard Richter: Painting in the Nineties*, London: Anthony d'Offay Gallery, 1995.

10 See the discussion of de Maistre's "voyage" in chapter 5; and Xavier de Maistre, *Voyage around My Room* (1794), trans. Stephen Sartarelli, New York: New Directions Books, 1994.

11 de Maistre, *Voyage around My Room*, p. 64.

12 Ibid., p. 8.

13 The peculiarity of Richter's *Atlas* informs the shape of its cartographic architectonics and distinguishes it from other art projects involved in creating a sentimental museum. See, for example, the survey of sentimental museums in art offered by Jean-Hubert Martin in "The 'Musée Sentimental' of Daniel Spoerri," in Lynne Cooke and Peter Wollen, eds., *Visual Display: Culture Beyond Appearances*, Seattle: Bay Press, 1995.

14 On the function of landscape in Richter's work, see Jean-Philippe Antoine, "Photography, Painting and the Real: The Question of Landscape in the Paintings of Gerhard Richter," in Antoine, Koch, and Lang, *Gerhard Richter*.

15 This also occurs, although in minimalist fashion, in the work of reframing experienced as one moves filmically through Robert Morris's installation *Untitled* (1975). Here, framed mirrors frame the subject in movement and thus become filmic frames, creating a place where cadres become transformed into *cadres de vie*. On the importance of framing in Morris's work, see Annette Michelson, "Frameworks," in *Robert Morris: The Mind/Body Problem*, New York: Guggenheim Museum, 1994 (exhibition catalogue). Although Michelson does not discuss *Untitled* (1975), her argument is embodied in this work and has inspired my reading of it.

16 Walter Benjamin, "A Berlin Chronicle," in *One Way Street and Other Writings*, trans. Edmund Jephcott and Kingsley Shorter, London: Verso, 1979, p. 295. See chapter 8 for a discussion of this work.

17 On Makavejev's imagined project, see chapter 6.

18 *Silent Movie* was commissioned for cinema's centennial celebration by the Wexner Center for the Arts, in Columbus, Ohio. It was subsequently shown at the Museum of Modern Art, in New York, as part of the show "Video Spaces: Eight Installations," 22 June–12 September 1995.

19 In a text that engages the practices of collage and photomontage, Benjamin Buchloh discusses Richter's *Atlas* in reference to Warburg's model, presenting a reading that covers another aspect of their relation and offering a different interpretation than the one sustained in this book. See Buchloh, "Warburg's Paragon? The End of Collage and Photomontage in Postwar Europe," in Ingrid Schaffner and Matthias Winzen, eds., *Deep Storage: Collecting, Storing and Archiving in Art*, New York: Prestel Verlag, 1998.

20 See Carlo Ginzburg, "From Aby Warburg to E. Gombrich: A Problem of Method," in *Clues, Myths and the Historical Method*, trans. John and Anne Tedeschi, Baltimore: Johns Hopkins, 1989. See also Joseph Koerner, "Aby Warburg among the Hopis: Paleface and Redskin," *The New Republic*, 24 March 1997, pp. 30–38.

21 On this aspect of Warburg's work, see Simon Schama, *Landscape and Memory*, New York: Vintage Books, 1995, especially pp. 209–14.

22 Sixty panels tracing itineraries of different genealogies, including astrological configurations, were completed.

23 Aby Warburg, "Introduzione all'Atlante *Mnemosyne*," (1929), in *Mnemosyne. L'Atlante della memoria di Aby Warburg*, ed. Italo Spinelli and Roberto Venuti, Rome: Artemide Edizioni, 1998, p. 38 (my translation). An incomplete English translation of Warburg's "Introduction to *Mnemosyne Atlas*" is published in Uwe Fleckner, ed., *The Treasure Chests of Mnemosyne: Selected Texts on Memory Theory From Plato to Derrida*, Dresden: Verlag der Kunst, 1998, pp. 248–52. All following citations are taken from the complete Italian version, which follows the original text preserved in the Warburg Institute.

24 Ibid., p. 38.

25 Ibid., pp. 38, 40, 42.

26 Ibid., p. 43.

27 See Christian Boltanski, *Archives*, Arles: Le Méjun and Actes Sud, 1989; *Reconstitution: Christian Boltanski*, London: Whitechapel Art Gallery, 1990 (exhibition catalogue); Boltanski, *La Maison manquante*, Paris: Flammarion, 1991; Lynn Gumpert, *Christian Boltanski*, Paris: Flammarion, 1994; *Els Límits del Museu*, Barcelona: Fundació Antoni Tàpies, 1995; and Boltanski, Tamar Garb, Didier Semin, and Donald Kuspit, *Christian Boltanski*, London: Phaidon Press, 1997. Boltanski's latest exhibition, *Les dernières années*, was presented at the Musée d'art moderne de la Ville de Paris in 1998.

28 Boltanski's experimental film work includes *L'Homme qui tousse* (1969), *Essai de reconstitution des 46 jours qui précédèrent la mort de Françoise Guiniou* (1971), and *Appartement de la rue de Vaugirard* (1976). On this subject, see Didier Semin's notes on *L'Homme qui tousse*, in *Premises: Invested Spaces in Arts, Architecture, and Design from France 1958–1998*, New York: Guggenheim Museum, 1998 (exhibition catalogue), pp. 206–7.

29 *Die Winterreise* was directed by Hans Peter Cloos and, after its Paris run, was staged at the Brooklyn Academy of Music, New York, 4–8 November 1998. The film was made by Boltanski with Cloos, Jean Kalman, and Marie Pawlotsky in January 1993.

30 See, among others, Reesa Greenberg, Bruce W. Ferguson, and Sandy Nairne, eds., *Thinking about Exhibitions*, New York: Routledge, 1996; *The End(s) of the Museum*, Barcelona: Fundació Antoni Tàpies, 1996 (excerpts of the symposium held with the exhibition *Els Límits del Museu*); Cooke and Wollen, eds., *Visual Display*; Tony Bennett, *The Birth of the Museum*, London: Routledge, 1995; Daniel J. Scherman and Irit Rogoff, eds., *Museum Culture: Histories, Discourses, Spectacles*, Minneapolis: University of Minnesota Press, 1994; Susan M. Pearce, *Museums, Objects and Collections: A Cultural Study*, Leicester, England: Leicester University, 1992; Ivan Karp and Steven D. Lavine, eds., *Exhibiting Cultures: The Poetics and Politics of Museum Display*, Washington, D.C.: Smithsonian Institution Press, 1991.

31 The work of Silvia Kolbowski, among others, testifies to this resonance between art and architecture.

32 Lewis Mumford, "The Death of the Monument," in J. L. Martin, Ben Nicholson, and N. Gabo, eds., *Circle: International Survey of Constructivist Art*, New York: E. Weyhe, 1937, p. 267.

33 See especially chapter 5.

34 There are obvious and established institutional differences between the gallery and the museum, which are not discussed here. It is important to note, however, that in terms of modes of display, curatorial strategies, and the amount of space offered to contemporary art, the distance between the two has diminished in the United States. Here, young artists move easily and quickly between gallery and museum exhibitions, many intersecting and hybrid exhibition spaces have been created, and alliances between all of these have taken place. These reasons partially excuse an excursus that combines the two discourses without delving into their differences.

35 On this film, see Robert Beck, "Paranoia by the Dashboard Light: Sophie Calle's and Gregory Shephard's *Double Blind*," *Parkett*, no. 36, 1993, especially p. 109. On Calle's photographic work, see Sophie Calle, *La Visite guidée*, Rotterdam: Museum Boymans-van Beuningen, 1996 (exhibition catalogue); *Sophie Calle: Absence*, Rotterdam: Museum Boymans-van Beuningen, 1994 (exhibition catalogue); Calle, *Sophie Calle: Proofs*, Hanover, N.H.: Hood Museum of Art, Dartmouth College, 1993 (exhibition catalogue); Robert Storr, *Dislocations*, New York: Museum of Modern Art, 1991 (exhibition catalogue); and Calle, *Suite Vénitienne*, Seattle: Bay Press, 1988, with a postface by Jean Baudrillard. See also Luc Sante, "Sophie Calle's Uncertainty Principle," *Parkett*, no. 36, 1993, pp. 74–87.

36 Larry Clark directed *Kids* (1995); Robert Longo directed *Johnny Mnemonic* (1995); David Salle directed *Search and Destroy* (1995); Julian Schnabel directed *Basquiat* (1996); and Cindy Sherman directed *Office Killer* (1997). On artists making films, see Thyrza Nichols Goodeve, "Fade to Blue," *Guggenheim Magazine*, no. 10, Spring 1997, pp. 40–47.

37 On Horn's film and installation work, see Giuliana Bruno, "Interiors: Anatomies of the Bride Machine," in *Rebecca Horn*, New York: Guggenheim Museum, 1993 (exhibition catalogue), with complete filmography and bibliography.

38 On one of the films of the Cremaster series, see Matthew Barney, *Cremaster 5*, New York: Barbara Gladstone Gallery, 1997 (exhibition catalogue). Other work in the series includes *Cremaster 1* (1995), *Cremaster 4* (1994), and *Cremaster 2* (1999).

39 On Jacobs's work see Bart Testa, *Back and Forth: Early Cinema and the Avant-Garde*, Toronto: Art Gallery of Ontario, 1993 (exhibition catalogue); and William C. Wees, *Recycled Images: The Art and Politics of Found Footage Films*, New York: Anthology Film Archives, 1993. On Conner, see *Bruce Conner: Sculpture/Assemblages/Drawings/Films*, Waltham, Mass.: Rose Art Museum, Brandeis University, 1965 (exhibition catalogue); Anthony Reveaux, *Bruce Conner*, Minneapolis: Walker Art Center, and St. Paul: Film in the Cities, 1981; Scott MacDonald, "I Don't Go to the Movies Anymore: An Interview with Bruce Conner," *Afterimage*, vol. 10, nos. 1–2, Summer 1982, pp. 20–23; and Leger Grindon, "Significance Reexamined: A Report on Bruce Conner," *Post Script: Essays in Film and the Humanities*, vol. 4, no. 2, Winter 1985, pp. 32–44.

40 On Douglas's work, see, among others, *Stan Douglas*, Paris: Centre Georges Pompidou, 1993 (exhibition catalogue); and *Stan Douglas: Monodramas and Loops*, Vancouver: UBC Fine Arts Gallery, 1992 (exhibition catalogue).

41 Kerry Brougher, "Hall of Mirrors," in Russell Ferguson, ed., *Art and Film since 1945: Hall of Mirrors*, New York: Monacelli Press, and Los Angeles: Museum of Contemporary Art, 1996, p. 137. This catalogue of the exhibition, organized by Brougher, makes a groundbreaking contribution to the subject of the contemporary intersections between film and art. On this subject, see also *A.D. Art and Design*, special issue "Art and Film," no. 49, 1996.

42 "Spellbound: Art and Film" was held in London at the Hayward Gallery, February 1996. Contributors to the exhibition were Fiona

Banner, Terry Gilliam, Douglas Gordon, Peter Greenaway, Damien Hirst, Steve McQueen, Eduardo Paolozzi, Paula Rego, Ridley Scott, and Boyd Webb. See Philip Dodd and Ian Christie, eds., *Spellbound: Art and Film*, London: British Film Institute and Hayward Gallery, 1996 (exhibition catalogue).

43 See Laura Mulvey, "Cosmetics and Abjection: Cindy Sherman 1977–87," in *Fetishism and Curiosity*, Bloomington: Indiana University Press, 1996; and Rosalind Krauss, *Cindy Sherman, 1975–1993*, with an essay by Norman Bryson, New York: Rizzoli International Publications, 1993, which includes a bibliography of the extensive studies of this artist's work. See also *Untitled Film Stills: Cindy Sherman*, with an essay by Arthur Danto, New York: Rizzoli International Publications, 1990; and Abigail Solomon-Godeau, "Suitable for Framing: The Critical Recasting of Cindy Sherman," *Parkett*, no. 29, 1991, pp. 112–21.

44 See his own assessment of this exchange in Victor Burgin, *Between*, London: Institute of Contemporary Art, 1986 (exhibition catalogue). See also *Victor Burgin: Passages*, Villeneuve d'Ascq: Musée d'art moderne de la Communauté Urbaine de Lille, 1991; Burgin, *Some Cities*, Los Angeles: University of California Press, 1996; and Burgin, *In/different Spaces: Place and Memory in Visual Culture*, Los Angeles: University of California Press, 1996. See also Jean Fisher, "Chasing Dreams: Victor Hitchcock and Alfred Burgin," *Artforum*, no. 22, no. 9, May 1984, pp. 39–43.

45 See, in particular, Blau's *The Conversation Piece* (1993–95), installed at Sperone Westwater, New York, 7 September–30 October 1993; *The Naturalist Gathers*, installed at SteinGladstone, New York, 1992; and the exhibition *Stills*, organized by Blau as guest curator at the Museum of Modern Art, New York, 14 July–11 October 1994. This exhibition reworked on the wall of the museum the archive of MoMA's film stills, comprising more than four million photographs, mostly publicity stills. This interesting photo-cinematic site of investigation was treated by Blau as a genre of picturing in its own right.

46 See *Alain Fleischer 1970–1995*, Barcelona: Fundació Joan Miró, 1996 (exhibition catalogue).

47 On Gordon's work, see, among others, Andrew Renton, "24 Hour Psycho," *Flash Art*, vol. 26, no. 172, November–December 1993; Michael Newman, "Beyond the Lost Object: From Sculpture to Film and Video," *Art Press*, no. 202, May 1995, pp. 45–50; and Amy Taubin, "Douglas Gordon," in Dodd and Christie, eds., *Spellbound*.

48 For an analysis of this film, see Giuliana Bruno, *Streetwalking on a Ruined Map*, Princeton: Princeton University Press, 1993, especially chapters 4 and 15. On the last occasion I tried to screen the print of *La neuropatologia* preserved at the film archive of the Museo del Cinema in Turin, the film was too damaged to be viewed. I was glad to see it recirculating in a museum space when *Hysterical* was presented as part of an exhibition associated with the Hugo Boss Prize 1998, at the Guggenheim Museum Soho, 24 June–20 September 1998, and was the prize winner.

49 Mario Dall'Olio, "La neuropatologia al cinematografo," *La gazzetta di Torino*, Turin, 18 February 1908.

50 I treat Warhol's "reel" in my "Reel Time," in *Andy Warhol: A Factory*, New York: Guggenheim Museum, forthcoming (exhibition catalogue).

51 See chapters 5 and 6, in particular, for a discussion of the topoi that follow here, including the mnemonic heterotopias of cinemas and cemeteries.

52 On this exhibitionary culture, see Patricia Mainardi, *The End of the Salon: Art and the State in the Early Third Republic*, New York: Cambridge University Press, 1993.

53 See, in particular, chapters 2 and 3.

54 Libeskind's statement is cited in Michael W. Blumenthal, ed., *Jewish Museum Berlin*, G + B Arts International, 1999, p. 41. See also Daniel Libeskind, "Between the Lines," *A.D., Architectural Design*, vol. 67, nos. 9–10, September–October 1997, pp. 58–63.

55 This building was designed over the period 1981–87.

56 Frank Gehry was interviewed by Michael Sorkin in "Beyond Bilbao," *Harper's Bazaar*, December 1998, p. 261.

57 *200 Minute Museum* is a project developed as Hani Rashid's "Paperless Studio" at Columbia University's School of Architecture. It was exhibited at the Storefront for Art and Architecture, New York, 12 December 1998. This gallery features a cutout facade designed by Vito Acconci and Steven Holl.

58 See Judith Barry, *Projections: Mise en abyme*, Vancouver: Presentation House Gallery, 1997 (exhibition catalogue); Barry, "The Work of the Forest," *Art and Text*, no. 42, May 1992, pp. 69–75; Barry, *Public Fantasy*, London: ICA, 1991; Barry, *Ars Memoriae Carnegiensis: A Memory Theatre*, Pittsburgh: Carnegie Museum of Art, 1991 (exhibition catalogue); Barry, "Casual Imagination," in Brian Wallis, ed., *Blasted Allegories*, Cambridge: MIT Press, 1987; and Barry, "Dissenting Spaces," in Greenberg, et al., *Thinking about Exhibitions*. See also Barry and Ken Saylor, "Design Notations," in *a/drift*, New York: Bard College, 1996 (exhibition catalogue). In their discourse on design space, the authors reappropriate El Lissitzky's 1920s wish for spectatorial, even tactile, agency in the design of the museum gallery.

59 On the relation between the museum and the shop, see Chantal Georgel, "The Museum as Metaphor in Nineteenth-Century France," in Scherman and Cogoff, eds., *Museum Culture*; and Erin Mackie, "Fashion in the Museum: An Eighteenth-Century Project," in Deborah Fausch, Paulette Singley, Rodolphe el-Khoury, and Zvi Efrat, eds., *Architecture: In Fashion*, Princeton: Princeton Architectural Press, 1994. On the basis of the cultural mapping exposed thus far, I am taking the liberty of adding cinema to these "metaphors" and to the genealogy that includes fashion.

60 See Pierre Bourdieu, *Distinction: A Social Critique of the Judgment of Taste*, Cambridge: MIT Press, 1984.

61 The notion developed here was introduced in chapter 5. I thank my student Eric R. Keune for a discussion that inspired me to pursue this matter further.

62 André Malraux, *Museum Without Walls* (1947), trans. Stuart Gilbert and Francis Price, New York: Doubleday, 1967. On the subject of Malraux's *musée imaginaire*, see Rosalind E. Krauss, "Postmodernism's Museum without Walls," in Greenberg, et al., *Thinking about Exhibitions*; and Douglas Crimp, "On the Museum's Ruins," in Hal Foster, ed., *The Anti-Aesthetic: Essays on Postmodern Culture*, Port Townsend, N.Y.: Bay Press, 1983.

63 Denis Hollier, "Premises, Premises: Sketches in Remembrance of a Recent Graphic Turn in French Thought," in *Premises*, p. 64.

64 Rosalind Krauss claims that this architecture renders a dimension of Malraux's *musée imaginaire* as built form. See Krauss, "Postmodernism's Museum without Walls," especially pp. 345–46.

65 Stephen Greenblatt, "Resonance and Wonder," in Karp and Lavine, eds., *Exhibiting Cultures*.

66 Andreas Huyssen, "Escape from Amnesia. The Museum as Mass Medium," in *Twighlight Memories: Marking Time in a Culture of Amnesia*, New York: Routledge, 1995, p. 15.

67 On the force of rituals and psychic dramas enacted in the museum setting, see Carol Duncan, "Art Museum and the Ritual of Citizenship," in Karp and Lavine, eds., *Exhibiting Cultures*; and Duncan, *The Aesthetics of Power: Essays in Critical Art History*, Cambridge: Cambridge University Press, 1993.

68 Pierre Nora, "Between Memory and History: Les Lieux de Mémoire," *Representations*, no. 26, Spring 1989, pp. 12–13.

69 Alfonso Frisiani so describes the daguerreotype's potential future in the *Gazzetta privilegiata di Milano*, 3 December 1838. As cited in Giuliana Scimé, *On Paper*, January–February 1997, p. 28.

70 Yi-Fu Tuan, *Topophilia: A Study of Environmental Perception, Attitudes, and Values*, New York: Columbia University Press, 1990 (new edition with a new preface). See also Tuan, *Space and Place: The Perspective of Experience*, Minneapolis: University of Minnesota Press, 1977, which also offers some insights on lived space and the body, with a hint of architectural awareness. This book, however, is embedded in the same problematic systems as the previous one.

71 Robert Harbison, *Eccentric Spaces*, New York: Avon Books, 1977, especially chapter 7.

72 This is the thesis Schama presents in his *Landscape and Memory*.

73 For a discussion of Whiteread's work, see chapter 3.

74 A beginning approach to landscape in film that touches on this subject can be found in the special issue of *Wide Angle* on "Landscape and Place," ed. Widdicombe Schmidt and Michael Naimark, vol. 15, no. 4, December 1993.

75 See Alain Corbin, *The Lure of the Sea: The Discovery of the Seaside 1750–1840*, trans. Jocelyn Phelps, London: Penguin Books, 1994; and John R. Stilgoe, *Alongshore*, New Haven: Yale University Press, 1994. For another perspective on oceanic life, see Allan Sekula, *Fish Story*, Rotterdam: Center for Contemporary Art, 1995; and on maritime landscape, Renzo Dubbini, *Geografie dello sguardo: visione e paesaggio in età moderna*, Turin: Einaudi, 1994, chapter 6.

76 See *Doris Salcedo*, New York: New Museum of Contemporary Art, 1998 (exhibition catalogue), as discussed in chapter 3.

77 Gaston Bachelard, *The Poetics of Space*, trans. Maria Jolas, Boston: Beacon Press, 1969, pp. 10, 62.

11 Views from Home

1 On this subject, see, among others, Giulio Pane and Vladimiro Valerio, *La città di Napoli tra vedutismo e cartografia*, Naples: Grimaldi, 1987 (exhibition catalogue); and *All'ombra del Vesuvio: Napoli nella veduta europea dal Quattrocento all'Ottocento*, Naples: Electa, 1990 (exhibition catalogue).

2 See Cesare de Seta, ed., *Città d'Europa: Iconografia e vedutismo dal XV al XIX secolo*, Naples: Electa, 1996.

3 See Vladimiro Valerio, "Il duca di Noja e la cartografia napoletana," in *Arte e scienza per il disegno del mondo*, Milan: Electa, 1983 (exhibition catalogue), which contains other bibliographic information on this map.

4 Charles Dickens, *Pictures from Italy*, New York: Coward, McCann and Geoghegan, 1974, pp. 214–15.

5 On Naples and the grand tour, see Cesare de Seta, *L'Italia del Grand Tour da Montaigne a Goethe*, Naples: Electa, 1992; de Seta, "L'Italia nello specchio del Grand Tour," in *Storia d'Italia*, vol. 5, Turin: Einaudi, 1982; Attilio Brilli, *Il viaggio in Italia: Storia di una grande tradizione culturale*, Milan: Silvana Editoriale, 1987; Gianni Eugenio Viola, ed., *Viaggiatori del Grand Tour in Italia*, Milan: Touring Club Italiano, 1987; and Pierre Pinon, "Le Voyage d'Italie," in *Architecture: recits, figures, fictions*, Cahiers du CCI, no. 1, Paris: Editions du Centre Pompidou/CCI, 1986.

6 See Richard D. Altick, *The Shows of London*, Cambridge: Harvard University Press, 1978.

7 See *Trois siècles de papiers peints*, Paris: Musée des Arts Décoratifs, 1967 (exhibition catalogue), pp. 46 and 81; and *Papiers peints panoramiques*, Paris: Flammarion and Musée des Arts Décoratifs, 1998, p. 301.

8 *Art Journal*, N.S. 7, 1861, p. 319, as cited in Ralph Hyde, *Panoramania!: The Art and Entertainment of the 'All-Embracing' View*, London: Trefoil, in association with the Barbican Art Gallery, 1988, p. 38.

9 Thomas Bernhard's statement is cited in Fabrizia Ramondino and Andreas Friedrich Müller, eds., *Dadapolis: Caleidoscopio napoletano*, Turin: Einaudi, 1989, p. 181 (my translation). The book offers a collage of writings on Naples.

10 An occasion to review the image of Naples on film was offered to me when I served as consultant for a film retrospective on Naples held at the Museum of Modern Art, New York (12 November 1993–7 January 1994). The subject of Naples in film is treated in Adriano Aprà, ed., *Napoletana: Images of a City*, Milan: Fabbri Editori, 1993 (exhibition catalogue), to which I contributed the essay "Voyage to Naples: A City Viewed, Traversed and Displaced," in which some aspects of the image of the city in film developed here had their initial formulation.

11 François Dagognet, *Etienne-Jules Marey: A Passion For the Trace*, trans. Robert Galeta with Janine Herman, New York: Zone Books, 1992, p. 8.

12 *La pelle* was inspired by the novel of the same title (Florence: Vallecchi, 1963) by Curzio Malaparte, owner of Casa Malaparte, the location for Godard's *Contempt*.

13 On this notion, see Homi K. Bhabha, *The Location of Culture*, London and New York: Routledge, 1994.

14 The film was based on Patricia Highsmith's literary imagination of the city in her *The Talented Mr. Ripley*, London: Heinemann, 1966.

15 For a discussion of *Contempt* and Casa Malaparte, see chapter 1.

16 See Giuliana Bruno, *Streetwalking on a Ruined Map*, Princeton: Princeton University Press, 1993.

17 On Totò, see Goffredo Fofi, *Totò*, Rome: Savelli, 1972.

18 Pier Paolo Pasolini, *Lettere luterane*, Turin: Einaudi, 1976. See, in particular, p. 17.

19 Francesco Rosi interviewed by Jean A. Gili, in "Naples entre la raison et la passion," in *Cités-Cinés*, Paris: Editions Ramsey, 1987 (exhibition catalogue), p. 91 (my translation).

20 This latter film does so by mixing theater and film in interesting ways. Martone began his film career as a theater director and founder of the experimental group "Falso movimento." He is still prominently active in both theater and film. Martone's directorial debut in film, *Death of a Neapolitan Mathematician*, established him as a driving force in the rejuvenation of Italian (independent) cinema. *L'amore molesto*, which is treated further in the next chapter, has been critically acclaimed in Italy and was selected for the Cannes Film Festival. Besides feature films, Martone has made videos, shorts, and documentaries. Among them are the short *Antonio Mastronunzio, pittore sannita* (1994); *Rasoi*, from a 1991 performance piece with texts by Enzo Moscato; and *Lucio Amelio/Terrae motus* (1993), a documentary on the life and work of the late Lucio Amelio, a Neapolitan gallerist who was a major figure in the Italian art world. For an introduction to Martone's work, see Georgette Ranucci and Stefanella Ughi, eds., *Mario Martone*, Rome: Dino Audino Editore, 1995.

21 Elsa Morante, unpublished writings from 1952, cited in Ramondino and Müller, *Dadapolis*, p. 16.

22 For an insider's chronicle of 1990s Italian filmmaking, see Vito Zagarrio, *Cinema italiano anni novanta*, Venice: Marsilio, 1998.

23 For information on Neapolitan cinema, see Maria Cristina De Crescenzo, Antonio Lucadamo, Chiara Masiello, and Adriana Muti, eds., *Napoli, una città nel cinema*, Naples: Biblioteca Universitaria, 1995 (exhibition catalogue).

24 See chapter 1, fn. 66, for a discussion of the various titles that have accrued to this film.

25 See Michel de Certeau, *The Practice of Everyday Life*, trans. Steven Rendell, Berkeley: University of California Press, 1984, pp. 115–22; and André Bazin, "In Defense of Rossellini," in *What is Cinema?*, vol. 2, ed. and trans. Hugh Gray, Berkeley: University of California Press, 1971, p. 98.

26 For an astute reading of modes of vision and sightseeing in this film, see Noa Steimatsky, *The Earth Figured: An Exploration of Landscapes in Italian Cinema*, Ph.D. Dissertation, New York University, 1995, chapter 2. On subjectivity and ways of seeing, see also Alain Bergala, *Voyage en Italie de Roberto Rossellini*, Crisneé, Belgium: Editions Yellow Now, 1990.

27 "Ingrid Bergman on Rossellini," an interview with Robin Wood, *Film Comment*, vol. 10, no. 4, July–August 1974, p. 14. Peter Brunette, author of the first substantial American study of Rossellini, uses this interview to speak about autobiography in the director's work. See Peter Brunette, *Roberto Rossellini*, New York: Oxford University Press, 1987, in particular pp. 154–71. Other works in English include Peter Bondanella, *The Films of Roberto Rossellini*, Cambridge: Cambridge University Press, 1993; and Dan Ranvaud, ed., *Roberto Rossellini*, London: British Film Institute, Dossier no. 8, 1981. For Rossellini's own account see *Il mio metodo*, ed. Adriano Aprà, Venice: Marsilio, 1987; and *Quasi un'autobiografia*, ed. Stefano Roncoroni, Milan: Mondadori, 1987. For an extensive international bibliography, see Adriano Aprà, ed., *Rosselliniana: Bibliografia internazionale*, Rome: Di Giacomo Editore, 1987.

28 See chapter 6.

29 Anon., *Beaten Tracks or Pen and Pencil Sketches in Italy by the Authoress of a 'Voyage en Zigzag'*, London: Longmans, Green, 1866. The 'authoress' remains nameless in the book.

30 For a photographic history, see Antonella Russo, with research by Diego Mormorio, "The Invention of Southernness: Photographic Travels and the Discovery of the Other Half of Italy," *Aperture*, Summer 1993, pp. 58–67.

31 E. and R. Chevallier, *Iter Italicum: Les voyageurs français à la découverte de L'Italie ancienne*, Paris: Les Belles Lettres, 1984, p. 78 (my translation).

32 John L. Stoddard, "Naples," in *John L. Stoddard's Lectures*, vol. 8, Boston: Balch Brothers, 1898, p. 115.

33 Ibid., pp. 132–34.

34 Ibid., pp. 176–77.

35 Ibid., p. 200.

36 Ibid., pp. 140–41.

37 In the film, a little girl who is not aware of the "show" walks into the frame, but is promptly taken out of view.

38 See Edward W. Said, *Orientalism*, New York: Vintage Books, 1979; and Said, "Traveling Theory," in *The World, the Text and the Critic*, London: Faber and Faber, 1984.

39 See, among others, Georges Van Den Abbeele, *Travel as Metaphor from Montaigne to Rousseau*, Minneapolis: University of Minnesota Press, 1992.

40 Walter Benjamin and Asja Lacis, "Naples," in *Reflections*, ed. Peter Demetz, trans. Edmund Jephcott, New York: Harcourt Brace Jovanovich, 1978, p. 171.

41 Norman Lewis, *Naples '44: An Intelligence Officer in the Italian Labyrinth*, London: Eland, 1983, p. 157.

42 L. Russell Muirhead, *The Blue Guides: Southern Italy*, London: Ernest Benn, 1959, p. lxxvii.

43 Roland Barthes, "The *Blue Guide*," in *Mythologies*, trans. Annette Lavers, New York: Hill and Wang, 1972, pp. 74–75.

44 Mariana Starke, *Travels in Italy between the Years 1792 and 1798*, 2 vols., London, 1802.

45 Germaine de Staël, *Corinne, or Italy*, trans. Avriel H. Goldberger, New Brunswick, N.J.: Rutgers University Press, 1991. The book was first published in 1807.

46 See Mary Shelley, *Rambles in Germany and Italy in 1840, 1842, and 1843*, 2 vols. London, 1844.

47 Mrs. [Anna] Jameson, *The Diary of an Ennuyée*, Boston: Ticknor and Fields, 1886, pp. 228–31. The book was first published in London in 1826.

48 Mrs. G. Gretton, *The Englishwoman in Italy. Impressions of Life in the Roman States and Sardinia*, London: Hurst and Blackett, 1860. Mrs. Ashton Yates, *Winter in Italy in a Series of Letters to a Friend*, London: Henry Colburn Publisher, 1844.

49 Yates, *Winter in Italy*, vol. 1, pp. 280–85.

50 See chapter 4.

51 The small, private Vuitton museum, located in a Paris suburb, is interestingly housed in the luggage maker's former home, an art nouveau structure connected via a courtyard to the factory, a classic nineteenth-century industrial architecture of iron and glass. The museum exhibits its own architecture and objects of travel collected by the family as well as the history of Vuitton luggage, organized in relation to travel history.

52 See Shirley Foster, *Across New Worlds: Nineteenth-Century Women Travellers and Their Writings*, New York: Harvester Wheatsheaf, 1990, chapters 1 and 2.

53 Jameson, *The Diary of an Ennuyée*, p. 2.

54 Johann Wolfgang von Goethe, *Italian Journey, 1786–1788*, trans. W. H. Auden and Elizabeth Mayer, New York: Schocken Books, 1968, pp. 176–90.

55 Yates, *Winter in Italy*, pp. 246–47.

56 Marquis de Sade, *Histoire de Juliette*, in *Oeuvres complètes*, Paris: Pauvert, 1965 (my translation). See also de Sade, "Naples," in *Voyage d'Italie*, Paris: Tchou Editeur, 1967, pp. 381–457.

57 Tahar Ben Jelloun, *Il Mattino*, 1989, cited in Ramondino and Müller, eds., *Dadapolis*, p. 14 (my translation).

58 Stendhal, *Rome, Naples and Florence*, trans. Richard N. Coe, London: John Calder, 1959, p. 358.

59 [Barbara H. Channing], *The Sisters Abroad: or, An Italian Journey*, Boston: Whittemore, Niles and Hall, 1856, pp. 38–44. The first edition of the book was published anonymously, but later editions show the author's name.

60 Dickens, *Pictures from Italy*, p. 219.

61 Auguste Laugel, *Italie, Sicile, Boheme: Notes de Voyage*, Paris: Henri Plon, 1872, cited in Henry James's review of the text in *Nation*, vol. 16, 27 February 1873, p. 152.

62 Walter Benjamin, Review of Jakob Job, *Neapel. Reisebilder und Skizzen*, in *Critiche e recensioni*, Turin: Einaudi, 1979 (my translation). The text dates from 1928.

63 Henri Lefebvre, *Writings on Cities*, trans. and ed. Eleonore Kofman and Elizabeth Lebas, Oxford: Blackwell, 1996, pp. 227–38. The citations are from part 4 of the book, where Lefebvre articulates his "Elements of Rhythmanalysis" in sections devoted to "Seen from the Window" and "Rhythmanalysis of Mediterranean Cities."

64 See J. Douglas Porteous, *Landscapes of the Mind: Worlds of Senses and Metaphor*, Toronto: University of Toronto Press, 1990.

65 Henry James, *Italian Hours*, ed. John Auchard, University Park: The Pennsylvania State University, 1992, pp. 303–20.

66 Jameson, *The Diary of an Ennuyée*, pp. 197–225.

67 On this subject, see Alain Corbin, *The Lure of the Sea: The Discovery of the Seaside in the Western World 1750–1840*, trans. Jocelyn Phelps, London: Penguin Books, 1994, especially pp. 250–52.

68 On the architecture of the *thermae*, see Fikret Yegül, *Baths and Bathing in Classical Antiquity*, Cambridge: MIT Press, and New York: Architectural Historical Foundation, 1992.

69 Marguerite, Countess of Blessington, *The Idler in Italy*, 3 vols., London, 1839–40.

70 Frances Elliot, *Diary of an Idle Woman in Italy*, vol. 1, Leipzig: Bernard Tauchnitz, 1872, pp. 9–13.

71 Ibid., vol. 2, p. 302.

72 Walter Benjamin, "One Way Street," in *One Way Street and Other Writings*, trans. Edmund Jephcott and Kingsley Shorter, London: Verso, 1985, p. 82.

73 Gustave Flaubert, *Notes de Voyage*, in *Oeuvres complètes*, Paris: Louis Conard, 1902, pp. 186–94 (my translation).

74 Théophile Gautier, *Arria Marcella*, in *Little French Masterpieces*, ed. Alexander Jessup, trans. George Burnham Ives, New York: G. P. Putnam's Sons, 1903, pp. 105–6.

75 Djuna Barnes, *Nightwood*, New York: New Directions, 1961, pp. 157–58. The book was first published in 1937.

76 The point regarding Joyce is made by Luciana Bohne in her "Rossellini's *Viaggio in Italia*: A Variation on a Theme by Joyce," *Film Criticism*, vol. 3, no. 2, Winter 1979, pp. 43–53.

77 Gérard de Nerval, "Octavie," in *Les Filles du feu*, Paris: Astrée, 1957, p. 214 (my translation).

78 This is a place where one may even think of informing the dead of a great victory at a soccer game by putting a huge banner on the gate of the cemetery: "You have no idea what you have missed."

79 Henry James, *Italian Hours*, p. 320.

80 Simone de Beauvoir, ed., *Witness to My Life: The Letters of Jean-Paul Sartre to Simone de Beauvoir, 1926–1939*, trans. Lee Fahnestock and Norman MacAfee, New York: Charles Scribner's Sons, 1992, pp. 64–67. This letter, which reports on the journey de Beauvoir and Sartre made to Naples, is written by Sartre and addressed to Olga Kosakiewicz.

81 See Matilde Serao, *Il ventre di Napoli*, Milan: Treves, 1884.

82 Jean-Paul Sartre's description of Naples, written in 1936, was published in *Il Mattino*, February 1982 (my translation).

83 de Staël, *Corinne*, pp. 197–99.

84 Anna Maria Ortese, "La città involontaria," in *Il mare non bagna Napoli*, Milan: Rizzoli, 1975, pp. 61–63 (my translation).

85 Susan Sontag, *The Volcano Lover: A Romance*, New York: Doubleday, 1992.

86 Dorothy Carrington, *The Traveller's Eye*, New York: Pilot Press, 1947, p. 55.

87 See Horace Walpole, *History of the Modern Taste in Gardening* (1771–80), in his *Anecdotes of Painting in England*, London, 1782.

12 *My "Voyage in Italy"*

1 Sigmund Freud, *The Interpretation of Dreams*, Standard Edition of the Complete Psychological Works, vol. 5, trans. J. Strachey, London: Hogarth, 1955–73, p. 385.

2 On Bourgeois's cells and memory sites, see Charlotta Kotik, Terrie Sultan, and Christian Leigh, *Louise Bourgeois: The Locus of Memory, Works 1982–1993*, New York: Harry N. Abrams, 1994 (exhibition catalogue). See also Marie-Laure Bernadec, *Louise Bourgeois*, Paris: Flammarion, 1996; Christiane Meyer-Thoss, *Louise Bourgeois: Designing for Free Fall*, Zurich: Ammann Verlag, 1992; and Lucy Lippard, Rosalind Krauss, et al., *Louise Bourgeois*, Frankfurt: Frankfurter Kunstverein, 1989 (exhibition catalogue).

3 Elena Ferrante, *L'amore molesto*, Rome: Edizioni e/o, 1992.

4 Interview with Mario Martone by Mario Sesti, in Georgette Ranucci and Stefanella Ughi, eds., *Mario Martone*, Rome: Dino Audino Editore, 1995, p. 56 (my translation).

5 Stendhal, *Rome, Naples and Florence*, trans. Richard N. Coe, London: John Calder, 1959, p. 350.

6 See my "Ramble City: Postmodernism and *Blade Runner*," *October*, no. 41, Fall, 1987, pp. 61–64; reprinted in Annette Kuhn, ed., *Alien Zone: Cultural Theory and the Science Fiction Film*, London: Verso, 1990. I have written on Naples' city films in *Streetwalking on a Ruined Map*, Princeton: Princeton University Press, 1993; and in "City Views: Naples and the Cinema," *The Museum of Modern Art Quarterly*, Fall 1993. On Naples and New York, see my "City Views: The Voyage of Film Images," in David B. Clarke, ed., *The Cinematic City*, New York: Routledge, 1997.

7 The coincidence of our intellectual narratives was illuminated for me by Paola Malanga in her review of my book *Rovine con vista* (Milan: La Tartaruga, 1995), entitled "Rovine con vista," *Lapis*, no. 31, September 1996, pp. 60–61.

8 Interview with Mario Martone by Giuseppe Martino, in Lucilla Albano, ed., *Il racconto tra letteratura e cinema*, Rome: Bulzoni Editore, 1997, pp. 132–36 (my translation).

9 Julia Kristeva, *Strangers to Ourselves*, trans. Lon S. Roudiez, New York: Columbia University Press, 1991, especially chapter 1, in which Kristeva, speaking of the silence of polyglots, ventures to put herself in the picture.

10 See Julia Kristeva, *La révolte intime: Pouvoirs et limites de la psychanalyse II*, Paris: Fayard, 1997, p. 8. *Revolt* contains the ancient roots of "wel" and "welu," which evolved into "volume" as well as "return."

11 See Maria Antonietta Macciocchi, *Cara Eleonora*, Milan: Rizzoli, 1993, a book devoted to Eleonora Fonseca Pimentel and her role in the Neapolitan revolution of 1799; and Jean-Noël Schifano, *Cronache napoletane*, trans. Carmen Micillo and Felice Piemontese, Naples: Tullio Pironti Editore, 1992.

12 See Iain Chambers, *Migrancy, Culture, Identity*, London: Routledge, 1994, pp. 104–7, in which he voyages "Under Vesuvius" and in which Naples is read as an example of "Cities without Maps"; and Chambers, *Border Dialogues: Journeys in Postmodernity*, London: Routledge, 1990.

13 Fabrizia Ramondino, *Star di casa*, Milan: Garzanti, 1991; and Ramondino, *In viaggio*, Turin: Einaudi, 1995.

14 Ramondino, *Star di casa*, p. 8 (my translation).

15 Ermanno Rea, *Mistero napoletano*, Turin: Einaudi, 1995, p. 265 (my translation).

16 Ibid., p. 122 (my translation).

17 For a discussion of the notion introduced by Kevin Lynch and developed by Fredric Jameson, see chapters 3, 7, and 8.

18 Michel Foucault, "What is an Author?," in *Language, Counter-memory, Practice*, ed. Donald F. Bouchard, trans. Bouchard and Sherry Simon, New York: Cornell University Press, 1977, p. 138.

19 Henri Lefebvre, *The Production of Space*, trans. Donald Nicholson-Smith, Oxford: Blackwell, 1992, p. 251.

20 In particular, the self-analytic discourse of theory, as Edward Said has claimed, must be understood within a dynamic relation to the place and time from which it emerges. See Edward Said, "Traveling Theory, " in *The World, The Text and The Critic*, London: Faber and Faber, 1984, pp. 226–47.

21 See, in particular, chapters 3, 7, and 8.

22 Donna J. Haraway, "Situated Knowledges," in *Symians, Cyborgs and Women*, New York: Routledge, 1991, p. 195.

23 Ibid., p. 190. On mappings, see also, Haraway, *Modest Witness*, New York: Routledge, 1997.

24 See, in particular, Homi K. Bhabha, "The World and the Home," *Social Text*, nos. 31–32, 1992, pp. 141–53; and Bhabha, *The Location of Culture*, London: Routledge, 1994.

25 See, among others, James Clifford, *Routes: Travel and Translation in the Late Twentieth Century*, Cambridge: Harvard University Press, 1997, in particular the chapter "Traveling Cultures"; and Clifford and George Marcus, eds., *Writing Culture: The Poetics and Politics of Ethnography*, Berkeley: University of California Press, 1986.

26 Clifford, "Notes on Travel and Theory," *Inscriptions*, no. 5, 1989, p. 177.

27 Annette Kuhn, *Family Secrets*, London: Verso, 1995, p. 28.

28 Trinh T. Minh-ha, *Woman, Native, Other: Writing Postcoloniality and Feminism*, Bloomington: Indiana University Press, 1989, p. 39.

29 See chapter 7 for a discussion of this theoretical imaging, built on a reading of the portrait of Theoria in Cesare Ripa, *Iconologia*, Rome: Heredi di Gio. Gigliotti, 1593.

30 Remo Bodei, *Geometria delle passioni: Paura, speranza, felicità: filosofia e uso politico*, Milan: Feltrinelli, 1991.

31 On the relation of space to "bodily lived experience," see Lefebvre, *The Production of Space*.

32 Walter Benjamin, review of Jakob Job, *Neapel. Reisebilder und Skizzen*, cited in Fabrizia Ramondino and Andreas Friedrich Müller, eds., *Dadapolis*, Turin: Einaudi, 1989, p. 89 (my translation).

33 Alfred Döblin, *Destiny's Journey*, ed. Edgar Pässler, trans. Edna McCown, New York: Paragon House, 1992, pp. 111–12.

34 Walter Benjamin, *Charles Baudelaire: The Lyric Poet in the Era of High Capitalism*, trans. Harry Zohn, London: Verso, 1973, p. 172. Benjamin quotes here from *Diary of a Madman* (Paris, 1907).

35 Svetlana Alpers, *The Art of Describing: Dutch Art in the Seventeenth Century*, Chicago: University of Chicago Press, 1983, pp. 126–27.

36 Ibid., p. 127.

37 Jonathan Crary reads these two portraits as representing the paradigm of the Cartesian camera obscura, where the room becomes a site of projection of the world, to be examined by the mind. See Jonathan Crary, *Techniques of the Observer: On Vision and Modernity in the Nineteenth Century*, Cambridge: MIT Press, 1990, pp. 43–46.

38 See Svetlana Alpers, "The Strangeness of Vermeer," *Art in America*, May 1996, p. 68. On Vermeer and cartography, see also James A. Welu, "Vermeer: His Cartographic Sources," *Art Bulletin*, no. 57, 1975, pp. 539–47; and Welu, "The Map in Vermeer's *Art of Painting*," *Imago Mundi*, no. 30, 1978, pp. 9–30. See also Daniel Arasse, *Vermeer, Faith in Painting*, trans. Terry Grabar, Princeton: Princeton University Press, 1994.

39 Hiroshi Sugimoto's statement is cited from the wall text of his exhibition at the Metropolitan Museum of Art in New York, 21 November 1995–14 January 1996. See chapters 1, 9, and 10 for further treatment of these pictures.

40 Roger Caillois, "Mimicry and Legendary Psychasthenia," *October*, no. 31, Winter 1984, pp. 17–32.

41 See chapter 7.

42 See *Louise Bourgeois: Femme Maison*, Chicago: The Renaissance Society at the University of Chicago, 1981 (exhibition catalogue). On these topoi in Bourgeois's art, see, in addition to the works mentioned earlier in this chapter, Lucy Lippard, "Louise Bourgeois: From the Inside Out," in *From the Center, Feminist Essays on Women's Art*, New York: Dutton, 1976; and Christian Leigh, "Room, Doors, Windows, Making Entrances and Exits (When Necessary): Louise Bourgeois's Theatre of the Body," *Balcon*, nos. 8–9, 1992, pp. 142–55.

43 Louise Bourgeois, *Album*, New York: Peter Blum, 1994. See also Bourgeois, *Destruction of the Father/Reconstruction of the Father: Writings and Interviews 1923–1997*, Cambridge: MIT Press, in association with London: Violette Editions, 1998. See also Jerry Gorovoy, *Louise Bourgeois, Blue Days and Pink Days*, Milan: Fondazione Prada, 1997 (exhibition catalogue); and *Louise Bourgeois: sculptures, environments, dessins, 1938–1995*, Paris: Musée de l'Art Moderne de La Ville de Paris, 1995 (exhibition catalogue), all including further bibliographical reference.

44 Rosi Braidotti, *Nomadic Subjects: Embodiment and Sexual Difference in Contemporary Feminist Thought*, New York: Columbia University Press, 1994, p. 14.

45 Chantal Akerman, audio recording from the installation *Bordering on Fiction: Chantal Akerman's "D'Est,"* organized by the Walker Art Center, Minneapolis; exhibited at the Jewish Museum, New York, 23 February–27 March 1997.

Color Plates